ABOUT THE AUTHOR

David Tovey was born in 1953 and was educated at his father's preparatory school, Tockington Manor, near Bristol, and at Clifton College. He won a scholarship to read Jurisprudence at Pembroke College, Oxford and qualified as a solicitor in 1979. Whilst practising law in London and Cheltenham, he developed an intense interest in the St Ives art colony, as his great-grandfather, William Titcomb, was one of the early settlers in the colony. In 1996, David resigned from his law partnership and completed a three year degree in History of Art at the University of Warwick. In 2000, he published *George Fagan Bradshaw - Submariner and Marine Artist - and the St Ives Society of Artists*, which was the catalyst for this Exhibition. He has spent the last three years locating work for this show and researching further into the lives of the 300 artists that were involved with the Society in its first 25 years. In addition, he has also curated for Penlee House in 2003 an exhibition devoted to his great-grandfather, *W.H.Y.Titcomb : A Newlyner from St Ives*, and has published an exhibition catalogue and biography of Titcomb, divided into two parts

W.H.Y.Titcomb : A Newlyner from St Ives, dealing with the years 1858-1908
(Wilson Books, 2003 ISBN 0 9538363-2-0)
and
W.H.Y.Titcomb : Bristol, Venice and the Continental Tours, covering the years 1909-1930
(Wilson Books, 2003 ISBN 0 9538363-1-2)

What the critics said about David Tovey's original work

George Fagan Bradshaw - Submariner and Marine Artist - and the St Ives Society of Artists
(Wilson Books, 2000 ISBN 0 9538363 0 4)

"This is one of those books that, almost before one is aware of it, half the pages have been devoured. It is really a superb tale... [Bradshaw] is portrayed here so expertly that much of his angst is felt by the reader too. An enthralling read about a man who could trace his forebears back to Charlemagne." - Bill Simpson, Art Critic, **Western Morning News**

"His research is exceptional. A tribute to the traditionalists that paved the way for the modernists."
- Frank Ruhrmund, Art Critic, **The Cornishman**

R 759.2 S

Paperback edition first published in 2003 by
WILSON BOOKS
11-13 Mill Bank, Tewkesbury, Gloucestershire GL20 5SD
(01684 850898)
Email : w.books@millavon.fsnet.co.uk

Hardback edition first published in 2003 by
HILMARTON MANOR PRESS
Calne, Wiltshire, SN11 8SB
(01249 760208)
Email : mailorder@hilmartonpress.co.uk

Copyright - D.C.W.Tovey

A catalogue record for this book is available from the British Library
ISBN for the paperback edition 0 9538363 3 9
ISBN for the hardback edition 0 904722 38 4

Printed and bound in England by Rowe the Printers, Hayle, Cornwall, TR27 4QZ

Creating a Splash
The St Ives Society of Artists
The first 25 years (1927-1952)

CONTENTS

AUTHOR'S NOTE

The Exhibition, for which this catalogue has been produced, was prompted by the interest aroused in the St Ives Society of Artists by my book, *George Fagan Bradshaw and the St Ives Society of Artists*, published in 2000. Initially, it had been my intention that that book could serve as a form of catalogue to the Exhibition, as it contains not only a detailed history of the St Ives Society of Artists ("STISA") from its formation until 1960, the date of Bradshaw's death, but also a plethora of illustrations of work by members of the Society, including many paintings which feature in this Exhibition. However, that book, not unnaturally, concerned itself to a significant extent with Bradshaw's own involvement with STISA and only relatively brief biographical details were able to be included in respect of its many other members. Furthermore, in my search for works to be included in this show, I have come across so much more information about member artists and their works that I felt it would a shame if all artists involved in the incredible success of STISA could not be feted appropriately, particularly as information on many of them is scarce and difficult to locate. Nevertheless, I am extremely conscious of the need to avoid repetition of facts and quotations contained in the Bradshaw book and have therefore approached the Society's development from a number of different angles in this catalogue. I concentrate here on the make-up of STISA and the manner in which it changed or was manipulated as its reputation grew and on the strengths and weaknesses of the various sections within it - e.g. oil versus watercolour and 'black and white', landscape and marine versus still life and portraiture, etc. Given that there is a general perception that representational art stood still during this period, I also analyse the stylistic trends and innovations that can be detected in members' work.

It is very difficult in one Exhibition to cover twenty-five years of development and, accordingly, I have reproduced and commented upon a series of the catalogues of STISA's successful touring shows, so that a better feel can be gauged of the make-up of individual exhibitions. As regards the intricate detail of STISA's formation, progress and the fatal split with the moderns, this has already been set out in the Bradshaw book, to which reference should be made for minutes, correspondence and newspaper articles, and here I merely summarise such developments, with appropriate comment.

A separate catalogue also affords the opportunity of including images not only of many of the works included in the Exhibition but also of further works for which, unfortunately, there is no space. Again, I have taken the conscious decision not to illustrate in the catalogue more than a couple of works that were included in the Bradshaw book so that as many as possible of the works on show are illustrated somewhere. Where exhibits are illustrated in the Bradshaw biography, a footnote to this effect has been included in the section dealing with such work.

I also highlight in the catalogue a number of different areas where the respect accorded this group of artists can be demonstrated. The impact that the artists had on tourism to Cornwall, by virtue of depictions of Cornish beauty spots being hung on Gallery walls around the country, might be felt to be limited, but postcards and fine art prints of their works brought the county's scenic attractions to a much wider audience, who were not only entranced by the views depicted but also intrigued by the artists themselves. The collection of the National Railway Museum also indicates just how many railway posters were commissioned from STISA members for the promotion not merely of west country lines but of the whole network. Illustrated travel books were also written by several members on behalf of railway companies. Another indication of their status at the time is the number of books on art technique published by members, some of which became standard works and remained in print for up to fifty years. Yet another indication of their renown is the extent to which members were familiar to the public through their book illustrations and, in the 1940s, STISA acquired some members whose reputations were based principally on their work as illustrators. These are all new areas of research that I discuss in the catalogue.

EXHIBITION AND PRINCIPAL CATALOGUE SPONSOR

I am deeply indebted to Graham Bazley of W.H.Lane & Son, the Penzance auctioneers and valuers, not only for being sole sponsor of this touring exhibition but also for being the principal sponsor of this catalogue. In addition, he has made available many photographs of works sold at the auction house for use as illustrations. His support for the project at all times has been immensely uplifting and my own knowledge of Cornish art is constantly expanded due to the string of fine works that regularly pass through his showrooms.

OTHER CATALOGUE SUPPORTERS

I am also very grateful to the following who have kindly supported the publication of this catalogue and, in particular, the Society itself for its most generous contribution. There were times when the project seemed too vast and expensive to bring to fruition but such expressions of support greatly assisted my resolve.

The St Ives Society of Artists (see feature on p.10)
Michael Wood Fine Art (see feature opposite p.168)
The Mill Gallery, Ermington (see feature on p.4)
The Lander Gallery, Truro (see feature on p.4)
Nina Zborowska (see feature opposite p.153)

David and Mercia Romeo, Cotswold Surveys
Lionel Aggett, artist and current member of STISA
Judy Joel, artist, and Curator of STISA
Paul Joel, production designer - film and television
Sidney Lee, artist and current member of STISA
Nicola Tilley, artist and current member of STISA

ACKNOWLEDGEMENTS

I am of course indebted to many, many people, without whose assistance, this Exhibition and catalogue would never have occurred. It is, of course, sad that an Exhibition devoted to STISA should not be mounted in St Ives but, in its current incarnation, Tate, St Ives has no interest in St Ives representational art. That said, in my travels around the public Art Galleries of Britain, there are few places that exude the wonderful ambience of Penlee House Gallery and Museum, Penzance, and I am truly delighted that Alison Lloyd, its Director, agreed to host the Exhibition. The interest that this long overlooked generation of Cornish artists can generate is amply illustrated by the fact that the tour will take in six venues and I am particularly pleased that it will be touring Lincoln, Hereford and Sunderland, three venues that welcomed STISA touring shows in the 1930s and 1940s.

I have bombarded Curators of many Art Galleries around the country with long lists of STISA members in an attempt to locate suitable works for inclusion and I am infinitely grateful to those who bothered to reply - by no means a certainty - and, in particular, those who went to great lengths to produce surprisingly long lists of relevant work. Nevertheless, it was, on occasion, depressing to discover that some Galleries had no idea what work they held, where it was or in what condition it was in, and that photographic records were largely non-existent. The efficiency of the Art Galleries in New Zealand and Australia that I contacted put many of ours to shame. Lack of funding and low staff morale seem prevalent.

Many private collectors have welcomed me into their homes and have been delighted to show me their prized acquisitions and to share their own knowledge about the artists. It has not been possible to include as many of these works as I initially thought, due to the quantity and quality of other work being located and the need to restrict the total number of exhibits. Many relatives of artists have helped me to track down important works, have lent me precious family papers and have made available family photos. I cannot thank them enough.

Particular thanks are due to the following:-

Rosalind Adams, Jane Alexander, John Allan (Mandell's Gallery, Norwich), Roger and Sue Allen, Irene Allen (St Ives Arts Club), Barbara Anglicas (Rochdale A.G.), Janet Axten, Wilhelmina Barns-Graham, Graham Bazley (W.H.Lane & Son), Bearne's, Exeter, Hugh Bedford, Andrew Bell, Edward Bell, Rhona Bell, Julia Berlin, Pauline Birtwell (Blackburn A.G.), Lady Bolitho, David Bradfield, Pep and John Branfield, David Capps, Michael Carver (Royal Cornwall Polytechnic Society), Andrew Charlesworth (Huddersfield A.G.), Michael Child (Messum Galleries), Barbara Cole (National Railway Museum, York), Natasha Conlan (The Museum of New Zealand, Wellington), Richard Connor (Honiton Galleries), Peter Cotterill (Much Wenlock Fine Art), Roger Cucksey (Newport A.G.), Lord Dunsany;

Simon Edsor (Fine Art Society), Helen Entwisle, Magdalen Evans, Pat Fleetwood-Walker, Paul Flintoff (Grundy A.G., Blackpool), Eric Ford (Kenulf Fine Art, Stow-on-the-Wold), Peter Fox (Gallery Oldham), Letitia Frazer, Sir Terry Frost, Keith Gardiner, Pat Garnier, Amanda Gawler, Norah Gillow (William Morris Gallery), Anthony and Sonia Green, Iris Green,

Jon Grimble (Market House Gallery, Marazion), Irving Grose (Belgrave Gallery), John Haddock, Audrey Hall (Walker A.G., Liverpool), Nicholas Halliday, Jean Haylett, Viv Hendra (Lander Gallery, Truro), Olivia Hicks, Douglas Hill, Mrs J. Hill-Derksen, Christine Hopper (Cartwright Hall, Bradford), Barry Hughes, Rowan James, Eileen Jellis (Perth), David Fraser Jenkins (Tate Gallery), Paul and Judy Joel, Laura Jocic (Auckland A.G.);

Adam Kerr, Joan King, Mary Kisler (Auckland A.G.), Charles Lane, Wharton Lang, Sheila Lanyon, Martin Lanyon, David Lay (Penzance Auction House), Sarah Lay, Charles Law, Victoria Law (Richard Green), Mary Leppard, Dave Lewis, Moira Lindsay (Walker A.G., Liverpool), Jennifer Lowe (Cornwall County Council), Francis Marshall (Harris A.G., Preston), Robert Meyrick, Brian Mitchell, Hannah Neale (Abbot Hall A.G.), Peter Ogilvie (Salford A.G.), Mrs J.F.Palmer, June and Lewis Passow, Anne Pilling, Katia Pisvin (Ashmolean, Oxford), Alison Plumridge (Leamington A.G.), Andy Pollard, Margaret Powell, Geoff Preece (Doncaster A.G.), John Preston (St Austell Brewery), Dr Richard Pryke;

Margaret Read, Janice Reading (The British Museum), Roy Ray, J.H.Riley, Barbara Robinson, Hugh Robinson, Sonia Robinson, Simon Rogers, Dave and Mercia Romeo, Frank Ruhrmund, Geoffrey Sandys, John Schofield, Mary Schofield, Peter Scrase, Hyman Segal, Jennifer Shaw (Bolton A.G.), Jennifer Shimon, Tessa Sidey (Birmingham A.G.), Colin Simpson (Williamson A.G., Birkenhead), Janet Skea, Dr Roger Slack, Brian Smart, Michael Borlase Smart, Neil Smith (South Devon Railway Trust), Dr David Spackman, David Staunton, Chris Stephens (Tate Gallery), Brian Stevens (St Ives Museum), Brian Stewart (Falmouth A.G.), Sheena Stoddard (Bristol A.G.), David Swindell, G.E.Sworder and Sons;

Clare Taylor (Swindon A.G.), John F. Tonkin, Chris Trant (Mill Gallery, Ermington), Ruth Trotter (Laing A.G., Newcastle), Keith Turner, Paul Vibert, Tim Walker, Louise Millar Watt, Mary Millar Watt, Norma Watt (Norwich A.G.), Jessica Weale, Genevieve Webb (Dunedin A.G.), Angela Weight (Imperial War Museum), Marion Whybrow, John Wilcox, John Wileman, N. Wilin-Holt, David Wilkinson (Book Gallery, St Ives), Cath Willson (Hereford A.G.), Bryen Wood (Bushey A.G.), Michael Wood (Michael Wood Fine Art, Plymouth), Austin Wormleighton and Nina Zborowska.

Special thanks are due to all the staff at Penlee House, particularly to Alison Lloyd and Katie Herbert, Mario and Paul, Zia, Emma, Julia and Sandra.

I have attempted to locate relatives of all artists whose work is reproduced herein for the requisite copyright consent and am grateful to all who have kindly given such consent. It has not proved possible in all cases to locate the relevant persons, despite reasonable endeavours. I trust that the additional publicity afforded such artists is welcome.

Finally, only my partner, Sherry, knows quite how much effort has gone into this exhibition and publication. Her support, in good and bad moments, has been unflinching and I cannot thank her enough.

ABBREVIATIONS

IS	International Society of Sculptors, Painters and Gravers	RSA	Royal Scottish Academy
		RSMA	Royal Society of Marine Artists
NPS	National Portrait Society	RWA	Royal West of England Academy
PS	Pastel Society	RWS	Royal Society of Painters in Watercolour
QMDH	Queen Mary's Doll's House	SGA	Society of Graphic Art
RA	Royal Academy	SM	Society of Miniaturists
RBA	Royal Society of British Artists	SMA	Society of Marine Artists - later RSMA
RBC	Royal British Colonial Society of Artists	SSA	Society of Scottish Artists
RBS	Royal Society of British Sculptors	SSWA	Scottish Society of Women Artists
RCA	Royal Cambrian Academy	STISA	St Ives Society of Artists
RCPS	Royal Cornwall Polytechnic Society, Falmouth	SWA	Society of Women Artists
RE	Royal Society of Painter-Etchers and Engravers	SWE	Society of Wood Engravers
RHA	Royal Hibernian Academy	WIAC	Women's International Art Club
RI	Royal Institute of Painters in Watercolours		
RMS	Royal Society of Miniature Painters	A	Associate
ROI	Royal Institute of Oil Painters	P	President
RP	Royal Society of Portrait Painters	VP	Vice-President

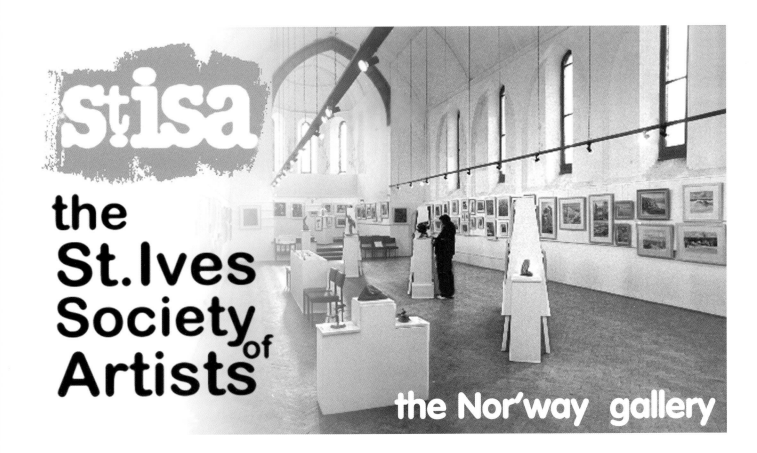

stisa

the St.Ives Society of Artists

the Nor'way gallery

The Society was founded in 1927. Its annual exhibition is shown in the Nor'way Gallery, the main body of the former Mariners Church. This imposing building, in the heart of the old quarter of St. Ives, now provides a large well-lit gallery, visited by over 20,000 people each summer. There are fifty full and associate members, exhibiting over two hundred works of art in the gallery at any one time, which are replaced as sold, making an ever changing show.

The Nor'way gallery is open from March to early November, Monday to Saturday, and Bank Holiday Sundays.

The building dates from 1905. Built as an outpost of the parish church, it became redundant and has been the home of the society since 1945.

The Mariners gallery is in the lower part of the building, offering the best show space available for hire in the area. It is the venue for single artist and group exhibitions throughout the season.

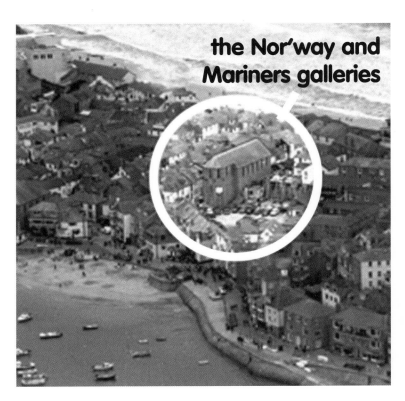

the Nor'way and Mariners galleries

Norway Square, St Ives, Cornwall TR26 1NA

telephone: 01736 795582
email: gallery@stisa.co.uk
website: www.stisa.co.uk

INTRODUCTION - CREATING A SPLASH

Artists first began to settle in St Ives in 1885 and the first century of the colony can usefully be divided into three periods. The first period, extending to the end of the Great War, saw the colony develop an international reputation as a centre for marine and landscape art, with a number of its residents subsequently becoming Royal Academicians. Although during the inter-war period, resident artists did not gain such high individual honours, an astonishing unity of purpose developed within the colony and they promoted their art so well that the colony became much more widely known than before. This was the great achievement of STISA, which was formed in 1927 and which enjoyed its heyday in the 1930s. This second period really extended until 1949, the year when the tensions that had been building up between traditionalists and modernists within the Society finally came to a head. The third period saw the success of the modernists on both national and international stages in the 1950s and 1960s, although historians of this movement would date its commencement to 1939, the year that Ben Nicholson and Barbara Hepworth moved to Cornwall. This Exhibition, therefore, concentrates on the second period - at the moment, the least well known - but major artists from all three periods are represented in the show, for they all played crucial roles in the success that STISA enjoyed in its first quarter century.

Ever since the Arts Council in the 1950s gave grants solely to artists embracing modernist movements, representational painters have struggled to compete on a level playing field. The attitude of Tate, St Ives, since its establishment a decade ago, has only exacerbated the situation as it continues to promote the St Ives modernists within its collection, whilst ignoring totally the first 50 years of the colony. As a result, the achievements of STISA have, to date, been largely overlooked, and historians of the St Ives modernists tend to dismiss the inter-war years in St Ives as a period when St Ives was populated by second-rate, traditional artists, who proved incapable of embracing modern trends. What the records show, however, is that, by uniting together and sharing common goals, this group of professional artists transformed St Ives from a colony that was divided and moribund into a vibrant community, with a Society of Artists that was in demand the length and breadth of the country, and even abroad. They created quite a splash, in fact, and they achieved this not only by producing attractive, technically accomplished and often innovative art but also by good organisation, forceful leadership and inspired marketing and publicity. Initially by offering honorary memberships, and subsequently by virtue of their success, they attracted to the Society any well-known artist who had at some juncture had links with Cornwall. Within a short time, therefore, STISA could boast that six Royal Academicians were members. This soon rose to eight and, all told, during the twenty-five year period covered by the Exhibition, no less than fourteen Royal Academicians were involved with the Society. The roll of members, in fact, makes the Society fully representative of the first seventy years of Cornish art, as it includes

(i) the surviving members of the first generation of St Ives artists,
(ii) students from the Olsson/Grier/Talmage Schools of Painting,
(iii) the surviving members of the Newlyn School,
(iv) students from the Forbes and Harvey/Procter Schools of Painting,
(v) the second generation of Newlyn/Lamorna artists and, of course,
(vi) the then current residents of the Duchy.

With such a membership, annual RA exhibitions soon contained at least 70 works by members and, in 1938, the figure touched 80. This resulted in the Society being noticed in London art circles and by Curators of Public Art Galleries and soon STISA was inundated with requests for touring shows. These, in turn, brought more publicity, more members and improved standards. One show in 1936 attracted an astonishing 75,000 visitors. Within such an environment, many of the less well-known professional artists blossomed and one of the surprising features of the touring exhibitions is that the works purchased by host Galleries for their permanent collections were not by the big names but by artists like Bernard Ninnes and Thomas Maidment, whose work now is little known. The establishment of a School of Painting in St Ives in 1938 led to an influx of students, particularly during the War years, and many of these artists were to contribute to the next phase of the colony's development.

Emerging from the War with Ben Nicholson and Barbara Hepworth within the ranks led to tensions with the older traditional artists, which exploded after Borlase Smart's death in 1947, and, in 1949, the moderns resigned *en masse* and formed the Penwith Society. This, coupled with a general trend away from representational art and the death and departure of many long-standing members, meant that, by 1952, STISA was facing an uncertain future. Nevertheless, the continuing appeal of St Ives as an art colony is reflected by the fact that both STISA and the Penwith Society are still flourishing, albeit the heights reached by STISA in its initial 25 years have not been seen again.

It is not anticipated that any historians of British art during the twentieth century will feel the need to adjust their analyses to any significant extent as a result of this Exhibition but nevertheless STISA, in its first quarter century, did constitute a phenomenon - and a popular and successful phenomenon at that. Quite apart from the artistic achievements of individual members, its

promotional activities ensured the future of Britain's most important art colony. As Peter Lanyon accepted, the dramatic rise in profile of the colony during the 1930s not only attracted young artists to the colony but also laid the base for the later success of the modern movement. Furthermore, STISA's impact on tourism to Cornwall was acknowledged at the time to be immense. Given the interest that this Exhibition has already generated and the huge number of visitors to Tate, St Ives who expect to see the sort of depictions of Cornwall incorporated in this Exhibition, rather than the abstract work of the moderns, there is clearly great scope for the further promotion of early St Ives representational art. It is too early, perhaps, to talk of a Gallery devoted just to such art but I am delighted that Penlee House Gallery and Museum, Penzance has agreed to broaden its remit so that it will specialise not only in the early Newlyn and Lamorna artists but also in St Ives representational painters. It is time for the artists of STISA to create a splash again.

THE ART COLONY AT ST IVES

Herbert Truman, one of the artists responsible for framing the proposals for the formation of STISA, outlined the principal attractions of the art colony in 1926:-

"The advantages possessed by St Ives, as a centre for artists, are many. The great variety of subject matter includes cottage architecture, harbour and coast scenery, seascape, moorland, boat and figure subjects in correct environment. The town is splendidly equipped with large well-lighted studios, situated to give excellent vantage points. There is a brilliance of light and colour, even on grey days. The weather effects are beautiful especially during winter and the climate is healthy and mild, making sketching possible during the greater part of the year. It is served by an agent for the transport of pictures to and from London and provincial exhibitions and also for artists' materials. Lanham's Gallery, although small, is well-known and a great asset. Perhaps its one disadvantage is its distance from London."[1]

Ever since the railway had opened Cornwall up to visitors, artists had been drawn to the natural attractions of St Ives and, in the mid-1880s, they began to settle in the town. Whereas Newlyn attracted figure painters who painted the fisherfolk at work and at leisure, St Ives seemed a magnet for landscape and marine painters and the establishment in 1895 by Julius Olsson (q.v.) and Louis Grier of a School of Painting, with an emphasis on marine work, merely encouraged this trend. By the turn of the century, many of the artists associated with the Newlyn School had moved away or changed style, and the St Ives fraternity, led by Olsson, Arnesby Brown (q.v.), Algernon Talmage (q.v.) and Moffat Lindner (q.v.), began to attract more attention from the London critics. Other landscape artists like Arthur Meade (q.v.) and Fred Milner (q.v.) settled in the town and there was a constant stream of talented students from all over the world that came to train under Olsson, Grier and Talmage. However, the First World War disrupted the artistic community immensely. Many artists left to serve their country. Those that were too old or were ineligible found it hard to continue to paint. Supplies were short, the ban on outdoor sketching was rigidly enforced and the horrors of the War often stilted the muse. The inflow of students dwindled and Olsson had packed up and left for London by 1915. Between 1916 and 1918, Show Day, the highlight of the artistic calendar, when works to be submitted to the RA were exhibited in artists' studios, was cancelled and the local paper contains no reviews of art exhibitions at all. It was a bleak period, with considerable financial hardship.

When peace did eventually come, tentative steps were taken to continue old traditions but there was a distinct feeling that the colony was a pale shadow of its former self. All members or associates of the RA had left, Grier died in 1920 and William Fortescue and William Cave Day were ailing. The only members of the first generation of artists still living in St Ives and continuing to be successful at the RA were Moffat Lindner, Arthur Meade, Fred Milner, Alfred Hartley (q.v.) and Mabel Douglas (q.v.). However, a significant newcomer was Charles Simpson (q.v.) and some hope was offered by the School of Painting which he had set up with his wife, Ruth, in 1916. This attracted George Bradshaw (q.v.) and his future wife, Kathleen Slatter (q.v.), and two former Olsson students, John Park (q.v.) and Borlase Smart (q.v.) also settled in the town. Smart, who had previously been art critic for the *Western Morning News*, made an immediate impression, with his reviews for the local paper of all art shows in the colony, but he bemoaned the fact that the work of amateurs was being hung next to that of the professionals to adverse effect.

This was a period when any advance seemed to be offset by a reverse. Some of the artists who had featured strongly in the exhibitions of the immediate post-war years, such as Claude Barry (q.v.), Marcella Smith (q.v.) and Louis Sargent (q.v.) moved away. In 1922, the Hanging Committee responsible for organising the exhibitions at Lanham's Galleries, then the principal exhibition venue, was forced to issue a circular, pleading with artists to send better work to the local exhibitions and not to send all their best work to London. The biggest blow, though, occurred in 1924, when Charles and Ruth Simpson closed their School and moved to London. The artists did manage to pull together to organise an Exhibition in Cheltenham in 1925 but the departure of Borlase Smart to Salcombe that year removed the most potent dynamic force from their midst. Accordingly, when George Bradshaw and newcomer Herbert Truman reviewed the state of the colony in 1926, they became profoundly depressed. It seemed to them to be completely moribund.

[1] *St Ives Times*, 14/1/1927.

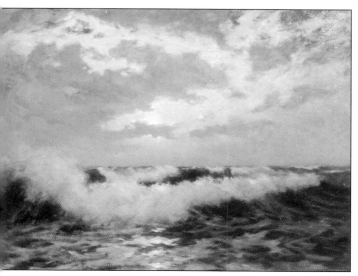

Fig. 1-1 Julius Olsson *Moonlit Breakers* Fig. 1-2 Herbert Truman *St Ives Harbour*

THE FORMATION OF THE SOCIETY

A number of problems were highlighted in the discussions that ensued. Whilst no-one disagreed that there were fewer artists of standing now resident in the town, this factor had been exacerbated by the lack of any *esprit de corps*. The top artists operated independently, using their own London agents and connections, and did not assist other artists with constructive criticism and tips on technique. There was no encouragement for students or for the other artists striving to make their way. It was felt that the artists should work together more to promote and market the colony as a whole and to raise general standards. It was hoped that this would attract other artists of repute to join the Society and that, in due course, the Society would produce work that "mattered in Artistic circles". Nevertheless, no-one was terribly confident that the formation of a Society would achieve anything. The proposal was passed simply because *anything* was better than the apathy that had currently taken hold.

THE EARLY YEARS

The first year of the Society was not a great success. The main event was a Retrospective Exhibition, designed to demonstrate to both artists and public alike the standing of the colony in the past. Forty-one paintings were gathered together and these included works by many of the great names of the past as well as good examples of the work of the current resident artists. The low ebb to which the colony had sunk can be gauged by the fact that the number of visitors to this show - two hundred - was considered satisfactory. The monthly meetings of the artists, however, were not well attended and, at the first A.G.M., a motion was put forward, supported even by Bradshaw, that the Society should terminate. This was defeated and a new Committee installed, with a mandate for more positive action. Immediately, some of the major issues were addressed. Firstly, steps were taken to secure for the Society its own Gallery to act not only as an exhibition venue for the sole use of the Society but also as a headquarters, meeting and lecture room. The space secured was 5, Porthmeor Studios, Olsson's former studio, and this was soon adapted to the Society's requirements. Olsson himself was invited to perform the opening ceremony. Membership subscriptions were raised to cover the additional costs and the artists took turns to curate exhibitions until a permanent Curator was appointed in May 1929.

It had always been the intention to attract to the Society high profile artists from the past but little effort had been made in this direction in the first year. Now, invitations to become honorary members were sent out to the Royal Academicians Adrian Stokes, Arnesby Brown, Julius Olsson and Stanhope Forbes and, when these were accepted, further invites were sent to Algernon Talmage and later Terrick Williams. Invitations were also extended to prominent artists in West Cornwall to exhibit work with the Society, and Lamorna Birch, Thomas Gotch, Henry Tuke and Dod and Ernest Procter duly obliged. Joan Manning-Sanders (q.v.), who, at the age of 14, had caused such a stir at the RA in 1928 with her painting, *The Brothers*, depicting two fishermen playing draughts in a Sennen Cove pub (see Fig. 3M-4), was also invited. Other artists with Cornish connections to contribute to the first Exhibition in the new Gallery included Fred Hall (q.v.), Frank Gascoigne Heath (q.v.), John Gutteridge Sykes, Alethea Garstin (q.v.), Billie Waters (q.v.) and Reginald and Mrs Tangye Roberts (q.v.).

Publicity and marketing initiatives were also pursued with renewed vigour. The first Committee had produced a brochure about the Society, which contained a short history of the colony and a list of members, with a map drawn by Francis Roskruge indicating the location of the main studios. This was now distributed to hotels, the Great Western Railway and to members of the Press attending Show Day. Posters and handbills were also designed and circulated to hotels and local shops. Advertisements were

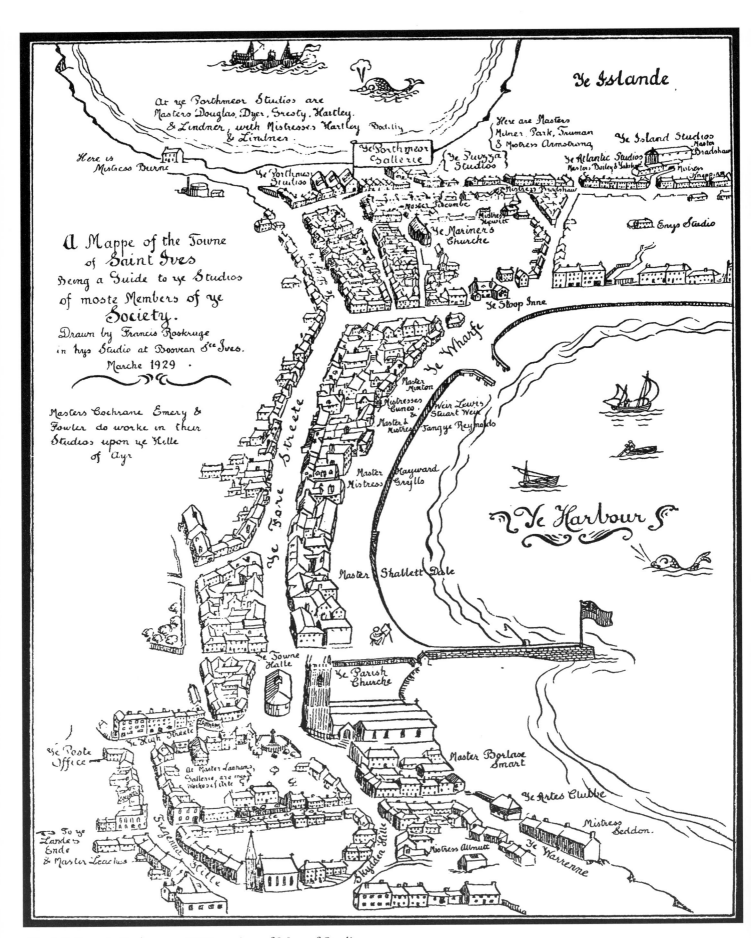

Fig, 1.3 Francis Roskruge - 1929 version of Map of Studios

placed in *The Year's Art* and *The Artists' Almanack* and a slide produced for use in the local Cinema. Any celebrities staying in town were given special invitations to the Society's current exhibition. Reporters were given guided tours of Show Days and exhibitions, during which innovatory or outstanding work was pointed out, and care was always taken to mention and welcome new arrivals.

In order to ensure that the technical expertise that had been acquired by some of the senior members was shared, a series of lectures were organised, which proved very popular. There is little doubt that these encouraged artists to try different media and to experiment with different techniques. Smart was also aware of the importance of framing and had the London picture framer, Robert Sielle, give a talk on the subject. Smart went on to ban the use of black frames and deplored the use of gold mounts for watercolours; both had been traditional practices in the past. A list of known lectures given in the early years of the Society is contained in Table A.

Table A - Lectures

28/3/1928	Alfred Bailey	*The History of Painting in Watercolours*
30/5/1928	John Park	*Painting in Oils*
28/11/1928	Alfred Hartley	*Etching*
28/3/1929	Borlase Smart	*Preparation of Canvases, Use of Media, Colour*
24/4/1929	Moffat Lindner	*Water Colour Painting*
30/10/1929	Francis Roskruge	*Aquatint Demonstration*
27/11/1929	Borlase Smart	*The Art Of Stencilling Applied to Home Decoration*
26/2/1930	Bernard Leach	*The Training of an Eastern Artist*
18/7/1930	Borlase Smart	*Art*
1930	Moffat Lindner	*Reminiscences of A Sketching Tour*
12/2/1931	Lamorna Birch	*Water Colour Drawing*
26/2/1931	Borlase Smart	*Art Criticism and Press Notices*
17/12/1931	Borlase Smart	*Cliff Painting in Oil Colours & Composition*
3/3/1932	R.Morton Nance	*Luggers*
24/6/1933	Borlase Smart	*The History of Cornish Art*
2/1934	A.W.Andrews	*Climbing the Cornish Cliffs with a Camera*
4/1934	Robert Sielle	*The History of Frames and their proper application to Pictures*
1935	Bernard Leach	*Japan Revisited*
2/1936	R. Morton Nance	*15th Century Shipping*

THE DEPRESSION

Just as the Society was beginning to blossom, economic circumstances deteriorated alarmingly and sales were hard to come by. STISA responded by designating the 1929 Winter Exhibition as a Five Guinea Exhibition, with all works to be priced under that figure. A note was circulated to emphasize that, whereas small works were acceptable, poor quality ones were not. Nevertheless, the Society did manage to make significant progress through 1929 and 1930, with sales up 66% in 1930.[2] Total membership increased from 66 in 1927 to 162 by 1930, of which nearly one hundred were artists. Sales did take a dip in 1931 but the Society responded bravely by incurring the additional expense of putting on touring exhibitions in order to bring members' work to the attention of a wider public. It was a completely novel concept that Public Art Galleries should host shows devoted to a single colony of artists but, in the depressed conditions of the time, some Curators were won over by Borlase Smart's enthusiasm. Furthermore, as the increase in the membership had led to exhibitions becoming crowded, the Society also took on the adjacent Porthmeor studio as an extension of its Gallery space. Subscriptions were doubled but the initial pain proved well worthwhile, for sales too almost doubled in 1932, a year when most artists were suffering dreadfully. No wonder Smart was able to boast at the next AGM that artists would now *have* to come to St Ives.

[2] This was probably due to the purchases made on behalf of the Mackelvie Collection - see STISA in the Dominions.

THE ARTISTS (1927-1939)

The Organisers

The artists had no doubt who should act as the first President of the new Society. Moffat Lindner, then aged 75, was held in such respect by his fellows that the formation of the Society would not have got off the ground unless he had been strongly in favour and his standing in the art world and his friendship with many of the leading St Ives artists of the past marked him out as the obvious candidate. However, he was no mere figurehead. He made a conscious effort to attend all committee meetings, often hosting them in his own house, and was active in recruiting both artist and associate members. His experience and advice was much appreciated and he helped practically by serving on hanging committees and performing duties at opening ceremonies. There was never any suggestion of an alternative candidate and he was re-elected as President each year until 1945, despite his advancing years and the failing health which dogged him in the 1940s. He took great interest and pride in the burgeoning success of the Society and described his involvement as one of the greatest pleasures of his life. Financially, the Society also owed much to Lindner, particularly as he purchased the freehold of the whole block of Porthmeor Studios in 1929 and made available, at a reasonable rate, two of them for the Society's Exhibition Gallery.

In its first uncertain year, the Society had two joint Secretaries - George Bradshaw and Francis Roskruge, although Bradshaw seems to have assumed the principal role. Unable to remove the cloak of apathy that hung round many of his fellow artists, he was replaced in 1928 by the efficient and conscientious Alfred Cochrane. The principal organisational duties during 1928 and 1929 were assumed by Herbert Truman, one of the first Committee's strongest critics, along with Arthur Hayward and Hugh Gresty. Pauline Hewitt was also very involved in 1928 but, in 1929, she was replaced by Borlase Smart, who had returned to St Ives at the beginning of 1928. It was not long before Smart's energy and enthusiasm ensured that he was in charge of the Society's direction. Truman, a slightly prickly individual, was voted off the Committee in 1930 and Hayward and Gresty left the Committee in 1931. Hayward was co-opted on to the Committee during 1931 but both he and Gresty left the Society in 1932, indicating a possible personality clash with Smart.

Roskruge assumed the role of Treasurer in 1928 and retained this office until 1939. Alfred Cochrane was re-elected Secretary each year until he was forced through ill-health to resign in 1933. Smart took over and retained the position until his death in 1947. The principal officers therefore changed very little during the Society's first twenty years.

The balance of the Committee of seven changed on a yearly basis. Bradshaw was restored to the Committee in 1930 and was re-elected most years, becoming Smart's right-hand man throughout the successes of the 1930s. Bernard Ninnes, who was later to become Chairman, served for four consecutive years from 1934 and Shearer Armstrong, who was to take over the Treasurership in 1940, was elected for three consecutive years from 1935. Millar Watt, the cartoonist, who only settled in St Ives in 1935, served for five years between 1936 and 1943. Many other artists also served for one or two years, indicating a general willingness to become involved, but there is no doubt that it was the vision of Borlase Smart that dictated the direction that the Society took. He instigated many of the publicity initiatives and organised the touring exhibitions that made the Society known nationally. It was he that managed to foster the perpetual desire for improvement in quality of members and quality of work. It was he who always sought the bigger stage. He managed to engender an extraordinary spirit of endeavour that kept the artists remarkably focussed and free of internal rivalry. It is, accordingly, Smart that should be given the principal credit for transforming a listless local art society into a nationally acclaimed body of artists. He mastered the ship that created the splash.

Table B analyses the make-up of the membership of STISA in the inter war period, indicating the split between male and female artists and between current residents in both St Ives and other parts of Cornwall, past residents (including students) and visitors. In the case of St Ives residents, a further division is made between those that were part of the first generation of artists to settle in the colony, those who had settled in the town by the time of STISA's formation and those that arrived subsequently.

Other St Ives Residents

At the time of the formation of the Society, the resident artists with long established reputations were Moffat Lindner, the landscape artists, Fred Milner and Arthur Meade, the watercolourist, John Bromley, and the etcher Alfred Hartley. Younger male talent included John Park, Arthur Hayward, George Bradshaw, Hugh Gresty, Herbert Truman and Alfred Bailey, who had developed his own distinctive style of watercolour painting. The female contingent was less strong. Only Mabel Douglas, the miniaturist, had recently had regular success at the RA but both Shearer Armstrong and Pauline Hewitt were hung for the first of many times in 1927. The style of Mary F.A. Williams meant that she had had more success at the Paris Salon and Nora Hartley, Winifride Freeman and Gussie Lindner had had success at the RA in the past. Kathleen Bradshaw, Helen Seddon and Francis Ewan were other promising artists.

Table B - Breakdown of Prominent Members of STISA 1927- 1939

St Ives Resident	Cornish Resident	Former Cornish Resident	Visitor
Male Members			
Pre-War Residents	RAs	RAs	RAs
John Bromley			
John C Douglas	Lamorna Birch	St Ives - Permanent Resident	Stanley Spencer
Lowell Dyer	Stanhope Forbes	Arnesby Brown	
Alfred Hartley		Julius Olsson	
Moffat Lindner		Adrian Stokes	
Arthur Meade		Algernon Talmage	
Fred Milner			
Jack Titcomb		St Ives - Habitual Visitor	
		Frank Brangwyn	
Other Residents at Formation		Sydney Lee	
Alfred Bailey		Terrick Williams	
George Bradshaw			
Alfred Cochrane	-------------------------------	-------------------------------	-------------------------------
Hugh Gresty	Stanley Gardiner	Newlyn	George Boden
Arthur Hayward	Geoffrey Garnier	Hall, Fred	Harry Fidler
Frank Moore	Arthur Hambly		Bernard Fleetwood-Walker
John Park	Harold Harvey	Students - St Ives	John Littlejohns
Herbert Truman	Frank Heath	Sir William Ashton	Leonard Richmond
Arthur White	Robert Hughes	Charles Bryant	Salomon Van Abbé
	Enraght-Moony	Arthur Burgess	
Residents after Formation	William Parkyn	Richard Heyworth	
John Barclay	Elmer Schofield	Guy Kortright	
Fred Bottomley	Richard 'Seal' Weatherby	Hely Smith	
Jack Coburn-Witherop			
Leonard Fuller		St Ives	
Thomas Maidment		Percy des C. Ballance	
Bernard Ninnes		Hurst Balmford	
Job Nixon		Fred Beaumont	
Arthur Quigley		Terence Cuneo	
Raymond Ray-Jones		A. Moulton Foweraker	
Borlase Smart		W. Westley Manning	
John Millar Watt		Reginald Reynolds	
Female Members			
Pre-War Residents	RAs	RAs	
Mabel Douglas	Dod Procter	Laura Knight	
Nora Hartley	-------------------------------	-------------------------------	
Augusta Lindner			
	Midge Bruford	Annie Bryant	Constance Bradshaw
Other Residents at Formation	Maud Stanhope Forbes	Nell Cuneo	Irene Burton
Emily Allnutt	Jill Garnier	Helen Knapping	Eleanor Charlesworth
Shearer Armstrong	Eleanor Hughes	Hettie Tangye Reynolds	Daphne Lindner
Dorothy Bayley	Annie Walke		Edith Reynolds
Kathleen Bradshaw			Dorothea Sharp
Frances Ewan			Marcella Smith
Winifride Freeman			Mary Thompson
Mary Grylls			Helen Stuart Weir
Pauline Hewitt			Nina Weir-Lewis
Helen Seddon			Emily Wilkinson
Mary F. A. Williams			
Residents after Formation			
Dorothy Everard			
Mary McCrossan			
Marjorie Mostyn			
Blanche Powell			
Phyllis Pulling			
Amy Watt			

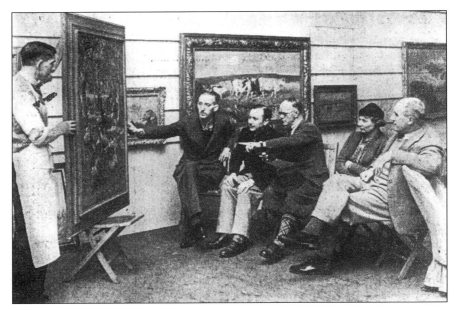

Fig. 1-4 The Hanging Committee in 1937
From the right - George Bradshaw, Shearer Armstrong, Borlase Smart, Bernard
Ninnes and Millar Watt. Tonkin Prynne stands by the work.

The colony was soon enhanced by the return in 1928 of Borlase Smart and Mary McCrossan. McCrossan, a highly regarded artist with a distinctive style, had been a student of Olsson's in the 1890s and had visited St Ives regularly but she now decided to live in the town. Fred Bottomley arrived in 1929, having lost two fortunes in the Wall Street Crash, and Thomas Maidment came from Newlyn in 1932. Bernard Ninnes also arrived in 1932 and his distinctive work was soon to provoke favourable comment. Job Nixon, who had taught etching at South Kensington, moved across from Lamorna in 1934, although he had joined the Society initially in 1931. Another etcher, Raymond Ray-Jones, became a member when he moved to Carbis Bay in 1933. The cartoonist, Millar Watt, and his wife, Amy, made an immediate impression on arrival in 1935, and Amy enjoyed regular success at the RA. The decorative work of the Scot, John Barclay, who also arrived in 1935, provided further innovation.

In 1938, Borlase Smart eventually persuaded his good friends Leonard Fuller and his wife, Marjorie Mostyn, to move to St Ives to set up a School of Painting, which Smart considered was essential to attract more talented young artists to the town. The School, which is still in existence, has been an immensely important facet of the art colony ever since.

Arthur White, known for his depictions of St Ives harbour and the church tower, was one of the few artists in the town, who did not join the Society immediately. He joined in 1938, as did the Liverpudlian, Jack Coburn-Witherop, who was based in the town for a number of years in the late 1930s. His etchings and tempera work were well regarded.

Other Cornish Residents

Fellow artists from Newlyn and Lamorna had for many years been exhibiting at Lanham's Galleries in St Ives (as the St Ives artists had at Newlyn) and, accordingly, it is not surprising that invitations to exhibit with the Society were extended to some of the better known artists, who were resident in other parts of Cornwall. Stanhope Forbes was the key figure and the Committee was delighted when he accepted in 1928 the offer of honorary membership and even more so when, in 1931, he offered to pay. Harold Harvey, Lamorna Birch, Stanley Gardiner and Dod and Ernest Procter were invited to exhibit at some of the Society's early shows but not all joined the Society at that juncture. Birch was offered honorary membership in 1930 but Dod Procter did not join until 1937 and Stanley Gardiner not until the following year. Harold Harvey may, in fact, never have joined but his wife, Gertrude, joined for a while after his death. The early success of the Society meant that, in 1931, it could introduce a rule insisting that all exhibitors should be members. As a result, many from the Lamorna circle joined in the early 1930s. Richard "Seal" Weatherby, the etcher, Geoffrey Garnier and his talented wife, Jill had all joined by 1932 whilst Robert and Eleanor Hughes joined in 1933, Frank Gascoigne Heath in 1934 and Annie Walke in 1935. Midge Bruford joined a little later in 1938, whilst Alethea Garstin became involved in the 1940s.

Artists from other parts of Cornwall also began to realise that it was in their interests to join the Society. The distinctive imaginative and symbolic subjects of the Irish-born, Enraght-Moony, who lived at Mount Hawke, Truro were seen at the Society's shows as early as 1928 while Arthur Hambly, the Headmaster of Camborne and Redruth School of Art, began over forty years of membership in 1930. William Parkyn, a former Olsson student now living at the Lizard, joined in 1933.

Former Cornish Residents

One of the keys to the Society's early success was to persuade all of the members or associates of the RA, who had previously lived and worked in St Ives to become members. Very soon, therefore, the Society could boast that its members included the Royal Academicians Arnesby Brown, Adrian Stokes, Julius Olsson, Algernon Talmage and Terrick Williams, as well as Stanhope Forbes and Lamorna Birch. Another Royal Academician, Sydney Lee, who had worked in St Ives in the early years of the century, joined in 1931, making a distinctive contribution to the "black and white" section. The addition to the membership of Frank Brangwyn, then without doubt the best known British artist on the international stage, was a further coup in 1935.

A number of artists formerly connected with Newlyn, such as Percy Craft and Fred Hall, also joined during the 1930s. Of the next generation, Dame Laura Knight was a significant addition in 1936 and Alfred Munnings in 1944. However, although the latter became President of the Society, there is no record of him ever exhibiting any work.

Other respected artists who had studied at the School of Painting run by Olsson, Louis Grier and later Talmage, such as Guy Kortright, Richard Heyworth, Hely Smith and the Australians Arthur Burgess, Charles Bryant and Sir William Ashton, were also encouraged to join. Norman Wilkinson was another famous student, who joined later.

More recent St Ives residents such as Percy des Carriere Ballance, Nell Cuneo and her son, Terence, Hurst Balmford, who had moved to become Headmaster of Morecambe School of Art, and Reginald Reynolds and his wife, Tangye Reynolds, continued to maintain contact with the Society from time to time.

Regular and Occasional Visitors

St Ives has always attracted artist visitors and many came on a regular basis, even maintaining studios in the town. The wealthy American still life painter, Helen Stuart Weir, lodged each summer at the St Ives Bay Hotel, often accompanied by her mother, Nina Weir Lewis, who was also an artist. Marcella Smith, who lived in St Ives during the First World War but who, during this period, lived in London with Dorothea Sharp, was a regular visitor along with Sharp and they both joined the Society in 1933. They later were to move to St Ives during the Second World War. The artist and author of countless books on art technique, Leonard Richmond, was also a regular visitor and he joined the Society in 1931. In 1935, he set up a Summer Painting School in St Ives and he too later lived in the town (1946-1949). John Littlejohns, who worked with Richmond on his books on painting in watercolour and in pastels, was a less regular visitor, but he joined in 1933 and remained a member for some 14 years.

The portrait painter, Bernard Fleetwood-Walker, brought students from Birmingham down to Cornwall most summers and he joined STISA in 1936 and shared a studio with a number of artists on his visits. He later was elected a Royal Academician. Salomon Van Abbé, best known for his etchings, was also a regular visitor and may have been based in St Ives for part of the War. By the late 1930s, the reputation of the Society was such that artists of note were keen to join and the Committee, always looking to improve the quality of the membership, were occasionally happy to overlook the fact that the Cornish connection might be slight. The addition of Stanley Spencer to the roll of members in 1937, during his ill-fated honeymoon in St Ives, was considered an immense coup, albeit the extent of Spencer's subsequent involvement is difficult to decipher.

THE ST. IVES SOCIETY OF ARTISTS

PORTHMEOR GALLERIES, ST. IVES, CORNWALL

Fig. 1-5 The heading on the Society's notepaper from the mid-1930s, showing the Porthmeor Galleries

ST IVES EXHIBITIONS

After the establishment of the Porthmeor Gallery in 1928, STISA held three separate exhibitions there each year. In 1932, due to the increase in the membership, the adjoining studio (No.4) was incorporated into the Gallery so that watercolours could be hung separately. In 1936, again due to an increase in works submitted, the number of exhibitions per year was increased to four - Spring (March-June), Summer (June-September), Autumn (September-December) and Winter (December-March).[3] Each of these often contained over 200 works and new work was strongly encouraged for each show. Accordingly, an astonishing number of paintings were produced and hung during the period covered by this Exhibition. Visitor numbers soon increased markedly, with the shows in 1930 attracting 3,500 people. This figure was not matched until the Jubilee year in 1935 and visitor numbers of 4,162 in 1936 were the best achieved during the 1930s. With the surge of interest in art after the War, this record was soon eclipsed and, no doubt due to the publicity resulting from the split, 1949 was the best ever year during this period when 11,000 people came to see what the fuss was about. These numbers, however, are totally eclipsed by visitors to the Society's touring exhibitions and I will therefore concentrate on these shows, as it was the publicity generated from these that brought members to national prominence.[4]

THE TOURING EXHIBITIONS OF THE 1930S

1925 Cheltenham

The idea of an exhibition in one or more Municipal Public Galleries outside Cornwall devoted solely to St Ives artists, which was exploited to such telling effect by Borlase Smart in the 1930s and 1940s, derived from an Exhibition organised in Cheltenham Art Gallery and Museum in 1925. The choice of Cheltenham as a venue suggests that either Fred Milner, who had lived there for some time, or Richard Heyworth, who was a good friend of the Curator, D.W.Herdman, were at least partially responsible for organising the show, which was billed as an *Exhibition of Oil and Watercolour Paintings, Etchings and Pottery by Artists of St Ives*. Moffat Lindner, whose brother lived in Cheltenham, was also actively involved. He contributed the Foreword to the catalogue, which outlines the history of the art colony, and he also presided at the opening ceremony. The novelty of the idea of having a show devoted solely to artists of one town seems to have been recognised as the catalogue contains a quotation from Sir Robert Witt, which includes the following observation:-

"The chief difficulty with which every gallery has to contend is the danger of stagnation... The danger can be met only by constant activity and initiative."

Aware of the privilege afforded them, the artists strove to make the Exhibition as significant as possible and the catalogue contained a biographical note on each artist and a lengthy account of the Leach Pottery. In addition to the principal artists then resident in St Ives, such as Lindner, Milner, Meade, Dyer, Bromley, Smart, Park, Bradshaw, Hewitt and Hayward, former residents Olsson, Talmage, William Titcomb, Simpson and the Australian, David Davies, were included as well as the late Millie Dow and the late Louis Grier. Henry Tuke seems to have been the only artist involved that did not have some St Ives credentials.

There were some significant works on show. Heyworth included a massive canvas *Teignmouth*, a work that had hung at both the RA and the Paris Salon, priced at £250 and other works in this price bracket included Millie Dow's *Springtime in Cornwall* and Fred Milner's *September in the Cotswolds* - a work which the local paper felt should have been purchased for the Gallery's permanent collection. Other works that had already been exhibited at the Paris Salon were John Park's *When The Boats Are In* and Borlase Smart's *Cornish Cliffs*, which is now in the Royal Cornwall Museum, Truro. Charles Simpson contributed works from his *Herring Season* series (see Plate 75) and Olsson sent a typical pair of Cornish seascapes, one a moonlit scene and the other showing the coast at sunset.[5] Arthur Hayward was represented by two recent RA successes *The Crinoline* and *In a Sunlit Garden*, the latter until recently being owned by Auckland Art Gallery.[6] Of the female contingent, the most notable contributions were from Nell Cuneo and Mary McCrossan, whose watercolour *The Doge's Palace, Venice* is now in the Atkinson Art Gallery, Southport. Cheltenham Art Gallery decided to acquire Lindner's *Golden Autumn* from the show for its permanent collection, which also now includes Heyworth's *Teignmouth*.[7]

[3] Sometimes the Winter show did not start until January, which causes confusion as it becomes the first show of the year rather than the last.
[4] The St Ives exhibitions are dealt with in detail in David Tovey, *George Fagan Bradshaw and the St Ives Society of Artists*, Tewkesbury, 2000.
[5] Dunedin Art Gallery's work by Simpson is called *On the Quay* whereas one of the works included in the Cheltenham show was called *Loading Fish on the Quay*.
[6] *In A Sunlit Garden* is illustrated in David Tovey, *George Fagan Bradshaw and the St Ives Society of Artists*, Tewkesbury, 2000 at p.65.
[7] Cheltenham's collection now also includes several works by Lindner, Heyworth and Milner and works by Noble Barlow, Olsson, Park, Stanley Spencer, William Titcomb, Percy Ballance, Claude Muncaster and Jack Merriott. *Sunset in Provence* by Adrian Stokes is included in this Exhibition.

The etchings and aquatints in the Exhibition were contributed almost exclusively by Alfred Hartley, the acknowledged 'black and white' master in the colony, and his twelve exhibits included the aquatints *Evening in a Shropshire Valley* (V & A) and *Landing Place, Lake Como* and *In Old Bordighera* (both British Museum). However, one of the most fascinating aspects of the Exhibition was the inclusion of twenty-seven pots thrown by Bernard Leach, including Stoneware, Galena Slip-ware and Raku work, as, once STISA was formed, craftwork was excluded from its exhibitions. The artists managed to secure that the Exhibition was reviewed in *The Studio* and a number of works were illustrated.

1931/2 Huddersfield - Southsea - Brighton - Stoke

The fact that the Cheltenham experiment was not repeated for some time suggests either that the sales achieved had not warranted the costs involved or that economic conditions had deteriorated to such an extent that such an undertaking was not feasible. The following year witnessed the General Strike and the last years of the decade were desperately hard, with many people adversely affected financially by the Wall Street Crash of 1929. The Minute Book of STISA does not reveal any formal discussions in the early 1930s about revitalising the concept of a touring show, but suddenly, in late 1931, the Society started to receive letters from Curators of Public Galleries asking it to provide works for a dedicated show. It is highly unlikely that these appeared out of the blue, given the regularity of their receipt, and one suspects that Borlase Smart had been canvassing the idea around a number of Public Galleries.

Fig. 1-6 Alfred Hartley *Christchurch Gate, Canterbury* (The Trustees of the British Museum)

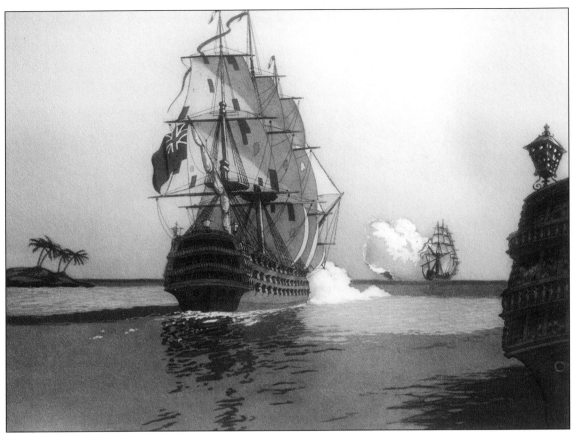

Fig. 1-7 Geoffrey Garnier *The End of the Chase* (Private Collection)

The first of the provincial Gallery shows of the 1930s was held at Huddersfield Art Gallery and ran from 14th December 1931 until 2nd January 1932. The exhibition comprised 102 works selected by Lindner, Smart and Park principally from the Society's Autumn show and, as no catalogue survives, it is best to reproduce the review contained in the *Huddersfield Daily Examiner*.

"Ever since Whistler and Sickert went there in 1884, St Ives has had a busy colony of artists, many of whom are among the most notable painters of today. Unlike some such schools, the St Ives Society is wedded in no particular 'ism'. Its members work to no slavish formula and their paintings exhibit a wide variety of styles. There are in the present show artists so diverse in manner as Algernon Talmage and Lamorna Birch, Julius Olsson and Moffat Lindner. There are in this exhibition two of the very best Talmage paintings - his *Reflections* is a beautiful study in cool greens, and *St Cecilia Beach* is a notable essay in economy of means. Lamorna Birch is represented by several good examples of his characteristic delicacy of colour and fine lines. Borlase Smart sends a remarkably well-composed study, *Land's End, Moonlight*: there is a striking small study by Arnesby Brown and Pauline Hewitt has several notable canvases in which strong light and shadow are well suggested by the adroit use of flat tones.

Moffat Lindner, this time no longer a Venetian painter, offers work informed by a high sense of Nature's pageantry. His *Fresh Breeze on the Maas* has a decorative breadth that is refreshing, and his watercolour *The Spanish Bridge, Ronda* combines suggestiveness of effect with precise draughtsmanship. There are also efficiently painted seascapes by Julius Olsson and picturesque Italian street scenes by Hugh Gresty, and several good still life studies. The watercolours are the more disappointing section. The etchings are good (and reasonably priced). Job Nixon's drypoint, a study of *Marseilles*, is notable for its clean line and sense of atmosphere."

Despite the Exhibition only lasting three weeks, it attracted 3,900 visitors and, for its Autumn Exhibition that year, Huddersfield selected work from the RA Summer Exhibition by Talmage, Lindner, Olsson, Birch, Smart, Nixon, F.S.Beaumont and Charles Bryant.

STISA received three other invitations from Public Galleries in 1932. In March and April, the Society, at the request of Portsmouth City Council, exhibited 157 works in the new galleries at Cumberland House, Southsea. Between 21st May and 10th July, an exhibition of 153 works was mounted at Brighton Art Gallery and, from this show, 50 selected works then progressed to the Hanley Museum, Stoke-on-Trent from 23rd July to 1st October. Unfortunately, there are no definitive records of the Southsea show and, at one juncture, the Society was envisaging having 57 works returned to it from Southsea, with 100 going on to Brighton. However, given the eventual number of works in the Brighton show, it is likely that the same group of paintings toured each venue. Clearly, the invitation from Brighton, which had developed an unique reputation for its exhibitions of international art, was considered the most prestigious and Smart commented that the Society was to be congratulated that "the standard of work

of the Colony is of that quality that can maintain its reputation in such an important art centre as that of Brighton". Despite the large number of works, the Curator, Henry Roberts, commented that all the pictures were so consistently good that he was able to hang them all in three hours and, directly the finishing touches were made with the sculptures, the individual works appeared as if they had been especially painted for the spaces they occupied.[8] The Exhibition was opened by the St Ives M.P, Walter Runciman, then President of the Board of Trade, and the Society was represented by Smart and Olsson and an American artist, who was in temporary residence, Mildred Turner-Copperman. Everyone involved considered it to be the highpoint of the Society's existence to date.

Appendix A lists the artists and exhibits involved in the 1932 touring shows. Clearly, the inclusion of six Royal Academicians - Stanhope Forbes, Lamorna Birch, Julius Olsson, Algernon Talmage, Arnesby Brown and Adrian Stokes, along with Terrick Williams, then ARA, was of infinite importance for publicity purposes but what would have pleased the Committee especially was the excellent work produced by new members. Fred Bottomley, Bernard Ninnes and Thomas Maidment were all new arrivals and it was Maidment's *Farm Scene, St Ives* (Fig. 2M-1) which Brighton decided to purchase for its permanent collection, whereas Stoke went for Ninnes' *In For Repairs*.[9] Another new member, Leonard Richmond, contributed two significant oils, of which *Lake O'Hara, Canadian Rockies* was bought from the show for Worthing Art Gallery.

The black and white section, so reliant previously on the outstanding work of Alfred Hartley, received a real boost with the arrival of Job Nixon. His huge etching, *Italian Festa* (cat.no.61) caused several reviewers to go into raptures. His engraving *The Flour Mill* is also now in the British Museum collection, and his drypoint *Bank Holiday, Hampstead Heath* is at Oldham. The distinctive coloured aquatints of Geoffrey Garnier, which included *The End of the Chase* (Fig.1-7), were another boost to this section and so impressed Walter Runciman that he arranged for the Board of Trade to acquire six. Hartley, in the meantime, included in his exhibits what many considered to be his finest aquatint, *Christchurch Gate, Canterbury* (cat.no.31 - Fig.1-6).

The watercolour section was often reliant on the contributions of Moffat Lindner and Lamorna Birch. Birch, on this occasion, only exhibited oils but the section was boosted by the contributions of Terrick Williams and Adrian Stokes being solely in watercolour. Job Nixon, who worked in all media and was a member of RWS, also contributed a significant work *The Slipway, St Ives, Cornwall*.[10]

1933 London - Barbizon House

The St Ives artists came to think of the annual RA exhibition as their London show but, in 1933, an exhibition at Barbizon House, Cavendish Square was devoted solely to works by members of the Society.[11] The exhibition was open for a month from the middle of March and there were 72 works on show. The outstanding exhibit, in terms of quality, was considered to be Arnesby Brown's "exquisitely tender green and silver landscape", *The Valley* (RA 1928).[12] Other notable exhibits were Stanhope Forbes' *Roseworthy* (RA 1930), Adrian Stokes' *A Shadowed Stream in the Dauphiné* (RA 1930) - "a real gem of light and atmosphere", Talmage's *Suffolk Marshes* (RA 1929), Sydney Lee's *The House with Closed Shutters* (RA 1926), which was subsequently bought for the RA's permanent collection, *Trewoofe Mill, Lamorna* (RA 1932) by Birch and *The Setting Sun, Amsterdam* (RA 1928) by Lindner (see Plate 73). Frank Rutter, the well-known art critic of *The Sunday Times*, considered that some of the best work were the depictions of St Ives. "Special attention should be paid to the admirable water colour drawing *Low Tide, St Ives* by Borlase Smart and his brilliant little oil painting *The Pilots of St Ives*. Some delightful souvenirs of the boats and beaches of St Ives are also contributed by Mary McCrossan, Leonard Richmond and John Park".[13] In the watercolour section, Terrick Williams' *Boats, St Ives* was singled out for praise and Job Nixon's *Peasants Resting* was hailed as a "classic example of pencil work".[14]

1934 Oldham - Southport - Harrogate - Lincoln

This touring show started in Oldham in January 1934, when it contained 160 pictures, and finished at the end of September in Lincoln, by which time it contained 174 pictures and three pieces of sculpture. Unfortunately, only the Lincoln catalogue is still extant and it is not possible to judge how the exhibition changed during its run. However, it was phenomenally successful, with 36,000 people visiting it over the nine month period and, as a result, sales doubled that year.

[8] *St Ives Times*, 27/5/1932.
[9] *In for Repairs* is illustrated in David Tovey, *George Fagan Bradshaw and the St Ives Society of Artists*, Tewkesbury, 2000 at p.93.
[10] This is illustrated in David Tovey, *George Fagan Bradshaw and the St Ives Society of Artists*, Tewkesbury, 2000 at p.97.
[11] In July 1931, there had been a small exhibition of some 40 works organised by the Kernow Group, which was held in West Wing, the mansion in Regent's Park, owned by the dancer, Miss Maud Allan, but this was not exclusively for STISA artists - *St Ives Times*, 17/7/1931.
[12] Frank Rutter, *The Sunday Times*, reproduced in *St Ives Times*, 24/3/1933.
[13] ibid.
[14] *St Ives Times*, 17/3/1933.

Fig. 1- 8 Mary McCrossan *The Harbour, St Ives* (1930) (W.H.Lane & Son)

The Oldham exhibition was enhanced by the Gallery also hanging works by members from their permanent collection. These included one of Stanhope Forbes' finest works, *The Drinking Place* (RA 1900), a large and noble Olsson, *Rising Moon, St Ives Bay* (RA 1905), Birch's *The Serpentine Quarry, near Mullion* (RA 1920), a typical Lindner watercolour *Dutch Boats at anchor on the Maas* and two works that Oldham have kindly lent to this Exhibition - Terrick Williams' stunningly luminous depiction of *Cassis* (RA 1929) (cat.no.94) and Eleanor Hughes' fine watercolour of the ruined bridge at *Sauveterre de Béarn* in the French Pyrenees, which the Gallery had bought in 1925 (cat.no.38).

Highlights of the principal exhibition included Birch's *A Haunt of Ancient Peace* (RA 1932), a painting of the Forss River, Thurso, executed during a fishing holiday in Scotland with Moffat Lindner, in which Lindner models as the angler. In addition, he showed *The Spey at Craigellachie* (RA 1933). There was also Terrick Williams' *Low Tide, St Ives*, now in the collection of Rochdale Art Gallery, Fred Milner's *A Tidal River* (RA 1922), John Park's *Fringe of the Tide*, (cat.no.64) and one of George Bradshaw's most highly regarded tempera works *The Lobster Fishers* (RA 1933).[15] Mary McCrossan, who died that year, contributed *The Harbour, St Ives* (see Fig. 1-8). Frank Gascoigne Heath, one of the Lamorna circle, sent some of his finest works, including *Mousehole Harbour* (RA 1922, Paris 1927) (cat.no.34). Olsson's work *Approaching Gale* was considered one of his finest works in his finest style - "the subject demanded the outlet of a big vision and a big space for its translation".[16] Arthur Burgess, one of the contingent of Australian marine painters that had studied under Olsson, contributed *Crossing the Bar* and *The Pilots of Port Jackson* to the Oldham show and, when the latter was withdrawn so that it could be exhibited at the RA that year, it was replaced with his 1930 RA exhibit *The Stillness of the Fjord*. Fellow Australian marine painter, Charles Bryant, who had joined STISA in 1932, sent *Yacht Race, Sydney Harbour*, a work that was to grace a number of STISA shows.

One painting that attracted considerable attention at the Oldham Private View was Herbert Truman's *Egypt: Ancient, Medieval and Modern*, an amazingly detailed work that drew on Truman's considerable knowledge of Egyptian antiquities gained during his thirteen years in that country as chief inspector of art and trade schools. Several new members were well represented. Harry Fidler contributed one of his distinctive, impressionistic farm scenes, *The Binder* (RA 1932) and, among Dorothea Sharp's exhibits, was one of her typical scenes of children playing on the beach - *Low Tide, St Ives*. Bernard Ninnes sent *Street in Spain* (RA 1934), which was later bought by the Russell-Cotes Art Gallery and Museum, Bournemouth, and other RA exhibits included Fred Bottomley's *The Cut Rick* (RA 1931), Lindner's *Fresh Breeze on the Maas* (RA 1930) (see cat.no.47), an old Forbes portrait *Madame Gilardoni* (RA 1907), and one of Milner's occasional seascapes, *Westerly Seas, St Ives* (RA 1933). Weatherby showed the fruits of his visit to India, Meade had been to Tangier and Park revealed the new colour values that had been inspired by his trip to Mallorca (see cat.no.65).

[15] Williams' *Low Tide, St Ives* is illustrated in David Tovey, *George Fagan Bradshaw and the St Ives Society of Artists*, Tewkesbury, 2000 at p. 87.
[16] *St Ives Times*, 24/11/1933.

1. Julius Olsson *The Water Spout* (Cartwright Hall Art Gallery, Bradford)

2. Arnesby Brown *After the Heat of the Day*
(Mackelvie Trust Collection, Auckland Art Gallery Toi o Tamaki)

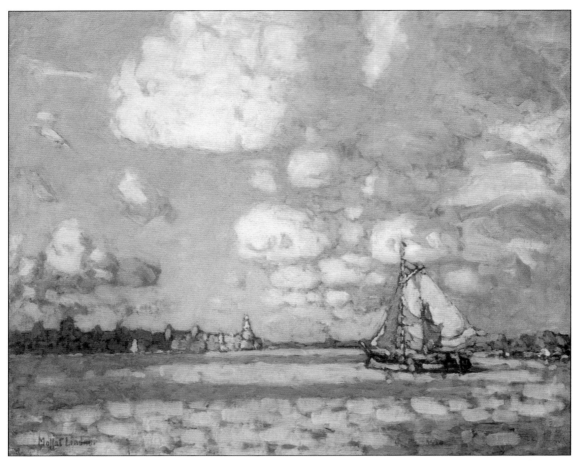

3. Moffat Lindner *On the Maas* (Private Collection)

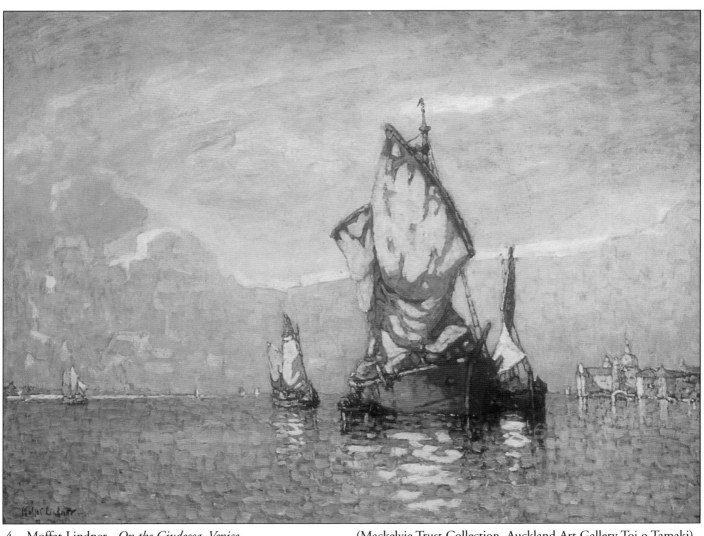

4. Moffat Lindner *On the Giudecca, Venice* (Mackelvie Trust Collection, Auckland Art Gallery Toi o Tamaki)

5. John Park *May Pageantry* (Gallery Oldham)

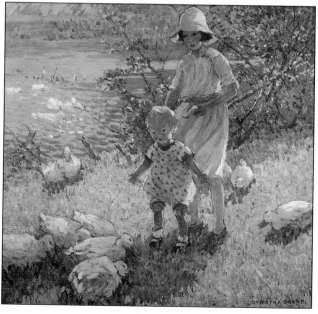

6. Dorothea Sharp *White Ducks*
(Doncaster Museum and Art Gallery, Doncaster MBC)

7. Dorothea Sharp *Sea-Bathers*
(Newport Museum and Art Gallery)

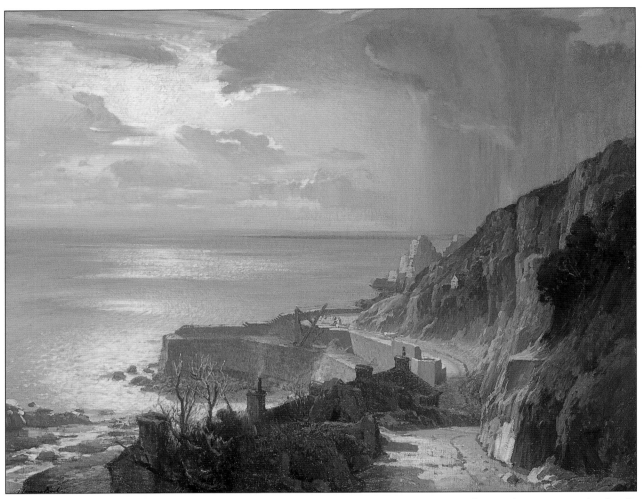

8. Lamorna Birch *Morning at Lamorna* (Williamson Art Gallery and Museum, Birkenhead)

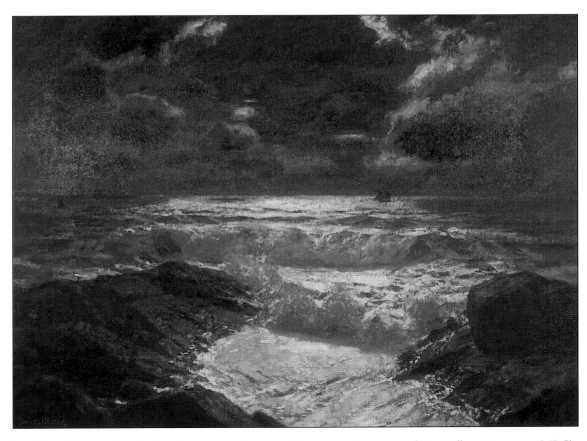

9. Julius Olsson *Cloudy Moonlight* [trannie] (Doncaster Museum and Art Gallery, Doncaster MBC)

The watercolour section gets less coverage but works by Lindner and his wife, Augusta, are singled out as are the three exhibits of Eleanor Hughes. Job Nixon and his wife, Nina Berry, are also mentioned and, in the still life section, Marcella Smith and Frances Ewan gain the plaudits. The three exhibits of new member, John Littlejohns, were noted, given his writings on watercolour technique, and two appear to have sold during the course of the tour. However, it is the black and white section that provided several of the highlights of the exhibition. Sydney Lee's works included the very famous *The Limestone Rock* (Fig. 2L-3), still considered one of the finest wood engravings produced, and his coloured aquatint of *The Sloop Inn, St Ives*, dating from 1904, both of which are now in the collection of the Victoria and Albert Museum. His aquatint *The Sleeping Square* is also one of his best. Job Nixon had five prints, including *An Italian Festa* (Fig. 2N-3) and *The Madonna in the Wall, Subiaco* (Auckland Art Gallery - Fig. 1-9). Alfred Hartley's exhibits included *Clare Bridge, Cambridge* (V & A) and *In the Forest* (British Museum), and there were also several fine prints from a new member, Raymond Ray-Jones, including the etchings *Pont St Benezit, Avignon*, *La Rue des Quatre Vents* and his acknowledged masterpiece, the large etched *Self-Portrait*, (cat. no.69 - all British Museum). Geoffrey Garnier was the other major figure in the black and white section and his exhibits included aquatints of *Mousehole* and *The Old Harbour, Newlyn*.

During the Exhibition's two month run at Lincoln, there were 15,624 visitors and the Director commented, "The show was of fascinating interest, and clearly one of the best we have had. I hope when times are a little more prosperous that we may be allowed to arrange a similar exhibition."[17] Two years later, that wish was fulfilled.

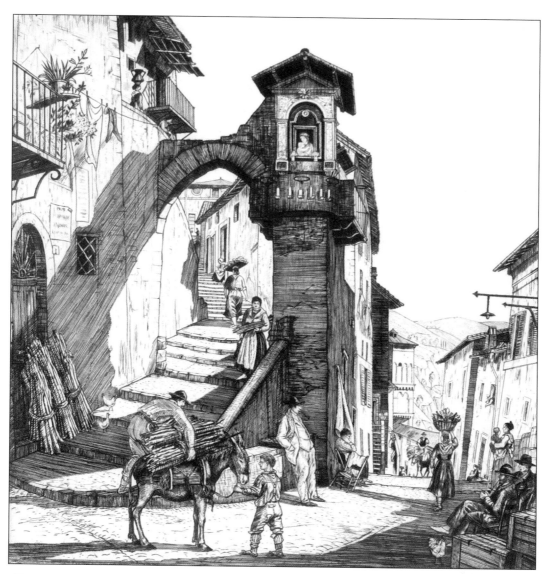

Fig. 1-9 Job Nixon *The Madonna in the Wall, Subiaco*
(Auckland Art Gallery Toi o Tamaki)

[17] *St Ives Times*, 12/10/1934.

1936 Hastings - Birmingham - Cheltenham - Hereford

1935 was dominated by the King's Jubilee and curators of Municipal Galleries concentrated on putting on special Jubilee Exhibitions, to which members of STISA were frequently asked to contribute, but the only exhibitions outside St Ives devoted solely to the Society were in Falmouth at the Royal Cornwall Polytechnic Society and in Plymouth at the Gallery of Harris and Sons. No catalogues are extant for these shows. However, the presence of numerous overseas visitors for the Jubilee resulted in record sales - more than double the previous year. 1936, however, saw the Society in huge demand as not only did it run its own touring show but it also contributed the bulk of work to an Exhibition devoted to the artists of Devon and Cornwall selected by the Curator of the Towner Art Gallery, Eastbourne.

The Society's own touring show went to Hastings, Birmingham, Hereford and Cheltenham but it varied in size from venue to venue. Again, only one catalogue - that for the Birmingham show - is extant but this was the biggest and most prestigious exhibition of them all, attracting an astonishing 64.000 visitors. The total for the whole tour was almost 75,000. Sales could not possibly match those of the Jubilee year but were nicely up on 1934.

The Hastings Exhibition was in March and April and was restricted to some 60 works, whereas the full exhibition which ran in Birmingham between 10th July and 29th August had 193 works. 89 paintings were included in the Hereford show before the full exhibition was re-assembled in Cheltenham. Several works from this tour are included in the present exhibition. *The Café Born, Palma, Mallorca* by Bernard Ninnes (cat.no.59) is an example of his unusual figure paintings that verge on the edge of caricature and it was acquired from the tour for the permanent collection of Hereford. *A June Morning; the Deveron at Rothiemay* (RA 1929) by Lamorna Birch (cat.no.6) is a depiction of Birch's favourite fishing river and is now owned by Leamington Art Gallery. John Park, at this period, was keen to move away from harbour scenes and *May Pageantry* (cat.no.66) is one of his superlative river landscapes, which was acquired by Oldham Art Gallery in 1937. *Christ Mocked* by Annie Walke (cat.no.90), the wife of Bernard Walke, the controversial vicar of St Hilary, near Marazion, was a work that generated such interest that it was included in more touring shows over the next twelve years than any other painting. This has more recently been acquired by the Royal Cornwall Museum, Truro. Finally, *The House of Mystery*, an aquatint of a property in Barnard's Castle by Sydney Lee (cat.no.46 - Fig.1-10), was so highly regarded that it was purchased by both Hereford and Cheltenham Galleries.

There were, of course, the usual array of RA exhibits. These included one of Shearer Armstrong's exotic still life 'Decorations', *Bamboo and Fruit* (RA 1935), Richard Weatherby's *The Chestnut Mare* (RA 1935) and Leonard Richmond's *St Ives from the Malakoff* (RA 1934, when it was called *The Harbour, St Ives*). Arnesby Brown sent *Study for 'The Beach'*, his RA exhibit of 1932. The other RAs, Forbes, Talmage, Birch and Williams were also represented, as was Adrian Stokes, although he had died the previous year.

New members included Frank Brangwyn, who contributed an oil, *Notre Dame, Paris*, now owned by The Museum of New Zealand, Wellington, and the figure painter, Bernard Fleetwood-Walker, who was one of the most respected and influential lecturers at the Birmingham School of Art and who may well have had a hand in organising the Birmingham show. Laura Knight had also joined by the time of the Cheltenham show. Her new Acting President of SWA, Constance Bradshaw, was now a member of STISA as well and she sent some Portugese landscapes. Some more ex-Olsson students had joined - Will Ashton, who sent some French scenes, and Guy Kortright, who contributed some of his decorative landscapes. New arrivals in St Ives included the cartoonist Millar Watt, whose exhibits included one of his 'Pop' cartoons, and his wife, Amy Watt, who at that juncture specialised in flower paintings. John Barclay exhibited with the Society for the first time as did Arthur Quigley. A greater variety of artists contributed etchings but the section was a pale shadow of its former self, with the loss of Alfred Hartley, who had died, Job Nixon, who had left to teach at the Slade, and Raymond Ray-Jones, who appears to have ceased membership. A new recruit was Daphne Lindner, Moffat's niece, and her etchings did arouse interest in Cheltenham, where she lived. One of her exhibits, *The Harpist*, is in the collection of the British Museum but it is not a significant work.

1936 Eastbourne - Lincoln - Blackpool - Leamington

This touring exhibition, which was entitled *Pictures of Cornwall and Devon*, was the novel idea of the Towner Art Gallery, Eastbourne - its aim, as stated in the catalogue, being "to reveal to the public, through the medium of pictures, something of the incomparable beauty and charm to be found - and found alone - in the western spur of this island". The paintings, therefore, were all of local scenes and were selected by A.F.Reeve Fowkes, the Eastbourne Curator, with considerable assistance from Borlase Smart. Fowkes commented that, in many cases, the pictures were transported - hardly dry - from easel to exhibition. There were 116 works in the show, of which over 80 were by STISA members. Four works from this tour are included in this Exhibition. Mention has already been made of Frank Heath's *Mousehole Harbour* (cat.no.34) and John Park's *Fringe of the Tide* (cat.no.64).

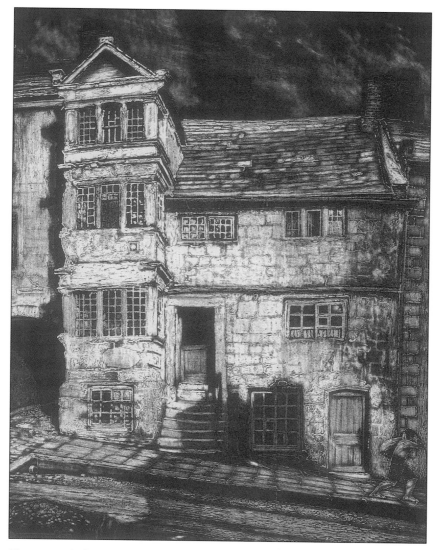

Fig. 1-10 Sydney Lee *The House of Mystery*
(Hereford City Museum and Art Gallery)

The latter was purchased from the Leamington section of the tour, as was Terrick Williams' *The Quiet Harbour, Mevagissy* (cat.no.95) and the superlative *The Boatbuilder's Shop* by Bernard Ninnes (cat.no.58).[18]

The price list indicates that the most significant works were *Sir Walter Raleigh's House, Mitchell, Cornwall* by Stanhope Forbes, *Sleeping Waters, St Ives Bay* by Lindner, *The Cury Hunt*, a depiction of his own hunt, by Richard Weatherby and *Under the Bough, Lamorna* and *A Border Stream 'twixt Cornwall and Devon* by Lamorna Birch. Other RA exhibits included *Land's End and Longship Light* by Julius Olsson (RA 1936) and *The Deserted Mine* by Fred Milner (RA 1926). One of Frank Heath's other exhibits, *The Store Pot*, now hangs in The Queen's Hotel, Penzance and Ernest Procter's watercolour *Rising Tide* is now owned by Penlee House Gallery and Museum, Penzance.

During the year, the Society not only ran its customary four exhibitions at the Porthmeor Galleries in St Ives, which attracted a record number of visitors, but also had another show in Plymouth. The publicity that the Society accordingly achieved in this one year was phenomenal and this also, of course, helped to promote tourism to Cornwall. In fact, the Eastbourne tour was specifically designed to do just that.

1937 Bath

This exhibition contained 170 works and was held in the Victoria Art Gallery, Bath from 10th June to 24th July 1937. No mention is made of this or any other touring exhibition in the review of the Society's activities during that year and it would appear to have been merely a one-off show, as many of the works were included in the Society's Autumn show in St Ives. Several new members were to the fore. The most significant work was Laura Knight's *Myself and Model* (National Portrait Gallery), which was

[18] Leamington also own Mary Duncan's *Whitesand Bay*, which was another exhibit in this exhibition.

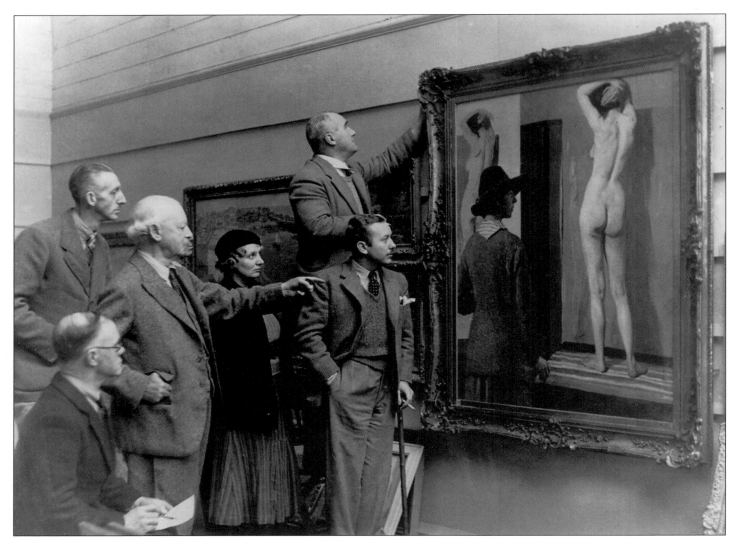

Fig.1-11 Laura Knight's *Myself and Model* being studied (from left) by Borlase Smart (seated), Millar Watt, Moffat Lindner (pointing), Shearer Armstrong, Bernard Ninnes and George Bradshaw (adjusting frame).

priced at the enormous sum of £525. This painting had been included in the Cheltenham section of the 1936 tour and in the Spring Exhibition in St Ives in 1937, where the famous photograph was taken showing Lindner explaining its merits to the whole committee (Fig. 1-11). Hardly less important was the exhibit of another new member, Dod Procter. Her painting *Light Sleep* (RA 1934 - Fig.1-12), priced at £400, was called the most startling picture in the Exhibition, when it was later that year exhibited at STISA's Autumn Show. "It is one of the most striking of her recent canvases, showing a nude girl lying in a graceful position on wonderfully painted silk cushions and a patchwork quilt...A feature of this remarkable canvas is the beautiful drawing of the figure and the finely painted hands".[19] The former Newlyn School artist, Fred Hall, was also a new member and his painting *Up from the Shadowed Vale* was considered one of the most beautiful works in the Exhibition. "Although the composition is big, the subject-matter is carried out with a very tender feeling for atmosphere and light".[20] Another new name was Salomon Van Abbé, who is best known as an etcher and who specialised in studies of the judiciary. He was represented by three etchings, including the typical *Counsel's Opinion*, an oil and a watercolour.

The original Royal Academician members were perhaps less in evidence. Both Stokes and Williams had died, Talmage was ill and so was represented by work previously shown, and Brown did not exhibit. Birch had been in New Zealand and was only represented by one oil, *Autumn, Green and Gold*, and a couple of watercolours. Forbes exhibited *The Smith's Workshop*, a painting dating from 1916, and a more recent work, *The Old Weighing-in House, Penzance* (Fig. 1-21). Olsson's most significant contribution was a dignified moonlight scene, *Beachy Head*. However, Frank Brangwyn contributed a monumental oil, *Ponte Rotto, Rome*, now owned by The Museum of New Zealand, Wellington. "It shows a ruin of a wonderfully designed bridge on the Tiber, with effective light and shade playing over all. Some interesting boats in the foreground give scale to this grand piece of architecture." His watercolour *Church, Cahors* was also rated the masterpiece in this section, being "remarkable in construction,

[19] *St Ives Times*. The painting was sold to an Australian collector at the Fine Art Society's Exhibition of the work of Dod and Ernest Procter in 1973.
[20] ibid

dignified in colour, with beautifully expressed figures in the street".[21] Another watercolour in the show was Winifride Freeman's *St Ives in Jubilee Time* (Fig. 3F-5), which now hangs in St Ives Guildhall.

Other significant works were *The Chateau Gaillard* by Fred Milner, *Bonne Nuit, Jersey* by Leonard Richmond, *Moonrise, St Ives* by Borlase Smart and *At the Sign of the Sloop*, Bernard Ninnes' skit on holidaymakers in St Ives, whilst Dorothea Sharp, Constance Bradshaw, Helen Stuart Weir, Hetty Tangye Reynolds and Pauline Hewitt were amongst the female artists whose works were highly rated. One work from the Bath show included in this Exhibition is John Barclay's fine portrait of C.E.Venning, *A Cornish Scoutmaster* (cat.no.1), which has recently been loaned to Penlee House Gallery.

1938 Harrogate

One reason given for the increase in the membership subscription in 1938 was the cost of the extensive exhibition programme run by the Society. It is believed that the Society did organise an exhibition in Harrogate in 1938 but no records of it have been located and the deteriorating political and economic climate soon made further tours impracticable.[22] In fact, Borlase Smart commented that 1939 was the worst ever year he had experienced for the sale of pictures.

STISA IN THE DOMINIONS

It is perhaps not surprising that work by the Royal Academician members of STISA should have been acquired by Art Galleries in the Dominions but a recent dictionary of British Art held in Australasian public collections has shown just how many STISA artists are represented in Public Galleries in Australia and New Zealand. The essential Englishness of the scenes depicted by Lamorna Birch and Arnesby Brown ensured that they were well represented in many collections. Julius Olsson was another favourite and works by fellow Academicians Stanhope Forbes, Adrian Stokes, Terrick Williams, Laura Knight, Dod Procter and Algernon Talmage were acquired by various Galleries. However, a large number of the less well-known members of STISA also feature prominently in these collections. In the late 1920s and early 1930s, Lindner was particularly successful, with five sales to Dunedin, Adelaide and Auckland. The work of Harry Fidler was also bought by several Galleries in New Zealand and South Africa, whereas paintings by Charles Simpson can be found in Australia and New Zealand. Guy Kortright has as many paintings in New Zealand collections as he does in English ones. However, without doubt, the most astonishing collection of work by STISA members is now owned by Auckland Art Gallery. Most of these works derive from the Mackelvie Collection.

Mackelvie, a former shipping agent from Glasgow, made a fortune during his relatively brief stay in Auckland between 1865 and 1872. On retiring back to London, he indulged his passion for art and, on his death in 1885, he left his collections and a substantial bequest to the City of Auckland. Over the years, the Mackelvie Trustees have appointed various agents to advise them on suitable purchases to add to the Collection. Between 1897 and 1915, this was Marcus Stone RA, who bought Frank Bramley's *For of such is the Kingdom of Heaven*, one of the most popular works in the Collection, but who otherwise selected typical Victorian narrative and history paintings. In 1920-1, some of the better purchases made by Sir Cecil Lees, one of the Mackelvie Trustees, whilst on a visit to England, were works by Alfred Munnings and Laura Knight. In 1930, E.W.Payton, the former director of the

Fig. 1-12 Dod Procter *Light Sleep* (Fine Art Society Ltd)
In Plate 14, Dod Procter depicts Midge Bruford, who had broken her leg in a riding accident, making the patchwork quilt upon which the girl lies.

[21] ibid
[22] No mention of touring shows is made in the local press in 1938 but Hugh Ridge, in his article on the Society in Canynge Caple's *A St Ives Scrapbook* of 1961, does indicate that there was a show in Harrogate in 1938.

Elam School of Art in Auckland, was sent to Europe with authority to spend £6,000 on paintings. Himself a strong critic of the Victorian purchases of Stone, he determined to buy work "by the foremost workers of the day" in Scotland, England and France. Hearing of the status of the art colonies at Newlyn and St Ives, he came down to Cornwall and was escorted around the studios by Borlase Smart. As a result, he acquired for the Collection work by Forbes, Birch (3), Bradshaw (2), Lindner (2), Meade (3), Milner (2), Hurst Balmford (2), Hambly (2), Hartley, Hayward (2), Park (2), Olsson, Sharp, Smart, Miss E.M.Willett and Gotch. Stuck in the grip of the Depression, the artists can hardly have believed their good fortune. On the same trip, Payton also acquired work by William Ashton, Terrick Williams and John Littlejohns. In 1933, a further group of etchings were acquired and the Gallery now has prints by Job Nixon and Salomon Van Abbé and no less than eight works by Alfred Hartley. Later in the 1930s, further works by Lamorna Birch and Lowell Dyer were acquired.

Payton returned to Auckland with 84 oils, 50 watercolours and drawings and 123 prints. Some felt he had sacrificed quality for quantity. For instance, some watercolours had cost a mere £3-£7 and these, and a number of lesser oils, were soon deemed not of Museum quality. Over the years, due to financial constraints and changing tastes, works from the Collection have been sold off but not all have proved poor investments. Arthur Hayward's *In a Sunlit Garden*, bought for just £20 in 1930, sold for NZ$25,000 (c.£8,500) in 1999. A full list of acquisitions and disposals is given in Appendix D. Nevertheless, there are still some fine works by STISA members in the Collection. These include Arnesby Brown's *After the Heat of the Day* (Plate 2), probably one of the earlier purchases recommended by Marcus Stone, Lamorna Birch's superb *Old China Clay Pit, Penwithack* (Plate 36), one of the most expensive purchases at c.£260 and Stanhope Forbes' *Penzance* (Plate 22), which cost c.£165. Oils by non-Academicians still retained include Arthur Meade's *A Dorset Farmyard* (Plate 42), purchased in 1930, but dating from somewhat earlier, and Lindner's sumptuous version of *On the Giudecca, Venice* (Plate 4). There is also Terrick Williams' beautiful watercolour, *Concarneau* (Plate 83), and some fine prints, including *St Ives Harbour* by Alfred Hartley (Fig.1-13) and *Madonna in the Wall, Subiaco* by Job Nixon (Fig,1-9). It is quite extraordinary that a Gallery the other side of the world should have an infinitely better collection of works by STISA members than any Gallery in Cornwall. On various occasions during the period covered by this Exhibition, the artists campaigned for more and better Public Art Galleries in Cornwall. In St Ives, both Treloyhan Manor and the property that became the Guildhall were touted as possible sites. This, however, was one objective they did not achieve and so the vast majority of works for this show have had to be drawn from collections outside Cornwall.[23]

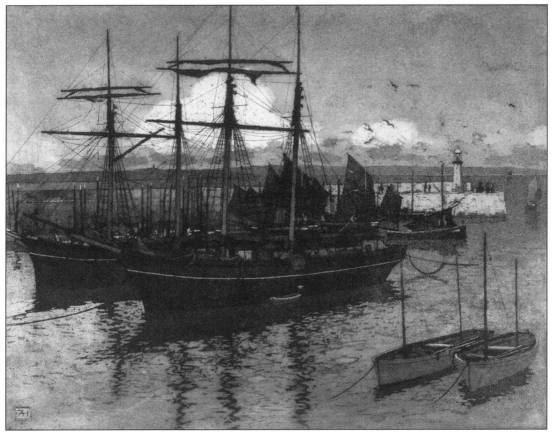

Fig 1-13 Alfred Hartley *St Ives Harbour* (aquatint/etching)
(Mackelvie Trust Collection, Auckland Art Gallery Toi o Tamaki)

[23] I am greatly indebted to Mary Kisler and Laura Jocic of Auckland Art Gallery for their assistance in providing information and photographs of work in the Mackelvie Collection. See also, J.M.Stacpoole, *James Tannock Mackelvie and his Trust*, an essay in the catalogue for *The Mackelvie Collection - A Centenary Exhibition 1885-1985*, Auckland, 1985.

THE WAR YEARS

Membership Changes

During the 1930s, the nucleus of the Society had remained remarkably stable. The onset of War naturally brought many changes to the colony and the Society that Smart attempted to move into the modern era in the years after the War was very different to the traditionalist preserve of the 1930s.

The late 1930s had seen the Grim Reaper at work amongst some of the early members. Adrian Stokes had been claimed in 1935 and Terrick Williams in 1936. Job Nixon, having left to teach at the Slade, died tragically young in 1938, and Algernon Talmage, John Bromley, Lowell Dyer and Fred Milner died in 1939. Neither Julius Olsson nor Arthur Meade survived the War and, when peace came, Laura Knight and Frank Brangwyn ceased exhibiting and Lindner, Forbes and Arnesby Brown produced little new work.

During the War, as Bradshaw had been called away for naval duties, Leonard Fuller helped Smart with the running of the Society. Smart was determined that the impulse gained over the 1930s should not be lost and organised as active a programme of exhibitions as conditions and finances permitted. There was no shortage of artists, as although some were away on active service, St Ives was seen as a safe haven, particularly by artists normally resident in London. Some arrivals, such as Dorothea Sharp and Marcella Smith were, of course, already well-known, as were Louis Sargent and Claude Francis Barry, who had formerly resided in the town during the Great War.

The lack of catalogues from the War years and the briefness of exhibition reviews make it difficult to reconstruct this period fully. However, membership numbers boomed with 50 new members in 1942 alone. There were clearly a number of artists, who stayed solely whilst the conflict raged. These include Edith Mitchell, a friend of Dorothea Sharp, and Kathleen Temple-Bird, whose portrait of Mahatma Gandhi, which was exhibited with the Society, is now in the Luxembourg Museum in Paris. Others newcomers who stayed on were William Todd-Brown, who had been Headmaster at the Reigate and Redhill College of Art,

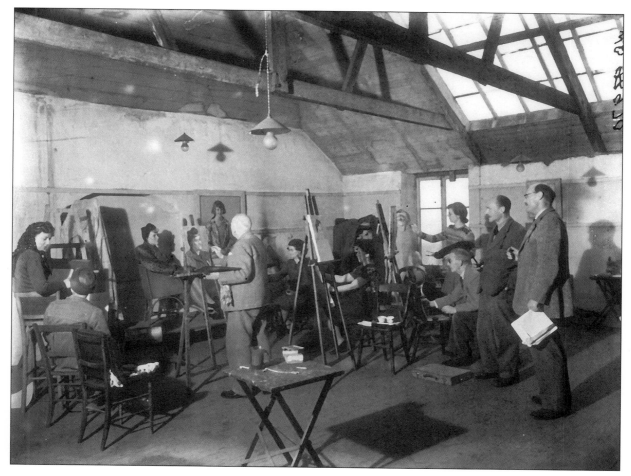

Fig. 1-14 Leonard Fuller (2nd from right) teaching at the St Ives School of Painting (March 1944) (Roy Ray)

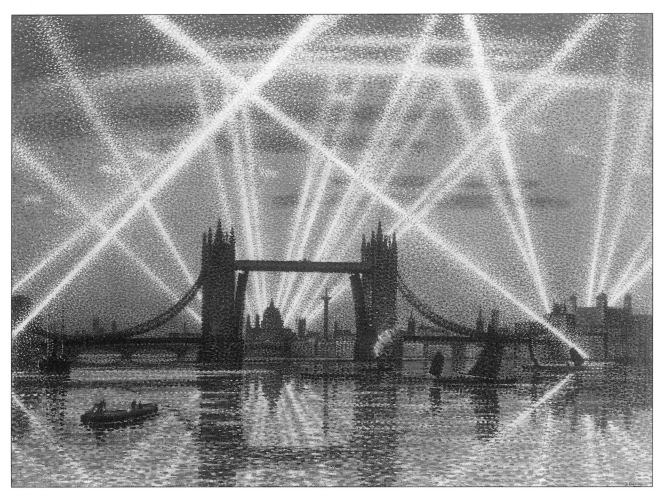

Fig. 1-15 Francis Barry *The Tower Bridge - A War-time Nocturne*
(Swindon Museum and Art Gallery: photo Witt Library, Courtauld Institute of Art, London)

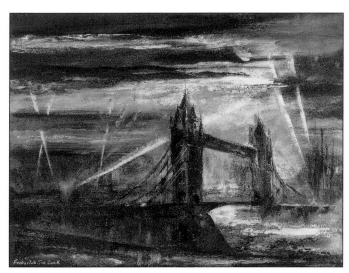

Fig. 1-16 Frederick Cook *A Flying Bomb over Tower Bridge*
(Imperial War Museum)

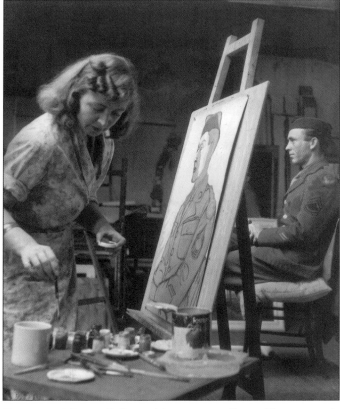

Fig. 1-17 Misomé Peile working on one of her military portraits
(Gilbert Adams)

Thomas Heath Robinson, the gifted illustrator of historical and religious books, Harry Rountree, another well-known illustrator of children's books, and Maurice Hill, the Secretary of the newly formed Society of Marine Artists.

Many of the new recruits were students, who had been attracted to the town by Leonard Fuller's School of Painting. These students joined the Society initially as Associates and then were granted full membership as their talents blossomed. Isobel Heath, Misomé Peile, Marion Grace Hocken and Dorothy Alicia Lawrenson are examples of students who stayed on to make significant contributions to the art colony.

War Artists

A number of members of STISA were appointed War Artists during the conflict. Laura Knight received various commissions from the War Artists Advisory Committee, chaired by Sir Kenneth Clark. She is best known for her portrayals of women at work in the war effort. *In for Repairs* features the WAAF balloon fabric workers mending balloons but her most celebrated painting was *Ruby Loftus screwing a breech-ring for a Bofors gun*, showing one of the most talented girl workers tackling one of the most difficult operations in the making of armaments. Stanley Spencer, who was greatly in debt, was also employed by the War Artists Advisory Committee and between 1940 and 1946 produced an exceptional series of paintings depicting men at work at Lithgow's shipyards at Port Glasgow on the Clyde. Leonard Richmond did a series of paintings of blitzed buildings in London and his *Bow Church, St Mary-le-Bow* was bought by Clark for the Imperial War Museum. Pauline Hewitt and Frederick Cook, who later moved to Polperro, did some similar subjects and Cook has nine works in the Imperial War Museum collection (see Fig.1-16).

STISA members were also involved in recording the War at Sea. Arthur Burgess was fully employed depicting convoys and individual ships for concerned shipowners. Charles Pears and Norman Wilkinson, as SMA founder members, are likely to have been encouraged to join STISA in 1939, albeit that their duties as official war artists meant that they did not exhibit with STISA until afterwards. Both had served as war artists in the First World War as well and the Imperial War Museum holds 107 works by Pears, whereas Wilkinson's *War at Sea* series of 53 paintings is owned by the National Maritime Museum. A number of Pears' war paintings were subsequently exhibited with STISA.

Not unnaturally, war scenes were also prevalent amongst the exhibits in St Ives. Smart produced *Waste Paper Salvage* and *Scrap Iron for Munitions*, Parkyn *Channel Patrol*, Hill *The Depth Charge* and Rountree *Air Power* whilst Fuller portrayed tanks, Ninnes an air battle and Barns-Graham scenes from the camouflage factory in which she worked. Isobel Heath did a series of paintings showing men and women at work in sheet metal, munitions and camouflage factories (see Fig.3H-10) and Misomé Peile painted American commandos (see Fig.1-17). However, it was Barry's searchlight paintings, such as *Tower Bridge - A War-time Nocturne* (cat.no.3), that aroused the greatest interest and, when peace came, the colour intensity of his Moscow fireworks paintings (see Plate 31) astonished all who witnessed them.

The Introduction of the Moderns

With the approach of War in 1939, Ben Nicholson and Barbara Hepworth moved down to Cornwall and stayed initially with the writer, Adrian Stokes, and his wife, Margaret Mellis, in Little Parc Owles in Carbis Bay. They were followed shortly by the Russian Constructivist, Naum Gabo and his wife, Miriam Israels. Younger artists were naturally drawn towards these major figures, who had been involved in such modernist movements as Unit One, Abstraction-Création and Constructivism. Peter Lanyon, who had initially taken lessons from Borlase Smart, and John Wells, then a doctor in the Scillies, but an old friend of Nicholson, started to produce work that was clearly influenced by Gabo and later by Nicholson and Hepworth (see for example, Lanyon's *Green Form 1945* - cat.no.44). In 1940, Wilhelmina Barns-Graham visited her art school friend, Margaret Mellis, and decided to stay in St Ives, mixing with both traditional and modern camps. It was she who first persuaded Borlase Smart of the merits of the approach of the moderns. Smart came to feel that it was wrong that artists of international renown were living in the area but were not members of the Society. Having gained an introduction through Barns-Graham, he persuaded Nicholson and Hepworth to join in 1944 and made available his own studio for Nicholson to exhibit on Show Day. This did not please the traditionalists but soon a modern section developed in the Society involving, inter alios, Nicholson, Hepworth, Barns-Graham, Peter Lanyon, Sven Berlin, John Wells and Bryan Wynter.[24]

The New Gallery

The huge increase in membership during the War years meant that exhibitions were becoming crowded in the Porthmeor Galleries and, buoyed by an increase in public interest, the Society decided in August 1945 to create a new gallery space in the recently

[24] From the chronology included in The Tate Gallery's *St Ives 1939-1964*, London, 1985, it appears that very brief appearances were made in STISA shows by Miriam Israels, the wife of Naum Gabo, in 1944 (although Gabo himself declared he was not a Society man) and Adrian Scott Stokes and his wife, Margaret Mellis, in 1946. None are included in the Dictionary of Members.

deconsecrated Mariners' Chapel in Norway Square. This was called the New Gallery and has been the home of STISA ever since, although it is now known as the Norway Gallery. The following year, the large crypt was fitted out as a further Gallery "to accommodate one-man shows and exhibitions connected with the Arts Council of Great Britain".[25] It was in the Crypt Gallery that the young moderns staged their now famous group exhibitions.[26] They also had joint and one-man shows at the Castle Inn in Fore Street, run by Endell Mitchell, brother of Denis Mitchell (q.v.), and at George Downing's Bookshop at 28, Fore Street (see Fig. 2B-2).

Show Days

During the 1930s, Show Days in St Ives had become so popular that special trains were laid on from London for visitors to attend the event and the huge number of works being submitted to the RA also required special railway facilities. In 1945, as one of several initiatives designed to widen the appeal of fine art, Show Day was moved to a Saturday in order to enable those at work to attend and, in 1947, the interest so aroused led to the introduction of two Show Days, one on the traditional Thursday and the other on Saturday.

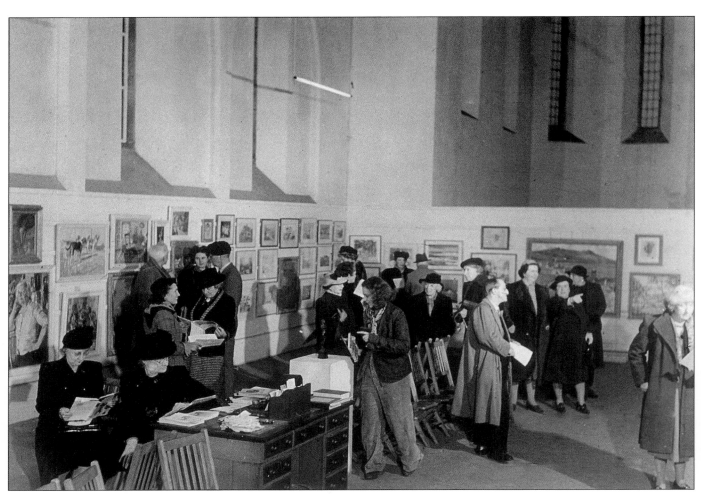

Fig. 1-18 A STISA exhibition in the New Gallery in 1947
Marion Grace Hocken, in trousers, stands in the centre. Behind her are Dorothea Sharp, in wide brimmed hat, and to the right Pauline Hewitt. Wilhelmina Barns-Graham is standing talking to Dorothy Everard to the left, and immediately behind them are Fred Bottomley (left), his daughter and Leonard Richmond.
(W.Barns-Graham)

[25] B.Smart, *The St Ives Society of Artists, The Studio*, 1948.
[26] This is now known as the Mariners' Gallery.

Table C - Breakdown of Prominent Members in Post-War Period

Artists shown in bold type resigned in 1949 and exhibited as members at the first exhibition of the Penwith Society, which opened on 18/6/1949.

(F) designates a Founder Member of the Penwith Society at the meeting on 8/2/1949. Non-STISA members who were also founder members of the Penwith were the printer, Guido Morris, and the craftsmen, Dicon and Robin Nance. There were 19 Founder Members in total.

Those artists whose names are also underlined rejoined STISA at a later date.

Former STISA member, W.Arnold-Foster, also exhibited as a member at the first exhibition of the Penwith Society, as did Anne Sefton Fish and Barbara Tribe, who were later to join STISA. Jack Coburn-Witherop also contributed to this Exhibition but was not listed as a member.

CONTINUING MEMBERS FROM THE 1930S	1940s NEW MEMBERS	NEW MEMBERS - POST 1949 SPLIT
Shearer Armstrong (F)	Malcolm Arbuthnot	Edith Lovell-Andrews
Dorothy Bayley	**Garlick Barnes**	Stuart Armfield
Lamorna Birch	**W. Barns-Graham (F)**	John Barclay (returning)
Fred Bottomley	Medora Heather Bent	Howard Barron
George Bradshaw	**Sven Berlin (F)**	Amelia Bell
Kathleen Bradshaw	Frances Blair	Sydney Josephine Bland
Midge Bruford	Sir Francis Cook	Charles Breaker
Arthur Burgess	**David Cox (F)**	Alice Butler
Irene Burton	Olive Dexter	David Cobb
Jack Coburn-Witherop	**Agnes Drey (F)**	Frederick Cook
Mabel Douglas	**Jeanne du Maurier**	Cuthbert Crossley
Frances Ewan	Terry Frost	Violet Digby
Dorothy Everard	Meta Garbett	Anne Sefton Fish
B. Fleetwood-Walker	Hilda Harvey	George Gillingham
Maud Stanhope Forbes	**David Haughton**	Malcolm Haylett
Leonard Fuller (F)	**Isobel Heath (F)**	Eric Hiller
Stanley Gardiner	**Barbara Hepworth (F)**	E. Bouverie Hoyton
Geoffrey Garnier	**Marion Hocken (F)**	Faust Lang
Jill Garnier	Maurice Hill	Una Shaw Lang
Alethea Garstin	**Hilda Jillard**	Wharton Lang
William Gunn	Leslie Kent	Denys Law
Fred Hall	E. Lamorna Kerr	Marjorie Mort
Arthur Hambly	**Peter Lanyon (F)**	Ernest Peirce
Pauline Hewitt	D. Alicia Lawrenson	William Piper
Eleanor Hughes	**Denis Mitchell (F)**	Hugh Ridge
Robert Hughes	Arminell Morshead	Dorcie Sykes
Frank Jameson	Sir Alfred Munnings	Barbara Tribe
Bernard Leach (F)	**Ben Nicholson (F)**	
Thomas Maidment	Charles Pears	
William Westley Manning	**Misomé Peile**	
Marjorie Mostyn (F)	George Pennington	
Bernard Ninnes	Dora Pritchett	
John Park	Tom Heath Robinson	
William Parkyn	Harry Rountree	
Dod Procter	**Hyman Segal (F)**	
Hettie Tangye Reynolds	Charles Simpson	
Eleanor Rice	William Todd-Brown	
Leonard Richmond	Billie Waters	
Helen Seddon	**John Wells (F)**	
Dorothea Sharp	Fred Whicker	
Borlase Smart	Gwen Whicker	
Marcella Smith	Clare White	
Stanley Spencer	Denise Williams	
Annie Walke	Kathleen Williams	
Richard Weatherby	Rendle Wood	
Helen Stuart Weir	**Bryan Wynter**	
Arthur White	Allan Wyon	
	Eileen Wyon	

THE TOURING EXHIBITIONS OF THE 1940S

1945/6 Sunderland - Gateshead - Middlesborough - Carlisle - Darlington - Swindon

As George Bradshaw had been posted to Sunderland during the War and had had a one-man show at Sunderland Art Gallery, he may well have been involved in organising the northern section of this tour, although Borlase Smart made initial contact with the Tullie House Museum and Art Gallery in Carlisle.[27] The exhibition started in Sunderland on 4th August 1945 and continued until January 1946, when it terminated in Swindon. There were 83 works on show and visitor numbers just during the twenty-seven days it was in Sunderland totalled 15,000. There appears to have been a particular interest in the exhibition from members of the armed forces - no doubt because the depictions of Cornish beauty spots were a tonic after the horrors of War. In Swindon, the show was held in the Town Hall but a new Art Gallery was being built and several works were purchased from the Exhibition by F.C.Phelps, for presentation to the new Gallery. These were *Refugee* by Kathleen Williams, *Near Archerton, Post Bridge, Devon* by Arthur Hambly, and *The Tower Bridge, London - A War-time Nocturne* by Francis Barry (Fig. 1-15).[28] In addition, the new Gallery bought *Ebb Tide on the Reef*, Borlase Smart's 1943 RA exhibit. Barry's work (cat.no.3) and *Top Hat*, a distinctive still life by Helen Stuart Weir (cat.no.92), are included in the present Exhibition.

The most significant work in the Exhibition, however, was Laura Knight's *The Young Hop-picker*. Stanley Spencer's exhibit *Choosing A Dress* had been seen before at STISA shows. Leonard Richmond, who moved to St Ives the following year, exhibited a painting of his studio in the town and there were important works by Borlase Smart, Charles Simpson and Bernard Ninnes. Hilda Harvey's *Holidays in Cornwall* (Fig. 1-19) was a great success. Neither Nicholson nor Hepworth were included, however, although Wilhelmina Barns-Graham and Peter Lanyon did feature.

Fig. 1-19 Hilda Harvey *Holidays in Cornwall*

[27] The Gallery had purchased Bradshaw's work *Lobster Fishing* from this show and he had also donated to the Gallery a painting of H.M.S.Delhi, which Sunderland had adopted.

[28] Hambly's *Near Archerton, Post Bridge, Devon* is illustrated in David Tovey, *George Fagan Bradshaw and the St Ives Society of Artists*, Tewkesbury, 2000 at p. 169.

Fig.1-20 An early meeting of the Crypt group with Peter Lanyon (hiding Guido Morris), Sven Berlin, Wilhelmina Barns-Graham and John Wells (C.O.I.)

1946/7 St Austell - Newquay - Fowey - Falmouth - Truro

Egbert Barnes, a director of the St Austell Brewery, was a keen follower of contemporary art and he decided in 1944 to host exhibitions of paintings by members of STISA at The White Hart, the brewery's foremost hotel. In 1946, there was a special exhibition devoted to *Cornish Inland Landscapes* and the brewery bought works by Smart, Nicholson, Barns-Graham and Dorothy Bayley. The following year the title was *Industry other than Fishing*. Later, Barnes recalled his colleagues' "pained surprise" at his choice of pictures but an £80 investment in works by Nicholson subsequently realised £2,350 and paid for the entire refurbishment of the Hotel![29] Shows at The White Hart continued on a regular basis for many years, with the Brewery buying paintings to the value of £150 annually.

In 1946, a pilot exhibition was held in Newquay, for Smart felt that tourists to other holiday destinations in Cornwall would appreciate the work of the Society. The success of this show led to a touring exhibition the following year going to Newquay, Fowey, Falmouth and Truro. Paintings singled out in reviews include *The River Barle, Withypool*, one of Leonard Richmond's best works, John Park's river landscape *Spring Is Here* (RA 1946) and one of Borlase Smart's modern experiments, *Atlantic Weather, Land's End*, described as "a mass of churning water with a complete disregard of line and form". David Cox, who was then living in Newquay, may have been involved in some of the organisation of this tour and his work *Ballerina* was also highlighted. Other artists mentioned favourably are Lamorna Birch, Arthur Burgess, Richard Weatherby, Fred Hall, Bernard Ninnes, Marcella Smith, Dorothea Sharp and Medora Heather Bent.

1947 South Africa

During 1946, Borlase Smart managed to arrange for a touring exhibition of work by STISA members to go to South Africa to coincide with the King's visit in March 1947. In making the initial selections, the Committee of STISA were keen to emphasize the scenic attractions of Cornwall, so as to encourage visitors to Cornwall, particularly the many South Africans with Cornish roots. The show comprised in total 150 works of which 121 were sent from St Ives. The exhibition was organised in conjunction with the Maskew Miller Art Gallery in Cape Town, where it was opened by Mrs Waterson, the wife of the Premier, and it was scheduled to go from Cape Town to Johannesburg and then to Durban, Bloemfontein and Pietermaritzburg. All the principal members of the Society were represented, but only Wilhelmina Barns-Graham from the modern contingent. Segal's *Kimani* (cat.no.74), one of the works executed by him during the time he served in Africa during the War, was, however, rejected by the South Africans, as it was considered "inappropriate" for white owned Galleries to show "native portraits". Unfortunately, no catalogue has been located but *Rural Essex*, a large oil by John Park was purchased for the Cape Town Gallery.

[29] Liz Luck, *Brewing for Cornwall - A Family Tradition: The Story of St Austell Brewery, 1851-2001*, St Austell, 2001, p.40-1.

Fig. 1-21 Stanhope Forbes *The Old Weighing In House, Penzance*
(W.H.Lane & Son, © courtesy of the artist's estate/Bridgeman Art Library)

1947 National Museum of Wales, Cardiff

The Society held a show in London at Heal's in the spring of 1947 but, without doubt, the major Exhibition of this busy year was at the National Museum of Wales at Cardiff. Smart considered this Exhibition to be the most important the Society had ever held and, in its blend of traditional and modern art, he saw it as the way forward. Unfortunately, he died before the Exhibition was over and his dream never materialised. A full list of the 132 works exhibited is included in Appendix B. There were sculptures by Hepworth and Sven Berlin and two typical still lifes by Ben Nicholson. Peter Lanyon, Bryan Wynter, Wilhelmina Barns-Graham, John Wells and Terry Frost were represented, as were many other young artists, such as Hyman Segal, Misomé Peile, Isobel Heath, Marion Hocken and Hilda Jillard. There were two Stanley Spencers and several works by Dod Procter. There were recent RA exhibits from Leonard Fuller, Bernard Fleetwood-Walker, Fred Hall and Charles Pears, two examples of the work of the late Stanhope Forbes and a medalled work by Greville Irwin, whose suicide had shocked the colony that year. Lesser known artists who contributed RA exhibits included Denise Williams, Mornie Kerr, Eleanor Charlesworth, Maud Stanhope Forbes, Stanley Gardiner, Arminell Morshead, Maurice Hill, Midge Bruford, Alethea Garstin and Thomas Maidment. New members included Norman Wilkinson, Sir Francis Cook and Lamorna artist, Denys Law. These coupled with the solid body of work produced by long-term members of the Society must have resulted in an impressive show. Certainly, Smart rated it as the best display ever staged by the Society. Coburn-Witherop's *Hillside Farm, Wales* was bought from the exhibition for the Contemporary Art Society of Wales and Hepworth's *Sculpture with Colour Blue and Red* (wood, painted with strings) (Fig. 1.43) is now in the collection of the Tate. Included in this exhibition are Alethea Garstin's *Regatta Day, Hayle*, (cat.no.27), Fred Hall's *One Winter's Morn* (cat.no.29) and Annie Walke's *Christ Mocked* (cat.no.90) and other works illustrated include Terry Frost's *The Chair* (Plate 20), Barns-Graham's *Grey Sheds, St Ives* (Fig. 2B-2), Bernard Fleetwood-Walker's *Nude* (Plate 13), Stanhope Forbes' *The Old Weighing-In House, Penzance* (Fig.1-21) and Fred Beaumont's *National Gallery - Interior* (Fig. 3B-4).

THE SPLIT OF 1949

Tensions Rise

The extraordinary unity of purpose which characterised the Society during the 1930s was never evident during the 1940s. The War years led to a change of attitudes and values, particularly amongst the young. As the first generation to have studied at art school the modern movements of the early twentieth century, there was a great desire amongst the younger artists joining the Society for change and a move away from traditional representational art. The older artists, apart from being traditionalists in their approach to painting, also had difficulties with the morals and the arrogant attitudes of some of the younger members. The fact that Nicholson, Wynter and, initially, Berlin and others in their circle had been pacificists clearly did not help in the eyes of those, like Bradshaw, who had served in both World Wars. Certainly, Smart's decision to invite Nicholson to join caused a few raised eyebrows amongst the older members, who felt that Smart had gone out on a limb somewhat. As modern works came to be hung in STISA exhibitions, their concerns heightened. Lamorna Birch, having viewed one show, sat with some friends in silence for some time at a café, before putting into words all their thoughts, "Ghastly stuff, wasn't it. Simply ghastly".[30] It was Harry Rountree that first sounded off in public. In September 1946, Lanyon, Berlin, Wells, Wynter and the printer, Guido Morris, keen to exhibit a wider range of work than could be included in STISA shows, held a joint exhibition in the Crypt of the New Gallery. Borlase Smart agreed to open the exhibition. In a letter to *The Western Echo*, pointedly directed at Smart, Rountree raged,

"Surely those who are encouraging our modern artists are doing a great dis-service both to the artists and art. What a pitiful racket this alleged art is... Fifty years I have been a professional artist and I see nothing in these alleged modern ideas... This modern racket started in France: it rotted French art - in France, it is now dead... Young men, drop it, get back to work and sweet sanity."[31]

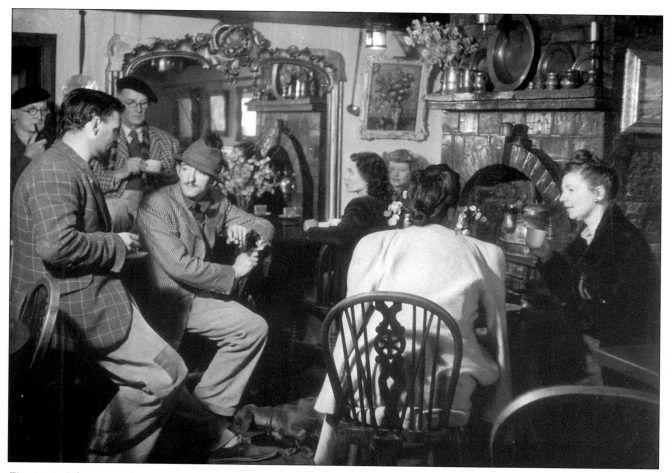

Fig. 1-22 The group that worked to save the Porthmeor Studios in the Copper Kettle - Pop Short (the proprietor with pipe) and Leonard Richmond (back left), Sven Berlin and David Cox (front left), Wilhelmina Barns-Graham and Olive Dexter (back right) and Denise Williams (back view) and Misomé Peile (front right).

A. Wormleighton, *A Painter Laureate - Lamorna Birch and his Circle*, Bristol, 1995.
Western Echo, 21/9/1946.

Fig. 1-23 Hyman Segal *Painter-Organiser David Cox*
(H.Segal)

In subsequent correspondence, Rountree responded to Smart "I would remind him that some people are so tolerant that they hunt with the hounds and run with the hare. Surely this brand of tolerance commands no respect?".[32] Whereas others may not have favoured the pugnacious approach of Rountree, his words indicate the sense of betrayal that many of the traditionalists felt.[33] However, Smart's charisma and leadership qualities ensured that an uneasy peace was maintained - the moderns felt that their works were being shepherded quietly into an inconspicuous corner, whilst the traditionalists continued to be baffled as to how such paintings constituted art of substance in accordance with the yardsticks that had held true during their long careers. Nevertheless, the Exhibition at Cardiff in 1947 displayed the best of both camps, with Smart satisfied that it was STISA's best ever show.

Smart's death left a void that was difficult to fill. In his last year, he had been both President and Secretary of the Society. The standing of STISA at that time is exemplified by the fact that the then President of the Royal Academy, Alfred Munnings, was persuaded to take over as President, but he had little involvement in the day to day affairs of the Society. Leonard Fuller, Borlase Smart's right-hand man since 1940, remained as Chairman and became Vice-President, in acknowledgement of Munnings' figurehead status. A relative newcomer, David Cox, was perceived to have the organisational abilities to assume Smart's position as Secretary and he immersed himself in the role immediately. Not only did he organise more travelling exhibitions but he became the colony's art critic, opening and reviewing many of the shows put on by the young moderns not only in the Crypt but in venues such as Downing's Bookshop and the Castle Inn. He also organised the Borlase Smart Memorial Fund, which, in conjunction with a significant Arts Council grant, raised sufficient funds to purchase the Porthmeor group of studios that Lindner was wanting to sell.

Cox's sympathies lay with the moderns and the rule changes introduced at the 1948 AGM were clearly promoted by the modern contingent. Quite who was involved in their formulation is not known, but, from subsequent events, it is likely that Nicholson and Hepworth were prominent parties. It was these rule changes - and the manner in which they were introduced - that led eventually to the split. The changes were not discussed at Committee stage but, instead, the new rules were printed and presented as a *fait accompli* at the 1948 AGM, which was not held in February as usual but in June. Given that the Society had lost its President and Secretary in November 1947, the delay is surprising and one might fairly assume that a plan to gain greater control over the Society was being hatched by the moderns during this period. The rule changes included the introduction of a five year ruling Council, a very significant departure from previous practice, concerning which there had been no prior consultation with members; even certain proposed Council members did not know of it. However, the change which led to the biggest upset concerned the right to exhibit. For the first twenty-one years of the Society's existence, membership of the Society entitled a member to have at least one work included in each exhibition. Members were only elected on merit, and once the Society had found its feet, membership was not conferred lightly. However, given the costs of membership, it was felt only fair that each member should be able to be represented at each show. Clearly, there must have been occasions when the quality of a member's work slipped but the matter seems to have been dealt with by having a quiet word. The rule change did away with this right, so as to enable the hanging committee to select the best show possible. There seemed nothing too alarming about such a change, as all artists were keen that the Society's shows were as good as possible. However, it was the way the new rule was operated that resulted in righteous indignation. Bradshaw, who became the spokesman for the traditionalists, commented that since the change,

[32] *Western Echo*, 5/10/1946.
[33] Francis Barry supported the moderns - see his Dictionary Entry in Part A.

"work of established and experienced members of the society has been thrown out left and right". Rountree, one of those affected, found it particularly galling when, on going to the gallery, one was confronted with "a picture of what looked like a diseased snake". Resentment built up as established artists were omitted from the Summer and Autumn shows in 1948 and the Winter Show in early 1949 but it seems that the selection of works for the 1949 Swindon show triggered the requisition for an Extraordinary General meeting in February 1949 to discuss "a more satisfactory conduct" of the Society "more in keeping with [its] traditions".

The 1949 Swindon Exhibition

The Swindon show was restricted to 72 works, some 60 works less than the Cardiff show, which clearly gave rise to selection difficulties of its own. There was no sculpture section and no artist had more than two works included. Signatories of the requisition for the E.G.M. who were not hung included Harry Rountree, clearly one of the most aggrieved, Thomas Heath Robinson and Frances Ewan, but Pauline Hewitt, Helen Stuart Weir, Helen Seddon, Midge Bruford, Dorothy Bayley and Eleanor Charlesworth are female artists that one would have expected to see amongst the exhibitors, whilst Stanley Gardiner, John Littlejohns and Maurice Hill were also missing. Nevertheless, the selection did not unduly favour the modern contingent. Nicholson, Barns-Graham, Lanyon, Wells and Wynter were restricted to one work each but newcomer, Denis Mitchell, was represented by two works. Younger artists with modernist leanings, such as Agnes Drey and Hilda Jillard were included and newcomer, Fred Whicker, was represented by a work called *Doodling*. However, all the major works were still provided by the traditionalists. The highest priced work at £210 was Charles Pears' *Four Mast Barque Signalling for a Pilot* (RA 1939) (Fig. 2P-3), a work acquired but now seemingly lost by Royal Cornwall Museum, Truro. There were some significant portraits, with Maud Forbes exhibiting her portrait of her late husband, Stanhope Forbes. Leonard Fuller showed a study of his late father-in-law, entitled *The Late Tom Mostyn ROI at work* and his portrait, *Mrs Perkins*, which was the colour illustration when he featured in the *Artists of Note* series in *The Artist* in July 1950. The exhibition also included two portraits of the Secretary, David Cox, one by Bernard Fleetwood-Walker (Fig. 2F-1) and one by Leonard Richmond. Cox himself had two portraits included, of which *Le Temps qui s'ecoule* was priced at £157-10s. 'Seal' Weatherby sent his previous year's RA exhibit, *The Hill Field*, but some of the other major works were some years old with Dod Procter's *Nude* and *Smiling Girl*, both being RA exhibits of 1940 whilst Park's *Snow In Majorca* might even date from the 1934 RA Exhibition. Rather strangely, Annie Walke's *Christ Mocked* (cat.no.90) was included yet again. A local reviewer commented, "A feature of the exhibition is its representation of different schools of thought from classical to the most modern... Of the modern painting, the most striking is *Looking at a Drawing*, a strong work by Stanley Spencer, but there is such diversity of treatment that no-one can fail to find a completely satisfying aesthetic delight."[34] Such favourable reviews were, however, immediately overtaken by events in St Ives.

An Extraordinary General Meeting

Wilhelmina Barns-Graham has confirmed that Nicholson and Hepworth had planned to use the extraordinary general meeting called in February 1949 to engineer a split in the Society. The intention had been for a small group of modernists to resign and form a new body. No-one predicted the size of the split and the ill-feeling that was caused. During the meeting, Bradshaw, speaking for the traditionalists, is reputed to have lost his temper and waved his fist uncomfortably close to the chin of Leonard Fuller, the Chairman. He blamed Fuller for allowing David Cox, the Secretary, to have too free a rein in formulating the new rules. Nevertheless, his suggestion that a Committee be formed for reviewing the new rules was accepted but, in a secret ballot, none of the moderns were elected. To overcome this, Hepworth was asked to join the Committee but she refused. Sven Berlin states that he proposed a vote of confidence in David Cox, as Secretary, but that, egged on by Nicholson and Hepworth, demands for his resignation were made. Cox duly resigned, shortly followed by Fuller and the whole of the moderns and many of the younger more traditional artists, such as Hyman Segal, Isobel Heath and Marion Hocken. The loss of Fuller and his wife, Marjorie Mostyn, was deeply regretted, as was the resignation of one of the founder members, Shearer Armstrong. However, on balance, the traditionalists were glad to be free of underhand machinations and to have a united body once again. Bernard Ninnes, as Vice President, and George Bradshaw, as Secretary, assumed control and sales in 1949 were the highest ever, as were visitor numbers of 11,000. 1950 saw sales increase again by a staggering 46% to £3,362 (Penwith Society sales £417) and 1951 matched the previous year's total (Penwith Society sales £476). Accordingly, the split did not appear initially to have had any adverse effect whatsoever.

[34] Unidentified newspaper cutting from David Cox papers. The Spencer could have been purchased for £65, whereas a Marion Hocken flower piece was £49!

Fig. 1-24 Faust and Wharton Lang

A FRACTURED COMMUNITY

The 1951 Festival of Britain Exhibition

After the split, the new Committee found that the finances of the Society were in a poor state and considered that, in these circumstances, the expense of putting on further touring shows could not be countenanced at that time. Accordingly, the Festival of Britain Exhibition in 1951 was the most important show since the split. For this event, a fund had been established by the Arts Council and the Borough Council, working in conjunction with both Societies, to enable works to be purchased for the permanent collection of the Town. The first prize of £75 was awarded to Bernard Ninnes for his *A Cornish Hamlet (Nancledra)* (cat.no.60), his marvellous aerial view, showing a range of activities going on in this old Cornish village. Other works purchased from the STISA Exhibition included John Park's *Symphony in Grey, St Ives Harbour*, a typical Park of boats in the Harbour, *Dutch Boat, Hayle* by Dorothy Bayley (Fig, 3B-3), an oil by Thomas Maidment of old houses off The Stennack, rendered with meticulous detail in his usual subdued tones, and Faust Lang's wooden sculpture, *Tern*. Other established artists strongly represented were Lamorna Birch, Charles Pears, George Bradshaw, Stanley Gardiner, Pauline Hewitt, Robert Hughes, Charles Simpson, Richard Weatherby and Helen Stuart Weir. Dorothea Sharp and Marcella Smith also exhibited and there were contributions by a range of relative newcomers, who were to be the core of the Society for the next twenty or more years, such as Bouverie Hoyton, the head of Penzance School of Art, Charles Breaker, Eric Hiller and Marjorie Mort, who had just formed the popular Newlyn Holiday Sketching group, and the portrait painters, Malcolm Haylett and Frank Jameson. Other new faces that were to feature in STISA shows into the 1970s and beyond were the marine painters, Hugh Ridge and Leslie Kent, the miniaturist, Alice Butler, the tempera authority, Stuart Armfield, and the idiosyncratic, Clare White. The sculpture section was boosted by the arrival of Faust Lang and his son, Wharton. The catalogue for the 1951 Exhibition (see Appendix C) lists 184 works but such was the interest in the Exhibition that the Society's records reveal that 199 pictures were sold from the show. Accordingly, replacement works also sold rapidly and the success of the Exhibition has not been matched before or since.

Returns from the Penwith

The early days of the Penwith Society were troubled by yet further rows. Disturbed at the number of traditional painters within their midst, Hepworth and Nicholson introduced a proposal whereby artists should be categorised as

- Group A to comprise Traditional, Representational, "Port", Right, "Ancient",
- Group B to comprise Contemporary, Abstract, "Starboard", Left, "Modern", or
- Group C to comprise Crafts

When electing hanging committees, an artist's vote would only count towards the selection of members representing his or her group. Segal, Heath, Berlin, Guido Morris and Lanyon immediately resigned and Cox, who had assumed the role of Secretary of the Penwith initially, was so appalled that he left St Ives completely and wrote a lengthy letter to the local paper dismissing the proposal as "complete nonsense". Slowly, some of the more traditional artists started to return to STISA - Fuller and Mostyn began exhibiting with STISA again in 1952 and showed with both Societies for a while but, by 1956, the Penwith Society had become almost exclusively the preserve of non-representational artists. Heath, Segal, Hocken and Garlick Barnes became members of STISA again and even Shearer Armstrong and Misomé Peile, who had both devoted themselves exclusively to abstract work for a time, rejoined before their deaths.

1950s Decline

The huge success of the Festival of Britain Exhibition in 1951 might suggest that the Society was set fair for a number of years but its decline was astonishingly rapid. 1952 saw sales drop by 26% and the quality of the membership reduced by a significant number of deaths and departures.[35] Although a great effort was made for the Coronation and Festival Exhibition of 1953 and it was felt, within the Society, to be the most interesting and stimulating show seen at the New Gallery for many years, it was slated in the B.B.C. broadcast on the St Ives Festival. Even Ben Nicholson was sufficiently incensed by the attitude taken by the B.B.C. to write to the local paper condemning the broadcast, but it was indicative of the change of mood within art circles. Even if the Society had had the funds to mount a touring show, no Curator at this juncture would have wanted a display of representational art. As Art Council funds were directed solely to the Penwith Society, considerable resentment grew not only amongst STISA members but also amongst the members of the Newlyn Society of Artists, for whom Peter Lanyon often spoke. As the reputation of the moderns took off during the 1950s, various broadcasts were made from St Ives but all either ignored or misrepresented the traditionalists. Not surprisingly, collectors also took notice of the new-found infatuations of the art critics and sales of traditional art dried up at an alarming rate. Even the great tradition of Show Day faded away as artists no longer bothered or could afford to send works to the RA. The traditionalists felt powerless and speeches at opening ceremonies become obsessed with the curse of modern art. Even Claude Muncaster, who had been elected President of the Society on Lamorna Birch's death in 1955 and who was shortly also to be elected President of SMA, launched into an astonishing tirade at his first AGM, calling extremist forms of modern art "dangerous, decadent and destructive" and "a sort of Teddy-boy business" influenced by the Russians!

The splits not only in the original Society but also in the Penwith resulted in considerable ill feeling, which did not abate with time. David Cox was so distressed by what had occurred that he would not talk about this period in his career to his students. Sven Berlin left St Ives in 1953 convinced that there was a brooding Presence in Cornwall that brought desolation, loneliness, and destruction. Bradshaw would wave his stick angrily at Hepworth, whenever he saw her, and would cross the road rather than acknowledge Ben Nicholson. Malcolm Haylett, who had an open mind as regards modern art, was nevertheless moved to write in the foreword to the STISA catalogue in 1958, "You will not be likely to find any canvases which have been ridden over by bicycles, although the various techniques employed in this gallery may be acidly criticised by those who do."[36] The atmosphere within the modern camp was no less tense, with the Penwith Society seemingly in imminent danger of implosion at any time as fads came and went and various factions vied for control. But, as Segal commented, "Those on the Bandwagon who survived the Splits, split their sides laughing all the way to the Tate."[37]

This then was the background to Marion Hocken's *The Hollow Men* (cat.no.37), an indictment not only of the art colony but also of the town, which she considered had sold its soul to tourism. The availability of studios decreased alarmingly as properties were converted to fish and chip shops and guest houses. Of the 100 studios that had previously existed, only thirty-eight remained.[38] Swinging increases in the rates payable for properties in St Ives following the tourist boom meant artists could ill afford the studios remaining and many were forced to find part-time work to supplement their meagre income. Many were reduced to dire straits. The atmosphere in the town was, accordingly, not pleasant - cliques abounded, success seemed to depend as much on ability with the pen as with brushes, there was much fawning towards those who influenced the direction of grants, and bitterness, envy and resentment held sway. It was all a far cry from the unity of purpose that had characterised the first twenty years of the Society. Hocken held up a mirror but no-one liked what they saw and Hocken, as a result, became a recluse for the rest of her life. Even Leonard Fuller, who had championed the moderns after Smart's death and had become the first Chairman of the Penwith Society, had become embittered by the time he published his book of poetry, *Cornish Pasty*, in the early 1960s.

[35] Gardiner, Weatherby, Todd-Brown, Hill, Robertson, Titcomb, Bertie Hughes and Mrs Stanhope Forbes died around this time and Park and Hewitt left St Ives. Bradshaw was forced to resign as Secretary due to a second coronary. By 1955, Lamorna Birch and Dorothea Sharp had also died.
[36] Foreword to the catalogue for the Summer Exhibition 1958.
[37] H.Segal, *A Storm in a Paint Pot*, 1986, reproduced in *As I Was Going to St Ives*, St Ives, 1994.
[38] *St Ives Times*, 6/6/1947.

No call for sneers
Or snarling jeers,
Ye moderns, pause
Take heed
Because
Your own attempts
To leap the moon
May bring you soon
Hilarity and scorn
Like cow with crumpled horn! [39]

For further detail about the 1949 split, see the Dictionary entries in Part A for David Cox, Bernard Ninnes and Hyman Segal and in Part B for Sven Berlin.

For further detail about the early travails of the Penwith Society, see the Dictionary entries in Part A for David Cox, Hyman Segal and Peter Lanyon and in Part B for Isobel Heath.

STYLISTIC TRENDS

At the meeting in January 1927 at which it was agreed to form the Society, Lindner commented that the St Ives colony of artists in the past had always been "rather proud of each going on their own way" and had abhorred what had happened in Newlyn, where the artists had "all adopted the same style of painting".[40] Such a spirit still existed in the colony and, accordingly, by encouraging discussions of art techniques, the Society was seeking not to establish a recognisable style but to help artists to develop their own individual outlooks more effectively. The term, the St Ives School, therefore, does not relate to any of the early generations of St Ives artists but to the moderns of the 1950s and 1960s, who did influence and draw from the work of each other. Nevertheless, there are some trends in the inter-war period that merit some comment.

Fig. 1-25 Harry Fidler *Working Horses* (W.H.Lane & Son)

[39] From *Pre-Raphaelites and Moderns*, Poem No.21, in L.Fuller (illustrated by M.Mostyn), *Cornish Pasty*, St Ives.
[40] *St Ives Times*, 21/1/1927.

'British Impressionism'

The initial contingent of landscape painters in St Ives had been more influenced by the Barbizon School than by the Impressionists, whose work will have been derided during their sojourns in Paris but, by the 1920s, artists like Arnesby Brown and Algernon Talmage were painting in a looser, more atmospheric style, with less regard for detail. This was not as bold or as sparse as, say, the work of Steer or Sickert, but each brushstroke was visible and placed so as to get maximum suggestion of form, colour and tone. A keen and persistent observation of nature was still crucial to such works, even if they were largely painted in the studio. *Summer Pastures - The Marshes near Norwich* (cat.no.13) is a superb example of Brown's style at this time. Fred Hall, who, like Brown, painted animals in pastoral landscapes, also developed a broader, looser style. David Messum and Laura Wortley were among the first to classify such work under the term 'British Impressionism' and both Wortley and Kenneth McConkey have now written books on the subject. The term, however, seems to be used to cover so many variants (many of which have little connection with French Impressionism), that it is almost meaningless. Nevertheless, in the inter war period, many British artists were loosening their brushwork and adjusting their colour values in personalised responses to Impressionism and senior STISA members such as Brown, Hall, Talmage, Williams, Lindner, Forbes and Laura Knight can be termed British Impressionists, if it is necessary to attempt to classify them.

Another landscape artist from the early years of the century was Elmer Schofield, who returned to Cornwall and joined STISA in the late 1930s, when his son bought Godolphin House. Now acknowledged as one of the leading American Impressionists, his painting *Godolphin Ponds in Winter* (cat.no.72), a typical snow scene, shows that his ability to paint large canvases out of doors boldly and vigorously had not decreased with age. Unfortunately, with the onset of War, his influence upon STISA shows was not as marked as it might otherwise have been.

Another artist of the same generation, who adopted a very individual impressionist style in later life, was Harry Fidler (see Fig.1-25). Flooded with sunlight, his subjects - often of man and beast working the land - are depicted with heavily textured paint, laid on with a coarse brush, palette knife or even thumbs, to convey feelings of monumentality. As in his own day, these works are instantly recognisable. Of the next generation, there were a number of artists, whose brushwork was loose and vigorous, but John Park and Dorothea Sharp stand out as the two artists most influenced by the French Impressionists. Park's depictions of St Ives harbour are manifold but less attention is paid to the correct delineation of boats afloat than to the special atmosphere of the moment. Colour and light are king, as can be seen in works such as *Fringe of the Tide* (cat.no.64). Like Park, Dorothea Sharp is also immensely popular now with collectors. Her seemingly endless array of depictions of children playing in the shallows attract not only because of their subject matter but also because of the vibrancy of their colours vigorously applied in broad, paint filled strokes. These merits transcend an undoubted weakness in her figure drawing. For many, her works, such as *Low Tide* (cat.no.77) and *Sea-Bathers* (cat.no.78), capture those happy, innocent times spent by the seaside on long, hot summer days during childhood - they encapsulate the perfect Cornish family holiday.

Before leaving this section, mention should be made of 'Seal' Weatherby. Although now not nearly as well-known as many of his contemporaries, he was highly regarded in his day, known for his 'white-hot' application of paint and for the consequent freshness and luminosity of his work. His portrait, *Stanley Gardiner Painting* (cat.no.91), painted out of doors demonstrates his sure touch and is a *tour de force*.

From *plein air* realism to decorative effect

Both the original Newlyn and St Ives colonies had been strongly influenced by *plein air* realism, which the artists had first experienced in the ateliers of Paris and Antwerp. By the 1920s, however, very few adhered rigidly to this principle and contemplated the execution of a complete canvas out of doors. This was largely due to the vagaries of the English weather. Even if wind and rain did not interrupt one's work, the passage of time would alter shadows and reflections and, in any event, many effects that the artists were wishing to capture were fleeting. Even those able to paint quickly and boldly found that they could not necessarily produce a satisfactory result. Nevertheless, the principle still had some adherents. Stanhope Forbes always preferred to paint out of doors if he could, believing that this gave a "quality of freshness" that was difficult to achieve otherwise. Lamorna Birch spent a large percentage of his days on the banks of rivers, fishing if he was not painting, and the small scale upon which Park normally worked meant that his easel was an ever present feature around the harbour in St Ives. Borlase Smart, too, considered painting done in the open was far more luminous in tone and was prepared even to clamber down rock faces with his canvas and easel.

Even if *plein air* realism was in decline, sketching on the spot was still considered to be essential by the vast majority of early members. "Paint, look around you and observe. Paint some more." was the advice Lamorna Birch gave to his daughter and Leonard Richmond, in his book on Landscape Painting, told students that, in favourable weather conditions, they should be

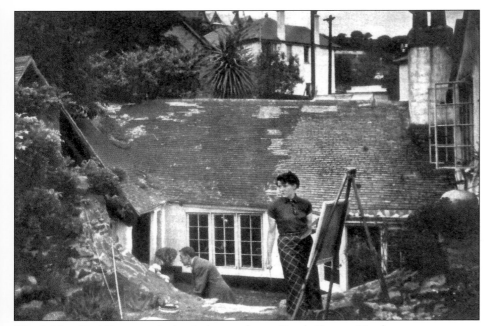

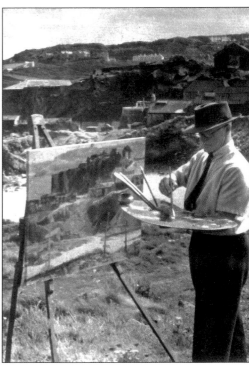

Fig. 1-26 Dod Procter painting in her garden at North Corner, Newlyn

Fig. 1-27 Borlase Smart painting near St Ives

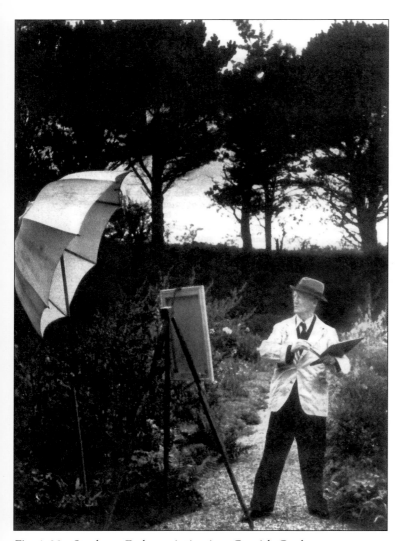

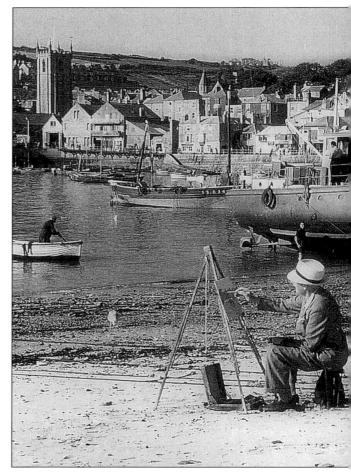

Fig. 1-28 Stanhope Forbes painting in a Cornish Garden

Fig. 1-29 John Park painting on the harbour beach

seeking to complete between three and five sketches a day.[41] Whereas some artists might start a painting on the spot and then return to the studio to work it up into a finished piece, more and more merely produced an array of sketches, which noted details that might be of further use when at work in their studios later. Dorothea Sharp would do as many as six preliminary sketches in oil and pencil and also some charcoal notes and she ascribed her failures, as often as not, to starting without enough preliminary sketches.[42] Artists like Terrick Williams and Moffat Lindner, on their *plein air* forays, took to making quick sketches of the composition selected and of important details within it, to which they would add some colour notations. They then used these as a basis for a new work executed completely in the studio. This led to a greater degree of artistic licence, as features were altered to improve the whole composition, and to less attention to detail. For both, it was the effect that they had witnessed that was paramount - normally, the light of sun or moon upon water - and the composition and colouring was adjusted to enhance its appeal. Both claimed to be able to remember effects from such drawings and notations for many years, leading Lindner, in particular, to reproduce similar scenes time and time again. *The Quiet Harbour, Mevagissy* (cat.no.95) is interesting in this connection as it is the final studio version of a sketch illustrated and discussed by Williams in his series of articles *Harbour and Fishing Subjects* which were published in *The Artist* in 1935.

From decorative effect to decorative pattern

One of the most interesting developments that can be determined amongst the membership of STISA during the 1930s is the concern with decorative pattern. This is a trend in British art which is almost completely ignored in art histories. A distinction can be drawn between paintings of realistic subjects, which concentrate on a particular decorative effect, and a work, whose starting point is a decorative pattern conceived by the artist, which may take on the appearance of a realistic subject. Increasingly, works concerned with pattern came to incorporate stylised features. The artists had most probably been looking at Art Deco design and its influence on the burgeoning poster market.

An interesting exponent of such method of painting was Guy Kortright, who wrote a series of articles in *The Artist* on *Decorative Landscape Painting* in 1934. In selecting a subject, Kortright looked for "pattern and design, line and arrangement - not forgetting the important spaces". Above all, he sought "line - clear-cut, decisive, determined line".[43] When, with the aid of many sketches of details, he set to work on the final painting, he would begin by drawing the principal outlines on the canvas before applying any pigment and, as they represented a sure and certain guide to his desired pattern, he would try to maintain such outlines for as long as possible, "filling in the space between with the required colours almost in the fashion of *cloisonne* enamel". *Castillon de Plana* (cat.no.43), with its striking ground and rock patterns, is an excellent example of his style.

Despite his method of painting, Kortright decried invented landscapes but this held no problems for John Littlejohns. He was always primarily concerned with the overall design of the subject and the way in which the colours used harmonised so as to produce a decorative result. Realism was of little or no consequence to him and the title, *A Scottish Harbour*, (cat.no.49) suggests that this scene is at least partly imaginary.

Borlase Smart also encouraged readers of his book, *The Technique of Seascape Painting*, to look to the bigger picture and encouraged them to endeavour "to emulate Nature as an ideal pattern". For him, patterns could be determined in rock faces and in the surge of sea and foam and it was these that should determine the composition of a sea painting. His treatment of the rock strata in *Or Cove* (cat.no.81) is an example of his approach.

Of particular interest is the adoption of such concerns by figure painters. Commenting on his work at this time, Bernard Fleetwood-Walker observed, "All I thought about at first was the arranging of the parts to form a design. I did not think about what those parts were; I was not interested in anything in the painting for what it was, but merely as a collection of forms that I could arrange into a decorative and ordered design."[44] There are accordingly many stylised elements in his depictions of females in his nude studies and in works such as *Mollie and Stella* (cat.no.18).

Unsurprisingly, still life painting was also affected by this trend. Helen Stuart Weir (see cat.no.92) was constantly being praised for her decorative interpretations and Shearer Armstrong (see cat.no.79) even prefaced the titles of a number of her RA exhibits with the word 'Decoration'. In 1934, she showed *Decoration: Bamboo and Fruit*, in 1935, *Decoration: Gay Fruits* and in 1940, *Decoration: The Mischievous Cat*. Billie Waters also realised the decorative possibilities of animal forms (see Fig.1-39) and she produced decorative patterns, combining stylised tree and plant forms with simplified animal studies. In this stylisation of elements in their works, artists were clearly familiar with the forms of Synthetic Cubism.

[41] L.Richmond, *The Art of Landscape Painting*, London and New York, 1928 at p.32.
[42] D.Sharp, *Oil Painting*, London, 1937, p.14.
[43] G. Kortright, *Decorative Landscape Painting, The Artist*, October, 1934, p.37.
[44] Quoted by R.Seddon in the Catalogue to the Royal Birmingham Society of Artists B.Fleetwood-Walker Memorial Exhibition.

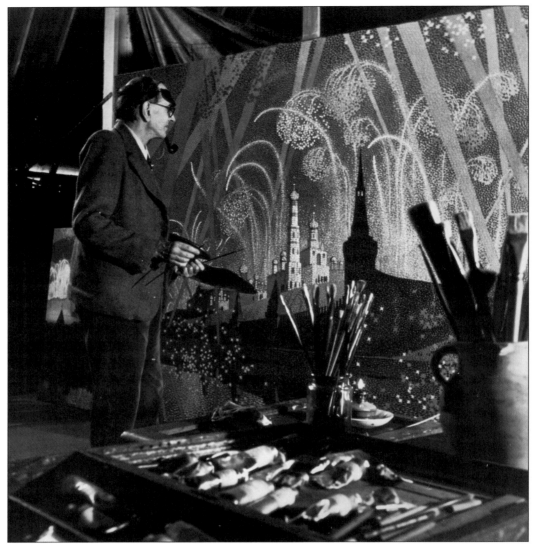

Fig. 1-30 Francis Barry at work in his Porthmeor Studio on *Peace Celebrations, Moscow*, 9th May 1945.
(David Capps)

"A Quickened Sense of Colour"

In 1933, Borlase Smart wrote an article in the local paper about the impact of French modernism, in all its various incarnations, upon British art. 'The Cult of the Ugly', as he described it, using a popular expression of the time, was, in his view, on the wane. "But something has arisen out of all this chaos. British Art has scored. It has become happier in palette discipline. Gone are 'the amber notes' of the Victorians. The experiments of the French masters of painting have been analysed. The ugliness of form and idea has been sifted, leaving us with a quickened sense of colour and we acknowledge their influence in this respect."[45]

Many of the members of STISA from this period who are most popular now, such as Lamorna Birch, John Park and Dorothea Sharp, are artists known for the vibrant colour of their work. Without doubt, the Cornish coast can boast beautifully deep blue waters, and sparkling reflections from the multi-coloured boats are ever present but the artists were not averse to increasing its charms. Lamorna Birch's obituarist in *The Times* felt that he was sometimes "apt to overdo the colour" but, for Birch, ever the pragmatist, "the brighter the picture, the more chance it'll be noticed and the more chance I'll find a buyer".[46] A work such as *My Garden: February* (cat.no.5), possibly produced with reproduction as a greetings card in mind, is a case in point. This work dates from the early 1940s, when Birch seemed particularly keen on the use of purple colours.

John Park's handling of colour is the key to his work and was appreciated by many of the modernists who followed. In this respect, Harold Sawkins, the Editor of *The Artist*, considered that Park's trip to Majorca in 1934, which resulted in works such as *Roman Bridge, Pollensa* (cat.no.65), had been the turning point of his career. The strong Mediterranean light had re-awakened his interest in the French masters, such as Cezanne, that he had studied in France in the early years of the century.

[45] *St Ives Times*, 2/6/1933.
[46] A. Wormleighton, *A Painter Laureate*, Bristol, 1995, p.16.

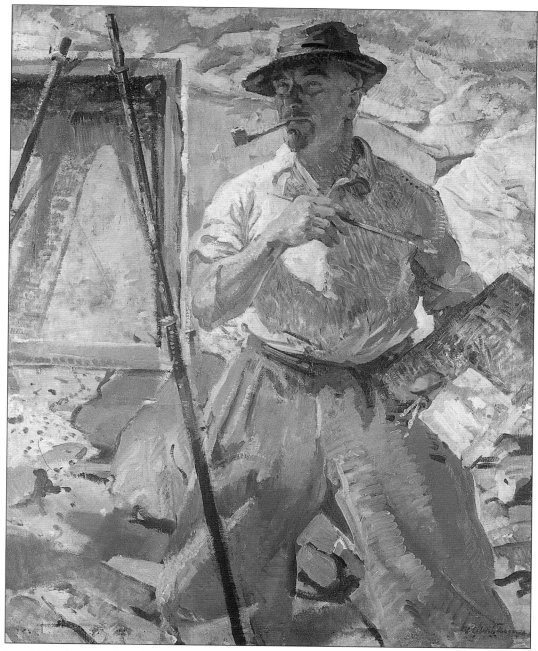

10. Richard Weatherby *Stanley Gardiner Painting* (Penlee House Gallery and Museum, Penzance)

11. Richard Weatherby *Hounds Running*
(Private Collection - photo Colin Bradbury)

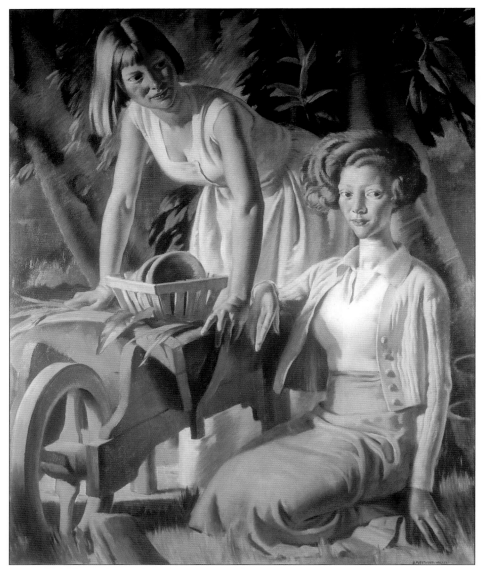

12. Bernard Fleetwood-Walker *Mollie and Stella* (Private Collection)

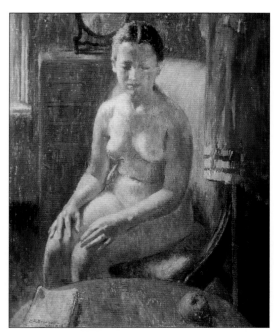

13. Bernard Fleetwood-Walker *Nude*

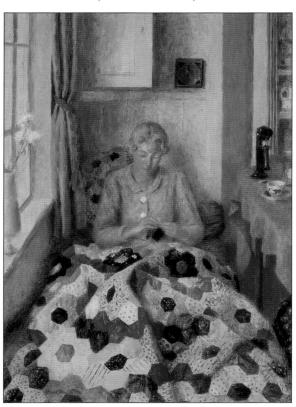

14. Dod Procter *The Patchwork Quilt*
(David Messum Galleries)

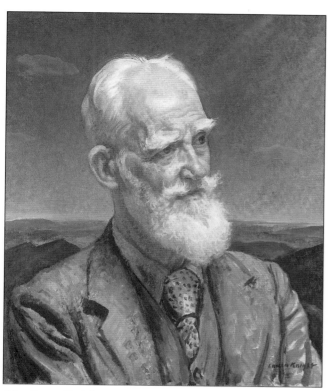

15. Laura Knight *Bernard Shaw*
(Hereford Museum and Art Gallery, © Estate of Laura Knight)

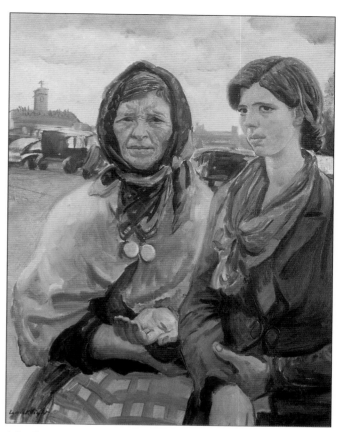

16. Laura Knight *Gypsies at Ascot*
(Hereford Museum and Art Gallery, © Estate of Laura Knight)

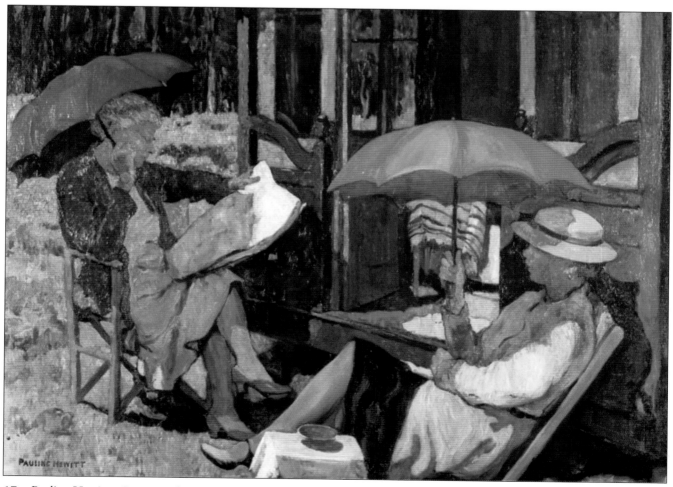

17. Pauline Hewitt *Summer Afternoon*

(Private Collection)

18. Harold Harvey *My Kitchen* (Gallery Oldham)

19. Terry Frost *Interior, 12 Quay Street*
(Private Collection, courtesy of Belgrave Gallery)

20. Terry Frost *The Chair* (Sir Terry Frost)

Julius Olsson was another artist who realised colours might be heightened to gain a greater emotional response. Having observed that sea-spray was rarely white, as it had been traditionally depicted, but could take on all the colours of an opal, his depictions of foaming breakers became ever more colourful, leading the critic, Paul Konody, at one time to complain that his works had come to resemble Neapolitan ices! Nevertheless, his silver tinged surges under moonlit skies, such as *Cloudy Moonlight* (cat.no.62), proved enduringly popular.

Individual Visions

There are a number of artists, who developed very personal styles that cannot be neatly categorised and whose distinctive contributions played an important part in keeping STISA shows interesting. Stanley Spencer had just resigned from the RA when he came to St Ives because two of his works had been rejected and many traditionalists did not agree with his action. Yet, he was welcomed as a member of STISA and his unique style was much discussed. The fantasy world of Enraght-Moony, in which faeries inhabited colourful Cornish landscapes, was unique and his application of tempera distinctive, whilst the 'modern' colour touch and three-dimensionality of the work of Bernard Ninnes always provoked comment. The three works by Ninnes included in this Exhibition (cat.nos. 58-60) also demonstrate the diversity of his output. However, one of the most striking contributions was the individually developed pointillist style of Francis Barry, seen to dramatic effect in works like *Tower Bridge, London - A War-time Nocturne* (cat.no.3) and *Peace Celebrations, Moscow* (Plate 31).

MEDIA AND SUBJECT MATTER

The make-up of the Society's Exhibitions did not alter to any significant extent throughout its first quarter century. The majority of exhibits were oil paintings but there was nearly always a strong 'black and white' section, featuring etchings, drypoints, aquatints and woodblocks. There was also a wide range of watercolourists and one of the rationales behind the acquisition of another of the Porthmeor studios in 1932 was to be able to hang the watercolours separately from the oils.

Oil Paintings

Landscape

Many of the early settlers in St Ives were renowned landscape painters and the Royal Academicians Adrian Stokes, Arnesby Brown and Algernon Talmage specialised in this genre. Other long-term members of the colony whose landscapes had graced the Academy's walls frequently were Fred Milner and Arthur Meade.

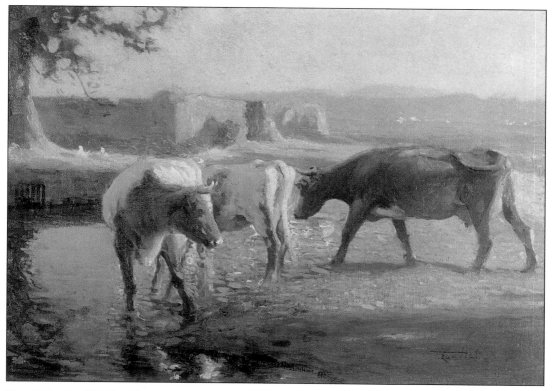

Fig. 1-31 Fred Hall *The Home Pond* (W.H.Lane & Son)

The horrors of the First World War led to an abandonment of the aesthetic of the machine age and modern movements, such as Futurism and Vorticism, died out. Instead, there was a resurgence of interest in more traditional painting and a demand for images that depicted enduring aspects of the English countryside and rural life. Arnesby Brown's paintings of cows in a rural landscape were in much demand and the exceptional *Summer Pastures - The Marshes near Norwich* (cat.no.13) was bought upon Julius Olsson's recommendation for the Art Gallery of New South Wales, Sydney. Algernon Talmage also produced a series of pastoral scenes in the early years of STISA, of which *The Young Shepherd* (cat.no.86) is a classic example. The majestic old tree has provided shade for flocks of sheep for centuries and the young boy with his crook confirms that rural life will continue much as before. Two other artists, who catered for this market were Fred Hall, with his paintings of agricultural life on the Berkshire Downs, and Harry Fidler, with his unique, paint-laden, impressionist images of man and beast toiling in harmony on the Wiltshire Downs.

Lamorna Birch's depictions of grand river and coastal vistas all over Britain reached a similar audience, keen to forget the impact of industrialisation. He also introduced to a wide public the bewitching delights of his beloved Lamorna Valley. *Morning at Lamorna* (cat.no.4) is in fact the view from his front garden. His friends and STISA colleagues, Bertie Hughes and Stanley Gardiner, and later, Denys Law, were equally enchanted by the valley. Gardiner and Law produced many images of majestic trees lining the Lamorna stream, as it weaved its merry way through the valley (see Figs.2G-1 and 3L-8), whilst Hughes concentrated more on the rocky coast near Lamorna (see *Below Carn Barges* - cat.no.39).

Fred Milner's work (see *An Exmoor Valley* - cat.no.56) also evokes the peace and timelessness of the English countryside but he, and to a lesser extent, Arthur Meade, generally remained more soberly Victorian in their technique. On the other hand, the work of Adrian Stokes, towards the end of his life, became more decorative and poetical; *Sunset in Provence* (cat.no.85), his Royal Academy exhibit of 1927, with its rocky foreground depicted in colourful patterns, is a typical example.

Another STISA member to write a series of books on landscape painting in oils was Leonard Richmond and he contributed many boldly painted landscape compositions to STISA shows - see, for example, *A Sunny Morning, Withypool* (cat.no.71). He advocated strong handling, rich colouring and striking pattern, with subjects being kept as simple and free from detail as possible. It was ludicrous, in his view, to use a paint brush like a lead pencil - delicacy rarely led to strength.

In addition to Guy Kortright and Elmer Schofield, whose styles have already been discussed, there were many other fine landscape painters within STISA. Constance Bradshaw, one-time Acting President of SWA, was another artist, who specialised in this genre. She exhibited a number of Welsh landscapes and had a particular penchant for depicting farms (see Fig. 3B-10). Ninnes also found inspiration in the mountains of Snowdonia (see Fig. 2N-2) and Park, when away from the sea, was fond of river landscapes (see *May Pageantry* - cat.no.66).

Marine

At the turn of the century, St Ives was famed for its speciality in marine painting. Its unrivalled location naturally made marine subjects an obvious choice but its reputation was largely due to the School of Painting that Julius Olsson and Louis Grier set up in 1895. Both were marine painters and, accordingly, there was a tendency at the School to specialise in this branch of painting; as a result, artists keen on marine work came down to St Ives to study. Olsson became the leading seascape painter of his generation and many of his pupils went on to become prominent marine and seascape painters of the next generation. His influence on the marine section of STISA was, accordingly, massive and he was revered by all marine painter members. He also was a stalwart supporter of the Society and his sunset and moonlight scenes, such as *Cloudy Moonlight* (cat.no.62), were a regular feature of Society exhibitions.

Olsson considered his star pupil to be John Park and he settled in St Ives, only moving away for brief periods in the 1930s. Other students who settled in St Ives were Borlase Smart and Mary McCrossan. Smart was to develop a personal style of seascape painting, with bold impasto depicting swirling currents crashing over rocks and reefs. As in *Or Cove* (cat.no.81), he sought to capture the immensity of the Cornish cliffs and the power and turbulence of breaking waves pounding at their feet. In 1934, he wrote and illustrated *The Technique of Seascape Painting*, which was to become the standard work on the subject with new editions being published in America more than 20 years after his death.

Another student, William Parkyn, settled at the Lizard and made the painting of sand a speciality in his coastal subjects. Hely Smith is also likely to have studied under Olsson and he exhibited with STISA some of his typical storm scenes. Other students, who joined the Society having become specialist marine painters, included Norman Wilkinson and the Australians, Arthur Burgess, Charles Bryant and Sir William Ashton. Burgess, in particular, was very highly rated for his depictions of modern sea-faring craft and received many commissions from shipbuilding firms.

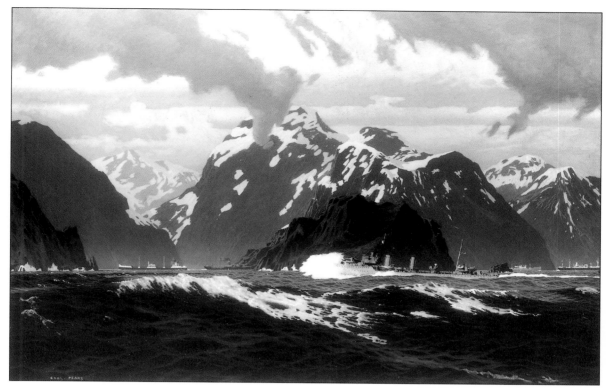

1-32 Charles Pears *The Norwegian Coast - Spring 1940* (Imperial War Museum)

The contribution of the President, Moffat Lindner, should also not be forgotten. He had won great acclaim, including medals at International Exhibitions, for his sunset and moonlit depictions of continental waterways and his work was still highly rated and much in demand, even though his advanced age meant that his subjects were repetitive.

After Olsson moved back to London, a new School of Painting was established by Charles and Ruth Simpson in 1916. Marine painting was one of Simpson's many accomplishments and, among the students who studied under him and subsequently settled in St Ives, was George Bradshaw, who had developed a love of the sea during his first career as a submarine commander. His speciality was the realistic portrayal of all kinds of craft, but he was particularly fascinated with the tall sailing ships that were fast disappearing off the high seas.

Many of STISA's marine section were involved in the initial exhibitions of SMA, which was founded in 1939. Smart, who played an important role in its formation, was its first Treasurer and both Charles Pears, its President for its first 19 years, and Maurice Hill, its first Secretary, also became members of STISA. Bradshaw and Burgess were also founder members and Simpson, Parkyn, Charles Tracy and David Cox exhibited at early shows. The close connection between the two Societies has continued ever since. Claude Muncaster was already President of STISA when he was appointed President of SMA in 1958 on Pears' death and former STISA member, David Cobb, also later became President of SMA. Leslie Kent and Hugh Ridge, who was Vice-President and Chairman of STISA for 18 years, were both long-term members of SMA. Even now, Sonia Robinson is on the Committees of both Societies and the sculptor, Wharton Lang, a member of STISA for over 50 years, is an Honorary Member of SMA.

Harbour and Townscape

The harbour in St Ives is the focal point of the town and it is not surprising that it features regularly in the work of both resident and visiting artists. With the steep streets of the town affording enchanting vistas across grey roofs to the distinctive shape of the Island headland and across the bay to Godrevy lighthouse, there were numerous subjects for artists to interpret in their own individual ways. In addition to Park, who found endless inspiration from the reflections cast by brightly coloured boats at anchor, both Herbert Truman and Leonard Richmond made many studies not only of the constantly changing scene in the harbour, but also of the old houses and quaint streets which could still be found around the town. The group of properties in *Old St Ives* (cat.no.88) was one that Truman depicted from various angles time and time again. Thomas Maidment was another artist, who in both oils and watercolours, made a meticulous record of old quarters in the town. *Old Houses, St Ives* (cat.no.51) shows his interest in roofs and tiles and old walls. Borlase Smart also did a series of studies of scenic parts of the town, in which he showed his considerable ability as a draughtsman. Many of these were in charcoal and wash (see Fig. 2S-10) but he also produced some oil paintings, such as *The Pilot's Boathouse* (cat.no.82). The two lighthouses on Smeaton's Pier, particularly the distinctive cupola of the old wooden clad one, shown in George Bradshaw's *Smeaton's Pier* (cat.no.9), were a constant attraction (see Figs.1-36 and 2B-8).

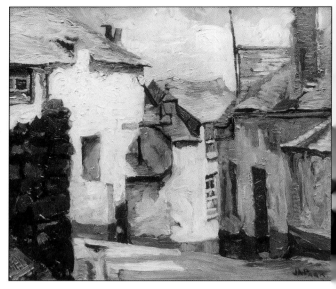

Fig. 1-34 John Park *St Ives* (exh.ROI) (W.H.Lane & Son)

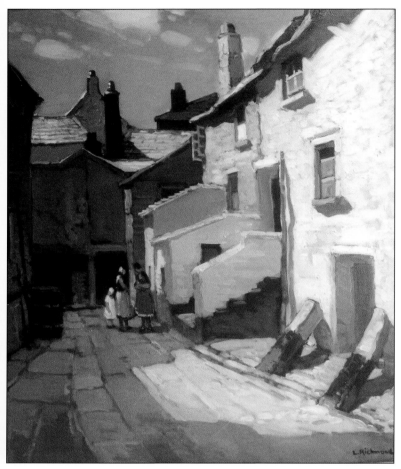

Fig. 1-33 Leonard Richmond *Pudding Bag Lane* (W.H.Lane & Son)

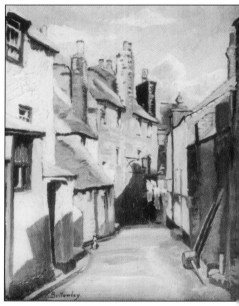

Fig. 1-35 Fred Bottomley *Salubrious Hous (where the artist lived) (W.H.Lane & Son)

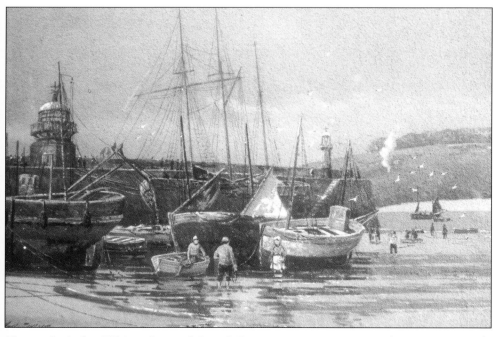

Fig. 1-36 Arthur White *Smeaton's Pier, St Ives* (W.H.Lane & Son)

Views over the grey roofs of the town to the Island headland or towards Godrevy were popular. Maidment's *The Old Harbour, St Ives* (cat.no.50) is the classic view over the harbour from the Malakoff, a scene that tempted many artists, including Leonard Richmond and Stanley Spencer (Plate 76). Mary McCrossan attacks it from a slightly different angle in *St Ives* (cat.no.53), with the Island appearing to loom over the houses of the town.

Cornwall, of course, possesses many other enchanting harbours and depictions of these were also regular features of STISA shows. Jack Coburn-Witherop seems to have been particularly fascinated by fishing nets as a foreground to his harbour studies and his tempera painting *Polperro* (cat.no.15) is a good example of his style. In addition to Terrick Williams' *The Quiet Harbour, Mevagissy* (cat.no.95) dating from 1935, this Exhibition also includes his oil *Evening, Mousehole* (cat.no.93), painted on a visit in 1932. Mousehole also features in Frank Heath's *Saturday Morning in Harbour* (cat.no.34), a Salon picture which won a 'Mention Honorable'.

Figure Painting and Portraiture

The leading figure painter in St Ives during the 1920s was Arthur Hayward, who specialised in self-portraits (see, for example, *The Boatman* (cat.no.33)). Hayward's resignation in 1932 was a serious blow to this section. Stanhope Forbes also exhibited portraits, of which one of the finest was *The Violinist Walter Barnes* (cat.no.21), which was shown with STISA prior to its submission to the RA. Typical 1930s stylisation can be seen in the much exhibited *Christ Mocked* (cat.no.90) by Annie Walke and the stylised figure studies of females by Bernard Fleetwood-Walker, such as *Mollie and Stella* (cat.no.18), made a significant impression when he first joined the Society in 1936 as did his nudes, such as *The Model's Throne* (cat.no.19). In his later work, his style changed, with his brushwork becoming looser, and he relied more on tone to depict form, such as in his *Nude*, included in the 1947 Cardiff show (Plate13).

The famous photograph showing the Committee of STISA discussing the merits of Laura Knight's *Myself and Model*, (Fig.1-11) demonstrates the intense interest that this painting engendered, when it was first seen in St Ives in 1937. She followed this with her portrait of *Bernard Shaw* (cat.no.41) in 1938 and some of her gypsy studies (see cat.no.42). The renewed involvement of Dod Procter, after the death of her husband, was also a major boost and *Light Sleep* (Fig. 1-12) and *Little Sister* (cat.no.68) attracted much attention. The large, virile portrait of fellow member *Stanley Gardiner painting* by 'Seal' Weatherby (cat.no.91) also caused

Fig. 1-37 David Cox *The Black Slip*

Fig. 1-38 David Cox *The Green Peignoir*
(Royal West of England Academy, Bristol)

a sensation, being hailed as a "complete change of outlook in life size portrait painting". By this juncture, Pauline Hewitt's bold, colourful figure paintings, such as *Summer Afternoon* (cat.no.36), were attracting increasingly appreciative comments. The arrival in 1938 of Leonard Fuller and Marjorie Mostyn, both of whom specialised in portraiture, boosted the section immensely and Fuller's portrait of his wife, *Knitting* (cat.no.23), was his first success at the RA after his arrival. Many of Fuller's earlier successes at the RA were also exhibited with STISA in his early years in St Ives. Midge Bruford, whose portrait of *'Elephant Bill'* is included (cat.no.14), also joined at this time.

After the War, the Society was joined by David Cox, who specialised in the depiction of semi-naked young girls, such as in *The Green Peignoir* (cat.no.16), which were concerned more with colour and tonal abstractions than plastic three-dimensional modelling. Hyman Segal also exhibited at this time his powerful pastel portraits of African natives executed during the war (see *Kimani* - cat.no.74 and *Head of a Masai* - cat.no.75). In the 1950s, the portrait section of the Society was one of its strengths, featuring Fuller and Mostyn, Frank Jameson and Malcolm Haylett and Leonard Boden, who had painted H.M. the Queen, and his wife, Margaret. Segal, Bruford and Eileen Wyon were also involved for periods in this decade.

Animal Painting

Charles Simpson was the most well-known animal painter within the Society and he published a book on *Animal and Bird Painting* in 1939. Rated by some as the best bird painter in the country, he produced a huge series of depictions of Wild Birds, but he was particularly fond of depicting gulls and ducks. *The Stream at Clapper Mill, Lamorna* (cat.no.80), which was exhibited at the RA in 1947, is one of his finest works, showing Aylesbury ducks on and beside the Lamorna stream. Simpson also spent much of the late 1920s and 1930s depicting equestrian scenes, but he was quite happy to acknowledge the supreme mastery of Alfred Munnings in this field. In the 1930s, Algernon Talmage, who was a keen huntsman, also received many commissions for portraits of horse and rider and a number of these were shown at the RA (see also *November Morning* - cat.no.87). Arminell

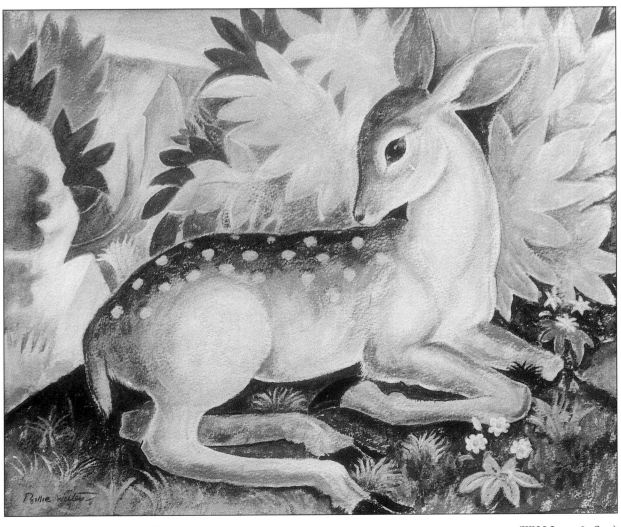

Fig. 1-39 Billie Waters *Reclining Deer* (W.H.Lane & Son)
Waters used animal forms for decorative purposes.

Morshead was also well-known for her equestrian portraits and polo subjects. Richard Weatherby was another keen rider and exhibited with STISA some fine paintings of his horses, his hounds and his hunt staff, for he became master of the Cury Hunt. *Hounds Running* (Plate 11) is a delightful study, seemingly done in a flash but full of movement. Simpson's paintings and drawings of foxhounds are also delightful.

As regards the depiction of cows, Simpson rated Arnesby Brown as one of the finest artists not merely of his day but of all time. *Summer Pastures* (cat.no.13) and *After the Heat of the Day* in the Mackelvie Collection (Plate 2) support his judgement. As has already been seen, farm animals play a significant role in the pastoral landscapes of Hall (Fig. 1-31), Fidler (Fig. 1-25) and Talmage (*The Young Shepherd* - cat.no.86).

Still Life

The leading artist in this section throughout the period covered by this Exhibition was Helen Stuart Weir, one of three STISA members to be Acting President of the SWA. She concentrated almost exclusively on still life and was constantly fascinated by texture and reflection. *Top Hat* (cat.no.92) features an unusual selection of objects, without the customary backdrop. Shearer Armstrong moved from bold flower paintings to more ambitious decorative arrangements, such as *Conversation Piece (Flowers with a Bird)* (cat.no.79), and made a distinctive contribution in the 1930s. Eleanor Charlesworth, Hettie Tangye Reynolds and Maud Forbes also produced good work in this section. In the late 1940s, both Dorothea Sharp and Stanley Gardiner (see *Sun Daisies* - cat.no.25) turned their attention to this genre and produced a series of bold flower paintings, which are now highly regarded. Leonard Richmond normally used his own work to illustrate his books on art but, in his 1936 book, *The Technique of Still Life Painting in Oil Colours*, he also included colour reproductions of some exceptional still life compositions by fellow STISA members Dod Procter, Shearer Armstrong, John Park, Bernard Ninnes, Helen Stuart Weir, Marcella Smith and Mary Richey. His own style is represented in this Exhibition by *Autumn Flowers* (cat.no.70), clearly painted in his Porthmeor studio window.

Miniatures

There was always a small section of miniaturist painters in the Society in its early years. Mabel Douglas was the leading figure initially, having had many successes at the RA with her portraits, and she was joined in the late 1930s by Blanche Powell, also principally a portraitist, and Ethel Roskruge, a flower painter. The next generation of miniaturists comprised Alice Butler, who specialised in landscape and flower studies, and Laura Staniland Roberts, another portraitist. Butler was a member of STISA for 45 years and died in 1995.

Watercolours

As is so often the case, the reviews of STISA's shows paid less attention to the watercolour section than the oils and, in most exhibitions, the watercolours were probably not as strong as the oils. Nevertheless, there were some accomplished watercolourists amongst the membership. The leading contributors were Moffat Lindner and Lamorna Birch, both of whom were for many years stalwarts of the RWS. Lindner, in view of his age, was now painting more in watercolour than oil and his use of pure colour with little drawing was a constant source of admiration. *Venice from the Lido* (cat.no.48) is an example of Lindner's watercolour style at its best. Although Birch's major works were in oils, he was so prolific in both media that his contributions to STISA shows often included watercolours, although these do tend to be of more variable quality than his oils. *A Highland Burn - Springtime* (cat.no.7), though, is an excellent example that was drawn from Oldham's permanent collection to include in the 1934 show there. Other members of RWS in STISA included Job Nixon, Bernard Fleetwood-Walker, Sydney Lee and Laura Knight, whose *Newlyn Old Harbour* (cat.no.40) was another work lent to a STISA show by Oldham, but all these artists tended to exhibit with STISA in other media.

Members of the rival watercolour society, the RI, included its President, Terrick Williams, but the majority of his exhibits with STISA appear to be oils. Frederick Beaumont, another elderly member, contributed a few highly acclaimed works, such as his *National Gallery - Interior* (Fig. 3B-4). John Littlejohns and Leonard Richmond, joint authors of the standard book on watercolour technique, were both members, although Richmond worked in all media. *Scottish Harbour* (cat.no.49) is an example of Littlejohn's technique. Eleanor Hughes, who was made an RI in 1933, was one of the few artists to exhibit with STISA only in watercolour and she was best known for her paintings of trees, such as *Beech Trees* (Fig. 2H-16). Her *Sauveterre de Béarn* (cat.no.38) was another work from Oldham's permanent collection added to the 1934 show. A number of London critics felt that Mary McCrossan was one of the leading female watercolourists of the day and *Brixham* (cat.no.55) is one of her last exhibits with STISA, as she died in 1934. Other artists, who made significant contributions to the watercolour section included John Bromley, represented here by *The Island from Porthmeor* (cat.no.12), Thomas Maidment, Alfred Bailey, who developed his own unique style of watercolour painting, which was intensely colourful, Arthur Hambly, the Headmaster of Redruth School of Art, and William

Parkyn, renowned for his sand studies. Hugh Gresty's works in this medium, such as *The Baths of Caracalla* (cat.no.28), were highly regarded, as, using pure colour washes, he managed to achieve as much power in his watercolours as he did in his oils.

There were also a large group of female artists, who specialised in still life in watercolour. The best known of these is Marcella Smith, who wrote a book on *Flower Painting in Watercolours* and had her work accepted regularly at the RA. *White Roses* (cat.no.83) is a typical example of her direct handling and use of pure colour. Helen Seddon, represented by *A Spring Selection* (cat.no.73), Gussie Lindner, Francis Ewan, Mary Grylls and Kathleen Bradshaw are some of the other long-serving members of this group.

Tempera

Not many members painted in egg tempera but some made it a speciality. The distinctive work of Enraght-Moony was nearly always in this medium and many of Coburn-Witherop's paintings from his Cornish period are also in tempera. A typical example of the cool tones he achieved with this medium is *Polperro* (cat.no.15). Stuart Armfield became one of the leading exponents of tempera painting and, in a series of articles in *The Artist*, he described it as "the be-all and end-all of painting".

'Black and White'

STISA was formed right at the height of the speculative bubble that afflicted the etching market in the 1920s. Interest in etchings had been increasing since 1880, the date when the Society that became the Royal Society of Painter-Etchers and Engravers was first formed, but new impetus was given in the 1920s by the formation of the Print Collector's Club in 1921 and the launch in 1923 of the high quality publication *Fine Prints of the Year*. The Society of Wood Engravers was also formed in 1920. The craze for etchings became so great in the period between 1925 and 1929 that they became more like negotiable securities. Subscribers to new issues could be assured that if they immediately put prints up for auction, they would receive as much as ten times the original price. A price of over £400 was even paid for one etching by James McBey - an astonishing figure when, say, a top Lamorna Birch oil could then be acquired for £100.

Seeing the enormous sums being earned by etchers during this period of madness, many artists started to learn the art. Lamorna Birch was a classic example. Told by Laura Knight of the fortune to be made, he took lessons from Geoffrey Garnier (q.v.), but had only produced some four prints by the time the Wall Street Crash effectively ended the bonanza. In 1933, Malcolm Salaman in *Fine Prints of the Year* laments, "The etching market has fallen upon meagre times." and, in 1938, the last year the publication was produced, Campbell Dodgson recorded, "Some of the most distinguished etchers and engravers have suspended their activity in the field of graphic art in favour of the more remunerative practice of painting."

This background explains much about the composition of the 'black and white' section during this period. A St Ives Print Society was originally formed in 1922 for the encouragement of the graphic arts in West Cornwall. Alfred Hartley was President, but there is little comment on its activities in the local press. However, its 1924 Exhibition was reviewed and this contained work by Alfred and Nora Hartley, Frank Moore, Turland Goosey, Bernard Leach, Fred Milner, Borlase Smart, Francis Roskruge, E.Sykes and the Misses Dorothy Cooke, Frances Ewan, D.G.Webb, Bliss Smith and Mackenzie Grieve. Geoffrey Garnier also exhibited some religious subjects. Hartley was the key figure and, as the art of etching grew in popularity during the 1920s, many artists turned to him for advice. A number of these artists continued to exhibit etchings with STISA in its early years and Shearer Armstrong also showed woodcuts from time to time. However, until his death in 1933, Hartley was considered the master and he won two gold medals in California in 1929 and 1932.

The 'black and white' section was boosted immensely in the early 1930s by the arrival of Job Nixon, who had taught etching at South Kensington, and his large etching, *An Italian Festa* (cat.no.61), which had first brought him to the notice of the public in 1923, was considered a real *tour de force*. The Royal Academician, Sydney Lee,

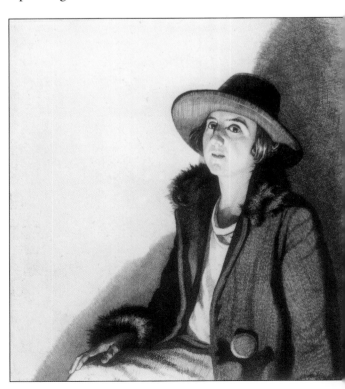

Fig. 1-40 Raymond Ray-Jones *Lamplight*
First exhibited with STISA in the 1934 Summer Exhibition

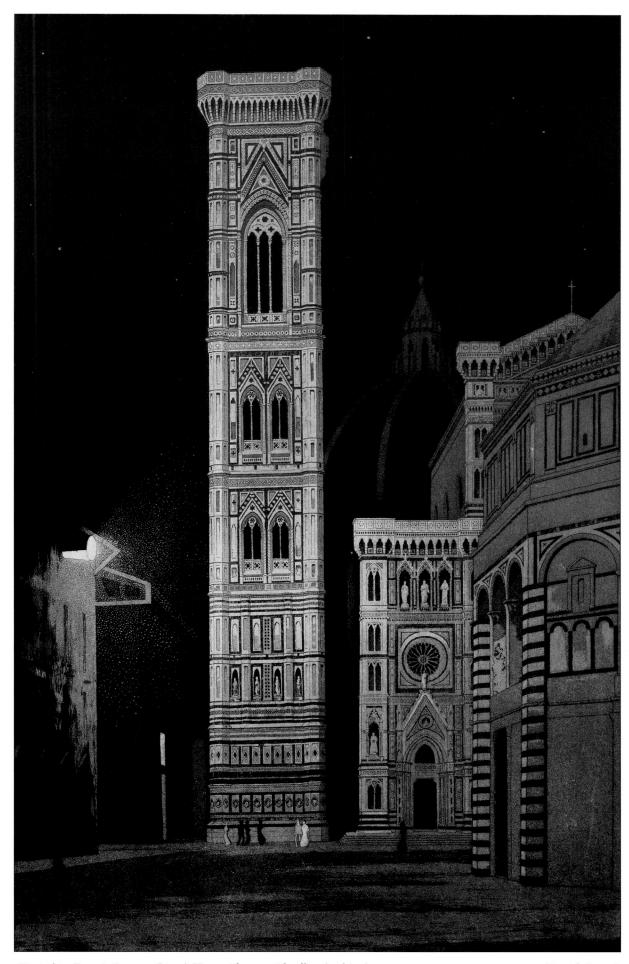

Fig.1-41 Francis Barry *Giotto's Tower, Florence, Floodlit* (etching) (David Capps)

who had been the first person to teach wood engraving at a London art school, also contributed some of his finest work as well. Raymond Ray-Jones was another newcomer, whose work commanded attention. He exhibited the full range of his output, but his portraits, such as *Lamplight* (Fig. 1-40), were considered to be his forté. Geoffrey Garnier's coloured aquatints, such as *Dawn over Trencrom* (cat.no.26), were a distinctive feature of STISA shows for many years and he became an acknowledged authority on the processes used in the eighteenth century by the artist William Daniell. By 1934, the quality of the 'black and white' section was such that it was often felt to constitute the finest part of an exhibition and was dealt with first by reviewers. Nevertheless, due to the etching market at that time, little new work was being done and many of the prints were much earlier productions.

In the late 1930s, after the death of Hartley and Nixon and the departure of Lee and Ray-Jones, the section was dominated by the large, dramatic etchings of Frank Brangwyn, executed in the early years of the century, of which *Mill Wheel, Montreuil* (cat.no.11) is a particularly attractive example. He was joined in 1937 by Salomon Van Abbé, best known for his etchings of the judiciary, and, in 1938, by William Westley Manning, whose aquatints are held in many public collections abroad as well as in this country. *Bridge at Staithes* (cat.no.52) was one of his first exhibits. Jack Coburn-Witherop also joined at this time and a number of the etchings that he exhibited with STISA, such as *Thames - Flood-tide* and *Morning at Billingsgate Fish Market*, are held by the Walker Art Gallery, Liverpool. During the War years, another significant artist in this section was Francis Barry, who had concentrated on etchings during his time on the Continent in the 1920s and 1930s. His superlative etchings of Italian cities were highly rated when they were first shown, but unfortunately all his plates were destroyed in an Allied bombing raid on Milan in 1944. By the mid 1940s, the section had ceased to exist, with only Manning still exhibiting 'black and white' work.

Railway Posters

In 1923, the rationalisation of the rail network led to the establishment of four railway companies - Great Western Railway (GWR), Southern Railway (SR), London Midland and Scottish Railway (LMS) and London and North Eastern Railway (LNER) - and, as the four companies vied with each other in publicising the superior attractions of their own area, the great era of the railway poster was born. Norman Wilkinson, who had been a student of Olsson in St Ives and who was later to be a member of STISA briefly, was instrumental in taking poster art to a new level. In 1923, he persuaded LMS that, to raise standards, a group of Royal Academicians should be asked to submit designs. He also took the view that modern industries and the railway itself could be made attractive subjects. This brave attempt to combine fine and commercial art was a great success and Stanhope Forbes (*The Permanent Way - Relaying*), Julius Olsson (*Dunluce Castle*), Adrian Stokes (*Warwick Castle*) and Arnesby Brown (*Nottingham Castle*) were amongst the Academicians involved. Algernon Talmage and Lamorna Birch also did posters for LMS that year and, when in 1928, LMS issued a list of their best selling posters, Talmage's *Aberdeen - Brig o'Balgownie* was the fourth most popular. The period covered by this Exhibition was the heyday of the railway poster - holiday traffic on the railways more than tripled in this time - and many members of STISA received commissions for poster work. The objections some artists might have had to becoming involved with commercial art rather fell away when distinguished Academicians had led the way and the publicity that such commissions afforded, as one's art was plastered on thousands of billboards around the country could not be lightly dismissed. As poster art developed, a huge amount of interest was engendered in the different styles of design and regular poster artists became widely known, with copies of their posters able to be bought by the public. Whereas the status of the railway poster warranted special exhibitions in Public Galleries solely devoted to the medium, it was the continuing exhibition on station platforms around the country that made reputations. Even those not interested in the destinations advertised delighted in the glorification of the nation's scenery and the modernity of its industries, of which the railway network itself was part. A number of STISA members created a splash in this unlikely pool.

Given that Cornwall was one of the premier holiday destinations, it is not surprising that Cornish subjects were in demand from STISA members. Forbes followed up *The Permanent Way* with *The Terminus*, featuring holidaymakers disembarking from the Cornish Riviera Express in Penzance Station, and the original oil painting (Plate 21) was exhibited in STISA's 1929 Summer Exhibition. Borlase Smart did two Cornish posters, with one, *St Ives, Carbis Bay and Lelant*, being of the 'bird's eye view' type, indicating places of interest in West Penwith.[47] Two designs featuring St Ives by Leonard Richmond and Herbert Truman have recently been re-issued and have been immensely popular. Truman's poster, *St Ives, Carbis Bay and Lelant* (Plate 24), showing boats in St Ives harbour, was the only one he ever did and it won him a prize of forty guineas in an open competition run by GWR in 1938. The other finalist was Borlase Smart. The poster competition was part of a publicity drive initiated by the St Ives Chamber of Commerce and 4,000 copies of Truman's poster were displayed all over the country. The campaign inevitably became a war casualty but it was re-printed in the 1950s and used again, when it also won an award for the best resort advertising poster.

Leonard Richmond was a prolific poster designer and, in 1936, he published *The Technique of the Poster*, a book that now sells for over £100. Richmond mainly worked for GWR and SR and his posters advertised such far flung places as Venice, Brussels, Jersey, Wales and Ireland. His 1937 poster featuring St Ives is, in fact, entitled *Cornwall* (Plate 26) and is a semi-realistic view from half-way

[47] Smart did a similarly styled map of St Ives for the local Chamber of Commerce.

down Smeaton's Pier, with lobster pots, lighthouse, enhanced purple cliffs, transported beaches, cool green waters and rust coloured sails. Like many of Richmond's posters, it is very colourful and decorative - ideal for its purpose. In 1937, his poster, *Ramsgate*, was awarded the Tattersall Cup for the best poster of the year and, in 1945, he designed *Penzance in the Duchy of Cornwall* for GWR. Richmond also illustrated a number of travel books written by E.P.Leigh-Bennett, which were commissioned by SR, including *Devon and Cornish Days* (1935).

Richmond's writing partner, John Littlejohns, was also in demand as a poster designer. His interest in decorative art was ideally suited to this medium. He worked solely for LNER and his posters are principally of the Lake District and Scotland. *Whitley Bay* (Plate 27), depicting stylishly clad bathers swimming off the rocks, as a path of sunlight lights up the sea, is a good example of his decorative style. Another prolific poster designer was Charles Pears. He worked for all four railway companies and, accordingly, his subjects were drawn from all parts of the British Isles, including the Channel Islands and Isle of Man. Being principally a marine painter, he often depicted the steamers used by the companies. *Sunset over Guernsey* (Plate 25) is a highly romanticised colour extravaganza, with the modern steamer juxtaposed with one of the last tall ships, bound inevitably for its own sunset due to the greater speed and efficiency of steam power. During the War, Pears did a special study of the different roles such steamers played, such as *SR Cargo Steamer Under Attack from German Aircraft* and *SR Steamers as Hospital Ships at Dunkirk*.[48] Like Richmond, he was also commissioned to illustrate holiday guides published by SR, such as *Yachting on the Sunshine Coast*.

Lamorna Birch did quite a few posters for LMS in the 1920s but was a bit non-plussed when GWR asked him to ensure his Cornwall poster did not feature the sea or cliffs. He eventually grew tired of the restrictions contained in his instructions and his posters, whilst fine examples of Birch's landscape art, are neither simplified nor decorative enough to stand out as eye-catching advertisements.

Dorothea Sharp's posters for LNER are typical Sharp scenes of children playing on rocks by the sea. They were used for Filey and the East Coast generally, but, although immensely colourful and redolent of seaside holidays, they could have been of any seaside resort in the country. Wilkinson himself was one of the most prolific poster artists, doing well over a hundred designs for LMS. Talmage also did a number of other designs for LMS, principally of the Lake District. Laura Knight, Sydney Lee and Arthur Burgess also did posters for LNER in the mid-thirties. The highly coloured, romanticised depictions of resorts by Jack Merriott, who did not join STISA until the 1950s, were much in demand and *Newquay* (twice), *Penzance* and *Cornwall* were some of the subjects he covered amidst a vast output. Terence Cuneo, with his depictions of the intricacies of the railway network itself, perhaps became the most famous poster artist of them all, but he had ceased membership of STISA by this time.

The railway poster epitomises this period and its impact on fine art has not been fully considered. For good poster design, artists had to learn the value of elimination and of reducing every subject to its simplest forms and bare essentials. Bright, flat colours were then used to give these forms maximum impact. This dovetails in with the move by many members of STISA towards decorative pattern. The later paintings of Francis Barry - stylised forms depicted in a few bright colours - are a good example of the influence of poster art and such work is getting very close to complete abstraction. The number of commissions received by STISA members for poster art is another example of the high regard in which many of these artists were held and their adaptability to the new medium is further evidence of a progressive outlook.

Murals

The high profile of the artists as a result of their exhibitions led to commissions in mural work and other related fields and, although practicalities tended to mean such work was not included in STISA exhibitions, the originals or preliminary sketches were often on view on Show Days. George Bradshaw designed interior decorations for the local cinema and for various hotels and cafés as well as receiving a commission to redecorate sections of Porthleven Church. Both Smart and Bradshaw did work for Navy Week displays and John Barclay, shortly after his arrival, executed four large mural decorations of the Seasons for the City of Leicester Education Authority, which were one of the principal attractions of Show Day in 1938. In 1940, inspired by the tercentenary of St Ives as a borough the previous year, he executed for Curnow's Café in St Ives four decorative panels, descriptive of events in St Ives' history, which are now housed in St Ives Museum. Barclay's largest commission for this type of work was a huge mural for the Club Room of Wembley Stadium in 1953, which incorporated a detail from every sport featured at Wembley. This achievement was matched by Malcolm Haylett, who, in both 1954 and 1955, was selected to design the Ideal Home Exhibition.

Art Books

One of the ways of illustrating the status enjoyed by the Society during this period is to highlight the large number of books on art technique commissioned from members, many of which were to become the standard works on such subjects for many decades. Adrian Stokes published *Landscape Painting* in 1925, a major review of the genre. Terrick Williams wrote a small Art

[48] The original oils of these and other similar works are held by National Railway Museum, York.

Manual, *Landscape Painting in Oil Colour*, for Winsor and Newton in the late 1920s, whereas how to depict landscapes in watercolour was a subject that was tackled by John Littlejohns in various books, culminating in 1933 with *Landscape Sketching and Composition*. Littlejohns also wrote in 1931 an acclaimed survey *British Watercolour Painting and Painters of Today* and he and fellow member, Leonard Richmond, in fact, dominated the market by producing a whole series of books on different media. *The Technique of Watercolour Painting* and *The Technique of Pastel Painting*, written jointly by Richmond and Littlejohns in the late 1920s, were still being repackaged and reprinted in the 1970s, while Richmond, on his own, produced another multi-edition work, *The Technique of Oil Painting*. He also produced a book on still life painting and on the technique of the poster and several works entitled *From the Sketch to the Finished Picture* in various media. Both Littlejohns and himself also produced various books on the use of colour and several volumes in the *Art for All* series. Littlejohns also tackled subjects such as *How to Enjoy Pictures*.

Another work that enjoyed several reprints over a long period both in this country and the States was Borlase Smart's *The Technique of Seascape Painting*. Originally produced in 1934, this was still being reprinted in the States in the 1960s. Other members to be asked to write about technique were Dorothea Sharp, who produced a Students' Manual on *Oil Painting* for Pitman in 1937 and Marcella Smith, who wrote and illustrated *Flower Painting in Watercolour* also for Pitman in the early 1950s, the latter in any event also being published in New York. Pitman also published posthumously Terrick Williams' *The Art of Pastel*. Finally, in 1939, Charles Simpson wrote *Animal and Bird Painting*, a work that discusses and illustrates the author's choice of the best works of this genre. He also published a number of books on photography, with particular regard to the depiction of the figure, during which he compares the respective merits of art and photography.

Illustrators

Amongst the early members of STISA, Francis Ewan was perhaps the best known illustrator and some of her early exhibits were 'black and white' work. Shearer Armstrong and Averil Mackenzie-Grieve also exhibited some book illustrations on occasion. Terence Cuneo, during his period of membership, was finding his career as an illustrator somewhat of a struggle but he did exhibit some of his designs with the Society. Millar Watt, the cartoonist and creator of the successful 'Pop' character in *The Daily Sketch*,

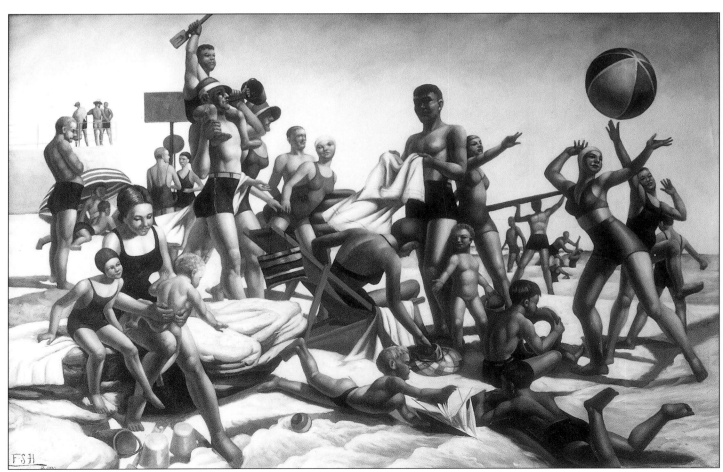

Fig.1-42 'Fish' *Holidaymakers at St Ives*
Well-known for her depictions of the flapper lifestyle, 'Fish' was another illustrator who joined the Society after the War.

moved to St Ives in 1935 and, although the majority of his exhibits were serious works of art, some 'Pop' cartoons were occasionally included (see Fig. 3W-5).[49] Van Abbé was perhaps the best known illustrator, who was a member during the 1930s, but, in general, book illustrations and illustrative art did not feature much in STISA shows. This changed, though, during the Second World War, when a number of well-known illustrators joined the Society. The New Zealander, Harry Rountree, had an international reputation as an illustrator of travel books and books on animals but he was best known for his comic illustrations in children's books, such as *Alice in Wonderland, Aesop's Fables, Swiss Family Robinson, Brer Rabbit* and various Enid Blyton stories. Another arrival was Thomas Heath Robertson, whose work was also in demand for children's books but who specialised in illustrating religious books and historical novels. He also designed and exhibited book-plates, a genre to which Geoffrey Garnier increasingly turned his attention. Their illustrations and designs soon became a feature in STISA shows.

Other artists, who joined STISA in the War years, who had already established reputations as illustrators were Charles Pears, who had illustrated both travel and children's books, working in fact with Thomas Robertson on an edition of *Alice in Wonderland*, and Charles Simpson, who had illustrated a large number of books on country pursuits and who used the pseudonym 'The Wag' for his humorous work. However, the inclusion of work by illustrators in STISA shows was one of the issues that hastened the split, as the 1948 Hanging Committee felt it inappropriate for 'commercial art' to be included in exhibitions by a Fine Art Society. As a result, both Rountree and Robinson began to find their work excluded.

Sculpture

During the 1930s, the only sculptor exhibiting with the Society was Caroline Jackson, about whom little is known. However, it is not surprising that when one of Britain's premier sculptors, Barbara Hepworth, joined the Society in 1944, increased interest was shown in this medium. She was soon joined by Allan Wyon, who worked in marble and bronze and who also designed medals. Whereas his marble bust, *Pax Dolorosa* (Royal Cornwall Museum, Truro), was the sole exhibit in the sculpture section in the 1945 Winter Collection, by 1948, the section included work by Hepworth, Wyon, Sven Berlin, Barbara Tribe and "Caeeinion". After the split in 1949, Wyon and Tribe were joined by the German woodcarver, Faust Lang and his son, Wharton, and the sculpture section was one of the strongest elements of the Society during the 1950s.

Crafts

Although the first exhibition of St Ives artists outside Cornwall in Cheltenham in 1925 contained a selection of 28 pots by Bernard Leach, and Leach and the craftsman, R. Morton Nance were founder members of the Society, it was soon decided that it was inappropriate for craftwork to be exhibited in the Society's shows. Leach's contributions were therefore restricted to some drawings and there was no place for the models and theatrical designs of Marjorie Ballance, for the embroidery pictures of Alice Moore, which featured in the first Penwith show, or for the highly praised needlework pictures of Mrs Francis Barry.

WOMEN ARTISTS WITHIN STISA

Quite rightly, there has been a resurgence of interest recently in women artists in Cornwall. The opportunities open to female artists when the Cornish art colonies were first established were limited by conventions of the day and male prejudices. Many women artists found their ability to paint severely restricted by their roles as wives, mothers and mistresses of the household. A number of talents were completely overshadowed by the careers of their husbands, who may not always have been better artists. This is a topic that merits a book on its own and it was disappointing that further funds were not available to make the *Women Artists in Cornwall (1880-1940)* Exhibition at Penlee House Gallery and Museum, Penzance in 2002 a more in-depth study.

Sadly, by the time of STISA's formation, the majority of the major female artists of the first generation of Cornish painters had died or stopped painting. Elizabeth Stanhope Forbes died young in 1912, Marianne Stokes died in 1927 and Mia Arnesby Brown in 1931, whereas Jessie Titcomb had stopped painting when she left St Ives in 1905. Accordingly, as noted above, the only female artist, who was still successful at the RA when STISA was formed was Mabel Douglas and it cannot be said that her miniature portraits are of any special significance. However, the transformation in the quality of the female section of STISA was, if anything, even more marked than that of their male counterparts. In ten years, STISA could boast within its membership the first woman to be elected a Royal Academician in the twentieth century - Laura Knight. She had also been President of SWA from 1932 - a position she was to hold until 1967. STISA also provided three other senior members of SWA - Dorothea Sharp, who was Acting President 1932-3, Vice-President 1934-6 and Secretary 1937-1954, Helen Stuart Weir, who was Acting President between 1934 and 1936 and Constance Bradshaw, who succeeded her in the post between 1937 and 1939. Marcella Smith became Vice President in 1949, a position she retained for fourteen years. Many other members of STISA, including such relatively unknown artists as Emily Allnutt, Ellen Fradgley and Edith Mitchell, became members or associates of SWA and many more exhibited at SWA exhibitions.

[49] The 1936 Birmingham tour included one, for instance.

Fig. 1.43 Barbara Hepworth *Sculpture with Colour Blue and Red (wood, painted with strings)*
(Tate Gallery, London, 2003 - Bowness, Hepworth Estate)
This work was exhibited at the 1947 Cardiff show.

Dod Procter, having exhibited in some of the early shows, also joined STISA in 1937 and she was to become, in 1942, only the second female artist to be made a Royal Academician that century. She also became President of STISA in 1946. Amongst the St Ives residents, Shearer Armstrong and Pauline Hewitt made great strides forward during the 1930s and were regularly hung at the RA, as was Amy Watt after her arrival in 1935. Dorothy Bayley and Phyllis Pulling produced some striking work and there was always a large group of flower painters, of whom Maud Stanhope Forbes, Eleanor Charlesworth, Irene Burton and Kathleen Bradshaw were regular contributors. Portraitists included Lucia Walsh, Dorothy Everard and Leonard Fuller's wife, Marjorie Mostyn. The Society was also joined by some individual female artists from the Lamorna circle. Eleanor Hughes made a significant impression with her watercolours of trees and streams, Midge Bruford alternated portraits and broadly painted landscapes and Jill Garnier showed some exquisite still lifes.

Whereas by the 1930s, female artists were freely able, for example, to study from the nude and to paint in the open air without adverse comment, they still had to balance their roles in the home with their artistic goals. Both Laura Knight and Dod Procter managed to achieve this and, in fact, became more successful than their husbands. The Knights' marriage seems something of a cold affair, with each going their own way, but Dod Procter achieved success, with a son to bring up as well. However, Dorothea Sharp revealed in an interview in 1935 that she had nearly married but had decided that this would interfere with her painting, which had to come first in her life. Most female artists with children found putting their painting first impossible and it is quite clear that a number of women gave up painting altogether whilst they were bringing up a family. Examples are Pauline Hewitt, who waited until her son was twelve before she took up a brush again, Garlick Barnes, who raised four children before devoting herself to art, and Kathleen Temple-Bird and Hilda Harvey, who each took a long break from their careers Many others found their output drastically curtailed.

Shearer Armstrong, who did not have children, spoke about the other pressures on the home-maker. She commented, "I feel that the woman artist - particularly if she is married - must get right away from her home if she is to go on with her painting." and so insisted on having a separate studio in St Ives, where she could work undisturbed.[50] Although Jill Garnier had a separate studio, it was only in her garden, and so she was often heard to complain, "Why *do* I have to waste my time buying blasted sausages, when I could be painting?".[51] Sharing of household tasks between the sexes was a concept that was still some decades away. As a result, it is only now being appreciated that, as an artist, Jill Garnier had at least as much to offer as her husband, Geoffrey.

There seems little evidence of sexual discrimination in the management of STISA. Female artists were always welcomed - over 120 are included in this Dictionary - and many served on the Society's Committees, although the majority of officers were men. Pauline Hewitt and Shearer Armstrong, the two leading female artists resident in St Ives, were regularly involved in the 1930s and Dorothea Sharp and Marcella Smith were both Committee members during the War years when they moved down to St Ives. Kathleen Bradshaw and Gwen Whicker played leading roles in the 1950s.

As already noted, the War years brought a large influx of artists to the colony, including, of course, Barbara Hepworth and Wilhelmina Barns-Graham, both of whom were to become giants of modern art. There were also many female students attracted to a School of Painting in the relative safety of St Ives, as a number of London Schools had closed. By now, an art career for a woman was not considered as Bohemian as it had been earlier in the century and many more opportunities were open to female artists. A number of these new arrivals, such as Hilda Jillard, Agnes Drey and Garlick Barnes, also embraced modernism and others, such as Misomé Peile, Marion Hocken, Isobel Heath and Jeanne du Maurier, had sympathies with the moderns, even if their own work was representational. All resigned in 1949 but a number resumed membership of STISA during the 1950s.

Fig. 1-44 Gwen Whicker *Still Life* (Falmouth Art Gallery)

[50] *News Chronicle*, 1939, Cornish Artists : 14.
[51] Peter Garnier, *Geoffrey S. Garnier ARWA, SGA (1889-1970) and Jill Garnier, FRSA (1890-1966)* in H. Berriman, *Arts and Crafts in Newlyn 1890-1930*, Penzance, 1986 at p. 66.

Fig. 1-45 Clare White *The Horses of San Marco, Venice*

Some more women artists from Newlyn and Lamorna, who for some reason did not join during the 1930s, did so after the War. These included that connoisseur of Post-Impressionism, Alethea Garstin, Harold Harvey's widow, Gertrude, and Billie Waters, whose distinctive stylised decorations have already been mentioned. Other new arrivals, who were to play a leading role in the affairs of STISA for many years included the sculptor, Barbara Tribe, the miniaturist, Alice Butler, Clare White, whose decorative style of painting seems to be becoming ever more popular, Gwen Whicker, Marjorie Mort, Alicia Lawrenson, the caricaturist, Fish, Lamorna Birch's daughter, 'Mornie' Kerr, Una Shaw Lang, Edith Lovell Andrews and Sydney Bland. However, with the exception of Barbara Tribe, none of this group had the profile of the leading female artists of the 1930s and 1940s, who contributed so significantly to the success of STISA in this period.

21. Stanhope Forbes *The Terminus*
(National Railway Museum/Science and Society Picture Library, © courtesy of the artist's estate/Bridgeman Art Library)

22. Stanhope Forbes *Penzance*
(Mackelvie Trust Collection, Auckland Art Gallery Toi o Tamaki)
© Courtesy of the artist's estate/Bridgeman Art Library

23. Thomas Maidment *Old Houses, St Ives*
(Williamson Art Gallery and Museum, Birkenhead)

24. Herbert Truman *Ives, Carbis Bay and Lelant*
(South Devon Railway Trust - Tindale Collection)

25. Charles Pears *Sunset over Guernsey* (National Railway Museum/Science and Society Picture Library)

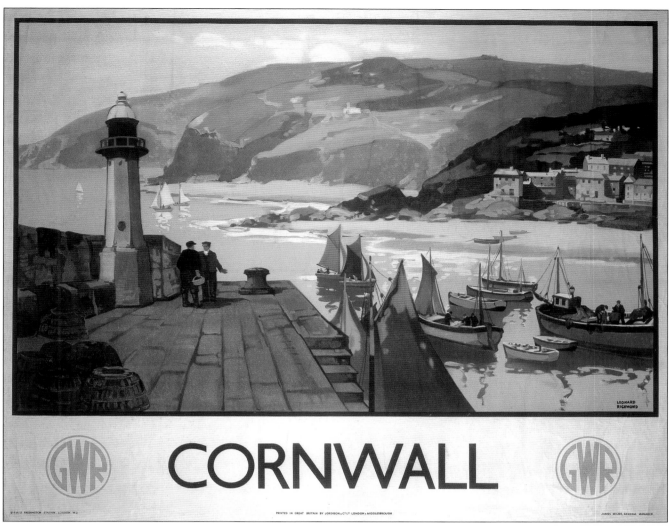

26. Leonard Richmond *Cornwall* (National Railway Museum/Science and Society Picture Library)

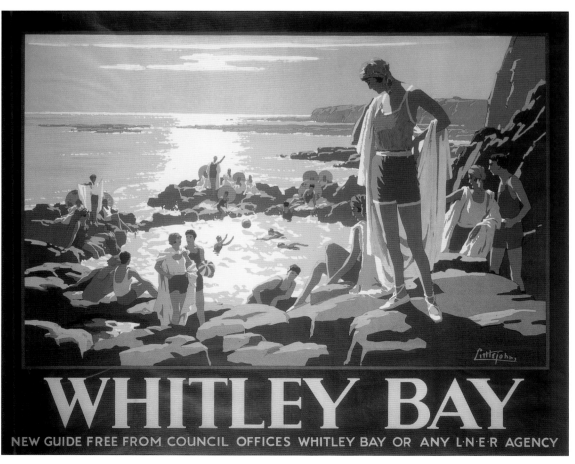

27. John Littlejohns *Whitley Bay* (National Railway Museum/Science and Society Picture Library)

28. Bernard Ninnes *The Café Born, Palma* (Hereford Museum and Art Gallery)

29. John Littlejohns *A Scottish Harbour*
(Hereford Museum and Art Gallery)

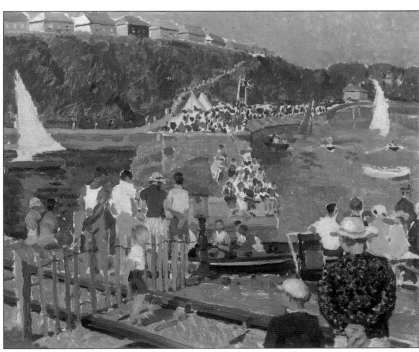

30. Alethea Garstin *Regatta Day, Hayle* (1949)
(Royal West of England Academy)

THE ST IVES SOCIETY OF ARTISTS
(1927-1952)

DICTIONARY OF MEMBERS

PART A - EXHIBITING MEMBERS
(WITH CATALOGUE OF EXHIBITS)

Selecting works for an exhibition such as this is no easy task. Only just over 80 works can be hung in most venues and yet more than 300 artists exhibited with STISA during its first quarter century. Furthermore, for much of the period, STISA held four exhibitions each year in St Ives, not to mention the various touring shows and other exhibitions to which members contributed. These exhibitions frequently had more than 200 exhibits and so it is impossible in an exhibition of this size to do full justice to the range of artists involved and the variety of work that will have been exhibited. It is for this reason that some of the catalogues of the period have been reproduced as Appendices so that a better assessment can be made of a typical STISA show.

Given that the Society did derive enormous kudos from the Royal Academicians and the other well-known artists within its ranks, the selection has inclined in their favour, particularly as it has been easier to trace good quality works. It is appreciated that, in some cases, this has led to the inclusion of an artist, whose involvement with STISA was brief or whose commitment to the Society was far less than that of many artists who have been excluded. However, often the work included made a distinct impression at one of STISA's shows. Furthermore, in the case of other artists vying for selection, the quality of the work available has tended to be of more importance than their length of service to STISA. There are many long-term members, who have sadly been excluded not because their contributions were unimportant but because the good work that often merited favourable reviews has not come to my attention. It is for this reason that I felt it was imperative to include Part B of this Dictionary, which contains biographical notes on all those artists who are not represented in the Exhibition, as many played an equally important role in the success story. In a number of instances, it has been possible to include illustrations of their work as well.

Wherever possible, work has been sought that has actually been exhibited with STISA, although in the absence of a full set of catalogues, it is not always possible to be sure on this point. Royal Academy exhibits produced during the artist's membership of STISA have also been included, as the annual RA exhibition was very much considered to be STISA's London show. Any work by a St Ives resident artist that was hung would, in any event, have already been exhibited on Show Day in St Ives.

I have also tried to ensure that each segment of the Society is adequately represented, but it has proved impossible to do full justice to all the genres and styles. Financial constraints and the Hepworth centenary exhibition combined to make the inclusion of a sculpture section infeasible, and this was particularly disappointing, as it has prevented the Exhibition from paying due respect to Wharton Lang, the only current member of STISA who was exhibiting in the period covered by this Exhibition. With so many artists to consider and so many works to choose from, the only certain thing about my selection is that everyone will find fault with it! If that means there needs to be another Exhibition to feature my omissions, I will settle for that!

Dates of membership of STISA given in the biographical notes are not in all cases guaranteed but are likely to be correct in the main. The Society's Minute Book for the years 1927-1932 was rescued off a rubbish tip by Roy Ray, former head of the St Ives School of Painting, but whereas this does record a number of applications for membership, it clearly does not tell the full story. In this period, non-members were often invited to exhibit with the Society and therefore mention of an artist's work in a review of a STISA exhibition does not indicate membership, particularly if that artist is already well-known. The Minute Book does, however, contain a list of members as at 1932. This is a helpful checkpoint at this juncture, particularly as in that year, a new rule was introduced that all exhibitors had to be members. Therefore, I have assumed thereafter that inclusion in an exhibition

denotes membership. However, apart from the catalogues of the touring shows, just one catalogue of a St Ives show has been located from the 1930s. One is therefore very dependent on newspaper reviews, which vary in length and quality from year to year. A further list of members as at 1938 does exist but this is missing the section L-R. In some cases, therefore, I have had to assume that an artist, whose work is no longer mentioned, has ceased to be a member from the date of the last reference to his/her work. Clearly, this may be incorrect, either because further work did not merit a mention or because the artist retained membership, even though not exhibiting. For instance, a number of artists contributed to the Society's present to mark Moffat Lindner's 90th birthday in 1942 despite not having been mentioned in reviews for years.

During the War, reviews are very sparse and contain very little detail and no catalogues for the years 1941-1944 have been made available to me. This is disappointing as there was clearly a lot of movement in and out of the colony during this period. From 1950, a fairly full set of catalogues exist and, from 1957, these include a list of members with their addresses. Accordingly, between 1957 and 1983, when formal catalogues ceased to be produced, membership details can be guaranteed.[1]

Please note that not all works will be exhibited at each venue on the tour.

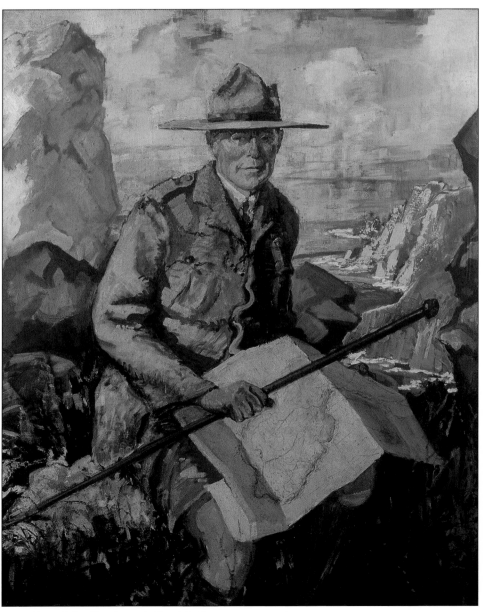

Fig. 2B-1 John Barclay *A Cornish Scoutmaster*
(Private Collection on loan to Penlee House Museum and Gallery, Penzance)

[1]The only exception relates to members joining or leaving in 1973, where no catalogues have as yet been located.

John Rankine Barclay (1884-1964) Exh. RA 1
STISA: 1936-1939 and 1955-1964, Secretary 1959-1963
STISA Touring Shows: 1936, 1937.
Public Collections include Penzance (on loan), Stoke and St Ives.

Barclay was a Scot, who was born in Edinburgh. At the age of 14, he started work as an engraver, attending art classes in the evening. He became a student at the Royal Scottish Academy Schools in 1908, winning a travelling scholarship in 1911, which probably enabled him to go to Paris and Madrid. Shortly afterwards, he won the Guthrie award. He admitted to being greatly influenced by the French Impressionists but commented, "That was my instinctive way of painting - even before I went to Paris."[2] During the Great War, he served with distinction in France with the Highland Light Infantry, winning the Military Cross and Bar.

Barclay moved to St Ives in 1935, living in a lonely stone cottage at Zennor, when his work was welcomed as "modern in spirit and yet in touch with tradition". Although he painted the wild moors around his home, he became principally known for his decorative and mural paintings. His work was in demand for plays and pantomimes and his four large mural decorations of the Seasons, executed for the City of Leicester Education Authority, were one of the principal attractions of Show Day in 1938.[3] These were to be hung in a children's school and depicted the playtime seasonal games of the children and were painted in vibrant colours. In 1940, inspired by the tercentenary of St Ives as a borough the previous year, he executed for Curnow's Café in St Ives four decorative panels, descriptive of events in St Ives' history. These represented (1) the arrival of the King's Messenger with the Charter, (2) the reading of the Charter in the Town Hall to the Council, (3) the blockade of roads leading to the town with hogsheads filled with sand by the inhabitants to prevent the entry of the Royalist Army after the defeat of the Roundheads at Longstone Downs and (4) the building of the St Ives Parish Church.[4] They now hang in St Ives Museum. Barclay's largest commission for this type of work was a huge mural (32ft x 11ft) for the Club Room of Wembley Stadium in 1953, which incorporated a detail from every sport featured at Wembley including soccer, ice hockey, speedway, racing, rugby league, skating, greyhound racing, tennis, women's hockey, table-tennis, boxing and athletics. Working on scaffolding, it took Barclay three months to complete.[5]

Such works were, of course, too big for STISA shows but he was a versatile artist, who was elected on to the Committee in 1938. His one-man show at Lanham's in 1939 contained landscapes with sky studies, depictions of London parks and Cornish harbour and moor scenes. A reviewer commented, "His work is varied, and he modifies his technique to suit his subject, which indicates that he is always striving to express what he sees as it strikes him. He does not treat nature as a theme for clever variations, and is in consequence a sincere impressionist."[6] He also did woodcuts and other illustrations for books.

Barclay epitomised the hardy Scot. He disliked creature comforts. He preferred sketching when it was windy and cold, feeling that he produced dull work on warm summer days, and likewise he worked in his studio without a fire. "If I am too comfortable, I do not let myself go".[7] He never lost his Scottish accent nor forgot his Scottish roots - his favourite exhibition venue being the RSA where he showed 52 works. Notwithstanding his success, life was still a struggle. "There were times when I hardly knew where the next meal was coming from. But I wouldn't have had it otherwise. The artist often paints at his best when he is really up against it."[8]

With the outbreak of the Second World War, he served as a gas officer with the RAF and ceased to be a member of STISA for quite some while. He is next mentioned on Show Day in 1952, when he was exhibiting in the Crypt scenery for *Goodnight, Vienna*. In 1954, he spent four months in America, visiting his son - also an artist - and, on his return, he held a one-man show in the Castle Inn, entitled *Impressions of New York and Connecticut*. He rejoined STISA in 1955 and, in 1957, he was elected on to the Council. He was a kind critic, who always encouraged new members, and he also helped Fuller out at the School of Painting. He became Secretary of STISA in 1959, retiring on health grounds shortly before his death. Barclay was a regular at the 'Sloop Inn', always occupying the same corner seat in the small bar, and is featured in a Rountree caricature (Plate 69) as well as in Hyman Segal's *Dominoes at the Sloop* (Fig. 2S-4).

[2]*News Chronicle*, 1939, Cornish Artists 18.
[3]The St Ives Archive Centre have a copy of the operatic catalogue for *The Duchess of Danzig*, illustrated by Barclay, who also designed the scenery for the production.
[4]*St Ives Times*, 10/5/1940.
[5]*St Ives Times*, 8/5/1953.
[6]*St Ives Times*, 8/9/1939.
[7]*News Chronicle*, 1939, Cornish Artists 18.

1. *A Cornish Scoutmaster* oil on canvas (126.5cm x 100cm)
(Private Collection on loan to Penlee House Museum and Gallery, Penzance) (Fig. 2B-1 and Plate 58)
This was the first painting exhibited by Barclay upon being elected a member of STISA. It was included in the 1936 Summer Exhibition and was then accepted but not hung at the 1937 RA exhibition. It was also shown in Bath in 1937. It features Major C.E.Venning, who had begun the scouting movement in Madron Parish in 1911. It is likely, therefore, to have been commissioned to celebrate the Madron Troop's twenty-fifth anniversary. Venning was a well-known local solicitor and was Mayor of Penzance in 1920.

(Ms) Wilhelmina Barns-Graham CBE HRSA HRSW (b.1912)
STISA: 1942-1949
STISA Touring Shows: 1945, 1947 (SA), 1947 (W), 1949.
Public Collections include Aberdeen, Birmingham, British Council, British Museum, Contemporary Art Society, London, Cornwall Educational Committee, Government Art Collection, Hull, Hove, Imperial War Museum, Isle of Man Arts Council, Kirkcaldy, Leeds, Manchester, Manchester (Whitworth), Plymouth, Portsmouth, Scottish Arts Council, Scottish National Gallery of Modern Art, Edinburgh, Sheffield, Tate Gallery, Victoria and Albert Museum, Wakefield, Wolverhampton and Sydney.

On her arrival in St Ives in 1940, the young, attractive Barns-Graham was welcomed by elderly members of STISA, but her move towards abstraction and her friendship with the moderns eventually led to animosity. Born in St Andrews, Fife, she started her art training at the Edinburgh School of Art in 1932. By 1936, she had her own studio in Edinburgh, but her family did not want her to become a professional artist. A post-graduate travelling scholarship enabled her to leave Scotland and, in 1940, she came to St Ives to see an old art student friend, Margaret Mellis, who had recently married the writer, Adrian Stokes. Through her, she met Nicholson, Hepworth and Gabo. She also befriended Borlase Smart, who arranged for her to take over at a reduced rental George Bradshaw's studio, 3, Porthmeor, as he had been called up. Smart, whom Barns-Graham has described as "a great and real friend", also repeatedly encouraged her as a painter, whilst listening to her own exposition of the merits of modern art. Eventually, Smart asked Barns-Graham to engineer a meeting between himself and Nicholson, at which he asked Nicholson to join the Society. On Bradshaw's return from the War in 1945, Smart let Barns-Graham take over his studio at 1, Porthmeor, whilst he moved into 5, Porthmeor, following the Society's move to the New Gallery in the deconsecrated Mariners' Church.

At this juncture, Barns-Graham's paintings displayed dramatic differences in stylistic approach. Wartime sketching restrictions led to her work combining a mixture of direct observation and imaginative reconstruction. Her sketches on the spot tended to concentrate on colour notations and her reliance on her memory for other details led to increasingly abstracted interpretations of her subjects. Her biographer records that her concern at this time was to capture "essential character, rhythm and formal relationship, not accurate detail."[9] Her interest in more abstract work led her to mix with other young artists in the colony, such as Sven Berlin, John Wells and Peter Lanyon (see Fig. 1-20). However, she was away in Scotland when the first Crypt Group exhibition was held in July 1946. She was included, though, in the second show in August 1947 and the third in August 1948.

For STISA shows, her three submissions tended to incorporate two representational works and one abstract. Works hung included *In A War Factory*, which is presumably one of the exceptional pastels she did whilst working briefly in the camouflage factory, *Hayle 1947*, *Night Driving*, *Rubbish Dump*, probably inspired by Borlase Smart's use of this subject, *Grey Sheds - St Ives*, *Mevagissey* and *Cornish Landscape 1948*. She also exhibited at the shows put on by the Society at The White Hart in St Austell and, in 1945, her painting, *Halsetown*, was bought by the directors of the St Austell Brewery from the *Cornish Inland Landscapes* Exhibition held there. The following year, they also bought her work, *Tin Stream Workings, Camborne*, from the exhibition entitled *Industry other than Fishing*. Having exhibited with the other modern artists at the Castle Inn and Downing's Bookshop, she had her first one-man show at Downing's in June 1947, at which she showed 37 works. In 1948, she visited Switzerland and her glacier drawings were to inspire her first major series of abstract work. She admits that, at the EGM in February 1949, there was a pre-ordained plan to split the Society but the plotters had not expected such a fall-out. She was a founder member of the Penwith Society and has survived all the dissentions that have affected that Society down the years. In 1999, she was duly honoured as the only artist to have contributed to every exhibition by members over its fifty year history. In 1949, she married the writer, David Lewis, and, by the mid-1950s, she had acquired an international reputation. In 1960, she was left the Balmungo estate in Fife by her aunt and, in 1963, the year her marriage was annulled, she acquired 1, Barnaloft on Porthmeor Beach. Since then, she has divided her time between Scotland and St Ives and her work's standing is as high now as it has ever been. In 1989-90, a Retrospective Exhibition was organised by the City Art Centre, Edinburgh and, in 1999, Tate, St Ives mounted an exhibition devoted to her work, entitled *An Enduring Image*. In 2001, she was made a CBE for services to art and that year was the subject of an in-depth critical biography by Lynne Green.

[8] ibid.
[9] L.Green, *W. Barns-Graham : A Studio Life*, London, 2001.

Fig. 2B-2 Wilhelmina Barns-Graham and George R.Downing at the installation of the exhibition, *Cornish Paintings: W.Barns-Graham*, at Downing's Bookshop, St Ives in June 1947. The painting at top right is *Grey Sheds, St Ives*, a work she also exhibited with STISA. (W.Barns-Graham)

2. ***Studio Interior*** oil on canvas (61cm x 46cm)
 (W. Barns-Graham) (Plate 65)
This painting, which dates from 1945, is considered to be one of the most advanced works that Barns-Graham exhibited with STISA. The 1945 Summer Exhibition included a work entitled *The Scarlet Stool*, which may be the same or a similar work, but a work entitled *Studio Interior* was exhibited at the 1948 Spring Exhibition, when it was described as a thoughtful, neat and austere painting, which conveys much, with astonishing economy of means.[10] The painting would have appealed to both traditionalist and modern camps, as it demonstrates both fine draughtsmanship and an advanced use and knowledge of colour. No traditionalist could have found fault with the stark but accurate rendition of the studio space with the strong lines provided by the fenestration, the roof beams and the easel. However, as her biographer notes, "The 1945 painting is also an essay in the constructive role of colour and tone, with the scarlet stool hitting the high note in a rich colour chord. It is a studied and silent image. The more one looks at it, the stronger its geometric and abstract qualities become evident, and the more complex it seems. Within it, three pristine canvases, each of a subtly different tone, are spatially linked by a flat white palette that carries a touch of the jug's yellow. This is a mature and sophisticated canvas." [11]

Sir Claude Francis Barry (1883-1970) Exh. RA 17
STISA: 1939-1946
STISA Touring Shows: 1945.
Public Collections include Manchester, Swindon and Société Jersiaise.

Barry came from an affluent aristocratic family and yet next to nothing was known about his career until a stunningly illustrated 'Introduction' to his life, *Moon Behind Clouds*, by Katie Campbell was published in 1999. I am therefore deeply indebted to this for the following information.

Claude Barry's grandfather, Sir Francis Tress Barry, was, in 1876, granted the title Baron de Barry of Portugal in recognition of his services to Queen Victoria, during which he had amassed a fortune by washing the residue from exhausted Portugese copper mines. From 1890-1906, he was Conservative M.P. for Windsor. His son, Sir Edward Barry of Ockwells Manor, near Maidenhead, succeeded to the Baronetcy in 1907. Ockwells Manor required a staff of sixty to manage the house and a similar number to look after the grounds. This was where the young Claude Francis Barry, eldest son of Sir Edward, was brought up and the family's summer home was Keiss Castle in the remote north east of Scotland. However, Barry's mother died when he was two and his father remarried and had four children by his second wife. Barry went to Harrow in 1897 but left in 1899 after some form of breakdown. Always keen on drawing, he embarked on a tour of Italy for six months with a tutor, Dr Prentice. On his

[10] *St Ives Times*, 23/4/1948.
[11] L.Green, op cit. at p.84.

return, he declared he wanted to be an artist and he studied for some months in 1900 at Bournemouth Art College. His family, still concerned about his mental state, refused to allow him home, censored his mail and forced him to lodge with various doctors. Eventually, in 1905, he broke free and, at the suggestion of Sir Alfred East, he went to Cornwall. East, who had been engaged by the family to oversee his artistic work, was clearly a significant influence as Barry's unpublished treatise on painting is dedicated "with lifelong gratitude, to the memory of my beloved master and friend, Alfred East".

Initially, Barry studied at the Forbes School in Newlyn. He had his first success at the RA in 1906 and appears to have been influenced initially by the Newlyn School. However, because Sir Alfred East often visited St Ives, he was known in that colony as well and he is signed in as a guest of Fred Milner at St Ives Arts Club in December 1906. In 1908, he married Doris Hume-Spry, who was descended from the Dukes of Rutland, to whom he had been engaged for five years, but his family did not approve. By this stage, his stepmother had ensured that he was effectively disinherited. The newly-married couple moved to 2, The Terrace in St Ives and shared a studio first at Tregenna Hill and then at St Leonards, Back Road West. The influence of the St Ives landscape and marine artists seems immediately apparent in titles like *"The day passes slowly and softly but surely away"* and *"When clouds come sailing over the sea": Land's End* (both RA 1910). Two fine, huge canvases depicting St Ives harbour from Skidden Hill, but in different conditions, also from this period can be seen at the Carbis Bay and Treloyhan Manor Hotels. Barry may well have taken further instruction from Julius Olsson at this time as moonlight scenes appear with regularity amongst his RA exhibits in the ensuing years. He also records the influence that Frank Brangwyn had on him, claiming that Brangwyn had taught him to reduce his palette to seven tones - "four tones of light and three of shadow".

Barry was elected an RBA in 1912 and exhibited 78 works with that society. The reviewer of Show Day in 1913 observed, "There is no more prolific worker than Mr C.F. Barry, whose spacious studio contained almost enough exhibits for a 'one-man show'. Mr Barry is essentially a colourist, and some of his schemes take one aback."[12] However, in that year, according to one unsubstantiated account, Barry left for Italy with his mistress and his wife sold off, or possibly burnt, all his paintings! Certainly, he did not exhibit on Show Days in 1914 and 1915. Possibly, the outbreak of War saw him return to St Ives and, as a pacifist, he was drafted to do agricultural labour. The six months he spent picking potatoes he described as "the worst six months of my life".

Barry became well-known for his searchlight paintings during the Second World War but his first efforts were, in fact, done on Peace Night at the end of the First World War. Feeling that this would make a good subject, he spent months in London waiting for peace to be declared and then his wife and himself spent the evening making notes to work up into big pictures. *Peace Night in Trafalgar Square* showed joyous crowds "madly jazzing under the shadow of Nelson's monument", with the scene illuminated by a magnificent firework display, whereas *The Grand Fleet on Peace Night*, showed the Fleet outlined by criss-crossing water searchlights. His wife, whom he had met at Bournemouth Art College, became well-known for her needlework pictures, which involved embroidering landscapes and seascapes in delicate silks on the finest of linen. Her portrait was painted by both Louis Sargent (q.v.) and Mabel Douglas (q.v.).

In 1920, Barry held a one-man show in St Leonard's Studio, Porthmeor, which contained *The Merry Woods of Windsor*, a work that had been highly complimented when hung at the Paris Salon the previous year, and a series of ten etchings classed as "souvenirs of St Ives". However, shortly afterwards, Barry deserted his family and moved to the Continent.[13] Having divorced Doris in 1927, he immediately remarried Violet Prettyman, who was prepared to tolerate his philandering. During this period, he concentrated on etching, an art form he probably learnt from East and Brangwyn and one which was more appreciated on the Continent. In his prints, he combines accurate architectural detail with atmospheric renderings of water, light and sky, all pulled together by his masterful skill at composition. He particularly favoured the stark contrasts offered by moonlit or floodlit scenes. He exhibited regularly at the Paris Salon and was awarded gold, silver and bronze medals for his etchings in both France and Italy. Alpine villages in the Pyrenees, Tuscany and Southern Germany were among his favourite subjects.

Barry returned to St Ives in 1939, having been ordered by the Italian authorities to depart from Bordighera within 48 hours, and took over Fred Milner's huge studio at 2, Piazza.[14] Some of his first exhibits were large, decorative etchings of Venice, capturing firework displays at festival time and St Mark's Square illuminated at night. However, Barry gave up etching on his return and, sadly, all his plates were destroyed in an Allied bombing attack on Milan in 1944. Instead, he returned to the pointillist technique he had been developing at the end of his previous stay in St Ives. Barry describes his working methods in his unpublished treatise.

[12] *St Ives Times*, 28/3/1913.

[13] Barry was also a fine croquet player, winning the open championship challenge cup at Roehampton in 1919 and, for the croquet player, the ultimate honour, the Menton Croquet Championship in 1922, 1923 and 1929.

[14] Misome Peile commented, "No one who goes to see Francis Barry in his studio will ever forget that experience...Most of the glass was blacked out, and he would answer your knocking wearing an ancient eye shade, cigar stump hanging from his lips. Inside among stacks of huge canvasses was a small table holding an immaculate palette and hundreds of clean brushes. On it stood a cup of Bovril for the guest who sat in a black horsehair armchair. It was a world far removed from the Atlantic rollers roaring outside the flimsy glass." Campbell, ibid, p.27-8.

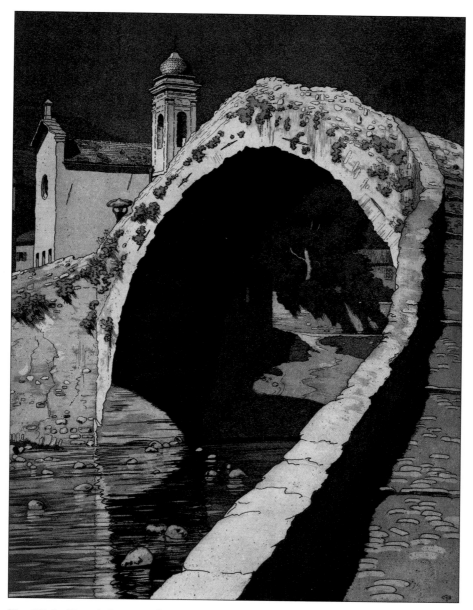

Fig. 2B-3 Francis Barry *The Bridge, Dulce Aqua* (etching) (David Capps)

First, he would sketch out the design with charcoal directly on to the canvas, then he would cover the surface with a thin layer of neutral paint and it was only then would he begin to apply the vivid colour that is the hallmark of his work. "Colour" - he said - "is the heart and soul, the joy and glory of painting." Barry rejoiced in using pure and unmixed colour and when secondary colours were required, he advocated his pointillistic approach. "Don't paint orange" - he advised - "but get the orange by spots of red and spots of yellow which mix in the eye when seen at the proper distance." Shadow he created by the use of complimentary colours, and in this and much else on the subject of colour, he acknowledged the mastery and influence of Matisse.

Misomé Peile (q.v.), who befriended Barry, commented that his studio was like another world, with the big windows all blacked out. "Day after day the explosions of colour grew, painstaking charcoal designs, studies from life...Barry was never satisfied, he complained he could not draw, was troubled over human anatomy, could not get high enough colour..." Yet, Barry's exhibited works were highly regarded, although the series of provocative nudes in his house made the authorities decide it was not an appropriate billet for refugees! In addition to his searchlight paintings of the Blitz, he produced bold figure studies, for several of which Peile modelled, but, on Show Day in 1946, his exhibits were considered the finest works of his career. From data supplied by the Russian Embassy, he painted two huge canvases, executed in his distinctive pointillist method, depicting the celebrations in Moscow in 1945, full of fireworks and their golden rain, coloured searchlights and flood lighting, all illuminating the Kremlin and the distinctive cupolas of other palaces and cathedrals in the city. Peile commented, "When the great Moscow Fireworks was finished, all the pent up fury and determination had somehow been controlled by the delicate balance of true artistic genius; the fireworks seemed to blast the studio asunder." - (see Plate 31).

In July 1946, Barry held a farewell exhibition, indicating he was moving to Paris, but he was still in St Ives in September that year. When Rountree criticised the first Crypt show, Barry wrote to the local paper in defence of the young moderns. "It should be obvious to any professional artist that the work now being exhibited in the Crypt is the result of much thought and much hard work and deserves on its merits to be taken seriously and encouraged. Many of the pictures are very beautiful in colour and quality of paint. Some are very well drawn - they are well composed in a decorative manner and fill the canvas. Also they are alive and one leaves the exhibition stimulated, pleased and excited."[15] However, Barry did leave St Ives shortly thereafter and settled in Jersey where he lived until his death. In 1949, his father died and he inherited the family title, becoming known as Sir Francis, but this did not affect his finances. His later work is still immensely colourful but simpler, with pared down shapes, stylised forms and sinuous lines and has similarities to the poster art of the 1930s. After his wife died in 1957, he became increasingly eccentric but continued painting until 1965. He left all his works to a local artist, Tom Skinner, who had helped to look after him in later years.

3. ***Tower Bridge, London - A War-time Nocturne*** oil on canvas (73cm x 94.5cm)
(Swindon Museum and Art Gallery) (Fig. 1-15)
The title recalls Whistler's famous nocturne featuring Battersea Bridge with the faint illumination of fireworks. Barry develops the same theme with the bridge thrown into relief by the anti-aircraft shells and searchlights of a Second World War air raid. He made a series of similar pictures using searchlight patterns as part of the composition, all painted in his distinctive pointillist technique. This painting was included in the 1945 tour and was one of three works bought by F.C.Phelps from the exhibition and presented to the new Swindon Art Gallery.[16]

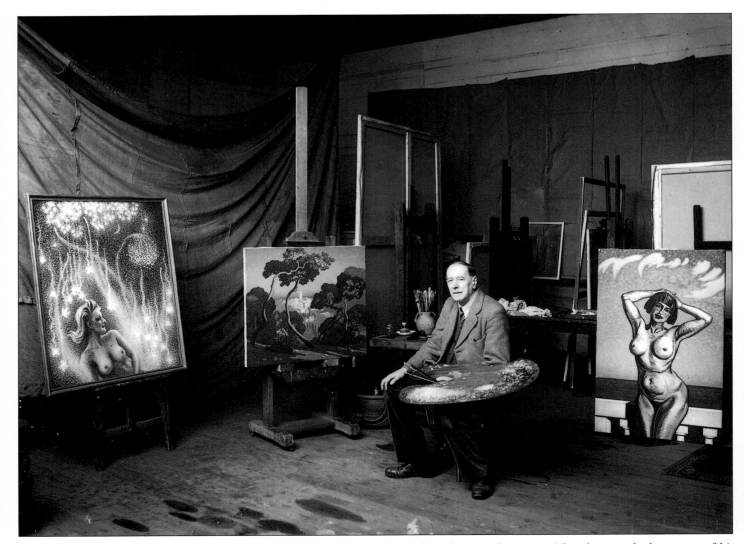

Fig. 2B-4 Francis Barry in his Porthmeor Studio, 1945, with an old sail draped across the room. The photograph shows two of his extraordinary nudes - *Riviera Nocturne* on the left and *The Sunbather, Monte Carlo* on the right. The painting on the easel is *Old Town, Bordighera*.
(David Capps)

[15] *St Ives Times*, 9/1946.
[16] I am indebted to Swindon Art Gallery for the description of this painting.

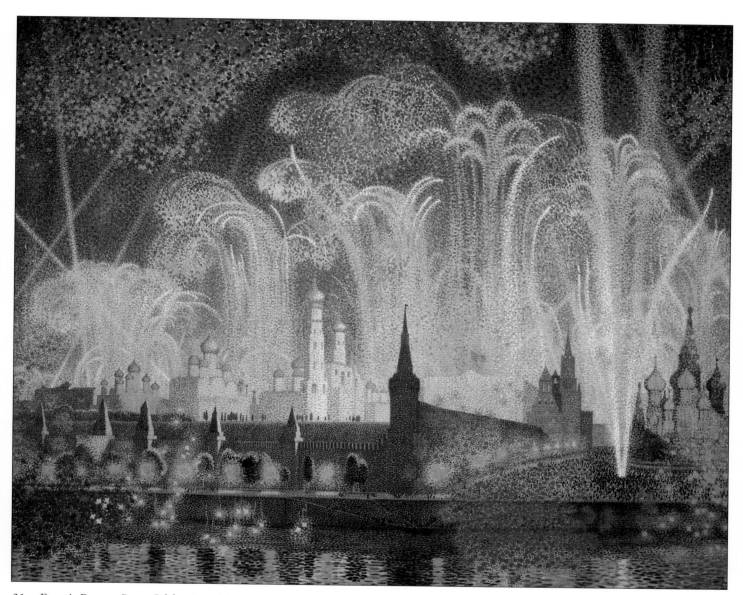

31. Francis Barry *Peace Celebrations, Moscow*

(David Capps)

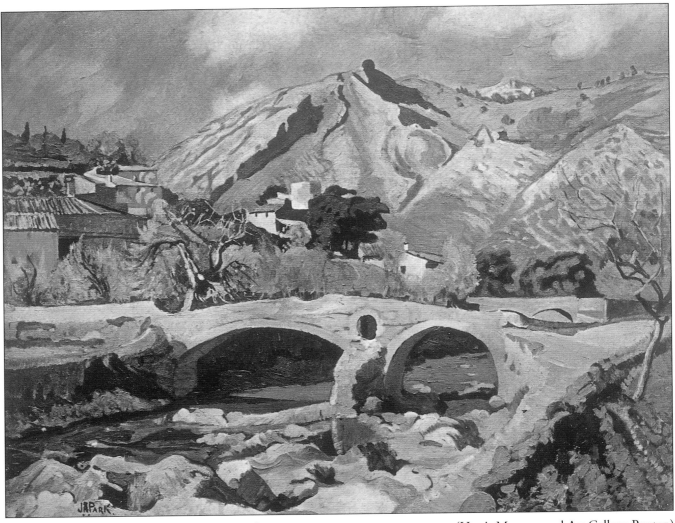

32. John Park *Roman Bridge, Pollensa* (c.1934) (Harris Museum and Art Gallery, Preston)

33. Hugh Gresty *The Baths of Caracalla* (Cartwright Hall Art Gallery, Bradford)

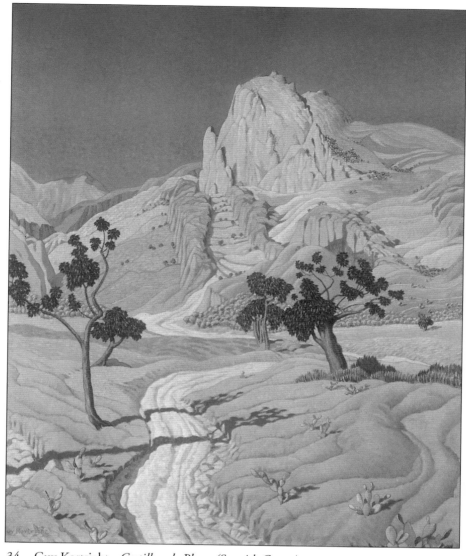

34. Guy Kortright *Castillon de Plana (Spanish Cactus)*
(Williamson Art Gallery and Museum, Birkenhead)

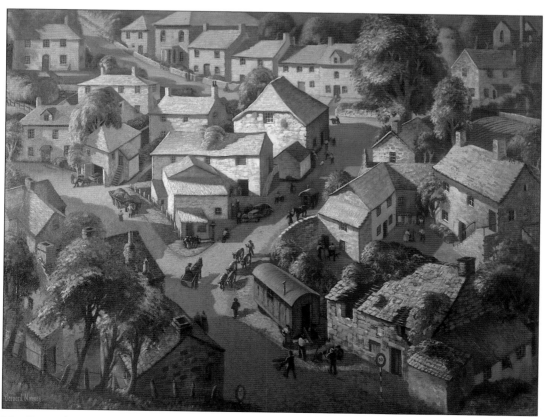

35. Bernard Ninnes *A Cornish Hamlet - Nancledra* (St Ives Town Council)

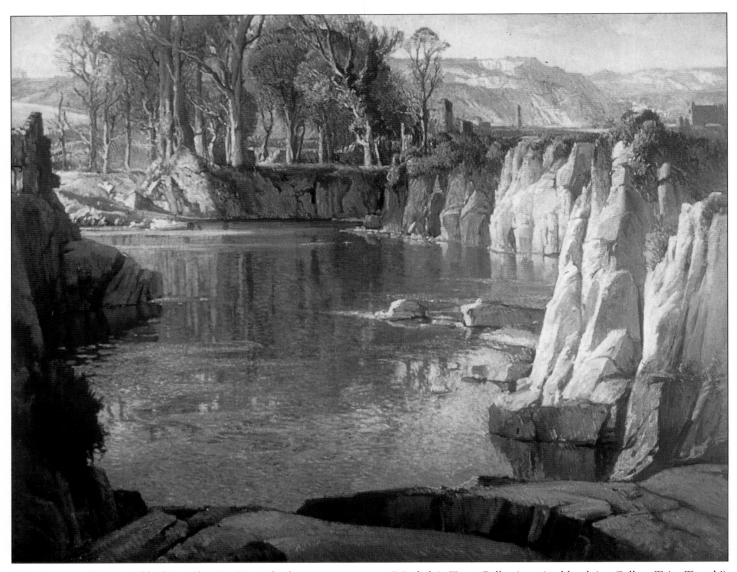

36. Lamorna Birch *Old China Clay Pit, Penwithack* (Mackelvie Trust Collection, Auckland Art Gallery Toi o Tamaki)

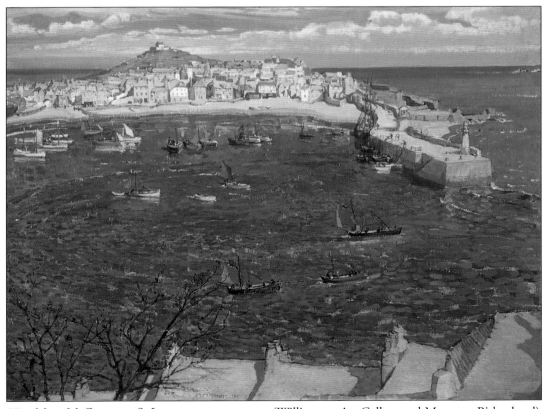

37. Mary McCrossan *St Ives* (Williamson Art Gallery and Museum, Birkenhead)

Samuel John Lamorna Birch RA RWS RWA (1869-1955) Exh. RA 237
STISA: 1930-1955, President 1950-1955
STISA Touring Shows:1932, 1934, 1936, 1937, 1945, 1947 (SA), 1947 (W), 1949. Also FoB 1951.
Public Collections include Royal Collection, QMDH, Tate Gallery, RA, Birkenhead, Birmingham, Bournemouth, Brighton, Bristol, Derby, Dudley, Huddersfield, Hull, Kendall, Lancaster, Leamington, Liverpool, Manchester, Manchester (Whitworth), Newcastle, Newport, Oldham, Penzance, Plymouth, Preston, Rochdale, Sheffield, South Shields, Sunderland, Truro, York (NRM), and abroad, Adelaide, Hobart, Perth, Sydney, Auckland, Christchurch, Dunedin, Nelson, Wanganui, Wellington, Rhode Island, Toronto and Durban.

Of all the Royal Academicians involved with STISA, Birch contributed the most. He was one of the few to become actively involved with STISA, serving on Committees in the 1930s, opening exhibitions, giving lectures and eventually serving as President from 1950 until his death. In addition, being such a prolific artist, his contributions to exhibitions far outnumbered any of his distinguished counterparts. Being one of the most well-known and popular artists of the time, Birch's inclusion in STISA shows added immeasurably to their public appeal.

The son of a house painter, Birch was born in Egremont, Cheshire but grew up and was educated in Manchester. The eldest child of a poverty stricken family of, eventually, nine children, Birch left school in 1881 to work in the warehouse of an oil cloth manufacturer, but he always wanted to be an artist and he drew and painted in his spare time. In 1886, he managed to have some paintings hung at Manchester City Art Gallery and some wealthy families took an interest in his work. Having visited Cornwall for the first time in 1889, he decided in 1892 to move to Cornwall to become a full time painter. He settled initially in Boleigh Farm at the top of the Lamorna Valley and had his first painting accepted by the RA in 1893. In December 1895, at the suggestion of Stanhope Forbes and Norman Garstin, he went, somewhat reluctantly, to Paris for seven months to study at Colarossi's and, whilst there, discovered the work of the Impressionists, which he considered a revelation. On his return, he adopted the name 'Lamorna' to distinguish himself from another local artist, Lionel Birch. In 1902, he married Houghton Vivian, an art student he had been teaching, and they moved to Flagstaff Cottage, Lamorna Cove, which was to be their home for the rest of their lives. However, Birch understood the commercial realities of the art world and realised that he had to maintain and expand his range of patrons up north and elsewhere. He always had a gift for making friends and, with his great love of fishing, he began to make contacts with some of the owners of the great sporting estates around the country. In this way, he managed to combine some tuition of family members with opportunities to paint and fish in idyllic surroundings. Usually, he also landed the odd juicy commission. In addition, Birch cultivated a number of prominent picture dealers and was never averse to painting to order. In 1905, he became a member of the RBC and, in 1908, he had the first of many one-man shows at the Fine Art Society. Soon his work was in demand at international exhibitions and he was securing sales to foreign Art Galleries. In 1914, he became a member of both the RWA and the RWS, the latter becoming the principal outlet for his watercolours.

The outbreak of War disrupted the idyllic existence of the Lamorna community, which now included Harold and Laura Knight and Alfred Munnings. Being too old for active combat, Birch served with the Army Volunteer Force in Cornwall along with Robert Hughes. The horrors of war, however, increased interest in pastoral landscapes. In 1926, he was elected an ARA but his reputation had already spread far and wide, for it was estimated at that time that there were more works by Birch in overseas Art Galleries than by any other British painter. His landscapes seemed to capture the essence of the Old Country so that he had become, in the words of *The Cornishman*, "a household name throughout the Empire".[17] Yet his style was a very individual one - he was, as Laura Knight observed, "in a school of his own".[18]

Although Birch exhibited with STISA regularly at their request from 1928, he was not offered Honorary Membership until 1930. He gave a talk to members on Water Colour Drawing in February 1931 and was elected on to the Committee in 1932 and 1933. His exhibits with STISA were drawn from his wide range of subjects. There were, of course, many scenes from the Lamorna Valley, whose delights Birch almost single-handedly introduced to the public, with beguiling titles like *Our Little Stream Comes Dancing Down* and *Through Our Little Golden Wood*, arousing visions of a tight-knit community in an enchanted valley.[19] The brilliant greens and turquoises of Lamorna Cove, with its distinctive quay, appeared time and again as did the mighty Tregiffian Cliffs and Pedn-a-Vounder. Lamorna landmarks like Hosking's Barn and the Clapper Mill at Trewoofe became familiar to art lovers around the country. Then there were the results of his sallies around Cornwall, particularly to St Ives. In 1938, his picture of low tide at St Ives, merely entitled *St Ives, Cornwall* was purchased for the Chantrey Bequest, in 1939 *The Lifeboat Slip, St Ives* was rated by many, including Munnings, as the best picture Birch had ever painted and, in 1942, his RA exhibits included three St Ives scenes, of which *The Hive: Morning, St Ives*, smashed the previous auction record for a Birch painting in 2002.[20] There

[17] A.Wormleighton, *A Painter Laureate*, Bristol, 1995 at p.18
[18] ibid p.18.
[19] Birch's RA Diploma work, *Our Little Stream*, Lamorna was first exhibited with STISA.
[20] The painting sold at Phillips, London for £46,000 but this price has now been eclipsed.

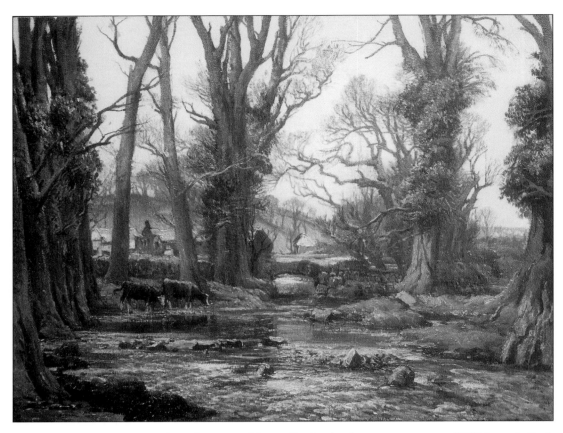

Fig, 2B-5 S.J. Lamorna Birch *The Quiet of Our Valley* (1940-2) (W.H.Lane & Son)

were also the fruits of his fishing trips to Scotland, often in the company of Moffat Lindner, and his other extensive travels both in Britain and abroad. His major pieces were in oils but his many watercolours were crucial to the success of that section of STISA. Like many STISA artists, Birch's work was also widely known as a result of his railway posters during the 1920s and 1930s.

4. *Morning at Lamorna Cove* oil on canvas (101.5cm x 127cm)
(Williamson Art Gallery and Museum, Birkenhead) (Plate 8)
Lamorna Cove in the early morning was a favourite subject for Birch and the precise date of this work is unknown, although it is believed to have been painted in the 1930s. A painting *Lamorna, Morning* was exhibited at the 1930 Winter Exhibition of STISA. The scene is the view from the garden of Birch's home, Flagstaff Cottage, and sunshine lights up the sea, as a storm passes off to the right.[21] Like many of Birch's works of this period, the colouring is enhanced to increase its appeal.

5. *My Garden: February* oil on canvas (45cm x 74cm)
(Private Collection) (Plate 47)
In his early years, Birch's snow scenes were immensely popular and he painted many to order. This picture, though, was exhibited at the RA in 1941 and shows his beloved Lamorna stream which ran through his garden near his studio. Wormleighton comments that, in winter, he could be found there "crouched on a low stool in muffler and mittens and wide-brimmed hat; a cigarette in a long ivory holder clenched in the centre of his mouth; a jug of coffee laced with whisky at his side."[22] For Birch, streams and rivers held an endless fascination and his ability to capture the play of light on water is unrivalled, reflecting the endless hours that he had sat on river banks with either brush or rod in hand.

6. *A June Morning: The Deveron at Rothiemay* oil on canvas (62.5cm x 75cm)
(Leamington Spa Art Gallery and Museum)
In the 1920s and 1930s, Birch went most summers on a fishing trip to Scotland and his paintings of the rivers he fished are some of his most popular works. The River Deveron was a particular favourite, as it "glides pleasantly through upland pastoral land, at times through rich woods, now over sparkling shingle, or breaks more roughly through rocky glades. Often it hurries along merrily, and yet it often pauses mid meadows or by some overhanging woods".[23] Birch at one juncture declared it "the

[21] The painting is illustrated in David Tovey, *George Fagan Bradshaw and the St Ives Society of Artists*, Tewkesbury 2000, at p.161.

[22] A.Wormleighton, *A Painter Laureate*, Bristol, 1995 at p.18

[23] W.L Calderwood, *The Salmon Rivers and Lochs of Scotland*, quoted in Wormleighton at p.155.

most beautiful fishing river I have ever been on".[24] This painting was originally hung at the RA in 1929 but was included in the 1936 Birmingham tour.[25]

7. *A Highland Burn, Springtime*
(Gallery Oldham)

watercolour (34cm x 44cm)
(Plate 88)

Birch was equally highly regarded as a watercolourist and during his membership of RWS he exhibited an astonishing 350 works. This painting was one of those added from Oldham's permanent collection to the 1934 STISA show at Oldham. In 1931, he was asked for comments on his technique by John Littlejohns (q.v.), for his book on British Water-Colour Painting. "I cannot say that I have any particular method, though, if I have any particular liking, it is for the good old way - the light tones first, then the half-tones, and finally the darks or shadows. The latter are put on boldly so as to envelop the whole as it were...I rarely mix colour on the palette, but use it pure, and alter and correct it on the paper".[26] This was the year that Birch gave a talk to STISA members on painting in this medium. As he indicated to Littlejohns, his advice to the would-be watercolourist was, "Be brave: use plenty of water: don't be afraid of using a good strong dark while the paper is wet: don't niggle: get as much expression and drawing as you possibly can out of each brushful."[27] In the same year, Birch told *The Studio* that he used up to 22 colours in his watercolour work, one of the widest ranges in the survey.

George Fagan Bradshaw SMA (1887-1960) Exh. RA 10
STISA 1927-1960, Secretary 1927 & 1949-52, Vice-President & Chairman 1955-7
STISA Touring Shows: 1932, 1934, 1936, 1937, 1945, 1947 (SA), 1947 (W), 1949. Also FoB 1951.
Public Collections include Royal Navy Submarine Museum, Gosport, Sunderland and Truro.

Lieutenant-Commander George Bradshaw had a central role not only in the formation of STISA but also in the split in 1949. Born in Belfast, Bradshaw came over to England in 1902 to train as a naval officer at Dartmouth. He went into the Submarine Service and was a submarine commander during the Great War, winning a D.S.O.. Always keen on drawing, he trained, whilst he was based in Malta in 1912-3, under Edward Dingli, a portrait and genre painter of renown. A number of his paintings of submarines and depot ships are owned by The Royal Navy Submarine Museum at Gosport. On his discharge from the Navy in 1921, he settled in St Ives and studied at the Simpson School of Painting, where he met his wife, Kathleen. By 1922, he had become an assistant teacher at the School and, in 1923, he had his first painting hung at the Royal Academy. This work, *The White Barque*, has just been donated to the Royal Cornwall Museum, Truro.

Bradshaw, along with Herbert Truman, was responsible for putting forward the proposals for the formation of STISA. At the formation meeting, he commented, "The rough idea of the Society would be that they would meet for artistic discussion, they would endeavour to get their work criticised by Artists of repute and eventually endeavour to interest the outside world in the work of the group. It would be a very slow thing and they could not hope to meet with success under a couple of years, but anything was better than the present state of affairs."[28] He was elected the first Secretary but, stung by Truman's criticisms of the lack of progress made in the first year, he did not seek re-election until Borlase Smart assumed control in 1930. Throughout the 1930s, he was invariably re-elected on to the Committee and Borlase Smart described him as "my old faithful one". He served repeatedly on Hanging Committees and helped to organise the touring shows.

Bradshaw concentrated exclusively on marine painting, drawing on the hours he had spent in the Navy observing ships and the sea. One of his specialities were depictions of the old sailing ships that were fast disappearing off the high seas, but he also recorded the visiting French crabbers and east coast trawlers, and the local mackerel luggers and motor gigs, that were used for lobster fishing. A keen sailor and fisherman, he often went out sketching with the local fishermen. From 1929, Bradshaw worked in 3, Porthmeor Studios and breakers pounding on to Porthmeor beach in a northerly gale was another favourite subject.

By the late 1930s, he had developed a reputation as a consummate master of his craft and he was dismayed to be called up to serve again in the Second World War, which he spent first in Falmouth and then in Sunderland. On his return to St Ives in 1946, his beloved Society had changed considerably, with an influx of young blood, and he had little time for modern art. When following Smart's death, the rules on a member's right to exhibit were changed and several friends and longstanding colleagues were excluded from exhibitions, he agreed to be the spokesman for the traditionalists at the extraordinary general meeting called by them in February 1949. At the meeting, Bradshaw lost his temper in spectacular fashion and it terminated in bitter acrimony, with the

[24] ibid p.157.
[25] The painting is illustrated in colour in David Tovey, *George Fagan Bradshaw and the St Ives Society of Artists*, Tewkesbury 2000, Plate 6 - between pp.68/9.
[26] J.Littlejohns, *British Water-Colour Painting and Painters of To-Day*, London, 1931, p.25-6
[27] ibid, p.26.
[28] *St Ives Times*, 27/1/1927.

Fig. 2B-6 Bradshaw's painting *Departure for the Herring Fishing* being reviewed in 1939 by the Hanging Committee of (from right) Leonard Fuller, Borlase Smart, Bradshaw himself and Thomas Maidment. Tonkin Prynne stands by the work.

moderns and a fair few of the traditionalists resigning. Bradshaw concluded correctly that he had been set up by Nicholson and Hepworth and refused to have anything to do with them again. He became Secretary of STISA again until a second coronary forced him to retire in 1952. He returned in 1955 as Vice-President and Chairman, when he had to deal with the scandal of the then curator selling off paintings for her own benefit. He also supervised the Society's acquisition of the freehold of its current Gallery. In the 1950s, Bradshaw executed a number of fine moonlit scenes but the tide had turned against traditional art. This, poor health and an ever deteriorating financial position made him a bitter and irascible old man in his later years. Nevertheless, he was primarily responsible for the formation of STISA and he gave it dedicated service for the rest of his life. He was not alone in his inability to comprehend modern art and, although his outburst ensured the split was acrimonious, the parting of the ways was inevitable.

8. ***Westward and Candida*** oil on panel (38cm x 48cm)
(Private Collection)
This painting was exhibited at the Summer Exhibition in 1931 and features a pair of celebrated racing yachts in full sail. It is a relatively calm hot summer's day, thus allowing some delicious multi-coloured reflections, which are the central feature of the work. *Westward* was designed and built in 1910 at Bristol, Rhode island by the famous American, Nathaniel G.Herreshoff for Alexander Corocoran so as to enable him to mount a challenge to the Kaiser's schooner *Meteor IV*. She was built of steel and rigged as a gaff schooner, carried 15,498 square feet of sail and needed thirty-five crew. She was very successful, winning eleven races in her first year but, by the time Bradshaw painted her, she was owned by F.T.B.Davies of Guernsey, who raced her against the big class yachts, winning the King's Cup in 1934. *Candida* was one of the phenomenally expensive *J*-class yachts - only ten were built - that constituted the premier league of racing yachts in the 1930s. Dating from the late 1920s, she was owned by the banker, Herman Andreae until, in 1935, he acquired the famous *Endeavour*. Accordingly, in the early 1930s, these yachts would have raced each other several times, generating enormous interest on each occasion.[29]

9. ***Smeaton's Pier, St Ives*** gouache (27cm x 38cm)
(Private Collection)
This attractive view of boats and reflections in front of Smeaton's Pier, with its distinctive lighthouse, was exhibited with STISA in 1930. The principal boat featured is the St Ives mackerel boat *Gratitude* - ss626, built in 1887. The boat was owned by H.Paynter and had a distinctive raised washboard at its stern. It was also unusual in having three engines and three propellers, its first engine being fitted in 1914. Nets are being loaded or unloaded both from her and from the other boat moored behind her against the quay.[30]

[29] I am indebted to John McWilliams for the history of these yachts. This painting is illustrated in colour in David Tovey, *George Fagan Bradshaw and the St Ives Society of Artists*, Tewkesbury 2000, Plate 13 - between pp.120/1.
[30] I am indebted to John McWilliams for the history of this boat. This painting is illustrated in colour on the front cover of David Tovey, *George Fagan Bradshaw and the St Ives Society of Artists*, Tewkesbury 2000.

Sir Frank Brangwyn RA (1867-1956) Knighted 1941 Exh. RA 55
STISA: 1935-c.1946
STISA Touring Shows: 1936, 1937.
Public Collections: "His work is represented in virtually every major art gallery and print room in the world"
- *Dictionary of National Biography*

Brangwyn's acceptance of membership in 1935 must have been considered a great coup by STISA, for he was the most famous artist of his day and was the first British artist to gain world-wide recognition in his lifetime. Yet he had had little formal training.

Born in Bruges, his father, Curtis, who was of Anglo-Welsh stock, was an architect and textile designer, who had been forced through hazardous financial circumstances to try his luck on the Continent, but he returned to Shepherd's Bush in London in 1875. Although he became involved in the design of Tower Bridge, his financial position remained precarious and Frank, who was not a scholar, was withdrawn from school at the age of 12. He roamed the streets, taking in the sights and sounds of London, and his first introduction to painting was when, as a boy, he came across the Cornish artist, Napier Hemy, painting by the side of the Thames at Putney. Fascinated, he spent hours watching Hemy at work and started to sketch himself. He later commented, "The Fields and the Streets were my School of Art".[31] He also discovered the collections of the V & A and the British Museum and it was while drawing in these Museums that he was befriended by Harold Rathbone, a pupil of Ford Madox Brown, and by the architect, Arthur Mackmurdo, a friend of Ruskin. It was the latter who introduced him in 1882 to William Morris, under whom Brangwyn trained for two years as a draughtsman. This was his only formal training. In 1885, he had his first painting accepted at the RA but his financial position remained precarious. This coupled with a love of the sea and a lust for travel and adventure meant that he frequently took off on sea journeys, paying for his passage with paintings. In 1887, he was offered the chance of a painting trip to Cornwall and he stayed in Mevagissy for several months. Although he had already painted in ports such as Sandwich and Rye, this was a memorable time. "The whole harbour was filled with boats and men getting ready for the fishing; it was a sight that knocked me silly".[32] However, it was an inland scene of men on a Cornish hillside, entitled *Barkstrippers*, that was, in 1888, his first important work at the RA, where it was compared to the work of the Newlyn School. Brangwyn, however, never settled in Cornwall, although he returned to visit on regular occasions. In particular, he developed a close friendship with Alfred East, who admired his work immensely, calling him "The Rembrandt of Tomorrow". Grace Ellison, a friend of East, tells the story of a reception thrown for these two distinguished artists whilst they were in St Ives. Brangwyn, during his visits to the town, received many invitations but, being uncomfortable in social gatherings, tended to refuse all but, on this occasion, both he and East accepted "Both of them started with me", Ellison comments, "but unfortunately for the guests neither of them arrived at their destination. Brangwyn on the way met a cart of slaughtered bullocks on a truck and stayed to make a study. East was very cross with him and did not approve his lack of courtesy. That did not prevent East, however, from getting out at the next station to make a study of a sunset, and I therefore went to the reception alone. Everyone understood. All is forgiven to genius."[33]

When Brangwyn moved away from the muted tones of his early seascapes and began to produce animated and sophisticated designs in rich, often blazing hues, not all British critics were impressed but, in France and elsewhere on the Continent, he was hailed as a master and won a succession of medals at International Exhibitions. At the RA, by contrast, his work was skied and, having suffered this indignity for two years in 1897/8, he ceased to exhibit there. He was somewhat surprised, therefore, when staying with Alfred East in St Ives in 1904, to learn that he had been made an ARA.[34] The critic of *The Morning Post* rejoiced:-

"Here we have a painter who is not so much a painter as a designer, a master of colour, of composition, whose pictures suggest ordered riot and splendid repose. Whether his pictures are of the sea, or of Oriental magnificence or Western Commerce, one must be struck by the power of the painter, who always feels even more than the subject, the significance of his work as decoration. And he is not a painter only, but an etcher, black and white man and illustrator, a designer of carpets, textiles, etc., and of furniture and fittings and the like, when these are wanted to complete the harmony of a room he may be decorating...If ever the Academy selected a young genius who is marked out for greatness, Mr Brangwyn is the man - as foreign countries have already recognised."[35]

Brangwyn's relationship with the RA, however, was always uneasy. He did not get on with his fellows and, despite being eventually made a full RA in 1919, he rarely bothered to exhibit there. It is somewhat ironic, therefore, that, in 1952, at the insistence of Sir Gerald Kelly, he became the first living Academician to be honoured with a retrospective at Burlington House.

[31] R.Brangwyn, *Brangwyn*, London 1978.
[32] Quoted in R.Brangwyn, *Brangwyn*, London, 1978 at p.39.
[33] Grace Ellison, *My Tales of A Sailor Artist*, Unidentified newspaper interview from 1930s.
[34] On 7/7/1933, the *St Ives Times* in a review of a Brangwyn exhibition at Brighton commented, "Mr. Brangwyn visited St Ives many years ago and had one of the Piazza Studios, where he worked on some large etchings".
[35] Quoted in R.Brangwyn, *Brangwyn*, London, 1978 at p.91.

In his own day, Brangwyn was best known for his monumental mural decorations. These adorned such buildings as the Royal Exchange, Lloyds of London, a Court House in Cleveland, Ohio, the State Capitol of Missouri, the Manitoba Legislative Building, Winnipeg, Canada and the Rockefeller Center, New York. For such work, he could command colossal fees of £20,000. There were also the famous Empire Panels, destined for, but rejected by, the House of Lords just a few years before he joined STISA. By the mid-1930s, however, his star was on the wane and his output was dropping both in quantity and quality and, ever conscious of his own mortality, his principal concern was to ensure that the vast body of work that he had produced during his lifetime was dispersed to suitable institutions. Many Galleries were gifted works but the creation of a Brangwyn Museum in the town of his birth, Bruges, in 1936, to which he donated 444 works, and the establishment of the William Morris Gallery in Walthamstow, to which he donated his collection of Victorian pictures and 23 of his best oils, were two significant acts of largesse.

Notwithstanding the amount of work that Brangwyn was giving away at this time, he still made available to STISA some fine examples. His exhibits included the oils *Notre Dame, Paris* (Spring 1936 & Birmingham tour) and *Ponte Rotto, Rome* (Autumn 1937), both of which are now in the The Museum of New Zealand, Wellington. There was also *The Bridge of Alcantara, Spain* (Summer 1938), *Towing*, a work dating from 1890, (Autumn 1938), *The Fishermen's Quarters, Venice* (Autumn 1939) (cat.no.10) and the very fine *Entrance to the Bosphorus* (Autumn 1939), which was illustrated in *The Artist* in August 1941, where it was noted for its "powerful design and rich, luscious colour". Although he commented, "I can still do a bit of wild watercolour", only one seems to have been shown - *Church, Cahors*. This was considered to be the outstanding watercolour at the 1937 Autumn show, being "remarkable in construction, dignified in colour, with beautifully expressed figures in the street". His principal contribution, however, was probably to the 'black and white' section, as he sent a number of etchings, drawn from the first quarter of the century when he was breaking new ground in this medium.

Brangwyn first took up etching in 1900 and soon developed a very individual style that flouted traditional methods. He rarely made preparatory sketches but etched directly from nature. He began to use huge plates and he immersed these in the acid several times so that the main design features were bitten deeply into the metal. He also mixed burnt sienna with black printing ink to make it look less opaque and to aid tonal effects further, he indulged in the practice, abhorred by traditionalists, of foul biting, whereby acid was allowed to penetrate parts of the varnish covering the unetched areas. The consequential mottled effect can be seen in a work such as *The Pigsty* (Gaunt 45), which was etched on the spot at Wormwood Scrubs in 1904 and included in the 1940 Spring Exhibition, along with *Tour de Faure* (1911), *A Roman Bridge* (1921) and *Strand on the Green* (1923). Bridges were a constant fascination and he was also drawn strongly to industrial scenes, tending to emphasize the smallness of man by exaggerating the size of his creations. Violent contrasts often played a leading role in his designs. A reviewer of an exhibition in Brussels in 1939 commented, "It is almost a truism that, since Rembrandt, there has not been an etcher who has captured with such penetration the magic of chiaroscuro and the material substance that immortalizes human drama."[36]

Clearly, at this juncture of his life and career, when he had been elected as an honorary member of many famous international art societies, membership of STISA meant little to Brangwyn but his name still had sufficient cachet for his involvement in STISA exhibitions to be of great value and, as always, the ability to study his technique at first hand will not have been missed by his fellow members. In 1941, he was knighted but, fearing an invasion, he had already moved the contents of his studios from his home at Ditchling, Sussex to Chipping Campden, Gloucestershire and it is unlikely that new work was made available to STISA thereafter. A major retrospective organised at Worthing Art Gallery as part of the Festival of Britain celebrations in 1951 led to a further series of exhibitions in the years immediately preceding his death.

10. ***The Fishermen's Quarters, Venice*** oil on canvas (60cm x 97cm)

(Harris Museum and Art Gallery, Preston) (Plate 74)

The 1939 Autumn Exhibition had no less than three full page reviews in the *St Ives Times*, with one article concentrating solely on the work of the Royal Academicians within the Society - *Cornish Farm* by Forbes, *Cattle in Pasture* and *Spring Landscape* by Brown, *Crystal and Flowers* by Laura Knight, a New Zealand scene by Birch, *Shipbuilders* by Spencer, *From the Miramar* by Dod Procter and *Entrance to the Bosphorus* and this painting by Brangwyn. The critic concluded that this group of work on its own would form a distinguished art collection. He was particularly taken by the Brangwyns and his comments on this work were as follows:-

"The canvas tells the story well. These richly coloured palaces, where, in the historic days of Venetian prosperity, the grandees held sway, are now the homes of humble fishermen. Their craft are moored at the very doors of the decayed glories of the past. What a feeling for form there is in the brushwork of this lovely picture. How beautiful is the central lighting, and how harmonious the whole".[37]

[36] From *Le Soir*, quoted in R.Brangwyn, *Brangwyn*, London, 1978 at p.301.
[37] *St Ives Times*, 10/11/1939.

11. ***Mill Wheel, Montreuil*** etching (35cm x 32.5cm)
(Doncaster Museum and Art Gallery) (Fig. 2B-7)
Montreuil was a favourite venue for Brangwyn and his wife and he produced a series of etchings of the Mills there. This one (Gaunt 35) featuring the old mill wheel and millpond dates from 1904 and is particularly attractive. An etching of these mills was one of six by Brangwyn included in STISA's 1940 Spring Collection. *A Turkish Cemetery* (Gaunt 31), another etching from 1904 which was also exhibited with the Society, is in the collection of the St Ives Arts Club.

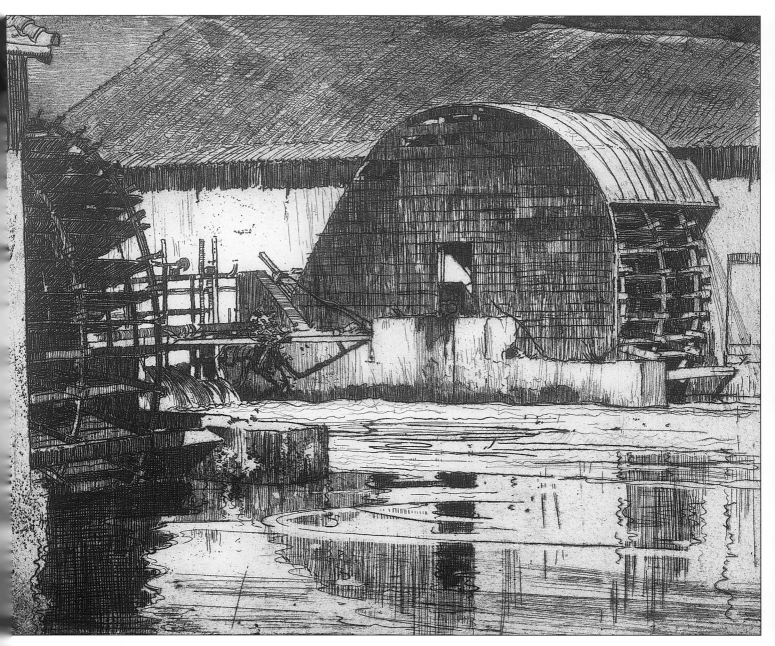

Fig. 2B-7 Frank Brangwyn *Mill Wheel, Montreuil* (Doncaster Museum and Art Gallery, Doncaster MBC)

John Mallard Bromley RBC (1858-1939) Exh. RA 17
STISA: c.1929-1939
STISA Touring Shows: 1932, 1934, 1936.
Public Collections include St Ives.

Bromley came from an artistic family. His great-grandfather, William Bromley ARA, had engraved the Elgin Marbles for the Government, his grandfather, John Bromley, was an engraver and his father, William, was an RBA, whilst his brother, Val, was also a distinguished painter. He studied initially under his father and then in Paris under Leon Bonnat. In 1879, he won the medal for watercolour painting at Sydney and, in 1881, was first hung at the RA. He showed at the first exhibition of the Institute of Watercolour Painters and received another medal at the International Exhibition in 1884. He moved to St Ives in 1897, joined the Arts Club, where he often served on the Committee, and, having acquired and demolished certain dilapidated cottages in Quay Street, he built Quay House, which was to afford him, for the rest of his life, an ideal position from which to paint pictures of the harbour and the bay. He worked in oils and watercolour, exhibiting 87 times at the RBA, but it is as a watercolourist that he is best known. In these, he employed little drawing and used touches of colour for background impressions. His colour sense was perhaps not as vibrant as some of his contemporaries, with sombre browns sometimes too prevalent. A significant work of boats in St Ives harbour dating from 1900 hangs in St Ives Library. During the war, he was a Sergeant in the Artists' Rifles, becoming a crack marksman.

Bromley was included in the 1925 Cheltenham show but was not a founder member of STISA and is not mentioned in reviews of STISA exhibitions until 1929. Thereafter, he contributed fresh landscapes and marine subjects regularly to exhibitions, but his works were not as distinguished as those of his prime and are rarely singled out for special comment. His widow, also a member, died in 1940.

12. ***The Island from Porthmeor Beach*** watercolour (49.5cm x 73.7cm)
(Private Collection) (Plate 38)
This is possibly the watercolour of Porthmeor Beach, with the Island in the background, which was exhibited in the Spring Exhibition 1930, described as a pleasing effect of golden sand with the Island idealised in the background.

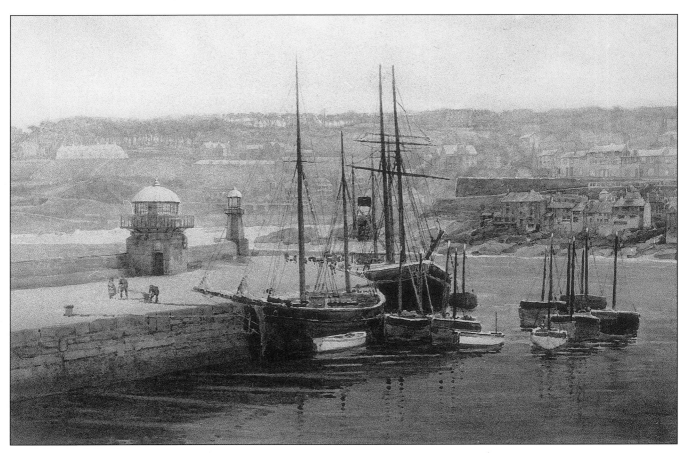

Fig. 2B-8 J.M.Bromley *Smeaton's Pier, St Ives* (W.H.Lane & Son)

38. John Bromley *The Island from Porthmeor*
(W.H.Lane & Son)

39. Lamorna Birch *Old Quarry, St Just in Penwith*
(W.H.Lane & Son)

40. Frank Heath *Porthminster Beach, St Ives*
(Private Collection)

41. Algernon Talmage *November Morning* (Private Collection)

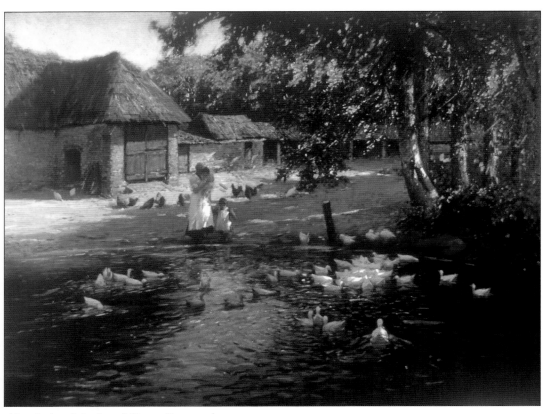

42. Arthur Meade *A Dorset Farmyard*
(Mackelvie Trust Collection, Auckland Art Gallery Toi o Tamaki)

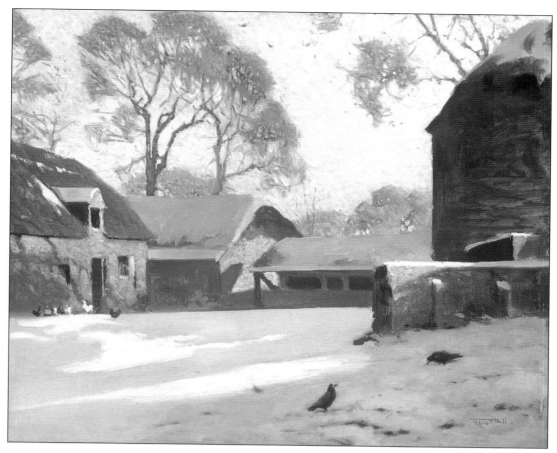

43. Fred Hall *One Winter's Morn* (Williamson Art Gallery and Museum, Birkenhead)

44. W.Elmer Schofield *Godolphin Ponds in Winter* (Mary Schofield)

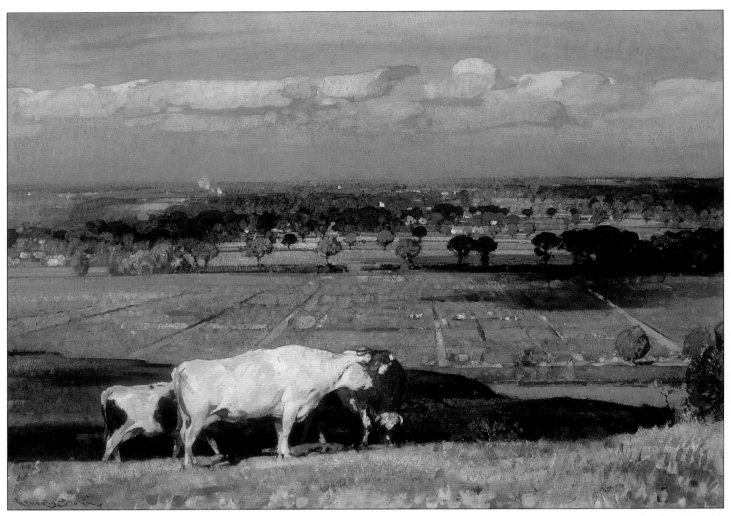

45. J.Arnesby Brown *Summer Pastures - The Marshes near Norwich* (Richard Green)

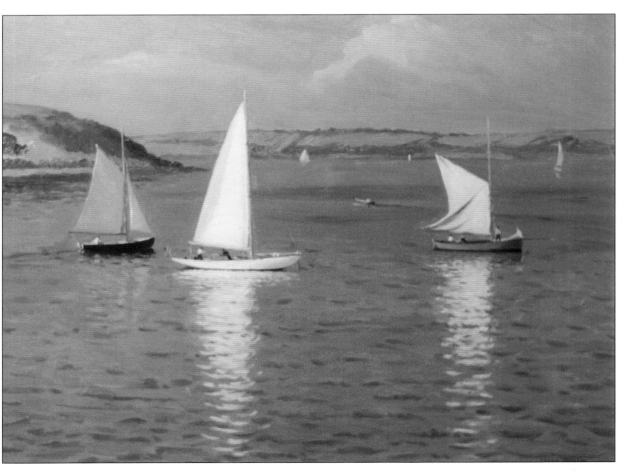

46. Frank Jameson *August* (Private Collection)

Sir John Alfred Arnesby Brown RA RBA RWA (1866-1955) Knighted 1938 Exh. RA 141
STISA: 1928-1947
STISA Touring Shows: 1932, 1934, 1936, 1945, 1947 (SA).
Public Collections include QMDH, RA, Tate Gallery, Bristol, Falmouth, Harrogate, Huddersfield, Hull, Liverpool, Newcastle, Norwich, Nottingham, Port Sunlight, Preston, Southport, York (National Railway Museum) and, abroad, Adelaide, Brisbane, Mildura, Sydney, Auckland, Christchurch, Dunedin, Timaru, Wanganui, Wellington and Cape Town.

Arnesby Brown was one of the four Royal Academicians that were invited to become the first honorary members of STISA in 1928 and whose contributions did so much to arouse interest in the Society in its early years. Brown, despite his advanced age, remained involved for twenty years. Born in Nottingham, his father was a wine merchant, with an interest in art. Brown studied at the Nottingham School of Art and under the Nottingham landscape painter, Andrew McCallum, but derived most benefit from his time at the Herkomer School, Bushey between 1889 and 1892. He first exhibited at the RA in 1891, one of his three successes being *St Ives, Cornwall*. The following year, he exhibited a portrait of Mia Edwards, a fellow student at Bushey who became known for her child portraits, and, for nearly twenty years, they divided their time between East Anglia and St Ives, tending to spend the winters in St Ives. They married in 1896. Brown, along with Olsson, Talmage, Noble Barlow, Lindner, Milner and Meade, brought St Ives landscape and marine painting to national prominence at the turn of the century and he was the first to gain official recognition. In 1901 and 1910, his paintings *Morning* and *Silver Morning*, both featuring his favourite subject, cows, were purchased by the Chantrey Trustees and he was made an ARA in 1902 and a full RA in 1915. His visits to St Ives were sufficiently lengthy to warrant him being elected President of the St Ives Arts Club in 1904 but, in 1910, his direct connection with St Ives ceased when he bought a home in Chelsea, where they spent the winters until Mia died in 1931.

Brown is best known as a landscape artist, influenced by the Barbizon School and the Impressionists. Believing in simplicity and directness in art, Brown had the largeness of vision and breadth of understanding about nature's moods to capture the essence of his landscape subject. Unnecessary detail he omitted. Most works were started in the open air but his initial impression and the effect he was working for would remain with him for some time, enabling him to finish them off in his studio. Whilst aware of the need for decorative balance, his paintings still remained direct inspirations from nature. Charles Marriott, the art critic of *The Times*, who, as a fledgling novelist, had known Brown from his time in St Ives at the beginning of the century, passed comment on Brown's paintings in his book *Masterpieces of Modern Art*:-

"Indeed the most remarkable thing about them is the inclusive character of the brushwork, as if to get the maximum suggestion of form, colour and tone with a single statement of the brush and without departing from a naturalistic rendering of the scene. They mark the convenient limits of breadth in painting without some definite reduction of Nature to a formal or decorative design."

In the special *Studio* publication devoted to his work in 1921, A.L.Baldry highlights one special talent which he considered placed him far above his contemporaries - his ability to depict skies:-

"Not only has he a most intimate knowledge of varieties of cloud form and of what may be called sky construction, but he has also an eminently correct judgment of the part which the sky should display in a landscape composition. His skies are not mere backgrounds: they are always of vital importance in his general scheme and they have a dramatic quality which is immensely valuable on account of the assistance it gives to the story his picture has to tell. They fix the moment and season of the subject, they define the atmospheric episode which he has felt inspired to record, they provide in many cases the main motive for the whole design, and almost without exception they are peculiarly right in relation to the more concrete details of the landscape itself."[38]

Moffat Lindner was so impressed by the sky in one of Brown's exhibits at the 1929 Summer Exhibition that he told all artists present to study it. Brown was not a prolific contributor to STISA's shows but his exhibits included detailed studies for his RA works *The End of the Village* (1929), *The Lane* (1931) and *The Beach* (1932). In the 1930 Spring Exhibition, his *Autumn Morning*, a typical picture of cows in a meadow, was considered masterly in composition and brushwork and in the blending and contrasting of colours, and was sold within an hour of the opening. In the 1931 Winter Exhibition, it was again the "beautifully transparent and airy" sky in *The North Wind* that was the finest feature but "every brushmark meant something".[39] At the Barbizon House show in London in 1933, his "exquisitely tender green and silver landscape", *The Valley*, dominated the collection in both size and quality and, in the 1933 Summer show, his exhibit *The Coming Harvest* was hailed as "the hallmark of consistent greatness in knowledge, handling and reality of expression."

[38] *The Studio, Modern Painting III : The Work of Arnesby Brown*, 1921 p.4.
[39] *St Ives Times*, 4/12/1931.

Fig. 2B-9 Arnesby Brown *Fellside Village* (Mandells Gallery, Norwich)
This sketch was included in the 1945 Tour

In 1934, Brown's work was chosen to represent Britain at the Venice Biennale and, in 1935, a major retrospective of his work was held in Norwich Castle Museum. In 1938, he was knighted for his services to painting. Although his last RA exhibit was in 1942, he continued to exhibit with STISA until 1947, when he was 81 and becoming increasingly blind. In his obituary in the *Times*, he was described as "a big, slow-moving man, suggesting a country squire, exceedingly quiet in manner and scant of speech, though he was a good companion and well-liked."[40]

13. ***Summer Pastures - The Marshes near Norwich*** oil on canvas (80.5cm x 110cm)
(Richard Green) (Plate 45)
Like many STISA members, Brown's work was in keen demand in the 1920s and the 1930s from Art Galleries in the Dominions. His pictures of cows, so redolent of the timeless quality of the English landscape, were particularly appealing in the aftermath of the Great War and this painting was selected by Julius Olsson on behalf of the Art Gallery of New South Wales, Sydney. In a move which they may later regret, a number of these Art Galleries have taken to selling off works of this period from their collections. In this exceptional work, the brightly lit flanks of the white cow stand out sharply against the cloud shadow, which marks the limits of the foreground. The powerful, uneven contours of its back contrast with the grid like pattern of the marshes and the horizontal lines of trees and clouds. The setting for the painting is clearly similar to that of *In June* (Lady Lever Art Gallery), which Charles Simpson praised highly in his book *Animal and Bird Painting*. Writing in 1939, Simpson considered that, in the previous three centuries, there had scarcely been a dozen great painters of cattle and Arnesby Brown was one of the few English artists that he included in this select group.

(Miss) Marjorie [Midge] Frances Bruford (1902-1958) Exh. RA 32
STISA 1938-1958
STISA Touring Shows: 1947 (W). Also FoB 1951.
Public Collections include Penzance.

Midge Bruford was born in Eastbourne and was educated at Badminton School, Bristol. She observed in 1939, "I have all my life intended to be a painter, and my father was sympathetic and encouraged me."[41] A shared interest in art ensured she became friends with Mornie Birch, daughter of Lamorna Birch, who was also at Badminton. This friendship first brought her to Cornwall and she studied at the Forbes School in 1927, with supplementary informal tuition from Birch himself. She also studied at the School run by Harold Harvey and Ernest Procter and exhibited alongside Harvey on several occasions. She also had a period in Paris. She was well-liked by the Newlyn artists and modelled for Dod Procter (see Plate 14). She also was a keen horsewoman and, for a period, hunting and riding made large demands on her time, particularly when she was engaged to another keen artist

[40] *The Times*, November 1955.
[41] *News Chronicle*, 1939, Cornish Artists 23.

rider, 'Seal' Weatherby (q.v.). Unsurprisingly, they had met at Birch's house, Flagstaff Cottage, and a painting by Harold Harvey (q.v.) entitled *Midge Bruford and Fiancé* shows the two of them standing on either side of a gate on Combe Hill, Newlyn. The relationship, however, did not last. Her first success at the RA in 1924 was a picture of her sister posed against a dresser laden with Cornish 'clome' and she continued to be successful at the RA for over 30 years. She specialised in portraiture during the 1930s, including a self-portrait which was exhibited at the RA in 1938, but, in the 1940s, she turned increasingly to pastoral landscape compositions. She moved addresses in the locality regularly but was based for much of the time in Paul, near Penzance.

Probably due to her earlier involvement with Arthur Hayward's 'Cornwall Group', Midge did not join STISA until 1938 but remained a member until her death. However, she was not represented in every show and only exhibited with STISA on a regular basis from the late 1940s. The catalogue for the Cardiff show indicates that her exhibit *The Visitor* was hung at the RA in 1946 but it does not appear in the RA listings. An animal lover, it is believed that her death resulted from a bite that she received from an organ grinder's monkey to which she had given a home.

14. **'Elephant Bill'** oil on canvas (71.5cm x 91.5cm)
(Penlee House Gallery and Museum, Penzance) (Fig. 2B-10)
This was the name given to Lieutenant-Colonel J.H.Williams O.B.E., because of the book of that title that he published in 1950, recording his experiences with the elephants of Burma from the early 1920s to the end of the Second World War. His descriptions of how the elephants worked the teak forests and how the British used them for bridge building purposes in the war against the Japanese were immensely popular and the book was reprinted repeatedly during the 1950s. He also published a second book about his experiences, entitled *Bandoola*. In 1955, when opening the Summer Exhibition of STISA, 'Elephant Bill' made reference to his own painting experiences:-

"I struggled for many years to paint a picture before I ever succeeded in writing a book. My two brothers thought it was very "cissie" of me to try to paint, when I should have been playing cricket. However, I not only got a thrill from trying to put something on canvas or paper, but I learned something from it. What I learned was to use my eyes. I owe any success I may have attained in my books to having acquired, in Cornwall, in trying to paint, the art of using my eyes."[42]

After the War, Williams lived with his brother in 'Menwinnion', the home built by Frank and Jessica Heath (q.v.) in Lamorna. Ironically, given his wartime experiences, he died under an anaesthetic whilst undergoing an appendix operation. Bruford's painting was exhibited at the Royal Society of Portrait Painters in 1956.[43]

Fig. 2B-10 Midge Bruford *Elephant Bill*
(Penlee House Gallery and Museum, Penzance)

Fig. 2B-11 Midge Bruford *High Summer* (RA 1947)
(W.H.Lane & Son)

[42] *St Ives Times*, 1/7/1955.
[43] This painting may only be on display at Penzance.

Jack Coburn-Witherop ARCA (1906-1984) Exh. RA 6

STISA: 1938-1949

STISA Touring Shows: 1947 (SA), 1947 (W).

Public Collections include Birkenhead, Bradford, Contemporary Art Society of Wales, Liverpool and Salford.

Coburn-Witherop studied at the Liverpool School of Art between 1924 and 1930 and then won a scholarship to the Royal College of Art, where he studied under Sir William Rothenstein and Malcolm Osborne until 1933. He also did some restoration training under Ernest Tristram. He won a further travelling scholarship to Rome, studying there for several months. This included a course on restoration at the Vatican studio. He rented a studio in St Ives from 1936-1939 but did not join STISA until 1938, when both his etchings and his watercolours soon attracted attention for their fine feeling of line and amazing detail. His drypoint etchings *Thames - Flood-tide* and *Morning at Billingsgate Fish Market* were particularly highly-rated and these are in the collection of the Walker Art Gallery.[44] However, he began to paint in tempera and was particularly attracted by Cornish harbour subjects, which he depicted in an individual, stylised manner. During the War, he returned to Liverpool, where he worked for five years in the Air Ministry. In 1945, he started teaching part time at the Liverpool School of Art and first became involved in restoration work for the Walker Art Gallery.

His painting *Hillside Farm, Wales* was purchased from the 1947 Cardiff Exhibition by the Contemporary Art Society of Wales. By then, he was developing a thicker, looser style and, on the split in 1949, he resigned from STISA and later exhibited with the Penwith Society. By 1968, he was so much in demand as a restorer for the Walker, Lady Lever and Derby Art Galleries that he gave up painting. The extensive Walker Art Gallery collection of his work also includes *Fishing Nets, St Ives* (1939), *Polperro, Cornwall* (1949), *Cornish Harbour* (1954) and *Tin Mines, Cornwall* (1954).

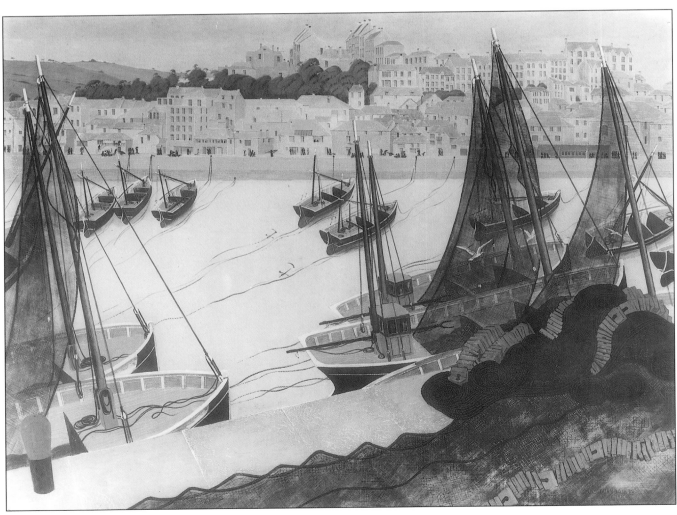

Fig. 2C-1 Jack Coburn-Witherop *Fishing Nets, St Ives*
(The Board of the Trustees of the National Museums and Galleries on Merseyside, Walker Art Gallery)

[44] *St Ives Times*, 7/10/1938.

15. *Polperro* tempera (75cm x 60cm)
(Salford Museum and Art Gallery) (Plate 84)

The use of fishing nets hanging out to dry as a foreground was used by Coburn-Witherop in his depictions of the harbours of both St Ives and Polperro. One wonders whether the inspiration for using nets as a foreground in this way was *Boats at Honfleur*, the work used as the catalogue cover for the Memorial Exhibition of fellow Liverpudlian, Mary McCrossan, held both in St Ives and in Liverpool (see Fig. 2M-5), in which she uses the sails of boats in a similar way. *Polperro* is a very individual, stylised work in cool, low tones but it exudes an ethereal light. The work was bought by Salford from the Arts Council Exhibition of the Liverpool based Sandon Studios Society in 1952.

David Cox ROI RWA (1915-1979) Exh. RA 9
STISA: 1946-1949, Secretary 1948-9
STISA Touring Shows: 1947 (SA), 1949.
Public Collections include RWA.

Cox is one of the only artists who left St Ives with few happy memories. In fact, in later life, he could not bear to talk of his experience. Nevertheless, despite his brief sojourn, Cox played an important role in the Society in the period leading up to the split.

Born in Falmouth, Cox was educated in Bude and Weymouth before going to King's College, London. Although he trained and worked as an engineer, his blood relationship with the famous early watercolourist of the same name had always given him a desire to develop his artistic inclinations, despite the objections raised by his parents. Accordingly, although not attending any art college, he "studied art by working in the company of others" and, when his travels took him abroad to such places as Paris, Italy, Greece, and Spain, he sought to learn from others how to develop his own skills.[45] When war broke out, a perforated ulcer made him unfit for active service and so his engineering expertise was utilised. While based in Taunton with his wife and newly born son (c.1942-4), he started painting seriously and, in 1944, he moved to Cubert, near Newquay.[46] He soon made himself known in St Ives for, in 1946, he exhibited on Show Day in the studio of Borlase Smart, who admired "his sensitive and luminous canvasses of figure and landscape subjects".[47] That year, he also exhibited at the first exhibition of SMA and had a show at Heal's in London with Mary Fedden. Already, at this juncture, his work had a distinctive style and his landscapes were characterised by "a certain grey misty effect that never obscures his object but gives [them] an atmosphere all his own".[48] In 1947, he was successful at the RA for the first time with *The Fal at Lamorran*.

By the time of Smart's death in 1947, Cox had moved to St Ives and had impressed sufficiently to be elected Secretary of STISA in his place. He took over Smart's Porthmeor studio and shared this with Leonard Richmond, who painted Cox at work in the studio.[49] Bernard Fleetwood-Walker also seems to have had the use of the studio on his visits to St Ives - both artists did portraits of each other (see Figs. 2F-1& 2) - and his later, more impressionistic style can be detected in Cox's approach to his subjects and in his brushwork. Cox was at this juncture developing his depiction of young girls, semi-nude, seeking to capture essentials of light and atmosphere rather than concentrating unduly on form. Young skin, he considered, reflected light better than old as well as having a more brilliant pigmentation.[50] Richmond referred to the "dreamy, artistic atmosphere" of his portraits and that they were always painted "with a fine sense of tone".[51] Despite his other commitments, Cox worked hard at his painting, starting at 10 a.m. and happy to work by electric light until late at night. In this way, he could produce two canvases a week.[52]

As Secretary, Cox immediately set out to try to fill the role that Smart had played but a certain arrogance meant that he never commanded the same degree of respect. He took it upon himself to open and review in the local press one-man shows by some of the young modern artists, such as Peter Lanyon, Hyman Segal, Sven Berlin, Marion Hocken and Hilda Jillard, as well as exhibitions by craftsmen like Alice Moore (embroidery) and Francis Cargeeg (beaten copper). One of Smart's last ideas was a touring exhibition to other seaside resorts in Cornwall and Cox may well have been involved in the organisation of the pilot exhibition in Newquay in 1946, which attracted 1,900 visitors, and the full touring show in 1947, which took in Newquay, Fowey, Falmouth and Truro. The show in Truro had to be hung a week after Smart's death and Cox immediately assumed responsibility for this. In an interview, Cox stated that one of the aims of these shows was to encourage official patronage with a view to the

[45] G.S.Whitter, *David Cox, The Studio*, August 1952, p.46.
[46] He exhibited with the art section of the Social Club of his employers Avimo Limited and won high praise.
[47] B.Smart, *The St Ives Society of Artists, The Studio*, 1948.
[48] *The Times*, 4/1946.
[49] This work was exhibited at the 1949 Swindon show and was used for the cover of Richmond's book, *From the Sketch to the Finished Picture: Oil Painting*, London, 1953.
[50] G.S.Whitter, *David Cox, The Studio*, August 1952, p.49.
[51] In his review of the 1951 RA exhibition in *The Artist*, Vol.51.
[52] *News Review*, London, 11/3/1948.

Fig. 2C-2 David Cox painting a nude in 5, Porthmeor Studios

establishment of further public Art Galleries in the County.[53] He also arranged a further exhibition in Swindon in January 1949. Like Smart had done in 1946, he went up to Swindon to perform the opening ceremony. He was instrumental in founding the Borlase Smart Memorial Fund and he organised the fundraising which led to the purchase, with the aid of an Arts Council grant, of the Porthmeor studios from Moffat Lindner. However, his attempt to alter the constitution of the Society, to introduce a ruling council with a five year mandate and to deny a member the right to be hung at each exhibition led directly to the split. To what extent Cox was acting on orders from the moderns is not known but his handling of the situation, whereby the new constitution was rushed through without the opportunity for detailed discussion, infuriated the traditionalists and Bradshaw complained at the extraordinary general meeting that Cox had been doing too much on his own and that Fuller, the Chairman, should have kept a tighter rein on the affairs of the Society. As the meeting became ever more heated, Sven Berlin describes his friend Cox as standing "in the light looking just like the ghost of Robert Louis Stevenson, with his trailing moustaches and white face, his fingertips touching the table, unable to make himself heard."[54] According to Berlin, as part of the pre-ordained plan to split the Society, calls for his resignation were promoted by Barbara Hepworth. Cox duly resigned from STISA and widely publicised his reasons, implying that, by wishing to retain the rule that membership gave the right to be hung at each exhibition, the traditionalists wanted to return to a more localised society without regard to merit. This argument was thereafter consistently put forward by the moderns to the intense annoyance of the traditionalists. Cox was duly appointed Secretary of the new Penwith Society and was elected to membership of the RWA and ROI in 1949 but he resigned from the Penwith Society and left St Ives the following year, a completely disillusioned man. He considered the new rule proposed by the Hepworth camp, namely "the regimentation and division of members into small watertight compartments of minor monopolies voting for themselves", was "in complete contradiction" to the ideals of Borlase Smart and that it was "complete nonsense" that "artists are unable to give a valuable vote on work that is of a different outlook from their own".[55]

[53] *The Guardian, Cornish Art Exhibition at Newquay,* 8/1947.

[54] S.Berlin, *The Dark Monarch,* London, 1962, p.167/8.

[55] Letter published in *St Ives Times,* 17/3/1950.

Cox moved to Wick, near Stoke-by-Nayland in Essex and, ironically, found himself a neighbour of his former President, Sir Alfred Munnings, who frequently entertained his family to dinner.[56] He took up teaching and remained in contact with Leonard Richmond, now editor of *The Artist*, for whom he wrote a series of articles in 1950. His nude figure paintings were featured in an article in *The Studio* in 1952 but, by 1958, Cox's style of painting had changed dramatically and a series of six articles in *The Artist* (Vol.56), entitled *The Creative Outlook*, feature Picasso inspired work on a much larger scale, with simplified forms, verging toward the abstract, and great expanses of bright colour.[57] In 1959, he held a one-man show in Cambridge, before moving briefly to France in 1961, where the strong sunshine revitalised his colour sense. He returned to Suffolk in 1964, had a one-man show in Ipswich in 1965 but thereafter he rarely exhibited, although he continued to paint and teach.

16. *The Green Peignoir* oil on canvas (45.5cm x 38cm)
(Royal West of England Academy, Bristol) (Fig. 1-38)
This typical example of Cox's semi-nude figure paintings, which *The Studio* called compositions concerned with "colour and tonal abstractions rather than plastic three-dimensional modelling", was acquired by the RWA in 1949, the year he was elected to membership.

(Miss) Frances Ewan Exh. RA 1
STISA: 1932-1963
STISA Touring Shows: 1932, 1934, 1936. Also FoB 1951.
Public Collections include Bushey.

Ewan was yet another St Ives artist that had been trained at Bushey. An article in the *Windsor Magazine* in 1898, describes her as one of the "rising stars" of magazine illustration. Fond of drawing from an early age, she studied at the Manchester School of Art under R.H.A.Willis and then, in 1891, she enrolled at the Herkomer Art School, Bushey. She worked for a while on the staff of an illustrated weekly newspaper before moving to London in 1896, where she was soon in demand as an illustrator for periodicals such as the *Sunday Magazine* and the *Windsor Magazine*. During the first decade of the new century, she illustrated a number of books, particularly for the publishers Blackie, Ward, Lock and Collins. Her range of subjects was extraordinarily varied and authors for whom she did several works include Eliza Pollard, who wrote about the Elizabethan and Stuart period, Ethel Turner, the Australian children's writer, and G.A.Henty.

By 1911, she appears to have moved down to St Ives, working from 6, Porthmeor Studios, although she later moved to 2, Porthmeor Studios. She became a member of the Arts Club but her art is not often mentioned. A special supplement of *Eve*, the ladies pictorial, dated 5/12/1923 contains a photo of Ewan returning to her studio by rope ladder. She may then have left St Ives for a while as she does not feature on Show Days and, when she exhibits at Lanham's in 1928, the reviewer cannot recall seeing her work before. She did attend one of the foundation meetings in 1927 but is first mentioned in STISA shows in 1930 and did not become a member until 1932. Her early exhibits tend to be aquatints and etchings, reflecting her background as an illustrator. She had four black and white works included in the 1932 tour but, in the later tours of the 1930s, she also showed watercolours and oils. She produced a number of portraits as well as coastal and harbour scenes. Her technique was described as crisp and emphatic, with the forms carefully drawn.

During the 1940s, although she continued to exhibit with STISA in shows in St Ives, she was not represented in the touring shows. Possibly due to disillusionment at being excluded, she was one of the ten signatories requisitioning the EGM in February 1949. After the split, she exhibited regularly with STISA until 1963, possibly her date of death. By this time, she is concentrating almost exclusively on flower studies.

17. *Catherine Richards, wearing a Crysede Dress* oil on canvas (90cm x 74cm)
(Bushey Museum and Art Gallery) (Fig. 2E-1)
Ewan occasionally painted portraits - in fact, her one success at the RA in 1907 is simply entitled *A Portrait*. On Show Day in 1922, her portrait of the young Beata Bennett in Japanese kimono, backed by a Japanese screen, was much admired as being an excellent likeness and full of glowing colour and the 1936 tour included a portrait of a Hungarian peasant. This portrait, which was exhibited in 1929, shows a girl, Catherine Roberts, who worked in the Crysede factory, at the Island Works in St Ives, wearing a dress made by her overseer and friend, Kitty Ninnis. Crysede, which was set up Alec Walker in 1920 in Newlyn and moved to St Ives in 1926, became well-known, particularly in the late 1920s when it was managed by Tom Heron, for its specially dyed and hand block-printed textiles in vibrant colours made to the semi-abstract designs of Walker himself and London fashion designer, George Criscuolo. The skirt of the dress is made from crepe-de-chine, gathered at the waist, and the top is of printed silk. The business provided much-needed jobs and training opportunities, particularly for young girls leaving

[56] Cox's daughter, Amanda Gawler, recalls that 'Black Night', Lady Munnings' famous pekinese, now deceased and stuffed, sat at table with them.
[57] Cox also contributed three articles on *The Elements of Drawing for The Artist*, Vol.66, in October, November and December 1963.

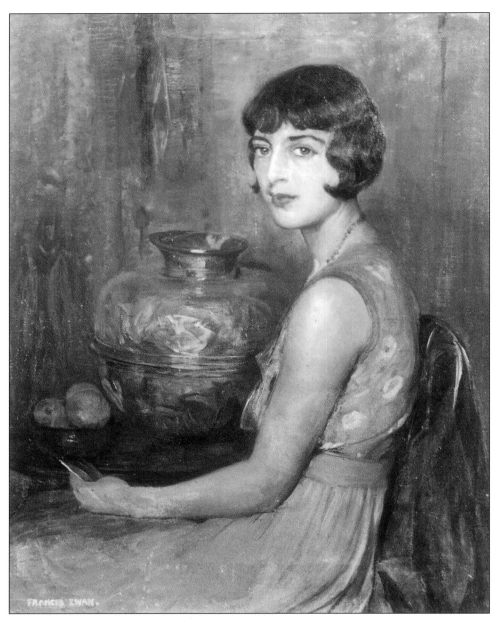

Fig. 2E-1 Frances Ewan *Catherine Richards, wearing a Crysede Dress*
(Bushey Museum and Art Gallery)

school. In 1933, Borlase Smart, aware of the forthcoming *Art in Industry* show at the RA, organised a visit by STISA members to the factory followed by a Mannequin Parade in the Society's Gallery, in which some of the gowns were considered works of art in their own right. Sadly, Walker suffered a nervous breakdown in 1929, Heron was dismissed and the firm never quite regained its vitality, going into voluntary liquidation in 1941.

Bernard Fleetwood-Walker RA RWS NEAC RP ROI (1893-1965) Exh. RA 147
STISA: 1936-1949
STISA Touring Shows: 1936, 1947 (W), 1949.
Public Collections include Royal Collection, RA, Imperial War Museum, Birmingham, Coventry, Dudley, Leeds, Liverpool, Stoke, Wolverhampton, Dublin, Vienna, Copenhagen, Stockholm and Wellington (NZ).

Fleetwood-Walker is one of the few members of STISA whose Cornish credentials are a little thin and, rather like Stanley Spencer, he may well have been asked to join whilst on a visit to St Ives, after a series of stunning nude figure paintings at the RA had marked him out as an original and special talent.

Fleetwood-Walker was a Birmingham man through and through. He was born there, was educated there and lived there for the majority of his working life. His father was William Walker, an electrical engineer who was the co-inventor of the Walker-Wilkins battery, but an artistic streak did run in the family as his great-grandfather was Cornelius Varley, the well-known early nineteenth

century watercolourist. Fleetwood-Walker was particularly proud to be a member of the RWS as Varley had been a founder member.[58] However, Fleetwood-Walker started his training in the arts as a gold- and silver-smith and developed his interest in painting through low relief and three dimensional work. He went on to study painting at the Birmingham School of Art and Crafts, followed by spells in London and in Paris under Fleury, winning bronze medals and awards for modelling, life drawing and painting. His training was, however, interrupted by the war, during which he served in France as a sniper in the Artists' Rifles, where he was wounded and gassed. He may well have met Borlase Smart at this time.

After the war, he started to teach art, first at King Edward's Grammar School, Aston and, from 1929, at the Birmingham College of Art, where he became one of its most respected and influential lecturers. He had strong views on a number of topics and hated pretentiousness and shoddiness but he was remarkably liberal in outlook and lectured perceptively on contemporary movements. Each year he would take a group of students down to Cornwall, often staying in Polperro, and it was no doubt on one of these trips that he visited St Ives and was persuaded to join STISA. It will be no coincidence that the first Exhibition to which he contributed was the Birmingham tour of 1936 and he may indeed have been involved in its organisation. For the Autumn Exhibition that year in St Ives, he sent his superlative 1934 RA exhibit, *The Maidens* and, when this was required for an Exhibition at the Walker Art Gallery, Liverpool, he substituted the equally acclaimed *The Toilet* (RA 1936). Both pictures depict two stylised female nudes sitting in a woodland clearing, attending to their hair and are very much of their period - see Fig. 2B-6, where *The Maidens* can be seen hanging behind Fuller. Commenting on his work at this time, Fleetwood-Walker observed:-

"All I thought about at first was the arranging of the parts to form a design. I did not think about what those parts were; I was not interested in anything in the painting for what it was, but merely as a collection of forms that I could arrange into a decorative and ordered design."[59]

Fleetwood-Walker was an indefatigable worker and he is best remembered as a figure and portrait painter, his child studies being particularly charming. His style did develop and, in his later work, he moved away from elaborate decoration and instead attempted to reproduce his initial mental image of the scene he was depicting. His object, in his own words, was "to see the whole subject in a flash".[60] A comparison between *The Model's Throne* (RA 1940) (cat.no.19) and his *Nude*, exhibited at the RA in 1947 (Plate 13) demonstrates his development quite clearly.

In the late 1940s, he appears to have become friendly with David Cox (q.v.), who took over as Secretary of STISA from Borlase Smart, and Cox was clearly influenced by him. On his visits to St Ives, he shared Cox's studio and both painted portraits of each other (Figs. 2F-1 & 2). In 1948, he also painted a portrait of John Park.

Fleetwood-Walker's talent was recognised by his membership of many different art societies and he won silver and bronze medals at the Paris Salon. In 1946, whilst a member of STISA, he was elected as an ARA and he featured in the *Artists of Note* series in *The Artist* in April 1947. He became a full RA in 1956 but, by this time, he had ceased to exhibit with STISA. Being of liberal outlook, he will not have sided with the traditionalists in 1949 and will have abhorred the treatment of his friend David Cox, the Secretary. He did not, however, join the Penwith Society and, after his retirement from the Birmingham School of Art, he moved in 1951 to Chelsea so that he could continue teaching at the RA Schools, where he was Assistant Keeper. Despite having achieved Academy honours, he is yet another artist that has been sadly neglected.

18. *Mollie and Stella*

oil on canvas (127cm x 101.5cm)
(Private Collection, courtesy Belgrave Gallery)
(Plate 12)

This large painting was exhibited at the RA in 1938 and at STISA's 1939 Summer Exhibition, when it took centre stage and was praised for its masterly composition and drawing and for being beautifully painted in "soft restrained greens and rose".[61] Two girls are shown posed by a wheelbarrow but their clothes and the astonishing hair style and colour of the right hand figure indicate that they are unlikely to have been gardening. Fleetwood-Walker has designed the composition and chosen the colour scheme to produce a decorative arrangement. Fleetwood-Walker aficionados rate this as one of his finest works.

[58] Under Varley's Will, Fleetwood-Walker, as the first family member to become an RWS, became entitled to his studio and studio collection, which had been left untouched since his death. Many of the works so inherited were given to the V & A.
[59] Quoted by R.Seddon in the Catalogue to the Royal Birmingham Society of Artists B.Fleetwood-Walker Memorial Exhibition.
[60] ibid.
[61] *St Ives Times*, 21/7/1939.

Fig. 2F-1 Bernard Fleetwood-Walker *David Cox*
(Private Collection)
This painting was exhibited in the 1949 Swindon Exhibition.

Fig. 2F-2 David Cox *Bernard Fleetwood-Walker*
(Private Collection)

19. *The Model's Throne* oil on canvas (94cm x 74cm)
(Private Collection) (Plate 60)
This painting was exhibited at the RA in 1940 and is an excellent example of the type of decorative nude Fleetwood-Walker was painting in the 1930s. *The Model's Throne* was included in the 1999 touring exhibition *The Artist's Model - From Etty to Spencer*. In the catalogue, Martin Postle and William Vaughan ponder the meaning of the title and draw attention to the book, *Thais*, lying on the floor. Thais was an Athenian courtesan, who travelled with the army of Alexander the Great during the invasion of Persia, and is chiefly remembered for persuading Alexander to set fire to Persepolis. However, *Thais* was also the title of a book by Anatole France, first published in 1890 but reprinted many times, including in 1939. The heroin of the book was a saint, Thais, who was a reformed prostitute and Postle/Vaughan consider this scene might represent the moment when Thais reflects on her beauty before her salvation. My own interpretation is rather different.

The canvas leaning against the chair signifies that the room is an artist's studio and that the girl is a model. The scene depicted, however, does not appear to be a formal pose set up by the artist. This would surely have involved the model reclining on the chair, draped partially by the sheet. What the artist has instead depicted is a break in the proceedings, with the girl tidying her hair. The throne of the title is surely not the chair. Instead, the girl is kneeling before the throne and Thais on the book reveals the nature of that throne - a fire! What could be worshipped more in an artist's studio by a nude model than a source of heat! The skin of her thighs, in particular, glows in the firelight.

Stanhope Alexander Forbes RA (1857-1947) Exh. RA 247
STISA: 1928-1947
STISA Touring Shows: 1932, 1934, 1936, 1937, 1947 (SA), 1947 (W).
Public Collections include Tate Gallery, Imperial War Museum, QMDH, Birmingham, Blackpool, Bradford, Bristol, Hartlepool, Hull, Ipswich, Liverpool, Science Museum, Manchester, Newlyn, Newport, Norwich, Oldham, Penzance, Plymouth, Preston, Sheffield, Truro, Worcester, National Railway Museum, York and, abroad, Auckland, Brisbane, Geelong, Perth and Sydney.

When the Committee decided in 1928 that the standing of STISA would be enhanced by offering honorary membership to distinguished artists with connections with West Cornwall, Forbes was top of the list. Born in Dublin, Forbes had arrived in Newlyn in 1884, fired with enthusiasm for plein air painting after his experiences in the ateliers of Paris and in the art colonies of Brittany. From the time that his painting *A Fish Sale on a Cornish Beach* announced in 1885 the arrival of a new talent and a new French influenced style of figure painting, he had been recognised as the leader and figurehead of what became known as the Newlyn School. Whereas by the turn of the century the initial impetus had dissipated and many fellow Newlyners had departed for pastures new or changed their style, Forbes remained based in Newlyn and continued to paint local scenes largely unaffected by modern art movements. By the time STISA was formed, his canvases were smaller, due to the requirements of the modern home, and his compositions concentrated more on topographical details than on the figures that had so dominated his early work. These works, by comparison with his early output, have been rather overlooked but they provide fascinating glimpses of village and country life at this time and are now important documents of social and architectural historical record. In the aftermath of the horrors of the Great War, these depictions of the timeless nature of the countryside and country pursuits were of considerable appeal. He also depicted a number of street scenes in Penzance, Helston and other local towns (see Plate 22). In keeping with modern trends, these works are more colourful than his nineteenth century output and the brushwork looser.

Not only did Forbes accept honorary membership but he contributed good quality works to STISA's exhibitions, including a number of RA exhibits, such as *Florist and Fruiterer* (1923), *The Courtyard, Pendeen Manor* (1927), *Roseworthy, Cornwall* (1930), *Sir Walter Raleigh's House, Mitchell* (1933), *Evening on the Highway* (1939), *The Pigeon Loft* (1940) and *Causewayhead, Penzance 1943* (1944). For the Summer Exhibition in 1929, he sent *The Terminus, Penzance*, the original of a work made into a railway poster (Plate 21). It was the inclusion of such works by Forbes and other distinguished artists that immediately raised standards and attracted the attention of the Press. By 1931, Forbes himself had benefited sufficiently from SISA's activities to insist on paying a membership fee and, in March that year, he had a one-man show at Lanham's Galleries.

The influence of Forbes upon STISA was also evident in the number of students from his School of Painting who settled in the area and became valued contributors to STISA exhibitions. In fact, romance seems to have blossomed within the confines of the School for not only was Forbes' second wife, Maud Palmer, originally a student but also four couples - Frank and Jessica Heath, Dod and Ernest Procter, Robert and Eleanor Hughes and Geoffrey and Jill Garnier - all first met at the School. Claude Barry, Arthur Hayward, Midge Bruford, Stanley Gardiner and Frank Jameson were also former students who became prominent members of STISA. Speaking of his teaching aims, Forbes commented that he had no wish to force his own methods on to his pupils but he wanted them to grasp the broad principles which must underlie every work of art. "Students are taught to group their subject as a whole in its big lines and masses: I teach them to *see*."[62]

For someone used to teaching students, it was somewhat surprising that "the Professor", as Forbes was known, should have refused to speak on art to the members of STISA due to "nerves". However, he did actively support the Society and, in his opening address at the 1939 Summer Exhibition, he mentioned his admiration of Borlase Smart:-

Fig 2F-3 Stanhope Forbes, with *The Courtyard, Pendeen Manor* (RA 1927). This was exhibited in STISA Winter Exhibition 1931 - "the whole picture is painted with the startling realism characteristic of Mr Forbes' magic brush, every stroke of which is typical of Cornwall"[63]

[62] *The Artist*, October 1933, p.59.
[63] *St Ives Times*, 4/12/1931.

"He is one of those who has time not only to produce some very fine work himself, but also to help other artists. I have every reason to be grateful to him for what he has done for me and the help he has given me in my work."[64]

Forbes' presence in exhibitions of STISA for nearly twenty years was of immense importance to its standing.

20. ***The Pond*** oil on canvas (50cm x 63cm)
(Newport Museum and Art Gallery) (Plate 48)
Forbes captures a truly delightful scene as a family visit a woodland pool by the edge of a road. One child is about to launch another stone into the pond to add to the ripples emanating out from the first missile thrown. The mother has brought two buckets to fill with water, and the reflection of her clothing in the surface of the pool provides an important colour note. Father arrives on horseback to give his mount a drink, while the family dog watches proceedings with interest. Although the scene is set largely in the shade, it is the manner in which the sunlight breaks through the trees and reflects off the surface of the pond that is the work's principal focus and this is handled masterfully. During the 1930s, representatives of Newport Art Gallery used to visit each RA exhibition with a view to acquiring modern works to add to its permanent collection. This work was, accordingly, purchased straight from the walls of the Academy in 1930. Another work by Forbes, *Still Waters*, was purchased by Newport in similar fashion in 1934.

21. ***The Violinist, Walter Barnes*** oil on canvas (92cm x 71.5cm)
(Penzance Orchestral Society - on loan to Penlee House Gallery and Museum, Penzance)
Forbes had always been in demand as a portrait painter and many of his portraits were hung at the RA. Some of his earlier portraits - namely *R.G.Rows* (of Helston) (RA 1907) and *Madame Gilardoni* (RA 1907) - were included in STISA shows but this portrait was included in the 1933 STISA Winter Exhibition before being hung at the RA the following year. It was not a commissioned portrait for Barnes was a good friend of the artist. Forbes had always been a keen musician and Barnes had founded the Penzance Orchestral Society in 1906 and was its conductor until 1941.

Barnes (1884-1942) left school at the age of 14 and was for many years employed in a solicitor's office but, in the early 1920s, he gave up his career to concentrate on his first love, music. Though largely self-taught, he was an outstanding musician, being particularly accomplished as a violinist, and had a great influence on the musical life of Cornwall. In addition to his work with the Penzance Orchestral Society, he was leader of the Cornwall Symphony Orchestra and also travelled throughout Cornwall playing for many societies. When soirées were held at Newlyn Art Gallery, for instance, it was always Barnes to whom the artists turned to produce musicians. He also devoted much time to teaching and encouraging young musicians.

When it was hung at the STISA Exhibition, the *St Ives Times* commented, "As a subject, it is superb in painting and character and there is as much character, or portraiture, in the hands as in the finely modelled head. As to the foreshortening of the violin, well, if any artist or student has attempted to draw such an instrument, let alone paint it, they will know and appreciate the mastery of Mr. Forbes in this one part alone."[65]

The painting was purchased by public subscription and was presented to the Penzance Orchestral Society in 1937.

Sir Terry Frost (b.1915)
STISA: Exh. 1947-1948
STISA Touring Shows: 1947 (W).
Public Collections include Tate Gallery, Government Art Collection, British Council, Bristol, Hull, Leamington, Manchester Education Authority, Edinburgh, Sheffield (Graves), Stromness and Vancouver.

Currently enjoying a dramatic resurgence of interest in his art, Frost has become one of the most lauded artists of the St Ives moderns. However, his involvement with STISA was brief. Born in Leamington Spa, he left school at 14 and, being a member of the Territorial Army, was immediately accepted into the forces in 1939. In 1941, he was captured in Crete and spent the rest of the War as a prisoner but, during this time, he met Adrian Heath, who encouraged him to paint. After the War, Frost married and returned to his job in Birmingham, but went to art classes in the evenings. In May 1946, on the advice of Adrian Heath, he came to Cornwall and studied first in Mousehole under George Lambourne and Edwin John and then under Leonard Fuller in St Ives. Frost, who was often hard up at that time, recalls the generosity and camaraderie of the immediate post-war years. Fuller let him study at half price and John Park and Sven Berlin would buy him a half of bitter in The Sloop and then slip a half crown and a packet of Woodbines into his jacket. Lanyon took him out exploring and sketching the landscape.[66] Berlin recalled, "His

[64] *St Ives Times*, 14/7/1939.
[65] *St Ives Times*, 24/11/1933.
[66] See David Lewis, *Terry Frost*, Aldershot, 1994.

enthusiasm was unbounded, painting like Vuillard in crimsons, yellows, veridians, blues beyond the power of the tube and I was early to realise that he was more in love with colour itself than the image".[67] At this juncture, though, Frost was producing representational paintings and he was represented in the Cardiff show by *The Chair* (Plate 20) and *Homage to Cezanne* and, in the 1948 Summer Exhibition, by a palette knife executed self-portrait. He also had an exhibition, *Paintings with Knife and Brush*, at Downing's Bookshop in late July 1947.

Frost sought further training at the Camberwell Art School, which put him off realist painting and, with the encouragement of Victor Pasmore, whom he termed "my God", he turned more towards abstract work. He was not involved with the split and wondered on his return to St Ives whether his work would be acceptable to the Penwith. However, 1950 saw the production of his seminal work, *Walk Along the Quay*. He took 4, Porthmeor Studios, next to Ben Nicholson, who gave him many helpful tips, and a period as an assistant to Barbara Hepworth in 1951 was also formative and led to his use of shapes in collages. In 1952, he had his first one-man show at the Leicester Galleries, London - others were to follow in 1956 and 1958 - and, in the 1950s and 1960s his work was included in many prestigious international exhibitions devoted to abstract art. In the early 1950s, he taught at the Bath Academy before becoming Gregory Fellow at Leeds University between 1954-7. He moved between Leeds and Cornwall in the period 1957-1963 before settling in Banbury in 1964 to teach and be closer to London. He returned to Cornwall in 1974. For a period, his work went out of fashion, but a recent knighthood and seemingly continuous exhibitions of his paintings, collages and prints around the country confirm his spectacular return to prominence.

Fig. 2F-5 Terry Frost (Gilbert Adams)

Fig. 2F-4 Leonard Fuller *My Friend, Frost* (W.H.Lane & Son)
This portrait of Terry Frost was exhibited on Show Day 1947.

[67] S.Berlin, *The Coat of Many Colours*, Bristol, 1994 at p.134.

22. ***Interior - 12, Quay Street, St Ives*** oil on canvas (41cm x 51cm)
(Private Collection, courtesy Belgrave Gallery) (Plate19)
This painting dates from 1947. Frost and his wife initially lived in a caravan when they came to St Ives but eventually rented a room in 12 Quay Street from Pippa Renwick, whom Frost had met at Fuller's School. One of Frost's early still lifes was *Teapot and Vim Tin*. This prompted Leonard Richmond to snort, "You'll never get anywhere with a cracked teapot and a tin of Vim. What people want are a polished table and a bowl of fruit".[68] Frost duly obliged in this work but, interestingly, also features his painting *The Chair* (Plate 20), one of his exhibits at the 1947 Cardiff Exhibition, hanging on the wall. In relation to *The Chair*, Frost has commented, "I did this painting by the light of an electric light bulb between midnight and three in the morning. Matisse would have been pleased with that bit of chair".

Leonard Fuller ROI RCA (1891-1973)
STISA: 1938-1949 and 1952-1973, Chairman 1946-1949
STISA Touring Shows: 1945, 1947 (SA), 1949.
Public Collections include Newport, Penzance, St Paul's Cathedral, Cornwall Educational Committee and St Ives.

Fuller is an important figure in the history of the St Ives art colony and played a crucial role in STISA during and after the Second World War. Born in Dulwich, he was educated at Dulwich College and trained at the RA Schools between 1912 and 1914 where he was a silver and bronze medallist. In 1913, he won the British Institute Scholarship in painting. The Great War, however, interrupted his studies and, in 1915, he enlisted as a private in the Royal Fusiliers before gaining a commission in the Machine Gun Corps (1915-8). It was during this time that he became friendly with Borlase Smart. After the War, Fuller married Marjorie Mostyn, the daughter of the artist Tom Mostyn, whom he had met at art school, and it was his father-in-law that persuaded him to take up painting seriously. He accordingly returned to the RA Schools between 1919 and 1921, where he benefited from the teaching of Sargent, Clausen and Orpen. He later indicated that he owed a great deal to the combined gaiety and serious study of his fellow students, a "brilliant group", who included Ivon Hitchens, Gerald Brockhurst, Gilbert Ledward and Randle Jackson.[69] At the same time, he also studied at the Clapham School of Art under L.C.Nightingale, who had been his Art Master at Dulwich. His first exhibit at the RA in 1919 was a portrait of his wife, who was always known as Nancy, and, the following year, he was successful with a portrait of her father. His young son also proved a useful model and he came to consider his painting *My Son John* (RA 1923, Paris 1927) one of the best works he ever painted.

Fuller could not afford to live only from sales of his work and so he took up teaching. He became assistant professor of art at St John's Wood Art Schools (1922-32) and also taught at his old school, Dulwich College (1927-37). During this time, he became increasingly well-known as a portraitist and his sitters included the ladies' golf champion, Diana Fishwick, and the cricketer, Jack Hobbs. In 1927, he was a silver medallist at the Paris Salon and, in 1932, he won a Mention Honorable for *Autumn Sunshine*, a work bought from the 1933 RA exhibition by Newport Art Gallery. He became a ROI in 1932 and a RCA in 1939.

Borlase Smart had been hankering after the establishment of a permanent art school in St Ives for many years and, eventually, in 1938, he persuaded Fuller to try his luck in St Ives. The St Ives School of Painting established by Leonard and 'Nancy' soon won itself a fine reputation, with the War boosting numbers as young female artists sought to study away from the horrors of London. As a teacher, Fuller always insisted that a student must first master the accepted rudiments of drawing. After that, the aspiring painter could express his individuality as he pleased. Fuller confessed, "I hardly know which gives me most pleasure - painting or teaching. I enjoy having the students around me - and I find I can learn quite a lot from them".[70] Students who were or became members of STISA include Isobel Heath, Misomé Peile, Marion Grace Hocken, Peter Lanyon, Terry Frost, George Pennington, Hilda Freeman, Gai Layor, Eileen Izard, Douglas Woollcombe, Mary Millar Watt, Wharton Lang, Denise Williams and Laura Staniland Roberts.[71]

On joining STISA, Fuller exhibited a number of his earlier successes at the RA but his teaching did not stop him producing quality new work and he was very successful at the RA in the early 1940s, with works like *Homage to Vermeer*, *The Silver Ship : Laity's of St Ives* and *Junk* (Fig. 2F-7) but it was a depiction of the local Woolworths, *Threepence and Sixpence*, that won the highest plaudits at STISA's shows. He also received a string of commissions to paint local dignitaries. Speaking to *The Artist* in 1950, Fuller commented, "The technical accomplishments of Art should be like the spokes of a wheel in rapid motion: we know that they are there, but we are not too much aware of their presence."[72]

[68] David Lewis, *Terry Frost*, Aldershot, 1994 at p.34-6.
[69] G.M.Place, *Artists of Note - Leonard Fuller, The Artist*, July 1950.
[70] *News Chronicle*, 1939, Cornish Artists 20.
[71] Names taken from a list included in an article celebrating the School's 21st Anniversary - *St Ives Times*, 13/3/1959.
[72] G.M.Place, ibid at p.110.

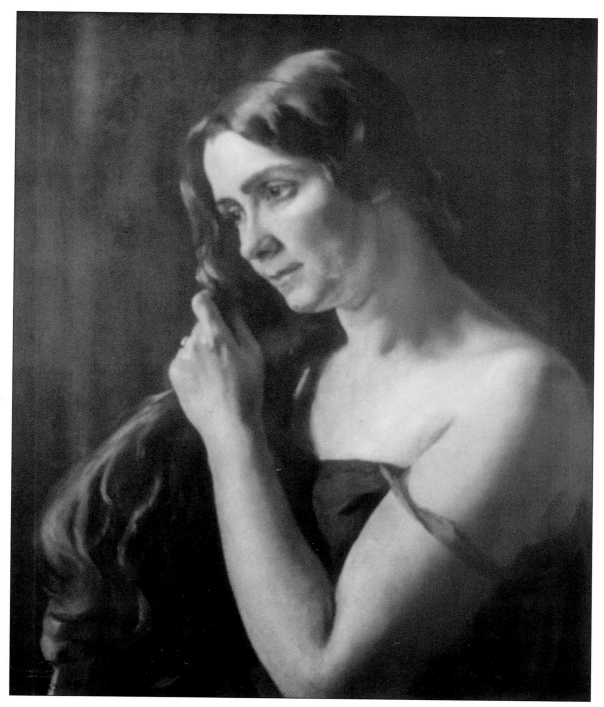

Fig. 2F-6 Leonard Fuller *Woman with Long Hair* (St Ives Town Council)
A portrait of his wife, Marjorie Mostyn, which was added to the 1937 Autumn Exhibition in February 1938.

During the War, the absence of Bradshaw on active service and Smart's prolonged indisposition during 1941 and 1942, first through war duties and then through illness, left Fuller with much of the organisation of STISA's activities and he emerged from the war period as Smart's right-hand man, having been elected Chairman in 1943. He overcame his initial concerns about the involvement of the moderns and, by Smart's death, shared his vision. However, he was unable to stop the bitter disagreements between the moderns and the traditionalists from boiling over and he resigned from STISA at the time of the split. Although elected the first Chairman of the Penwith Society, his art soon sat uneasily next to the increasingly abstract work of his fellow members and his attempts to modernise his own style failed dismally. Accordingly, he was soon welcomed back as a member of STISA and made a significant contribution to a strong portrait section in the 1950s and 1960s. He continued to devote much of his time to teaching and the St Ives School of Painting went on to develop an international reputation. By the early 1960s, over 1,000 students from all over the world had studied there, benefitting from the wise counsel of a popular and well respected man.

23. ***Knitting*** oil on canvas (72cm x 59cm)
(Private Collection)
This delightful, domestic portrait of Fuller's wife, Marjorie Mostyn, was exhibited on their first Show Day in 1939. Marjorie had met Leonard at art school, where they had both won the British Institute Scholarship in painting, and she sat for him many times. The painting was accepted and hung at the RA in 1939.[73]

24. ***Sven Berlin*** oil on canvas
(St Ives School of Painting)
This portrait was painted shortly after Sven Berlin resigned from the Penwith Society in 1950 and Fuller commented that he had done it in an attempt "to try and find out about Sven". Writing in his autobiography, Berlin commented, "In a few sittings he produced that fine portrait...working with great excitement, the brushes flashing through his hands, looking fantastic with that Magritte-like image in shirt sleeves. I thought he worked on it too long after the last sitting and lost a lot of vitality by overworking and trying to get it right...But I saw it recently and I was surprised how good it was and how well constructed, with mellow colour, well drawn, even the fag was still alight".[74] Fuller portrayed a number of his fellow artists, from both the traditional and modern camps. Moffat Lindner (RA 1943 Fig. 2L-4), Leonard Richmond, Terry Frost (Fig. 2F-4), John Barclay and his long-term friend, Adrian Hill all sat for him. A painting, *Melody*, also featured Mrs Bryan Wynter playing the accordion.[75]

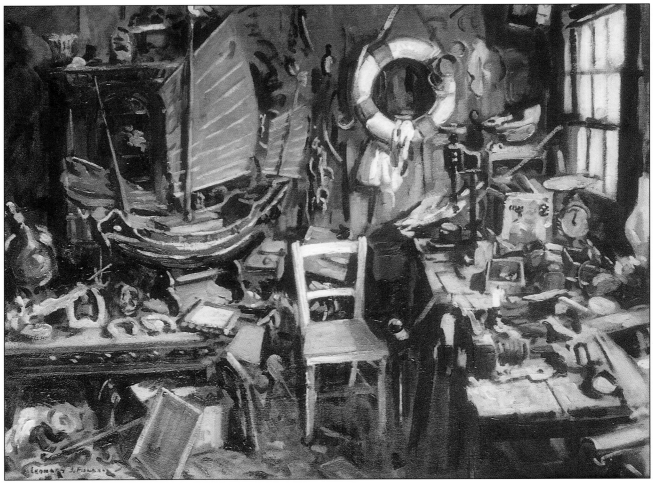

Fig. 2F-7 Leonard Fuller *Junk* (RA 1945) (W.H.Lane & Son)

[73] This painting is illustrated in colour in David Tovey, *George Fagan Bradshaw and the St Ives Society of Artists*, Tewkesbury, 2000, Plate 24 (between pp.144/5).
[74] S.Berlin, *The Coat of Many Colours*, Bristol, 1994, p.254.
[75] The Sven Berlin portrait is illustrated in David Tovey, *George Fagan Bradshaw and the St Ives Society of Artists*, Tewkesbury, 2000 at p.189.

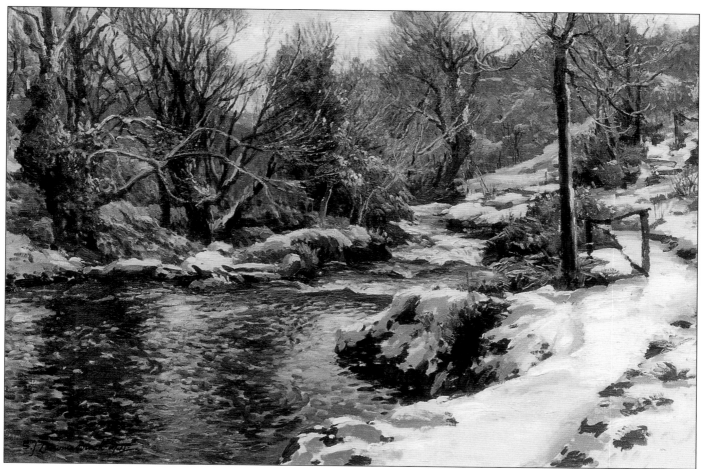

47. S.J.Lamorna Birch *My Garden, February*

(Private Collection)

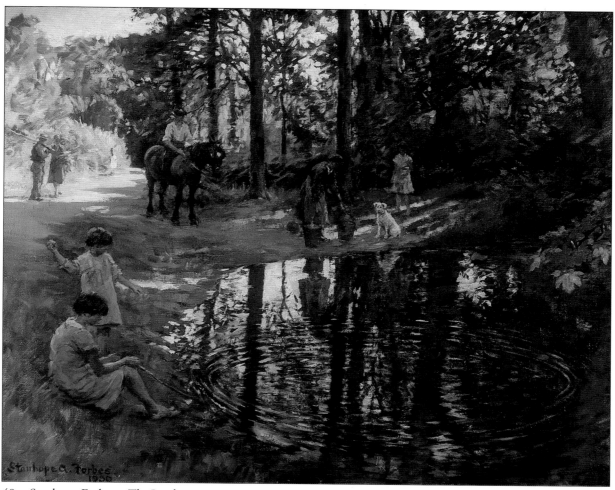

48. Stanhope Forbes *The Pond*
(Newport Museum and Art Gallery, © courtesy of the artist's estate/Bridgeman Art Library)

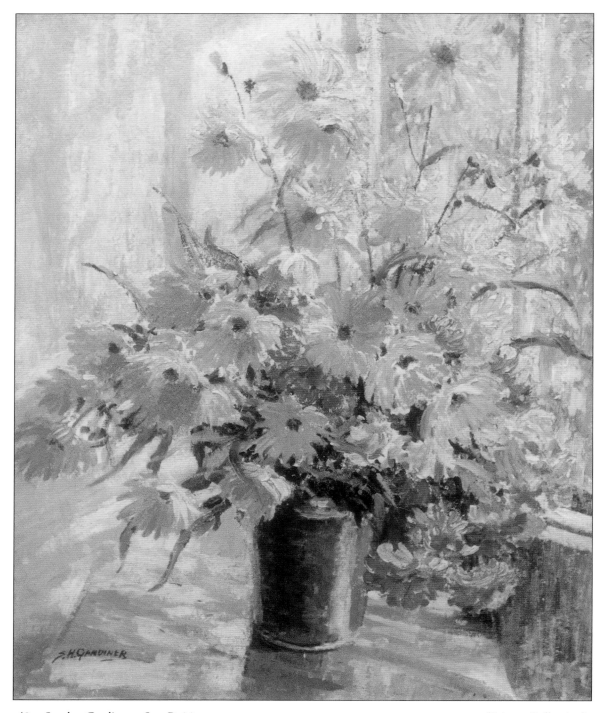

49. Stanley Gardiner *Sun Daisies* (Private Collection)

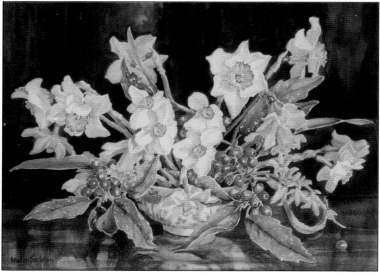

50. Helen Seddon *A Spring Selection* (Private Collection)

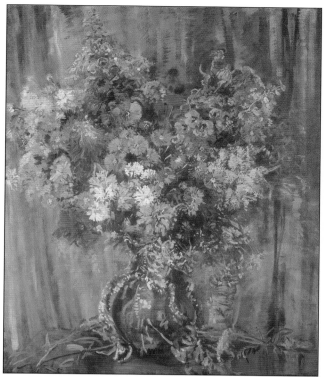

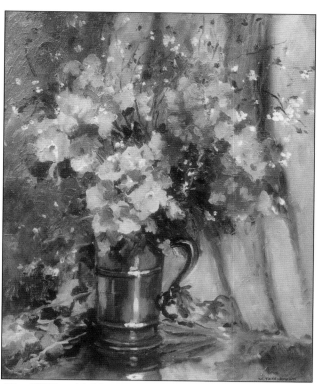

51. Amy Watt *High Summer* (Private Collection)

52. William Todd-Brown *Mallow and Gypsophilia*
(Private Collection)

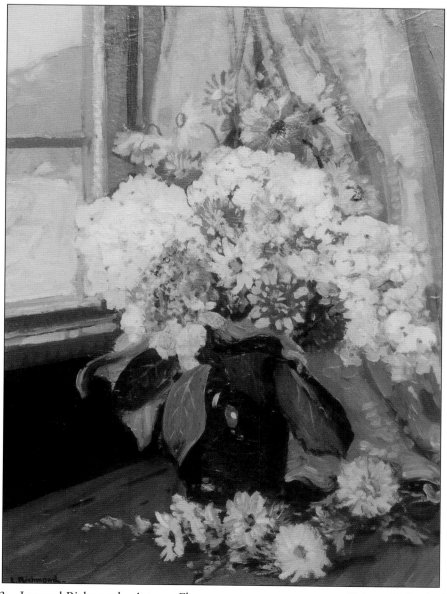

53. Leonard Richmond *Autumn Flowers* (Private Collection)

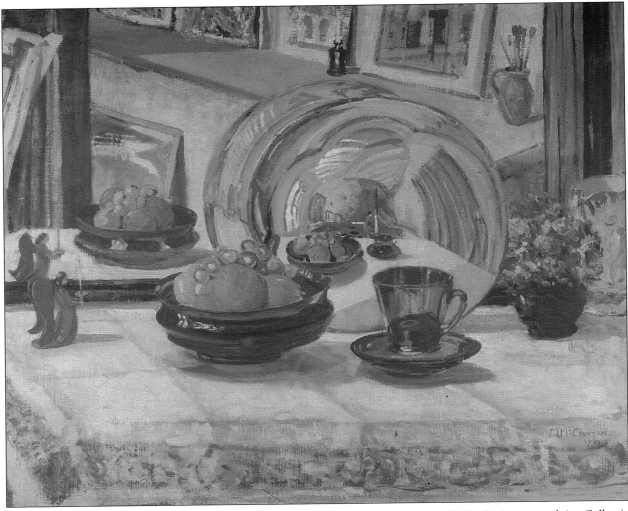

54. Mary McCrossan *The Witch Ball* (Salford Museum and Art Gallery)

55. Shearer Armstrong *Conversation Piece (Flowers with a Bird)*
(St Ives Arts Club)

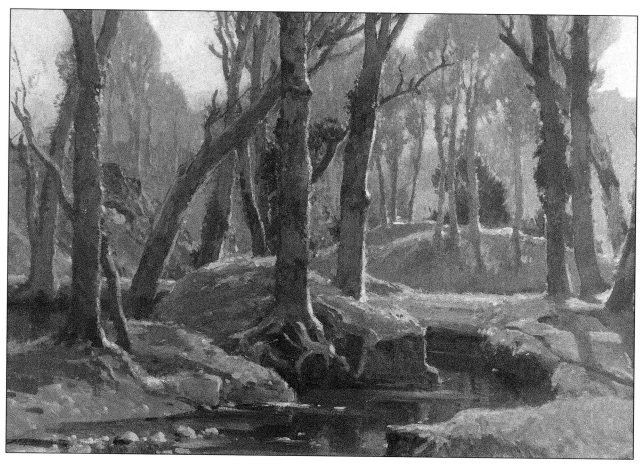

Fig. 2G-1 Stanley Gardiner *April Morning, Lamorna*

(W.H.Lane & Son)

Stanley Horace Gardiner (1887-1952) Exh. RA 18
STISA 1938-1952
STISA Touring Shows: 1947 (SA), 1949. Also FoB 1951.
Public Collections include Royal Collection, Norway and Penzance (on loan).

Born in Reading, Gardiner was initially apprenticed to a house decorator, necessitating a daily ride of 14 miles on a ramshackle bike. His first artistic efforts were produced using house paint on cardboard but, by attending evening classes, he won himself a scholarship to Reading University to study Fine Art under W.S.Collingwood, one-time secretary and associate of Ruskin. He then went to the Allen Fraser Art College in Arbroath in Scotland to work in oils, where he won the Well's Prize. Having finished his training, he decided to try his luck in the States, where he sought to make ends meet by painting, teaching and working as a lumberjack, but he often starved. Returning to England, he married the girl who had initially encouraged his artistic ambitions but then the War intervened. An exhibition of his paintings realised sufficient sales to enable the family to move down to Cornwall in 1923 and, encouraged by Lamorna Birch, they settled in Lamorna. Initially, their home was an old Army hut behind the local pub, The Wink, and times were hard as Gardiner studied further at the Forbes School in 1926. To make ends meet, Gardiner was forced to work as a deckhand on fishing boats and to make picture frames for Stanhope Forbes, Birch and other artists. However, as he developed his own style of landscape painting, which was heavily influenced by Birch, success began to come his way and the family moved down the valley to Lily Cottage, where the Lamorna stream comes tumbling through the garden. He built his own studio there and, in 1927, had his first success at the RA. He did exhibit occasionally with STISA in its early days but did not become a member until 1938, by which time he was exhibiting regularly at the RA. He also ran a small painting school from his home. In February 1939, he had his first London one-man show at the Fine Art Society, where he exhibited 42 paintings of Cornwall. In his introductory note to the catalogue, W.H.Giffard observed:-

"Grey stone farm buildings huddled round mudded yards, or blazing sunlight on simple haystacks, trees in early Spring when noontide yet retains its pristine freshness, the patterned fields of market gardens on cliffsides and sand glowing emerald through blue water are the inspiration of his work."

A reviewer praised him for "his fluent use of paint and swift impressionism, born of long companionship with nature and singleness of purpose." Despite his success, he remembered the hard times and, when a young clerk and his wife were taken with one of his paintings but could not afford it, he let them have it on trust. "They were strangers: there was no deposit. They paid in regular instalments. Why shouldn't every little home have a few paintings in a similar way?"[76]

Having joined STISA, he was a regular and important contributor. Mostly, his works were Cornish landscapes, often featuring his beloved Lamorna Valley (see, for example, Fig. 2G-1), but the 1947 Cardiff Exhibition did include his 1947 RA exhibit *The Torridge Vale, N. Devon*. One of his works was purchased by Queen Maud of Norway. Towards the end of his life, he concentrated on still life paintings, mainly of flowers, which are vibrant with colour and light. His death in 1952 robbed STISA of yet another artist of consequence.

25. ***Sun Daisies*** oil on canvas (74cm x 62cm)
(Private Collection) (Plate 49)
A radiant example of his still life work that was exhibited at the RA in 1942. The bold brushwork and use of impasto bears similarities to Dorothea Sharp's still life paintings of the same period.

Geoffrey Sneyd Garnier ARWA SGA (1889-1970) Exh. RA 2
STISA: 1932-1953
STISA Touring Shows: 1932, 1934, 1936, 1937. Also FoB 1951.
Public Collections include Royal Collection, Accrington, Oldham and Preston.

Garnier made a distinctive contribution to STISA through the technical excellence and poetic mood of his coloured aquatints. The son of the author, Russell Garnier, Geoffrey was born in Wigan and was educated at Charterhouse. He obtained a City and Guilds certificate in engineering before obtaining a job in Canada. It was while in Canada that he first decided to pursue art as a career but, knowing its financial constraints, he tried his luck at gold prospecting in the Yukon for a year. On his return to England in 1910, he studied for two years at Bushey before continuing his training at the Forbes' School in Newlyn. He shared lodgings and a studio with R.C.Weatherby (q.v) at Trewarneth Farm, at the top of Chywoone Hill - a property previously occupied by Stanhope and Elizabeth Forbes and Harold and Laura Knight. Garnier made it a venue for weekly fancy dress parties and male-only dinner parties - a time described by C.E.Vulliamy as "days of merry, unprofitable adventure, and of busy idleness".[77] On the outbreak of war, he enlisted in the Army but was shortly discharged with a duodenal ulcer. In 1916, he re-enlisted, this time in the Royal Navy, and rose to the rank of Lieutenant.

In 1915, his first cousin, 'Jill' Blyth, came to study at the Forbes School. They fell in love and were married at St Peter's Church, Newlyn in 1917. Garnier's naval service continued until 1921 and, for a brief spell, he set up as an engineer in Birmingham, as part of the firm Horton and Garnier, but, in 1922, the family returned to Newlyn. They extended Orchard Cottage, Belle Vue in Newlyn, in which they had stayed during their honeymoon, and bought some more land, enabling Garnier to build a large studio in the garden. This property, which has extensive views over Mount's Bay, was to be their home for the rest of their lives.

Garnier was one of the few local artists to concentrate on printmaking and he made a significant contribution to what was called the 'black and white' section of STISA, although many of his exhibits were, in fact, coloured aquatints. Garnier became fascinated with the work of William Daniell (1769-1837), whose aquatints had a delicacy that could not be achieved by contemporary methods. Having located a manuscript book of one of Daniell's pupils, he was able to approach very closely the methods of the old masters and he became an internationally acclaimed authority on the processes involved, with pupils coming to him from as far away as America. One of the greatest attractions of Daniell's methods was the speed with which work could be produced. In relation to one of his aquatints of old ships, the plate was immersed in the acid bath fourteen times, the period of each biting being only 30 seconds, whereas modern methods would have required at least a two hour immersion in the same strength of acid.[78]

Garnier exhibited with STISA from the outset but did not become a member until 1932 - a year in which he had two works purchased by Her Majesty the Queen and six by the Board of Trade. A reviewer commented,

"The colour prints of G.S.Garnier are in a class by themselves: the work is so dainty, the colour so equable. There is the tang of old Dutch prints about his work."[79]

[76] *News Chronicle*, 1939, Cornish Artists : 11.
[77] C.E.Vulliamy, *Calico Pie*, London, 1940, at p.123.
[78] Peter Garnier, *Geoffrey S. Garnier ARWA, SGA (1889-1970) and Jill Garnier, FRSA (1890-1966)* in H. Berriman, *Arts and Crafts in Newlyn 1890-1930*, Penzance, 1986 at p. 62.
[79] *St Ives Times*, 10/6/1932.

Garnier restricted himself to a limited range of subjects. He did a number of etchings of old Newlyn, including one entitled *The Condemned Village 1937*, a year when the local artists and fishermen, led by Phyllis Gotch, fought a bitter campaign to stop the demolition of some 300 houses in Newlyn and Mousehole. Aquatints of local scenes like *The Sand Cart* and *St Michael's Mount* proved of enduring popularity. He also loved depicting sailing ships and made arrangements with Lloyds to be informed when any windjammer was approaching Falmouth. On receiving a call, he and his friend Oliver Hill, a retired Naval Commander, would dash over to Falmouth, board a quay punt and put to sea to meet the ship as she sailed into Falmouth for orders. Details recorded in the photographs and sketches made from these trips were used to aid authenticity in many of his aquatints, but subjects like *Becalmed* (Fig. 2G-2) and *The End of the Chase* (Fig. 1-7) were imaginary scenes evoking the heyday of the sailing ship. He also found a market for reproductions of depictions of sea battles or wrecks of the past.[80] Not having the time or inclination for marketing himself, he employed the Penzance bookseller, J.A.D.Bridger as his agent.

He was also in demand as an engraver of heraldic bookplates, having acquired from the Rev. Allan Wyon (q.v.) an important old engraving machine dating from 1800. One of his bookplate designs was even exhibited at the RA in 1934. His talent as an engraver was highly regarded by a fellow professional, Malcolm Pitcher:-

"Geoffrey had the uncanny gift of being able to go direct onto a copper plate without having first drawn his design, and using the tool almost as an extension of himself. You have to be very, very clever to draw direct with an engraving tool, and when you can, you're very special."[81]

Fig. 2G-2 Geoffrey Garnier *Becalmed* (Private Collection)
This was first exhibited with STISA in the 1932 Winter show

[80] Works exhibited with STISA, for instance, included *H.M.S.Malabar Leaving Harbour, H.M.S.Orion at Trafalgar, H.M.S.Revenge and French Prize Hulk* and *The Wreck of the Delhi*.
[81] This quotation and most of the biographical information on Garnier is drawn from the exhibition catalogue to a show of his work at The Pilchard Works, Tolcarne, Newlyn in 1999.

Fig. 2G-3 Geoffrey Garnier with his aquatint *Bodmin Moor* in 1936

During the Second World War, Garnier ran the local Home Guard and he did not exhibit with STISA between 1940 and 1950. During this period, he ceased producing new aquatints and turned almost exclusively to engraving but his return to STISA was welcomed at the 1950 Summer Exhibition and he contributed some prints of earlier work to a number of shows during the early 1950s.

Garnier was a man of many talents, enjoying bookbinding and cabinet making, and he had a love of cars and motoring. He wrote short stories and, in 1936, published a novel *Bargasoles*. However, he also found time to be very involved in community affairs in Newlyn. He loved messing about in boats and was responsible for writing and illustrating the programmes for the Harbour Sports - now considered to be collectors' items.

26. ***Trencrom at Dawn*** coloured aquatint (28cm x 36cm)
(Private Collection)
This aquatint, printed in an edition of 100, was first exhibited with STISA in the 1938 Spring Exhibition but was also included in several shows in the early 1950s. A tranquil early morning scene with long shadows cast, it is coloured almost entirely in browns, with the red jacket of the fishermen at work in his boat the sole exception.[82]

(Miss) Alethea Garstin RWA (1894-1978) Exh. RA 29
STISA: 1945-1949
STISA Touring Shows: 1947 (SA), 1947 (W)
Public Collections include Government Art Collection, RWA, Bristol, Plymouth and the National Trust.

Alethea was the daughter of the artist, Norman Garstin, who wrote eloquently about the early artists of Newlyn and St Ives in *The Studio* and other art magazines. An articulate, intelligent Irishman of great personal charm, Garstin was in demand as an art teacher and he guided Alethea's progress, clearly passing on to her his understanding of and regard for the French Impressionists and their successors. Although she only started painting seriously when aged 16, she was successful for the first time at the RA in 1912, just two years later, when her work was much admired by Sir Edward Poynter. She was a sympathetic and talented artist, painting on a remarkably small scale and with a sober and limited palette. She had a deep understanding of French Post-Impressionism and Patrick Heron even went so far as to say that her work was "as good as Vuillard". Michael Canney, for many years the curator at Newlyn Art Gallery, commented that she had an individual voice and delivery and that her paintings were miracles of economy and understatement: "She had a gift for describing a boulder, a chicken, a palm-leaf, a rusting fishing boat, with a mere touch of the brush."[83] She also had some success as an illustrator for magazines such as *Punch*, *Tatler* and *The Graphic*. Artists who influenced her work included Edward Wolfe and Morland Lewis and she became friendly with Alfred Wallis.

She contributed to the first STISA show in the Porthmeor Gallery in 1928 and was invited to join STISA in May 1930 but she did not exhibit regularly with the Society until after the War. An inveterate traveller, her studio when she was on the move was her small red Morris Eight Tourer, with its soft roof and a running board on which she would often perch to sketch. She drew directly with paint on canvas or board, using a toned ground and working up to the lights and down to the darks.[84] However, like her great friend, Dod Procter, a companion on a number of her adventures, she did not exhibit with STISA after the split. A warm person, with a lively sense of humour, she continued to exhibit with the Penwith Society for many years, although, with characteristic modesty, she ascribed the continued acceptance of an 'old codger' by the young moderns as due to the fact that her paintings were so small that they were easily hidden.[85] In 1960, as her garden and studio at Wellington Terrace, Penzance, where she had lived all her life, became a municipal car park, she moved to 'The Old Poor House' at Zennor, close to Eagle's Nest, Heron's home. Her portrait by Dod Procter is illustrated in Nina Zborowska's feature opposite page 153.

[82] The work is illustrated in David Tovey, *George Fagan Bradshaw and the St Ives Society of Artists*, Tewkesbury, 2000 at p.96.
[83] Michael Canney, *Newlyn Notebook*, unpublished but reproduced in Ed. M.Hardie, *100 Years in Newlyn-Diary of A Gallery*, Penzance, 1995.
[84] From catalogue to *Norman and Alethea Garstin - Two Impressionists*, Penwith Society, 1978.
[85] M. Tresilian, *Art In Cornwall VI, The Cornish Review*, Spring 1972, No 20, p.64-6.

Fig. 2G-4 Alethea Garstin *Little Farm Place* (RWA 1952)
(W.H.Lane & Son)

27. *Regatta Day, Hayle* oil on board (32cm x 39cm)
(Royal West of England Academy, Bristol) (Plate 30)
This unusual composition is full of interesting angles. The gaze of the two cut off figures on the right and the temporary fence closing off the railway line draw the viewer's gaze towards the colourful group, watching a boat coming in to the harbour, and the breakwater beyond. White and red tops worn by the spectators are matched by white and red sails on the boats in this happy, summer scene. This work was included in the 1947 Cardiff show and was acquired for the collection of the RWA when she was elected a member in 1949.

Hugh Gresty RBA (1899-1958) Exh. RA 20
STISA: 1927-1931
Public Collections include Burnley, Liverpool, Nelson and Southport.

An excellent draughtsman, able to convey the huge masses of ancient structures, Gresty was a keen, young, highly-rated member of STISA in its early days but seems to have been one of the few casualties to internal strife. Born in Nelson, Lancashire, his father was a weaver before founding the furnishing firm, Waters and Kidd. He attended Nelson School of Art where he was considered an ideal pupil - quiet and unassuming, clean, precise, hard working and passionate about art. During the First World War, he served in the Army and was wounded at Ypres. He suffered the effects of gassing for the rest of his life. Afterwards, he won a Government scholarship to Goldsmith College, London, where he studied for approximately two years under Harold Speed and Edmund Sullivan before sharing a studio with others in Lincoln's Inn. He first exhibited at the RA in 1924 and this work, *Fragment, England,* was included with eight others, principally of Italy, in the 1924 Summer Exhibition at Towneley Hall, Burnley. In 1926, immediately after his marriage, he moved to St Ives and he had his first work hung at Lanham's in November 1926. He immediately became involved in the discussions leading up to the formation of STISA and he was a founder member, with his wife, Elizabeth, joining as an associate member. In 1928, he was elected on to the Committee and, for three years, played a major role in getting the Society off the ground. Meanwhile, his art was attracting very favourable comment and he was elected an RBA in 1927. Gresty travelled to Italy and Spain repeatedly and he specialised in painting ancient buildings, often ruins. His masterly sense of proportion often imbued these with a monumental character and a calm dignity. *Beneath The Arch of Severus* (Burnley), exhibited on Show Day 1928 and successful at the RA, was noted for its excellent colour scheme in soft tones and, the following year, his Show Day exhibits - *The Baths of Caracalla* (Bradford) and two depictions of the *Alcantara Bridge, Toledo* (moonlight version - Burnley) prompted Borlase Smart to comment:-

Fig. 2G-5 Hugh Gresty *Alcantara Bridge, Toledo*
(Towneley Hall Art Gallery and Museum, Burnley Borough Council)

"This artist is quite an acquisition to the St Ives Arts Colony and also shows three of the finest works this year. They reflect sound constructional ability and rich sense of colour, and a great searching after truth. Last, but not least in these *modern* days when so many so-called artists take the line of least resistance, they are full of most beautiful and appealing sense of perfect drawing."[86]

Being a sound draughtsman, it is not surprising that Gresty did occasionally contribute etchings to STISA shows but he also sometimes experimented with a more modern approach and his painting *Rocky Landscape, Yorkshire* (Southport) met with a mixed response when exhibited at STISA's Spring Exhibition in 1930. "'Massive' is the only word I can think of to describe the picture titled *Yorkshire* by Hugh Gresty. Masses of solid colour in the foreground in the 'modernist' style, with a background of hills, give an impression of power and strength. But I like Mr Gresty better in his more pictorial moods."[87]

[86] *St Ives Times*, 22/3/1929.
[87] *Western Morning News*, 18/4/1930.

Gresty was a tall man, who walked with a slight stoop. He was quiet and unassuming and avoided the limelight. He and his wife lived initially at 'Ship Aground' on The Wharf and, during his time in St Ives, he appears to have used a variety of studios. He had a passion for classical music, which he played in his studio whilst he was painting. Sibelius was a particular favourite. He was also a keen cook and enjoyed the company of a few close friends.

Quite why Gresty failed to renew his membership of STISA in 1932 is unknown. However, Gresty was friendly with Arthur Hayward, with whom he shared a studio for a while, and Hayward left at the same time, apparently because he objected to the doubling of the subscription. This, however, seems a strange reason for Gresty to take such action, as his wife came from a wealthy family. The fact that Gresty takes issue with a number of articles written by Smart in the *Art Notes* section of the local paper in 1933 suggests that there had been some sort of personality clash, for Gresty had lost his place on the Committee soon after Smart had begun to take a firmer grip on the Society's affairs.

Gresty remained living in the locality until his death and exhibited with Hayward's 'Cornwall Group' in the mid 1930s. Although he did not participate in Show Days, he was very successful at the RA until 1940. That year he advertised classes in various branches of drawing, painting and design at his new home, 'Mincarlo', in Carbis Bay. However, he had been in poor health for some years prior to his death in 1958. His tombstone in Lelant Churchyard reads "An eye for beauty and a heart for a friend".[88]

28. ***The Baths of Caracalla*** watercolour
(Cartwright Hall Art Gallery, Bradford) (Plate 33)
This was one of the works so highly regarded on Show Day in 1929 by Smart, who commented:-

> "This drawing is quite an object lesson in the power that can be obtained in this medium in the hands of an expert. In fact, at first glance, it could easily be mistaken for a powerfully painted oil. On a detailed inspection, however, all the grace of sound water colour art is revealed. The shadow construction here too emphasizes the antiquity of the famous ruins in Rome."[89]

Completed in c.230A.D., this Baths complex extended over 27 acres and was the most immense monument in ancient Rome. Its brick ruins were a favourite haunt for Romantic painters and poets and Shelley wrote *Prometheus Unbound* here.[90] Gresty became an RI in 1934.

Frederick Hall (1860-1948) Exh. RA 69
STISA: 1936-1948
STISA Touring Shows: 1937, 1945, 1947 (W).
Public Collections include Blackburn, Blackpool, Bradford, Bury, Leeds, Northampton, Truro, Warrington and, abroad, Geelong and Wellington.

Apart from Stanhope Forbes, Fred Hall was the only member of the original Newlyn School group to survive long enough to make a distinctive contribution to STISA. Born in Stillington in Yorkshire, he studied at the Lincoln School of Art between 1879 and 1881 and then at Verlat's Academy in Antwerp in 1882/3. He visited Newlyn in 1884 and settled there soon after. He had his first success at the RA in 1887 but his work is not typical of the Newlyn School, with a number of his early RA exhibits being humorous anecdotal scenes. Accordingly, in the Newlyn School context, he is probably best known for his caricatures of his fellow artists. In the 1890s, he started to produce the subjects for which he is now best known - pastoral landscapes and agricultural scenes. He left Newlyn in 1897 and married in 1898, his pretty wife inspiring some of his best portraits. In 1911, they moved to a cottage near Newbury and he lived there for the rest of his life, gaining inspiration from the local Berkshire countryside and working from a studio converted from a shed in the rickyard of Rectory Farm, Speen. Many of his paintings were of quintessentially English scenes of farm animals feeding or working in the fields with the Berkshire Downs stretching away into the distance under open skies. A great admirer of Monet, his later work is now classified under the heading 'British Impressionism', with its broad, paint-filled brushstrokes, and is highly regarded. He won a gold medal at the Paris Salon in 1912 and continued to be a regular contributor to RA exhibitions.

Hall contributed to the first show in the Porthmeor Gallery in 1928 but did not become a member until 1936. His painting *Up from the Shadowed Vale*, with its "very tender feeling for light and atmosphere", was one of the highlights of the 1937 Autumn show.[91] He continued to exhibit with STISA until his death.

[88] Information derived from (i) *News Chronicle* 1939, Cornish Artists 31, (ii) M.Whybrow, St Ives 1883-1993, Woodbridge, 1994, p.98/9, (iii) Obituary in *Nelson Leader* 15/8/1958
[89] *St Ives Times*, 22/3/1929.
[90] The Harris Art Gallery, Preston have *The Baths of Caracalla* by David Young Cameron, painted in 1924.
[91] *St Ives Times*, 1/10/1937.

Fig. 2H-1 Fred Hall *Calves in a Barn* (W.H.Lane & Son)

29. *One Winter's Morn* oil on canvas (51cm x 61cm)
(Williamson Art Gallery and Museum, Birkenhead) (Plate 43)
After heavy snow, Hall captures a farmyard in early morning light as the rising sun heralds a fine day. A couple of crows pecking in the snow provide the only foreground interest and some hens emerge from a barn at the rear. However, Hall's principal interest is in the play of light across the farm buildings and the different roof styles of each barn. The autumnal colouring of the fine trees to the rear, enhanced by the morning sun, indicate that snow has come early this year. The painting was exhibited at the RA in 1935, along with *Preparing for Sheep-Washing* which is now owned by Bury Art Gallery. It was also included in the 1947 Cardiff Exhibition.

Alfred Hartley RE RWA RBC (1855-1933) Exh. RA 65
STISA: 1927-1933
STISA Touring Shows: 1932, 1934.
Public Collections include British Museum, Victoria and Albert Museum, RE, QMDH, Nottingham and, abroad, Adelaide, Auckland, Los Angeles, Rome and Venice.

The son of a parson, Hartley was born in Stocking Pelham, Hertfordshire and studied at the Royal College of Art, South Kensington, where fellow students included J.J.Shannon and W.Llewellyn, and at Westminster under Brown, in company with Frampton, Greiffenhagen and Anning Bell. Folliott Stokes observed, "No man could be more artistic than he looks. There is a glint of joyful alertness in his keen grey eyes which, combined with the delicate contours of his face and figure, would at once suggest the artist to the least observant."[92] However, a severe accident whilst he was a young man left him lamed for life.

In his early career, he was renowned for his landscapes in oils and his portraits - his sitters including Lord Randolph Churchill, Lord Russell of Killowen and Lord Asquith. He became a member of the RBA in 1890 and of the ROI in 1899. He received a bronze medal at the Paris Exhibition of 1889, a silver medal at the Anglo-German Exhibition in London and a Certificate of Honour at the Wembley Exhibition. In an article on photography, he set out his approach to landscape work. "The painter's endeavour is to portray by means of his paint that which is noblest in nature.....By his imagination, he may give us an impression which is fuller than the impression made by nature upon the eye alone; he may suggest the breath of the morning air or the heat of the midday sun; he may paint not only what he actually sees, but something also of what he feels."[93] This was written in 1894, some fifty years before John Wells' oft-quoted comment about the problems of "painting the warmth of the sun" and Peter Lanyon's concern with portraying his own reaction to the landscape.

Hartley, however, was best known during his time in St Ives as a master in the art of etching and aquatint. His first attempts with the needle were made at home prior to beginning his art training but he ascribed most of the knowledge that he acquired about

[92] A.G.Folliott Stokes, *Alfred Hartley, Painter and Etcher*, The Studio Vol 64 1915 p.98.
[93] A Hartley, *A Painter's View on Photography*, The Studio, Vol IV, 1894, pp.59-64.

Fig. 2H-2 Alfred Hartley *Regatta Night, St Ives* (The Trustees of the British Museum)

the craft to Sir Frank Short. An article on French colour-printing made a big impression on him and he adopted this method not only for colour etching but also for monochrome work. For his coloured aquatints, he usually limited himself to three plates - one for each colour - , believing that the less colour elaborated, the better the result in this class of work.[94] He was elected an ARE in 1894 and to full membership in 1897. He and his wife, Nora, who was also an artist, appear to have moved to St Ives in 1904 living at first at 4, Bellair Terrace and then at No.7, although they may have retained a London address for a few years. They joined the Arts Club in November 1906.

Hartley was a master at evocative atmospheric effects. His architectural studies, although full of intricate detail, are never simply dry representations. The dexterous handling of the fall of light ensure that they live and are full of character (see, for example, Figs. 1-6 & 2H-3). His clever use of reflections and the contrast between light and dark masses make his depictions of St Ives harbour and its fishing fleet as attractive as many colourful oils (see, for example, Fig. 1-13) and, in some of his landscape subjects, large areas of the plate were left open, resulting in the creation of an ethereal atmosphere, redolent of early mornings when colour has yet to be awakened by the sun's rays.

[94] ibid p.103.

Fig. 2H-3 Alfred Hartley *At the Boatbuilder's* (The Trustees of the British Museum)

Hartley developed a considerable reputation internationally for his print work and a number of students came to study under him. Christopher Nevinson trained with him for a while after his return from being a war artist in France. In 1922, Hartley founded the New Print Society in St Ives and was the undisputed head of the 'black and white' section of STISA, always willing to help and dispense sound advice at a time when the popularity of etchings reached record levels. Many of the St Ives artists will accordingly have been introduced to the mysteries of the craft by this sincere, diffident man and it was natural, in 1928, when the Society's lecture series began that he should be asked to give a talk on *Etching* - and that there should be a large attendance. Smart commented, "To see him pull a proof from his press was like watching a magician." Nevertheless, even in the early 1920s, Hartley was not in good health. Averil Mackenzie-Grieve (q.v.), who found him "gentle and rare-spirited", commented that "he was severely crippled with arthritis and could barely drag himself on two sticks across the Island to his studio".[95] In 1931, he decided that a move to the Spa town of Llandrindod Wells might assist him but he died in 1934. A Memorial Exhibition was held at Lanham's in March 1934, which included a number of his St Ives scenes, such as *Regatta Night, St Ives* (RA 1924), depicting a firework display (Fig. 2H-2), *Between Showers: St Ives* (RA 1919), a view of the harbour (V & A), *The House Called Little in Sight*, a property on The Stennack, *Waiting for High Water*, a line etching of the fishing fleet and *Godrevy Lighthouse and Hayle Bar*.

In 1929, he won a gold medal at the International Exhibition in California for *Storm on the Alps* and, in 1932, he won a gold medal in Los Angeles for his etching *Snow Scene on the Alps* and there are extensive collections of his aquatints in the British Museum and the V&A, as well as at Nottingham Castle and in Auckland. The King and Queen of Italy were also keen collectors.

[95] A. Mackenzie-Grieve, *Time and Chance*, London, 1970 at p. 37.

30. *At the Boatbuilder's* aquatint (37.5cm x 30cm)
(The Trustees of the British Museum) (Fig. 2H-3)
This work was exhibited at the RA in 1912 and was acquired for the collection of the British Museum the following year. It shows the pokey, cluttered domain of a boatbuilder but the manner in which the light comes through the small-paned windows and lights up the room, particularly sections of the boat and the ceiling timbers, is masterfully handled.

31. *Christchurch Gate, Canterbury* aquatint (36cm x 30cm)
(The Trustees of the British Museum) (Fig. 1-6)
This aquatint was one of the last ones executed by Hartley and was considered by many of his admirers to be the finest one he had done. It was exhibited at the RA in 1930 and included in both the 1932 and 1934 tours. Hartley also did another Canterbury scene, *West Window, Canterbury Cathedral* (RA 1931).

Harold Charles Francis Harvey (1874-1941) Exh. RA 55
STISA: Exh. 1928-1931
Public Collections include Birmingham, Cardiff, Huddersfield, Leamington, Leeds, Manchester (Trafford Park), Oldham, Penzance, Southport, Truro and Vancouver.

Harvey was one of the few artists associated with the Newlyn School to have been born locally. His father was a respectable middle-class banker but, growing up in Penzance in the 1880s, Harold will have constantly seen artists at work around the town, as *plein air* painting was one of the fundamental principles of the early Newlyners. Inspired, or in any event intrigued, by these slightly exotic creatures, he enrolled at the Penzance School of Art, which was then run by Norman Garstin, one of the most knowledgeable and eloquent of the Newlyners. He then studied at the Julian Academy in Paris for two years. In 1895, he exhibited with the Newlyners at the inaugural exhibition of the Newlyn Art Gallery and, in 1898, had his first work accepted by the RA. His style at this juncture was strongly influenced by the first generation of Newlyn artists.

In 1911, Harvey married Gertrude Bodinnar, a young Cornishwoman, who had occasionally modelled for local artists, including Laura Knight. The arrival of Laura and Harold Knight in 1907 and the rapid progress made by two of Forbes' star pupils, Ernest and Dod Procter, had injected new ideas into the colony and the Harveys became close friends of both couples. Inspired by the Impressionists' approach to colour and light, they all began to paint bolder compositions, full of vibrant colour. Each artist within this group of friends seems to have borrowed and given inspiration in equal measure.

The onset of war and the outdoor sketching restrictions forced Harvey to move away from *plein air* subjects and, probably influenced by Harold Knight, he decided to concentrate on sophisticated, modern interiors. These often featured Gertrude in their own home, Maen Cottage - a property with a grand vista over Mount's Bay - and are fascinating time-pieces, showing the accoutrements of fashionable, middle-class living at this period. Gertrude's sister, Sophie, worked for the textile designer, Alec Walker, and their home was furnished with Crysede printed silks and linens as well as their own arts and crafts objects. The impact in an interior of light and reflected light seems to have fascinated him but the rooms are always airy and bright, enabling him to pick out objects or clothing in full colour. Some critics feel that these works also reflect Harvey's admiration for 17th century Dutch painting, which the Knights had observed at first hand on their trips to Holland.

In 1920, Harvey and Ernest Procter combined to found a School of Painting and pupils included future STISA members Midge Bruford, Billie Waters and Dorcie Sykes. Harvey, who rarely travelled away from Cornwall, still continued to paint scenes of Cornish life, using local people as models. His conversion to Catholicism in 1926 was to inspire a new phase in his work and he was one of the artists to help with the decoration of Bernard Walke's St Hilary.

Harvey was one of the first of the "prominent artists from West Cornwall" to be asked in 1928 to contribute paintings to STISA's exhibitions and he contributed a number of works to STISA early shows, including *The Movies*, *Off to Penzance Market*, *The Mirror, Gardener, Newlyn Fishermen* and *Drift Farm* and, in May 1930, was invited to become a member. He appears to have declined as he ceases to exhibit with STISA after 1931, the year in which a new rule was introduced restricting exhibitors to members or special invitees. Instead, he exhibited as part of the "Cornwall Group" at Arthur Hayward's Shore Studio. He died in 1941.

Fig. 2H-4 Harold Harvey *Gertrude Reading* (W.H.Lane & Son)

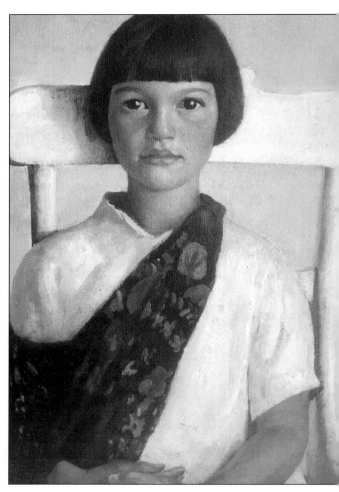

Fig. 2H-5 Harold Harvey *Zena Symmons with a Crysede scarf*
(W.H.Lane & Son)

32. *My Kitchen* oil on canvas (100cm x 77.5cm)
(Gallery Oldham) (Plate 18)
This work was included in the first STISA exhibition at the new Porthmeor Gallery in 1928, although it was executed in 1923. In the catalogue raisonée included in Harvey's biography, the models for the two women in this picture are stated to be unknown, although the seated woman with the black jacket and hat and striped skirt (no doubt a Crysede creation) is felt to be Gertrude. In fact, Gertrude is the woman standing, dressed all in white, who has been set, intriguingly, against a white wall. With her left hand resting on a small wooden table and her right hand on her hip, her gaze is directed at the basket of fruit and vegetables that the seated woman has on her knee and from which she is selecting an orange. The model for the woman in black would appear to be Winifred Francis, who was wearing the same hat when she posed with her sister for *Girls Outside the Gaiety Cinema*. Of equal importance in the picture is the still life group on the wooden table, featuring a lobster on a plate, with its claw hanging over the edge of the table, some green vegetables, a blue bowl and an empty glass. Hanging down into the top of the picture from an unseen clothes drier are a bright yellow cloth, a striped apron and a metal bucket.

In an earlier work from 1918, *In the Kitchen*, the figures are much stiffer with little inter-relationship. Here, the scene is much more natural. Also it is clear that the Harveys have had a new black and white chequer-board floor installed and this provides a strong design element in the work and helps to map spatial relationships. It is no accident, therefore, that the two women are also dressed one in white and one principally in black. For contrast, strong, bright colour is introduced in the still life segment, particularly the vivid red lobster, and in the yellow cloth hanging down into the top of the picture. Design continued to play a central role in Harvey's interiors and he returned to the kitchen with *Kitchen Interior* in 1930.

Arthur Hayward (b.1889) Exh. RA 22
STISA: 1927-1931
Public Collections include National Portrait Gallery, Leamington and Warrington.

Why such a stalwart supporter of STISA should suddenly resign is one of the mysteries of the Society's history and his decision removed from STISA's ranks the leading portrait painter in the colony. Born in Southport, Hayward initially studied architecture at South Kensington, winning a bronze medal for design, but he gave up architecture for painting and studied at Warrington and under Forbes at Newlyn. During the War, he was a Captain in the Royal Field Artillery. Afterwards, he joined the Newlyn Society of Artists and was elected on to the Committee in 1920, where he joined Birch, Robert Hughes and Frank Heath. He was appointed Assistant Secretary in 1923. However, he then moved to St Ives, living at Treveneth and, in 1926, he took Shore Studio, which had formerly been used by Charles Simpson. His first two successes at the RA, *The Crinoline* (RA 1920) and *In a Sunlit Garden* (RA 1922) were included in the 1925 Cheltenham show and the latter was again included in the second exhibition of STISA in the Porthmeor Gallery in 1928, before being acquired by the Trustees of the Mackelvie Collection. Other RA exhibits that were included in STISA shows were *The Nursery Window* (1927), *The Blue Dress* (1930), a figure standing before a fireplace of pale golden tiles, and *Cornish Saints and Sinners* (1932).

In 1924, Hayward set up a painting school in St Ives but remarkably little is known about this school and its pupils, although, in his entry in *Who's Who in Art* in 1934, Hayward is still describing himself as the Principal of the St Ives School of Painting. In the late 1920s, there is a reference to John Park assisting at the school and, on occasion, other artists - most probably his students - exhibit with Hayward on Show Day in Shore Studio. Hampden Minton (q.v.) is an example in 1926. However, I have yet to find any reference by an established artist to a period of study under Hayward.

Hayward was a founder member of STISA and, in 1928, he was elected on to the Committee along with Herbert Truman and his friend, Hugh Gresty, and played an important role for a number of years in that crucial period. Even when not elected back on to the Committee in 1931, he was co-opted as a member during the absences of others. It is, accordingly, very strange that he should have refused to re-join the Society in 1932 and should have refused to have anything more to do with STISA for the rest of his life, despite still living in St Ives. The only clue to the problem from the Minutes is that Hayward (and Truman) voted against any increase in subscriptions in 1932, when the Committee proposed doubling them. This was a difficult time for many artists and Hayward may have felt that the additional expense was not affordable or he could have disagreed with Smart's grandiose plans for nationwide touring exhibitions. In 1933, having sold all three of his RA exhibits, he built a studio in his garden and turned Shore Studio into an art gallery. Among those exhibiting with him - styling themselves as the 'Cornwall Group' - were Harold and Gertrude Harvey, Hugh Gresty and Ernest and Dod Procter. Alison Rose and Midge Bruford also showed work. This will not have pleased STISA and it is interesting that none of these artists exhibited with STISA for some while afterwards.[96]

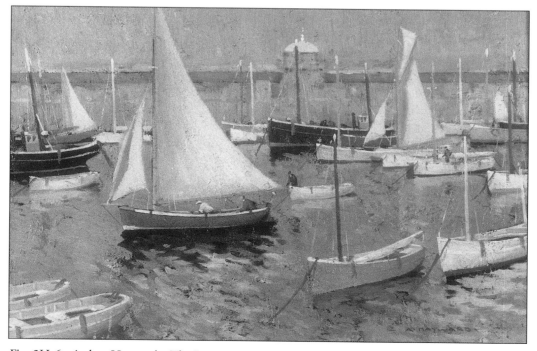

Fig. 2H-6 Arthur Hayward *The Return* (W.H.Lane & Son)

[96] Hayward, Gresty, Harold Harvey and Ernest Procter did not exhibit with STISA again. Dod Procter, having become an ARA, was asked to join in 1937. Bruford did not join until 1938, Alison Rose until 1944 and Gertrude Harvey until 1945, after her husband's death.

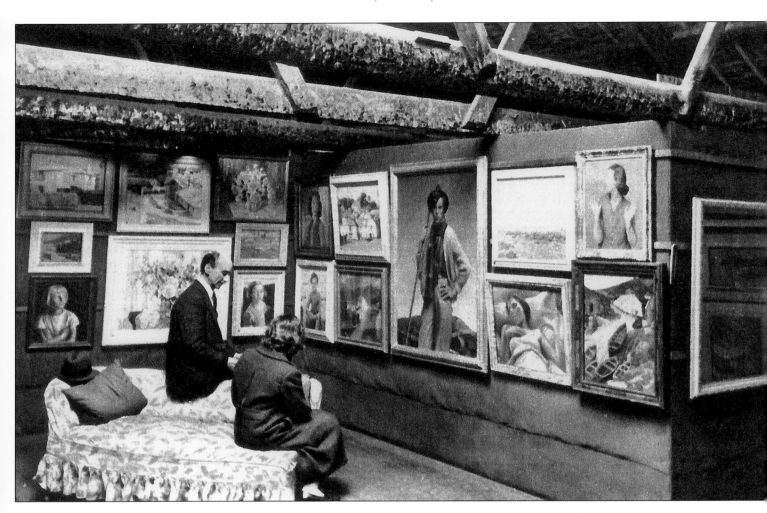

Fig. 2H-7 Arthur Hayward and Dod Procter in Shore Studio, St Ives during an exhibition of the 'Cornwall Group'.
The large painting is another Hayward self-portrait, probably *Cornish Goatherd*. Bottom right is Ernest Procter's *Porthgwarra* and, on the far left
of the photo at the bottom, is Dod Procter's, *Betty*, the daughter of Cissie Barnes' sister, Gwendolen Pollard.

For such a talented and highly respected artist, the details of Hayward's later life are surprisingly vague. He continued to have
repeated success at the RA during the 1930s and he also produced a series of colourful depictions of the harbour (see, for example.
Fig. 2H-6), many of which were reproduced as fine art prints by Frost and Reed. After 1940, Hayward's name is never mentioned
in the local press, although he was successful at the RA in 1947. Hyman Segal has indicated that he moved to London. His date
of death is sometimes given as 1971 but this may be the result of confusion with the artist Alfred Hayward, who died that year.

33. *The Boatman* oil on canvas (100cm x 91cm)
(Private Collection) (Plate 59)
In the late 1920s, Hayward embarked on a series of magnificent self-portraits. The first one recorded was exhibited on Show
Day 1929 and was called *Plein Air* and showed him with black hat and yellow jumper against a brilliant blue sky. The first of
the series accepted by the RA was *Cornish Saints and Sinners* (RA 1932), the title of a popular book of Cornish folk-lore written
by J.Henry Harris, in which Hayward features in a group of figures playing a guitar. When this was exhibited on Show Day
1930, under the title *Cornish Mendicants*, it was considered a remarkable achievement in a style similar to Laura Knight, and
it was given pride of place in the 1930 Summer Exhibition. However, a comment that a number of figures looked too
prosperous to be mendicants might have prompted the change in title. This was followed in 1933 by *A Cornish Painter*
(National Portrait Gallery), in 1935 by *The Onion Man* (Leamington Spa Art Gallery), in 1937, by *Cornish Goatherd* and *El
Charro* (featuring Hayward as a Mexican) (Fig. 2H-8), in 1938, by *Ski-er*, in 1939 by this work *The Boatman*, in 1940 by *The
Poacher* before the series finished in 1947 with *The Artist*. A painter who concentrates to such a degree on self-portraits is likely
to have a commanding ego. Perhaps that was a cause of the problem in 1932.[97]

[97] *The Onion Man*, which features him in black beret, yellow jumper and striped scarf, against a similar backdrop to *The Boatman*, is illustrated
in colour in David Tovey, *George Fagan Bradshaw and the St Ives Society of Artists*, Tewkesbury, 2000, plate 28, opposite p.145.

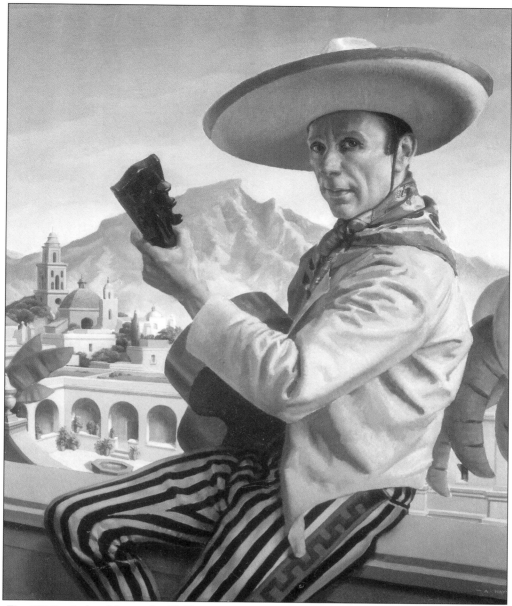

Fig. 2H-8 Arthur Hayward *El Charro* (W.H.Lane & Son)

Frank Gascoigne Heath (1873-1936) Exh. RA 27
STISA: Exh.1928-1936
STISA Touring Shows: 1934, 1936.
Public Collections include Bradford, Rochdale, Truro and Sydney.

Heath was born in Coulsdon in Surrey and was the youngest of twelve children. His father, a Building Surveyor in London, died when he was seven. He was educated locally and, as he suffered from chest problems, was sent off to sea to toughen him up, serving as an apprentice on a windjammer sailing to Australia. However, his true love was painting and he studied at South Kensington, Croydon and Westminster Art Schools and then abroad in Antwerp between 1895-7. Still keen to learn, he attended at Herkomer's School at Bushey from 1897-1900 before deciding, after a short painting trip to Brittany, to enrol at the Forbes School in Newlyn in 1901/2. On completing his studies, he settled in Cornwall and he was successful for the first time at the RA in 1904. His early work shows the clear influence of Forbes, with whom he became good friends. Being musical, he joined in all the entertainments put on by Forbes, the students and the likes of Phyllis Gotch and, in 1908, he met and fell in love with Jessica Doherty, who had also enrolled at the Forbes School. They were married in 1910 and lived initially in Polperro but, in 1912, they moved to Lamorna and built 'Menwinnion', which was to be their home for the rest of Frank's life. Friends included Alfred Munnings (q.v.) and his beautiful but tragic wife, Florence, and 'Seal' Weatherby (q.v.). The comfortable family life depicted in his 1914 RA exhibit, *The Morning Room at Menwinnion*, with Jessica playing the violin, was soon interrupted by the War and Frank was badly gassed soon after his arrival in France in 1915 and was invalided out of the Army with cerebral meningitis. His recovery was slow and he suffered from poor health and depression for the rest of his life.

Fig. 2H-9 Barbara Hepworth Gilbert Adams)

Fig. 2H-10 Frank Heath in 1930 (Hugh Bedford)

Notwithstanding his mental and physical difficulties, Heath's work of the 1920s is bursting with colour and light. *The Cornishman* at this time referred to him as "the sunshine artist" and, in addition to his successes at the RA, he had six works hung at the Paris Salon between 1927-1930. Heath was not prolific but painted, mainly in oil, a wide range of subjects - figure paintings of children and adults, landscapes, marine scenes, interiors, flowers in the garden, animals - and he was equally assured in all. In his obituary, *The Times* commented, "He was essentially an open-air artist, direct in his methods with a good sense of values and a fine taste in colour."[98]

Heath's closest ties were to the Newlyn Society of Artists but he exhibited with STISA irregularly from its inception and his contributions included *The Butterfly*, a picture showing his daughter Gabriel sitting on the side of the bath at 'Menwinnion' with a butterfly settled on her knee, which was exhibited at the RA in 1928 and at the Paris Salon in 1930, and *The Store Pot*, which was exhibited at the Paris Salon in 1928 and now hangs in the Queen's Hotel in Penzance. Other works include *The Model*, depicting the back of a nude girl surrounded by gaily coloured balloons, *The Farm Gate* and *Porthminster Beach*, which showed his family enjoying a day on the beach in St Ives (see Plate 40). In 1935, Heath collapsed with breathing problems and died the following year.[99]

34. ***Mousehole Harbour*** oil on canvas (126cm x 100cm)
(Private Collection) (Plate 77)
This painting was originally called *Saturday Morning in Harbour*, when it was exhibited at the RA in 1922, but it was renamed when hung at the Paris Salon in 1927, where it was awarded a 'Mention Honorable'. It was exhibited as *Mousehole Harbour* both in the 1934 Lincoln Exhibition and in the *Exhibition of Paintings of Cornwall and Devon*, which toured Eastbourne, Lincoln, Blackpool and Leamington in 1936/7.

[98] *The Times*, 23/6/1936.
[99] The majority of this information derives from H.Bedford, *Frank Gascoigne Heath and His 'Newlyn School' Friends at Lamorna*, Teddington, 1995.

Dame Barbara Hepworth DBE (1903-1975)
STISA: 1944-1949
STISA Touring Shows: 1947 (W).
Public Collections include Tate Gallery, Aberdeen, Belfast, Arts Council, British Council, Cardiff, Government Art Collection, Halifax, Harlow New Town, Hull, Kendal, Leeds, Manchester (Whitworth), St Ives, Scottish Arts Council, Stromness, Swansea, Wakefield, and Auckland, Wellington, Helsinki, Ottawa, United Nations Plaza, New York and many others, including a number of universities

Without doubt, Britain's leading female sculptress, Hepworth was a strong character, who was not universally liked and her machinations helped to make the split in STISA and its aftermath acrimonious. Born in Wakefield, Yorkshire, she won a scholarship to the Leeds School of Art in 1920, where Henry Moore was a fellow student, and then to the Royal College of Art in 1921, which she attended as a student of sculpture until 1924. In that year, an award enabled her to travel to Italy, where she lived mainly in Florence. In 1925, she married fellow sculptor, John Skeaping, and they lived at the British School in Rome, where they both learned the traditional Italian technique of marble carving. On their return to England, they held a joint exhibition at their studio in St John's Wood but, in 1928, she moved to Parkhill Road studios in Hampstead, where her neighbours were Henry Moore and Ben Nicholson. In 1932 and 1933, she travelled with Nicholson to Paris, where they met Picasso, Braque and other modern masters and they were married in 1934. Her early carvings were, like Moore's, inspired by the human figure, but her involvement with groups like Abstraction-Création and Unit One led her to more geometrical forms. Although abstract, her work was still inspired by nature. "In the contemplation of Nature, we are perpetually renewed, our sense of mystery and our imagination is kept alive and, rightly understood, it gives us power to project into a plastic medium some universal or abstract vision of beauty."[100]

In 1939, Hepworth and Nicholson and their triplets moved down to Cornwall at the invitation of Adrian Stokes and settled in Carbis Bay. Naum Gabo, the Russian Constructivist, joined them and they formed the nucleus for a group of artists with abstract leanings and were an inspiration to young artists arriving in St Ives after the War. During the early part of the War, unable to obtain materials for carving, Hepworth drew and made small works in plaster. In September 1942, the Nicholsons moved to Chy-an-Kerris in Headlands Road, Carbis Bay, which afforded grand views of St Ives Bay, and, with much improved studio space, she started to carve again. Many of her pieces were inspired by what she called "the remarkable pagan landscape" between St Ives and Land's End. She began to paint the interiors of her hollowed out forms blue or green to represent the sea and she used strings, like Gabo and Moore, to reflect what she called the tension between herself, the wind and the sea. In April 1943, she had her first retrospective at Temple Newsam House, Leeds.

In 1944, she was invited to join STISA along with Nicholson, but the nature of her work meant she was not included in many of the touring shows. However, she was represented in the 1947 Cardiff Exhibition by *Sculpture with Colour Blue and Red* (wood, painted with strings), which is now owned by the Tate Gallery (Fig.1-43), and *Nesting Stones*, in white marble. Other work known to have been exhibited with STISA includes *Large and Small Forms* (Cornish Elm) (Summer 1947), *Wood and Strings* (Summer 1948) and some of her hospital studies (Winter 1948).

In 1949, she bought Trewyn Studios and, after her marriage to Nicholson was dissolved in 1951, she lived there permanently, until her unfortunate death in a fire in 1975. She had two major retrospectives at the Whitechapel in 1954 and 1962 and at the Tate in 1968. She was made a C.B.E. in 1958 and a Dame in 1965. She was a Trustee of the Tate Gallery between 1965 and 1972. Her studio is now a Public Museum and one of the most popular visitor attractions in St Ives.

35. ***Seated Figure***　　　　　　　　　　　　　　　　　　pencil on oil ground on board (38cm x 32cm)
(Courtesy Hepworth Estate)　　　　　　　　　　　　　　　　　　　　　　　　　　　　(Fig. 2H-12)
The major exhibition to celebrate the centenary of Hepworth's birth is co-terminous with this Exhibition and this has made it very difficult to obtain work from her STISA period. Furthermore, financial constraints have meant that it has not been possible to include a sculpture section. Hepworth did, however, exhibit with STISA a number of the hospital studies that she made in various London Hospitals during 1948 (see Fig. 2H-11). Reviewing what proved to be the final exhibition before the split, when she exhibited *Theatre Group 4* and *Conclusion*, *The Cornishman* commented, "In these oil and pencil studies,...Miss Hepworth has departed from abstractionism to give us an intensely human glimpse of the drama enacted every day in that part of a hospital appropriately called "the theatre". At the same time, the more familiar Barbara Hepworth is present in every line, in the clinical detachment of the surgeons, in the concern for form, in the sculptor's feeling for depth and texture, as recognisable in the drawings of Michelangelo."[101] This oil and pencil study from the same period gives the figure a monumentality that is sculptural and somewhat reminiscent of Henry Moore.

[100] *Unit One* 1934.
[101] *The Cornishman*, 20/1/1949.

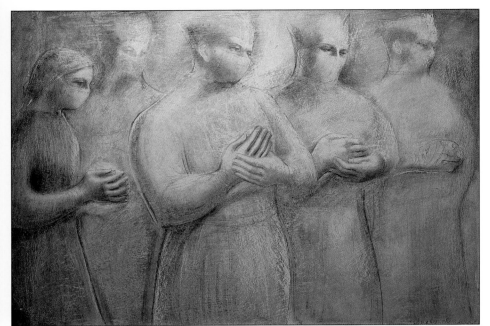

2H-11 Barbara Hepworth *The Hands*
(Bristol Museum and Art Gallery - Courtesy Hepworth Estate)

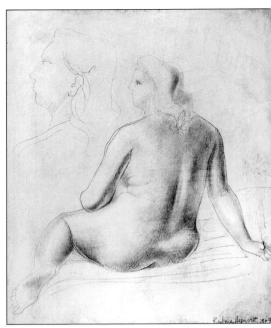

2H-12 Barbara Hepworth *Seated Figure*
(Courtesy Hepworth Estate)

(Mrs) Beatrice Pauline Hewitt ROI SWA (1873-1956) Exh. RA 19
STISA: 1927-1954
STISA Touring Shows: 1932, 1934, 1936, 1937, 1947 (SA), 1947 (W), 1949. Also FoB 1951.

Described by Terence Cuneo in his autobiography as "a first rate painter", Pauline Hewitt was one of the leading resident female artists in the colony. Her work in the late 1930s and early 1940s was particularly highly regarded. For some reason, Hewitt's date of birth is incorrectly recorded as 1907 in all the major reference books. Her obituary in the *St Ives Times* in December 1956 records her age as 83, which suggests she was born in 1873. She had a battle to pursue an art career as her mother was dead against the idea. "It was considered very Bohemian in those days for a girl to become an artist", she later commented.[102] However, a small legacy when she was 21 persuaded her to study art seriously and she spent six years at the Slade. Among her fellow students were Augustus John and Sir William Orpen. "John never cared how he dressed, and his sister shocked us all (in those days) by coming to classes without stockings."[103] Hewitt then won a scholarship and studied also in Germany and Paris. Marriage, however, curtailed her painting ambitions and she gave up completely until her son reached 12. It was in 1912 that she came to St Ives for a holiday and, with the sun shining and the sea a wonderful blue, she decided to stay. Initially, she bought an old net loft, converting it into a studio and a flat, and lived there about 7 years. When she went back to her painting, she found she could paint better than before. However, the first time her work is mentioned in reviews is in 1921. She specialised in landscapes, beach scenes and figure paintings and developed a vigorous style with a striking use of colour. Other descriptions speak of her work as being powerful, fearless and full of vitality. After working initially from St Peter's Studio, Porthmeor, she moved in 1931 to St Andrew's Studio in St Andrew's Street.

She was not at the foundation meeting of STISA but joined shortly afterwards and served on the dynamic Committee of 1928. In addition, she took responsibility for organising the first Drawing Classes in the Society's new Gallery. She also was on the Committee in 1931 and more regularly from 1942. She travelled extensively, always going away each summer. "If you go on living in the same place indefinitely, you lose your freshness of vision", she observed.[104] Her RA exhibits, which span a twenty year period from 1927, are accordingly frequently foreign subjects and only *Herring Packing, St Ives* in 1928 is a local scene. She also exhibited regularly with SWA.

In 1940, she was elected an ROI and, in August that year, a coloured reproduction of her painting *Austrian Tyrol* was reproduced in *The Artist*. The painting shows an Alpine snow scene with holidaymakers skating on a small pond in front of a church, watched by groups of spectators. However, the artist was accorded the exceptional honour of having the Editor lavish it with praise for

[102] *News Chronicle*, 1939, Cornish Artists 10.

[103] ibid.

[104] ibid.

more than a page, pointing out how much could be learnt from studying works of art of such quality. The subject, in his view, captured the essence of the Tyrol - holidaymakers enjoying both strenuous and relaxed activities whilst dwarfed by the grandeur of the mountains. He extolled the broad, simple method of painting which the artist had used to obtain a unified effect in her subject, with pigment laid on freely and fairly thickly. Unnecessary detail had been eliminated. Strong contrasts of colour and tone had been used to achieve the main effects. Warm colours used in the clothing of the figures were set against the coldness of the snow running all through the landscape, and deep shadows on the mountain's slopes gave it additional emphasis. Vivid, glowing colour made the painting palpitate with light. In fact, her marvellous handling of reflected light, particularly in the shadows, was one of the main causes for his admiration of the work. In its first 25 years of existence, I do not recall another contemporary painting being singled out in *The Artist* for such detailed and laudatory comment.

She also painted portraits and her study of fellow member, *Kathleen Bradshaw*, was included in the *Women Artists in Cornwall* Exhibition at Penlee House in 2002. A self-portrait was shown in the 1933 Winter show and, in 1944, her work *The Empty Plate* was rated as the best portrait seen for some time in St Ives.[105]

Having been a stalwart of the colony for over 40 years, she eventually left St Ives in 1954 due to failing health in order to be near her son and she died in Surrey.

36. *Summer Afternoon* oil on canvas (76cm x 102cm)
(Private Collection) (Plate 17)
The 1938 Autumn Exhibition, which included works from the permanent collection of Oldham Art Gallery, was so popular that it was extended until Show Day 1939. However, in January 1939, about 20 new works were added to the show, including this accomplished and colourful painting of two ladies resting in deck chairs outside a summer house. A reviewer commented, "The colour is intense and rich and fearlessly handled".[106] When Hewitt was photographed in her studio in 1939, she chose to display this painting on her easel.

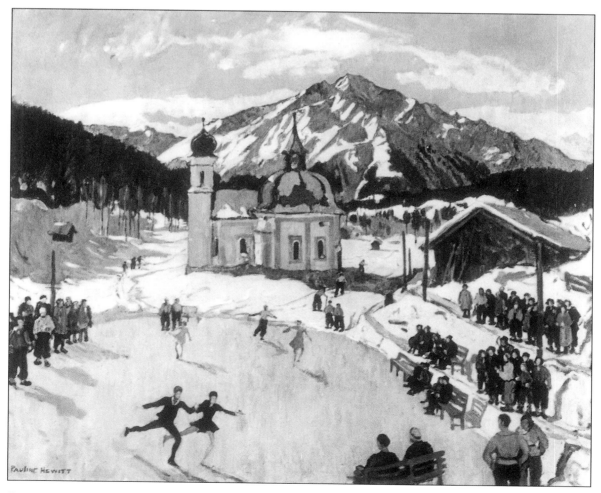

Fig. 2H-13 Pauline Hewitt *Austrian Tyrol*

[105] *St Ives Times*, 10/3/1944.
[106] *St Ives Times*, 20/1/1939.

(Miss) Marion Grace Hocken Exh. RA 1
STISA: 1942-1949 & 1952-1958
STISA Touring Shows: 1945, 1947 (SA), 1949.

Marion Hocken is generally perceived as one of a large group of competent women flower painters who were a constant feature in the ranks of STISA. This would probably be a fair assessment, were it not for one extraordinary painting, *The Hollow Men* (cat.no.37), which caused such outrage that she became a recluse and never exhibited publicly again. Born and brought up in Zennor, Hocken displayed considerable artistic talent as a schoolgirl. She was also a keen botanist and was made a Fellow of both the Zoological Society and the Royal Entomological Society. This work entailed much detailed drawing and explains her subsequent concentration on flower painting. She studied painting at Brighton and was one of the female artists drawn to St Ives during World War II, when she studied under Arthur Hambly at Redruth.[107] She first exhibited with STISA in 1942 and, from the outset, specialised in flower studies, although one exhibit, *Kwan Yin* (the Buddhist Goddess of Compassion), in the 1945 Winter Exhibition, was described as the frontispiece for an Anthology of Oriental Pottery. Her one success at the RA, *Dainty Summer*, was in 1947, when she was working from Wheelgate Studio, Lelant and, the following year, she was also successful at the Paris Salon. In 1948, she held a one-man show at Downing's Bookshop, where she exhibited oil paintings, gouaches, wood engravings and woodcuts. Her earlier work was in a flat, decorative style, often with a pale greenish tone, but later her outlook broadened and her colour became richer. Sometimes, however, the reviewer felt there was a tendency "to allow the size of the canvas and the weight of the blooms to overpower a slender vase".[108] She was stated to have considerable drive and energy, despite being lame - a physical handicap from birth - and Berlin refers to her as Bernard Leach's "amanuensis", during the period of his involvement in the Bah'ai religion, when he could be seen standing on a soap box denouncing immorality.[109]

John McWilliams remembers that when, as a boy, he went to view Marion Hocken's work on Show Days, there was a note on the door, which read:-

> *It's no use knockin'*
> *for Marion Hocken*
> *She doesn't hear too well*
> *So take a look*
> *above the hook*
> *and ring the little bell*

On Show Day in 1945, however, Hocken was the subject of a violent attack by Harry Rountree, which so distressed her that she fainted on the spot and was unable to pick up a brush for six months.[110] She was accused of the heinous crime of criticising Rountree's caricatures in 'The Sloop Inn' (see Plates 68-71 and Figs. 3R-5-8) but, despite protesting that she had never even been into 'The Sloop', it took her six months to get Rountree to drop his accusation, and she never received an apology. Hocken, therefore, had sympathy with the moderns, who had also been lambasted by Rountree, and she exhibited with Lanyon, Barns-Graham, Bryan Wynter, Denis Mitchell and Guido Morris at the pioneering show at Downing's Bookshop in 1947. She too resigned from STISA in 1949 and became one of the nineteen founder members of the Penwith Society, of which only two - Peter Lanyon and herself - were Cornish born. However, she was exactly the type of artist that the moderns did not want in their ranks and, by 1952, she was back exhibiting with STISA.

In 1953, she was elected a member of ROI and, in 1954, her exhibits at the RSA included an eight-foot long canvas *Uplong, Downlong* and several other paintings of St Ives. In St Ives, though, she continued to exhibit mainly flower paintings until she launched *The Hollow Men* on an unsuspecting audience. What feelings and frustrations led up to this bitter critique of St Ives can only be surmised. What had been said about her art by members of the Penwith Society when she had been ushered as quickly as possible out of the Society? Did she rile at the ever-increasing hype surrounding the output of the modernists? Was she frustrated by the complete absence of respect for old-fashioned virtues, such as technique? As a botanist, did dismissive comments about flower painting strike doubly hard? Did the breakdown of an affair of the heart have an impact? Did her religious fervour end on a sour note? Had she suffered unkind comments about her deteriorating physical condition? Someone may at some juncture investigate the background to this astonishing painting further - it certainly deserves more detailed study - but, from what is known, there were deep divisions within the artistic community in the late 1950s and Hocken was brave enough to pass pointed comment. The furore caused by her painting, coupled probably with problems on the home front, led her to withdraw from

[107] See S.Berlin, *The Coat of Many Colours*, Bristol, 1994 at pp.72 and 236.

[108] *St Ives Times*, July 1948. The reviewer is probably David Cox.

[109] S.Berlin, *The Coat of Many Colours*, Bristol, 1994 at p.236.

[110] She in fact inserted a notice in the local paper stating that, "owing to commissions accepted, she was unable to cope with further commission work for 6 months". *St Ives Times*, 16/3/1945.

society and she remained reclusive for almost thirty years, despite her marriage, in 1960, to the scientist, Mervyn Paul. Letters reveal that they had an interest in various alternative issues, such as the occult and alien landings, and that she did keep in contact with some figures in the art world, such as Misomé Peile, Shearer Armstrong and Arminell Morshead.[111] Her studio sale also revealed that she had still been painting quiet corners of her garden at Boskerris Worllas in Carbis Bay, where she moved in 1965.

37. ***The Hollow Men*** oil on canvas (127cm x 102cm)
(Private Collection) (Plate 63)
The title of the painting is taken from a poem of the same name by T.S.Eliot, published in 1925. Like a number of Eliot poems, it has different sections, written and often initially published separately, but drawn together subsequently as indicative of a common mood. *The Hollow Men* follows on from *The Wasteland* (1922) and shares its despair at the sterility of mankind. In fact, one commentator has said, "In the graph of Eliot's spiritual progress, *The Hollow Men* would be at the lowest point" and the poem concludes, "This is the way the world ends/Not with a bang but a whimper".[112] By adopting the poem's title, Hocken, who was also spiritually inclined, was clearly highlighting her own despair at developments not only in the art colony itself, with its constant bickerings and clashing egos, but also in the town as a whole, where she perceived an increase in commercialism matched by a decline in values. Although Eliot's lines do not seem fully understood, the first part of the poem may have had particular resonances for her. It reads as follows:-

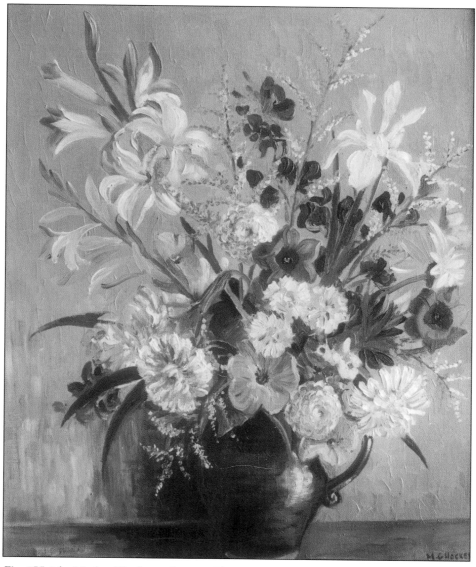

Fig. 2H-14 Marion Hocken *Summer Flowers* (W.H.Lane & Son)

[111] Photocopies of a series of letters have kindly been made available to the St Ives Archive Centre.
[112] M.Schofield, *T.S.Eliot - The Poems*, Cambridge, 1988.

We are the hollow men
We are the stuffed men
Leaning together
Headpiece filled with straw. Alas!
Our dried voices when we whisper together
Are quiet and meaningless
As wind in dry glass
Or rats' feet over broken glass
In our dry cellar

Shape without form, shade without colour,
Paralysed force, gesture without motion;

Those who have crossed
With direct eyes, to death's other Kingdom
Remember us - if at all - not as lost
Violent souls, but only
As, the hollow men
The stuffed men

As regards the painting itself, where does one start? Clearly, the style with landscape vistas intermingled with still life studies echoes the work of Ben Nicholson (see cat.no.57). The low tone colouring, with the preponderance of grey-blues, and the use of sgraffito also reflects his work. The style and colouring is so unlike any other work done by Hocken that it must have a message in itself. Having been rejected by the Penwith Society, has she deliberately set out to show that it is really not that difficult to paint in such a manner, should she so desire? Is this Eliot's "Shape without form, shade without colour/Paralysed force, gesture without motion"?

Hocken lived at 'Meadow Way House', close to the old Gasworks, the site now of Tate, St Ives, and many of the sights she will have become familiar with close to her home are shown in the painting. These, though, are depicted individually and not in strict correlation to each other. The Gasworks themselves naturally feature as does the house 'Sunset', which stands on its own above Porthmeor Beach. Frank Ruhrmund stated in Hocken's obituary that other properties represented "houses that had sold their souls for bed and breakfast".[113] However, many of the images are drawn from the cemetery - the gate to the cemetery, the railings around it, various tombs within it and the glass-domed canopies that were placed on tombs are all featured. Is this implying that St Ives or St Ives art is in terminal decline or is it a reference to "Those who have crossed...to death's other Kingdom"? Certainly, Alfred Wallis' grave, with its lighthouse design by Bernard Leach, features prominently, and boats in the bay are depicted in Wallis' style. Some read this as a tribute to Wallis - the only good artist is dead; it is certainly a comment on the obsession with Wallis displayed by Nicholson, Berlin and many of the moderns but, given that by this time, Hocken had fallen out with Leach, it may not be complimentary. Although the artists ensured Wallis was not buried in a pauper's grave, he still died forlorn in a workhouse. How would he remember them?

The line of gravestones outside the chapel has been interpreted as representing members of STISA, who have waited so long for their works to be hung that they have died first! However, the chapel depicted is not the Mariners' Chapel, which became the Society's Gallery, but the cemetery chapel, where one would expect to find gravestones nearby.

The three central figures are based on local traditional wooden dolls, known as 'Joannies'. Ruhrmund observed that, for Hocken, the dolls "represented rigidity and repression, hypocrisy, lifelessness in life and even cruelty".[114] The dolls, however, would certainly have been empty and hollow and, having been depicted, in typical modern art style, from both front and back in the same figure, can be said to be two-faced. Despite the title of the painting, the figures are female and one wonders whether they were intended to represent particular personages. Some feel that one might refer to a Ms Hepworth.

The above comments are put forward diffidently and raise more questions than they answer but, hopefully, the painting's inclusion in the Exhibition will tempt others on to the quest.

[113] *St Ives Times*, 12/7/1987.
[114] *St Ives Times*, 12/7/1987.

(Mrs) Eleanor Mary Hughes (1882-1959) Exh. RA 37
STISA: 1933-1949
STISA Touring Shows: 1934, 1936, 1937, 1947 (SA), 1947 (W), 1949.
Public Collections include Oldham, Penzance and Dunedin.

Eleanor Waymouth was born in Christchurch, New Zealand on 3rd April 1882. Her parents had emigrated from England and her father became Managing Director of the Canterbury Frozen Meat Company. Encouraged by her grandfather, who gave her a fine wooden box of watercolours, she was awarded, at the age of 18, a medal by the Canterbury Society of Art for her drawings of trees and architectural studies around Christchurch. Accompanied by her sister, she came to London to study at the well-known 'Yellow Door' Studio under Frank Spenlove-Spenlove. In 1907, she moved to Newlyn in Cornwall to study under Stanhope and Elizabeth Forbes and, whilst there, met and fell in love with a fellow student, Robert Morson Hughes. They married on 29th January 1910 at St Buryan Church, near Penzance. After staying briefly at Cliff House in Lamorna, they moved in 1912 to 'Chyangweal', near St Buryan, a house built to their own design. This was to be their home for the rest of their lives. Eleanor maintained a studio in the Lamorna valley, where she worked and her husband and herself were fully involved in the social life of the valley, which revolved around Lamorna Birch. She remained friends with Harold and Laura Knight after their move to London in 1918, and also fraternised with Dod Procter and Charles Simpson amongst others.

Hughes was primarily a landscape painter and she worked almost exclusively in watercolour, favouring the outline and wash method. She first exhibited at the Royal Academy in 1911 and was a regular contributor until 1939, exhibiting 37 works in all. She also exhibited 34 times at the RI, being elected a member in 1933. Locally, she exhibited with the Newlyn Society and joined STISA in 1933, being represented in the major touring of the 1930s and 1940s. The majority of her work depicts the local Cornish countryside, concentrating on trees, stone walls, streams and waterfalls. She was also fascinated by old tin mines. One reviewer described her aptly as "a portrait painter of trees".[115] Whereas Birch would be drawn to the old and quaint buildings of favourite local haunts, like Trewoofe and Boleigh Farm, Eleanor would find untold majesty in the surrounding trees. These she recorded in intricate detail and she had a great ability to use light and shade to create space.

Fig. 2H-15 Eleanor Hughes at the piano in 1939.

Robert and herself also travelled extensively, particularly to France, and they had a love for the Alps and the Pyrenees. Accordingly, there are a number of works depicting Alpine villages nestled beneath majestic mountains and of rocky torrents.

In the late 1930s, she took up etching, her style being well-suited to this medium, but examples are rarely found. In 1940, she sold her studio and, during the War, helped evacuee children. Her painting output dropped significantly thereafter, particularly as her husband was ill for a long time prior to his death in 1953. They had no children. In addition to her art, she was an accomplished pianist, loved gardening and cooking and made her own clothes. Her niece remembers her as a person of great warmth and zest for life.

38. ***Sauveterre de Béarn*** watercolour (49cm x 39cm)
(Gallery Oldham) (Plate 85)
This was one of the works from Oldham's permanent collection which was added to STISA's 1934 exhibition at Oldham. The painting had originally been exhibited at Huddersfield and Oldham in 1925 and had been bought off the artist that year. It shows the view from the banks of the River Oloron of the remains of the fortified bridge at Sauveterre de Béarn, now covered in creeper. The impressive fortifications of the Chateau de Nays are seen in the background. The peaceful reflections in the pool in the foreground contrast with the fast flowing current of the river. The world salmon fishing competition is now held here. The 2002 *Women Artists in Cornwall* exhibition contained another watercolour, depicting the view from the Chateau looking down upon the fortified bridge, presumably dating from the same visit (see Plate 86).

[115] *St Ives Times*, 7/10/1938.

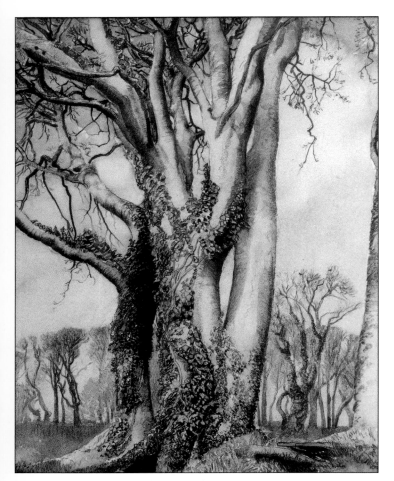

Fig. 2H-16 Eleanor Hughes *Beech Trees*
(Private Collection)

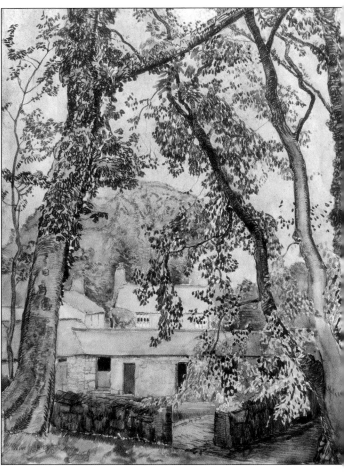

Fig. 2H-17 Eleanor Hughes *Trewoofe, Lamorna*
(Private Collection)

Robert Morson Hughes (1873-1953) Exh. RA 21
STISA: 1933-1953
STISA Touring Shows: 1934, 1936,1937. Also FoB 1951.
Public Collections include Penzance.

Born in Sussex, Bertie Hughes lived until he was 20 in Kent and was educated at Sevenoaks. His father was agent to an estate and Bertie was lined up for a career in agriculture but this held little attraction. His father commented, "If you want something without much work, you had better go in for art". Bertie, who was keen on sketching, leapt at the opportunity and studied for a session at the Lambeth School of Art, before coming under the influence of Buxton Knight. In 1905, he came to Lamorna, with Charles Crombie, the popular illustrator, and became a close friend of Lamorna Birch. They both shared a passion for fishing and shooting and Hughes is featured as the angler in a number of Birch's works. In 1907, when Hughes was back living in Kent and studying art in South London, Birch went to stay with him and, when they were not painting, they were out shooting. In 1909, he returned to Lamorna and attended the Forbes School and there met his wife, Eleanor. They married the following year, which was also made memorable by his first success at the RA. In 1912, he was elected to the Newlyn Society of Artists, a body with which he was to be closely associated for many years. Too old for active service in the War, he joined Birch in the local Volunteer Force.

Principally, a landscape painter in oil, Hughes depicted the woods and valleys around his home at St Buryan and the rocks at Lamorna. An interviewer in 1939 felt that the following motto might aptly apply to his work, "Art is truth. I will be faithful. I will not ornament my vision" but, although some of his work can seem lacking in inspiration, he did produce some evocative works, helped by lyrical titles, such as *Green-Robed Senators of Mighty Woods*, *The Coming Gold that Melts into the Grey* and *The Unnumbered Smiling of the Sea*.[116] The Birch family would often refer jokingly to the "Bertie Hughes method of painting". Whereas most artists would search out a suitable subject and, having found it, would settle down to record it, however great the discomfort, Bertie would apparently find the most comfortable, wind free spot he could and then paint what he saw![117] For holidays, France was a favourite destination and paintings of the French Alps feature regularly in his exhibits at the RA.

[116] *News Chronicle* 1939, Cornish Artists 13.
[117] I am indebted to Adam Kerr for this reminiscence.

Like many of the Newlyn and Lamorna artists, Hughes had exhibited in St Ives before the formation of STISA. In fact, he exhibited there on Show Day in 1924, when he included the original study for *Rhododendron Dell at Kew Gardens*, one of eight works commissioned by Queen Mary. Although he contributed to several early STISA shows, he did not join STISA until 1933. He was a regular contributor for the rest of his life, although, after the war, he was seriously ill with cancer of the tongue and his work is not mentioned in exhibition reviews as much and was not included in the 1940s touring shows.

39. ***Below Carn Barges*** oil on canvas (51.5cm x 60.5cm)
(Newlyn Art Gallery, on loan to Penlee House Gallery and Museum) (Fig. 2H-18)
Carn Barges, which is an impressive cliff close to Lamorna Cove, was a favourite haunt of the Hughes family and the view back towards Lamorna is featured in a Jessica Heath painting (Fig.3H-11). Although this painting is called *Below Carn Barges*, an almost identical painting was illustrated with Borlase Smart's article on STISA published in *The Studio* in 1948, under the title *Boscawen Point*. Without doubt, the triangular formation of rocks featured in the painting are those at Boscawen Point, situated about a mile down the coast from Carn Barges, although the pillars of rock framing the view might be derived from Carn Barges, which does have somewhat similar layered rocks beneath it. The painting has two principal features - a decorative treatment of rock formations and an impressive handling of sunlight glaring off a calm sea.

Dame Laura Knight DBE RA RWS RE RWA PSWA NSA (1877-1972) Exh. RA 283
STISA: 1936-1945
STISA Touring Shows: 1937, 1945.
Public Collections include Tate Gallery, National Portrait Gallery, Royal Academy, Government Art Collection, RE, Birmingham, Blackburn, Blackpool, Bolton, Bradford, Bristol, Cardiff, Doncaster, Harrogate, Hereford, Hull, Leeds, Manchester, Newcastle, Newport, Nottingham, Nottingham University, Oldham, Oxford (Ashmolean), Penzance, Port Sunlight, Preston, Rochdale, Sheffield, York (National Railway Museum) and, abroad, Adelaide, Auckland, Brisbane, Dunedin, Perth, Sydney, Wellington, Johannesburg, Cape Town, Pietermaritzberg and Ottawa.

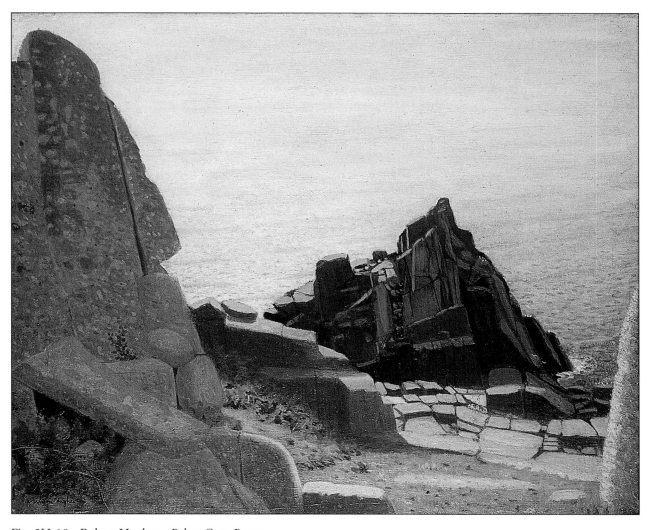

Fig. 2H-18 Robert Hughes *Below Carn Barges*
(Penlee House Gallery and Museum, Penzance)

Laura Knight joined STISA in the year that she became the first woman to be elected a full RA that century and the year which saw the publication of her autobiography. Unsurprisingly, she made an immediate impact. Born in Long Eaton, Derbyshire, Laura Johnson was brought up in Nottingham, along with her two sisters, by her mother, Charlotte, as her father had left home before she was born. Her mother taught art and encouraged Laura's talent. She spent a year attending an art school near Paris and then, in 1890, went to Nottingham School of Art, where she met Harold Knight. In 1895, she joined Harold Knight in Staithes on the Yorkshire coast, revelling in "the freedom, the austerity, the savagery, the wildness".[118] In 1903, the Knights married and, for three consecutive years between 1905-1907, they visited Holland, where they were much taken with the work of Rembrandt, Vermeer and Frank Hals. In 1907, they decided to move to Cornwall and soon made friends with some of the younger artists studying under Stanhope Forbes - particularly, Dod Shaw and her future husband, Ernest Procter and Charles Simpson. Laura wrote, "We had never known the joys of youth before. We danced, played games and lived half the night as well as working hard all day." Alfred Munnings was often the instigator of the entertainment and their vivacious personalities and total commitment to their art ensured mutual attraction and admiration. The carefree and convivial life in Newlyn affected her art. "An ebullient vitality made me want to paint the whole world and say how glorious it was to be young and strong and able to splash with paint on canvas any old thing that one saw."[119] Although she had had her first success at the RA in 1903, under her maiden name, she now was producing work that was receiving considerable attention and her two exhibits of 1910 *Flying a Kite* and *Boys* were bought by George Clausen for South African Public Galleries.

In 1912, the Knights moved into the first home of their own, Oakhill, near Lamorna, and the local landowner, Colonel Paynter, converted a hut on the cliffs near Lamorna as a studio. He also did not object to Laura painting London models in the nude out of doors - a practice which raised a few eyebrows amongst the locals. She also completed a number of large landscapes *en plein air*, one of which *Spring*, painted and exhibited at the RA in 1916 was eventually bought by the Chantrey Bequest in 1935.

War-time brought the idyllic life to an end and Harold Knight's pacifism was not popular.[120] The suicide of Munnings' first wife, Florence, who was a friend and model, was also a shock. Sketching restrictions meant outdoor work was difficult and, in 1918, the Knights decided to move to London, which remained their permanent base for the rest of their lives, although they did retain studios in Lamorna for a few years. Laura then started on the depictions of ballets, circuses and gypsies for which she is best known.

The first work that she exhibited with STISA was *Myself and Model*, showing Ella Naper posing nude for Knight, who depicts herself in "the Cornish Scarlet".[121] This large work, which dates from 1913 and is now owned by the National Portrait Gallery, is featured in one of the most fascinating images of the Society. When it was hung at the 1937 Winter Exhibition, which opened in January that year, a photograph was taken of the whole Committee standing before it, whilst Moffat Lindner explained aspects of its technique (Fig. 1-11). The presence of works by Royal Academicians was often used in this way to demonstrate painting processes that members would find informative. When the painting was included in the 1937 Bath show, it was priced at £525, by far the most expensive work exhibited with STISA during its first quarter-century.[122] Other major paintings exhibited with STISA included *Crystal and Flowers* (Autumn 1939), a painting of gypsies at a race-course, *The Thames from the Victoria Embankment* and *The Young Hop-Picker* (1945 tour). During the War, she worked as a war artist and she was then appointed to record the Nuremberg trials. She did not exhibit with STISA after the 1945 tour.

40. *Newlyn Old Harbour*　　　　　　　　　　　　　　　　　　　　watercolour (39.7cm x 50cm)
(Gallery Oldham)　　　　　　　　　　　　　　　　　　　　　　　　　　　　　　　(Plate 87)

Knight's biographer, Caroline Fox, comments, "The extreme refinement and delicacy of her watercolours contrast with the much broader brushwork of her oil paintings; as her critics have been quick to emphasize, her Cornish watercolours are some of the finest she produced."[123] The 1938 Autumn Exhibition was unique in that Oldham Art Gallery lent works from its permanent collection to the Society's show in St Ives. In addition to large oils by Olsson, Birch and Talmage, this watercolour by Laura Knight, dating from 1911, was included. The reviewer commented, "An amazing knowledge of the medium gives strength and variety to a very personal interpretation."[124]

[118] L.Knight, *Oil Paint and Grease Paint*, London and New York, 1936, p.75.

[119] ibid, p.186.

[120] This may explain why Harold Knight was never asked to be a member of STISA. Borlase Smart, George Bradshaw and Francis Roskruge, all military men, may well have not forgotten his stance.

[121] This was the name given by art critic, Paul Konody, to a red cardigan, which featured regularly in paintings by Knight and was also used once by Gertrude Harvey, when posing for her husband.

[122] The same exhibition included Dod Procter's *Light Sleep*, priced at £400 - the second highest price recorded in the same period.

[123] Quoted in Richard Green, *A Century of British Art 1900-2000*, London, 2001 at p.160.

[124] *St Ives Times*, 7/10/1938.

Fig. 2K-1 Smart, Fuller and Bradshaw hanging the 1938 Autumn show, helped by Tonkin Prynne. Smart is adjusting Laura Knight's portrait of Bernard Shaw.

41. *George Bernard Shaw* oil on canvas (60cm x 49.5cm)
(Hereford City Museum and Art Gallery) (Plate 15)
This work was painted while Knight and Shaw were attending the Malvern Theatrical Festival in 1932. It was originally exhibited at the RA in 1933 but was also included in STISA's 1938 Autumn Exhibition. A photograph shows it in the process of being hung by Borlase Smart (Fig. 2K-1). The reviewer commented, "The head and shoulders of the great satirist are seen in strong relief against a blue sky and mountainous background. As in this artist's watercolour work, the vigour of the approach is notable. The sitter is lit by a real out-of-door effect of half sunlight, emphasized by the complimentary background to the warm-toned features."[125] Knight discusses the portrait in *Oil Paint and Grease Paint*. It had been prompted by Shaw's comment, "I am offended that you have never asked me to pose for you." The task was not made easier by Shaw having agreed at the same time to sit for the Hungarian sculptor, Professor Stroedel, who wanted to model Shaw from a variety of angles, whereas Knight naturally wanted a single pose. Shaw immediately alerted the artists to certain of his features. "Do you notice the projection at the base of my skull behind? Catherine of Russia had the same. I am told it means excessive sexual development". Some days, Shaw sang airs from operas and often they discussed painting. He may not have been that knowledgeable, as later he admitted that a watercolour by Knight was the only painting he had ever bought. However, it was important to keep him talking. When the portrait was finished, Shaw made one final repartee, with a wicked glint in his eye. "Charlotte says that portrait you painted of me is the worst she has ever seen in her life: you made me a sincere man and all my life I have been an actor!"[126] A drawing *G.B.Shaw posing for his bust* is owned by Nottingham Castle Museum, but this is said to date from 1949.

42. *Gypsies at Ascot* oil on canvas (62cm x 48cm)
(Hereford City Museum and Art Gallery) (Plate 16)
It was Alfred Munnings, who first suggested that Laura Knight should go to Epsom, but he had anticipated that she would be interested in the horses, whereas, in fact, she became fascinated by the gypsies that attended such race meetings. In order that she could paint undisturbed amidst the huge crowds at both Epsom and Ascot, she hired an old Rolls-Royce, which had a high roof that could accommodate her easel. She soon herself became quite a public attraction at the race courses and the gypsies were keen to earn a modelling fee. She got to know them so well that she was invited to paint at their camp at Iver in Buckinghamshire and joined them for evenings around the camp fire. As a result, she produced many gypsy works in the late 1930s. This painting was bought by Hereford in 1942 for £100.

[125] *St Ives Times*, 7/10/1938.
[126] L.Knight, ibid, p.377-380.

Reginald Guy Kortright (b.1877) Exh. RA 33
STISA: 1936-1939
STISA Touring Shows: 1936, 1937.
Public Collections include Birkenhead, Bristol, Toronto and Wellington (NZ).

Kortright was a landscape artist, who developed his own distinctive, decorative style. He was the son of the Colonial Governor, Sir George Cornelius Kortright, and was born in Clifton, Bristol in 1877. He was educated at Newton College, Newton Abbot before moving with his family to Canada. His initial art training was with Wyly Grier, the Australian who had spent some time in St Ives, but, at the age of 20, he decided to continue his studies with Grier's brother, Louis, who was then running a painting school in St Ives with Julius Olsson. Writing in 1934, he paid special tribute to "that excellent artist, the late Louis Grier, who for many years was my instructor in Cornwall. He impressed on my mind, amongst other useful information, the importance and value of form and decoration in even the humblest of landscapes."[127] He first exhibited at RCPS in 1897 and, in 1899, he visited Paris in the company of two other art students from St Ives, Norman Wilkinson (q.v.) and Hugh Heard.[128] Wilkinson seems to have remained a friend, as Kortright signs him into the Arts Club in 1902. He appears to have returned briefly to Canada in 1903/4 but he was based in St Ives until c.1912, remaining a member of the Arts Club and occasionally exhibiting on Show Days, before deciding to settle in Wales. During the War, he was engaged as a camouflage officer at Liverpool but, afterwards, he moved to London, preferring to work in watercolour, rather than in oils as before. Whilst there, the countryside of West Sussex became very dear to him and he began to develop his own distinctive brand of decorative landscape painting. A reviewer of a London one-man show in 1926 commented that "his eyes have a sight of quite their own, concerned more with the broad feeling of the land than any topographical literal proprieties". He was accordingly "willing to let realism go if he can thereby gain the things of space and line and colour which he loves most fervently". His watercolours were considered to be "immensely expressive of the tenderness and purity of nature and her cool gentleness, especially in Spring". However, by the 1930s, when he joined STISA, he was again working in oils and his views on *Decorative Landscape Painting* were expounded in a series of articles in *The Artist*.

In selecting a subject, Kortright looked for "pattern and design, line and arrangement - not forgetting the important spaces". Above all, he sought "line - clear-cut, decisive, determined line".[129] Kortright was lucky to have a photographic memory. Accordingly, with the aid of sketches made many years previously, he could recreate landscape scenes that had taken his fancy. These sketches varied in the amount of detail that they contained. Sometimes mere outlines and some chalk colour notes would suffice. Others noted detailed patterns of trees, stones or shadow shapes. When setting to work on the final painting, he would begin by drawing the principal outlines on the canvas before applying any pigment and, as they represented a sure and certain guide to his desired pattern, he would try to maintain such outlines for as long as possible, "filling in the space between with the required colours almost in the fashion of *cloisonne* enamel".

Kortright often aimed to achieve a matt surface to his work and, therefore, used very little medium, avoiding oil as a medium all together. He felt this 'dry' manner of applying colour resulted in a rather pleasant 'grainy' surface but acknowledged that it had the disadvantage of being a somewhat slow process. Accordingly, where fairly rapid manipulation was required, as in painting a sky, he used turpentine as the medium and a very fluid white.[130]

Kortright was a modest man, who never pushed himself as an artist, and was delighted when Bristol and Birkenhead Art Galleries bought examples of his work. The Museum of New Zealand, Wellington also have two works - one a Welsh scene and the other Spanish. He has remained, however, little known and yet his style is very typical of the 1930s. He also exhibited decorated furniture, where his gifts of colour and decorative spacing made their mark.[131]

43. ***Castillon de Plana (Spanish Cactus)*** oil on canvas (76cm x 63.5cm)
(Williamson Art Gallery, Birkenhead) (Plate 34)
 This painting amply demonstrates Kortright's concern with "clear-cut, decisive, determined line" and decorative pattern. A watercolour version of this scene was illustrated in Kortright's first article on *Decorative Landscape Painting* under the title *In Valencia, Spain*. The composition is very similar, except that in the foreground of the oil, Kortright has inserted the deep channels in the soil to provide yet further pattern. The use of colour is limited, again so as to enhance the decorative effect. The sub-title draws attention to the scattered cacti in the foreground, whose colouring link into the somewhat stylised foliage of the few trees surviving in this arid district.

[127] G. Kortright, *Decorative Landscape Painting, The Artist*, October, 1934, p.36.
[128] A photograph by J.C.Douglas in the Arts Club, believed to have been taken in 1895, indicates that Guy Kortright is featured but I cannot find evidence that he was in St Ives that early. A Percy Kortright was signed into the Arts Club by Grier in October 1898 but again his prior movements are not known.
[129] G. Kortright, *Decorative Landscape Painting, The Artist*, October, 1934, p.37.
[130] G. Kortright, *Decorative Landscape Painting, The Artist*, December 1934, pp.104-106.
[131] Quotations and information largely derived from Guy Kortright by Jessica Walker Stephens, *The Studio*, Vol.91, Jan 1926, p20-23.

Fig. 2K-2 Leonard Campbell Taylor *Guy Kortright painting in Spain* (G.E.Sworder & Sons)

George Peter Lanyon (1918-1964)
STISA: 1937-1949
STISA Touring Shows: 1945, 1947 (W), 1949.
Public Collections include Tate Gallery, Government Art Collection, Arts Council, British Council, Birmingham, Kendall, Manchester, Manchester (Whitworth), Plymouth, Stromness, Truro and, abroad, Melbourne, Perth, San Antonio, Buffalo and others.

Peter Lanyon was the only member of the modern contingent to be born in Cornwall. His father, Herbert Lanyon, was a concert pianist and composer and was one of the early members of the St Ives Arts Club. He was also a distinguished photographer and many of the photographic portraits of the early artists were taken by him. Peter, therefore, grew up in an atmosphere where art, music and poetry were practised and discussed. In 1931, he was sent to Clifton College, Bristol and, on leaving, he received some lessons in drawing from Borlase Smart and accompanied him on sketching trips of the Cornish cliffs. After a visit to South Africa, where he exhibited some work in Johannesburg, he was elected an associate member of STISA in 1937 along with his sister Mary, who was to marry fellow member Sidney Schofield (q.v.). In that year, he met Adrian Stokes, the writer, who encouraged him to enrol at the newly-formed Euston Road School in London, where pupils were taught by William Coldstream and Victor Pasmore. Lanyon there became more inclined towards abstraction and considered Adrian Stokes' book *Colour and Form*, his 'Bible'. Through Stokes, he was introduced to Nicholson, Hepworth and Gabo and he studied for a while under Nicholson. He was also influenced for a period by Gabo's Constructionism. In the War, he served in the RAF as a flight mechanic, during which time he invented a Hydraulic Test Rig. He gave talks on the History of Art and continued painting, whilst also experimenting with his own Constructions. On his return, he used the studio in his father's house that Gabo had occupied during the War and bought Little Parc Owles, which Stokes had vacated. In 1946, he married Sheila St John Browne and, by 1954, they had had six children.

Fig. 2L-1 Peter Lanyon painting in Naples
(courtesy of Sheila Lanyon)

His War experiences altered his attitude to art and he found increasing inspiration from the Cornish landscape. Dissatisfied with the exposure the young moderns were getting at STISA shows, Lanyon joined forces with fellow STISA members Wells, Berlin, Wynter and Barns-Graham, along with the printer, Guido Morris and others, and, between 1946 and 1948, they held three exhibitions in the Crypt of the Mariners' Church, which had been altered in 1945 to become STISA's Gallery. These are now considered seminal shows and Lanyon is credited as one of the prime instigators. In July 1947, he exhibited at Downing's Bookshop with Nicholson and Hepworth and had his own show there that September. His contributions to STISA's touring shows were *Cote d'Azur* and *Ypres Cathedral* (1945), *Prelude* and, a watercolour, *Heart of the Sea* (1947) and *Elm Cross, 1948* (1949), while shows in St Ives included *The Yellow Runner, Construction in Green* and *Construction in Space, Spheric.* Lanyon was active in the split in 1949 and resigned from STISA at that time. He had his first London one-man show in October 1949 at the Lefevre Gallery. However, he was one of the artists to resign from the Penwith Society in 1950 and he became bitter at the influence of Nicholson and Hepworth on that Society. In 1956, he wrote, "While this Society by its constitution aims to maintain the older and more realist tradition, it is clear to anyone visiting the gallery, that this painting is being strangled, and that a largely abstract Society of painters is emerging." In these circumstances, he queried whether it was appropriate for the Arts Council funding, that had so supported the Society, to continue, particularly when STISA and the Newlyn Society of Artists could not get any such funding.[132]

Lanyon commented that the "breakthrough from the Gabo-Hepworth-Nicholson abstraction and the basis of all my paintings since" came with his painting, *Portreath*, upon which he started work in 1948.[133] The painting was shown at the Arts Council's Festival of Britain Exhibition in 1951 and is now owned by the Tate Gallery. From this start, Lanyon developed a new way of representing landscape visually. To familiarise himself with his subject, he experienced the landscape in all moods by walking, bicycling, and driving through it. Eventually, he took to gliding over it. In each instance, he would make drawings of different features, seen from as many angles as possible. When starting to paint, he had no idea of the form that would eventually materialise but, using details from his drawings, he would then plot the broad planes of movement into and across the picture surface. Inspired by the intense emotional impact of his experiences in the landscape, powerful, often difficult, images would eventually emerge after much trial and error. His work came to reflect not only people and buildings in the landscape but the weather, history, ancient myths and modern industries, such as farming, tourism and tin mining.

Lanyon is now recognised as one of the leading members of the St Ives Group of the 1950s and 1960s and his career was cruelly cut short by his death in a gliding accident in 1964.

Fig. 2L-2 Peter Lanyon at work on one of his Constructions
(Gilbert Adams)

[132] *St Ives Times*, 6/7/1956.
[133] Recorded talk by Lanyon in 1963, edited by Alan Bowness.

44. *Green Form, Italy* oil on paper (38cm x 27cm)
(Private Collection) (Plate 67)

This work is dated 1945 and accordingly was painted by Lanyon in Naples, where he was based between August 1944 and February 1946. Overlapping forms enable Lanyon to create spatial tensions using colour and the inclusion of the sort of strings used by Gabo and Hepworth in their work confirm that they, along with Nicholson, were the principal influences upon his art at this period. Although Lanyon did not return from Italy until 1946, Borlase Smart ensured that he was represented in the 1945 touring show by work presumably left whilst on leave. Surprisingly, this work has never been exhibited before.

45. *Generation* oil on plywood (88cm x 34cm)
(Private Collection) (Plate 66)

The Generation Series is considered to be the most important body of work Lanyon completed during his membership of STISA. Works from the series were first exhibited at the second Crypt Group exhibition in August 1947 but the catalogue for Lanyon's show at Downing's Bookshop in September 1947 specifically lists *Yellow Runner*, *Annunciation*, *Prelude* and *Generation* as part of the Generation Series.[134] In February 1949, Lanyon wrote to Gabo indicating that the series "took about 18 months to complete and consisted of eight works" but the other works have not been conclusively identified. Lanyon did confirm, however, that *Generation* completed the series and commented "The final picture of the series being vertical has a curious relationship to a mother and child."[135] The series as a whole was inspired by his marriage and the birth of his first child. Interestingly, by the time of the Downing's show, *Generation* had been acquired by the still life painter, Helen Stuart Weir (q.v.), a friend of the Lanyon family. This demonstrates that a traditional painter could find beauty in this exploration of form, colour and space. Being a sculptor as well, Weir will have appreciated the sculptural feel that the work possesses and the shapes and forms clearly owe as much a debt to Hepworth's pierced pieces as to any womb imagery. This painting was subsequently exhibited at the Salon des Réalités Nouvelles in Paris in 1949, at Lanyon's one-man show at the Lefevre Gallery in 1949, in Plymouth in 1955 and at the Arts Council show in 1968.

Sydney Lee RA RBA RE (1866-1949) Exh. RA 105
STISA: 1931-1937
STISA Touring Shows: 1934, 1936.
Public Collections include British Museum, Victoria and Albert Museum, Tate, QMDH, RA, RE, Manchester, Glasgow, Liverpool and Oxford (Ashmolean).

Although a celebrated artist in his day for his work in all media, it is his 'black and white' work for which he is most respected now and his exhibits with STISA were largely restricted to his superlative wood engravings and aquatints. Born in Manchester, he studied at Manchester School of Art and at Colorossi's in Paris. There is no record of him ever studying in St Ives but he appears to have visited on a regular basis. He was a guest at the Arts Club in October 1896 and he stayed at 8, Tregenna Terrace in August 1898. A coloured woodcut, *The Sloop Inn, St Ives*, which was included amongst his STISA exhibits, is dated 1904. As a printmaker, Lee was versatile in a wide range of media; in etching, drypoint, aquatint, mezzotint, lithography, wood engraving, and the wood cut (both black and in colour using the Japanese manner, a technique he learned from Frank Morley Fletcher). He was elected an ARE in 1905 and became a Fellow in 1915. He was also a founder member of the Society of Wood Engravers in 1920, an active member of the Society of Graver-Printers in Colour, and a member of the Council of Art and Industry. At Central, he taught the first wood engraving classes to be offered by a London art school.

As a painter and a printmaker, he is known for his mountainous landscapes, town scenes, and architectural subjects, often drawn from his tours in Spain, France, Switzerland, and Italy, particularly Venice. He was very successful internationally, winning gold medals at Munich and Milan, a bronze medal at Barcelona and Honourable Mentions at Paris and the Carnegie Institute, Pittsburg. He was elected an ARA in 1922, becoming a full Academician in 1929. He was then elected Treasurer of the RA in 1932 and was just beaten by Lutyens in the 1938 election for President. His painting *Among the Dolomites* was purchased by the Chantrey Bequest in 1924. He was married to the daughter of Edward Elgar and lived in Holland Park Road, Kensington, from 1909.

His work was first included in the 1932 Summer Exhibition, after he had paid a return visit to St Ives, and it is no coincidence that, for the first time, the 'black and white' section gets pride of place in the review. Other well-known prints exhibited with STISA include *The House with Closed Shutters*, *Cathedral Doorway* and *The Sleeping Square*.[136] Colnaghis held one man shows of his work as a printmaker and draughtsman in 1937, 1939 and 1945 but he appears to have ceased exhibiting with STISA in 1937. His exhibits at the RA in the year after his death include a work, *St Ives*.

[134] The series seems to have been inspired by a work called *Generator*, painted in 1946, which was illustrated with Borlase Smart's article, *The St Ives Society of Artists*, published posthumously in *The Studio*.
[135] Typescript of an Illustrated Slide lecture on English Landscape 1964.
[136] I am deeply indebted to Robert K Meyrick, Senior Lecturer and Keeper of Art, School of Art Gallery and Museum, University of Wales, Buarth Mawr, Aberystwyth for information contained in this biographical note and for comment on Lee's work but any errors are my own.

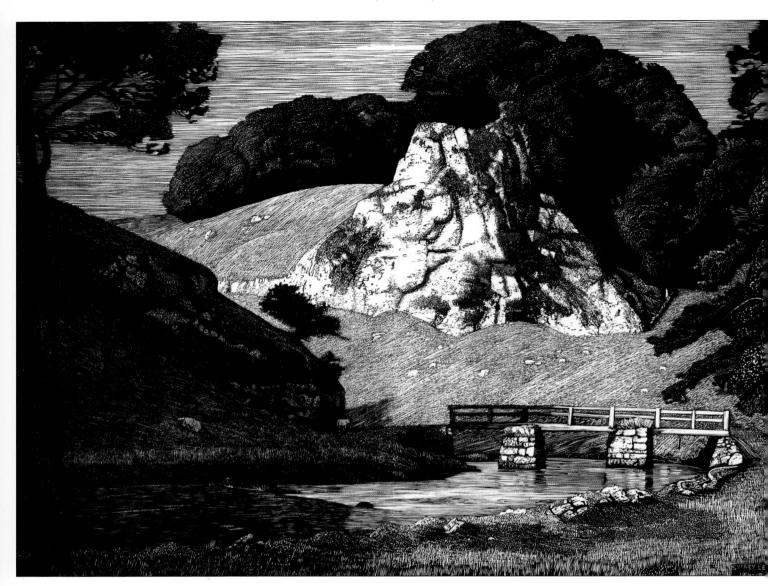

Fig. 2L-3 Sydney Lee *The Limestone Rock* (wood engraving) (Collection of Robert Meyrick

Lee was a seminal force in the revival of wood engraving in Britain in the early years of the 20th century. A keen exponent of the white-line technique, his unusually large wood engravings display a painterly attention to tone and texture. This print, which was included in the 1934 STISA tour, was first published in 1914 and was immediately hailed as one of the greatest examples of the art of wood-engraving. Its pictorial qualities its design, its well-balanced masses of tone and the expressive manner in which the material was used were all highlighted, as was Lee's ability to differentiate textures by the infinite variety of the character and direction of his incisions. Malcolm Salaman explained how Lee worked, "Mr. Lee' practice is to settle carefully the main lines of his design as to masses and placing, and then to develop his picture in detail as he goes, tool in hand and adopting suggestions from the material itself."[137] In the Foreword to the 1937 Colnaghi Exhibition Catalogue, Lee commented, "It i particularly gratifying to me, remembering my own attempts to revive an interest in this attractive medium, to witness the great interest now take in wood engravings."

46. *The House of Mystery* aquatint (46.5cm x 35cm)
(Hereford City Museum and Art Gallery) (Fig. 1-10)

This house was situated in Barnards Castle and copies of this print, originally executed in 1927, were purchased for the permanent collections of both Cheltenham and Hereford Art Galleries from the 1936 tour. It is a typical Lee subject, as he tended to concentrate on historic buildings or interesting architectural details for a work's central motif and then explored the play of strong sunlight on the crumbling stone, brick, or plaster. Often, although not in this instance, he added small groups of figures, a horse and cart, or oxen. When the print was exhibited in St Ives in the 1933 Winter Exhibition, the reviewer commented, "The quality of the surface rendering of the buildings leaves one mystified as to his methods but completely satisfied as to the result."[138]

[137] M.C.Salaman, *The Woodcuts of Mr Sydney Lee ARE*, *The Studio*, 1914, pp. 19-23.
[138] *St Ives Times*, 24/11/1933.

Moffat Peter Lindner RBA ROI RI RWS RWA RBC (1852-1949) Exh. RA 68
STISA: 1927-1949, President 1927-1945
STISA Touring Shows: 1932, 1934, 1936, 1937, 1945, 1947 (SA), 1947 (W).
Public Collections include QMDH, Blackpool, Cheltenham, Doncaster, Huddersfield, Hull, Liverpool, Northampton, Oldham, Auckland, Dunedin, Adelaide, Barcelona, Cape Town, Venice and Paris.

Moffat Lindner is one of the key figures in the success of STISA. As an artist of considerable national and international renown, he commanded great respect not only in the colony but in the art world in general. A quiet man, he nevertheless offered unfailing support, advice and encouragement, as well as financial assistance. The son of a wealthy merchant, he was born in Birmingham in 1852. In a talk to members of STISA in 1929, Lindner recalled his youth and training. By the age of 5, he was drawing ships in full sail and he used watercolour for the first time aged 10. Later he had lessons from a pupil of David Cox and "learnt to look at nature broadly". "I had many opportunities of seeing the Master's work and, to this day, I have always looked upon those lessons as the foundation of my present success." However, his father insisted that he join the family business. "It was not till I was about 22, that I resolved to cut the mercantile business under my father and to take to art as a profession. I realized that good drawing was essential and went to the Slade School for a term or two.[139] But I soon tired of that and began making elaborate studies from nature: trees, hedgerows, skies etc." His aim was to understand exactly how each object was constructed. His first success at the RA, in 1881, was a watercolour full of intricate detail, which took him six weeks to complete, but he gradually moved away from such an approach, rejecting detail and searching instead for an object's essence or truth, and he developed the loose, impressionistic style for which he is now well known. More than one critic considered "he had drunk at the Turnerian stream".[140] Lindner, however, was by no means merely a watercolourist and many of his major works were painted in oils. Nevertheless, in either medium, water was a favourite subject and he produced countless pictures of rivers and harbours at sunset, under moonlight or at the first flush of dawn. Lindner was not in favour of *plein air* painting. With the constant changeability of water and sky effects, he felt such work could never be real, true and perfect. Instead, he preferred to make some quick sketches on the spot before returning to his studio for the painting process. When sketching from nature, Lindner would work out the changes needed to the scene before him to make a better composition, having particular regard to the placing of the boats and the distribution of light and shade, and would then work feverishly, using brush and colour rather than pencil or charcoal and noting the different tones and colours. "Then I just sit there until the effect is gone, letting it soak into my mind and making mental notes...I can remember effects like these years afterwards if I refer to my notes."

Lindner was the only artist elected to membership of the RBA during Whistler's Presidency in 1888 and his nocturnes, in particular, betray the influence of Whistler, with whom he remained friendly until the end. So prevalent were such scenes amongst his output that, even as early as 1890, he had been dubbed 'the moonlighter'.[141] He was elected to the NEAC in 1889 and was to become good friends with Philip Wilson Steer. An exhibit, *Moonlight, St Ives*, in an exhibition at the Grosvenor Gallery in 1889 indicates he had already visited the town and he first exhibited with RCPS in 1890. He was a member of the St Ives Arts Club by the 1892/3 season but he tended to divide his time between London and St Ives. He was President of the Arts Club for the first time in 1899 and, in 1900, he entertained Steer and Fred Brown in St Ives, during which time Steer painted a beautiful portrait of Augusta Baird-Smith, a student at the Olsson School, who was to become Lindner's wife. He was re-elected President of the Arts Club many times - in 1911-12, 1914-17 and 1926.

Lindner, like many NEAC members, was not a great believer in the RA but, nevertheless, he exhibited there fairly regularly and he won a bronze medal at the Paris International Exhibition of 1900 with *Evening Glow - Dordrecht* and a gold medal at the Barcelona International Exhibition of 1911 with *The Storm Cloud, Christchurch*. In 1911, he began exhibiting in the *Landscape Exhibition*, the annual exhibition of a small group of leading landscape painters, and, in 1913, he had a one-man show of his watercolours at the Fine Art Society, entitled *Waterways of Venice and Holland*. In 1917, although already a member of RI (1906), he was made a member of RWS, its rival, and was a major supporter of this Society, exhibiting 165 works there. Even though Lindner was 75 when STISA was formed, he was still selling works regularly to Public Art Galleries in this country and abroad.[142] However, his range of subjects was becoming ever more limited - moonlight in St Ives, sunset at Amsterdam, the estuary at Etaples, the canals of Venice and the Maas at Dordrecht appeared time and again. Given Lindner's age, his reliance on old sketch books and tried and tested subjects might seem acceptable, but a critic writing as early as 1911 commented:-

"I can quite imagine the keen interest [Lindner's] group of pictures might arouse in anyone who is not acquainted with his art. How charmed one would be with the massive construction of his *Stormcloud* and with the glowing red orb half-veiled by the

[139] The reference books also indicate he attended Heatherley's.
[140] C.Lewis Hind, *Mr Moffat Lindner's Watercolours of Venice*, The Studio, 1904 Vol 32, p.188.
[141] *The Whirlwind*, 5/7/1890.
[142] Sales to Public Galleries at this time were 1924 - Doncaster, 1925 - Cheltenham and Northampton, 1926 - Dunedin (2), 1927 - Adelaide, 1929 - Blackpool and 1930 - Auckland (2).

Fig. 2L-4 Leonard Fuller *Moffat Lindner* (RA 1943) (Private Collection)

Fig.2L-5 Moffat Lindner with *On the Giudecca*, his RA exhibit of 1936. Works entitled *The Giudecca* were exhibited at the RA in 1922, 1923 and 1927 and this painting has an almost identical composition to that in Auckland Art Gallery (Plate 4).

vaporous murk of his *Sunset - Amsterdam*. But when one has seen the same cloud reflected in the same waters time after time, and when one has seen Amsterdam in the same tragic sunset for the last ten years, one begins to wonder whether Mr. Lindner's brushes have acquired the trick and do their work mechanically while the artist is asleep."[143]

An example of *Sunset - Amsterdam* is reproduced as Plate 73.

By the mid-1920s, Lindner was very much the elder statesman of the art colony and his influence should not be underestimated. He appears to have been one of the organisers of the Cheltenham Exhibition in 1925 and, so great was his standing amongst the artists, that the formation of a new Art Society would not have been mooted without his support. His election as first President of STISA was a formality. At the first AGM in 1928, Bradshaw paid tribute to his commitment and to his input, particularly in obtaining new members, and commented that, without Lindner's advice and experience, the Society would have petered out many months previously. Having acquired the Gallery at 5, Porthmeor Studios in 1928, the future was rendered very uncertain in 1929 when the whole block of Porthmeor Studios was put up for sale. Lindner came to the rescue by acquiring the freehold, thus, in the words of Borlase Smart, "preventing what might have been a serious crisis in the history of St Ives art".[144]

Lindner continued to take a great interest in the Society right to the end of his long life and his exhibits, both in oils and in watercolour, repeatedly won high praise. Terrick Williams, in an address in 1930, complimented him on being broadminded, "with a ready eye in noticing the excellence in all types of work, including the advanced".[145] Despite poor health in the 1940s, which often meant that he could not attend functions, he was still re-elected as President and, in 1942, on his 90th birthday, the members of STISA clubbed together to buy two of his watercolours and presented them to St Ives Town Council. For such a highly regarded artist in his own day, his work is now little known, with many of his finest pieces sitting unseen in Gallery basements.[146]

[143] Unidentified paper commenting on the 16th Landscape Exhibition - January 1911 - from the artist's scrapbook. Other critics refer to his "storm cloud" as having become a "studio property", wanting the inspiration of recent contact with nature. *Athenaeum*, January 1911.

[144] Many artists since then have been grateful to Lindner for his foresight and his generosity, as he made the studios available at reasonable rents. Just before his death, the studios were acquired by a Trust with the aid of the Arts Council and the Borlase Smart Memorial Fund and are still in use by artists. Without Lindner, these wonderful, enormous studios, so redolent of another age, would, in view of their prime position on the beach, have been converted to housing long ago.

[145] At the opening of the 1930 Spring Exhibition of STISA, *St Ives Times*, 18/4/1930.

[146] Quotations taken from a transcript of Lindner's talk to STISA on 24/4/1929 on Water Colour Painting. See also Dr G.C.Williamson, *Moffat P.Lindner and his Work, The Artist*, April 1902, pp.197-206.

47. ***On the Maas*** oil on canvas (51cm x 62cm)
(Private Collection) (Plate 3)
The Maas was another favourite subject and paintings such as *Fresh Breeze on the Maas*, *Storm Clouds on the Maas* and *The River Maas at Dordrecht* will be similar scenes. The lively brush strokes depicting the water indicate that a fresh breeze is blowing and the play of sunlight and shade on the river's surface is attractively handled. The great bulk of cumulus cloud was a feature of many of Lindner's works. Another version exhibited on Show Day 1937 was described as " a gay, breezy picture of dimpling water and speeding clouds".[147]

48. ***Venice from the Lido*** watercolour (35cm x 51cm)
(Private Collection)
Lindner was as adept at watercolour painting as he was in oils and he exhibited work in both media at the RA. His watercolour style is distinctive - very soft in colour and very wet. In his talk to STISA on watercolour painting, Lindner commented that "the charm of watercolour is in its transparency, its purity and its luminosity...A good watercolour has the air of being done easily and rapidly but it is the result of much concentration, observation and training of the memory."

An exhibition of Lindner's watercolours at the Fine Art Society in 1913 was described by *The Studio* as "a fascinating display of the capacities of an artist who has exceptional originality of outlook and a very high degree of technical confidence. His work is always worth studying for its brilliant directness of handling, its dainty charm of colour, and its luminous freshness of tone quality...In his Venetian studies especially, he is very happy in suggesting elusive subtleties of atmosphere and in conveying a telling suggestion of the chosen subject by means of the frankest possible devices of execution. He never fumbles, he is never in doubt, and he never weakens the strength of his statement by unnecessary elaboration".[148]

What is startling about this watercolour on close inspection is that the main focal points of the work - the principal sails of the boats and the hull of the lead boat - are pure white paper![149] Another version of this scene is in the permanent collection of Huddersfield Art Gallery.

John Littlejohns RI (b.1874)
STISA: 1933-1947
STISA Touring Shows: 1934, 1936, 1937, 1945, 1947 (SA).
Public Collections include Hereford.

Born in Orchard Hill, near Bideford, Devon, Littlejohns was a pupil-teacher of drawing at the Bideford School of Art at the age of 16. His wife, Idalia Blanche Littlejohns, was also a painter, writer and lecturer and they were based mainly in London, working from 4 Brook Green Studios. He was elected to the RBA in 1919 and was a regular contributor to their exhibitions, showing 163 works in all. Marion Whybrow records him as a member of the St Ives Arts Club sometime in the years 1911-1920 and he certainly visited on occasion, as the RBA exhibition of 1923 contains his work *Low Tide, St Ives*.

In the mid-1920s, he teamed up with Leonard Richmond to write and illustrate a book on *The Art of Painting in Pastels*. Littlejohns' illustrations included some striking portraits and some fine flower paintings. By 1926, the book, which looked at the three different methods of working in pastel, and demonstrated by reference to illustrations the various stages in working up a picture, was already being hailed as "a classic" and, so encouraged, the pair went on to dominate the world of books on art technique for the next 50 years.[150] The most popular of their books was on *The Technique of Watercolour Painting* and both this and the pastels book went through numerous editions, being enlarged and repackaged right into the 1970s. Littlejohns also wrote and illustrated on his own a number of books on art technique, such as *Sketching in Nature in Line and Tone*, *The Composition of Landscape* and *An Introduction to the Study of Colour*. There were educational works like *How to Enjoy Pictures* and *The Training of Taste in Arts and Crafts* (written jointly with A.Needham) and, in 1931, he published *British Watercolour Painting and Painters of Today*, a highly acclaimed survey of the British contribution to this genre. This was the medium that he preferred working in and he was elected as a member of the RI that year, contributing some 52 works to their shows over the years. During the 1930s, he also contributed articles on a regular basis to *The Artist*.

Littlejohns was also one of the members of STISA who was much in demand as a poster designer. Working for LNER, he produced a number of attractive posters (see, for example, Plate 27) in which bright, flat colours were used to enhance decorative patterns.

[147] *St Ives Times*, 19/3/1937.
[148] *The Studio*, Vol. 60, 1913 p.141.
[149] The painting is illustrated in David Tovey, *George Fagan Bradshaw and the St Ives Society of Artists*, Tewkesbury 2000, Colour Plate 3.
[150] *The Studio*, Vol.91, 1926, p.227.

Writing about his own art, he commented, "An inveterate experimentalist, I am continually trying new methods, and often choose and design subjects to suit the technical method in which I am, at the moment, especially interested". In the 1930s, he became increasingly interested in the decorative element of his work and, as a result of his study of Colour Harmony, he painted "with deliberately restricted colour schemes, finding that the loss in range was more than compensated by the gain in decorative restraint".[151]

49. ***A Scottish Harbour*** watercolour (36cm x 41cm)
(Hereford City Museum and Art Gallery) (Plate 29)
The location of this harbour scene, which was exhibited at the RBA in 1929, has not been identified but Littlejohn's paintings are rarely direct representations of particular places. He was much more concerned with the overall design of the subject and the way in which the colours used harmonised so as to produce a decorative result. In his view, an experienced painter "does not go to Nature with an empty mind but with tendencies, convictions, and ideals, looking for further material with which to express them". When sketching, therefore, he observed, "I seldom confine my drawing to just what I see, except when making pencil notes of details. Sometimes consciously, but more often unconsciously, numberless modifications creep in because I am thinking all the time of the coming picture. Some features are made larger, others smaller or left out altogether. The construction may undergo considerable changes."[152] In fact, he was quite prepared to produce landscape scenes that were wholly contrived, based on little more than a distant memory or a detail from an old sketch pad.[153] Accordingly, given that the artist himself conferred upon this work the title, *A Scottish Harbour*, it is unlikely to be a readily identifiable location.

Thomas Maidment (1871-c.1960) Exh. RA 21
STISA 1932-1959
STISA Touring Shows: 1932, 1934, 1936, 1937, 1945, 1947 (SA), 1947 (W), 1949. Also FoB 1951.
Public Collections include Birkenhead, Brighton, Manchester and St Ives.

In the 1930s, Maidment enjoyed considerable success with his distinctive, detailed depictions of quaint corners in old St Ives and he was particularly appalled at the Council's Slum Clearance Scheme and the eventual demolition of St Peter's Court and Pudding Bag Lane, one of his favourite subjects. Little, however, is known about his early life, although he did study at the Royal College of Art and won a travelling scholarship. He later indicated that he started out as a draughtsman, distinguishing himself in geometry and modelling. At that time, he had a yen to be a sculptor, but decided the life of a painter was not so precarious. Although not borne out by the RA exhibition listings, he claimed that his first RA exhibit was when he was 22 and that it was a scene painted in Normandy.[154] When he next exhibited at the RA in 1905, he was living in Ilford but, by 1910, he had settled in Newlyn, living first at 5, Antoine Terrace before moving to Elm Close by 1912. A note of a Committee Meeting of the Newlyn Society of Artists in April 1911 mentions that he was interviewed with a view to taking charge of the Gallery for a short time and he did exhibit with the Society for many years. However, further success at the RA eluded him until he moved to St Ives in 1932. It seems that the artistic environment in St Ives inspired him to better work and, for the rest of his career, he was a regular exhibitor at the RA and had a number of his works bought by public Galleries. His subject was almost invariably the quaint old houses of St Ives, which he recorded in painstaking detail. He was particularly interested in capturing the patina on roof tiles, chimney bricks and crumbling walls. The intricacy of his depictions always aroused comment and he was one of the artists who publicised the attractions of old St Ives. However, he had a very different set of colour values to Park, Richmond and Truman, who painted similar subjects. He felt that a painter should be true to nature and should not "force colour". Accordingly, he preferred sombre shades and grey tones. His method of working reflected his training as a draughtsman. He approached his subject slowly and methodically, doing "a sort of map of the place" first. "Then I get the drawing into the picture. I paint with oil more or less in the manner of watercolour painting. I like to get detail into my canvases."[155]

Maidment was frequently on hanging committees (see Fig. 2B-6) and served on the main Committee between 1939-1941, but he moved to Helston in 1944. In 1951, one of his works was purchased from STISA's Festival of Britain Exhibition for the Town's permanent collection and he is also represented in the public collections of Brighton (*Farm Scene, St Ives*, bought from STISA's 1932 Exhibition there - Fig.2M-1) Birkenhead and Manchester. In 1934, his RA exhibit *Farming Pattern : Hillside, St Ives* was so highly rated that it was exhibited by special invitation at both Brighton Art Gallery and the Royal Scottish Academy. He moved to Torquay in 1952 but was still exhibiting with STISA in 1957.

[151] J.Littlejohns, *British Water-Colour Painting and Painters of To-Day*, London, 1931, p.93/4.
[152] ibid.
[153] This work may only be on show in Hereford.
[154] *News Chronicle*, 1939, Cornish Artists 24.
[155] ibid.

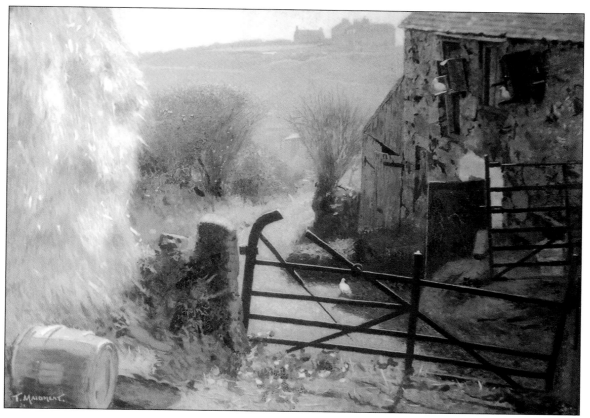

Fig. 2M-1 Thomas Maidment *Farm Scene, St Ives* (Brighton Museum and Art Gallery)

50. *The Old Harbour, St Ives* oil on canvas (71cm x 92cm)
(Manchester City Art Galleries)
When this painting, showing the classic view across the harbour from the Malakoff, was first exhibited on Show Day in 1937, Charles Procter commented, "This is photographic - I might almost say microscopic - in its exactitude of detail and painted with meticulous care, yet the whole composition is harmoniously effective."[156] It was hung in the main room of the RA Exhibition that year and was then exhibited by special invitation at Manchester Art Gallery, where it was purchased for the permanent collection.[157]

51. *Old Houses, St Ives* oil on canvas (76cm x 61cm)
(Williamson Art Gallery and Museum, Birkenhead) (Plate 23)
This painting, which was exhibited at the RA in 1935, is an interesting mixture, for the artist has chosen to depict certain portions of it in great detail but the cats, the figures by the harbour and the distant headlands are more like cardboard cut-outs and seem influenced by contemporary poster design. Even in his depiction of the tiles and the patina of old walls, there is concern for decorative pattern and the painting is a good example of the less colourful tonal range that he adopted.

William Westley Manning RBA ROI ARE (1868-1954) Exh. RA 34
STISA: 1938-1949
STISA Touring Shows: 1947 (W), 1949.
Public Collections include British Museum, Victoria and Albert Museum, QMDH, RE, Los Angeles, Johannesburg, Osaka, Stockholm, Moscow and Vienna.

Manning was educated at University College School before studying at Julians, Paris. It is not known whether he studied in St Ives but he certainly resided in the town for a while as he was a guest of Olsson at the Arts Club in October 1896 and, in 1899, he exhibited at the RA a work entitled *Lingering Light - St Ives*.[158] He went on to become a well-respected landscape painter and printmaker, winning a Mention Honorable in Paris, and his etchings and aquatints are held by many Art Galleries worldwide. He became a member of the RBA in 1901 and exhibited with that society an astonishing 222 works. In 1916, he was elected an ROI and the following year an ARE. In 1929, Colnaghi's published *The Aquatints of W.W.Manning* and it was, in the main, his 'black

[156] *St Ives Times*, 19/3/1937.
[157] This painting is illustrated in David Tovey, *George Fagan Bradshaw and the St Ives Society of Artists*, Tewkesbury, 2000 at p.134.
[158] In 1937, he is called a former resident of the Colony.

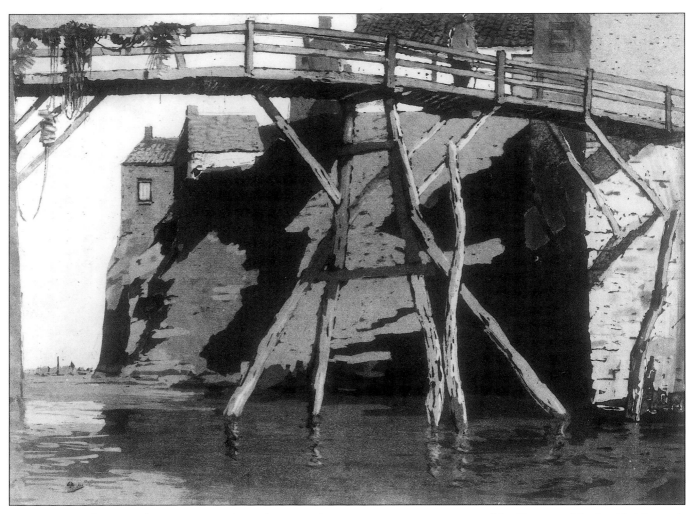

Fig. 2M-2 William Westley Manning *The Bridge at Staithes* (The Trustees of the British Museum)

Fig. 2M-3 William Westley Manning *The Alhambra, Granada* (The Trustees of the British Museum)

and white' work that he exhibited with STISA. Although he always lived in London, he came to work in St Ives during 1937 and was persuaded to join STISA. His exhibit in that year's Summer Exhibition was a painting of St Ives Bay. He returned to Cornwall in 1939, as the British Museum has an aquatint, *Mousehole*, executed on 20th March 1939. Its collection also includes an aquatint of the river near Truro. For the 1947 tour, Manning contributed *Settignano*, which had been exhibited at the RA in 1934 and which is illustrated in Guichard's *British Etchers 1850-1940*, and *Pembroke Castle*, another print in the collection of the British Museum, where he uses a mixed method of aquatint and etching with great success. Manning's last exhibit with STISA was an aquatint of *Durham* in the 1949 Swindon show - a print that had been purchased by the Austrian Government for Vienna Art Gallery.[159] Whether old age or the split put him off exhibiting further with STISA is not known.

52. *The Bridge at Staithes*
(The Trustees of the British Museum)

aquatint (26cm x 35.5cm)
(Fig. 2M-2)

This work, which was bought for the British Museum by the Contemporary Art Society, was originally exhibited at the RA in 1924. It was added to STISA's 1937 Autumn Exhibition in February 1938, along with *The Alhambra, Granada* (Fig. 2M-3 - also in the collection of the British Museum). With its strong angular lines and alternating patches of light and shade, it ranks as one of Manning's finest decorative designs.

Mary McCrossan RBA (1863-1934) Exh. RA 22
STISA 1927-1934
STISA Touring Exhibitions: 1932, 1934.
Public Collections include Liverpool, Salford, Southport, Birkenhead, Rochdale (formerly Contemporary Art Society).

The daughter of James McCrossan, a Liverpool ironfounder, she studied at the Liverpool School of Art under John Finnie. She then went to the Academie Delecluse, Paris, where she was awarded a silver medal, a "mention" and a scholarship for drawing and painting from the life. Her teachers in Paris included Messieurs Callot, Delance and L'Hermite. She completed her training in St Ives under Julius Olsson. James Hamilton Hay, a friend who also studied at Liverpool and at St Ives at the same time, considered "the careful study of values under Julius Olsson at St Ives" to be some of the most useful training he received.[160] McCrossan was probably in St Ives in 1897-9, as her first RA exhibits included *St Ives Harbour* and *White Gigs* (1898) and *Sunshine, St Ives* (1899).[161] On her return to Liverpool, she would have enjoyed the artistic revival in the City around the year 1900, when Herbert MacNair and Augustus John were teaching at Liverpool University and MacNair and Gerard Chowne at the Sandon Studios Society, of which McCrossan was a member.[162] She also joined the Liver Sketching Society.

One source indicates that she lived for a while at Oxford (where she depicted a number of the Colleges) before moving to 126 Cheyne Walk, Chelsea, where Hamilton Hay painted her in her studio overlooking the Thames. This painting shows her reading, whilst reclining on a window seat, with a full length, multi-coloured silk robe draped over her shoulders. A work of Egyptian art hangs behind her and the whole scene exudes taste and elegance. There is nothing as sordid as an easel on view.[163] However, she seems to have returned to visit St Ives on occasion - an exhibit at the 1908 Exhibition of the International Society of Sculptors, Painters and Engravers being *St Ives Harbour, Night* - and, in 1910, both her RA and NEAC exhibits record a St Ives address. She certainly took one of the Piazza studios at this time for a while, and gave painting lessons there, but it is likely that she remained based in London.

Her independent means enabled her to travel extensively and popular destinations were the South of France and Italy. In 1922, she had a show at the Goupil Galleries, which was described by *The Studio* as "a mass of glowing colour". A recent extended Italian tour is indicated by the inclusion of depictions of Rome, Amalfi, Florence, Assissi, Siena and Perugia. In 1925, she strengthened her connections with St Ives by exhibiting at 4, Island Studios on Show Day and she had four works included in the 1925 Cheltenham show. These included *The Doge's Palace, Venice*, a watercolour subsequently bought by Southport. In 1926, she was elected to membership of the RBA and, in 1928, the Contemporary Art Society bought her watercolour of *Southwold Harbour* for inclusion in the collection of the Tate Gallery, but this rather disappointing work has now found its way to Rochdale.

Although she was not in St Ives at the time of the foundation meetings of STISA in 1927, she joined almost immediately and, in 1929, she settled permanently in the town, living at 3, Seagull House. In 1932, she edited for publication the letters of her old Liverpudlian friend, Dixon Scott, described as "a pre-war young journalist, a bit of a poet who adventured into life with an

[159] *St Ives Times*, 8/4/1939.

[160] Walker Art Gallery, *James Hamilton Hay*, Catalogue to 1973 Exhibition, p.4.

[161] She first exhibited with RCPS in 1898 and, on Show Day 1899, she had in Olsson's studio "some clever marine studies" *St Ives Weekly Summary*, 25/3/1899.

[162] Hamilton Hay also acknowledged John's influence at this time, ibid, p.5.

[163] ibid, Plate 11.

Fig. 2M-4 Mary McCrossan

enthusiasm for anything offered" and "a person who knew most of those who were making literary and dramatic history at that time".[164] She was a regular and highly regarded contributor to STISA's early exhibitions, principally landscapes and harbour views with the occasional still life, and she also exhibited at Newlyn but, in 1934, she suddenly suffered a fatal stroke. After her death, a retrospective exhibition of 51 works was held in her old Porthmeor Studio (No.3), the oils being arranged by Smart and the watercolours by Moffat Lindner. Further retrospectives were held in 1935 at the Walker Art Gallery, Liverpool and at the Beaux Arts Gallery, Bruton Place, where she had held a successful exhibition, *Landscapes of Provence and Cornwall*, in 1928. In his appreciation of her work, Borlase Smart commented:-

"Miss McCrossan's art was very personal. Her general colour sense can be summed up in a predilection for silver, grey, pale gold and pastel blue. All her work in this scheme of colour values showed a beauty of tone and harmony most appealing to the art lover. She showed a lively reaction to the pattern of her subject. This appreciation of the design of Nature was especially to be noted in her interpretation of moving water."

Similar comments were made by the *Times* critic when reviewing her 1928 show:-

"Considering her extreme delicacy in both drawing and colour, it is astonishing how everything by Miss McCrossan reveals her; we cannot think of any contemporary artist who is more immediately recognisable in a mixed exhibition. The reason is partly her temperamental and playfully imaginative attitude to her subjects and partly her sense of rhythmical pattern."[165]

McCrossan was almost stone deaf and always wore around her neck a pencil and pad to assist communication. Nevertheless, she was adept at lip reading, witty in her remarks and bore her affliction with unfailing cheerfulness. Accordingly, she made friends easily and many fellow members of STISA and the Arts Club attended her funeral.[166]

53. *St Ives* oil on canvas (43cm x 58.5cm)
(Williamson Art Gallery and Museum, Birkenhead) (Plate 37)
Smart observed that McCrossan was "a loyal artist to the town of her adoption. She knew the Harbour and its immediate neighbourhood, and painted it with artistic understanding. Her clever realisation of new view points provided an element of surprise even to the busiest of painters of St Ives." If this vista is compared with the standard view from the Malakoff, as depicted by Spencer (Plate []) or Maidment (cat.no.50), one can see that McCrossan has found a higher vantage point further round towards Porthminster from which the Island headland seems to appear directly behind the town. This also affords a vista of the beaches on both sides of Smeaton's Pier, the sinuous line of which draws the eye of the viewer into the circular composition. The intense blue of the sea suggests a summer's day but the disturbance of the water's surface indicates a cooling breeze, which is being taken advantage of by several fishing boats with sails raised.

54. *The Witchball* oil on canvas (60cm x 50cm)
(Salford Museum and Art Gallery) (Plate 54)
McCrossan could hardly have devised a more complicated still life arrangement than this and yet she succeeds admirably. She has placed on a table covered by a blue-bordered cloth a silvered glass 'witchball', a blue bowl of fruit containing oranges, grapes and a lemon, a blue cup and saucer, a small dark grey vase of mixed flowers and a china figure of a red and blue angel holding a candle. These stand in front of a mirror, which also reflects a ledge on which are pictures, a jug containing brushes and a candle stuck in a bottle. In the witchball, there are distorted reflections not only of the objects on the table but the whole room, in the centre of which can be seen the artist standing painting at her easel. The painting was exhibited, to considerable acclaim, on Show Day in 1932 and was bought by Salford from McCrossan's Memorial Exhibition held at the Walker Art Gallery in Liverpool in 1935.

[164] Publicity sheet issued by the publishers, Herbert Joseph, London. Dixon Scott had also been a friend of Hamilton Hay, who had illustrated his book on Liverpool (1907).
[165] *The Times*, 9/5/1928.
[166] Much of the above biographical information is derived from papers held by Walker Art Gallery, Liverpool, which include a scrapbook maintained by one of the artist's sisters. I am deeply indebted to Moira Lindsay at the Gallery in this connection.

55. *Brixham*

watercolour (25.5cm x 35.5cm)

(Private Collection)

This is one of a series of watercolours of Brixham that McCrossan executed in 1933 and exhibited in 1934, the year of her death. It was as a watercolourist that McCrossan made her name, being considered one of the leading female artists in this medium, allying decorative charm to sound construction. Borlase Smart commented that her watercolour work "reflected the purist method of using the white paper as the source of light". As a result of this and the use of pure washes, her work had a luminous quality.[167]

Fig. 2M-5 Mary McCrossan in her St Ives Studio
The painting on the floor is *Boats at Honfleur*, which was used as the front cover illustration for her Memorial Exhibition catalogue. The painting of two yachts to the left of the painting on the easel is called *Regatta*. Her Witch Ball can be seen hanging from the ceiling.

[167] This painting is illustrated in David Tovey, *George Fagan Bradshaw and the St Ives Society of Artists*, Tewkesbury, 2000 at p.122.

Frederick Milner RBC RWA (c.1860-1939) Exh. RA 43

STISA: 1927-1939

STISA Touring Shows: 1932, 1934, 1936, 1937.

Public Collections include QMDH, Cheltenham, Eastbourne, Preston, Sunderland, Truro and, abroad, Auckland, Buenos Aires and Portalegre.

Like Moffat Lindner and Arthur Meade, Fred Milner was a survivor from the first generation of artists that had made the colony internationally renowned. Still a regular RA contributor, Milner's landscape work was always held in the highest regard at STISA shows. "He presents Nature as quiet beauty, as a balm to a tired world".[168]

Remarkably little is known about Milner's early life, although he studied at Wakefield and Doncaster Schools of Art. In the 1890s, he was living in Cheltenham and visited Cornwall on a regular basis. "Then one summer," Milner recalled "painting near The Lizard, I met Julius Olsson and he persuaded me to come to St Ives to live."[169] In April 1892, Milner was signed in as a guest of Julius Olsson at the St Ives Arts Club and his first RA exhibit that year was *Low Tide on the Bar*, showing surf breaking on Hayle Bar. In 1894, another RA exhibit was *Low Tide, Lelant Creek* but he does not appear to have settled permanently in St Ives until 1898. He lived initially at 'Draycot' before moving at the beginning of the century to 'Zareba', Trelyon Hill which was to be his home for the rest of his life and which he considered had one of the finest views in St Ives. A small man, Milner was both modest and convivial and was always well-liked by his brother brushes. In 1905, he was President of the Arts Club and he was particularly friendly with Sir Alfred East, with whom he used to go out painting. Smart, Bradshaw and other younger members of STISA never tired of hearing Milner's recollections of the days when East, Brangwyn, Arnesby Brown, Talmage and Americans like Elmer Schofield (q.v.) were painting in St Ives.

Milner's speciality was tranquil landscapes. The critic, 'Madder Brown', commented, "There are few better painters of the English countryside than Fred Milner. He makes us feel that our subscription to the Society for the Preservation of Rural England is overdue." Milner returned to the Cotswolds regularly for his subjects and Corfe Castle in Dorset held a particular fascination for him. So regular were his depictions of this "ancient stronghold" that they became known as Milner's "Corfe Drops". Unlike Brown and Talmage, however, Milner's art did not change unduly and he was often referred to as Victorian in his approach, although this was not intended as a criticism. Milner, in fact, welcomed being so described, as it implied a high level of technical accomplishment. Milner could also paint some fine seascapes. Smart commented, "I remember in the early days seeing two six footers of marine subjects on the line, which impressed my novice mind as the work of a master who knew his subject and who knew how to paint. What breadth and mastery!"[170] Julius Olsson was similarly impressed and told Milner that if he continued in that fashion, he would soon put him, Olsson, out of work.

Milner's sister married into the Robinson family, who were in the cork trade in Portugal, and, as he frequently went to see his sister, Portugese subjects are quite common amongst his work. For instance, his RA exhibits include *January in Portugal* (1905), *Portalegre, Portugal* (1911) and *In the Alemtejo, Portugal* (1919 & 1934). However, it was sometimes felt that he had bestowed too much of an English feel to the Portugese countryside.

Although Milner's major works were in oil, he also produced "scores of charming and simply expressed watercolour drawings, which were inspired, as he himself stated, by the master of that medium - Cotman".[171] In addition, he produced mezzotints, which revealed "the bigness of outlook so prevalent in his paintings".[172] It is, however, as an oil painter that he is best known.

Borlase Smart commented that he was always impressed by "the personality and dignity of his vast studio at the Piazza [No. 2]... It conveyed the impression that big things had been created there". Milner certainly felt inspired by the space, although he did recall one occasion when, during a particularly bad storm, the sea had burst through the window, leaving the floor covered in sand and pebbles.[173]

Milner was not at the foundation meeting but joined STISA in 1927 and exhibited regularly with the Society for the rest of his life. On Show Days, his RA submissions were on view and a number of these, such as *The Deserted Mine* (RA 1926), *Westerly Seas* (RA 1933) and *Rochester* (RA 1934 - now Truro), were also included in STISA shows. In addition to the Cotswolds, the

[168] *West Briton*, 17/7/1929.

[169] *News Chronicle*, 1939, Cornish Artists 12.

[170] *St Ives Times*, 10/1939. Smart is probably referring to the 1911 RA exhibition where Milner's exhibits included *A Bracing Breeze to a Gale It Blew* and *Westward as the Sun Went Down*.

[171] From Borlase Smart's Appreciation, *St Ives Times*, 10/1939.

[172] ibid.

[173] *News Chronicle*, 1939, Cornish Artists 12.

Fig. 2M-6 Fred Milner *Rainbow over Country Cottages* (W.H.Lane & Son)

Sussex Downs, Corfe Castle and Portugal, he was also particularly keen on depicting rivers - the valley of the Ouse, the Hampshire Avon, the Rother at Rye, the Thames at Greenwich and Dartford, the Medway, the Horseshoe Bend of the Severn and the Orme at Ludlow are merely some that feature in STISA shows. Skies were an important part of his paintings, and he used to say that he painted a sky a day. Spring and autumn were his favourite times of year for painting; he complained that, in summer, colours became "too dusty".

In his appreciation, Smart summarised Milner's characteristics as "An intense loyalty and faithfulness of purpose, hard work in the open air and in the studio, a distinguished style of painting, a charm of friendly intercourse with other artists and interest in their work, and a broad principle of encouragement to younger painters."[174] In short, Milner, who served on the Committee in 1934 and 1935, was the ideal Society man. A Memorial Exhibition was held at Lanham's Galleries in December 1939. His widow remained a member of STISA and died in 1947.

56. ***An Exmoor Valley*** oil on canvas (40cm x 31cm)
(Private Collection)
Milner's works are rarely inspirational but he captures the essence of the English countryside. Rolling hills, a farmhouse tucked into the bottom of the valley, surrounded by trees, and some striking autumn colours, all depicted quite broadly, combine to produce a tranquil and attractive scene.

Ben Nicholson OM (1894-1982)
STISA: 1944-1949
STISA Touring Shows: 1947 (W), 1949.
Public Collections are numerous but work from his STISA period is at the Tate, Aberdeen, Manchester, British Council, Arts Council, Cambridge (Kettle's Yard), Orkney and, abroad, at Perth, Sydney, Washington, New York, Buffalo and Wellington.

Nicholson was persuaded to join STISA by Borlase Smart and, after Smart's death, he tried to influence the direction the Society took but, as with his involvement with the Seven and Five Society, his goal of a body of abstract artists led to animosity and schism. Born in Denham in Buckinghamshire, he was the son of William Nicholson and Mabel Pryde, both of whom were painters. Apart from a brief spell at the Slade in 1910-11, where he met Paul Nash, he was without formal training. He did not apply himself to

[174] *St Ives Times*, 10/1939.

painting seriously until 1920, the year he married fellow artist, Winifred Roberts. During the 1920s, he painted still lifes and landscapes in a deliberately naive style. In 1924, he joined the Seven and Five Society, which had been formed in 1919, and became Chairman in 1926. Members were to include his wife, Winifred, Christopher Wood, Frances Hodgkins, Henry Moore and John Piper. Both he and Christopher Wood were greatly influenced by a meeting with Alfred Wallis on a visit to St Ives - Nicholson's first - in 1928 and, in 1930, they held a joint exhibition at the Bernheim Gallery in Paris. The following year, Nicholson had his first major exhibition in London, at the Bloomsbury Gallery, which impressed a young sculptor, Barbara Hepworth, who was to become his second wife in 1934. In 1932, Hepworth and himself went to Paris and made direct contact with Picasso, Braque, Arp and Brancusi and they joined the group Abstraction-Création and became members of Nash's Unit One, along with Henry Moore. Nicholson began to produce compositions that were influenced by Cubism and combined geometrical abstract shapes with sinuous lines incised into board. He also began to execute the white reliefs for which he is now well-known. His efforts in 1934 to make the Seven and Five Society solely open to abstract artists led to its demise amidst considerable acrimony, with members either resigning or being voted off. Other influences on Nicholson's work in the late 1930s were Piet Mondrian, whom he met initially in Paris in 1934 but who then came to live in the same road in Hampstead in 1938-9, and the Russian Constructivist Naum Gabo, with whom he edited the Constructivist book, *Circle*.

In August 1939, with War imminent, Nicholson and Hepworth and their triplets moved to Cornwall. Initially, they stayed at Little Parc Owles, Carbis Bay, at the invitation of Margaret Mellis and her husband Adrian Stokes, the writer.[175] They were soon joined by Naum Gabo and his wife, Miriam. Inspired by the countryside and coastal scenery, Nicholson's work became more figurative, but perspective gave way to planal geometry. Recognisable features of the St Ives townscape or still life objects from his studio make appearances in compositions where shape or line are the key, and space, as a result, becomes distorted or tightly compressed. However, the War years resulted in considerable financial hardship and, if Nicholson found a subject that sold, he produced a number of similar versions.

In 1944, Smart invited Nicholson and Hepworth to join STISA as he considered that it was wrong for artists of such stature not to be members, despite their different outlook. He even allowed Nicholson to exhibit in his studio on Show Day that year, a gesture that raised a few eyebrows. The 1945 Spring Exhibition contained three typical Nicholson works of the period, *Painted Relief 1942-44*, *Still Life, Carbis Bay, 1945* and *Collage, Relief, 1942*. However, his work was not included in the 1945 tour but his painting *Winter at Halsetown* was bought by Egbert Barnes from the *Inland Cornish Landscapes* show held by STISA at the Brewery's White Hart Hotel in 1945.

Nicholson, although not universally liked, was, of course, a great influence on many of the young artists in the art colony, such as Wilhelmina Barns-Graham, Peter Lanyon and Sven Berlin. He did not, however, exhibit with the Crypt Group. All, however, were included in the major 1947 show at Cardiff, where Nicholson exhibited *Painting, 1946* and *Still Life, 1946*, and the 1949 show at Swindon, where he was represented by *Towednack, Cornwall, 1943*.

Nicholson preferred to operate behind the scenes and so he never sought election to the Committee of STISA. It seems clear, though, that he gained some influence over David Cox, who became Secretary after Smart's death. It seems clear that the split in 1949 was the result of a pre-planned campaign by Nicholson and Hepworth and that the early travails of the Penwith Society, which saw many artists resign amidst equal animosity, were largely due to the fact that, as far as Nicholson and Hepworth were concerned, too many figurative painters had come across to the Penwith.

In the early 1950s, Nicholson's reputation grew dramatically both at home and abroad. He was commissioned to paint a mural for the Festival of Britain in 1951. He won the first prize at the Carnegie International in 1952, the first Guggenheim International prize in 1956 and the International Prize for Painting at the Sao Paolo Bienal in 1957. He left St Ives in 1958, his marriage to Barbara Hepworth having been dissolved in 1951. In 1968, he was awarded the Order of Merit.

57. ***1947, Nov.11 (Mousehole)*** mixed media (46.5cm x 58.5cm)
(The British Council) (Plate 64)
Norbert Lynton, in his biography of Nicholson, considered that his paintings of a still life subject set against landscape can be seen as fusing his relief works and the landscape paintings which preceded them. He comments, "The relief forms and tensions, now given more or less overt figurative meaning, are combined with broadly abstracted, firmed up transcriptions of Cornish scenery...In the Mousehole picture, the still life group seems almost a separate element, a cluster of forms collaged over the landscape, a Cubist incident within a semi-naturalistic account, a 1930s relief rendered flat and set against a simplified account of man in nature."[176]

[175] i.e. not Adrian Stokes, the former Royal Academician and STISA member, who had died in 1935.
[176] Norbert Lynton, *Ben Nicholson*, London, 1993 at p.226.

Bernard Trevorrow Ninnes RBA ROI (1899-1971) Exh. RA 4
STISA: 1932-1963, Vice-President & Chairman 1949-1954
STISA Touring Shows: 1932, 1934, 1936, 1937, 1945, 1947 (SA), 1947 (W), 1949. Also FoB 1951.
Public Collections include Bournemouth, Hereford, Leamington, Stoke and St Ives.

Bernard Ninnes, one of the stalwarts of STISA for many years, was a distinctive artist who was admired for his 'modern' touch and who enjoyed great success in the touring exhibitions of the 1930s. A review of a one-man show in 1949 commented:-

"Since the day when his picture *The Boatbuilder's Shop* [cat.no.58] proclaimed to St Ives artists, 20 years ago, the arrival of a newcomer with courage in colour, and something different in technique, Mr Ninnes has produced more exciting pictures than anybody else in the colony, and art-lovers, who have sought out his studio year after year in search of something interesting, have never been disappointed."[177]

Sadly, he is now rather neglected but his art merits a re-evaluation as his varied contributions to this exhibition demonstrate. Born in Reigate, Surrey, his father was an ironmonger of St Ives origin. He was inspired to pursue art as a career by winning prizes in a local flower show drawing competition and he studied at the West of England College of Art at Bristol and then, between 1927 and 1930, at the Slade under Tonks and Steer. In 1930, he married Edyth Mary Day and they settled in St Ives. He worked initially from Dolphin Studio, a converted sail and net loft. His art soon made an impression and Borlase Smart on seeing, on Show Day 1932, his depiction of a yacht *In For Repairs*, commented, "St Ives art circles will welcome Mr B.T.Ninnes, for he can paint". This painting was included in the 1932 STISA tour to Southsea, Brighton and Stoke and was the only work bought by the Stoke Gallery from that show for its permanent collection.[178] Other art Societies also recognised his talent for he was elected in 1933 to the RBA and in 1934 to the ROI. In 1934, he also was successful for the first time at the RA. One exhibit, *A Street in Spain*, was bought by the Russell Cotes Gallery, Bournemouth and a version of the other, *The Boatbuilders*, was eventually acquired by Leamington Spa Art Gallery.[179] He also had a work bought by Hereford Art Gallery from the 1936 tour. These successes from the 1930s tours far exceeded those of any other member of STISA and yet Ninnes only had two further works

Fig. 2N-1 Bernard Ninnes *Lobster Fishermen at St Ives*

[177] *St Ives Times*, 5/8/1949.
[178] *In For Repairs* is illustrated in David Tovey, *George Fagan Bradshaw and the St Ives Society of Artists*, Tewkesbury, 2000 at p.93.
[179] *A Street in Spain* was bought by Bournemouth in 1939 after both the Committee and the public voted it the best work at an Exhibition devoted to prominent living artists held in Bournemouth that year. The Curator commented, "This work, bright as a pastel, with sunny coloured walls, rendered more so by the abundant masses of very deep shadow in doorways and windows, is a modern masterpiece and worthy to be classed with some of the greatest masters whose home was in Spain." *St Ives Times*, 30/6/1939.

Fig. 2N-2 Bernard Ninnes *Crafnant*

shown at the RA. Instead, he concentrated on STISA and the exhibitions of the RBA, where up to 1962, he showed over 135 works. Nevertheless, he also exhibited at the Paris Salon and in Australia, South America and Canada and his works were reproduced in many magazines.[180]

Ninnes tackled a wide variety of subjects - landscapes, marine paintings, town and harbour scenes, interiors, figure paintings and still life.[181] In each genre, he produced distinguished and distinctive work, bold both in design and in colouring. It was his unusual colour values, which can sometimes now seem a little garish, that most often prompted comments about his 'modern' touch but he also imbued objects in his paintings with a solid, sculptural feel. A reviewer commenting on his work said, "The one thing that has made them different from the work of others has been his ability to separate the receding planes so that each object stands out from what is behind it, producing a stereoscopic effect that has enabled him, on many occasions, to give a dramatic presentation of the subject."[182]

The respect accorded Ninnes by the other artists is reflected by the fact that he was voted on to the Committee for four consecutive years from 1934-1937. He then appears to have left St Ives briefly but returned during the War, serving on the Committee in 1942, 1945 and 1947. He was now living at Hayeswood, Burthallen Lane in the Ayr district of St Ives and had a studio at his home. After the split, he was voted Vice-President and Chairman, a position he held until 1954. This was a difficult period during which time Ninnes became the spokesman for the Society. At the first A.G.M. after the split, he observed that, although another Society had been formed, which claimed to be carrying out the ideals of Borlase Smart, he thought that Smart's whole heart was in the old Society, and had he known of the crisis which had occurred, he would have approved of what they had done in trying to pull the Society out of the mire and put it once more on a sound foundation. This statement provoked outrage not only from the moderns but also from Smart's widow. Ninnes was an intelligent and personable man but he was not a leader in

[180] These include *The Times, The Bystander, Illustrated Sporting and Dramatic News, Oil Painting of Today* and *Art Review*.
[181] The still life *The Spectator* by Ninnes was discussed and illustrated in colour in Leonard Richmond's book *The Technique of Still Life Painting in Oil Colours*, London, 1936.
[182] *St Ives Times*, 5/8/1949.

the dynamic mould of Smart and the Society does seem to drift during his Chairmanship. Ninnes, however, was lame and suffered from haemophilia and could not be expected to be as active as his predecessor. Nevertheless, STISA made a real effort to put on quality exhibitions to mark the Festival of Britain in 1951 and the Coronation in 1953 and Ninnes' *A Cornish Hamlet - Nancledra* (cat.no.60) was bought from the 1951 Exhibition for the permanent collection of St Ives. He was ousted from the Chairmanship in 1955 as his views were too modern for the likes of Hugh Ridge and Bradshaw and he ceased exhibiting in 1963, being in failing health. In addition to his immense contribution to STISA, Ninnes was also President of the Arts Club in 1936 and 1953, a founder and one of the first Chairmen of the St Ives Society for the Advancement of Music and Arts and an Honorary Vice-President of the Friends of St Ives.

58. *The Boatbuilder's Shop, St Ives* oil on canvas (71cm x 79cm)
(Leamington Spa Art Gallery)
This painting cemented Ninnes' reputation. The scene is set in the same old boat building workshop on Wharf Road that was featured in his work *In For Repairs* (Stoke) and was probably painted at much the same time in 1932. The huge dilapidated window of the workshop is the central feature and the brilliant light that it lets in to the interior throws the figures into sharp relief. Glimpses through the window and open door of the pier with its lighthouses and boats tied up alongside and of the deep blue sea show where the boats being built are bound. Not that too much work is happening - there are matters to discuss. The bright colours used are akin to the railway posters of the day and, in much the same way, Ninnes has produced a romanticised image. An ordinary workshop, which in fact was soon pulled down, has been given the aura of a Cathedral.

The painting was bought for Leamington Spa Art Gallery's permanent collection from the 1936/7 *Paintings from Cornwall and Devon* tour. The catalogue price was £26-5s. Although the Gallery now own several works from this tour, this was the only one actually purchased by the Gallery itself. In 1934, Ninnes exhibited at the RA a work *The Boatbuilders*, which had previously been included in a Lanham's show in 1932, and a print of this work shows it to be an almost identical composition but there are some differences. The man in blue sitting on the bench with his back to the viewer is a new addition and different panes in the big window are coloured green. Furthermore, so far as it is possible to tell from a poor print, the colours used were less vibrant. Whether Ninnes reworked the original or did another version is not known.[183]

59. *The Café Born, Palma de Mallorca* oil on canvas (61.5cm x 74cm)
(Hereford City Museum and Art Gallery) (Plate 28)
"For variety of interest and individuality of outlook, this may be classed as one of the artist's best pictures to date" - so commented the *St Ives Times*, when reporting that the painting had been bought for Hereford Art Gallery's permanent collection from the 1936 STISA tour.[184] It had previously been exhibited at the RBA in 1934. Mallorca was a favourite holiday destination for Ninnes and his family and, like John Park, it appears to have influenced Ninnes' colour values. This interior scene, however, is one of a series of unusual figure studies that Ninnes did, which verge towards caricature. In 1939, he commented on such works:-

"People ask: 'Why do you bother to paint those queer figures and compositions of people doing such odd things?' The answer is that the commonplace has been so much neglected that it opens up a new field...I feel that part of an artist's work should be in the nature of a comment on our modern life. Every artist should try to leave behind him something typical of the times in which he lives."[185]

Another Mallorcan café scene, *Fonda*, was exhibited at the NEAC in 1933. His favourite painting in this style was a 9ft x 3ft canvas called *At the Sign of the Sloop*, which was a skit on holidaymakers in St Ives in August.

60. *A Cornish Hamlet - Nancledra* oil on canvas (105cm x 75cm)
(St Ives Town Council) (Plate 35)
The reviewer of the 1938 Summer Exhibition writes, "Bernard Ninnes always adds interest to a collection of pictures by his individualistic transcription of any scene he paints. Under the modest title of *A Cornish Village*, Mr Ninnes gives a panoramic effect of Nancledra with its old world cottages and phases of village life in the well-placed incidents scattered throughout its street."[186] Such a description clearly matches this work, which was purchased for the permanent collection of St Ives from the Festival of Britain Exhibition in 1951, where it also was awarded the first prize of £75. It is not known whether the scene was re-painted by Ninnes or whether this is the original work, although it would seem extraordinary that a work of this quality and interest should remain unsold for thirteen years. It now hangs in the Guildhall, in St Ives.

[183] This painting is illustrated in David Tovey, *George Fagan Bradshaw and the St Ives Society of Artists*, Tewkesbury, 2000, plate 11, opposite p.120.
[184] *St Ives Times*, 30/10/1936.
[185] *News Chronicle* 1939, Cornish Artists 6.
[186] *St Ives Times*, 15/7/1938.

Job Nixon RE ARWS (1891-1938) Exh. RA 36
STISA: 1931-1938
STISA Touring Shows: 1932, 1934.
Public Collections include British Museum, Victoria and Albert Museum, Tate, RE, Bolton, Bradford, Huddersfield, Leeds, Manchester - Whitworth, Oldham, Oxford (Ashmolean) and Dunedin.

Job Nixon was an unconventional character, who made an important contribution to the 'black and white' section of STISA before his untimely death. Born in Stoke-on-Trent, he studied at the Slade and at South Kensington and, in 1915, was successful at the RA whilst still a student. He painted in oil and watercolour, principally landscape and topographical scenes, but he is best known for his etchings, drypoints and line engravings, which he started producing from 1913. He was elected ARE in 1923 and, that year, he won the first competition for the newly endowed scholarship of engraving at the British School in Rome. It was while in Italy that he produced *An Italian Festa* (cat. no.61), the huge plate that first brought him to the public's attention. Critics see similarities in his satirical prints with the work of William Strang. There is the same angularity in his figures, with a hint of caricature and a pinch of the grotesque, but he does attempt to relate them to an architectural background. However, this was not his only style and English genre subjects form the majority of his work. Nevertheless, his appointment as assistant to Malcolm Osborne in the Engraving School at the Royal College of Art, South Kensington "came as a shock to the old-fashioned collector and connoisseur but the soundness of his technique and his mastery of etching processes, as well as the salutary influence he exercised in diverting his pupils from too slavish a pursuit of the landscape tradition, more than justified his appointment."[187] Whilst at South Kensington, Osborne executed an etched portrait of him.

Nixon started to exhibit watercolours with the RWS in 1928 and, over the next decade, exhibited with the Society some 93 times, becoming an associate member in 1934.[188] His watercolours do betray his primary calling, with line drawing prominent, and the subjects often the same, but he was complimented on his virile use of line and lively and generous love of colour. Two Falmouth scenes shown in 1929 indicate that he had paid a visit to Cornwall. One of the most stalwart supporters of the RWS at that time was Lamorna Birch and it was Birch, apparently, that persuaded Nixon to move to Cornwall in 1931 where he initially settled in Lamorna, working from Riverside Studio. In his first exhibition with the Newlyn Society of Artists, his large oil of a Romany encampment, entitled *Gypsies*, was awarded the position of honour and attracted considerable attention, due to its daring colour selection, unconventional composition and "modern" drawing style.[189]

Although Nixon did not move to St Ives until 1934, he joined STISA immediately on his arrival in Cornwall and a number of his exhibits in the early years both with STISA and at the RA were St Ives scenes. He exhibited work in all media but it was his etchings and drypoints that made the most impact and these included his RA works *The Castle at Josselin, Brittany* (1927), *Romantic Village* (1929), *Notre Dame de la Garde, Marseilles* (1931 and, by mistake, also in 1932), *Brixham Harbour* (1933) and *St Germain l'Auxerrios* (1934). With Alfred Hartley having left St Ives for health reasons in 1931, Nixon became the leader of the 'black and white' section and his teaching experience proved invaluable to his fellow members. He briefly ran a School of Painting in Back Road West on Tuesday and Friday evenings and, in his lecture on *The Art Of Etching* in April 1933, he also included a description of the methods of lino and woodcut work, lithography, aquatint and mezzotint engraving. He himself worked from St Peter's Studio, St Peter Street, formerly the studio of Pauline Hewitt. The local paper commented, "With his large black hat and his beard, he fulfilled the conventional idea of what an artist should look like" and he does seem to have lived a bohemian existence in St Ives in a caravan.[190] However, the offer of a teaching post at the Slade drew him back to London in 1935 and he ceased to exhibit with STISA, although works were still included in Lanham's shows. Sadly, he died in 1938, aged only 47.

61. ***An Italian Festa*** etching (66cm x 68cm)
(The Trustees of the British Museum) (Fig. 2N-3)
This etching was first executed by Nixon while in Italy in 1923 but this is a print from a reworked plate dating from 1925. It was included in the 1932 tour and exhibited again in the Autumn show in St Ives that year, where it caused Charles Procter to exclaim, "*Italian Festa* is a tour de force, an amazing achievement, a technical and artistic triumph".[191] When it was exhibited shortly after Nixon's return from Rome, the distinguished etcher, Campbell Dodgson, writing in *The Studio*, was no less fulsome in his praise:-

[187] J.Laver, *A History of British and American Etching*, London, 1929 at p.106-7.
[188] In 1933, he was also on the hanging committee of NEAC and had 6 works in the NEAC Exhibition that year. His wife, Nina Berry, Park, McCrossan, Ninnes and Stuart Weir were also represented.
[189] *Daily Mail*, 21/3/1931 and *Western Morning News* 20/3/1931.
[190] *St Ives Times*, 29/7/1938.
[191] *St Ives Times*, 12/2/1932.

Fig. 2N-3 Job Nixon *An Italian Festa* (Trustees of the British Museum)

Fig. 2N-4 Borlase Smart *Job Nixon* (drawing) (Bristol Museum and Art Gallery)

"*An Italian Festa* is in dimensions alone, if we except Mr. Brangwyn's etchings, one of the most remarkable productions of the modern British school. But it was not for its size that I secured it at first sight, when proofs first came to England, for the Contemporary Art Society. The groups of Italian peasants, dancing, eating, drinking, love-making, not always in the most decorous fashion, in the foreground and in the distance, where the same picturesque hill-town [Anticoli] is partly masked by the tall cypresses that so effectively divide the composition into several spaces, arrest and fascinate the attention. Big figures, little figures, near and distant, they are drawn with a *naivete* and disregard for convention that are more in the spirit of an old Flemish kermesse than in the usual sober style of the English. A bit rough in its technique - I saw Sir Frank Short looking at it rather dubiously - it is so full of life and communicates so well to the beholder the interest that its creator must have felt in every detail, that any petty faults in such a *capolavoro* may well be overlooked. And what courage was needed to attack so big a subject and carry it through to completion!"[192]

Other prints exhibited with STISA now in public collections include *Bank Holiday, Hampstead Heath* (Oldham and Whitworth Art Gallery, Manchester), *Madonna in the Wall, Subiaco* (Auckland) and *Italian Flour Mill* (British Museum).

[192] Campbell Dodgson, *Mr. Job Nixon's Etchings, The Studio*, Vol. 87, 1924, pp188-191.

Albert Julius Olsson RA RBA PROI RWA RBC (1864-1942) Exh. RA 175
STISA: 1928-1942
STISA Touring Shows: 1932, 1934, 1936, 1937.
Public Collections include Tate, QMDH, RA, Birmingham, Blackburn, Blackpool, Bolton, Bradford, Cheltenham, Doncaster, Harrogate, Hull, Leamington, Liverpool, Newcastle, Oldham, Preston, Rochdale, Sheffield, Sunderland, Truro, Worcester and York (NRM) and, abroad, Adelaide, Sydney, Christchurch and Nelson.

Unsurprisingly, given his popularity and his status as the leading seascape painter in the country, Olsson was one of the first Royal Academicians to be offered honorary membership and he responded by making a telling contribution to STISA's success. The son of a Swedish timber merchant and his English wife, Olsson was born in Islington and was brought up in Purley, Surrey and in London. After four irksome years in the City office of a bank, Olsson moved to the Channel Islands where he met an artist, who specialised in seascape "pot-boilers". Watching him at work was his only artistic education and he developed his own method of sea-painting, based on close observation, which was free from the traditions that had dominated the genre. He first came to St Ives in 1890, the year of his first success at the RA. Principally through his efforts, St Ives was known early in the new century as the centre for the country's leading group of marine painters. In 1895, he set up with Louis Grier the School of Landscape and Marine Painting, through which many of STISA's members passed. When Grier broke off to teach on his own, Olsson was joined by Algernon Talmage. Students who later became involved with STISA include Norman Wilkinson, the Australians Arthur Burgess, Will Ashton and Charles Bryant and leading lights Borlase Smart and John Park. All these artists became specialist marine painters. Of the female students, Augusta Lindner and Mary McCrossan also joined STISA, with the latter again becoming well-known for her marine work.

Olsson was a fervent believer in sketching out of doors and had his students standing before their easels on Porthmeor beach in all conditions.[193] He considered that it was only by constant observation and practice that sea painting could be mastered. Of greatest import was the study of reflected light on water surfaces. Due to the sea's movement and the ever changing light conditions, an artist also required a retentive memory and Olsson "believed in studying each bit of his subject mentally and intimately, assisted by quick colour notes".[194] One student, when asked Olsson's method, commented, "Values, always values, and then more values."[195]

Olsson liked variety of outlook and travelled around Cornwall for his subjects. However, his observation of the sea in all its moods was not restricted to the many hours he spent painting the Cornish coast, for he was an avid sailor, who spent the summer months cruising in his yacht. Folliott Stokes observed, "He knows the coast from the Scillies to the Isle of Wight as well as most men know their way to the nearest railway station." and, as a result, he developed an intimate knowledge of the movement and swell of the deep ocean and experienced the full range of atmospheric conditions at sea.[196] However, despite his ability to convey the ceaseless movement of the sea and to capture the dignity, beauty and grandeur of clouds, it was Olsson's sense of colour that made his seascapes stand out. In particular, Olsson observed that foam, which had historically been portrayed as white, was in fact a myriad of colours, reflecting hues from sky, cloud and sea. Romantic sunsets and moonrises issued forth from his studio in a seemingly endless chain and examples can be found in Art Galleries around the world.

Olsson contributed immensely to many aspects of life in St Ives. Having been a founder member of the Arts Club, he was President in 1895, 1901 and 1909. He became a Town Councillor and a Justice of the Peace and was President of both Lelant Golf Club and St Ives Tennis Club. Moffat Lindner, recalling those days, observed, "He was a most attractive and forceful personality, and he endeared himself to everyone in St Ives - fishermen, artists and townspeople and all who came in contact with him."[197] Although he had already won a gold medal at the Paris Salon in 1903 with *The Storm*, the purchase of his famous painting *Moonlit Shore* by the Chantrey Trustees in 1911 and his election as an ARA in 1914 persuaded him to move to London and his School of Painting closed. In 1917, he became President of the ROI and, in 1920, he was elected a full RA. However, he retained his links with Cornwall and his two contributions to the 1925 Cheltenham show were Cornish coastal scenes. On STISA's formation, dedicated gallery space was one of the first pre-requisites and it was Olsson's old studio, the vast 5, Porthmeor Studios, that became the Society's first Gallery in 1928. Olsson himself came down for the opening ceremony. For the rest of his life, Olsson made available good quality works to STISA exhibitions and many were considered to be the star exhibits of the show. Amidst a plethora of sunset and moonlit scenes, there were many pictures of St Ives, Falmouth, Penzance and Land's End, including his 1936 RA exhibit *Land's End and Longships Light*; there were scenes from his sailing trips to the Scillies and to the Hebridean island of Rum, and subjects from his visits to relations in Ireland and Sweden. Commenting on his *Fresh Breeze off*

[193] Dismissing some woodland studies she had done as "maudlin rubbish", Olsson shouted to a Canadian student, Emily Carr, "Go out there" - pointing to the glaring sands - "Out to bright sunlight - PAINT" T.Cross, *The Shining Sands*, Tiverton, 1994 at p.143.
[194] Borlase Smart, *St Ives Times*, 18/9/1942.
[195] *Black and White*, 12/9/1896.
[196] *The Studio*, Vol 48, p.283.

Fig. 2O-1 Julius Olsson *Sunlight on Breaking Waves* (W.H.Lane & Son)

Falmouth in the 1931 Spring show, 'Madder Brown' observed, "He always gets movement, depth and the sense of the infinite into his seas and skies".[198] At the 1934 Exhibition in Oldham, a "large and noble" work, *Rising Moon, St Ives Bay*, described as "a picture of emotional reaction to the view from Pednolver to Godrevy, lit by an early moonrise", was added to the show from the Gallery's permanent collection, and the same painting was lent by Oldham to the 1938 Autumn Exhibition in St Ives.[199] In 1936, Olsson opened the Cheltenham Exhibition, during which he made clear his distaste for most modern art.

Olsson continued to take the St Ives papers and, therefore, remained in touch with developments in the colony. Occasionally, he wrote to pass comment on views expressed or to proffer advice.[200] In 1933, he came down to St Ives for one of his occasional visits. Borlase Smart made available to him his own studio and 150 people turned up to pay their respects at the 'At Home' in the Gallery organised by Bradshaw to welcome him. A big man with broad shoulders, large hands and piercing blue eyes, Olsson supported STISA far more than any of the other RAs who had ceased to live in Cornwall and he may well have been responsible for encouraging his former students and other members of the Arts Club in Dover Street, who had Cornish connections, to join the Society. Shortly before his death, he moved to Ireland, where he had family, as his London property had been hit in the Blitz.

[197] *St Ives Times*, 18/9/1942.

[198] *St Ives Times*, 6/2/1931.

[199] *St Ives Times*, 7/10/1938.

[200] For instance, he wrote to praise Herbert Truman for his articles on art but later rebuked him for publishing in the press a letter criticising the proposal that one-man shows be allowed in the Gallery, as Olsson considered that such issues should be dealt with in private at a meeting.

62. *Cloudy Moonlight* oil on canvas (100cm x 74.5cm)
(Doncaster Museum and Art Gallery) (Plate 9)
Olsson has come to be recognised as the master of the moonlit scene. In his article on Olsson's work, his friend Folliott Stokes commented:-

"There is one other mood of the sea that Mr Olsson has made peculiarly his own. It is that tender half-time between day and night, when the moon, as yet but a pale disc, peeps over the distant horizon and lays down a ribbon of golden sheen across the face of the waters. It is a moment of intense beauty. The sun has gone, and with him the pomp and splendour of the day; and Nature with a sigh of regret is turning her chastened gaze towards the milder splendours of the queen of night. Everything is enveloped in a tender afterglow; there are no strong contrasts of tone. The mystery and charm is one of colour only: hence the attraction for our artist."[201]

This scene with a lone boat just entering the path of the moon, is a typical example, with the foam splashing up the rocks all the colours of an opal. It dates from the late 1920s.

63. *The Water Spout* oil on canvas
(Cartwright Hall Art Gallery, Bradford) (Plate 1)
This unusual phenomenon was probably witnessed by Olsson on his yacht, although he has chosen to depict it from the shore. Olsson often portrayed the imminent onset of a squall seen in a corner of the sky and effect of vaporising water from the two spouts is treated in much the same way. However, it is the glorious reflections of sunlit clouds in the gentle waves rolling up the beach that give the work its greatest appeal. The brushwork is that of a master hand.

John Anthony Park ROI (1878-1962) Exh. RA 72
STISA: 1927-1959, Acting President 1949-1951
STISA Touring Shows: 1932, 1934, 1936, 1945, 1947 (SA), 1949. Also FoB 1951.
Public Collections include Tate Gallery, Cheltenham, Kettering, Manchester, Newport, Oldham, Preston, Salford, St Ives, Southport, Southampton and Johannesburg.

Considered the star pupil of Olsson' School of Painting, Park's impressionistic touch with colour and light has won many admirers both during his lifetime and subsequently and he is now the most highly rated of the St Ives resident members of STISA. Born into a large family in Preston, he started working for the family business as a painter and decorator before leaving in 1897 to practise art full time. After a spell in Plymouth, he studied at St Ives under Olsson and Talmage between 1902-1904, before going to Paris in 1905 to train under Delacluse at Colarossi's. That year he had three works accepted at the RA. Inspired by the work of the Impressionists, Park returned to St Ives in 1906 but from 1912, he shared his time between Plymouth, Brixham and Polperro. Between 1916 and 1918, he served as a private in the East Surrey Regiment in France, before being discharged on health grounds. In 1919, after his marriage, he settled initially in Brixham, but, ever attracted by the special light and vivid colour of St Ives, he took a studio there in 1921 and moved to 3, Bowling Green, St Ives in 1923. That year he was elected an ROI and received a Mention Honorable at the Paris Salon and, in 1924, he was awarded a bronze medal in Paris.

Park, therefore, was already successful when STISA was formed and his exhibits with the Society were as important as those of the honorary members in arousing the interest of the public in the early years. Austin Wormleighton, his biographer, comments that, looking at his body of work now, "it is difficult to escape the conclusion that he must have spent the greater part of his painting life at the water's edge in St Ives, working there as if through one hot, endless Cornish summer".[202] Certainly, he is best known for his brilliantly coloured impressionistic depictions of boats in St Ives harbour, painted on the spot, but these do vary in quality, depending on whether they were produced for major exhibitions or as pot-boilers to sell to the tourists. Park himself commented, "Colour is everything. Anyone can be taught line, but you cannot teach a feeling for colour" and he felt that an artist succeeded when his interpretation of nature resulted in someone saying, "I have seen that hundreds of times, yet I have not appreciated it before".[203] Park also painted in many other parts of the country and some of his best works are landscapes, often featuring rivers. He commented, "I do not think I could live away from the sea or a stream. I am fascinated with the movement of water and the light on water. Water brings the sky down to earth.".[204] Park was also an accomplished still life painter, admitting that he had a great weakness for paintings of flowers, particularly for smaller rooms.

[201] *The Studio*, Vol 48, p.282.
[202] A.Wormleighton, *Morning Tide - John Anthony Park and the Painters of Light*, Stockbridge, 1998, p.10
[203] *News Chronicle*, 1939, Cornish Artists 22.
[204] ibid.

Fig. 2P-1 John Park *Heart of Exmoor* (Salford Museum and Art Gallery)

In 1931, Park was elected on to the Committee of STISA for the first time and served for three consecutive years before he was persuaded by his wife, 'Peggy', and Harold Sawkins, the editor of *The Artist*, that, if RA honours were to come his way, he would need to move to London. Accordingly, in 1933, he acquired a studio in Maida Vale, close to their friends Dorothea Sharp (q.v.) and Marcella Smith (q.v.). Trips to Majorca and Venice in 1934 and 1935 respectively produced some fine work (see *Roman Bridge, Pollensa* -cat.no. 65) and the Parks then had the opportunity of staying for a while with Alfred Munnings (q.v.) in Dedham. Before being distracted by Munnings' hospitality, Park produced some exceptional landscape work and, for RA exhibitions, he preferred to concentrate on landscapes for the next decade, as he felt that there were too many depictions of Cornish harbours being submitted by other artists. In respect of his landscapes, he observed, "I work much better in the winter. There is something fine and majestic about a winter landscape - it is more impressive because it is more solemn."

Somewhat unworldly, Park never felt comfortable with his wife's efforts to court higher artistic circles and he was glad to settle back in St Ives on a permanent basis in 1940, when he was immediately re-elected on to the Committee of STISA.[205] By this time, his work was gaining national recognition. The highlight was the purchase in 1940 of *Snow Falls on Exmoor* by the Chantrey Trustees but a number of Public Art Galleries were keen to add his work to their permanent collections - *Snow Falls in Essex* (RA 1938) was bought by Manchester, *Heart of Exmoor* (RA 1939) by Salford (Fig. 2P-1), *This England* (RA 1943) by Manchester and *The Monnow River* (RA 1947) by Newport. His work was also becoming known internationally and, in 1945, the National Gallery of South Africa in Cape Town bought *Snow in Essex* and he also sold *Rural Essex* from the Society's 1947 South African touring show to the same Gallery.

[205] He commented, "I would rather go to a Cup Final than a private view of the Academy". ibid.

Even Park failed to understand or appreciate modern art and, after the split in 1949, he found himself elected as Acting President of the Society. However, with the President, Munnings, absent and with Park increasingly in poor health (and, by this stage, a little eccentric and dishevelled and rather too fond of a drink), it was left to Vice-President Bernard Ninnes to become leader and public spokesman. With his wife dying of cancer and with the St Ives he loved fast disappearing under the assault of modern tourism, Park left for Brixham in 1952 and does not appear to have exhibited with STISA subsequently, although he is still recorded as a member in 1957. Given his significant contribution to St Ives art, it was appropriate that one of his last exhibits with STISA, at the Festival of Britain Exhibition in 1951, should have been bought for the permanent collection of the town. The work, *Symphony in Grey*, a typical Park of St Ives harbour, now hangs in the Guildhall. After several moves following his wife's death, he died almost penniless in the family home in Preston, his death unnoticed in the national press. Although Park himself was not a fan of modern art, several of the younger generation of 'moderns' considered Park to be the most advanced of the traditional painters. Sven Berlin rated him as one of the best of English colourists and unsurpassed as a painter of light. "He painted like an angel - simply cathedrals of light".[206]

64. *Fringe of the Tide*

(Leamington Spa Art Gallery and Museum)

oil on canvas (35cm x 46cm)
(Back Cover)

This RA exhibit of 1932 was highly regarded on Show Day that year. The subject is St Ives harbour and the beach is bustling with activity as the fishermen go about their chores. The winter sun is reflected in a sheen across the water, with Pednolva Point and the hills in the background lost in a wondrous blue haze. This work was illustrated in the article on Park in the *Artists of Note* series in *The Artist* in September 1935 and was included in the 1934 tour and also in the 1936/7 *Paintings of Cornwall and Devon* Exhibition, which toured Eastbourne, Lincoln, Blackpool and Leamington. It was purchased from the 1936/7 Exhibition by Alderman Holt of Leamington and presented to his local Gallery.

65. *Roman Bridge, Pollensa*

(Harris Museum and Art Gallery, Preston)

oil on canvas (60cm x 75cm)
(Plate 32)

A lucky bet by 'Peggy' enabled the Parks to take a holiday in Majorca in 1934 and this visit revitalised her husband's feeling for colour. Harold Sawkins considered it to be "the turning point of his career".[207] Under the strong Mediterranean sun, he worked with a freer hand and a heightened sense of colour. His biographer comments, "Instead of Pollensa, he might well have been in the mountains of Provence painting in the shadow of Cezanne".[208] The painting was exhibited at the RA in 1934.

66. *May Pageantry*

(Gallery Oldham)

oil on canvas (60cm x 49.5cm)
(Plate 5)

This is an excellent example of the river landscapes that Park was producing in the late 1930s. It was included in the 1936 Birmingham tour and was bought by Oldham in 1937. Accordingly, it is likely to have been executed in Munnings country in Essex. Another work of the same title was exhibited with STISA in the 1938 Summer Show, along with *A Peaceful Haven*, which is now owned by Cheltenham Art Gallery.

Charles Pears ROI PSMA (1873-1958) Exh. RA 16
STISA: c.1945-1958, President 1955, following Birch's death, Vice-President 1957-8
STISA Touring Shows: 1945, 1947 (SA), 1947 (W), 1949. Also FoB 1951.
Public Collections include Imperial War Museum, SMA, Eastbourne, Falmouth, Harrogate, Lincoln, Royal Exchange and Truro

An official Naval War Artist in both World Wars and President of SMA (founded in 1939) for its first 19 years, Charles Pears was one of the most well-known marine painters of his day. In fact, astonishingly, the Imperial War Museum hold 107 of his works.

Born in Pontefract, Pears' father was an amateur painter and musician and, from an early age, Pears was keen on both art and music. His art tutor, however, only painted 'pretty' watercolours and Pears learnt more by reading avidly on art and artists. By winning two drawing competitions, he gained an entry into London circles and he moved there in 1897. He won commissions for social and genre subjects from *The Studio*, *The Illustrated London News* and other periodicals and he also had work accepted by the famous *Yellow Book*. Between 1898-1902, he was theatrical caricaturist on *Pick-Me-Up*, initially working in a style influenced by Phil May, and he also had humorous drawings accepted by *Punch*. Poster design was another string to his bow and he worked for W.H.Smith & Son and received commissions from the London Underground and the Empire Marketing Board. A major project was the illustration of a complete edition of Dickens novels, published in 1912.

[206]A.Wormleighton, *Morning Tide - John Anthony Park and the Painters of Light*, Stockbridge, 1998, p.12.
[207] Artists of Note 7, *The Artist*, September 1935.
[208]A.Wormleighton, op.cit., p.65.

Fig. 2P-2 Charles Pears with *R.M.S. Orcades* in 1949

This work is all very different to the marine paintings for which he is now best known. Pears was a keen sailor and, in 1910, he wrote and illustrated a book describing a trip that he had undertaken *From the Thames to the Seine*. This was followed in 1914 by *From the Thames to the Netherlands*. Having also illustrated John Masefield's *Salt Water Poems and Ballads* (1911) and Richard Dana's *Two Years Before the Mast* (1911), he was established as a marine artist by the time the Great War broke out and he was appointed an official naval artist to the Admiralty. He also produced lithographs for propaganda purposes for the Government.

In the 1930s, Pears combined marine painting with poster work. He was greatly in demand from all four railway companies, as these also had steamer routes. Pears' love of windjammers is clear from his desire to include these in many of his poster designs (see *Sunset over Guernsey* - Plate 25). They provided a stark contrast to the speed and efficiency of the steamers but also added romance. The sight of sailing ships upon the high seas was becoming increasingly rare but steamers offered the tourist the possibility of a chance encounter. In his articles on *Marine Painting* in *The Artist*, Pears considered the depiction of a full-rigged sailing ship as "the supreme test of the marine painter".[209] In his view, there was no more beautiful sight than a big windjammer under sail.

> "First seen coming over the horizon, it looks like a delicate cloud, and as it nears you, the spider-like delicacy of cordage and steel wire rigging begins to assert itself. The spotless canvas reflecting the blue of the sky and with the glow of sunlight on it, its delicate shadow, and (as the sail bulges) the light coming through the cloth showing the straining seams - all this requires the technique of a master hand to put it satisfactorily on to the artist's canvas."[210]

Pears also wrote another sailing book *South Coast Cruising from the Thames to Penzance* (1931) as well as illustrating travel books for Southern Railway - *Yachting on the Sunshine Coast* (1932) and *Going Foreign* (1933). By this time, he was spending large parts of the year at his house at St Mawes and indulging his love of sailing.

In 1938, Borlase Smart wrote to the *Daily Telegraph* suggesting that "contemporary masters of marine art" should join together as a body and this suggestion was taken up by Pears, who had been working on the idea for some time. SMA was eventually formed in 1939 but the War made its early years difficult. Largely due to Pears' efforts, it flourished after the war and is now the leading Society in its field.

During the Second World War, Pears was again an official war artist, painting naval subjects for the War Artists Committee and these works were exhibited at the National Gallery. A painting, *Malayes Battleship*, was bought by the Malay States Government. It is not known when he actually joined STISA but he started exhibiting shortly after the War and his contribution to the Cardiff show was *Torpedoed Tramp Under Searchlight*, which had been exhibited at the RA in 1944.

[209] *The Artist*, January 1950, p.101.
[210] ibid.

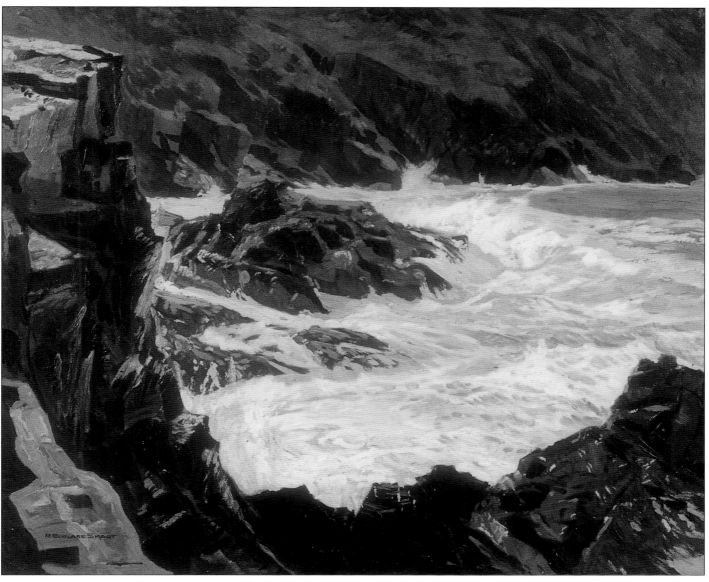

56. R.Borlase Smart *Or Cove* (Private Collection - photo Colin Bradbury)

57. Charles Pears *Downend from Dartmouth* (Private Collection)

58. John Barclay *A Cornish Scoutmaster* (Private Collection)
- on loan to Penlee House Gallery and Museum, Penzance

59. Arthur Hayward *The Boatman* (Private Collection)

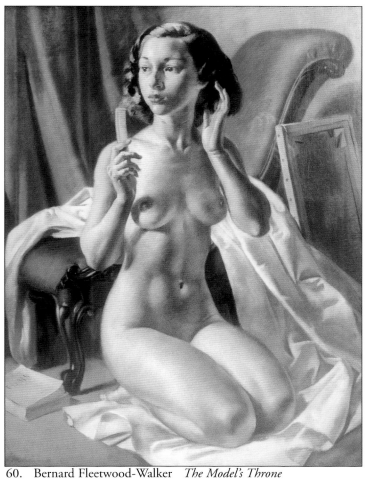

60. Bernard Fleetwood-Walker *The Model's Throne*
(Private Collection)

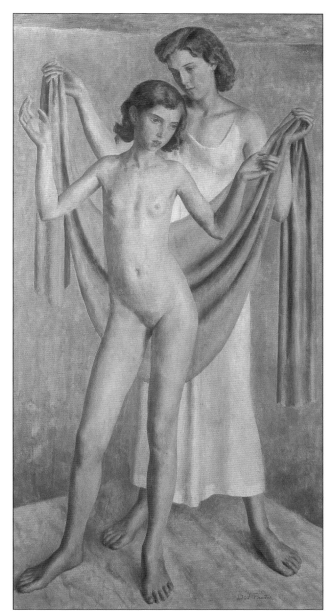

61. Dod Procter *Little Sister* (Private Collection)
- on loan to Penlee House Gallery and Museum, Penzance

62. Hyman Segal *Kimani* (Hyman Segal)

Nina Zborowska

Dod Procter 'Alethea Garstin' c1937 oil on board

Bloomsbury to St Ives
20th Century British Pictures

Damsels Mill, Paradise, Painswick,
Gloucestershire GL6 6UD

T 01452 812460 F 01452 812912

E enquiries@ninazborowska.com
www.ninazborowska.com

Another major work exhibited with STISA was *Four Mast Barque Signalling for a Pilot* (RA1939) (Fig. 2P-3), which was included in the 1949 Swindon show (priced at £210) and which was acquired by The Royal Institution of Cornwall, Truro. Writing about Pears' style, Laura Wortley comments,

"His was a deliberately un-naturalistic approach, editing forms to succinct outlines and then supplying the detail using colour and contrast, but it proved immensely effective, especially in the numerous advertising posters he produced between the Wars. Many of his techniques as a painter in oils seem to have evolved out of his graphic art - his practice of restricting his seas to rarely more than three colours, for instance, and his naive shorthand for water, long wavy lines picked out of the underlying ocean, light on dark, dark on light." [211]

Pears was forthright in his opinions and could not stand "humbug" in art or life. He was an outspoken critic of modern art and commented in the Foreword to the 1952 SMA catalogue:-

"Fortunately, we have no need to worry about artistic controversies, art dictatorships, distorters of the form divine, Himmlers of imbecility, and the incompetent forms of ultra Modern Art. You can't distort the sea and its meanings, you can't order it about, and there is nothing but hard work and deep study which will enable an artist to make it live on canvas."

He was not involved in the split in 1949 but there will be no doubt where his sympathies lay and he remained a stalwart supporter of STISA right up to his death, becoming Vice-President in his final years.

67. *Downend, Dartmouth*
(Private Collection)

oil on canvas (78cm x 112cm)
(Plate 57)

This work, in its scale and design, seems influenced by Pears' work as a poster artist. The stylised patterns in the triangular group of rocks are particularly noticeable, while the sky is, with the exception of a solitary cloud, depicted in a flat blue. The day, though, is very windy, as is shown by the waters of the inlet, which have been blown up into foam backed waves and it is these waves, and the patterns of foam that have developed around them, that are the principal feature of the work. A similar design of wave movement can be seen in a number of his War paintings, when he is clearly trying to provide some foreground interest to depictions of convoys or engagements in mid ocean.

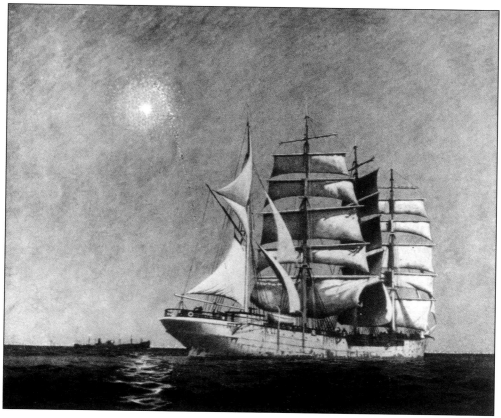

Fig. 2P-3 Charles Pears *Four Mast Barque Signalling for a Pilot*

[211] David Messum and Linda Wortley, *British Impressions*, Marlow, 1998 (No.76).

(Mrs) Dod Procter RA SWA (1892-1972) Exh. RA 217
STISA 1937-1949, President 1946
STISA Touring Shows: 1937.
Public Collections include Tate Gallery, RA, Birkenhead, Oldham, Penzance and, abroad, Hobart, Melbourne and Sydney.

Dod Procter was one of the leading artists resident in Cornwall during this period and one of the most advanced, as her work demonstrated that she had absorbed a number of modern influences ranging through Picasso, Renoir and Seurat. Doris Shaw was born in London but was brought up in Newlyn. In 1907-8, she studied at the Forbes School, lodging with Mrs Tregurtha at Myrtle Cottage with her mother. Fryn Tennyson Jesse, a fellow student resident, commented, "Dod Shaw was much the cleverest of the students, not only as regards drawing and painting where she was streets ahead of anyone else except Ernest Procter, whom she eventually married, but in the management of her life."[212] She followed Ernest Procter to Atelier Colarossi for a short while and they were married in 1912. In October 1913, they shared an exhibition of watercolours at the Fine Art Society. They lived initially in Dunton House, Newlyn and their only child, Bill, was born there in 1913. They enjoyed a dynamic and inspirational social life with the other artists. "They talked literature, some wrote tales and poems, some did woodcuts, some painted, some did all three. They dressed in tussore, silk, browns and art colours."[213] Laura Knight described Dod as "a charming young thing, with a brilliant complexion, enormous dark eyes and long slender legs - swift and active like a gazelle." [214]

In the catalogue to the retrospective exhibition following her death, the comment was passed that she was a single-minded artist and that "her visual perception influenced everything she did - from arranging flowers, posing a model or gardening". Her early female portraits have a sculptural quality and a haunting beauty. With full form painted out to a clear outline and with any clothing simplified, they convey a sense of monumentality reminiscent of Picasso's work of this period. The great success of her 1927 RA exhibit *Morning*, which was bought for the nation by the *Daily Mail* and hailed as Picture of the Year, meant that she was invited to exhibit with STISA from the outset but her contributions were erratic, as her new found fame meant that she spent a good deal of time in London. She joined the NEAC in 1929 and had the first of three exhibitions at the Leicester Galleries in 1932. In the mid-1930s, her style changed. The paint thinned, the hard edges became soft and the colour took on a translucent quality.

Soon after her husband died in 1935, she gave up her studio in London and returned to live permanently in Newlyn. In 1937, she was offered honorary membership of STISA and she began to make regular and important contributions to its shows. Some of her early exhibits were RA pieces from previous years, such as *Little Sister* (RA 1933) (cat.no.68), *Light Sleep* (RA 1934) (Fig. 1-12) and *The Tolcarne Inn, Newlyn* (RA 1936). In 1938, she toured the Canary Islands and her paintings of sun-drenched roofs in Tenerife, such as *From the Mirador* (RA 1940), were highly regarded. In 1939, her work, *The Orchard*, first exhibited at the RA in 1934, was purchased by the Chantrey Bequest. In 1942, she became only the second female to be elected an RA that century, the first being fellow STISA member, Laura Knight.

After her husband's death, she became friendly with Alethea Garstin, with whom she travelled extensively. Garstin's subtle sense of colour and tone was undoubtedly an influence upon her. Her portrait of Alethea, showing her later style, is illustrated in Nina Zborowska's feature opposite page 153. Another STISA member, with whom she became friends, using her as a model and travelling companion, was Jeanne du Maurier, who holidayed with her to Tenerife in 1946 and Africa in 1948. In 1946, on Lindner's eventual retirement, Dod was elected President of STISA but she was not re-elected the following year. This may be because her sympathies lay with the modern contingent and, certainly upon the split in 1949, she resigned from STISA and became a member of the Penwith Society. Michael Canney, the curator at Newlyn Art Gallery, remembered her as "a most likeable and intelligent woman and an artist of rare sensitivity but she did not suffer fools gladly and was, I suppose, somewhat eccentric. She had a cracked and perhaps affected voice that suited her opinions, which could be forceful and final." [215]

68. *Little Sister* oil on canvas (183cm x 95cm)
(Private Collection) (Plate 61)
The inclusion of two portraits of a nude child in the tours that took *Morning* around the country caused a certain amount of furore. This painting was exhibited at the RA in 1933, although it was not shown with STISA until the Winter Exhibition at the beginning of 1944. The full nudity of the young girl perhaps gives rise, rather unusually, to greater disquiet now, in times of increased concern about paedophilia, than when it was first painted, but, as in all Procter's depictions of the feminine form, there is a naturalness and self assurance that seems to reflect a deep understanding and respect for femininity. The long-legged girl may also have modelled for *Light Sleep* (Fig.1-12).

[212] J. Colenbrander, *A Portrait of Fryn : A Biography of F. Tennyson Jesse*, reproduced in Ed. M.Hardie, *100 Years in Newlyn - Diary of A Gallery*, Penzance, 1995.

[213] Journal of the Women's Art Slide Library May/June 1990 by Katy Deepwell, reproduced in Ed. M.Hardie, *100 Years in Newlyn - Diary of A Gallery*, Penzance, 1995.

[214] L.Knight, *Oil Paint and Grease Paint*, London, 1936.

[215] Michael Canney, *Newlyn Notebook*, unpublished but reproduced in Ed. M.Hardie, *100 Years in Newlyn - Diary of A Gallery*, Penzance, 1995.

Fig. 2R-1 Raymond Ray-Jones *Self Portrait*

Raymond Ray-Jones RE ARCA
STISA: 1933-5
STISA Touring Shows: 1934.
Public Collections include British Museum, Victoria and Albert Museum, RE, Ipswich, Manchester, Oxford (Ashmolean) and Sheffield.

Ray-Jones was a welcome recruit to the 'black and white' section of STISA during the mid-1930s. Born in Ashton-under-Lyme, he did not begin to study art until he was 21. After a spell in a local art school, he won a place at the Royal College of Art at South Kensington, where he studied under Sir Frank Short and Professor Moira. He then went to the Julian School in Paris, where he trained under J.P.Laurens, and was awarded a prize and a medal for portrait painting. He settled in Chelsea, specialising in etchings, and his work was exhibited in Paris, Venice, Hamburg, Dresden, Zurich, Geneva, Toronto, Sydney and Dunedin. When he decided to move to Carbis Bay in the early 1930s with his wife and two young children, he was immediately asked to join STISA. Four of the works he exhibited with STISA are in the collection of the British Museum - *Lamplight* (Fig. 1-40), *Pont St Benezit, Avignon*, *La Rue des Quatre Vents* and *Self-Portrait* (cat.no.69) - but he does not feature in any of the 1936 tours or in subsequent shows despite continuing to reside in Carbis Bay.[216] Guichard in *British Etchers 1850-1940* considered that his output might in fact have been restricted to just four or five plates.

69. ***Self-Portrait*** etching (24.5cm x 34cm)
(The Trustees of the British Museum) (Fig. 2R-1)
This stunning etching now sells for as much as £3,000. James Laver in *A History of British and American Etching* comments, "The best work of Ray-Jones has been in etched portraiture, notably the large self-portrait and the plates known as *Lamplight*. In both these, the exquisite modelling of the faces rivals that of Brockhurst. In architectural etchings, his manner is dignified and accurate, with a certain 'tightness' and lack of atmosphere. He strikes the critic as a very reserved artist who would do still better work with a little more confidence."[217]

Leonard Richmond RBA ROI (c.1890-1965) Exh. RA 32
STISA: 1931-c.1954
STISA Touring Shows: Exh.1932, 1934, 1936, 1937, 1945, 1947 (SA), 1947 (W), 1949.
Public Collections include Imperial War Museum, QMDH, Government Art Collection, Newport, Worthing and Houses of Parliament, Ottawa.

Richmond was a widely known and highly respected artist, poster designer and writer and lecturer on art, who was a stalwart supporter of the Society for many years. Born in Somerset, he studied at Taunton and Chelsea Polytechnic. He was elected an RBA upon the personal recommendation of the then President, Frank Brangwyn (q.v.), and a year later was elected an ROI. In 1915, he was awarded a bronze medal at the Panama-Pacific Exposition in San Francisco. During the First World War, he worked for the Canadian Government as a war artist and a huge picture, measuring 15ft x 10ft, entitled *Canadian Soldiers Constructing Light Railways at the Front* is hung in the Houses of Parliament in Ottawa. Afterwards, he settled in London and was first successful at the RA in 1920. During the 1920s, he began a long and successful career as an author of books on art technique, initially working with John Littlejohns (q.v.) for the books on painting in pastels and watercolours. On his own, he produced works on oil painting, on the technique of the poster, on landscape painting and composition, on still life painting in oils and on many other aspects of art. These books were copiously illustrated with his work and showed the various stages in the design and development of each picture. Some of these books became the standard works on the subject and went through countless editions over a period of 50 years.

In 1932, Richmond took a studio in St Ives and joined STISA. He was immediately successful, selling *Lake O'Hara, Canadian Rockies* from the Brighton show to Worthing Art Gallery. When the Editor of *The Artist* visited him in 1933, he had already in an eight week period produced twenty-four canvases and had designed two posters, revelling in getting away from London and "back to nature".[218] For the next four years, his RA exhibits were depictions of St Ives or Hayle and his 1934 exhibit *The Harbour, St Ives*, depicting the classic view from the Malakoff, was used by him to adorn the cover of the prospectus for the Summer Painting School that he established in St Ives in 1935. Many of his paintings of St Ives were reproduced as postcards. He also was in great demand as a designer of railway posters for places as far afield as Venice, Jersey, Ireland, Wales, Kent and, of course, Cornwall (see Plate 26). Richmond also illustrated a number of travel books written by E.P.Leigh-Bennett, which had been commissioned by Southern Railway, including *Devon and Cornish Days* (1935).

[216] In 1939, he is featured in the *News Chronicle* series, Cornish Artists 25.
[217] J.Laver, *A History of British and American Etching*, London, 1929.
[218] *The Artist*, September 1933, p.9.

Fig. 2R-2 Leonard Richmond in his St Ives studio (Gilbert Adams)

Richmond had some distinguished clients. Queen Mary commissioned a watercolour of Fiesole, near Florence and other art patrons included Princess Louise Duchess of Argyle, the Princess Lascelles, the Crown Prince of Siam and two Presidents of the RA, Sir Aston Webb and Sir William Llewellyn.[219]

In 1943, he did a series of 24 paintings of blitzed areas of London, one of which, *Bow Church, St Mary-le-Bow*, was bought by Sir Kenneth Clark for the Imperial War Museum. He then moved briefly to Lydney in Gloucestershire to set up a painting School but decided to move, with his daughter, Olive Dexter (q.v.), to St Ives in 1946, living at Carter's Flats. Not surprisingly, for the three years he was living in St Ives, he was on the Committee of STISA, and he became very involved in the battle to prevent many of the old studios from being converted to other uses. During this time, he shared a studio with David Cox (q.v.), and his painting, *David Cox in his Studio*, was not only included in the 1949 Swindon exhibition, but was also used as the front cover illustration of his book, *From the Sketch to the Finished Picture: Oil Painting*, published in 1953. This also contains illustrations of nearly all his RA exhibits between 1946 and 1952 and various depictions of his studios in St Ives and Chelsea. His large painting, *The Port of St Ives*, won a silver medal at the Paris Salon in 1947. Although on the Committee in 1949, he seems to have been away at the time of the split, and he did leave St Ives shortly thereafter to become Editor of *The Artist*. This was a post that he retained for many years and the magazine is full of his comments on art and frequently includes representations of his pictures. Increasingly, he was in demand as a lecturer on art and he made annual trips to America for Summer Schools. His contributions to STISA shows naturally lessened but he still retained an interest in the Society and, in 1954, made the effort to send a work from San Francisco to one of STISA's exhibitions.

[219] Webb told Richmond that he had chosen a particular picture as he loved the sunlight in the picture. On being told that it had been painted from a shop window as it was pouring with rain, he gallantly offered to pay more! *St Ives Times* 22/4/1949.

70. ***Autumn Flowers*** oil on canvas (59cm x 50cm)

(Private Collection) (Plate 53)

This still life was exhibited at Cartwright Hall Art Gallery, Bradford in 1945. The beach seen through the window marks it out as a St Ives work, although Richmond had not settled in the town by this juncture. In *The Technique of Still Life Painting in Oil Colours*, published in 1936, he stated that he preferred using oil paints for still life as they made it easier to suggest the varying textural surfaces of the objects selected. He also comments that it is rare to find pictures of ordinary indoor objects exposed to the sun and devotes a chapter to the subject. Here by placing the flower group by the studio window, he can capture the effects of light and shade as the sun pours through the window. As a result, the white hydrangea nearest to the window and in the brightest light appears less well defined than those in the centre and to the right. This central band of cool tones breaks up two areas of vibrant colour, which are picked up by the cut flowers laid out on the floor. The curtain draws together many of the colours in the arrangement and the blues of the vase, the right hand hydrangea and the curtain are matched in the hazy outline of the headland and the sky.

71. ***A Sunny Morning, Withypool*** oil on canvas (50cm x 60cm)

(Private Collection) (Plate 79)

Richmond's 1946 RA exhibit, *The River Barle, Withypool, Somerset*, was exhibited in St Ives on Show Day that year to much acclaim and was considered one of the highlights of the 1947 Cornish tour. This painting of delightful reflections on the Barle at Withypool is likely to have been executed at the same time. As Alfred Munnings was based in Withypool for much of the War, one wonders whether Richmond was paying him a visit. Note the striking red roof of the hut in the centre of the composition - a colour device frequently employed by Richmond - and the free brushstrokes employed. Other Withypool works are illustrated in Richmond's book, *From the Sketch to the Finished Picture: Oil Painting*.

Fig. 2R-3 Leonard Richmond demonstrating to two students in his studio (Gilbert Adams)

Walter Elmer Schofield RBA ROI (1867-1944) Exh. RA 2
STISA: 1938-1944
Public Collections include numerous American Galleries and Museums

Schofield was born on 10th September 1867 in Philadelphia. His parents had emigrated from England and his father became part owner of Delph Spinning Co in Philadelphia. Not enjoying the best of health as a child, he was sent out west by his father to toughen him up and, for eighteen months in 1884/5, he lived the life of a cowboy. His earliest works date from this period. Between 1889 and 1892, he studied at the Pennsylvania Academy of Fine Arts before, in late 1892, going to Paris, where he enrolled at Julian's Academy, studying under Bouguereau, Ferrier, Aman-Jean and Doucet. During his three years in Paris, he travelled to Fontainebleau and Brittany and was fired with enthusiasm for Impressionism. In 1894, he returned to the States and tried to work in the family business but it did not suit him. He returned to Europe in 1895 with his charismatic and influential friend, Robert Henri, and fellow art student, William Glackens, and, from Paris, they cycled round Holland and Belgium to view the Dutch masters. The following year, he visited England. In October 1897, he married Muriel Redmayne of Southport, whom he had met initially in Philadelphia. She did not take to life in America and so, in 1901, they moved to England, living initially in Southport. In 1903, he and his wife and their two sons moved to St Ives, living at 16 Tregenna Terrace. They stayed in St Ives for four years, during which time he was an active member of the Arts Club and helped to organise exhibitions at Lanham's Galleries. Schofield was primarily a landscape painter and this was the period when the landscape and marine work of Arnesby Brown, Julius Olsson, Algernon Talmage, Noble Barlow and Lindner, Milner and Meade was winning high plaudits at the RA. There is little doubt that he was influenced by the plein air approach of the St Ives artists and he adopted a broader view and lighter palette. Commenting to his friend, C.Lewis Hind, on his new found enthusiasm, he stated

"Zero weather, rain, falling snow, wind - all of these things to contend with only make the open-air painter love the fight...He is an open-air man, wholesome, healthy, hearty, and his art, sane and straightforward, reflects his temperament." [220]

On another occasion, he observed, "Nature is always vital, even in her implicit moods and never denies a vision to the real lover." [221] In addition, Schofield started to use huge canvases for his outdoor works and the result was panoramic landscapes, boldly and expansively painted.

Julius Olsson was a particular friend and, in 1908, the pair went on a painting trip to Dieppe with the American painter, George Oberteuffer. By that time, however, Schofield and his family had moved to Yorkshire. In 1912, they moved again to Bedfordshire. Schofield was a restless spirit. No sooner had he settled into any new home that Muriel had located for the family than he would announce "Well, it's time to be moving on." and he developed a lifestyle that involved him spending as much as six months a year - normally from October to April - in the States away from his family. Although a RBA and a ROI, Schofield always favoured the American exhibition circuit and American patrons and, as a result, during the first three decades of the twentieth century, he became regarded as one of America's leading landscape painters and is now lauded as one of the most important of the American Impressionists. His medal tally at American and International exhibitions is impressive and include a 'Mention Honorable' at the Paris Salon in 1900, a First Class Medal at the Carnegie Institute in 1904, a Gold Medal at the 1910 Buenos Aires Exhibition, the Medal of Honour from the Panama-Pacific International Exposition in San Francisco in 1915 and a silver medal at the Corcoran Gallery of Art, Washington D.C. in 1926. In fact, the Corcoran held three one-man exhibitions of his work in 1912, 1920 and 1931 and he was well-respected in art circles, serving on exhibition juries and selection committees.

Schofield made more than forty crossings of the Atlantic by steamer and, between 1902 and 1937, the only years when he did not visit the States were the War years. In 1915, aged 48, Schofield felt sufficiently deeply about Germany's actions that he enlisted as a private soldier in the Royal Fusiliers but, with Olsson's assistance, he received a commission from the Royal Artillery the following year.[222] He fought at the Somme and rose to the rank of Major but his only painting exploits were in camouflaging the guns under his command. In 1921, he returned to Cornwall, living at Doreen Cottage at Perranporth for four years, although, as always, he was constantly away from home, seeking new subjects, new inspiration and, most importantly, new purchasers. In 1925, the family moved to Otley, Suffolk, where his son, Sidney had started farming.

In the late 1920s and 1930s, with his marriage under strain, Schofield spent as much as nine months a year in the States and, in addition to returning as always to his home state of Pennsylvania, he spent long periods in California, Arizona and New Mexico, where he painted scenes of the American West. However, when his son, Sidney, in 1937, purchased Godolphin, the impressive manor dating from the 15th century, near Breage, he could not resist the lure of Cornwall again and he and his wife moved in

[220] C.Lewis Hind, *An American Landscape Painter, W.Elmer Schofield*, International Studio, 48, 1913, p.280-289.
[221] Quoted in Thomas C Folk, *The Pennsylvania Impressionists*, at p. 56.
[222] A card signed by 15 members of the St Ives Arts Club, including Schofield, dated 8/9/1915 indicates he had returned to visit St Ives at this time.

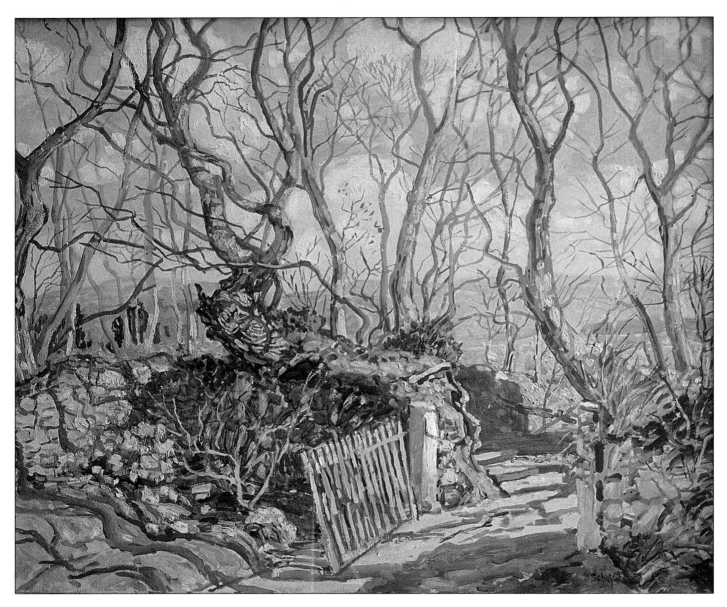

Fig. 2S-1 Elmer Schofield *The Slipp, Godolphin House* (John Schofield)

during the autumn of 1938. He immediately joined STISA - Moffat Lindner, Fred Milner and Arthur Meade would have been colleagues from his first visit to St Ives - and his exhibits soon were highly applauded. In 1941, after his son's marriage, he moved to Gwedna House, a smaller residence on the estate, where he died from a heart attack in 1944. [223]

72. *Godolphin Ponds in Winter* oil on canvas (74.5cm x 90 cm)
(Collection of Mary Schofield) (Plate 44)
Schofield was renowned for large snow scenes - in fact, one of these had been included in the Retrospective Exhibition organised by STISA in 1927. This painting of Godolphin was painted as a wedding present for his son, Sidney and his wife, Mary Lanyon, on their marriage in 1940. Schofield was selective in the features of the Cornish landscape that he chose to portray and seemed to hanker after subjects that evoked a bygone age. A typical primitive cottage with a thatched roof would tempt him time and again. He executed in his last years a number of large works depicting features of the Godolphin estate but, rather than focussing on the architecture of the house, he chose the woods and ponds and simple gates with their huge stone supports, so redolent of menhirs. These seemed ageless and mysterious. They exuded atmosphere, which he captured with his broad, free brushstrokes and bravura technique. They are some of the finest works of his career.

[223] Much of this information is derived from Valerie Livingston, *W. Elmer Schofield, Proud Painter of Modest Lands*, Bethlehem, Pennsylvania, 1988. See also Thomas C. Folk, *The Pennsylvania Impressionists*, New Jersey, 1997 and *The Pennsylvania School of Landscape Painting - An Original American Impressionism*, Allentown Art Museum, 1984 and Donelson F. Hooper, *The American Impressionists*, New York, 1981.

(Miss) Helen Priscilla Seddon
STISA: 1928-c.1972
STISA Touring Shows: 1932, 1934, 1936, 1937, 1947 (W). Also FoB 1951.

Helen Seddon was one of the stalwarts of the watercolour still life section of STISA for over forty years. The daughter of a New Zealand sheep farmer, she was, in fact, born in Shropshire and was educated in Worcester. She studied art in Edinburgh and Paris and is first mentioned in St Ives when she exhibited on Show Day 1923 at Crab Rock in The Warren. On arrival, she studied further under Charles Simpson and Fred Milner. She later took Morvah Studio at 17, The Warren. In addition to her "cleverly painted and brilliantly coloured" flower paintings, she also did landscape, marine and architectural subjects, with Polperro a favourite haunt. She served on the Committee in 1939.

73. *A Spring Selection* watercolour (36cm x 49.5cm)
(Private Collection) (Plate 50)
A delightful example of the luminous flower paintings that Seddon is best known for. Daffodils, pheasant-eyed narcissi and berries are depicted in a Chinese vase.

Hyman Segal RBA (b.1914)
STISA: 1947-1949 & 1957-1973
STISA Touring Shows: 1947 (W), 1949.
Public Collections include Cardiff and Manchester.

Although an artist keen on traditional values, Segal was one of the younger generation of artists and had little sympathy with the reactionary views of some of the 'bathchair brigade' but, having joined the Penwith Society, he soon found himself at loggerheads with Nicholson and Hepworth. He accordingly returned to STISA and remained a member until 1973. He continues to fling humorous darts at the moderns and the Tate Gallery, St Ives.

Born in London in 1914, Segal suffered from blindness in early childhood but he won a scholarship to St Martin's Art School at the age of 12, where he studied under Leon Underwood and Vivian Pitchforth. He worked initially as a freelance commercial artist and became N.R.D. (qualified designer in Industry) at the age of 23. Clients included London Underground (a poster for the 1936 All Blacks tour), Shell-Mex, Decca, Rolls-Royce, Courtaulds, *Vogue*, *Autocar* and the Ministry of Information. He also produced sculpture, decor and costume designs for ballet. During the Second World War, he served in Africa and produced many native studies. On his return, he joined STISA and exhibited in 1947 at the Paris Salon and at the Royal Society of Portrait Painters.[224] Phil Rogers, the landlord of 'The Sloop', also permitted him to show and sell his work in the Cellar Bar there - the start of a long association between Segal and that pub.[225] He also had one-man shows at Bankfield Museum, Halifax and Bagshaw Museum and Art Gallery, Yorkshire.

In 1948, Peter Lanyon and himself were elected on to the Committee to represent the younger element but both resigned at the time of the split in 1949. Segal's account of the extraordinary general meeting, entitled, *Storm in a Paint Pot*, refers to George Bradshaw holding his fist aloft and brandishing it uncomfortably close to the chin of the Chairman, Leonard Fuller. "The old sea-dog's quarter-deck expletives thundered and gusted within quiet walls which here-to-fore had echoed but approbation or mild criticism. They now shuddered at the stormy sounds of character assassination. Brother Brushes bristled, and the Chairman resigned. The raised fist became a signal for mutiny. A number of youngish artists abandoned ship, stripping their work from the corner of the Gallery which had harboured it grudgingly for a while as a hand-across-the-sea gesture to Contemporary Art."[226]

Segal was, however, the first of the foundation members to resign from the Penwith Society in 1950, objecting to the Committee's decision to divide members into self-voting groups, dependent on their style of art. He wrote to the *St Ives Times*, saying that, had these proposals been mentioned when the Society was formed, "they would have been laughed to scorn" and that he had no wish to remain involved with a Society "whose rules now make a mockery of the original high ideals".[227] Quite how quickly Segal became distanced from the moderns can be seen from six learned articles that he wrote between September 1951 and February 1952 for *The Artist* (Volume 42) on *Drawings of Character*. These were illustrated with his own work, including many of his African pastel studies, some charcoal portraits and a few of his wonderful sketches of cats. In these articles, he advocates a close

[224] *Cornish Farmer* and *East African* were exhibited at RP and *Boy in Airman's Helmet* and *Houseboy of Karen* were exhibited at the Paris Salon. The latter is illustrated in H.Segal, *As I Was Going to St Ives*, St Ives, 1994, at p.163. All four works were included in the Crypt Exhibition in September 1947.
[225] See H.Segal, *As I Was Going to St Ives*, St Ives, 1994, p.70-1.
[226] H.Segal, *As I Was Going to St Ives*, St Ives, 1994, at p.97.
[227] *St Ives Times*, 3/3/1950.

Fig. 2S-2 Hyman Segal sketching Mr Fifoot in his studio
(Gilbert Adams)

Fig. 2S-3 Hyman Segal in his studio
(Gilbert Adams)

study of old master drawings (including those from Picasso's classical phase), a detailed knowledge of anatomy, perpetual study of facial character and expression and a full appreciation of the rhythms and masses of drapery. All of this needs to be appreciated before the artist's own personal interpretation comes into play. An artist's life was, accordingly, one of continuous study. Such traditional values must have sounded rather outdated at the time and Segal confirms his outlook by castigating the so-called 'primitives' and other similar 'pets', who have merely lifted the superficial qualities of an established contemporary artist's work.

Segal rejoined STISA and was much admired for his work promoting art as therapy for patients at Tehidy Hospital.[228] In 1955, his oil painting *Dominoes at The Sloop* (Fig. 2S-4), featuring amongst others, John Barclay (q.v.), was the star exhibit of Show Day. This shows Rountree's caricatures on the walls of the pub but it is Segal's own portrait studies of local fishermen and other regulars, which are now admired at 'The Sloop'. A number of these come from Segal's *Familiar Faces of St Ives* series, first published by the *St Ives Times* and then in a separate book. A late portrait of Bernard Leach is now owned by the National Museum of Wales, Cardiff.

74. *Kimani* pastel (29cm x 23cm)
(Hyman Segal) (Plate 62)
The Crypt of the Mariners' Chapel was not just used for exhibitions of the Crypt Group and Segal held a one-man show there in September 1947, in which he exhibited 100 works, including drawings, pastels, oils and watercolours, together with some examples of his commercial art and some cartoons produced for the East African Command. Recalling this show recently, Segal commented, "I remember Borlase Smart poking his head in the door, taking a quick look and then going away, when I thought, well, that's it. To my surprise, he returned with a photographer, the show was featured and reviewed in the local press, and I was on my way! It was typical of the terrific encouragement I received from many of the older artists in St Ives at that time." Borlase Smart, in his review, commented that the show had been a revelation to his fellow artists who, from his few offerings at STISA shows before, had not appreciated "his power of observation, breadth of translation and variety of outlook".[229] The bulk of the exhibits were his African studies, and this dignified portrait in pastel was the highest priced work, at £60. It was put forward for the South African tour in 1947 but the Maskew Miller Gallery deemed it entirely inappropriate for it to exhibit 'native portraits'. Nevertheless, his African works did gain international exposure and he continued to employ art as a weapon against the horrors of apartheid. An album of reproductions and press cuttings was presented to Nelson Mandela on his State Visit to England in 1996.

[228] See for instance, *Art Therapy - Hyman Segal's Work in Cornwall*, *The Artist*, February 1953, p.132-3. Augustus John was among those who wrote to say how much he had enjoyed the Tehidy drawings.
[229] *St Ives Times*, 9/1947. The reviewer is not named but David Cox's annotated copy of the catalogue clearly shows that it was himself.

Fig. 2S-4 Hyman Segal *Dominoes at the Sloop*
The characters featured were (clockwise from front) Edward S. Harry (Curator of St Ives Arts Club) and Matt
Pearce playing dominoes with Gascoigne Paynter looking on. Philip Stevens and Thomas Andrews (coxswain of
the lifeboat) watch Wee Willie Stevens (holder of the Sloop skittle-playing championship) as do Ivor Short and
Edward Peters. F. Oldfield, who died shortly afterwards, stands next to the artist John Barclay (far right).

75. *Head of a Masai* pastel (32cm x 20cm)
(Private Collection)
Another of his African pastel portraits, which will be on show during the tour as *Kimani* is only available for the
Penzance section.[230]

[230] This work is illustrated in David Tovey, *George Fagan Bradshaw and the St Ives Society of Artists*, Tewkesbury, 2000 at p. 200.

(Miss) Dorothea Sharp RBA ROI (1874-1955) Exh. RA 54
STISA: 1933-1955
STISA Touring Shows: 1934, 1936, 1937, 1947 (SA), 1947 (W), 1949. Also FoB 1951.
Public Collections include Belfast, Bournemouth, Cardiff, Doncaster, Leamington, Manchester Newcastle, Newport, Northampton, Oldham, Rochdale, Worthing and, abroad, Auckland, Hobart, Johannesburg and Harare.

Dorothea Sharp was the second artist to feature in the *Artists of Note* series in *The Artist* in the 1930s and Harold Sawkins, the Editor, started with the observation, "I think I can say, without fear of contradiction, that Dorothea Sharp is one of England's greatest living woman painters. And I think I can supplement this by stating that no other woman artist gives us such joyful paintings as she. Full of sunshine and luscious colour, her work is always lively, harmonious and tremendously exhilarating."[231] Saleroom prices indicate that the modern collector is equally enchanted.

Eldest daughter of Mr James Sharp of Dartford, she was educated privately but her desire to follow an artistic career was blocked by her parents until a legacy from an uncle, when she was 21, enabled her to start a course of instruction. She studied initially under C.E.Johnson R.I. and then went to evening classes at the Regent Street Polytechnic, where visiting critics included George Clausen and Sir David Murray. She went to Paris chaperoned by her invalid mother and studied under Castaluchio, from whom, she stated, she learnt all she knew. Whilst in Paris, the paintings of Monet were a great inspiration and ever after she worked in the manner of the French Impressionists. On returning home, she nearly married but felt that painting must come first in her life. Her first painting was accepted by the RA in 1901 and, in 1907, she was elected to the RBA. She was then living in Maida Vale, looking after her invalid mother and working from a little back bedroom at their home. In 1916, they moved to 22, Blomfield Road, still in Maida Vale, and this was to be her London base for the rest of her life. Although, with the exception of the years 1926, 1929 and 1941-3, she was represented at the RA each year between 1916 and 1948, her reputation only took off after the death of her mother, in the early 1920s, gave her greater freedom. She was elected to the ROI in 1922.

She first came down to St Ives in 1920 and it was there that she met her life-long companion, Marcella Smith (q.v.). Despite moving to London, Smith retained her Porthmeor Studio and they would visit St Ives regularly during the summer. In an article entitled *A Cornish Chelsea*, Vera Hammens describes chancing upon Sharp at work. "I found her painting on the Porthmeor Beach, surrounded by children, mostly the daughters of fishermen, for these are her chief sitters. How they love to dress up in the pretty frocks from the children's wardrobe she always carries about with her!"[232]

She was invited to join STISA in 1928 and, although occasionally exhibiting with the Society, she did not actually become a member until 1933. Unsurprisingly, her contributions to STISA shows were highly regarded and sold well. She had her first one-man show at the Connell Galleries in 1933, which was a big success with visitors thronging the Gallery and 75% of the work being sold. She did a number of railway poster commissions for LNER, including *Filey for the Family*, a typical scene of children playing on the rocks. She was a central figure in SWA, being Acting President (1932-1933), Vice-President (1934-6) and Secretary (1937-1954). She was also President of the Art Section of Forum, the famous London Women's Club.

During the war, she moved down to St Ives and became more actively involved in the running of STISA. As a member of the Committee in 1948, she was unhappy with the exclusion of work by longstanding colleagues and, accordingly, was one of the signatories requesting the extraordinary meeting in 1949.

In her later years, she painted large numbers of vigorous and vibrant flower paintings, which are also very popular with collectors. The first mention of these are in a review of the Winter Exhibition at Lanham's in November 1943.[233] Her last picture was a huge flower piece commissioned to go over a fireplace in the Empress Britain.

76. ***White Ducks*** oil on canvas (82cm x 79cm)
(Doncaster Museum and Art Gallery) (Plate 6)
Children and ducks were two of Sharp's favourite subjects and here, in a delightful scene set beside a river, she has captured a young girl's fascination with the ducks who have been tempted near by titbits, whilst her elder sister tries to prevent her going too close, knowing how easily such interest can end in tears. Both the colourful wild flowers growing in the grassy bank in the foreground and the rippled water of the river are depicted both in full sun and in the shade, making an extremely colourful and balanced composition. The painting dates from the late 1920s.

[231] *The Artist*, April 1935, p.55.
[232] *St Ives Times*, 31/8/1923, reproduced from *Daily Graphic*.
[233] *St Ives Times*, 26/11/1943.

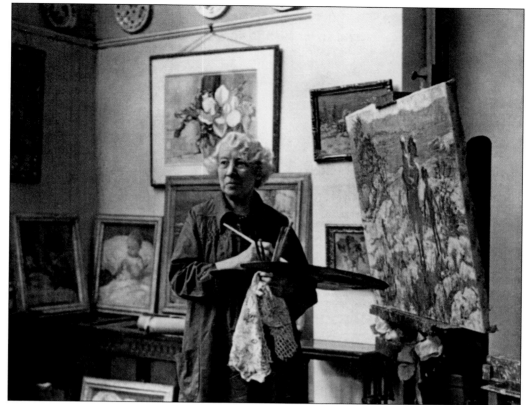

Fig. 2S-13 Dorothea Sharp in her studio in 1940

77. *Low Tide* oil on canvas
(Rochdale Art Gallery) (Front Cover)
The manner in which Dorothea Sharp composed this subject and completed the painting is set out at length in a chapter in her book, *Oil Painting*, entitled 'Studio Pictures from Sketches'. From this painting, therefore, one can learn much about her working methods, as she indicates that most of her paintings of any size are painted in the studio, using a series of pencil notes and sketches made out of doors. The scene here is not St Ives, as has sometimes been assumed, but Cassis in France. Her eye was caught initially "by the wonderful emerald green reflections contrasting with the sparkling translucent blue of the sea". That day, two small boys gave her the idea of a group of figures against the sun, something she always considered was a fascinating effect, and she completed an initial sketch. It was the next day when she witnessed the incident that she has depicted, - "a big girl wearing beautiful yellow paddlers, splashing her baby sister with water from a green bucket", with "the little one yelling for all she was worth"! She made a quick charcoal sketch of the incident and later made several oil notes of the incoming tide. "As the bigger girl would be rather important, I made another sketch from a little model posed in my own garden."

She started the studio picture by lightly and roughly drawing in the design with soft charcoal. She then started painting the most important object, as this gave the keynote of tone and colour to be carried through the entire scheme. "In this case" - she comments - "the key-note is the girl's green bucket - it is repeated in the small figures to the left of the central group, carried through the middle distance, emphasized in the green reflections of the cliffs and then again, though in a slighter degree, in the distant rocks. The yellow of the paddlers or knickers worn by the girl is repeated in the wet sand of the finished picture, and again repeated in a distant figure. It also serves as a foil to the fair hair of the baby. Had I made its hair darker, this patch of colour would have had to be richer in tone."

Having painted the figures, very broadly at first, she next painted the sea, making certain the colour was broken by putting on the paint loosely and not in regular sequence and then turned her attention to the foreground. "In painting this" - she observed - "the technique must be kept fresh and sparkling. A large brush was used, well loaded with paint, put on with broad, vigorous strokes. I finished this as far as possible in the first painting, for often one brushful of thick paint put on with expressive drawing is more effective....than much overpainting. The large brushwork also helps the perspective of the distance where the paint is kept flat." Two days work saw the painting largely completed, with a final review a week later when the oil was thoroughly dry.

78. *Sea-Bathers* oil on canvas (70cm x 80cm)
(Newport Museum and Art Gallery) (Plate 7)
Another typical Sharp scene of children splashing about in the shallows. Here the key colour note was the green swimming costume of the eldest girl, who is placed boldly in the centre of the composition. The different colours of the shallows play off the green of her swimsuit. The white dress of the girl with the shrimping net is picked up in the sails of the yachts in the background and in the seagulls and breaking waves. On the other side of the central figure, the bare luminous flesh of the nude child with golden hair is picked up in the two figures in the rear wearing yellow costumes. Again the foreground is broadly painted. This work was bought from the 1934 RA Exhibition for Newport's permanent collection. In recording this sale, Harold Sawkins, the editor of *The Artist*, who considered Sharp one of the most delightful women artists he knew, commented, "She has been doing remarkably well and, for this, much credit is due to Messrs James Connell & Sons, who took up her work some two years ago." [234]

(Mrs) Alixe Jean Shearer Armstrong (1894-1984) Exh. RA 10
STISA 1927-1949 & 1969-1984, Treasurer 1940-4
STISA Touring Shows: 1932, 1934, 1936, 1937, 1945, 1947 (SA), 1949.
Public Collections include the Duke of Edinburgh and Cornwall and Scottish Educational Committees.

As the only founder member of STISA to embrace modern art, Shearer Armstrong's progression as an artist is fascinating and deserves greater study. The daughter of Donald Francis Shearer, she was born in London and educated at Roedean. As her family had become wealthy through the Yorkshire wool trade, Shearer Armstrong was financially independent and she decided to pursue an artistic career, beginning her training in St Ives. She later commented, "When I first came to St Ives, Algernon Talmage took me out to do watercolours. What I did was so bad that he started me on oils right away". Afterwards, she studied portraiture in Karlsruhe, Germany under Otto Kemmer and went to the Slade, where she trained under Brown and Tonks. Having married Henry William Armstrong, she returned to Cornwall in 1924 and had some further lessons with Stanhope Forbes. A number of her early exhibits on Show Days were illustrations for books and she continued to produce woodcuts for many years. [235]

Although she lived in Carbis Bay, she always maintained a studio in St Ives, first at 1, Piazza Studios and then, from about 1930, at 9, Porthmeor Studios, as she felt it was important for a woman to get away from her home. To begin with, she specialised in flower paintings, first exhibiting at the RA in 1927. These were bold, strong works that commanded attention and she was complimented on having the courage to set herself problems that required concentration. [236] During the 1930s, she developed an individual style of still life, into which she packed a medley of objects, animals and views of distant landscape. The resultant works had an exotic flavour and revealed a vivid imagination. "In my opinion", she said, "pictures that give people something to think

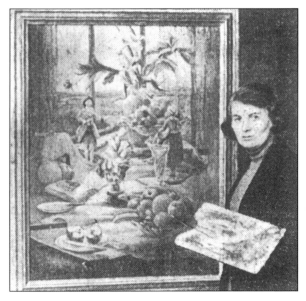

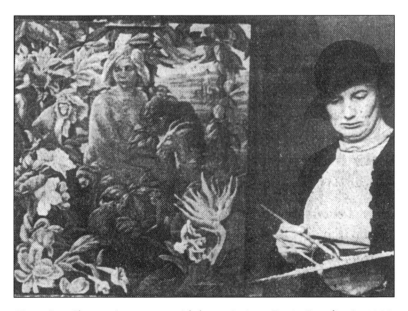

Fig. 2S-6 Shearer Armstrong with her 1936 RA exhibit, *Decoration: Gay Fruits*

Fig. 2S-7 Shearer Armstrong with her painting, *Eve in Paradise*, in 1939

[234] *The Artist*, 1934/5, Vol 8, p.107.
[235] In 1925, she exhibited some illustrations felt to be reminiscent of Arthur Rackham. One of these, *Ritournelle - title page*, was exhibited at SWA that year. In 1927, her Show Day exhibits included some illustrations for the *Arabian Nights* and, in 1928, for John Masefield's *Midnight Folk*. In 1948, she exhibited at SWA *The Sleeping Princess* for Charles Perrault's *Fairy Tale*. It does not appear as if any were ever used.
[236] *St Ives Times*, 18/3/1932.

about are much more stimulating than landscapes and sunsets. I am more interested in ideas and in things that are not just like nature. I take a long time to think out a picture but I do the painting very rapidly. I like decorative work best of all." In fact, she prefaced a number of the titles of her RA exhibits with the word "Decoration" and pride of place in her Porthmeor Studio was given to her 1935 RA work *Decoration : Bamboo and Fruit*. She also admitted to a great weakness for painting birds and animals and made a number of trips to London to sketch in the Natural History Museum and in London Zoo. In the late 1930s, she began to introduce figures into her work, often with religious connotations, whilst still striving for an overall decorative effect. In 1937, she exhibited on Show Day a decorative panel, *In Praise of St Luke*, which showed two lithe and graceful figures amongst Autumn flowers and fruits. This was followed by *Eve in Paradise* in 1938, considered her finest work to date, which had the 'first woman' seated amidst the luxurious foliage of tropical vegetation and surrounded by tropical birds and beasts, as well, of course, as the serpent. World events shaped her principal work at 1939's Show Day, *The Year of Grace 1938*, which was based on the story of the Four Horsemen of the Apocalypse and depicted tyranny, famine, war and death. This was a powerful image, painted with force and conviction.

A founder member, Shearer Armstrong was always actively involved with the Society. In 1928, she was elected Secretary in her absence, but felt unable to take on this role. She was often elected on to Hanging Committees and, in 1929, she was co-opted on to the main Committee during Lindner's absence. In 1936 and 1937, she served on the main Committee before taking over as Treasurer in 1940 from Francis Roskruge, a post she held throughout the War. Afterwards, however, she became friendly with Ben Nicholson, who had a strong influence on the direction that her art now took and she resigned from STISA at the time of the split in 1949. She became a founder member of the Penwith Society and her work moved towards complete abstraction - see Michael Wood feature opposite page 168. She remained a leading figure in that Society for some twenty years before returning to STISA in 1969, where she exhibited more traditional work until her death.[237] In her later years, she gave painting classes every week to the residents of St Teresa's Cheshire Home, a place she supported in many other ways. Her studio collection, which included paintings by Nicholson, Lanyon and Wallis, was sold at Bearnes, Torquay on 8th September 1983.[238]

79. *Conversation Piece (Flowers with a Bird)* oil on canvas (40cm x 30cm)
(St Ives Arts Club) (Plate 55)
This work, which dates from 1938, is an example of the more complex and unusual type of decorative arrangements that Shearer Armstrong was putting together in the late 1930s. She had probably sketched the birds in London Zoo.

Charles Walter Simpson RI (1885-1971) Exh. RA 48
STISA 1943-1955 and 1961-3
STISA Touring Shows: 1945, 1947 (SA), 1947 (W), 1949. Also FoB 1951.
Public Collections include QMDH, Victoria and Albert Museum, Blackpool, Bournemouth, Derby, Doncaster, Gateshead, Harrogate, Newcastle, Newport, Nuneaton, Paisley, Penzance, Plymouth, Sheffield, South Shields, Sunderland, Truro and, abroad, Christchurch, Dunedin and Perth.

The son of an Army Major-General, Simpson first came to St Ives in the autumn of 1905. As an artist, he was largely self-taught but he had studied for a while in 1894 at Bushey under Lucy Kemp-Welch, the well-known horse painter. In St Ives, he took lessons from Noble Barlow and Arnesby Brown. He also got involved with the Newlyn artists, selling his first work at the Newlyn Gallery in 1909 and contributing woodcuts to *The Paper Chase*, the publication put together by students at the Forbes School. He left for Paris in 1910 to study at Julian's Academy and he attributed his interest in depicting water to the floods in Paris that winter, when the Seine broke its banks and converted the Champs Elysees into a river, full of floating barrels, cattle and other debris. On his return, he became engaged to Ruth Alison, a fellow artist, just a couple of days after first meeting her. They were married in 1913, living first in Newlyn and then Lamorna. In 1915, he was awarded a gold medal at the Panama-Pacific International Exposition in San Francisco. Buoyed by this honour, the following year, Ruth and he moved to St Ives to set up their own School of Painting, which they ran from Nos 1 and 2 Piazza Studios until 1924. During this period, Simpson dominated the St Ives art scene, often working on a grand scale. He completed a large series of paintings of Wild Birds, which he exhibited at the Laing Art Gallery in Newcastle in 1920, and another series of the Herring Fishing Season in St Ives in 1924, which he painted from Shore Studio on The Wharf (see Plate 75). Kathleen Bradshaw, who studied under him, recalls him painting very quickly - "like quicksilver" - while Laura Knight commented, "He was so prodigal with paint, he could be traced by the colour left on the brushes!". He won a silver medal at the Paris Salon in 1923 and a gold medal at the VIII Olympiad in Paris in 1924. A number of his major works from this period, such as *Trink Hill* (RA 1920), *The Breakwater* (RA 1921), *Black-backed Gulls* (RA 1922 - Newcastle), *The Flight of Wild Duck* (RA 1922), *Seagulls Nesting* (RA 1923) and *Duck Shooting : The Punt* Gunner (RA 1925 - Bournemouth) are illustrated in *Unknown Cornwall*, the book published by his friend, C.E. Vulliamy, in 1925.

[237] See *News Chronicle*, 1939, Cornish Artists : 14.
[238] I am most grateful to Bearne's, Exeter for supplying me with a copy of this.

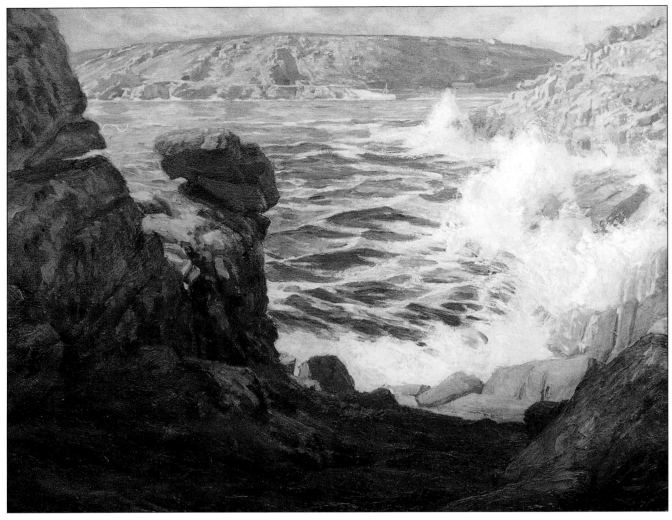

Fig. 2S-8 Charles Simpson *Stormy Weather on the Cornish Coast* (RA 1949) (W.H.Lane & Son)

Simpson himself started to write and illustrate books. *Il Pastorale*, illustrated by woodcuts, described bird life on a Sussex marsh. *El Rodeo* featured his depictions of the Great International Rodeo at Wembley Stadium in July 1924. As a result of this book, Simpson received commissions to write and illustrate histories of various famous hunts in Leicestershire and Yorkshire and he left St Ives in 1924 to concentrate on equestrian painting. In addition to fox hunting, he depicted the annual Grand National and other important races and held a succession of exhibitions of these works at the Fine Art Society. He was also in demand as an illustrator of books on country pursuits and, for his humorous work, he assumed the pseudonym 'The Wag'. None of his equestrian works, however, were hung at the RA and, although he returned to live in Cornwall in 1931, it was only when he reverted to painting pictures of the Cornish landscape in the mid-1930s that he was successful again at Burlington House. In 1938, he published *Animal and Bird Painting*, a review of the genre, which praised, in particular, the work of Alfred Munnings. In the same year, he also published *Photography of the Figure*, the result of his researches into the differing treatment of the figure in art and photography, and he retained a keen interest in this subject.

Given his strong St Ives connections, it is somewhat surprising that he did not join STISA on his return to Cornwall and it was only in 1943 that he became a member. Thereafter, though, he made significant contributions to STISA shows and, being no fan of modern art himself, he remained a member after the split. In 1948, he published *The Fields of Home*, a partial autobiography, and this includes colour illustrations of some of his exceptional RA exhibits of this period, including *Sunrise on the Estuary*, showing mallard taking to the wing, *Wheeling Gulls and Glittering Water*, a scene in Newlyn harbour, and *Evening Light on Carn Du, Cornwall*, a view from the beach at Lamorna. He was described by Guy Paget in *Sporting Pictures of England* (1945) as "the best bird painter living" and yet paintings from his Wild Bird series have passed through the salerooms recently without generating any interest. His paintings of the fishing industries in St Ives and Newlyn, however, do command high prices, whilst there is a keen market for his equestrian works in the States. However, as he was prolific and worked quickly, his output is variable in quality. Simpson also had a passion for music, making a life-long study of Beethoven, and a love of drama and literature (another of his books being a critique of Emily Bronte). Accordingly, he was an extremely cultured and interesting man whose full accomplishments have not been recognised.

MICHAEL WOOD FINE ART

Established 1967

'Modern masters to appreciate that appreciate'

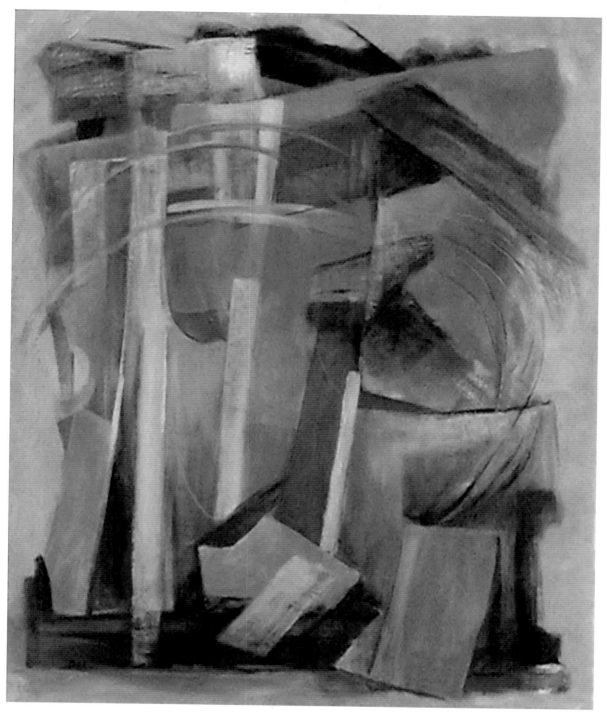

'Rock Presence'

oil on board 50" x 40"

Exhibit 74 – John Moores Liverpool Exhibition 1961

Alixe Jean Shearer Armstrong (1894-1983)

MICHAEL WOOD FINE ART ▪ The Gallery ▪ 1 Southside Ope ▪ The Barbican ▪ Plymouth PL1 2LL
Tel & Fax: 01752 22 55 33 ▪ Tues to Sat 10 am to 5 pm & at other times by appointment

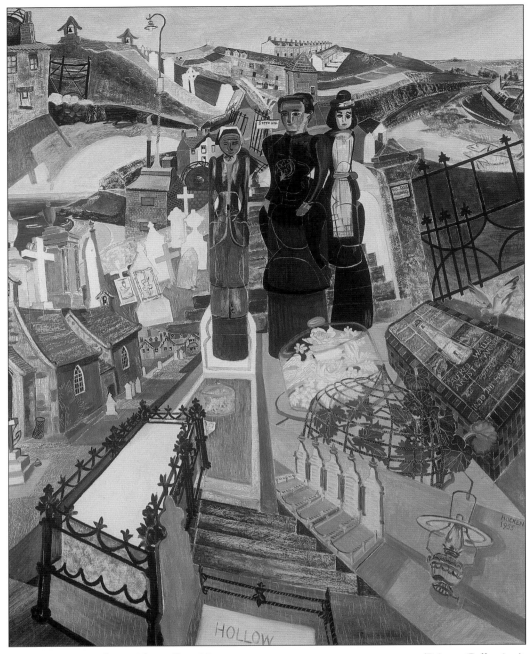

63. Marion Hocken *The Hollow Men* (Private Collection)

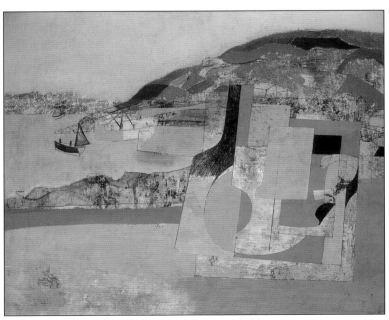

64. Ben Nicholson *1947 Nov.11th (Mousehole)*
(The British Council, © courtesy of the artist's estate/Bridgeman Art Library)

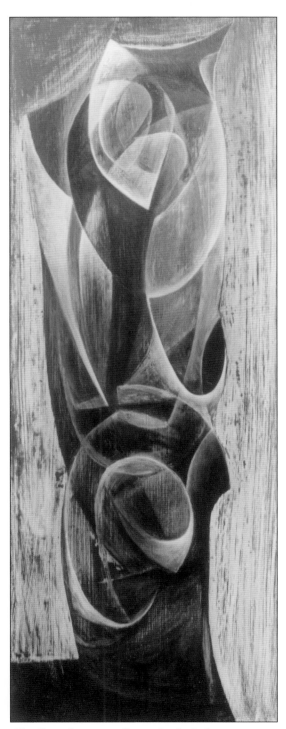

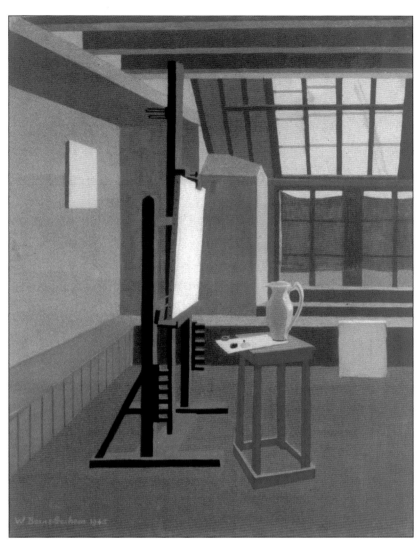

65. Wilhelmina Barns-Graham *Studio Interior* (W. Barns-Graham)

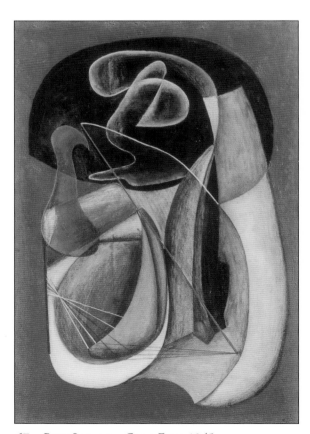

66. Peter Lanyon *Generation* [print]
(Private Collection)

67. Peter Lanyon *Green Form 1945*
(Private Collection)

68. Harry Rountree *Matt Pearce* (Private Collection)

69. Harry Rountree *John Barclay* (Private Collection)

70. Harry Rountree *Pop Short* (Private Collection)

71. Harry Rountree *The Artist* (Private Collection)

80. *The Stream at Clapper Mill, Lamorna* oil on canvas (102cm x 127cm)
(Newport Museum and Art Gallery)
Simpson decided to use a photo of this work as the frontispiece for his autobiography, *The Fields of Home*, published in 1948 and, accordingly, he rated it as one of his best works. Ducks on or by the water was a subject that Simpson returned to time and again and few artists can rival his ability to paint birds in their natural habitat. Simpson observed birds constantly, being a familiar sight in his motorbike and sidecar, binoculars to the ready. Whereas Simpson knew the intricate details of birds' plumage, he rarely portrayed this detail as he was more concerned with the play of light off feathers and water, which affected what the human eye actually saw. Here a group of Aylesbury ducks are depicted in sunlight and shade on the stream, while three, with their usual male mallard companion, are shown in the dappled sunlight on the bank. The treatment of sunlight and shade throughout the work is masterly. The painting was exhibited at the RA in 1945 from which it was bought by Newport.

Robert Borlase Smart RBA ROI RBC RWA SMA (1881-1947) Exh. RA 22
STISA: 1928-1947, Secretary 1933-1947, President 1947
STISA Touring Shows: 1932, 1934, 1936, 1937, 1945, 1947 (SA), 1947 (W), 1949.
Public Collections include Imperial War Museum, National Maritime Museum, QMDH, Bristol, Leamington, Plymouth, Sunderland, Swindon, Truro and Bombay.

It is impossible to overemphasise the part that Borlase Smart played in the success of STISA. Without his enthusiasm and energy, it is doubtful whether the Society would have survived, let alone gone on to achieve the astonishing success that it did. Born in Kingsbridge in Devon, he initially studied under F.J.Snell in 1896 and then at Plymouth College of Art under Shelley in 1897. A *Study from the Cast* was included in the RCPS Exhibition in 1897. He then obtained an Art Class Teacher's Certificate, with first class honours, at South Kensington in 1901. From 1903-1913, he was art critic for the *Western Morning News* and contributed a number of sketches, mainly of naval craft, to *Navy and Military Record*. His first RA exhibit in 1912 was *Moonlight on the Cornish Riviera*. Eager to learn from the master of such scenes, Julius Olsson, he came to study under him in St Ives in 1913. During the war, he served in the Artists' Rifles, the London Regiment, the Queen's Regiment and as Captain in the Machine Gun Corps, and a series of charcoal and wash drawings of his experiences in the trenches and of the devastation of northern France were exhibited at the Fine Art Society in July 1917 (and subsequently in Plymouth) under the title, *Sketches of the Western Front, Vimy Ridge to the Somme*. There is an intense, almost lyrical, feel about some of these deserted landscapes and 32 of the sketches are now in the collection of the Imperial War Museum.

In the same year, he married Irene Godson, the daughter of his platoon sergeant, who had been killed in action, and, in 1919, upon demobilisation, they settled in St Ives. He soon entered fully into the community life of the town, serving for a time on the Council, becoming involved with the Chamber of Commerce and forming the Sea Scouts. On the artistic front, his impact can be seen immediately in the heightened coverage given to the art colony in the local press. Although a newcomer, Smart was prepared to be quite sharp in his comments on the work of his fellow artists. His own work was felt to be promising and a series of charcoal drawings with coloured washes of old St Ives, which combined his skill as an architectural draughtsman with "frank" and "vigorous" colour, was well received (see Fig. 2S-[]). Some of these were used to illustrate an article on St Ives by Frank Emanuel in the *Architectural Review*, in which he complimented "the sureness of their drawing and the directness and rapid completeness of their handling."[239] For the Mayflower Centenary in 1920, he did a similar series of Plymouth, including some imaginative reconstructions of the past. He was elected to the RBA in 1919 and the ROI in 1922 and was successful at the RA with two outstanding marine oils, *Morning Light : St Ives* (RA 1922) and *Cornish Cliffs* (RA 1923, Paris 1924, Cheltenham 1925), both of which are owned by the Royal Cornwall Museum, Truro. Another work *Jewels in a Granite Setting* won a Mention Honorable at the Paris Salon in 1923.

In 1924, Smart went on a painting trip to Venice. He termed this a long-delayed honeymoon and it was a productive time, which saw him first tackling etching. However, the following year, possibly disillusioned with the state of the colony, he moved to Salcombe. He was therefore not involved at all with the formation of STISA. On his return in 1928, he became a member immediately and was voted on to the Committee in 1929, with responsibility for publicity. He was brimming with ideas for the furtherance of STISA and the vast majority of resolutions considered by the Committee were proposed by him. What he fostered was a new unity of purpose and "an all pervading spirit of real endeavour".[240] His objective was to make Art and the pursuit of Art in Cornwall a living and vital thing. His great friend, Leonard Fuller (q.v.), commented, "He had vision - the long vision - and was not swayed by the success or failure of the moment."[241] In 1933, when Alfred Cochrane resigned as Secretary through ill-health, Smart assumed this role and was to retain it for the rest of his life. By then, Smart had courted various curators of Municipal Galleries, suggesting that STISA should put on a touring show and the first one was held at Huddersfield in December

[239] Frank L.Emanuel, *The Charm of the Country Town, III- St Ives, Cornwall, Architectural Review*, July 1920.
[240] Art Notes, *St Ives Times*, 2/6/1933.
[241] Leonard Fuller in Catalogue to Borlase Smart Memorial Exhibition, Penwith Society, 1949.

1931. Soon, the requests for these flowed in and, for the rest of the 1930s, there were regular touring shows, all of which Smart organised. There was also a London show at Barbizon House.

On his return to St Ives, Smart concentrated on seascape painting and he had success at the RA with a series of large canvases, depicting the reef at Clodgy in gale conditions - violent, swirling, white-foamed water painted vigorously in thick impasto. Design and pattern began to play ever increasing importance in his compositions, as he sought to capture the power of ocean swells. His book, *The Technique of Seascape Painting*, published in 1934, became the standard work on the subject for some forty years, selling particularly well in America. Smart was also fascinated by the dignity and grandeur of cliffs and he was prepared to sacrifice topographical detail in order to portray their majestic immensity. Geological knowledge enabled him to simplify seemingly random piles of rocks into their basic strata. He wrote a series of articles for the *St Ives Times*, entitled *Unknown Sketching Grounds*, in which he not only named sites (often relatively inaccessible) offering grand cliff or coastal vistas but also indicated the best time of year and the best state of tide at which to capture their full glory.[242] In this way, he sought to rekindle interest in sketching spots which had once been frequented by the greats of the past, like Brown, Olsson, East and Noble Barlow. Invocations of the achievements of the first generation of St Ives artists was a common theme used by Smart both in publicising the Society and in encouraging its members on to greater things.

His boundless enthusiasm made him well-known in art circles and he was elected to the RBC in 1931 and the RWA in 1932. In the early 1930s, an inheritance made him financially secure and he spent a part of each summer in Scotland. He was particularly pleased in 1933 when the Duke of Sutherland bought fom the ROI his two oils of *Ben Loyal and the Kyle of Tongue*, commenting that the wild west coast of Sutherland was a revelation as a sketching ground and "much more paintable than the immensities of the Alps".[243] He turned his talents to a wide variety of artistic endeavours. He designed a number of posters for the Great Western Railway and, for the local Chamber of Commerce where he was an active member and one-time Secretary, he produced a pictorial map of St Ives, which was set up on the Malakoff for the benefit of visitors. A series of his charcoal and wash drawings of Lincoln featured in calendars produced by a Lincoln firm. He offered his services as an interior designer, redecorating the Seagull Café at the end of Wharf Road, and also did some scenery designs for a Navy pageant. Like many of his fellow members, Smart turned his hand to 'black and white' work and it was his design of boats in the harbour that was used as the front cover of all STISA's catalogues between 1936 and 1949.[244]

Fig. 2S-9 Borlase Smart *Ben Loyal, Sutherland* (W.H.Lane & Son)

[242] *St Ives Times*, 1933, Art Notes.
[243] *The Artist*, January 1933, p.128.
[244] This is illustrated in David Tovey, *George Fagan Bradshaw and the St Ives Society of Artists*, Tewkesbury, 2000 at p. 150.

Fig. 2S-10 Borlase Smart *St Ives from the Pednolver Rocks*
(charcoal and wash drawing) (Private Collection)

Fig. 2S-11 Borlase Smart *Mont St Michel* (etching)

Fig. 2S-12 Borlase Smart *Reconstructing the old 'Implacable'* (Private Collection)

During the Second World War, George Bradshaw (q.v.) arranged for him to undertake naval police work near Falmouth. After a breakdown in health, he was appointed to the clerical staff of the Home Guard but later he recovered to take a commission in the 14th Battalion. During the War years, he was adamant that STISA should continue and he was helped to a significant degree by Leonard Fuller. In 1944, he invited Ben Nicholson and Barbara Hepworth to join STISA, believing that the Society must progress and embrace modern tendencies, and he himself was soon eager to learn and experiment with modern approaches to painting. He was largely responsible for organising STISA's acquisition and refurbishment of the old Mariners' Chapel as a new Exhibition Gallery in 1945 and, when the young moderns put on their own show in the Crypt, it was Smart who opened it, being unbowed by the furious reaction of Harry Rountree and others to his perceived treachery. He continued to organise touring exhibitions not only around this country but also to South Africa. On being elected President of STISA in 1947, he urged members "to think widely and work vitally" and considered the exhibition at the National Museum of Wales in Cardiff in 1947 to be STISA's finest yet, combining the best of traditional and modern art. Sadly, he died as it came to a close and, with him, died all hopes of maintaining unity between the factions in STISA.

Some of Smart's characteristics that Leonard Fuller emphasized in the introduction to the catalogue of his Memorial Exhibition in 1949 were his "large hearted generosity and sympathetic understanding". He observed that he had "yet to meet the individual, old or young, who ever went to Smart in vain". This assistance could take many forms. He would give freely of his time to assist young painters, like Peter Lanyon. On being impressed by a Hyman Segal show, he arranged for the local reporter to do a feature in the paper. On hearing that Wilhelmina Barns-Graham wanted a studio, he arranged with his old friend, George Bradshaw, that she could use his while he was away on active service and he saw to it that Bradshaw's paintings were still included in STISA shows, despite his absence. His son, Michael, also recalls humane gestures like allowing the penniless Sven Berlin to come round for a weekly bath and not bothering that John Park would always put in an appearance at mealtimes. These are merely a few examples of the myriad of ways that Smart gave generously of his time and Fuller concludes, "One feels that had he allowed himself the time for his own work that he devoted to the service of others, he would have reached great heights."[245] Certainly, his own work, with its vigorous and highly individual rendering of tone, can be disappointing but his contribution to the reputation of St Ives as an art colony cannot be surpassed.

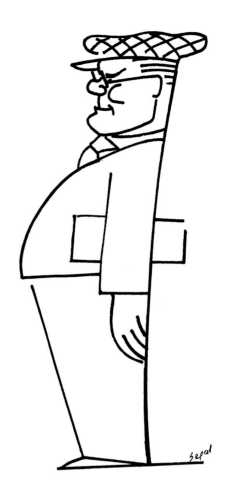

Fig, 2S-13 Hyman Segal
Painter - Organiser - Borlase Smart

81. ***Or Cove*** oil on panel (52cm x 64cm)
(Private Collection) (Plate 56)
This is one of Smart's most successful compositions, with both the foaming sea and the majestic cliffs combining to capture the grandeur of Cornwall's coastline. The imposing cliff face at the left and the rocks in the foreground are decoratively treated in strong colours and Smart's decision not to portray the top of the cliffs on the other side of the cove results in a more dramatic and claustrophobic atmosphere. The power of the incoming sea is made abundantly clear from the turmoil of the foam filled waters as the waves crash on to the rocks.

82. ***The PIlot's Boathouse*** oil on canvas (54cm x 64.8cm)
(Leamington Spa Art Gallery and Museum)
This painting features two well-known and oft-painted properties on Wharf Road in St Ives - Laity's Antique Shop (on the right) and the Pilot's Boathouse, with its intriguing doors and windows. Smart included the scene in his series of charcoal and wash drawings of St Ives but the date of this oil is not known. [246]

[245] Catalogue to Borlase Smart Memorial Exhibition, Penwith Society, 1949.
[246] This painting is illustrated in David Tovey, *George Fagan Bradshaw and the St Ives Society of Artists*, Tewkesbury, 2000, plate 12, opposite p.120.

(Miss) Marcella Claudia Smith RBA SWA (1887-1963) Exh. RA 27
STISA: 1933-1963
STISA Touring Shows: 1934, 1936, 1937, 1947 (SA), 1947 (W), 1949. Also FoB 1951.
Public Collections include Royal Collection, QMDH, Government Art Collection and RWA.

One of a pair of identical twins, Marcella Smith was born in East Moseley, Surrey but her family moved to America and she studied at the USA School of Design in Philadelphia. She then attended Colarossi's in Paris, where she was taught by Eugene Delecluse. She came to St Ives in 1914, when the outbreak of war forced her to leave Paris. With the Olsson School having closed and the Simpson School not opening until 1916, it is not certain whether she studied further in St Ives but she made great strides forward, having her first success at the RA in 1916 with *St Ives Harbour*. In these early years, she concentrated on landscapes and views of the town and her 1918 RA exhibit, *The Pool in the Wood*, was highly praised in *The Gentleman*:-

"This has romance and grandiosity; it is bravely handled in technique; it has something of the secret power, majesty and mystery of nature - some of the primeval spirit; it is full, as a satisfying landscape must be, of decorative charm."[247]

She was then living in Sea View Terrace and, by 1920, was working from 3, Porthmeor Studios and advertising lessons in oil painting during the summer months. She was elected to the RBA in 1920 and to the SWA in 1922. However, in 1921, she moved to London to live with Dorothea Sharp at 22, Blomfield Road in Maida Vale. Nevertheless, she appears to have retained her studio and Dorothea and herself were regular visitors. In 1924, as a sideline, she took up hat design, producing eye-catching creations in straw and raffia for the London season. Her work was known to the Royal Family, probably due to Queen Mary's involvement with SWA, and, in 1922, she was asked to contribute a painting to Queen Mary's Doll's House and, in 1929, she had a watercolour, *September Flowers*, bought by Queen Mary for the Royal Collection. She did occasionally contribute works to early STISA shows but, although she was invited to join in 1928, she did not become a member until 1933. Now concentrating on flower paintings in watercolour, she established a considerable reputation in this genre and was regularly hung at the RA. A critic commented "Powerful, direct, pure in colour, they reveal a method of direct handling that retains the freshness of the subject". Three flowers studies are in the Government Art Collection.

Fig. 2S-14 Marcella Smith *The Quayside, St Ives* (W.H.Lane & Son)

247 Reproduced in *St Ives Times*, 14/6/1918.

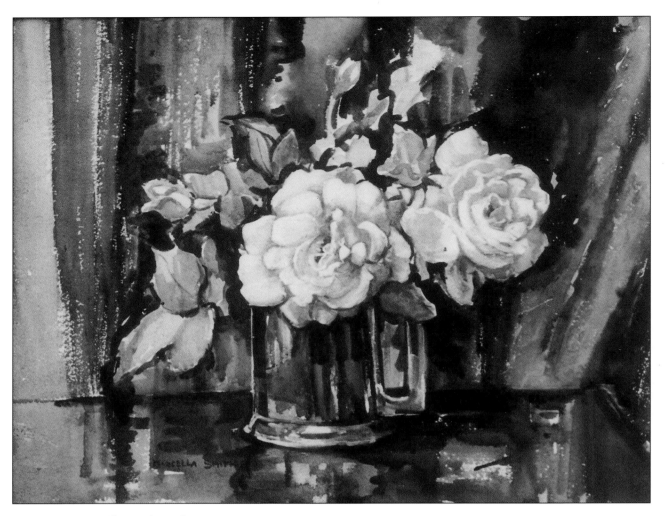

Fig. 2S-15 Marcella Smith *White Roses*

During the Second World War, Dorothea Sharp and Marcella Smith moved to the relative security of St Ives, working from Balcony Studio. Smith became involved in the organisation of the exhibitions at Lanham's Galleries that operated in parallel to STISA's own shows and she was a regular on the Committee of STISA during the 1940s. In 1949, she was one of the Committee members who signed the requisition for an extraordinary meeting. After the split, she remained a member of STISA but Dorothea and herself were now living back in London and so direct involvement was curtailed. Instead she became Vice-President of SWA, a post she was to retain for fourteen years.

83. ***White Roses*** watercolour (37cm x 47cm)
(Private Collection) (Fig. 2S-15)
This painting is a typical example of Smith's watercolours of flower arrangements and has many of the characteristics that she advocated in her book *Flower Painting in Watercolour* published by Pitmans in the early 1950s. She painted quickly and boldly to maintain the essential qualities "spontaneity and life" and used only rough white paper as it gave a painting "more character, more strength, life and brilliancy." This she only damped slightly so that it retained "more of its crispness and tooth." Although emphasizing the importance of drawing, she did not use a pencil, as she felt this tended to harden outlines. She therefore painted the flowers in their entirety direct on to the paper concentrating as much on the balance, growth and bulk of the flower as on the detail of its petals.

For backgrounds, she advocated the use of some softly-draped material. "The folds should be regulated in such a way that the shadows vary in intensity. The resultant play of light and shade offers great opportunities for lovely washes." Emerald green was an opaque colour that she felt was particularly useful for providing "an element of solidity in backgrounds". For foregrounds, she recommended a polished surface as this gave "wonderful opportunities for sparkling contrasts of light and shade in unexpected places". Flower-pots should be simple, without floral designs, definite patterns or hard lines. She tended to favour ones made of glass as it eliminated any possibility of violent contrast between flowers and vase and gave further scope for capturing effects of reflected light. However, this pewter tankard meets these criteria as well.

Sir Stanley Spencer RA (1891-1959) Exh. RA 66
STISA: 1937-1949
STISA Touring Shows: 1945, 1947 (W), 1949.
Public Collections include Tate Gallery, Cookham, Government Art Collection, Imperial War Museum, RA, Aberdeen, Belfast, Birmingham, Bradford, Cambridge (Fitzwilliam), Carlisle, Dundee, Hull, Leeds, Newcastle, Oxford (Ashmolean), Preston, Rochdale, Southampton, Swansea and, abroad, Adelaide, Perth, New York (Museum of Modern Art), Amsterdam and many others.

Stanley Spencer is now rated one of the most original British artists of the twentieth century and his involvement with STISA is little known. Born and forever associated with Cookham-upon-Thames, Spencer was educated by his two sisters at home amidst a large family that had musical and literary, but not artistic, leanings. After some local art lessons, he enrolled at the Slade in 1908, training for four years under Brown and Tonks. Complex in character and unpredictable in behaviour, his art recorded a very personal vision. Many works were inspired by places in his beloved Cookham and themes of love and religion were prevalent. He was elected as an associate of the RA in 1933, despite having never sent a picture to the Academy - an honour which he viewed with pride, although not a little surprise, and which traditionalists considered scandalous. This was also the year in which he finished his famous cycle of paintings in the Oratory of All Souls, Burghclere, having worked on them for six years.

Spencer's connection with St Ives was limited. It appears that he may have visited it only on the one occasion - in June and July 1937, during his honeymoon following his disastrous second marriage to Patricia Preece. This cannot have been a happy time for Spencer, as he arrived to find Patricia not only ensconced with her lesbian friend, Dorothy Hepworth, but also refusing to consummate the marriage. Having made over his home to Patricia as a condition of getting married, he was now in a difficult financial position as well. As always, though, he threw himself into his painting and produced six canvases of St Ives, of which the most well-known is the classic view across the rooftops of the town from the Malakoff, entitled *The Harbour, St Ives* (Plate []). While staying in St Ives, Spencer rented a cottage off John Park, who later confided to Wilhelmina Barns-Graham that the locals had considered him a "queer wee bugger".[248] The artistic community, however, were more impressed and *The Harbour, St Ives* was rated so highly by the members of STISA that they took the unprecedented step of hanging a reproduction of the work at one of their subsequent exhibitions. A critic writing some two years later commented:-

"[His] visit is still in the minds of those who saw him at work in the Digey and on the Malakoff. An amazing personality, and equally astonishing was his array of tiny brushes - but they co-operated with the master mind in the production of great art."[249]

Given Spencer's style and the fact that he had resigned from the RA in 1935 in a fit of pique at having two of his pictures rejected - an action that many traditionalists did not approve of - his enthusiastic welcome by STISA is to be applauded. At the 1939 Autumn Exhibition, he contributed *Shipbuilders*, a forerunner of the series of depictions of Clyde shipbuilders executed during the war, which was considered to be "full of a quiet and naive simplicity"[250]. Unfortunately, his exhibits during the war years are not recorded but, for the touring exhibition of 1945, he contributed *Choosing A Dress* and for the important exhibition at Cardiff in 1947, he showed *Looking at a Drawing*. Both these works were painted specifically for Spencer's one-man show at Tooths in 1936 and are part of what are described as his *Domestic Scenes* series. Although painted at the very time that he was seeking a divorce from his first wife, Hilda, a number of the scenes from this series, like *Choosing A Dress*, are recreations of simple moments in their relationship which had special significance to him. Aware that such calm domestic scenes would no longer occur, they represent the beginning of the process whereby Hilda was transformed into an idealised image.[251]

Looking at a Drawing, like a number of these works, has two layers of meaning. It is an interior scene showing the maid, Elsie, dwarfing Spencer as they look at a sheet of paper on a landing. In a letter written in 1949, Spencer indicated that the work was originally part of the *Marriage at Cana* scheme, which showed prospective guests as and when they receive in their respective homes invitations to the wedding. As such, he was going to call it *On the Landing*, because he wanted to express the sort of conversational encounters which occur in any part of the house, but he thought the word "landing" might be mistaken for a river or seaside landing-stage and not a stairs landing in a house. He therefore called it *Looking at a Drawing*, thus giving it a new layer of meaning. Stylistically, it is the first example of Spencer using the image of a small man dwarfed by a vast female figure, which was to be the central theme of his next series, *The Beatitudes of Love* 1937-8.[252]

[248] L.Greene, *W.Barns-Graham : A Studio Life*, London, 2001 at p.63.
[249] *St Ives Times*, 10/11/1939.
[250] ibid.
[251] Royal Academy, *Stanley Spencer RA*, London, 1980, p.142.
[252] ibid, p.144-5.

84. *The Harbour, St Ives* (Plate 76)

Although Spencer had work included in STISA exhibitions for some twelve years, the fact that all works known to have been exhibited are dated pre-1937 does raise the possibility that Spencer left them with STISA on his visit in 1937 and that his future involvement with STISA was minimal. In these circumstances, it seems appropriate only to exhibit work actually shown with STISA or work executed in St Ives. Unfortunately, at the time of going to press, all leads have proved fruitless and it may be necessary, as STISA itself did, to display only a reproduction of *The Harbour, St Ives*.

Charles Adrian Stokes RA VPRWS (1854-1935) Exh. RA 125

STISA: 1928-1935
STISA Touring Shows: 1932, 1934, 1936.
Public Collections include QMDH, Tate Gallery, Government Art Collection, Guildhall, RA, Birkenhead, Cheltenham, Leamington, Leeds, Liverpool, Manchester, Oldham, Preston, Southampton, Southport, Stalybridge and, abroad, Ottawa, Adelaide, Sydney, Christchurch, Dunedin and Nelson

Adrian Stokes was one of the initial generation of St Ives artists and, having become a Royal Academician, he was one of the first artists to be offered honorary membership of STISA.[253] Born in Southport, Stokes did not initially embark on a career in art and, after his desire to join the Navy was thwarted, he entered a firm of cotton brokers in Liverpool. However, he soon changed tack and gained entry to the Royal Academy Schools in 1872, leaving in 1875. He then went to France and mingled with established French landscape painters and students from all parts of the world in the art colonies of Fontainebleau and Pont-Aven, where in 1883, he met the Austrian artist, Marianne Preindlsberger, whom he married the following year. In 1885, he studied under Dagnan-Bouveret in Paris but, at the suggestion of Stanhope Forbes, whom they had met at Pont-Aven, the Stokes moved to Cornwall in 1886, living first at Lelant and then at 15, The Terrace, St Ives. Stokes was elected the first President of the St Ives Arts Club in 1890 and was again President in 1891 and 1896.

Stokes was primarily a landscape painter, although he also did some fine marine work, and he is best known for his decorative landscapes of mountain scenery in the Tyrol. He was influenced by Corot, whom he had met at Fontainebleau, and by earlier French landscape painters but could also appreciate Whistler and the French Impressionists. In 1888, his painting *Uplands and Sky*, an evening study of the Hayle River, was purchased by the Chantrey Trustees. However, in 1898, the Stokes left St Ives and were thereafter based in London, although they travelled extensively through France, Italy and Austria and, in 1909, produced a lavishly illustrated volume on Hungary. In 1903, *Autumn in the Mountains*, painted in the Austrian Tyrol, again found favour with the Chantrey Trustees and he was elected an ARA in 1910 and a full RA in 1919. His later work, which was often in tempera, became more poetical. His *Times* obituary commented, "The progress of Stokes was from careful naturalism to decorative abstraction, mainly through colour".[254] Variations on a theme of blue and gold were commonplace. In 1925, he published a book, *Landscape Painting*, which included an analysis of earlier landscapists. Stokes was also a leading member of the RWS, becoming Vice-President in 1933, but he admitted that watercolours caused him much pain. "For the more I learnt the more difficult they became."[255]

When Stokes was elected to STISA, he was 74 and had just lost his wife and his contributions to STISA shows, almost all of which were foreign landscapes, were somewhat irregular. However, they included his RA exhibits *A Shadowed Stream* (1930), *River Bed in the Dauphiné* (1932), *A Pond : Noon* (1935) and *Autumn in the South of France* and *An Essex Pond* (both 1936).

85. *Sunset in Provence* oil on canvas (61cm x 82cm)
(Cheltenham Art Gallery and Museum) (Plate 72)
This was one of Stokes' RA exhibits for 1927 and is typical of his later, more poetical work. The sun sheds a final orange glare as it is disappears behind the crest of a hill and lights up the evening clouds set against a still blue sky. The rocky terrain in the foreground is decoratively treated in greens, blues and oranges, applied boldly and broadly, whilst a plume of smoke from a fire rises up to provide a vertical impulse. The work was donated to Cheltenham by Miss Emily Sargent in 1927.

[253] Despite their very different styles of work, Charles Adrian Stokes is regularly mixed up with Adrian Scott Stokes (1902-1972), who is better known as a writer on art and who moved to Carbis Bay in 1939 and mixed with Nicholson, Hepworth and Gabo. The mistake is so commonly made that it is quite difficult to ascertain the Royal Academician's full Christian names. My source is his obituary in *The Times*.
[254] *The Times*, 2/12/1935.
[255] A.Stokes, *In Praise of Watercolour*, The Old Water-colour Society's Club, 8th Annual Volume, 1930-31 at p.65.

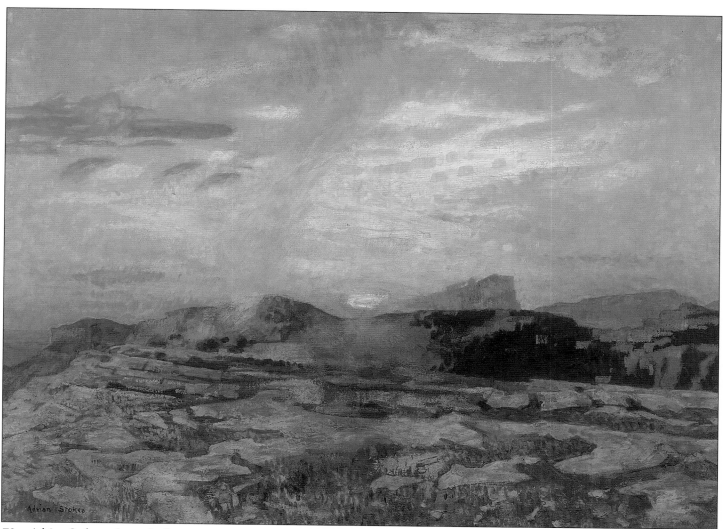

72. Adrian Stokes *Sunset in Provence*

(Cheltenham Museum and Art Gallery/Bridgeman Art Library)

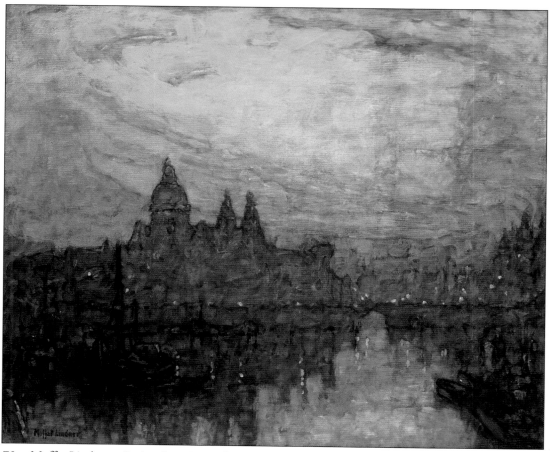

73. Moffat Lindner *Setting Sun, Amsterdam*

(Private Collection)

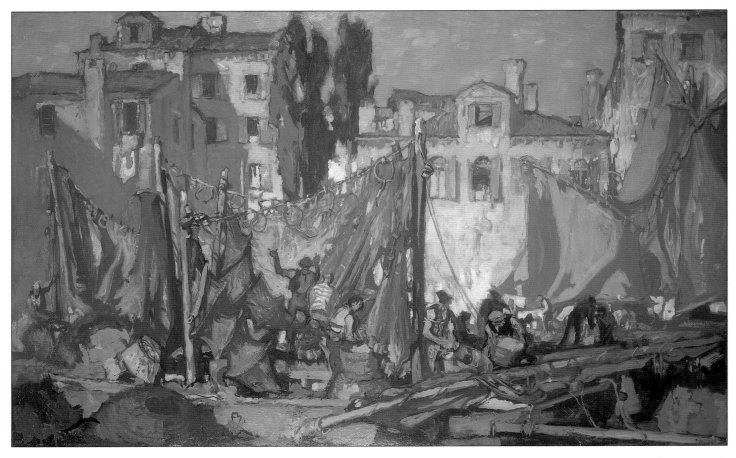

74. Frank Brangwyn *Fishermen's Quarters, Venice* (Harris Museum and Art Gallery, Preston)

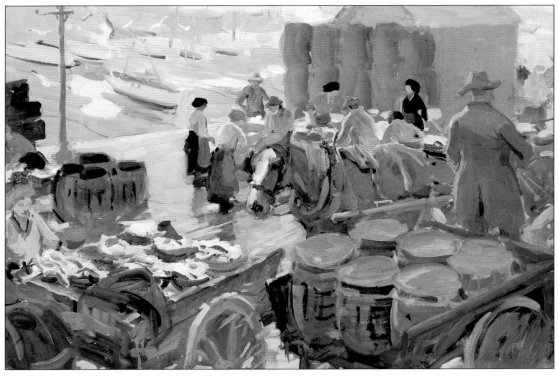

75. Charles Simpson *On the Quay - the Herring Season, St Ives* (Dunedin Art Gallery)

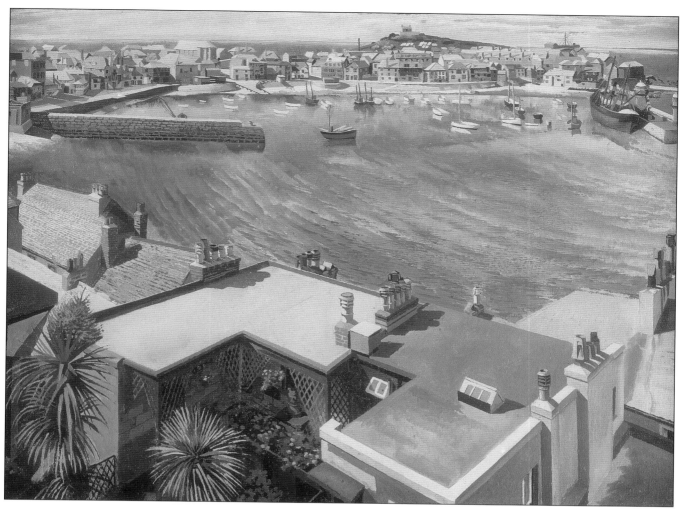

76. Stanley Spencer *The Harbour, St Ives* (© Courtesy of the artist's estate/Bridgeman Art Library)

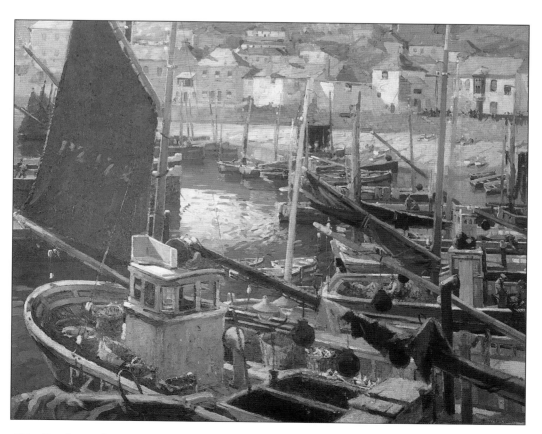

77. Frank Heath *Mousehole Harbour* (Private Collection)

78. Algernon Talmage *The Young Shepherd* (Private Collection)

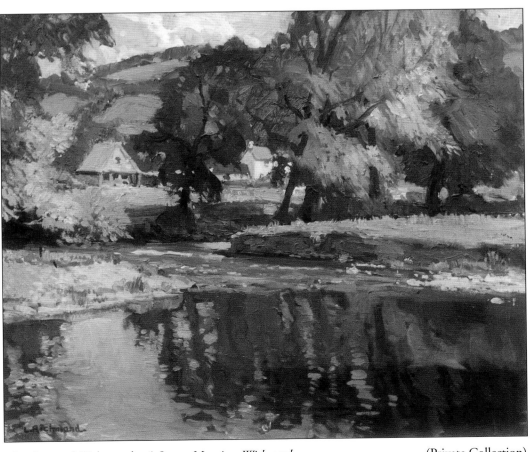

79. Leonard Richmond *A Sunny Morning, Withypool* (Private Collection)

Algernon Mayow Talmage RA RBA ROI RWA ARE (1871-1939) Exh. RA 140
STISA: 1928-1939
STISA Touring Shows: 1932, 1934, 1936, 1937.
Public Collections include RA, QMDH, British Museum, Bath, Bristol, Blackpool, Huddersfield, Manchester, Newcastle, Newport, Oldham, Preston, Sheffield, Yarmouth, York (NRM) and Pittsburg, Buenos Aires, Dunedin, Wellington, Adelaide, Perth and Sydney.

Talmage was one of the early honorary members whose involvement did so much to raise the profile and prestige of STISA in its infancy. Writing in *The Cornish Review* in 1949 with his memories of his time in St Ives in the early years of the century, Charles Marriott commented, "One of the most talented and certainly the most popular of the St Ives painters was Algernon Talmage. He was indeed a most attractive personality: modest, slightly reserved but always ready to do a kind action for a friend." Born in Oxford, the son of a clergyman, Talmage was three parts Cornish, his mother and his father's mother both belonging to old Cornish families. He studied at West London School of Art and, in 1892, at Bushey under Herkomer before moving to St Ives in 1893/4, where he joined former Bushey pupils William Titcomb, Arnesby and Mia Brown and Arthur Meade. He had his first success at the RA in 1895 and he succeeded Louis Grier as Olsson's partner at the St Ives School of Landscape and Marine Painting, although students were often baffled as the two principals gave differing advice and had conflicting views on the worth of the students' work. Talmage, whose right hand had been crippled in a boyhood accident, was felt to be rather more sympathetic to the difficulties faced by students, which he put down to the fact that his own art training had been a grind.[256] Each autumn he took the students to France, often Picardy, to study landscape painting, which was his own speciality. Like Olsson, he impressed upon his pupils "the importance of open-air study and the love of truth that it engenders".[257] The adverts for the School show that Talmage took an increasingly important role. In 1898, he is merely assisting Olsson; by 1901 the School is run by them both jointly; by 1903, Olsson is merely described as an honourable visitor and, in 1907, Talmage is running the School on his own, helped by his wife, Gertrude (née Row, a Redruth girl, that he had married in 1896). He was elected to the RBA in 1903 and the ROI in 1908.

Like Arnesby Brown, cattle feature prominently in Talmage's early landscape works and twilight was a favourite time of day. His works were considered to be true to nature with fidelity of form, tone and colour. In 1907, during a stay in London, Talmage decided to do a series of studies of city scenes, concentrating particularly on early morning light, reflections after rain and the glow of lamps at dusk and these works, which showed certain Whistlerian influences, were exhibited in a one-man show at Goupil Gallery in 1909 to considerable acclaim. Two examples are in the Adelaide collection. This success prompted him to leave St Ives and live in Chelsea. At this juncture, he was living with Hilda Fearon, a former student and sister of Annie Walke (q.v). She features in his 1914 RA exhibit *The Hammock* and he is the subject of a portrait sketch by her (Fig. 2T-1). Sadly, Hilda died tragically young in 1917.

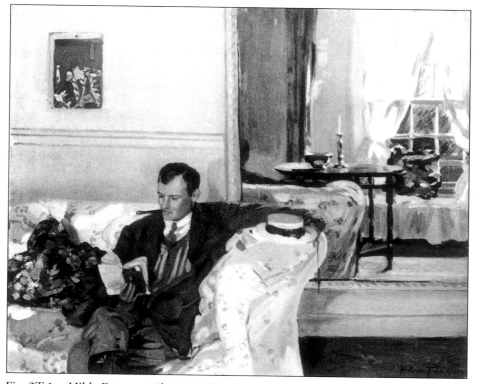

Fig. 2T-1 Hilda Fearon *Algernon Talmage*

[256] T.Cross, *The Shining Sands*, Tiverton, 1994, p.143.
[257] Folliott Stokes, *The Landscape Paintings of Mr Algernon M Talmage, The Studio*, Vol.42, 1907, p.189.

During the War, he was an official artist for the Canadian Government, painting the horses being cared for by the Canadian Veterinary Corps at the Veterinary Hospital in Le Havre, and he was later appointed art adviser to the Australian Government. In 1922, he was elected an ARA and won a gold medal at the Paris Salon to add to the silver that he had won in 1913. He also twice won prizes at the Pittsburg International Exhibition. In 1927, he started etching and executed some two dozen plates, including *By Cornish Seas*, and his work in this field is represented in the British Museum.

In 1925, he contributed five works to the Cheltenham show arranged by the St Ives artists and he accepted honorary membership of STISA in 1928. The following year he was made a full RA. His exhibits to STISA shows were regular in the early years and the first touring show to Huddersfield in 1931 included his 1930 RA exhibit *Reflections* and the Barbizon House show in London in 1933 included his 1929 RA work *Suffolk Marshes*. Suffolk scenes were quite regular in his output at this juncture as he was sponsored for a time by Montague Reynolds, Headmaster of Winchester, and stayed at Butley Abbey, near Woodbridge. For the 1938 Autumn Exhibition, Oldham Art Gallery lent from their permanent collection his 1906 RA exhibit, *The Ford*, a restful scene painted in the St Ives district showing cows drinking from a stream under moonlight. This enabled comparisons to be drawn between the careful, accurate drawing style of such an early work with the looser, impressionistic approach of his later work.

He was a keen sportsman who spent most of his spare time in the saddle and increasingly in the 1930s, possibly having seen the success of Alfred Munnings, he turned to equestrian portraits of horses and riders. Amongst his clients was the New York millionaire, Victor Emanuel, then living at Rockingham Castle, who also commissioned Charles Simpson (q.v.). A final major work was *The Founding of Australia by Capt Arthur Philip, RN, Saturday 26th January 1788*, now owned by the Tate Gallery. A copy was commissioned by Canberra Art Gallery. In his latter years, Talmage lived at Clark's House, Sherfield English, Romsey in Hampshire and he died there from a stroke in 1939.

Talmage's love life was never simple. Even while Hilda Fearon was alive, he had "adopted" Edith Leppard, the daughter of a builder's labourer then aged 16, and she became both his model and his mistress. In the 1930s, he became concerned about providing, outside the scope of his Will, for her support. He accordingly ensured that a number of his RA exhibits from the 1930s did not sell so that these could be sold by her as and when she needed funds. Unfortunately, she did not appreciate their value and an art dealer many years later found her living near Salisbury in distressed circumstances whilst the paintings were stacked in a barn. Works from his studio were sold at Christies, London on 6th November 1981. These included his *Self Portrait* exhibited at the RA in 1932 and his 1934 RA exhibit *The Window*, showing, most probably, Edith standing nude by a window in Butley Abbey.

86. *The Young Shepherd* oil on canvas (64cm x 79cm)
(Private Collection) (Plate 78)
In the late 1920s and early 1930s, Talmage completed a number of pastoral scenes, which were popular in the post-War era. This painting was exhibited at the RA in 1930 and was illustrated in Charles Simpson's book *Animal and Bird Painting*. It is typical of his work of this period. The huge tree, itself symbolic of the timelessness of the English countryside, provides shade for a flock of sheep supervised by a young boy, who, with crook in hand, is following in the footsteps of his father as generations have beforehand. Mellow sunlight, filtering through the branches of the tree, lights up sections of the ground and the backs of the flock. It is a quintessentially English scene.

87. *November Morning* oil on canvas (76cm x 92cm)
(Private Collection) (Plate 41)
This is another superb example of the pastoral scenes depicted by Talmage in the early 1930s and celebrates the glory of autumnal colours as a horse quietly feeds in a country lane, lined by magnificent old trees. This work was exhibited at the RA in 1933 and later at Liverpool. Oldham and Bradford.

Herbert Truman (1883-1957) Exh. RA 5
STISA 1927-c1940
STISA Touring Shows: 1932, 1934, 1936.
Public Collections include Bristol, Bristol Cathedral, Plymouth and Truro.

Truman, along with George Bradshaw, was the leading force behind the formation of STISA but his personality meant that his involvement on the Committee was short-lived. Born in Dawlish, he trained at the South London School of Art and then at St Martin's School of Art. He first exhibited at the RA in 1912 but later that year, at the instigation of Lord Kitchener, he went to Egypt as chief inspector of the art and trade schools there. "My aim," he said later, "was to revive the old arts and crafts of Egypt, rather than to introduce European ideas."[258] Whilst there, he was engaged by the Egyptian Secret Service to assist with the suppression of drug trafficking and later became Head of the Political Section of Cairo C.I.D., becoming friendly with

[258] W.C.Broome, *Biographical Sketches of Members of the Bristol Savages*, unpublished, 1977

Fig. 2T-2 Herbert Truman with a typical harbour scene in 1939

T.E.Lawrence. He later was transferred to the British General Staff and rose to the rank of Lieutenant Colonel. His art is first mentioned in the St Ives press in June 1925, when he held a joint exhibition with George Bradshaw at the Panton Art Club, and it was Bradshaw and himself that put together the proposals for the formation of STISA. Truman, being the more articulate, drafted the proposals that were published in the Press, whilst the well-respected Bradshaw led the discussions at the meetings. Truman declined to serve on the first Committee but was elected the following year after his stinging criticisms of the Committee's initial efforts and, in 1928 and 1929, Truman along with Arthur Hayward and Hugh Gresty took leading roles. Truman was, however, something of a prickly character and once Borlase Smart got on to the Committee, Truman was never re-elected. He did snipe from time to time in the Press at various actions or proposals, which had upset him, and his logic is often unassailable, but these comments, and the way they were aired in public, did nothing to endear him to the other artists.

As an artist, Truman is something of a puzzle, as he worked in a number of different styles, earning praise initially for his originality and versatility. Some early paintings of seagulls - *Wings and Waves* (RA 1927) and *Feathers and Foam* - were well regarded. He clearly thought deeply about his art and his articles on art aimed at students met with high praise from Julius Olsson.[259] Yet he seems to have come to the conclusion that the artist's path to fulfilment was to give pleasure to others, rather than to satisfy his own whims. He commented, "I think artists have lost a great deal of the sympathy of the public because so many of them adopt the attitude, 'This is art. If you do not like it, you are uneducated.' "[260] Accordingly, Truman set out to please the ordinary man in the street. His favourite subjects became the harbour and the quaint old houses at St Ives and the white mountains and azure pools of the China Clay Pits. He had over 60 works reproduced as prints and postcards, so that they were affordable to all. At his best, Truman's work can be quite delightful and can occasionally bear comparison with John Park (who, incidentally, felt Truman was copying his style) but often the perspective for his boats is not quite correct and his colours appear harsh and jarring. Works that did command attention, though, were those where he utilised his knowledge of Egyptian art to produce novel compositions. Unfortunately, none of these have yet been located but *Osirians* (depicting an ancient Egyptian burial ceremony - Show Day 1929), *The Lotus Eater* (Summer 1929 - depicting the Benou bird, which is emblematical of the Resurrection, appearing to the Lotus Eater to remind her of an indolent life) and *Egypt: Ancient, Medieval and Modern* (1934 tour) were highly regarded. After 1939, Truman did not exhibit at Show Day in St Ives, which suggests that he moved away, possibly to Plymouth, where he seems to have had close ties, although in 1940 he donated a 40 guinea picture of The Wharf to the St Ives Spitfire Fund.[261] In 1946, though, he moved to Bristol, where he became an active member of the Bristol Savages.

[259] Truman's first article, headed *Advice to the Student of Painting*, was published in *St Ives Times* on 19/5/1933 and Olsson, in his letter to the paper which was published on 26/5/1933, commented "I have never read more instructive or sound advice given by anyone, and not only students, but all those who are endeavouring to build up pictures from nature, can well ponder and learn from his few and very concise words."
[260] *News Chronicle*, 1939, Cornish Artists 46.
[261] This had been intended to be used for a print but the war put an end to the arrangement with the printers.

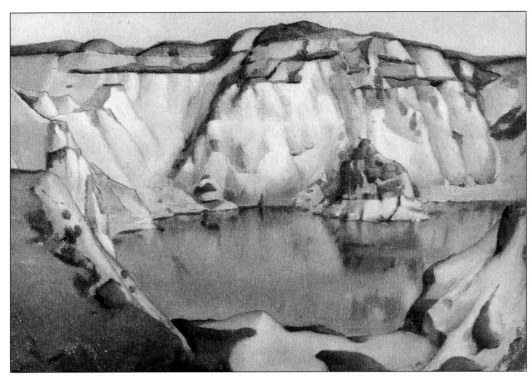

Fig. 2T-3 Herbert Truman *The Quarry Pool* (RA 1933)

88. *Old St Ives* oil on canvas
(Plymouth City Museum and Art Gallery)
This painting was one of four works exhibited by Truman on Show Day 1934 and features a group of properties on the harbour front at St Ives that Truman painted from different angles time and again.[262] The Pilot's Boathouse and Laitys - also featured in Borlase Smart's picture (cat.no. 82) - can be seen on the far right. The painting was also included in Truman's one-man show at Plymouth Art Gallery in 1935. The Curator, A.J.Caddie, who was retiring after nine years in the post, rated it so highly that he purchased it himself and immediately presented it to the Art Gallery.[263]

89. *Gorsedd 1933, Roche* oil on canvas
(Royal Institution of Cornwall, Truro) (Fig. 2T-4)
This painting represents another facet of Truman's art - group portraiture. It depicts the first Grand Bard, Henry Jenner, presiding for the last time, in 1933, at this assembly of old Cornish Societies, which took place at Roche Rock. Borlase Smart, who was being initiated as a Bard at this ceremony along with fellow STISA member, Ashley Rowe (q.v.), had chosen the Bardic title Ton Mor-Bras (being the Cornish name for his studio, Ocean Wave), and he considered that the massed effect of the blue-robed Bards against the mighty grey background of Roche Rock produced a very pictorial scene. His description of the ceremonials explains what occurred:-

"A background and skyline of magnificently proportioned rocks towering a hundred feet above the moorland, topped by a ruined hermitage, provided a setting thoroughly in keeping with the meeting of the College of Bards and the ceremonial of the occasion held on the slopes of Roche Rock, near St Austell. Bards in full robes and head-dresses preceded by the Initiates, robed, but carrying their head-dresses of black and gold, processed from the robing room at Roche to the sacred circle. The Initiates divided left and right outside the circle and formed a double row, through which passed the Grand Bard, Dr Jenner, and Bards, headed by the sword-bearer holding a weapon typifying Excalibur, the sword of King Arthur. The Corn Gwlas (Horn of the Nation) was sounded to the four points of the compass as a symbolic notification to all Cornwall that the Gorsedd had begun. The Gorsedd Prayer, followed by the shout of Cres (Peace) and the offering of the fruits of the earth were the first impressive features of the ceremonial. Then came the admirably sung stanzas to the Harp-Arta ?f a-Dhe, with harp accompaniment...Each Initiate was then called by name and his Bardic equivalent. Sponsored by two Bards and preceded by the sword-bearer, he advanced into the circle to be welcomed by the Grand Bard, who by placing the head-dress on the Initiate's head raised him to full Bardic Honours."[264]

[262] His 1932 RA exhibit *The Quayside*, which was published as a print by Frost and Reed, features the same group of buildings but was painted from the Laitys end.
[263] The painting is illustrated in David Tovey, *George Fagan Bradshaw and the St Ives Society of Artists*, Tewkesbury, 2000 at p.132 and a picture of Truman in his studio with his four 1934 Show Day exhibits, which include *Gorsedd 1933*, *Cornish Clay Pit* and *Egypt*, is also illustrated at p.68.
[264] *St Ives Times*, 1933.

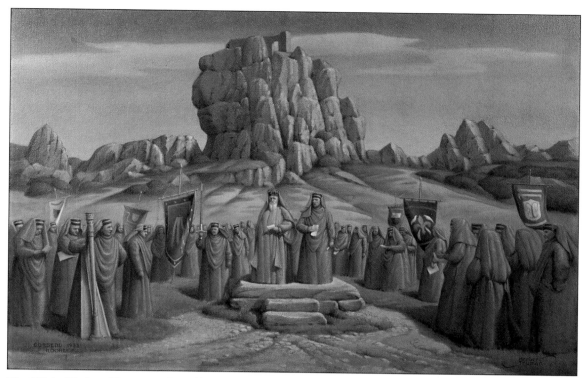

Fig. 2T-4 Herbert Truman *Gorsedd 1933, Roche* (Royal Institution of Cornwall, Truro)

There was then a speech by the Arch Druid of Wales and by a representative of the Gorsedd of Brittany before the Inter-Brythonic National Anthem was sung. Finally, there was the Ceremony of the Sword of Arthur on which all swore to be faithful to Cornwall their Motherland. It is probably this moment that Truman depicts. The sword-bearer, George Sloggett, donated the painting to the Royal Institution of Cornwall.

After the painting was exhibited initially, Truman reworked it during 1934 and re-exhibited it on Show Day 1935. Similar works executed by Truman included *Plymouth Fyshing Feaste, 1936,* showing the Lord Mayor and 50 prominent Plymouth citizens at this feast, and what many people considered to be his masterpiece *Queen Elizabeth II Entering the Council Chamber, Bristol,* executed in 1957.

(Mrs) Ann Fearon Walke (1888-1965) Exh. RA 1
STISA: 1936-1951
STISA Touring Shows: 1936, 1937, 1947 (W), 1949. Also FoB 1951.
Public Collections include Truro, Truro Cathedral and Penzance.

Ann Fearon was the sister of Hilda Fearon, whose promising artistic career was cut short by her untimely death in 1917. Ann was born in Banstead in Surrey and was educated at Cheltenham Ladies College. She attended both the London School of Art and the Chelsea School of Art, during which time she studied under Nicholson, Augustus John and Sir William Orpen. She then went to Dresden with her sister - Ann to study music and Hilda to study art. After Hilda moved down to St Ives to study under Algernon Talmage, she encouraged Ann to join her and to resume her art studies. Although she first met Bernard Walke in St Ives, when he was curate at the Parish church (1902-1904), they did not marry until 1911. He was then vicar of Polruan but, in 1913, he took over at St Hilary, a parish near Marazion that he made famous by the appeal of his plays, which were broadcast by the B.B.C. regularly from the church between 1926 and 1934, and by the controversy caused by his strong Catholic leanings. Annie Walke, as she was always known, even to her husband, improvised a studio by converting a stable in the vicarage garden, putting in a wooden floor and inserting a large window in the sloping roof. As one writer put it, "In this quiet unobtrusive little place, surrounded by tall shrubs, while the famous bells rang over the peaceful garden, the painter meditated and produced quiet-toned pictures of saints and portraits of distinction."[265] Their introduction to the Lamorna circle of artists was effected by Alfred Munnings, as Walke records in *Twenty Years at St Hilary*:-

"Now A.J.Munnings is as enthusiastic over his friends as he is over a landscape or passage of literature. Having discovered the Walkes, he was eager to introduce them to his friends at Lamorna. "Mrs Sidgwick shall give you a party, and you and Annie Walke

[265] *News Chronicle*, 1939, Cornish Artists 33.

shall be there," he said. "I will get them all to come and see you: and you will love every one of them: Harold and Laura Knight, wonderful people," he continued, "Lamorna Birch and the Hughes. You will like them, I tell you."

Annie Walke had already met Laura Knight and several other painters from Lamorna at the Newlyn Show. She would be at home with these people, but it was difficult for me to plunge into this company of which I knew nothing... Munnings, however, was insistent, and so it was that we rode our bicycles one morning in the spring of 1915 for the first time to Lamorna..."

The result, of course, was that the Walkes soon became firm favourites with the artists and Harold Knight, Ernest and Dod Procter, Harold Harvey, Norman and Alethea Garstin and the young Joan Manning-Sanders (q.v.) were some of the artists who helped with the unique decorative scheme devised for St Hilary, which is now so highly regarded. Annie Walke herself contributed a large oil, *St Joan of Arc*, a work sharing the muted colour and flat decorative qualities of the art of its time, and a depiction of *The Blessed Virgin Mary and the Christ Child*.

Walke received a number of commissions from churches - St Anselm's Catholic Church, St Mary's, Graham Street, London, Penzance Girls' School Chapel and a church in Plympton but her most well-known and important commission was for Truro Cathedral - an altarpiece in three panels, depicting *Christ Blessing Cornish Industries*. This enabled her to purchase a new and elaborate studio, which she placed in the middle of a luxurious meadow adjoining the vicarage grounds. After Walke's resignation through ill-health, this was moved to their new home, Battery House, in Mevagissey, where it afforded her a panorama of coast and harbour.[266]

In addition to her religious paintings, Walke exhibited with STISA a number of portraits of children, with *Cornish Children* of 1937, showing two girls in pensive attitude, being praised as "a real gem of painter-like qualities, reminiscent almost of the Dutch Masters".[267] Bernard Walke died in 1941 and, after 1950, Annie rarely painted, living very frugally, with no intimate friends. She published *A Boy Returns*, a book of poetry, in 1963, shortly before her death.

90. ***Christ Mocked*** oil on canvas (91.5cm x 79cm)
(Royal Institution of Cornwall, Truro)
This painting engendered so much interest wherever it was shown that it was included not only in the 1936 and 1937 tours but also in the much later exhibitions at Cardiff in 1947 and Swindon in 1949. It was most unusual for paintings to be included in more than one STISA exhibition but it was quite unique for a painting to be included so long after its initial showing. With its stylised figures, flat colour and decorative design, it is very much a work of its period and was the most successful of the striking religious groups that Walke exhibited with STISA.[268]

Richard Copeland Weatherby (1881-1953) Exh. RA 24
STISA: 1929-1951
STISA Touring Shows: 1934, 1936, 1947 (SA), 1947 (W), 1949. Also FoB 1951.
Public Collections include Penzance.

The name Weatherby is synonymous with horse racing and, accordingly, it is little surprise that horses and hunting should have played a significant role in both the life and art of 'Seal' Weatherby, as he was known to all from early childhood. Weatherby was one of the first of the Lamorna circle of artists to join STISA and his vigorous, distinctive style, suggesting execution at great speed, made an impression at STISA exhibitions for over twenty years. Born at Walton, near Chertsey in Surrey, his parents eventually had ten children, six boys and four girls. Seal was the sixth born. He was educated at Winchester before enrolling in 1903 at the Frank Calderon School for animal painting off Baker Street in London. He then studied at Westminster School of Art before moving on to St John's Wood Art Schools in 1909, where he was awarded a silver medal for painting from the nude and an honourable mention for drawing from life. In 1911, he went on to the Royal Academy Schools at South Kensington, where he became friendly with William Orpen, who painted his portrait (Fig. 2W-1). After finishing these studies, Weatherby appears to have moved to Cornwall (or in any event spent some considerable time there) as there is a watercolour portrait of him by Laura Knight dated 1913 and, in May that year, he took Lamorna Birch on holiday to his brother's house near Brill, Buckinghamshire. The following year he was sharing lodgings and a studio with Geoffrey Garnier at Trewarneth Farm at the top of Paul Hill in Newlyn, a venue renowned for its parties. Here he will have met Alfred Munnings, with whom he shared a passion for both painting and riding horses, and they no doubt hunted together. The war then intervened and he joined the Essex Yeomanry as a Second Lieutenant in 1915 and was attached to the 8th Cavalry Brigade. He saw action in a number of battles, including

[266] Annie Walke sold the studio prior to her death and it is now in the garden of Green Lawn House in Mevagissey.
[267] *St Ives Times*, 1/10/1937.
[268] This painting has been widely illustrated but is reproduced in David Tovey, *George Fagan Bradshaw and the St Ives Society of Artists*, Tewkesbury, 2000 at p.136.

The Somme, and was severely wounded in the right wrist in 1917 and discharged. Badly affected by his experiences, he recuperated at 'Menwinnion', the home of Frank and Jessica Heath in the Lamorna Valley and took some further instruction from Stanhope Forbes. He rented Munnings' old studio in the flour loft at Lamorna Mill, kept his horses in the adjoining stables and lived for a time at the local pub, 'The Wink'. However, he appears to have spent some time in London during the 1920s and to have only settled in Cornwall permanently at the end of the decade, after a visit to Kashmir.

Weatherby was principally a portraitist and a horse painter, and he painted boldly and vigorously. "Mr Weatherby works at top speed and, with a definite touch and disciplined hand, he places each tone upon the canvas with conviction and finality. His work certainly looks untouched and fresh, and the consequent luminosity is a feature of his art."[269] He first exhibited with STISA in 1929, the work being from his Kashmir trip, but he may not have joined until 1932/3 along with many of the other Newlyn and Lamorna artists. He also exhibited a series of Indian subjects in the 1934 touring show and in 1938, suggesting return visits. In 1939, he commented that successful sales of pictures from one of his trips to India had enabled him to buy a pack of hounds. This demonstrates his priorities. Hunting without doubt was the great love of his life and he joined the Cury Hunt, becoming Master between 1930 and 1935 and again in 1939. In the early 1930s, he moved to Cury Cross and he acquired a field above Mullion in which to erect a studio, but he then added a stable and quarters for his hounds and so, in 1938, 'The Grange', as he called it, became his home. A reporter sets the scene: "Colts push their way into the kitchen; hounds peer through the window: and while the master sweeps colour upon his latest canvas, a groom in the scullery scours garments muddied in yesterday's hunt."[270] Unsurprisingly, the hunting scene provided a number of subjects for his paintings. In 1933, he exhibited at the RA *My Hunt Staff*. A painting *The Cury Hunt* was exhibited in the 1936 *Artists from Cornwall and Devon* tour and his 1935 RA exhibit *The Chestnut Mare*, probably a depiction of his own horse, which he nicknamed 'Cheese Nut', was included in the Birmingham tour of the same year. On a lighter note, he produced a series of six cartoons entitled *Hounds Running*, which, having featured in *Tatler*, became very popular. An unrelated oil, *Hounds Running*, is illustrated as Plate 11.

Fig. 2W-1 William Orpen *Richard Weatherby* (Private Collection)

Fig. 2W-2 Richard Weatherby *Portrait of the Artist* (RA 1944) - detail (Private Collection)

[269] *St Ives Times*, 16/10/1936.
[270] *News Chronicle*, 1939, Cornish Artists 17.

Weatherby's gregarious nature and easy going charm made him popular with all the local artists, and he became particularly friendly with Stanley Gardiner, Lamorna Birch and his wife, all of whose portraits he painted in the 1930s. At one juncture, he was engaged to Midge Bruford (q.v.) but he eventually married Karenza Boscawen, an active member of the hunting fraternity, in 1943. He was 61 and she was 39 and their marriage had been delayed due to the opposition of her parents. They moved to live at Alverton House, Penzance and, the following year, he exhibited at the RA both a portrait of his wife and a self-portrait (Fig. 2W-2). Hunting and gardening remained passions and he continued to exhibit at the RA until 1948 but shortly thereafter, due to failing health, he moved back to his family home at Brill. He was still represented in STISA's Festival of Britain Exhibition in 1951 but he died in 1953 and is buried in Brill churchyard.

91. ***Stanley Gardiner Painting*** oil on canvas (127cm x 101.5cm)
(Penlee House Gallery and Museum) (Plate 10)
This portrait of fellow member, Stanley Gardiner, was first shown at the Society's 1938 Autumn show where it won high praise:-

> "Here is a complete change of outlook in life size portrait painting. Here is a man in his natural surroundings of light and air. Observe the modelling in paint touches of the anatomy of the face. The unaffected poise of the figure firmly stanced on the uneven shore. The action of the arm renewing a backward movement to the palette. All these details form part of a stupendous task undertaken on the spot, and earn our congratulations for its attack and white hot application apparently at top speed in the painting of it." [271]

The painting was later hung at the RA in 1945.

(Miss) Helen Stuart Weir RBA ROI RBC PS SWA (d.1969) Exh. RA 22
STISA: 1928-1959
STISA Touring Shows: 1932, 1934, 1936, 1937, 1945, 1947 (SA). Also FoB 1951.

Weir was an American born painter and sculptor, who was acting President of SWA between 1933 and 1936, and the leading still life painter in oils within STISA. "Art" - she said - "is the happiest profession in the world, because the artist does not put money-making first." [272] She could afford to pass such a comment as she inherited an estate on the Scottish borders and had a flat in London filled with Canalettos and other old masters. [273] Although based in London, she maintained a studio (Rose Lodge Studio) in St Ives in a loft once used for storing fishing nets, which afforded a view over the harbour and from which she could hear the fishermen auctioning their catch. On her summer visits, she would stay in the St Ives Bay Hotel. Having studied in the U.S.A, Germany and England, her work is first mentioned in St Ives in a review of Show Day 1915, when she exhibited a clay model of a rose bowl. She was successful for the first time at the RA in 1919, when she was represented not only by a bronze of a doe and fawn, entitled *The Caress*, but also by a still life. Although she won a medal for her sculpture in Bucharest, she concentrated primarily on still life paintings in oils of fruit, flowers, glass and pewter, with a fascination for reflections and the play of light on different textures. Borlase Smart commented, "Her art does not represent the slavish copying of flowers or natural objects, but is sympathetic in expression, decorative achievement, composition and colour values, with artistic selection of subject matter playing an important part." [274]

In 1922, she held a joint show at Lanhams with her mother, Nina Weir-Lewis (q.v.), and, in 1927, had a one-man show at Goupil Gallery in London, entitled *Flowers and Still Life - Brittany and the Basque Country*, which included twenty coloured drawings (including two of St Ives), twenty-three oils and her bronze sculpture *The Caress*. Highly regarded, she was a member of a number of leading art societies and became Acting President of SWA in 1933 in succession to Dorothea Sharp. In 1936, she included in the STISA Autumn show the three pastels that prompted her election to the Pastel Society. She also exhibited at the Paris Salon and in Rome. She was well-liked in St Ives circles and became a good friend of the Lanyon family.

92. ***Top Hat*** oil on canvas (50cm x 61cm)
(Private Collection)
This painting was included in the 1945/6 tour but won high praise when first exhibited at the 1939 Autumn Exhibition:-

> "[Miss Weir] gets away from the obvious in her work and it certainly takes courage to arrange a still life with a top hat in it...The painting is lovely, and note how easily she does it all. See the flat background in this picture, in fact in all her recent

[271] *St Ives Times* 7/10/1938.
[272] *News Chronicle* 1939 Cornish Artists 36.
[273] Weir's half-sister, Frances Lewis, a beautiful and talented pianist, married a wealthy Scot, Claude Cuthbert, but died young of food poisoning at Gleneagles, and, on Cuthbert's death, Weir inherited a Scottish estate and built a church in his memory.
[274] *St Ives Times*, 11/8/1922.

Fig. 2W-3 Helen Stuart Weir, with her painting *Tulips* in her studio (Gilbert Adams)

work. While other artists make life difficult for themselves with backgrounds of folds they cannot paint, or windows behind their groups that make the flowers look as if they were done behind the bars of a prison, Miss Weir's quick sense of proportion eliminates all seeming etceteras, she makes her objects fit a given space, and her backgrounds form part of the decorative whole, and so, we have a real picture, not an illustration for a seedman's catalogue of the post-Victorian era."[275]

The white gloves and bunch of tulips feature in *The Hall Table*, a still life group by Dod Procter reproduced in Leonard Richmond's *The Technique of Still Life Painting in Oil Colours*.[276]

[275] *St Ives Times*, 13/10/1939.
[276] *Top Hat* is illustrated in colour in David Tovey, *George Fagan Bradshaw and the St Ives Society of Artists*, Tewkesbury, 2000 colour plate 27 opposite p.145.

Terrick John Williams RA RBA PRI VPROI PS (1860-1936) Exh. RA 149
STISA: 1929-1936
STISA Touring Shows: 1932, 1934, 1936.
Public Collections include QMDH, Tate, Aberdeen, Bristol, Cardiff, Leeds, Newport, Oldham, and, abroad, Christchurch, Nelson, Timaru, Wanganui, Wellington, Perth, Sydney and Cape Town

Terrick Williams was an universally liked and acclaimed artist, who made a significant contribution in the early years of the Society. He was born in Liverpool but, from the age of seven, was brought up in Lewisham. On leaving school, despite wanting to become an artist, he was forced to work in the family soap and perfume business for eight years, until at the age of 25, he suffered a physical and mental breakdown. Allowed then to study art, he trained initially under the landscape painter Buxton-Knight, who taught him "the indispensable necessity of observing the relative tones of nature" by forcing him to paint initially in monochrome.[277] He then studied in Antwerp under Charles Verlat for two years from 1885 and, afterwards, in Paris, under Fleury, Constant and Bouguereau. He was successful at the RA for the first time in 1888. He never settled in St Ives but he first visited it in 1890, when he arrived with some fellow students from Paris. It was possibly during this trip that Williams, inspired by the local artists' enthusiasm for *plein air* painting, tried to paint a six foot canvas out of doors, an experience which put him off painting on the spot for life.[278] It did not put him off St Ives, however, and he returned many times, often staying for three or four months at a time.[279] After some further training at the Westminster School of Art, Williams took up art teaching and, in 1892, he was appointed Instructor in Landscape Drawing to the Military Academy at Woolwich, a post he retained until 1902, when he felt sufficiently confident to rely solely on sales of his paintings. He had one-man shows at the Leicester Galleries in 1908 and 1912 and won a silver medal at the Paris Salon in 1908 and a gold in 1911. He was elected as an ARA in 1924.

At the outset, although Williams' style was clearly influenced by the Impressionists, his realistic approach to the depiction of his subject matter - fishermen and local inhabitants going about their ordinary tasks - had some similarities with that of the first generation of Newlyn artists. From about 1915, however, the figures that had played a significant role in his early paintings had become smaller and indistinct and he concentrated more on the challenges involved in the depiction of water and atmospheric conditions. He became a master at creating evocative atmospheric effects and his acute awareness of tonal values was a key factor in his success.

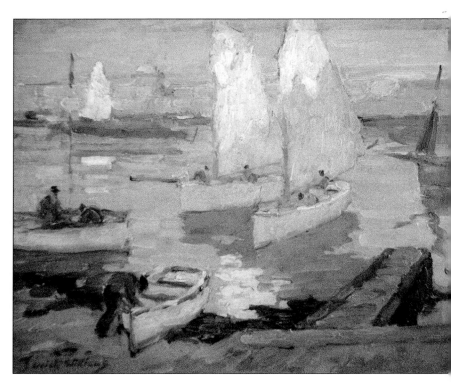

Fig.2W-4 Terrick Williams in his studio in 1935

Fig. 2W-5 Terrick Williams *Early Morning, St Ives* (W.H.Lane & Son)

[277] Letter to A.L.Baldry, 16/6/1925 quoted in C.Simon, *Mist and Morning Sunshine*, London, 1984, at p.13.
[278] Williams told Baldry "I painted in 1890 a six foot picture out of doors and decided then it was the wrong method!" Letter to A.L.Baldry, 16/6/1925 quoted in C.Simon, *Mist and Morning Sunshine*, London, 1984, at p.42.
[279] *St Ives Times*, Christmas Number, 1925. In his speech opening the 1930 Spring Exhibition of STISA, Williams listed his fellow students as including Boschrietz, Walter Jeyons, Harry Brown, Henry Bishop, and the Australian painter, E.E.Fox. *St Ives Times*, 18/4/1930.

Due to his delightful personality and his capabilities as an organiser, Williams was much in demand on the Committees of Art Societies and, from 1913 until his death, he was very involved with the RI, eventually becoming President in 1933. During his brief time as President, he ensured that lady members were at last entitled to full membership and given equal rights.[280] He also became Vice-President of the ROI. Williams was invited to become an honorary member of STISA in 1929 but he insisted on paying a subscription. He also accepted an invitation to open the 1930 Spring Exhibition, during which he lamented the changes that had occurred in St Ives since his first visit, particularly the vast number of bungalows that had been built on meadows formerly grazed by cows. Nevertheless, he appears in the last years of his life to have reawakened his love for Cornwall. To what extent his involvement with STISA contributed to this is uncertain but, in the early 1930s, he spent some considerable time in Cornwall each year and, as a result, his contributions to STISA shows were often paintings of Cornish ports, such as St Ives, Polperro, Mousehole and Mevagissy.

Williams' objectives when sketching were similar to those of Moffat Lindner, an artist who also concentrated on atmospheric effects. If he saw an effect that he wanted to capture, he knew that it would have dispersed by the time he had set himself up to paint on the spot and so he made quick pencil notes of the arrangement that attracted him and recorded some observations on colour in pastel. Just prior to his death, Williams, who had been a founder member of the Pastel Society in 1899, wrote a treatise on *The Art of Pastel*. In this he stated that some twenty years previously he had taken to using pastel for out of doors work as he found it quicker to make notes in this medium than watercolour or oil. He only made oil sketches if he wanted something precise in tone and colour. Having made some notes, he would then sit and watch the effect, trying to commit to memory the important tones, colours and general effect. Back in his studio, he would make a number of studies, again in pastel, before embarking on the final oil painting.

93. *Evening, Mousehole*
(Newport Museum and Art Gallery) oil on canvas (64cm x 76cm)

Williams spent eleven weeks in Cornwall in 1932, based in a house with a large window overlooking Mousehole Harbour. This tranquil evening scene is brought alive by the golden lights burning in a couple of cottage windows which are reflected in the waters of the harbour, and the last golden tints of the setting sun in the sky. It was exhibited at the RA in 1933 and bought from there for Newport's permanent collection.[281]

94. *Cassis*
(Gallery Oldham) oil on canvas (76cm x 94cm)
 (Plate 82)

This particularly beautiful, luminous work was exhibited at the 1934 STISA Exhibition at Oldham. It was one of eight works that Oldham added to the show from their permanent collection.[282] Originally, it had been exhibited at the RA in 1929. *Low Tide, St Ives*, another work exhibited at Oldham that year is now in the permanent collection of Rochdale, along with *A Silvery Sky*, another St Ives scene from the same period.[283]

95. *The Quiet Harbour, Mevagissy*
(Leamington Spa Art Gallery and Museum) oil on canvas (42.5cm x 61.5cm)

In 1935, Williams wrote a series of articles for *The Artist* entitled *Harbour and Fishing Subjects*, in which he discussed how he had chosen various subjects in Honfleur, St Ives and Mevagissy. In the April issue, he discusses a sketch that he had made in Mevagissy from which this painting was developed. "The time was late afternoon in August and the water in the harbour was completely still...I was very much impressed by the serene beauty of the whole scene...I did my utmost to retain a clear mental vision of what I saw as it was most improbable that I would see this particular effect again which was one of the most beautiful it has been my fortune to witness."[284]

The sketch of the scene reproduced in *The Artist* was done the next morning and Williams comments in the article, "I hope to paint a larger picture from this study in which I may refine the colour and values, improve the arrangement of the boats, and perhaps succeed in obtaining a fairly satisfactory rendering of a very beautiful thing."[285] This painting is believed to be that larger picture, which was exhibited at the RA in 1935. It was also included in the 1936 *Paintings from Cornwall and Devon* tour, which started at Eastbourne and then went to Lincoln and Blackpool before finishing at Leamington. There, the picture was bought by Alderman Holt and was later donated to the Art Gallery.[286]

[280] This would have been appreciated, inter alios, by new member Eleanor Hughes (q.v.).
[281] This painting is illustrated in colour in David Tovey, *George Fagan Bradshaw and the St Ives Society of Artists*, Tewkesbury, 2000, plate 20, opp. p.144.
[282] The other works were by Forbes, Olsson, Birch (3), Lindner and E. Hughes.
[283] The former is illustrated in David Tovey, *George Fagan Bradshaw and the St Ives Society of Artists*, Tewkesbury, 2000 at p. 87.
[284] *The Artist*, April 1935.
[285] ibid.
[286] This painting is illustrated in colour in David Tovey, *George Fagan Bradshaw and the St Ives Society of Artists*, Tewkesbury, 2000, plate 4, p.68/9.

Bryan Wynter (1915-1975)
STISA: 1947-1949
STISA Touring Shows: 1947 (W), 1949.
Public Collections include Tate Gallery, Arts Council, Victoria and Albert Museum, Newlyn and Nelson.

Wynter was another of the young artists, who resigned in 1949 and went on to become well-known as part of the St Ives Group. Born in London in 1915, Wynter was educated at Haileybury. He lived in Zurich during 1934 and worked in the family business before attending the Slade between 1938-1940. During the War, he was a conscienscious objector and worked on the land in the Oxford area. He came to St Ives in 1945 and settled in 'The Carn', a tumble down cottage, with no electricity or plumbing, high on the hill above Zennor, beside the large granite outcrop from which it took its name. The rough moorland landscape around him, which could be very bleak, had a significant influence on his art. Small farms and ruined tin mines enfolded by the landscape with birds riding the turbulent air currents overhead were common early themes but a rather sinister air often pervades the works, inspired by the occult associations of the Carn. Many of these early works were begun in monotype with gouache painted over the top.

Wynter was a founder member of the Crypt Group in 1946, although he was not included in the second show. STISA's exhibition in Cardiff in 1947 contained *Birds* and a wash drawing *Mountain Landscape*, both of which had been included in the First Crypt Exhibition in 1946, and the 1949 Swindon show included *Cottages, Castel an Dinas*, which had been included in the Third Crypt Exhibition in 1948. Wynter had shows at the Redfern Gallery in 1947 and 1948 and he also held a joint exhibition with Kit Barker in Downing's Bookshop in 1948. It was felt, however, that he had great potential as an illustrator. "He stacks emotional and particular contacts with Cornwall into small pen and ink drawings, whose brevity is admirable".[287] Wynter resigned in 1949 and became a founder member of the Penwith Society, but he did not in fact produce his first abstract painting until 1956. These large, colourful and vibrant works were nevertheless still influenced by the effects of nature on the landscape about him. From 1961, Wynter's experiments with kinetic constructions, which he called IMOOS, took up more of his time. Between 1959 and 1974, he had six shows at Waddington Galleries and a retrospective was held at the Hayward Gallery in 1976. His later work has more recently been re-assessed at Tate, St Ives in 2001.

96. ***Birds Disturbing the Sleep of a Town*** monotype and gouache on paper (35.5cm x 50.7cm)
(Newlyn Orion Gallery)
This is an example of Wynter's eerie paintings of birds inspired by the occultish associations of Zennor Carn. It was executed in 1948 and was included in his exhibition at Downing's Bookshop that year.

Fig. 2W-6 Bryan Wynter *The Old Gas Works* (1946) (now the site of Tate, St Ives)
(W.H.Lane & Son)

[287] *St Ives Times*, 8/10/1948.

THE ST IVES SOCIETY OF ARTISTS
(1927-1952)

DICTIONARY OF MEMBERS

PART B - MEMBERS NOT INCLUDED IN EXHIBITION

Gilbert Adams (1906-1996)
STISA: 1944-1949
STISA Touring Shows: 1945, 1947 (W).
Public Collections include National Portrait Gallery, Tate Britain.
Like his father, Marcus, Gilbert Adams became a celebrated photographer and he is better known for his photos of St Ives artists than his own art. Born and educated in Reading, he studied art at Reading University before working for his father at his Dover Street studios from 1929-1934. He set up his own studios in Reading in 1934 and exhibited at the London Salon of Photography for over sixty years. He also was very involved with the Royal Photographic Society and the Institute of Incorporate British Photography, being much in demand on Selection Panels, Councils and Committees. He joined the Reading Guild of Artists in the 1930s and his studio was used for evening life drawing classes.

A visit to St Ives to see Leonard Richmond and his family in 1926 first whetted his appetite for the town. He returned regularly for holidays and moved there with his family at the outbreak of World War II, staying until the early 1950s. They lived in The Digey. During that time, he exhibited work with STISA, often paintings of old St Ives, and photographed many of the major artists, sculptors and potters working in St Ives, including Borlase Smart, Leonard Richmond, Fred Bottomley, John Park and Leonard Fuller from the traditionalist camp. However, he was particularly friendly with Peter Lanyon, Denis Mitchell and Hyman Segal and he resigned from STISA along with the moderns in 1949. He continued to photograph artists and their work, many of his commissions coming from the British Council. In 1952, he was asked to direct the lighting for the Coronation of Queen Elizabeth II in Westminster Abbey and he was in great demand as a lecturer on Art, photography and lighting for the rest of his life.[1]

Marcus J Adams (1875-1959)
STISA: 1934-1959
STISA Touring Shows: 1934, 1936, 1937, 1945, 1947 (SA). Also FoB 1951.
Adams made his name as a photographer of children, his subjects including the then Princesses Elizabeth and Margaret, the Infantas of Spain and the Kennedys. A biography *Marcus Adams : Photographer Royal* was published in 1985 by Rosalind Thuillier. Adams, however, was also an artist and was a member of STISA for many years. Born in Reading, his father, Walton Adams had been a pioneering photographer in the 1860s and had developed a clientele that included English and European royalty. Marcus was one of seven children, of whom three pursued artistic careers - his brother, Christopher becoming a portrait painter and distinguished miniaturist and his sister, Lilian exhibiting from her Paris base at the Salon for over fifty years. Marcus himself studied at Reading Art College and later in Paris, but, in 1892, he became apprenticed to his father at his studio in Reading. Soon he built up his own list of distinguished clients and became a master of photographic techniques. Having found he had a particular affinity for photographing children, he decided, in 1919, to break from his father and set up the Nursery Studio in Dover Street in London. He said, "It was the desire of absolute truth which led me to be a child photographer" and he felt that it was only in children that he could capture the fleeting emotions so often concealed by adults.[2] Although every effort was made to ensure the child relaxed, there were still immense obstacles to be overcome due to the technical handicaps of the age before a satisfactory picture could be obtained. The ideal that he sought - and which he achieved so splendidly with his pictures of the young princesses - was the radiant look of a child for its mother. He was immensely successful in the 1920s, as parents began to turn from art to photography for children's portraits. He frequently looked for inspiration to the great portrait painters of the past and what he produced were not merely likenesses but "character studies of rare beauty and consummate skill".[3]

[1] I am greatly indebted to Rosalind Adams, Gilbert's widow, for information on her late husband and for permission to reproduce his photos.
[2] Rosalind Thuillier, *Marcus Adams : Photographer Royal*, London, 1985.
[3] *The Camera*, 1925, quoted in Rosalind Thuillier, *Marcus Adams : Photographer Royal*, London, 1985 p.17.

Fig. 3A-1 Gilbert Adams (Gilbert Adams)

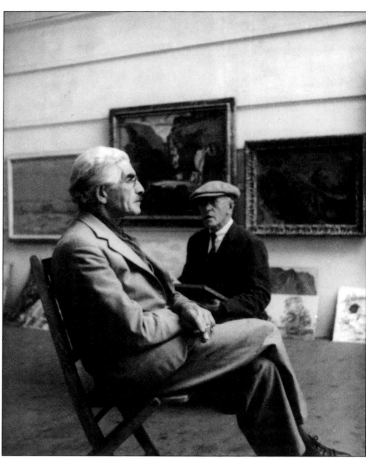

Fig. 3A-2 Marcus Adams sitting for Borlase Smart
(Gilbert Adams)

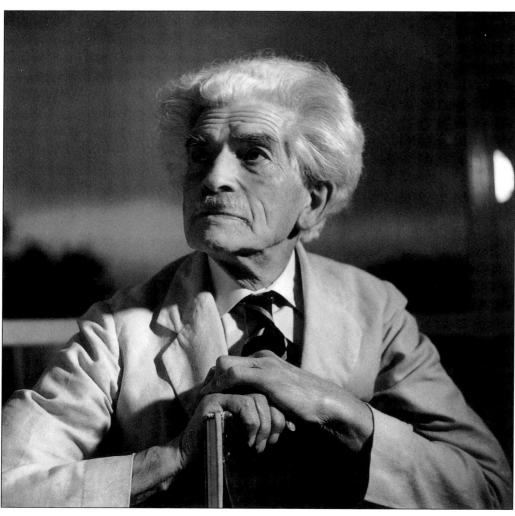

Fig. 3A-3 Marcus Adams - Eightieth birthday portrait (Gilbert Adams)

In 1935, he published *Rhythm of Children's Features*, which he illustrated with pen and ink drawings, in which he described how he mastered the more difficult details of his subjects. However, his paintings were of a wide variety of subjects, for he also had a love of the countryside and wild flowers and he travelled extensively. His contributions to STISA shows included landscapes in watercolour, still life and religious scenes. Prepared to experiment, he produced work that often startled. From an early age, he had been a deeply religious man and, at the 1951 Festival of Britain Exhibition, he exhibited *Moses Proclaiming the Blue Print to Mankind*, which was priced at the significant sum of £105. In the 1950s, he was living at Wargrave-on-Thames and he continued exhibiting with the Society until his death.

(Miss) Eileen W Aldridge (1916-1990)
STISA: 1939-c.1945
STISA Touring Shows: 1945.
Born in Teddington, she studied at Kingston School of Art between 1933 and 1938 and then at Regent Street Polytechnic. She is described as a new member in the 1939 Autumn Exhibition, when her watercolour, *Minster Lovell*, was considered one of the outstanding pictures in its section. Her work was notable for her breadth of style, strong composition and restrained colouring. She appears to have left after the War. She married the painter and etcher, Martin Ware, and wrote and illustrated a children's story about a giraffe called *Graffy* in 1947. In 1969, her book on Porcelain was a success in both this country and America and her husband and herself gained high reputations as restorers of porcelain, paintings and frames for National Galleries.

(Miss) Emily Allnutt ASWA (d.1944) Exh. RA 2
STISA 1927-1944
Allnutt painted portraits, landscapes and still life, sometimes in miniature. She studied at the Slade and in Paris and first started exhibiting with SWA in 1899, when she was living in Windsor, and was successful at the RA in 1905 and 1915. She first exhibited in St Ives on Show Day in 1912 but, at this juncture, she seems to have been a regular visitor rather than a resident as her address in SWA catalogues between 1917 and 1923 is given as in Gerrards Cross, although a number of exhibits are St Ives scenes. In 1924, she settled in St Ives at 15, Sea View Terrace before moving in 1931 to Chalfont Cottage, Carbis Bay. She was an associate member of SWA from 1917-1934 and exhibited 31 works with that Society. A founder member of STISA, she specialised in flower paintings in watercolour but she does not appear to have exhibited during the last decade of her life.

Howard Allport
STISA: 1950-1954
STISA Touring Shows: FoB 1951.
Very little is known about him. He exhibited at Birmingham in 1908/9. A painting of farm buildings at Nancledra dated 1932 was sold at W.H.Lane & Son in 1989.[4] His first Show Day was in 1950, when he exhibited at the St Ives School of Painting, which suggests he had come to study at the School. He also began exhibiting with STISA that year, his works tending to be portrait studies. His own portrait by Leonard Fuller was exhibited with the Penwith Society in the Summer Coronation Exhibition in 1953.

(Miss) Edith Lovell Andrews (1886-1980)
STISA: 1949-1978
STISA Touring Shows: FoB 1951.
Public Collections include British Museum.
Born in Newport, Monmouthshire, she studied at Glasgow School of Art between 1908 and 1910 under Fra. Newbery and then with Gerald Massey at Heatherley's between 1911 and 1914. Her work is first mentioned on Show Day in 1949, when she is described as a Devonshire woman who had formerly been a poster painter, and she also exhibited in the Spring show that year. She lived at 2, Bellair Terrace and was primarily a watercolourist. She painted local scenes, with the cliffs and seas of West Penwith, particularly around Zennor, having a strong attraction. She was fascinated by moving water and made a special study of the translucent, tumbling streams of the West Country. She joined the Council of STISA in 1955 and, in 1957, became Secretary of the Fabric Fund when £3,000 was required to be raised to purchase the freehold of the New Gallery (formerly the Mariners' Church). She was a good friend of 'Fish' and, in 1957, was the first person that 'Fish' allowed to hold a one-man show in Studio 27 in Digey Square. She was a loyal stalwart of the Society and served on the Council for over 20 years. She was made an Honorary Vice President in 1977.

[4] Sale date 28/9/1989 Lot 74

Fig. 3A-4 E. Lovell Andrews *The Gallery*
This scraperboard image of the Society's Gallery was used for the 1965 Summer Exhibition Catalogue.

W Donald Angier
STISA: 1928-1932
His first Show Day was in 1925. A reviewer of an exhibition of 28 watercolours and some pen and ink drawings that he held at Lanham's Galleries in April 1927 mentions that he had had an adventurous life in many parts of the world but had only begun to paint during the last few years.[5] He worked from Meadow Studio and he had a unique style that always drew comments. His paintings were deliberately decorative and he was particularly adept at portraying sky and water effects. His striking sign for the Society's Gallery was purchased by STISA.

Malcolm Arbuthnot RI FRSA (1874-1967) Exh. RA 2
STISA: 1940-1950
STISA Touring Shows: 1945, 1947 (SA), 1949.
Public Collections include Victoria and Albert Museum and Salford.
A multi-talented individual, Arbuthnot had a successful career as a photographer before taking up art. Born in Suffolk, he worked as a clerk between 1893 and 1905, before setting up a photographic studio in 1906. He worked freelance for papers such as *Illustrated London News* and *Sketch* and won a reputation as a portrait photographer. From commissions received from the Goupil Gallery, he came into contact with a number of artists and he decided to develop his skills in this direction. His art teachers included C.A.Brindley, J.D.Fergusson and W.P.Robins. He is first recorded as exhibiting his work in 1918 and he had his first success at the RA in 1923. In 1926, he closed his London photographic studio in order to concentrate on painting and sculpture. During a spell in France, he showed bronzes at the Paris Salon. He exhibited with a range of London Societies and, in April 1937, he had a one-man show, *Waterways in Watercolour*, at the Fine Art Society, comprising some 75 works. After a spell in Jersey, he moved to Carbis Bay in 1940 and joined STISA as an associate member in the autumn of 1940. He exhibited landscapes in watercolours, often of local scenes, for a decade.

Stuart Armfield (1916-1999) Exh. RA 6
STISA 1950-beyond 1982
STISA Touring Shows: FoB 1951.
Public Collections include United Nations (New York).
Armfield was educated at Sidcot School in Somerset and worked in the building trade for three years before enrolling at the Royal West of England College of Art to study Architecture and Design. He became Assistant Art Director at Ealing Film Studios for about five years before deciding to return to a "simple life" in Somerset, where he took up market-gardening. After a nervous breakdown, he settled in Polperro, where he ran his own market garden for several years before taking up painting as a full-time occupation. He worked solely in egg-tempera and his still life paintings and studies of birds have a distinctive, sharp style. While he would use a combination of objects set out before him as a basis to work from, his imagination often transformed them into an other-worldly setting. He was first successful at the RA in 1949 and exhibited there for five consecutive years. His last RA exhibit was in 1956. In the early 1950s, he published in *The Artist* three articles on *The Advantages and Use of Egg Tempera*, a medium which, for him, was "the be-all and end-all of painting" and upon which he became an authority. Its main advantage, he considered, was the added luminosity and clarity of effect that could be achieved and it was best used for work of a meticulous, delineated or closely detailed character. Armfield was a welcome new recruit after the split and remained a valued member of STISA for many years. In 1979, he moved to Plymouth and worked from a studio on the Barbican. James Colman Fine Art held a retrospective in 1996 to mark his eightieth birthday.

William Edward Arnold-Foster (1886-1951)
STISA: 1928-c.1932
Public Collections include Swindon.
The son of a member of parliament, Will Arnold-Foster studied at the Slade between 1905-1908. He exhibited at various Societies between 1908 and 1935, showing 120 works at the Goupil Gallery. He is recorded as a guest of J.C.Douglas (q.v.) at the St Ives Arts Club in February 1909 and his wife, Katherine, was a guest in 1913. In the War, he served in the Navy and, afterwards, in an effort to recover from its horrors, he decided to return to the depths of Cornwall and install himself, his wife and his young son "in a windswept, bleak house high above the cliff, with few trees, neighbours or modern conveniences." This was Eagle's Nest,

[5] *St Ives Times*, 22/4/1927. It is believed he was a racing driver.

Fig. 3A-5 W.D.Angier St Ives street scene
(Lander Gallery, Truro)

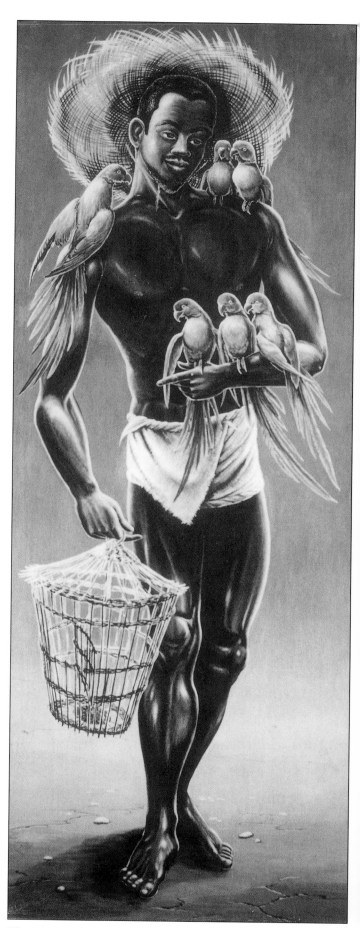

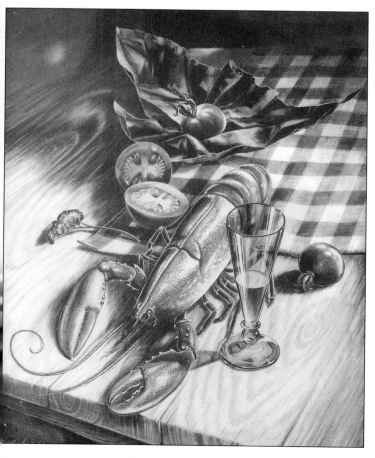

Fig. 3A-7 Stuart Armfield *Negro with Parakeets*
(W.H.Lane & Son)

Fig. 3A-6 Stuart Armfield *Still Life with Lobster and Tomatoes*
(W.H.Lane & Son)

Zennor, the property now so associated with Patrick Heron. After a visit in 1921, Virginia Woolf wrote, "Ka and Will sit among the rocks in Mrs Westlake's stone mansion, rather windblown, but sublime, observing hail storms miles out to sea, and the descent of the sun."[6] Keen gardeners, they created the garden that was to inspire Heron, and Will published, in 1948, *Shrubs for the Milder Counties*, which has become a classic and which was reprinted in 2000. He built his own studio at Eagle's Nest but he did not practise art full-time, as he himself joined the Labour Party, serving as Secretary to Lords Cecil and Parmoor in the second Labour Government. He also worked tirelessly for the League of Nations and other international good causes. He was a skilful portraitist but later concentrated on finely coloured remote landscapes, mainly in pastels. He contributed some landscapes in watercolours to the first STISA show in the Porthmeor Gallery in 1928 and to exhibitions in 1929 and he was one of the artists selected to represent STISA at the show at Harris and Sons, Plymouth in 1931 but, due to his political commitments, his work was not included in any of the 1930s touring shows and he had ceased to be a member by 1938. He reappears as a founder member of the Penwith Society, although he did not exhibit at the first show, and he urged a more conciliatory approach, without success, when members started to resign in 1950. A watercolour drawing *The Ridge* was presented to Swindon Museum and Art Gallery in 1950 and he held an exhibition in London in October 1951, the month he died.[7]

Sir John William Ashton ROI (1881-1963) Exh. RA 31
STISA: 1934-1936
STISA Touring Shows: 1936.
Public Collections include Auckland, Adelaide, Melbourne, Sydney, Perth and New South Wales.
Will Ashton was one of the group of Australian artists that studied in St Ives at the beginning of the century and joined STISA in the 1930s. Although born in York, Ashton was brought up in Australia and was educated at Prince Alfred College, Adelaide. His father, James, was an artist and art teacher and no doubt he encouraged his son to come over to England for further study. In 1900, he came to St Ives, either because he was already showing an inclination towards marine work or because of the Australian connection through Louis Grier. Certainly, it is Grier that signs Will in as a visitor to the Arts Club in January 1901 and his work is first mentioned in a review of Show Day 1901, when he exhibited a seascape. He returned to Australia in 1904 with Richard Hayley Lever, with whom he had been at school. He was also a good friend of another Australian student, Arthur Burgess (q.v.). At his leaving party, he showed some fifty paintings of seine boats and several marine and landscape paintings. Thereafter, he divided his time between Australia and England and he also frequently visited Europe, being particularly fond of Paris. He won the Wynee Art Prize in Sydney in 1908 (and again in 1930) and received an Honourable Mention at the Carnegie Institute, Pittsburgh in 1914. He remained great friends with Olsson and when, in 1914, Olsson decided to close his School of Painting, he offered Ashton the opportunity of taking it over, but he declined. In 1931, he was elected as a member of ROI and, in 1933, he was awarded the Godfrey Rivers Trust Prize in Brisbane for the best landscape. In the winter of 1933/4, he returned to visit St Ives as one of his 1934 RA exhibits is *Winter Sunshine, St Ives*. It was probably during this visit that he was persuaded to join STISA and he showed some studies of morning light at Concarneau in the 1934 Winter show. However, his contributions to STISA exhibitions were spasmodic. He is represented extensively in Australian public collections and both Adelaide and the National Gallery of New South Wales, of which he was a Director from 1937-1944, have works entitled *The Cornish Coast*. He served on the Commonwealth Art Advisory Board, of which he was Chairman in 1953, and was knighted in 1960.

Alfred Charles Bailey (b.1883)
STISA: 1927-1943
STISA Touring Shows: 1932, 1934, 1936, 1937.
He was born in Brighton, his father being an engineer, and he studied in Brighton and in St Ives under Louis Grier, but he was largely self taught. His work is first mentioned on Show Day in 1908. In about 1915, he gave up painting in oils and developed his own individual style of watercolour painting. He favoured marine subjects, landscapes and old buildings. A review of his one-man show in 1923 at the Goupil Gallery, a regular outlet for his works, observed that he was "an artist with a distinctly original point of view and a healthy disregard for the hard and fast conventionalities of the old school. There are more than 30 Cornish pieces in the collection and they are more bright and colourful than anything we have seen for a long time. Mr Bailey is daring to the point of recklessness in some of his pieces, but always knows when to draw rein on his enthusiasm. He is courageous in his choice of subject-matter too."[8] A later exhibition at the Redfern Gallery in 1926 prompted praise for "his recklessly clever landscapes, [which were] aimed at producing a gay and vivacious pattern rather than giving a credible transcription of nature".[9] He had a further one-man show at the Goupil Gallery in 1929, which contained paintings of Italy and Holland.

He was included in the 1925 Cheltenham exhibition and was a founder member of STISA. He worked from Atlantic Studio (see Roskruge's map - Fig. 1-3) and was a regular contributor in the Society's early years. In March 1928, his paper on *The History of*

[6] *The Question of Things Happening Vol 2, The Letters of Virginia Woolf*, 1912-1922, The Hogarth Press.
[7] There is a reference to him in Anne Bridges' novel *Peking Picnic*.
[8] *St Ives Times* 1/6/1923.
[9] *The Studio*, Vol.91, 1926, p.123.

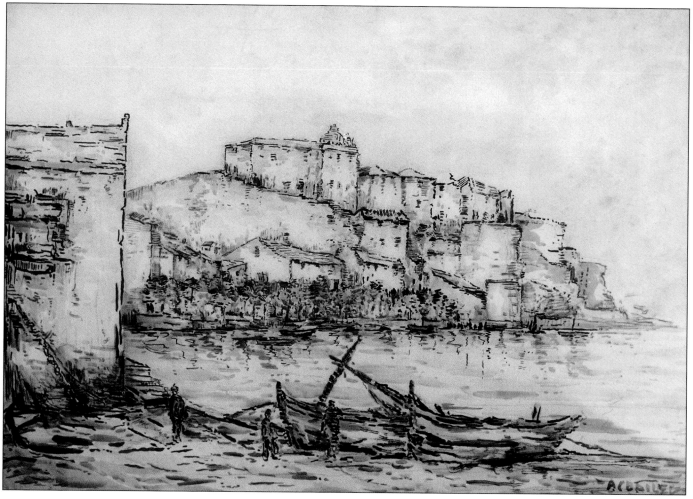

Fig. 3B-1 Alfred Bailey *Continental Port*

(Private collection)

Painting in Watercolour was the first of the lectures to be given to the Society. However, in 1930, he threatened to resign as he felt he was being unfairly treated by the Hanging Committee and he may well have moved from St Ives at this time as he ceases to feature on Show Days. By 1938, he was living in Chelsea but he still contributed to STISA shows. The onset of war clearly made it more difficult for him to supply work and the last mention of one of his exhibits is in 1943. He does not seem to have been involved with the Society after the war, when he appears to have moved to Richmond.

(Mrs) Georgina Bainsmith
STISA: c.1930-1937
Georgina Bainsmith (née Bucknall) was the sister of Mabel Douglas (q.v.). In her youth, she was a well-respected sculptor, working in marble and bronze, and she is mentioned in reviews of Show Days from 1897. Her work included a marble bust of General Peel Yates and a representation of Capt T.Row Harry, when mayor of St Ives, in embossed bronze, both of which won high praise. She won many awards for her sculpture but her contributions to STISA's exhibitions were spasmodic. Nevertheless, in the 1930 Winter Exhibition, she exhibited the first casting of a bronze panel of King Edward VII, which was presented to Queen Alexandra. In 1936, she exhibited a bust of Coxswain Henry Blogg of Cromer, a double VC. A reviewer commented, "Mrs Bainsmith is to be congratulated on the virility of her work, its mobile, rough-hewn power is outstanding. A woman of action and public spirit, we are pleased that her art has gained, not lost, by the years and energy devoted to public service since last she handled the tools.".[10] She was also known for her artistic photographs. However, she is not included in a list of members in 1938.

[10] *St Ives Times*, 11/1936.

(Miss) Marjorie Heudebourck Ballance (1898-1969) Exh. RA 1
STISA: c.1936-1950
STISA Touring Shows: 1937.
Born in Birmingham, her family moved to St Ives just prior to the Great War. Marjorie studied at the Slade and in Paris and first exhibited on Show Day 1920. Her painting was brilliantly coloured and highly decorative and she had her one success at the RA, *Merchants*, in 1922. This was an interior scene set in the 15th century, showing a lady choosing fabrics, and was hailed on Show Day as "a gem of decorative design". She also exhibited at the Jubilee Exhibition at the Walker Art Gallery that year and was successful at the Paris Salon. In her early paintings, she concentrated on scenes allowing her to create decorative effects by the depiction of clothing and textiles of the past but she was also renowned for her clever painted wooden models.

Unlike her brother, Percy, she remained in St Ives and was a stalwart of the Arts Club, for whom she designed stage settings. This was her greatest love and she also designed stage-sets for Masshouse Theatre, Edgbaston, the Children's Theatre, Aston, the British Shakespeare Society and Cheltenham and Malvern Colleges. In her work, she continued in the tradition of Gordon Craig, with simplicity, symbolic design and space construction being the dominant features. An exhibition devoted to her designs of costumes and settings for the stage was held at Downing's Bookshop in both 1948 and 1949, the catalogues for which were designed and printed by Guido Morris.[11]

In the 1930s, she features regularly on Show Days, exhibiting watercolours, colour prints from wood blocks and black and white work but her work is not mentioned in reviews of STISA shows. In 1936/7, she ran a life class for STISA members at a studio in the Belyars made available by Mrs Lanyon. On the outbreak of the Second World War, she was on holiday in Australia with her lifelong companion, Miss L.M.Larking (q.v.), who had been born there. As a Quaker, Marjorie had a keen interest in social work and, while forced to remain in Australia, they devoted themselves to the care of refugees and displaced persons. Returning to England in 1942, they did similar work helping displaced children in conjunction with the Society of Friends. They helped set up a home for refugee children at Warminster and had ten children at their home in the Belyars. After the War, she had some sympathy with the moderns and resigned at the time of the split but rejoined shortly afterwards. Nevertheless, she took issue with the comments passed by Rountree on *Down Your Way* in 1950 and does not appear to have exhibited with STISA subsequently, turning her attention to her work as a magistrate, a position she held from 1950 until 1968. In 1956, she was elected President of St Ives Arts Club - only the second female to be accorded this honour.

Percy des Carrieres Ballance (b.1899, still exh.1969) Exh. RA 15
STISA: 1932-c.1940
STISA Touring Shows: 1936, 1937.
Public Collections include Government Art Collection and RWA.
The son of Dr J.D.Ballance and brother of Marjorie, he was born in Birmingham but educated at Gresham School, Holt, Norfolk. By 1920, however, both Ballance and his sister were living at 'The Croft', Carbis Bay and working from 1, Piazza Studios. In those days, he was known as a breezy personality, whose seascapes were hailed for their vitality, reflecting the "rollicking gaiety of undaunted youth"[12]. He was hung at the RA for the first time in 1923 with *Dawn at Sea* and was also successful that year with two works at the Paris Salon, where he won a Mention Honorable. His oil *A Norman Castle* was included in the 1925 Cheltenham show but he left St Ives in 1927 and did not join STISA until 1932. He was included in the 1933 London show at Barbizon House and features regularly in exhibitions for the rest of the decade. By this time, he was living in the Wells area in Somerset and painted landscapes in a simple direct style in quiet restrained colours. He had a particular penchant for depicting old barns. He was a regular exhibitor at the RWA for the rest of his life. In 1938, he had a one-man show in London, which was visited by the headmaster of his old school in Norfolk and, as a result, in 1939, he put on an exhibition at the School. He does not appear to have remained involved with STISA after the outbreak of the War.

Hurst Balmford (b.1871) Exh. RA 8
STISA: c.1927-c.1939
STISA Touring Shows: 1934.
Public Collections include Manchester.
Born in Huddersfield, Balmford studied at the Royal College of Art and at Julians, Paris. His first exhibit at the RA in 1917 was *The Jetty, Polperro* and, by the time of his next, *Boats at Anchor, St Ives*, in 1924, he seems to have been living at Meadow House, St Ives. In 1926, he exhibited on Show Day at Beach Studio and was again successful at the RA with *The Running Stream*, a work he considered one of his best. He was also known for his love of music and he played the violin and viola. Although he contributed to a number of STISA's early shows, he moved in the late 1920s to Lancashire to become Headmaster of Morecambe School of Art. Nevertheless, he still took every opportunity to visit Cornwall and took one of the Island Studios in St Ives for a time. His

[11] This was reviewed by Bernard Ninnes, *St Ives Times*, 12/1948.
[12] *St Ives Times* 19/3/1921.

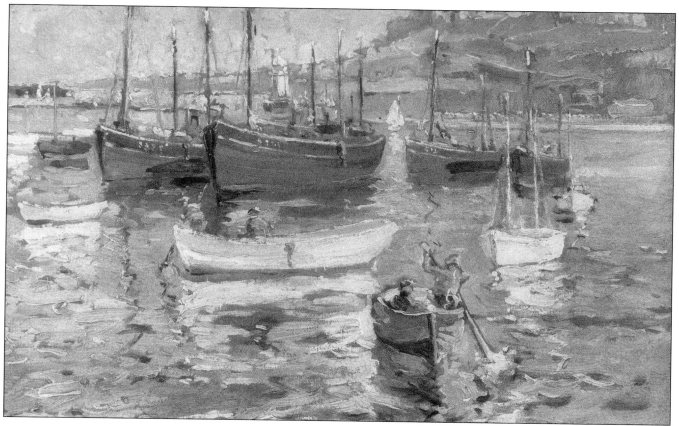

Fig. 3B-2 Hurst Balmford *St Ives Harbour*

(W.H.Lane & Son)

contribution to the 1934 Lincoln show was a Mousehole scene as was his RA exhibit of the following year and his two RA exhibits of 1937 were both Polperro scenes. He is still recorded as a member of STISA in 1938 but he was then living in Blackpool. This was the last year he exhibited at the RA and yet again the subjects were Cornish. Two oils, *Mousehole* and *Low Tide*, were acquired for the Mackelvie Collection (Auckland) in the early 1930s but have subsequently been sold off. In 1939, a large oil, *Watergate, on the Looe River*, was acquired for the permanent collection of Manchester Art Gallery.

(Miss) Helen Banning
STISA: 1945-1951
STISA Touring Shows: FoB 1951.
She first exhibited on Show Day in 1943 and her inexpensive watercolours of local scenes were included in STISA Exhibitions by 1945.

(Mrs) Garlick Barnes (1891-1987)
STISA: 1945-1949, 1957-1974
STISA Touring Shows: 1945, 1947 (SA), 1947 (W), 1949.
Public Collections include St Ives Museum.
Garlick Barnes raised four children before she could turn her full attention to art. She then studied at the Sidney Cooper School of Art, Canterbury and at Heatherley's. In 1936, she became a pupil of Walter Sickert in Thanet, Kent, exhibiting with him in Margate. She recalled how, surprisingly, Sickert did not paint much from life but used photos cut out of newspapers.[13] She moved to Cornwall at the outbreak of the War and first exhibited on Show Day in 1943. She had a one-man show at Downing's Bookshop in September 1947, about which a critic wrote, "The secret of her work is the dexterous handling of palette knife technique and a purity of pigment free from worry and overwork. The result is a happy sparkle of radiant colour." By scraping off paint while wet with little curving strokes, she gave an effect of transparency. Her work was varied in subject-matter and included portraiture but favourite scenes were the old houses of St Ives, and the cottages, barns and engine houses of the countryside, with its narrow winding lanes and stunted trees. She loved gardening and so flower paintings were also popular, some of these being delicate studies in watercolour. She was included in all the touring shows of the 1940s but she resigned with the moderns in 1949 and did not re-join STISA until 1957. The Salthouse Gallery, St Ives mounted a Retrospective Exhibition during Whistler week in 1984, when she was already well into her nineties. She lived at Karenza Cottage, Hellesvean, St Ives and worked for some time from The Loft Studio. She also wrote poetry. The St Ives Museum contains her painting of the oldest house in St Ives, in Fish Street. Her twin sons, John and Bill Barnes, were keen film-makers.

[13] *Western Morning News*, 15/5/1984.

Howard Barron ARAS (Aust.) (b.1900) Exh. RA 1

STISA: 1950-1962

STISA Touring Shows: FoB 1951.

Public Collections include Imperial War Museum, Canberra.

Born in Sidcup, Kent, he was educated at Christ's Hospital, Horsham before settling in Sydney, Australia between 1928 and 1949, where he studied under Will Ashton (q.v.). On his return to England, he studied further in 1950-1 with Robin Guthrie and Ralph Middleton Todd at the City and Guilds School. He will have heard of the St Ives art colony from both Ashton and Todd and he joined STISA in 1950, living for a while in Cornwall. His marine paintings were highly regarded and his work is in a number of Australian collections. However, by 1957, he was living in Sussex and he ceased to exhibit with STISA after 1962.

(Mrs) Dorothy Bayley

STISA: 1928-1967

STISA Touring Shows: 1932, 1936, 1947 (SA). Also FoB 1951.

Public Collections include St Ives.

Dorothy Cooke was living in Carbis Bay, when she first exhibited on Show Day in 1922, a year when she was successful at the RA with an aquatint *The Roadmaker*. This print was later exhibited under her married name, Dorothy Bayley, with STISA. She worked initially mainly in 'black and white' and was a member of the St Ives Print Society. Her prints were often hailed for their imaginative interpretations. Known as 'Dossie', she was rated by Averil Mackenzie-Grieve (q.v.), along with Percy and Marjorie Ballance, as one of the most talented young artists in the colony in the early 1920s and, in 1923, Nell Cuneo's portrait of her was entitled *A Modern Botticelli*.[14] She contributed to the first show in the Porthmeor Gallery in 1928 and her aquatints were a regular feature of the 'black and white' section. One entitled *The Coming of Saints to Cornwall on Millstones* was praised not only for its conception and design but also for its humour. She married in about 1932 and moved to Nancledra and turned more towards landscape and figure paintings, enjoying some success. Her *Trencrom* was bought by the brewery directors from the *Inland Cornwall* show at St Austell in 1946 and *Dutch Boat, Hayle* was one of the works acquired by the St Ives Town Council from the 1951 Festival of Britain show. She resigned from STISA in 1949 at the time of the split and became a member of the Penwith Society but she almost immediately rejoined STISA and remained a member for many years.

Fig. 3B-3 Dorothy Bayley *Dutch Boat, Hayle* (St Ives Town Council)

[14] A.Mackenzie-Grieve, *Time and Chance*, London, 1970 at p.38.

Fig. 3B-4 Frederick Beaumont *National Gallery - Interior*

Frederick Samuel Beaumont RI (b.1861) Exh. RA 21
STISA: 1929-c.1947
STISA Touring Shows: 1936, 1937, 1947 (W).
Public Collections include The Royal Collection.
Born in Huddersfield, Beaumont was brought up in Greenwich and educated at Camden House School in Brighton. Although winning the school drawing prize, he initially worked in a fancy goods warehouse in Brighton but continued with his drawing. A chance encounter with the painter, E. Goodwyn Lewis, who advised him he "might become as good a draughtsman as ever he pleased", persuaded him to change careers and he studied at the RA Schools from 1882-1888, winning a silver medal in life study. Portraiture was in fact going to be his principal source of income. He also studied at Julian's, Paris and spent time in museums in France, Italy and Spain studying the old masters. Later, he reflected that he wished he had spent more time in streets and cafés studying the people, their costumes and ways. After his marriage, he settled in Wimborne in Dorset, where he won commissions from leading families not only for portraits but also for house interiors. Although he used oils for his portraits, he also painted landscapes and some of his interiors in watercolours and was elected an RI in 1917. In this medium, he painted more freely and boldly than in oils. He also undertook mural decorations, and 23 decorative panels were bought by P & O.

Beaumont settled in St Ives for a period during the First World War. He was signed into the Arts Club as a guest of Alfred Hartley in February 1912 and was a member himself for some time. In 1918, he was elected on to the Lanham's Hanging Committee. He was proposed as a member of STISA by Lindner in 1929 and exhibited with the Society for the best part of 20 years, although, probably due to his advanced years, his contributions were infrequent and tended not to be singled out for special comment. His *Interior - St Paul's Cathedral* was bought by Queen Mary in 1933 and *National Gallery - Interior* (Fig.3B-4) won high praise at STISA's 1938 Summer Exhibition and was also included in the 1947 Cardiff show. He featured in the series *Artists of Note* in *The Artist* in August 1948. In his later years, he lived in Kensington.

Amelia M Bell
STISA: 1950-1976
STISA Touring Shows: FoB 1951.
A watercolourist, who enjoyed Scottish sketching holidays, she joined just after the split and remained a member for over 25 years. She lived at Tywarnhayle, Burthallon Lane, St Ives.

Joza Belohorsky
STISA: 1942-1946
STISA Touring Shows: 1945.
Belohorsky was a Czech artist, who came to St Ives as a refugee during World War II, where he was warmly welcomed by the artistic community. He was primarily a portrait painter and his exhibits included a portrait of George Manning Sanders but he also worked in pastels and did etchings, which were considered original in treatment and unique in outlook. Borlase Smart, in typical fashion, felt that art would be good therapy for the Czech soldiers stationed in St Ives and, in July 1943, he arranged for the soldiers to put on a display of art in STISA's Gallery. This was opened by Leonard Fuller.

(Mrs) Medora Heather Bent (b.1901)
STISA: 1943-1953
STISA Touring Shows: 1945, 1947 (W), 1949. Also FoB 1951.
Born in North Kilworth, Connemara, her first name was, in reality, Alannah. She was educated in England and studied at the Slade between 1930 and 1933 with Randolph Schwabe and at the Central School of Arts and Crafts, where she took in stained glass. Her work is first mentioned in a review of the Summer Exhibition at Lanham's Gallery in 1943 and she is likely to have been elected an associate member that year, as she was raised to full membership in 1944. On Show Day in 1944, she was hailed as a prolific and versatile artist. "Her war pictures are most arresting, painted symbolically, far removed from stark realism, and leave a haunting impression on the spectator's mind. Here is a poet as well as an artist possessing a fine sense of colour and rhythm".[15] On other occasions, reference is made to the dream-like quality of her works. Significant price-tags - often £100 - were placed on her paintings. In 1947, she moved to a new studio at 32, Fore Street and, in the early 1950s, she exhibited some sculptural models depicting religious scenes. She also painted furniture. In the mid-1950s, she moved to Wareham in Dorset and, in 1958, published *Paintings of Some of the Historic Homes of Purbeck*. In 1992, she wrote her autobiography.

Sven Paul Berlin (1911-1999)
STISA: 1946-1949
STISA Touring Shows: 1947 (W), 1949.
Public Collections include Tate Gallery, Victoria and Albert Museum, British Museum and the National Library of Scotland.
A colourful character, with a huge frame and a distinctive pointed beard, Berlin is revered as much for his personality and magnificent prose as he is for his sculpture and paintings. With an English mother and a Swedish father, Berlin was forced to leave school early to become apprenticed as a mechanical engineer due to his father's mounting debts. Both this apprenticeship and a spell at Beckenham School of Art were short lived and Berlin, tall and lithe, trained as an adagio dancer - a form of dance he described as "bastard ballet". He toured professionally with his partner and wife, Helga, for ten years, once supporting the Crazy Gang. When they decided to retire from dancing in 1938, they settled in Cornwall, living in a cottage on the Zennor moors, but they were often close to starvation. Sven studied under Arthur Hambly (q.v.) at Redruth School of Art, and so impressed his teacher that Hambly considered him the best and most hard-working student he had ever had. Describing this time, Berlin commented, "I learnt the shape of trees and hills, of waves and rocks and women and fields and horses. Nothing was too meagre. Ladybird, butterfly or sparrow hawk, oyster-catcher, curlew or turnstone; beetle, teacup or mouse. I went the whole round of creation doing endless drawings, making a great storehouse of them in my mind with their attendant feelings."[16]

On the outbreak of War, Berlin registered as a conscientious objector and worked for Adrian Stokes in his market garden, where he met Nicholson, Hepworth and Gabo, and saw the work of Alfred Wallis, which he described as "like hearing Beethoven for the first time".[17] He also helped in the Leach Pottery. However, in 1943, he joined the Royal Artillery and took part in the Normandy landings, before being discharged in 1945, suffering from nervous shock. His marriage had also broken down. On recovery, he rented an unoccupied building on the Island, called 'The Tower', which he turned into a sculptor's workshop. In 1946, Smart invited him to join STISA, whose sculpture section now included Hepworth, and Allan Wyon, soon to be followed by Barbara Tribe and 'Caeeinion'. Sculptural works exhibited by Berlin with STISA include *Mother and Child* (Summer 1947), *Women Singing* (bas relief - concrete) (Cardiff 1947) and *Crouching Woman* (alabaster) (Summer 1948). With help from Ben Nicholson, Berlin had his first one-man show at the Lefevre Gallery in London in 1946, and he was also a founder member of

[15] *St Ives Times*, 10/3/1944.
[16] Quoted in Catalogue to Wimborne Bookshop Exhibition, 1981, p.9.
[17] ibid, p.10. Berlin published a biography of Wallis in 1949 and this has recently been reprinted.

Fig. 3B-5 Sven Berlin by 'The Tower'

(Gilbert Adams)

the Crypt Group and exhibited in each of their three shows, although he considered the last one in 1948 to be of poor quality. He also disliked the art politics involved.

In his various accounts of the meeting at which the split occurred in 1949, Berlin emphasizes that the principal resignations that night were pre-planned by Nicholson and Hepworth, with Lanyon a willing lieutenant. Berlin resigned as well but commented, "When I came out under the cold moon, I felt the bowl of light had been broken. What tigerish act was this? What destruction of an organism that could have been resuscitated! What vandalism had been done?"[18] He joined the Penwith Society but soon

[18] S.Berlin, *The Dark Monarch*, London, 1962, p.167-8. His full account is reproduced in David Tovey, *George Fagan Bradshaw and the St Ives Society of Artists*, Tewkesbury, 2000 at p.188-9. His portrait by Leonard Fuller is also reproduced on p.189 of the same.

Fig. 3B-6 Sven Berlin *Mare and Foal* (W.H.Lane & Son)

resigned when he saw that his work was being rejected for not being abstract enough. In desperation, he entitled one drawing of ducks *Antelopes*. In 1949, he had a bitter spat with Peter Lanyon and, in 1950, he was evicted from 'The Tower' so that it could be converted into public conveniences. In 1952, his house at Cripplesease was destroyed by fire and, the following year, he bought a gypsy caravan and left for the New Forest, convinced that there was a brooding Presence in Cornwall that brought desolation, loneliness, and destruction. Living alongside the New Forest gypsies, he produced a collection of startling gypsy paintings and he continued to write highly regarded poetry and prose. His art enjoyed a resurgence in the decade before his recent death. His portrait by Leonard Fuller is included in the Exhibition (cat.no.24).

(Ms) Nina Berry
STISA: 1932-1934
STISA Touring Shows: 1934.
Nina Berry was the wife of Job Nixon and had exhibited at the NEAC before their move to Cornwall. Her watercolours were described as clever and modern in outlook and yet with qualities of expression and construction to convince the purist.[19] Due to Nixon's appointment to the Slade, her involvement was brief.

(Mrs) Emily Houghton Birch (1869-1944)
STISA: 1936-1944
STISA Touring Shows: 1936.
Houghton Vivian, the daughter of a mining agent at Camborne, was educated in Truro. Having qualified in London as a nursery nurse, she was working in Camborne, when she decided in February 1902 to ask Lamorna Birch for some painting lessons. They fell in love immediately and were married in August that year, moving to Flagstaff Cottage, their home for the rest of their lives. As their first child was born in 1904, she did not have much opportunity to develop her skills but, when time permitted, she painted landscapes and coastal scenes, principally in watercolour. She also made detailed studies of rocks and trees. Her involvement with STISA was brief.

(Miss) Joan H. Birch (1909-1993) Exh. RA 1
STISA: 1931-1934
STISA Touring Shows: 1932.
The younger daughter of Lamorna Birch, she painted landscapes and coastal scenes in oil and watercolour and was invited to join STISA in April 1931, having exhibited in the 1930 Winter Exhibition. She had her one success at the RA in 1934 with *Penberth, Cornwall*. She did not paint much after her marriage in 1934 to John Paxton-Petty and her involvement with STISA was limited. She emigrated to Australia in 1946.

[19] *St Ives Times*, 24/11/1933.

(Ms) Frances M Blair SSA SSWA (d.1954)
STISA: 1940-1954
STISA Touring Shows: 1947 (SA), 1949. Also FoB 1951.
Before her move to Cornwall, she was based in Edinburgh and had exhibited with various Societies since 1925. She contributed woodcuts and landscapes in watercolours to STISA shows. Her simple coloured woodcuts were well regarded.

(Ms) Sydney Frances Josephine Bland (b.1883)
STISA: 1950-c.1972
STISA Touring Shows: FoB 1951
Born in York, she studied at Heatherley's under Henry Massey between 1920 and 1922 and at Goldsmith's in 1922-3 with Harold Speed. She also undertook further study privately, particularly with Bernard Adams. She first exhibited with SWA in 1938, when she had a studio in the Fulham Road in London, although her exhibits were scenes from Newlyn and Polperro. By 1948, she was living in Newlyn, initially at 35, Fore Street and then at Swan's Flight in Boase Street. She painted principally in watercolour and Newlyn harbour subjects were prevalent in her output. In 1964, she moved to Ingwenia in Carbis Bay; by then in her 80s, her contributions unsurprisingly diminished.

(Miss) Alison (or Annie) Bliss-Smith
STISA: 1928-1932
STISA Touring Shows: 1932.
A wood engraver and a landscape painter in oils, her first Show Day was in 1921 and her first exhibition with STISA was the Summer show of 1928. Her contributions were, in the main, coloured woodcuts and favoured subjects were castles, bridges and old houses. A critic observed, "There is a charming softness of quality in her work and her pattern is always good".[20] She also exhibited regularly at Liverpool between 1925 and 1933 and at SWA between 1925 and 1938. A 1930 exhibit, *On the Cornish Coast*, was the sole Cornish scene. She is recorded as a member of STISA in 1932, when her address is given as in Hampstead Garden City, but she does not appear to have exhibited with STISA thereafter. Her Christian name is given as Annie on one occasion.

George A Boden (1888-1956) Exh. RA 3
STISA: 1934-1951
STISA Touring Shows: 1936, 1937, 1945, 1947 (SA). Also FoB 1951.
Public Collections include Glasgow.
Boden lived in Lincoln and studied at the Lincoln School of Art, at Colarossi's in Paris and at Antwerp. He also studied further at Camberwell School of Art and at John Hassall's Poster School at Kensington. Principally, a watercolourist, he also did linocuts and black and white work. He was first successful at the RA in 1918 and his work is first mentioned in St Ives in a review of the 1934 Winter Exhibition. His exhibit in the 1936 tour was *Egyptian Water Wheel*, his RA exhibit of 1920. In 1938, his depiction of 'The Sloop Inn' was "certainly not the Sloop as we know it in colour but an artistic impression in the general scheme of things and shall we say it is symbolical of the spot".[21] He appears not to have exhibited during the War years as, in 1946, he is described as a new contributor.

Fred Bottomley (1883-1960) Exh. RA 10
STISA: 1929-1955
STISA Touring Shows: 1932, 1934, 1936, 1937, 1945, 1947 (SA), 1947 (W), 1949. Also FoB 1951.
Public Collections include Oldham.
Bottomley was not an exceptional artist but he was a stalwart of the Society who was represented in all the touring shows. Southport appears to be his home town but he was educated at Truro High School. Although he started to attend art school at the age of 9, he did not keep it up and followed his father into the cotton business. A prosperous career was interrupted by the Great War and his three years in France gave him a completely different perspective on life. After the Armistice, he decided to follow his bent and renounce his business career for a life devoted to art. Having married and settled in Kent, he studied at the Slade from 1923-5. Expansive travel plans had to be scotched when the fortune he had earned himself and another that he had inherited from his family were lost in the slump and, after 18 months of exploring England, Bottomley and his wife arrived in St Ives in 1929. They decided to stay and lived at Salubrious House in Fore Street (see Fig.1-35), while Fred worked from Dragon Studio, Norway Square, in which he kept a table-tennis table and a darts board. He commented, "Some of those old business instincts die hard. I find myself leaving the house every morning just after 9 o'clock to go to my studio...and I certainly work longer hours now than I did in those days...I have never wanted to go back to business, although it is a much easier way of making money than painting! ...I believe it is better to be happy than rich"[22]

[20] *St Ives Times*, 21/11/1930.
[21] *St Ives Times*, 15/7/1938.
[22] *News Chronicle*, 1939, Cornish Artists 28

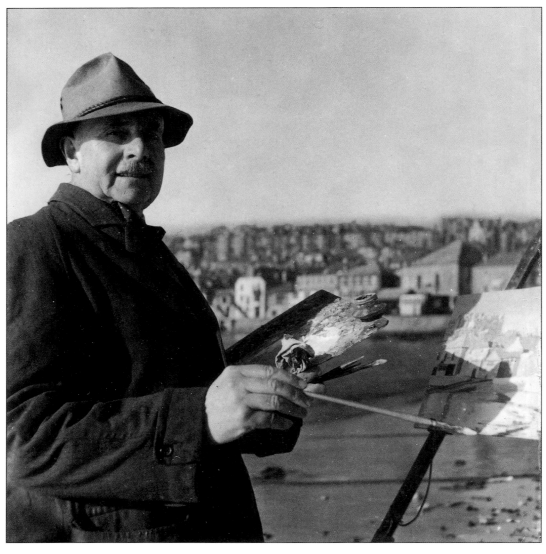

Fig. 3B-7 Fred Bottomley (Gilbert Adams)

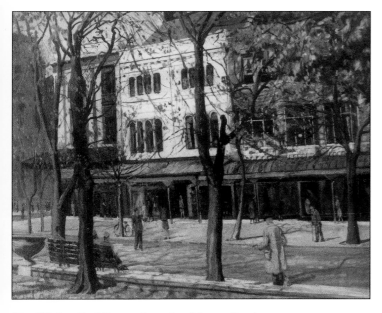

Fig. 3B-8 Fred Bottomley *Lord Street, Southport*
- one of his RA exhibits of the 1940s. (W.H.Lane & Son)

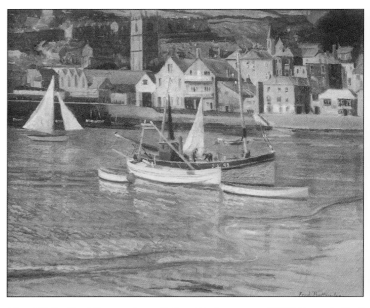

Fig. 3B-9 Fred Bottomley *St Ives Harbour* (W.H.Lane & Son)

Bottomley believed in working out of doors as much as possible - "That is one of the joys of being an artist" - and is best known for his vigorous oil paintings of the harbour and the streets of St Ives. One critic commented, "For Bottomley, dull, grey, stormy days do not exist. His many canvases, all shimmering under the summer skies, and silver seas, make happy pictures of old St Ives."[23] He was successful at the RA for the first time in 1931 and that year showed two works - a still life, *Begonia*, and *The Cut Rick*, which he considered to be one of his principal works. This, and a number of his other works, like *Bric-a-brac* and *The Slipway*, do appear in STISA shows more than once. He was particularly successful at the RA between 1938 and 1944, although for a couple of years during the war, he appears to have moved back to Southport. He was offered but declined the post of Secretary of STISA in 1933 - the year when he was also President of the Arts Club - but served on the Committee on various occasions - 1934, 1938, 1947 and in 1948/9, when he was one of the signatories requisitioning the meeting that led to the split. He was again on the Committee in 1951 but his contributions to STISA tail off and he ceased exhibiting altogether a few years before his death.[24]

(Miss) Constance H Bradshaw ROI RBA APSWA (d.1961) Exh. RA 16
STISA: 1936-1944
STISA Touring Shows: 1936, 1937.
Public Collections include Salford.
Constance Bradshaw, who was not related to George or Kathleen Bradshaw, was the third consecutive Acting President of SWA to join STISA, after Dorothea Sharp and Helen Stuart Weir. Born in Manchester, she studied at the Spenlove School of Art and first exhibited with SWA in 1899. She lived in Bickley in Kent and was elected to SWA in 1915 (associate 1912), to the RBA in 1920 and to the ROI in 1933. She was Acting-President of SWA between 1936-1939 and she may have been encouraged to join STISA by Sharp or Stuart Weir as, although her exhibits with SWA and RBA indicate that she was a regular visitor to Cornwall, only a 1924 work, *Hazy Morning*, is actually a St Ives scene. Bradshaw's early exhibits at the RA - the first was in 1928 - were still lifes but she became primarily a landscape painter in oils. A series of Welsh landscapes included in the 1944 Summer Exhibition at Lanham's were hailed as "outstanding in their vivid colouring, brilliant technique and strong feeling for patterned design".[25] Farm scenes are very prevalent in her work and Salford Art Gallery have *A Sussex Farm* (Fig. 3B-10), acquired in 1940. In 1945, she had four works hung at the RA but that was the last year she was successful there and she does not appear to have contributed to any STISA shows that year or subsequently, although a number of works were included in Lanham's Exhibitions as late as 1950 and Cornish scenes feature in her SWA exhibits up until her death. She exhibited a total of 170 works at the SWA.

(Mrs) Kathleen Marion Bradshaw (1904-1997) Exh. RA 1
STISA 1927-1959
STISA Touring Shows: 1932, 1934, 1936, 1945, 1947 (SA), 1947 (W), 1949. Also FoB 1951.
Kathleen Slatter was the daughter of a well-known big game hunter and was born and brought up in Rhodesia. On the death of her father in the Great War, she was sent to England under the guardianship of a great aunt, Lady Couchman, who lived in Gloucestershire, and she finished her schooling at Cheltenham Ladies College. Although she wanted to attend the Slade, she was sent to study at the Simpson School of Painting in St Ives and it was there that she met George Bradshaw. Despite the seventeen year age gap, they married in 1922 and lived in Ship Studio. She specialised in still life but worked in all media and her work was often praised for originality and variety. The use of mirrored framing was one innovation that attracted attention. She was one of the female artists that were the stalwarts of the still life section of STISA and she contributed to every major show of the Society. Her painting *Marigolds and Others*, which was hung at the RA in 1929, was one of a group of powerful flower studies that she had exhibited on Show Day that year, which were praised for being "fearless in style and glowing in directly painted tints". She also designed and made lampshades that she sold in London and exhibited at craft exhibitions in Newlyn.

In 1936, she gave birth to her first child, Robert, and found that, provided he was asleep, he provided an enchanting subject. A second child, Anne, was born while they were based in Sunderland during the War and Kathleen found it increasingly difficult to find time for painting. However, when she took the children out walking, she would usually manage to make a few notes in her sketch book and work these up into paintings at home. As Bradshaw's wife, she was intimately involved with catering requirements at private views, openings and lectures and, in 1951, she was elected on to the Committee in her own right for the first time and remained on the Committee for much of the 1950s. After Bradshaw's death in 1960, she remarried and gave up painting until shortly before her death. Without exception, she is remembered as a delightful, vivacious personality. Her portrait was painted by Charles Simpson, Ellen Fradgley and Pauline Hewitt and Borlase Smart did a drawing of her at one of the Arts Balls.[26]

[23] *St Ives Times*, 14/12/1945.

[24] At one juncture, I thought Bottomley may have moved away but a painting of St Ives harbour dated 1959 was sold at W H Lane and Sons, Penzance on 30/4/1992, Lot 264.

[25] *St Ives Times*, 4/8/1944.

[26] Two portraits are illustrated in David Tovey, *George Fagan Bradshaw and the St Ives Society of Artists*, Tewkesbury, 2000 - the Simpson on p.44 and the Hewitt as Plate 25 - between pp.144/5.

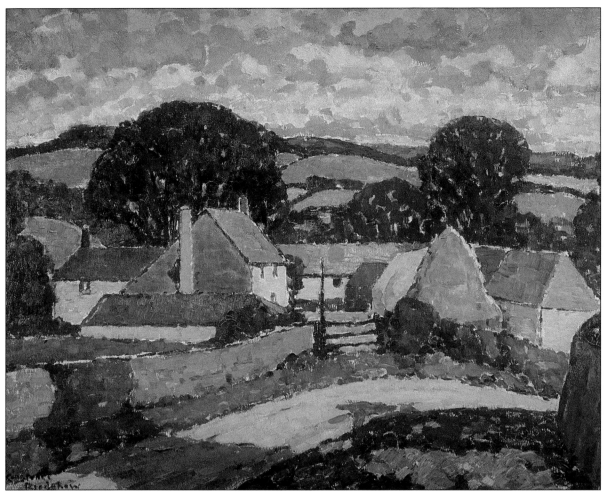

Fig. 3B-10 Constance Bradshaw *A Sussex Farm* (Salford Art Gallery)

Charles Breaker (1906-1985)
STISA: 1948-1980
STISA Touring Shows: 1949. Also FoB 1951.
In the catalogue to his Memorial Exhibition in 1986, Frank Ruhrmund observed, "It is impossible to think of the artist Charles Breaker without thinking of colour. His paintings worked in clean clear colour, "a touch of Matisse", his colourful knitwear which he designed and made, his cottage and its garden, "a pretty Burmese jungle", filled with flowers and a riot of colour - he was a colourful character and the streets of Penzance will seem drab without him."[27] Born in Bowness-on-Windermere, Westmorland, he worked initially with his father as a boatbuilder and then in the 1930s, he travelled extensively with his lifelong friend, Eric Hiller (q.v.), living in Majorca and then at Pont Aven in Brittany. During the War, he worked for Vickers Armstrong in the drawing office. In 1945, Breaker and Hiller came down from Yorkshire for a short holiday in Cornwall and stayed at Mousehole where they lodged with Mary Sampson and met Marjorie Mort (q.v.). They became friends and, in 1947, Hiller bought Gernick Field House and Studio.[28] In 1949, the three of them formed the famous Newlyn Holiday Sketching Group, which they ran together each summer for fifteen years. "Cooking, catering and coaching. I've always loved doing things with my hands. If I wasn't an artist, I'd like to have been a gardener or a chef perhaps."[29] Breaker first exhibited with STISA in the 1948 Summer Exhibition and his strong and vigorous watercolours immediately attracted attention. He was to be a mainstay of the Society for over 30 years. After Hiller's death in 1965, Breaker continued taking pupils at Gernick Field Studio for a while before moving to New Street in Penzance. In addition to his commitment to STISA, he was also Chairman of the Newlyn Society of Artists. In 1966, he was the subject of a film, *Landscape in Oils*, which showed him at work in the old harbour at Newlyn, "catching in close up its ropes and rusting chains, its green weed and golden lichen".[30] He continued painting out of doors and just before his death commented, "I've never made any money, always worked wherever I went, but I've always had an eventful life. Certainly done more than many, seen more than most, and I've no complaints at all."[31]

[27] From Introduction to the Charles Breaker Memorial Exhibition at Newlyn Art Gallery 1986.
[28] *The Studio* is now used by Sir Terry Frost.
[29] Ruhrmund, op cit.
[30] Ruhrmund, op cit.
[31] Ruhrmund, op cit.

(Ms) M Hilda Brown
STISA: c.1937-1938
Nothing much is known about Hilda Brown, who was principally a still life painter. She is first recorded as exhibiting in 1896 and she showed at an RCPS exhibition in 1902. She was successful at the RA in 1912, when she was living in Teignmouth. Her work is not mentioned in reviews of STISA exhibitions but she is listed in the catalogue to the 1937 Winter show and was a member in 1938.

(Mrs) Annie Bryant (b.1874)
STISA: 1930-1938
STISA Touring Shows: 1934,1937.
Although also of Australian origin, Annie Bryant was not the wife of Charles Bryant (q.v.) but of the Reverend Reginald Bryant and was best known as the Chairman of Exeter Art Society. Born Annie Smith in Port Adelaide in 1874, she studied at the Adelaide School of Design under H.P.Gill. She was a landscape and flower painter in oils who enjoyed success at the Paris Salon and she exhibited in St Ives on Show Day in 1922 and 1924.[32] She was offered associate membership of STISA in 1930 and exhibited first at the Winter Exhibition that year. During the 1930s, she offered Summer Sketching holidays based at her home, The Rectory, Clyst St Lawrence, near Exeter. She was still a member in 1938 but does not appear to have exhibited consequently.

Charles David James Bryant ROI RBA (1883-1937) Exh. RA 15
STISA: 1932-1937
STISA Touring Shows: 1934, 1936.
Public Collections include QMDH, Sydney, Victoria, Imperial War Museum and Australian War Museum.
Bryant was one of a group of Australian students who studied under Julius Olsson and went on to become highly acclaimed marine artists. Born in New South Wales, he was educated in Sydney. He started work as a bank clerk, but studied art under W.Lister. He exhibited at the Royal Art Society of New South Wales before coming over to England in 1908. He studied further at the John Hassall School of Art and was to become a long-term member of the London Sketch Club (President 1933). However, his talent as a marine artist was developed under Julius Olsson in St Ives and he first exhibited on Show Day in 1911. He was successful at the RA for the first time in 1913 and that year his painting *Morning Mists* won a Mention Honorable at the Paris Salon. He was the official artist to the Australian Imperial Forces on the Western Front in 1917 and, in 1923, was the official artist to the Commonwealth Government when visiting New Guinea. However, he returned to St Ives for visits from time to time and, in 1923, he exhibited at the ROI *The Harbour, St Ives*. He appears to have been persuaded to join STISA when he visited St Ives again in 1932 and he contributed to a number of shows prior to his untimely death, including the London show at Barbizon House. His RA exhibits in 1933, 1935 and 1936 were all St Ives scenes (see also Plate 80). His exhibits with STISA included *Yacht Race, Sydney Harbour* and this was also the setting for a major commission to paint the American Fleet, for presentation to Washington. He also became Vice-President of the Royal Art Society of New South Wales, and the National Gallery of New South Wales own *Low Tide at St Ives*.

(Mrs) Emma Bunt Exh. RA 1
STISA: 1932-1954
STISA Touring Shows: 1947 (SA). Also FoB 1951.
A resident of Falmouth, her one success at the RA was in 1913 and she exhibited with RCPS in 1920 and with the Cornish Artists at the annual Exhibition at Harris and Sons, Plymouth in 1923. A flower painter in watercolours, she was included in the 1930 Spring Exhibition but it was not until February 1932 that she was proposed as a member by Francis Roskruge. However, her work is rarely mentioned, although it was selected for the South African tour. By this juncture, she was living in Newquay.

Arthur James Weatherall Burgess RI ROI RBC (1879-1957) Exh. RA 57
STISA: 1931-1949
STISA Touring Shows: 1932, 1934, 1936, 1937, 1947 (SA), 1947 (W), 1949.
Public Collections include Imperial War Museum, QMDH, Birkenhead, SMA, Lincoln, Derby and Sydney.
Rated by the Editor of *The Artist* in 1942 as "one of our finest marine painters - if not *the* finest", Burgess was one of the Australian contingent that had first been attracted to St Ives by the Olsson School of Painting.[33] His father was an officer in the Australian Navy and a keen and able artist and so he was encouraged to draw from an early age. He attended schools in New South Wales and Tasmania and trained for three years in an architect's office but he spent all his leisure hours sketching ships in Sydney harbour. This was the time when steamships were displacing the great windjammers in the wool and grain trade. Just after his 21st birthday, he emigrated to England. He is signed in to St Ives Arts Club as a guest of Olsson in November 1901 and fellow students would have included his compatriots William Ashton (q.v.) and Richard Hayley Lever. He had his first work hung at the RA in 1904

[32] A Mrs G. A. Bryant exhibited as an amateur at RCPS in 1920.
[33] *The Artist*, February 1942.

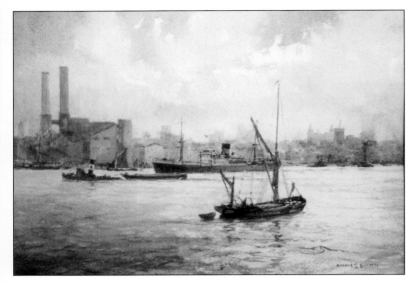

Fig. 3B-11 Arthur Burgess *On the Thames* (Private Collection)

Fig. 3B-12 Arthur Burgess *Romance of the River* (RA 1939)

and his marine illustrations were in demand with the *Illustrated London News, The Graphic* and other leading periodicals. He developed a reputation as a naval artist and exhibited large canvases of the Fleet. He returned to St Ives several times before the Great War, being signed into the Arts Club in both January 1912 and November 1914. During the War, he became Official Naval Artist for the Australian Government and several of his works depicting the first Australian fleet are now in Australian Galleries. Between 1922-1930, he was art editor and principal artist for *Brassey's Naval and Shipping Annual*.

In a series of articles for *The Artist*, Burgess observed that the main problem facing the marine artist was that his 'models' were in constant movement. Observation and memory were, therefore, of utmost importance and the artist must anticipate, indeed, must look for the recurrence of forms, shapes and patterns. He must also study the manner in which the different craft move through the water. Burgess himself would sketch craft from half a dozen different angles for use in several compositions and would do small watercolour sketches to record sky and water effects. With these pencil notes and colour impressions, he could subsequently produce a large picture in oils. A keen sailor himself, he had experienced his sketch book being soaked by sea water as he was washed down the alley-way of a coaster on a rough day. On another occasion, he recalled hanging on to to his palette in a howling north-east wind with frozen fingers. Hours spent at sea and days spent sketching in dockyards around the country provided him with the knowledge to compliment his technical skill as an artist. Sailors, shipbuilders and shipowners were his principal clients and he was rarely found wanting.

Burgess was one of the first of the ex-students from the Olsson School to join STISA and, although he does not seem to have painted any Cornish scenes during his time with STISA, he did visit old friends on occasion. In February 1932, his wife and himself were present to adjudicate at the first of the annual Fancy Dress Dances that became such a feature of the calendar in the colony. Burgess was successful at the RA most years during his membership of STISA and his exhibits with STISA included *The Stillness of the Fjord* (RA 1930) and *The Pilots of Port Jackson* (RA 1934) but it was a work entitled *The Restless Deep*, which was included in the 1936 tour, which won the highest praise.

During the Second World War, he was commissioned by various shipowners to paint pictures of merchant ships and convoys in ports all over the country. Having made rough sketches on the spot, he retired to his studio at Ludlow to complete the finished pictures, as his studio in London was hit in the Blitz. In March 1942, he was featured in the *Artists of Note* series in *The Artist*. Burgess was one of the non-resident artists who ceased to exhibit with STISA after the split.

(Mrs) Muriel Burgess Exh. RA 3
STISA: 1934-1936
STISA Touring Shows: 1934, 1936.
The wife of Arthur Burgess, she had three RA exhibits during the First World War. However, she was only briefly involved with STISA in the mid-thirties. It is not certain whether she is the same M.Burgess who attended the Forbes School of Painting in 1936/7.

80. Charles Bryant *Beached Boats, St Ives* (Honiton Galleries)

81. Frank Jameson *Fishing Boat SS122 setting out from St Ives harbour 1948* (W.H.Lane & Son)

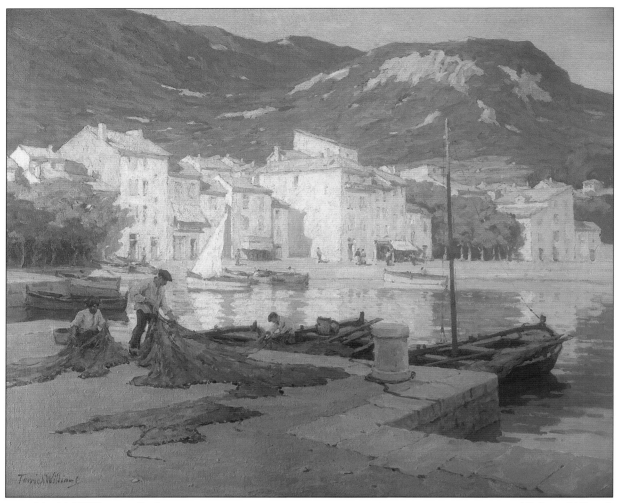

82. Terrick Williams *Cassis* (Gallery Oldham)

83. Terrick Williams *Concarneau* (Mackelvie Trust Collection, Auckland Art Gallery Toi o Tomaki)

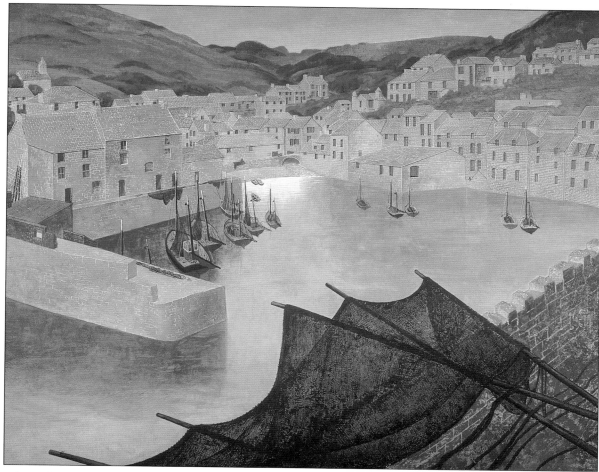

84. Jack Coburn-Witherop *Polperro* (Salford Museum and Art Gallery)

85. Eleanor Hughes *The Fortified Bridge, Sauveterre de Béarn*
(Private Collection)

86. Eleanor Hughes *Sauveterre de Béarn* (Gallery Oldham)

87. Laura Knight *Newlyn Old Harbour* (Gallery Oldham, © Estate of Laura Knight)

88. Lamorna Birch *A Highland Burn, Springtime* (Gallery Oldham)

(Miss) Winifred Burne (b.1877)
STISA: 1927-c.1929
The daughter of an actuary, Winifred Burne was born in Birkenhead and was trained at Birkenhead School of Art, at Liverpool School of Architecture and at Munich Kunstlerinnen Verein and also studied applied art under Hermann Groeber at Munich. She first exhibited in 1899 and appears to have moved to Carbis Bay in 1914 but her work is not mentioned in the *St Ives Times* until 1920. She exhibited with the Cornish Artists at the annual Exhibition at Harris and Sons, Plymouth in 1923. In addition to painting in oils and watercolours, she also produced lithographs and block prints. In 1925, her *Study of Boats* exhibited at Liverpool and *Stiff Breeze at Carthew Point* and *Summer Heat* exhibited at Derby won high praise in *La Revue Moderne*:-

"Miss Winifred Burne est une moderne. Elle a trop d'enthousiasme et de vibrant lyrisme pour se plier volontiers a la discipline sévére de la tradition classique. Mais, d'autre part, elle sait aussi la valeur des formules scolaires et des enseignements du passé, et, si elle se cherche en un libre épanouissement de sa personnalité, ce n'est ni sans réflexion ni sans measure. Autremont dit, son modernisme est sage et pondéré; c'est celui d'un peintre consciencieux et savant, honnete et expérimenté."[34]

In February 1927, an extract from an article she had written for the periodical *Drawing and Design* was published in the *St Ives Times* in which she criticised the way that exhibitions were hung. "The best places for the best persons" seemed to be the axiom with hanging committees, without regard to the tones and values of the works exhibited.[35] Despite being a founder member of STISA, she seems to have exhibited with the Society only occasionally and, although listed in *Who's Who in Art* in 1934 as still living at 'Sunset', Porthmeor (see Roskruge's map - Fig. 1-3), her last Show Day exhibits were in 1929 and she was no longer a member of STISA in 1932.

(Miss) Irene Burton SWA Exh. RA 1
STISA: 1936-1971
STISA Touring Shows: 1936, 1937, 1947 (SA), 1947 (W), 1949. Also FoB 1951.
Although a resident of Leamington Spa, Irene Burton was a stalwart of the Society for over 30 years. Her speciality was flower paintings in oils and her only success at the RA was in 1934, just before she joined STISA. Her work was selected for many of the touring shows and she was a member of SWA between 1951-57 (associate 1950). She was made an honorary member of STISA in 1967.

(Miss) Alice Caroline Butler RMA (1909-1995) Exh. RA 1
STISA: 1950-1995
STISA Touring Shows: FoB 1951.
After the death of Mabel Douglas, Butler and Mrs Staniland Roberts SWA continued the miniaturist tradition within the Society. Born in Bromley in Kent, Alice Butler studied at St Albans School of Art. Her one success at the RA was in 1933, when she was living in Malmesbury, where she ran a studio-shop. On moving to Perranporth, she joined STISA and her landscape and flower pictures were considered to be masterpieces of the miniaturist's art - delicate, precise and charming. Staniland Roberts, who joined in 1953, concentrated more on portraiture. In 1955, she illustrated *Friendly Retreat*, the story of the Parish of St Agnes, written by her husband, Maurice H.Bizley, whom she had married in 1938.

(Miss) Eleanor Charlesworth SWA (1891-c.1974) Exh. RA 7
STISA: 1932-c.1947
STISA Touring Shows: 1932, 1934. 1936,1937, 1947 (SA), 1947 (W).
The Charlesworth family were related to Augusta Lindner and were good patrons of Moffat Lindner's work. Eleanor studied at the Slade and lived in Holland Park and had private means. It is not known whether she ever studied in St Ives or whether her Lindner connection was enough to get her elected to membership. However, she did exhibit on Show Day in 1933 at Helen Stuart Weir's studio. She specialised in still life studies and exhibited at a wide range of venues including the RA, RI, ROI, SMA and SWA. She was a close friend of fellow member, Arthur Burgess, and she often accompanied Burgess and his wife on holidays. Austria was clearly a favourite destination as the Alps also feature strongly in her exhibits. She was successful at the RA between 1930 and 1947 - i.e. throughout her membership of STISA - and her 1943 exhibit *Syringa* was included in the 1947 Cardiff show. A portrait of her by William Lee Hankey was exhibited at the RA in 1932. She was made an associate member of SWA in 1940 and was a full member of that Society between 1948 and 1974, exhibiting a total of 94 works, but she does not appear to have exhibited with STISA after 1947. A 1951 exhibit with RSMA is entitled *Spring Tide, St Ives*.

[34] Reproduced in *St Ives Times*, 24/4/1925.
[35] *St Ives Times*, 4/2/1927.

Richard Chatterton
STISA: 1937-1938
STISA Touring Shows: 1937.
Described as a newcomer in the review of Show Day in 1937, his work was warmly received with his *Interior of the Artist's Studio*, with its glimpse of Smeaton's Pier through the window, being described as a "versatile performance" and "one of the best interiors seen in St Ives in years". His stay, however, was brief.[36]

Arthur Arderne Souter Clarence (c.1880-1966) Exh. RA 6
STISA: 1936-1945
STISA Touring Shows: 1936, 1945.
Arderne Clarence was born in Zululand but his father abandoned his mother and her four children at an early age and they returned to England. He was educated at Rugby School and studied art in Paris and under Frank Brangwyn, with whom he became great friends. It is possibly through Brangwyn that he established links with St Ives. His art education was enhanced by a 'Grand Tour' and he developed a love of travel. Between 1908 and 1912, he exhibited at the RA various eastern scenes, although he appears then to have been based in Kensington. Being an excellent shot, he became a 'sharp shooter' in France during the Great War. After the War, he married and settled in Sandbanks in Dorset. He painted in all media but was particularly known for his etchings, his watercolours and his portraits. He joined STISA in 1936 and his exhibits were principally watercolours. These reflected his travel lust, as foreign subjects in countries such as Germany, Spain, France and India predominated. Some "slightly painted watercolours" were considered among the best drawings in the 1939 Summer show. He remarried in 1938 and moved to Salisbury, where he developed a passion for rare birds. His step-grand-daughter, Nicola Tilley, is currently a member of STISA.

(Mrs) Averil Salmond le Gros Clark
See (Ms) Averil Salmond Mackenzie-Grieve

Fig. 3C-1 Arderne Clarence *Valerie Feeding the Geese*
Valerie was the artist's second wife (Nicola Tilley)

Charles David Cobb PRSMA ROI
STISA: 1951-1953
STISA Touring Shows: FoB 1951.
Public Collections include Government Art Collection and RSMA.
David Cobb was the third member of STISA to become President of RSMA, although, in his case, his involvement with STISA was brief. Cobb was born in Bromley and educated at Nautical College, Pangbourne. At some juncture, he studied under Borlase Smart. A great lover of the sea, he lived on his yacht, *White Heather*, which was normally based at Brockenhurst in Hampshire. Cobb was clearly known to George Bradshaw as, in 1948, Bradshaw exhibited at SMA a work entitled *Bringing In 'White Heather'*. Cobb, however, did not base himself and his yacht in Newlyn Harbour until 1950. He joined STISA in 1951 and exhibited well-regarded marine scenes during his stay in Newlyn. He married the painter Jean Main and became Vice-President of RSMA in 1973 and was President from 1978-1983.

Alfred Cochrane (d.1947)
STISA: 1927-1947, Secretary 1928-1933
STISA Touring Shows: 1932, 1934, 1937, 1947 (SA).
Cochrane's art is not mentioned prior to the meetings leading to the formation of STISA in January 1927 but he was elected a founder member and exhibited on Show Day that year for the first time. He agreed to assume the important but arduous role of Secretary of STISA in 1928. No-one at the AGM had volunteered for the post and Shearer Armstrong, elected in her absence, turned it down. Cochrane, a genial man, proved well-suited to the job, being very conscientious and thorough whilst possessing natural tact. He resigned as Secretary in 1933 through ill health but he continued to exhibit with STISA. As an artist, he specialised in landscapes, detailed interiors and delicate and refined still life paintings. His interiors, in particular, were well-regarded and his works *Ploughing at St Ives* and *Herrings, St Ives* were highly praised in 1939 and 1940 respectively.

[36] *A painting St Ives Harbour from my living room window* was sold at W H Lane & Sons on 27/3/1990, Lot 507.

(Mrs) Taka Cochrane
STISA: 1931-1951
STISA Touring Shows: 1932, 1936. Also FoB 1951.
The wife of Alfred Cochrane, she first exhibited with STISA in the 1930 Spring Exhibition, when her work *Camellias* was praised for reflecting "the qualities of the best Japanese art".[37] She specialised in still life in watercolour and was elected as a full member in April 1931. She and her husband lived at Parc-an-Carne, Carthew, St Ives.

Sir Francis Ferdinand Maurice Cook, Bart FRSA, CAS, JSA (b.1907) Exh. RA 2
STISA: 1940-1947 & 1961-1972
STISA Touring Shows: 1947 (W).
Francis Cook studied under Harold Speed from 1926-1932, under Arnesby Brown from 1932-1934 and under Lamorna Birch in 1935-1936. He had his first success at the RA in 1936 and was made an associate of the RBA in 1938. He came into his title in 1939 and moved to Porthallow Old House, Talland Bay, Looe in 1940, where he stayed for four years. He was described as a new associate member in the review of the 1940 Spring Exhibition, which featured his work *Cornish Studio - Winter Sunshine*, praised for its extraordinary richness of light. This work was also included in the 1947 Cardiff Exhibition and he does not appear to have been greatly involved during his initial period of membership but he re-joined in 1961, when he was living in Jersey, and remained a member for over a decade. Flower paintings were a speciality.

Frederick T W Cook RWA Exh. RA 11
STISA: 1952-beyond 1983
Public Collections include Imperial War Museum, Plymouth and RWA.
Born in London, he studied at Hampstead School of Art and, from an early age, spent every holiday in the West Country painting. During the War, he was an official fireman-artist. His war paintings were widely published and the Imperial War Museum hold nine works executed in oils (see Fig. 1-16). In the late 1940s, he settled in Polperro, where his studio overhung the harbour. He was fascinated by the interlacing curves of cottages, boats, gulls and draped nets and felt that gouache, used loosely, was "the complete medium to portray the pulsating atmosphere in the starkest of moorland landscapes".[38] He joined STISA right at the end of the period covered by the Exhibition but was a stalwart member for many years. He served on the Council from 1965 well into the 1980s.

(Miss) Dorothy Cooke - see under (Mrs) Dorothy Bayley

Percy Robert Craft RBC RCA (1856-1934) Exh. RA 38
STISA: 1934
STISA Touring Shows: 1934.
Public Collections include Penzance, St Ives and Port Elizabeth.
Craft was one of the original Newlyn School artists to join STISA but his involvement was brief. Born in London, he was educated privately and studied art at Heatherley's and the Slade (under Poynter and Legros), where he was a gold and silver medallist. He came to Newlyn in 1885 and his best known works are *Heva! Heva*! (1889), which was painted mostly in St Ives, and *Tucking A School of Pilchards off the Cornish Coast* (1897). After leaving Cornwall in the late 1890s, Craft was for over 20 years the organising secretary of the RBC, of which he had been elected a member in 1888, and was also involved with the organisation of the Imperial Arts League. Having been persuaded to join STISA, most probably by Lindner, a neighbour in Bedford Gardens, his contributions to the 1934 tour were *The Elder Sister* and *Harvest* but unfortunately he died later that year.

(Ms) Gertrude Crompton (b.1874)
STISA: 1946-1952
STISA Touring Shows: FoB 1951
Born in West Tanfield in Yorkshire, she was educated in London and studied at the Westminster School of Art under William Mouat Loudan and then in Paris. She first exhibited with SWA in 1897, when she was living in Kensington Court, and exhibited ten watercolours there between then and 1901. A number of these were harbour scenes. She also exhibited at the Goupil Gallery and was successful at the Paris Salon. She is recorded as having become a teacher of art but it is not certain where she did this or when she came to Cornwall. However, whilst living in Cornwall, she became a JP. She is described as a newcomer at the 1946 Autumn show held in the Crypt but she was already 72 at this time. Her infrequent exhibits with the Society included coastal scenes and still lifes, but, in 1952, she moved to Nailsworth in Gloucestershire.

[37] *St Ives Times*, 18/4/1930.
[38] Notes on Contributors, Cornish Review.

Cuthbert Crossley (1883-1960) Exh. RA 6
STISA: 1949-1960
STISA Touring Shows: FoB 1951.
Public Collections include Halifax, Leeds and Newcastle.
Crossley was a painter, printmaker and designer, notable for landscapes and architectural subjects, who retired to St Ives after World War II. Born in Halifax, he studied advanced applied design at Halifax School of Art, winning a King's Prize. Around 1907, he was a founder member of the Halifax Arts and Crafts Society. After the Great War, he had a spell as a carpet designer before becoming a full time artist in the early 1920s. In 1928, he did a series of etchings of Halifax and, in 1933, he illustrated T.W.Hanson's *Old Inns of Halifax*. He exhibited with a wide range of Societies and was successful at the Paris Salon. His work is first mentioned at the 1949 Spring Exhibition and he lived at Norland, Parc Bean, St Ives. His exhibits with STISA included inexpensive watercolours of different parts of the country and some still lifes in oils. A memorial Exhibition was held in Halifax in 1962 and another retrospective was held there in 1973.

(Mrs) Nell Marion (Tenison) Cuneo SWA (1867-1953) Exh. RA 11
STISA: 1928-c.1945
STISA Touring Shows: 1934, 1937, 1945.
The widow of the book illustrator, Cyrus Cuneo, and mother of the well-known artist, Terence Cuneo, Nell Cuneo was an artist of substance in her own right but, due to the nomadic urge that affected her after her husband's early and tragic death in 1916, she flits in and out of the STISA story. The daughter of Edward Ryan Tenison, a doctor who had been a naval surgeon, she was born in London and, with no support from her family, she studied at Cope's School before launching forth as an illustrator. She managed to save enough to fund herself through further training in Paris at Colarossi's Academy, where she won a medal for drawing, and at the Whistler School. There she met the Italian American, Cyrus Cuneo, and they married in 1903 and both worked as illustrators in London, Nell contributing to a variety of periodicals, such as *Madam*, *Sphere* and *Ladies Pictorial*. She was first successful at the RA in 1912 under her maiden name but the following year exhibited a portrait of her young son, *Terry*, under her married name. As an artist, she specialised in portraits and figure paintings. Following her husband's death from blood poisoning, she moved to Dartmoor and then to Cornwall, living first in Halsetown and then in St Ives. She bought Down-along House, which she restored and which became the famous *The Copper Kettle*. She first features on Show Day in 1922 and, in 1923, she exhibited on Show Day three portraits of fellow St Ives artists - Pauline Hewitt (q.v.), Dorothy Cooke (q.v.) and Mrs Alexander. She was included in the 1925 Cheltenham show and joined STISA shortly after its formation, being actively involved on Hanging Committees, Ladies Committees etc. Her figure paintings such as *Green Earrings*, *The Fortune* (depicting a figure in ballet dress telling fortunes by cards) and *The Mirror* (showing a girl deep in thought, reflected in a mirror) were highly regarded in the early STISA exhibitions and her portraits were praised for their fine colour schemes and interesting arrangements. However, she retained property in Bedford Park and, after 1930, she visited St Ives less often and her contributions to STISA exhibitions became irregular. However, a London show in 1933 included her portrait of Eleanor Hughes (q.v.). She was a member of SWA between 1917 and 1952.

Terence Tenison Cuneo (1907-1996) Exh. RA 3
STISA: Exh.1928-1939
Public Collections include the Royal Collection, Imperial War Museum, National Railway Museum (York), Cardiff, Hull, World Health Organisation and Corporation of Johannesburg.
Now hailed as the greatest railway painter of the twentieth century and known for his paintings of historic groups, battles and parades, in particular his depiction of the Coronation of H.M. the Queen in 1953, Terence Cuneo was, for much of the period when he was involved with STISA, a struggling illustrator. Not unnaturally given that both his parents were artists, he showed artistic talent at an early age. After some unhappy experiences at a variety of schools, he was advised in 1924 to train at Chelsea Polytechnic under Percy Jowett, who later expressed amazement at the quality of his 1949 RA exhibit, *The Underwriting Room at Lloyds*, as he had considered him one of the most unpromising students he had ever had.

Cuneo enjoyed his time in Cornwall. "St Ives in the early twenties", he commented, "was a truly wonderful place in which to live. It was eminently picturesque, full of character, and had a remarkable artists' colony, unselfconscious and brimming with artistic and theatrical talent."[39] His work is first mentioned when he exhibited some lino-cuts on Show Day 1925. He had always hankered after following in his parents' footsteps as an illustrator and he considered lino-cuts were valuable for the bold expression of simple lines and masses. "To me, Cyrus Cuneo was the greatest man of his day in this field and his work had an enormous influence on my whole approach to drawing and painting."[40] However, he considered the illustration class at Chelsea to be a waste of time as "its teaching was antiquated, misleading and utterly divorced from commercial realities", and so, in 1927, he ceased his studies and put together a folio of specimen illustrations with a view to trying to win some commissions from periodicals. He

[39] T.Cuneo, *The Mouse and His Master*, London, 1978, at p.16.
[40] ibid, p.19.

contributed some 'black and white' work to the first show in the Porthmeor Gallery in 1928 and he continued to exhibit some drawings and etchings with the Society each year, although he was now based in London. However, he was not elected a member for some time. After his first success with the children's magazine, *Chums*, he gradually expanded his range to include *Boy's Own*, *The Magnet, Christian Herald* and *Wide World Magazine*. The latter, in particular, presented a wide diversity of challenges. In 1931, he joined the London Sketch Club, where he was impressed by the work (and camaraderie) of future STISA members, Harry Rountree, Thomas Heath Robinson and Salomon Van Abbé. By 1938, he himself was a member of STISA and, in that year he exhibited *An Incident from Treasure Island* and *The Press Gang*, the latter being one of the specimen illustrations included in his autobiography. By this time, he was also writing and illustrating his own stories. During the war, he eventually managed to use his artistic talents in the war effort and his paintings of the Churchill tank production at the Luton works indirectly led to commissions for his first railway poster for LNER, the magnificent, *Giants Refreshed*, and for the Lloyds painting. The painting of the Coronation in 1953 confirmed his meteoric rise in the years after the war and he was never to look back. With commissions from royalty and industry flooding in, there was no need for such additional exposure as STISA could offer him and he ceased to exhibit.

Shallett Dale
STISA: 1929-c.1934
STISA Touring Shows: 1932.
A landscape painter in oils, his first Show Day was in 1926, but he was clearly living in St Ives before this, as his portrait by Arthur Meade was featured on Show Day in 1921. He did not exhibit with STISA until 1929 and his studio, close to the old lifeboat station, is featured in Roskruge's Map of the Studios for Show Day that year (see Fig. 1-3). His work is last mentioned in the 1934 Winter Exhibition.

Alexander C Dalzell Exh. RA 5
STISA: 1936-1938
STISA Touring Shows: 1936, 1937.
He was first successful at the RA in 1935, the year before he joined STISA, when he was living in Warwick Square in London, and he had three works hung in 1936, two of which were African scenes. A landscape painter, his work was described as modern, virile and vibrant with light and his *Farm at Zennor* was considered one of the highlights of the 1936 Autumn show. By 1938, he was living in Bexley, Kent but he was hospitalised shortly thereafter.

(Mrs) Kathleen Georgiana Maclellan Day (1867-1953)
STISA: 1927-1953
Widow of the artist, William Cave Day, she was a founder member of the Society and lived at Wheal Venture, Trelyon, St Ives before moving to Lynwood, Carbis Bay. Born in Whitby, she moved with her husband to St Ives in 1918. She specialised in studies of animals and flowers. A popular figure in the Arts Club and the town, she had been confined to her home for some years prior to her death.[41]

(Mrs) Olive Dexter Exh. RA 1
STISA: 1946-1949
STISA Touring Shows: 1949.
The daughter of Leonard Richmond, her work is first mentioned in a review of the Winter Exhibition at Lanham's in November 1944. Richmond himself did not settle in St Ives until 1946 and she may therefore have come to study under Fuller. She was very active in the campaign to save the Porthmeor Studios from redevelopment. She specialised in still life in oils and her approach can be gauged from two articles on *Still Life Painting* that she wrote for *The Artist* in the early 1950s. She was an ardent fan of Chardin and considered that the planning of colour masses was the vital key to a finished picture. Colour - she considered - could arouse the deepest thoughts and emotions and it was vital for the artist to show what he felt emotionally in the realm of colour and design, rather than merely paint an arrangement of objects without artistic expression. Her one success at the RA was in 1949 with a picture of her father's studio, entitled *The Studio Window, St Ives*. She appears to have left St Ives with her father in 1949.

(Mrs) Violet M. Digby
STISA: 1950-1960
STISA Touring Shows: FoB 1951.
Violet Digby (née Kidd) was born in Plymouth and studied at the Hastings School of Art under Philip Cole and Leslie Badham, at the Slade and at the Beaux Arts, Paris. Her work is first mentioned in St Ives in a review of the 1950 Summer Exhibition. She was then living at Studio Cottage, The Belyars, St Ives. She specialised in flower paintings in oil but, on Show Day in 1951, she exhibited oil paintings of Norway and, in 1953, she had visited India. Although she remained a member until 1960, she ceased exhibiting a few years before.

[41] Obituary in *St Ives Times*, 25/12/1953.

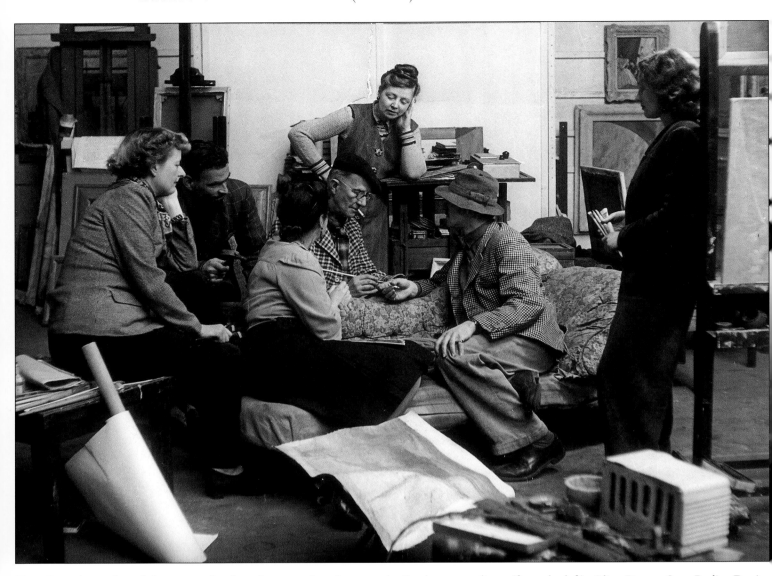

Fig. 3D-1 A meeting of the group of artists who campaigned to save the Porthmeor studios - (from the left), Olive Dexter, Sven Berlin, Denise Williams, Leonard Richmond, Misomé Peile, David Cox and Wilhelmina Barns-Graham.

(Ms) Vere G F Dolton
STISA: 1934-1938
STISA Touring Shows: 1936, 1937.
She first exhibited her watercolours with STISA in the Winter Exhibition of 1930 but she does not appear to have become a member until 1934. She lived at 2, Carter's Flats, St Ives but did not take part in Show Days.

John Christian Douglas (1860-1938)
STISA: 1927-1938
STISA Touring Shows: 1932, 1934, 1936.
A founder member, Douglas has the honour of being the first member to sell a work at one of STISA's exhibitions in its own Gallery.[42] This was probably *A Fisherman's Paradise*, depicting a stream running through a wood amidst a riot of Autumn colours, which was described as a *tour de force* on Show Day in 1928. Douglas came to St Ives in the 1890s and first exhibited at RCPS in 1896. He was a landscape and marine painter, who made a special study of the rocks and sea of the Cornish coast but is better known for his photography, which was used by Folliott Stokes to illustrate his three books on the Cornish coastline and the moors, published between 1908 and 1912. Unfortunately, his plates became mixed up with those of Herbert Lanyon but a number of his photos can be seen in Andrew Lanyon's *A St Ives Album* (Penzance, 1979). He served as Librarian on the Committee in 1928 and 1929 before the post was abolished. This was a post he had held for many years at the Arts Club, where he was a stalwart, and he was elected President in 1925. He lived at 10, Park Avenue and his wife, Mabel (q.v.), was also an artist. They both worked from Skidden Hill Studios.

[42] *St Ives Times*, 9/2/1940.

(Mrs) Mabel Maude Douglas Exh. RA 22
STISA: 1928-1953
STISA Touring Shows: 1932, 1934, 1937, 1947 (SA). Also FoB 1951.
The first mention of the work of Mabel Bucknall is on Show Day 1895, when she exhibited a portrait *Grief*. Her sister, the sculptor, Georgina Bainsmith (q.v.), was also a member of STISA. In 1897, she married the photographer and artist, John Christian Douglas (q.v.). She specialised in portrait miniatures and a reviewer commented, "Her delicacy of treatment and rich colouring impart a jewel-like quality to her work".[43] She was successful at the RA on a regular basis between 1904 and 1937 and her RA exhibits include portraits of Mrs Herbert Lanyon (1916), Mrs Barry, the needlework expert who was the wife of the artist, Claude Francis Barry (q.v.) (1917), Herbert Lanyon (1933) and her husband (1932 and 1937). Show Day exhibits in 1929 included portraits of fellow member, Taka Cochrane, and of General Sir Herbert Blumberg, an associate of STISA, whose wife painted under the name of E.Tudor Lane. The latter work was hung that year at the RA. Her portrait of another STISA member, Jack Titcomb, is illustrated below (Fig. 3T-1). She also painted still life scenes in oil and watercolour. In the late 1930s, the miniature section comprising Douglas, Blanche Powell and Ethel Roskruge often received favourable comment and Douglas' miniatures remained a feature of Show Days and STISA exhibitions until 1953.

(Miss) Agnes E. Drey (c.1890-1957)
STISA: 1943-49
STISA Touring Shows: 1947 (W), 1949.
Born in Withington, Manchester, Agnes Drey was the sister of the art and theatre critic, Oscar Raymond Drey, who married the artist, Anne Estelle Rice. Agnes studied with Frances Hodgkins, who painted her portrait. She first exhibited on Show Day in 1934 in Back Road West Studios with Job Nixon and his wife, which may indicate that she was also studying under Nixon. However, she did not join STISA until 1943 and she was raised from associate to full membership in 1944. She resigned in 1949 and exhibited with the Penwith Society for the rest of her life. Patrick Heron wrote an appreciation on her death, in which he referred to the significant influence upon her work of Francis Hodgkins. "Although it might be thought, at times, that her work charmed by virtue of certain naive elements in the drawing, I think hers was a decidedly sophisticated art.", he comments. "The 'frontal' presentation of table top or bowl was admittedly a simple device which she adapted in picture making. Yet she always managed to load the simple compositions thus arrived at with colour textures that rang true because they were personal. And in many of the female portraits, there was a surprising plastic power, the simplified image having a suggestion of volume that was at times remarkable." He also referred to her numerous still lifes, "in which very round flowers and very spherical fruit seemed to hang, as it were, in the luminous space of the picture."[44] Drey was a great friend of Eleanor Rice (q.v.), with whom she lived, and her sisters, Alice and Jeanne, were very involved in drama productions.[45]

(Miss) Jeanne du Maurier RWA Exh. RA 9
STISA: 1945-1949
STISA Touring Shows: 1947 (W), 1949.
Jeanne was the daughter of the famous actor, Sir Gerald du Maurier, and sister of the well-known novelist, Daphne. She studied at the Central School of Art in Southampton Row and was in the life class under Bernard Meninsky. She also learnt drypoint and etching there. Later, she attended the St John's Wood School of Art, studying painting under P.F.Millard. Her first studio was in Hampstead and she began exhibiting with SWA in 1938. After her father's death and the outbreak of War, her family moved permanently to 'Ferryside' at Fowey, their holiday home since 1926. During the War, she put painting aside and ran a market garden. She first exhibited with STISA at the 1945 Autumn Exhibition, which was opened by her mother, Lady du Maurier. She took a studio in St Ives and, on Show Day in 1946, she exhibited a self-portrait, which was hailed for "its bigness of style and directness of touch".[46] Dod Procter that day asked if she could paint her and the two formed a close friendship, spending two winters together in Tenerife and one in Africa. Her husband later commented, "Jeanne mostly paints still life, flowers and landscape, now and then a portrait. Her palette is high keyed, her colour singing. She cares more for colour than form and is always fascinated by the reflection of her subject in the looking glass so often placed beside or behind the original."[47] She resigned from STISA in 1949 and became a founder member of the

Fig. 3D-2 Jeanne du Maurier (right) and Dod Procter on holiday in the late 1940s

[43] *St Ives Times*, March 1922.
[44] *St Ives Times*, 19/7/1957.
[45] It is possible that Eleanor Rice was related to Anne Estelle Rice.
[46] *The Western Echo*, 23/3/1946.
[47] Noel Welch, *The Du Mauriers, The Cornish Review*, Summer 1973, No 24, pp.7-18.

Penwith Society. She exhibited flower paintings at the RA between 1951 and 1958, by which time she had moved to Manaton in Devon. She had a one man show in Oxford opened by Dame Ninette de Valois and her one-man show at the Beaux Arts Gallery in London was attended by the Queen.[48]

(Mrs) Ann Duncan Exh. RA 3
STISA: 1945-1947
STISA Touring Shows: 1945, 1947 (W).
A painter of figures, landscape and still life, she was married to the artist, John McKirdy Duncan. She had her first success at the RA in 1930, when she was living in London, and had a joint show with her husband at the Fine Art Society in April 1932, at which she showed 30 works. By 1933, they had moved to Mousehole and it is probably at this juncture that she studied further under Forbes. She is described as a new member at the 1945 Spring Exhibition. A portrait, *Negress*, was included in the 1945 tour and an oil, *Mousehole Harbour,* in the 1947 Cardiff show. Her involvement was, however, brief.

Lowell Dyer (1856-1939)
STISA: 1927-1939
STISA Touring Shows: 1934,1937.
Public Collections include Glasgow, Auckland and in the USA.
Dyer was one of the artists that had fraternised with the first generation of St Ives painters and was perhaps known more as a great wit and a stalwart of the Arts Club, where he was President in 1893/4 and again in 1918, than as an artist. He was an American, born in Brooklyn, and had studied art under Gerome at the Beaux Arts and with Collin in Paris. He came to St Ives in 1889 for a summer holiday and stayed for the rest of his life.

He had a studio in the grounds of Talland House and was primarily a figure painter, with a predeliction for paintings of children as angels, often imbued with a heavy symbolism. *Angel with Daffodil* - a work reminiscent of the style of Burne Jones - was his exhibit in the 1925 Cheltenham show (and at several STISA exhibitions) and a series of other highly regarded Angel works, *Adoring Angel, Angel of the Annunciation*, etc, which many felt would not look out of place in Florentine churches, graced the walls of early STISA exhibitions in the late 1920s. However, his eyesight had begun to fail by the time STISA was formed and he was almost totally blind by the date of his death.

R J Enraght-Moony RBA (1879-1946) Exh. RA 26
STISA 1928-1946
STISA Touring Exhibitions: 1932, 1945.
Public Collections include Chicago
Born at the Doone, Athlone into an ancient Irish family - his father was Lord Lieutenant of the County - Enraght-Moony always remained inspired by his Celtic roots. However, as a child, iron shutters barred the windows and English dragoons were quartered in the house for the protection of the residents. He was educated at Kingsley College, Westward Ho! He initially studied modelling at Leeds but became dissatisfied with the limitations of the medium and abandoned it for paint. He went to Julian's Academy, Paris, where he studied under Paul Laurens and Benjamin Constant. A painting tour took in Barcelona, Majorca, Venice and Verona before he returned to live in London. He first exhibited at the RA in 1909 and was elected an RBA in 1912. After his marriage in 1927, he moved to live at Chalcot Studios, Mount Hawke, Truro, although he retained a London property.[49] He exhibited with the Society at Lanham's Galleries in 1927 but did not become a member until the following year. He was a regular contributor to STISA shows for the rest of his life. His imaginative and symbolic subjects, often realised in mixed media, resulted in a quite unique and distinctive body of work. A critic commented, "He invests the most simple subjects with a halo of romance, and fairies dance and play in Cornish dells and along spray-swept golden Cornish strands." In 1936, Ruth Davenport allowed him to hold a one-man show of 23 tempera works in her studio, 6, Piazza Studios, and the following year they exhibited there together. His works *A Spring Evening* and *The Kite* were bought by the Chicago Trust and he held regular exhibitions at the Beaux Arts Gallery in London.

Enraght-Moony's paintings, with their suggestions of romance and adventure, were loved by children and it is no surprise that he was asked to illustrate *The Golden Age* by Kenneth Grahame. These stories of the golden age of childhood, first published in 1895 by the author of *The Wind in the Willows*, had already become a classic by the time that Enraght-Moony illustrated the 19th edition in 1915. Moony contributed 19 colour full page illustrations. Speaking in 1939, he commented:-

[48] ibid.
[49] The identity and nationality of his wife have confused me. His entry in *Who's Who in Art* in 1934, based on information he supplied himself, indicates that he married Abigale Maunsell. The *News Chronicle* feature on him in 1939 states that he married in 1927 a "charming Canadian born actress", while his obituary indicates that he married, in 1927, Miss Ysobel Barr, a musician and scholarship holder of the Chicago College of Music. If the latter is correct, it would explain the Chicago connection that led to the purchase of two of his works by the Chicago Trust.

Fig. 3E-1 R.J. Enraght-Moony standing beside one of his typical imaginative subjects

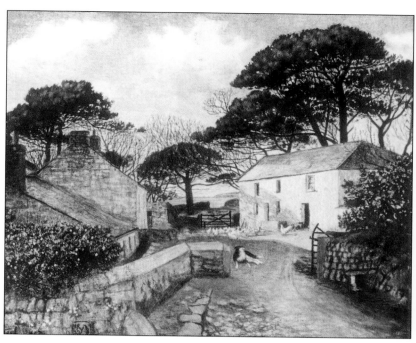

Fig. 3E-2 R.J. Enraght-Moony *Cornish Farm*

"I remember delightful walks with Grahame beside willow-fringed streams. He had the abandoned gaiety of a child - even when making a delicious salad, and trotting from the kitchen to the garden for herbs, he continued to talk ecstatically of the streams and willow trees we had seen that afternoon."[50]

Enraght-Moony remained a unique and individual talent within STISA and moved to Newlyn some eight years prior to his death in 1946. His obituary records that major collectors of his work included the famous art dealer Lord Duveen and, appropriately, the Irish author, poet and playright Lord Dunsany, well-known for his writings in the fantasy genre.[51]

C.S.Everard (d.1947)
STISA: c.1932-1947
STISA Touring Shows: 1936, 1937.
He is recorded as a member in 1932, when his address is given as St Andrews, Fife. However, it is not until Show Day in 1934 that his work is first mentioned, comment being passed on his unconventional outlook and the manner in which he managed to make his watercolours carry so much body. By this stage, his wife, Dorothy, and himself appear to have settled in St Ives at 3, The Warren and he was working from The Horse Shoe Studio. His works contained an element of fancy - *Wood Nymph* was one work remarked upon - but he was an infrequent exhibitor.

(Mrs) Dorothy Everard
STISA: c.1932-1949
STISA Touring Shows: 1936, 1937, 1945, 1947 (W).
She specialised in portraiture, in chalk, pastels or watercolour, and had a lively observation. The 1937 Winter show included her portrait of the well-known St Ives character 'Jimmy Limpotts'. She also painted still life and local subjects in watercolour. She had a separate studio to her husband - Dragon Studio in Norway Lane - and exhibited with SWA. She can be seen in the photo of the New Gallery in 1947 (Fig. 1-18). Her work is last referred to on Show Day in 1949.

Harry Fidler (1856-1935)
STISA: 1933-1935
STISA Touring Shows: 1934.
Public Collections include Blackpool, Northampton, Oldham, Rochdale and, abroad, Hobart, Nelson, Timaru and Wanganui.
A figure, rustic and domestic painter, Fidler is best known for his colourful, impressionist paintings of man and beast working the land. His obituary in the *Times* noted, "No painter was more immediately recognisable in a mixed exhibition. He had a fine,

[50] *News Chronicle*, 1939, Cornish Artists : 21.
[51] Lord Dunsany was one of those who congratulated Munnings on his speech at the 1949 RA Banquet, commenting "Sanity's tottering throne will be steadied by it". J.Goodman, *What A Go*, London, 1988, p.242.

robust feeling for the activities of rural life".[52] The son of a yeoman farmer, Fidler was born in Teffont Magna in Wiltshire. He was the ninth of ten children, of whom three, Fanny, Lucy and Gideon (1857-1942) also displayed artistic talent. In his early years, he worked on a farm, helping his brother, James, and it was this experience, which had a marked influence on his choice of subjects. He was well into his thirties when he enrolled at Herkomer's School at Bushey in 1891 and he probably studied there for two years, which would make him a contemporary of Algernon Talmage (q.v.) and the well-known horse painter, Lucy Kemp-Welch. He was back in Bushey in 1898, where he met and married another Bushey student, Laura Clunas. It appears they settled initially in Salisbury, possibly studying further at Salisbury Art College, and Harry leased an old Methodist Chapel in Tefford as a studio. His early work is decidedly Victorian in style and execution, and he signed it with a monogram 'Fid' or 'HFid'. He also had a taste for grandiose titles, such as *The Master of the Wheat Field is the Master of the World*.

The Fidlers visited St Ives on a number of occasions, possibly to meet up with old acquaintances from Bushey. Certainly, in December 1907, both are signed in as guests in the St Ives Arts Club by M.K Deacon, a relative of Bushey-trained artist, Allan Deacon.[53] In fact, they appear to have joined the Arts Club for a while. They eventually settled at 'The White House', Stoke, Andover, which was to be their home for the rest of their lives.

During the First World War, Fidler's style changed dramatically and he began producing the vivid, paint-laden impressionistic depictions of farm scenes, particularly horses at work, for which he is now known. Flooded with sunlight, his subjects are depicted with multi-coloured, heavily textured paint, laid on coarsely, and, as a result, have a monumental quality. This was often aided by the size of his paintings, with at least eight of his RA exhibits being six foot canvases. Everyday scenes on a working farm are thus given a dramatic, timeless quality, which satisfied the longings of a generation emerging from the horrors of war. His was as reassuring an image of Britain as the pastoral scenes of Arnesby Brown and Fred Hall.

He was elected an RBA in 1919, exhibiting 116 works with this society, and an ROI in 1921.[54] He had a well-received joint exhibition with William Lee-Hankey in Chicago and also was particularly successful in South Africa. In 1930, he had a show at Grundy Art Gallery, Blackpool, one of the northern Galleries that now hold his work. Although he joined STISA at much the same time as others with similar connections, his membership was cut short by his death. However, his exhibits with STISA included *The Binder*, one of his RA exhibits of 1932, and, in the year of his death, one of his exhibits at the RA was *St Ives Fruit Cart*. His other RA exhibit that year, *Energy* (Rochdale Art Gallery - Fig.3F-1), a typical Fidler subject, showing three horses working the land, was to have been included in this Exhibition but, like many Fidler paintings, it was found to be in a poor state of repair.[55] Unfortunately, his use of inferior canvas - frequently burlap or potato sacking - with little or no ground has meant that his pictures often need restoration. A portrait of Fidler was exhibited at the RA in 1930 by his wife, Laura, who died in 1936. A joint Memorial Exhibition was held at the Arlington Gallery in 1936 and interest was re-aroused in his work by an retrospective held by the dealer, Jeremy Wood, in Sussex in 1982.[56]

Fig. 3F-1 Harry Fidler *Energy* (Detail) (Rochdale Art Gallery)

[52] *The Times*, May 1935.
[53] The guest book indicates that they are from Salisbury, although the Andover address is given in an exhibition catalogue as far back as 1895.
[54] A 1920 work at the RBA is entitled *Herring at St Ives*.
[55] This painting was bought from a Loan Exhibition of Paintings at Rochdale Art Gallery at the end of 1935, which included work by many other artists who were or were to become members of STISA, including Arthur Hayward, John Park, Borlase Smart, Leonard Fuller, Dod Procter, Maurice Hill, Harold Harvey, Stanley Spencer, Annie Walke, Forrest Hewit, Clare White, Geoffrey Garnier and Malcolm Arbuthnot.
[56] See J.Wood, *Hidden Talents*, 1994, p.51 and A. Mackay, *Harry Fidler, Countryman Artist*, AC 9/1996, p.32-5.

(Miss) Anna Findlay (d.1947)
STISA: c.1928-1947
STISA Touring Shows: 1934, 1936.
An engraver and linocut artist, who had exhibited at a range of provincial Art Galleries, her colour prints are first mentioned in the 1928 Winter Exhibition and she contributed to some of the early tours but, by 1938, she had moved to Glasgow and does not appear to have exhibited with STISA again, although she retained her membership. She contributed to the United Artists' Exhibition in 1940 and to Lindner's 90th birthday presentation in 1942, as did a Colonel and Mrs J.M.Findlay.

(Mrs) Anne Sefton 'Fish' (d.1964) Exh. RA 1
STISA: 1952-1964
Public Collections include British Museum.
Born in Bristol, she studied under Charles Orchardson and John Hassall and at the London School of Art and in Paris. She signed her work, 'Fish', her maiden name. With her sharp, satirical commentaries on the flapper lifestyle, she was one of the mainstays of *The Tatler* during the 1920s and 1930s, contributing drawings and caricatures in a mannered Art Deco idiom deriving from Beardsley. Cornelis Veth regarded her as one of the most important social satirists of the day. He wrote that she depicted modern society with modern boldness, using its own weapons to attack it with cynical understanding. She produced a few etchings, of which the decorative *The Snake Charmer* is in the British Museum collection. In 1938, she published the amusing *Awful Weekends - and Guests*. She moved to St Ives with her husband, Walter Sefton (d.1952), an Irish linen merchant, after the War and she first exhibited "chunky oil paintings" with "humour rippling through immaculate line" on Show Day in 1949. She joined the Penwith Society initially, exhibiting at its first show, when her humour and gaiety were welcomed by one reviewer as an antidote to those members of that Society who were "inclined to view the business of painters with the solemnity of undertakers at a mass funeral".[57] However, she soon moved to STISA and exhibited with it for the rest of her life. A tall, upright woman, she painted Down-a-long folk and Down-a-long scenes with vitality and humour and showed great consideration for people around her. An animal lover, she became particularly well-known for her amusing paintings of cats. For eight years prior to her death, she held an exhibition of cat subjects at her Digey studio and donated the proceeds to the Cats Protection League. She also made available Studio 27 to other artists for one-man shows.

Fig. 3F-2 'Fish' *Quayside Cats* (W.H.Lane & Son)

[57] *St Ives Times*, 13/10/1950.

Fig. 3F-3 Maud Palmer *The Leisure Hour* (RA 1915)
(W.H.Lane & Son)

(Mrs) Maud C Stanhope Forbes (d.1952) Exh. RA 24
STISA: 1933-1952
STISA Touring Shows: 1936, 1937, 1947 (SA), 1947 (W), 1949. Also FoB 1951. Born in Canada, Maud Palmer was torn between a career in art and one in music, but, whilst staying in Jersey, she decided to study art in London. Her first success at the RA was in 1903. An uncle then sent her to study under Stanhope and Elizabeth Forbes and between 1911 and 1916 she was successful nine times at the RA, with still lifes, landscapes and figure paintings. On the death of Elizabeth Forbes, Stanhope Forbes asked her to stay on as Secretary for the School and they married in 1915. "Since then", she told the *News Chronicle* in 1939, "I have been busy with art and domesticity."[58] Her involvement with the School, however, seems to have impacted on her work as she did not exhibit at the RA again until 1930. That was also the year in which she first exhibited with STISA and she was made an Honorary Member in 1933. She continued to exhibit with STISA for the rest of her life. The Cardiff show in 1947 contained her 1938 RA exhibit *Statuette* and the 1949 Swindon show included her portrait of Stanhope Forbes, that had been exhibited at the RA the previous year. Known as Maudie, she was well-liked and appreciated as much for her talent as a musician as an artist.

Alexander Moulton Foweraker (1873-1941) Exh. RA 1
STISA: 1938-1941
Public Collections include Oldham.
Foweraker was one of the artists who had studied in St Ives at the turn of the century and who joined STISA in the mid-1930s as it was developing its reputation. Son of an Exeter clergyman, he graduated in science at Cambridge and did not take up painting until his early 20s. He studied art in Exeter and first exhibited with RCPS in 1897, which suggests that he studied further in St Ives before moving to Carbis Bay in 1901. He first exhibited on Show Day in 1902 and he was also elected as an RBA that year, where he exhibited 52 times. In 1903, he assisted Algernon Talmage with his Cornish School of Landscape and Sea Painting, being primarily responsible for watercolour tuition. In 1905, he advertised winter art classes in Andalucia and his address was given as 'Villa Camara' in Malaga. Classes were held in Malaga in January and February, in Cordoba in March and in Granada in April and he appears to have made regular trips to Spain as the scenery of Andalucia was to feature in his works throughout his career. When Charles Marriott, then the President of the St Ives Arts Club, was asked to write a travel book on Spain in 1908, Foweraker was the obvious choice for illustrator.[59]

[58] *News Chronicle*, 1939 - Cornish Artists 19.
[59] C. Marriott, *A Spanish Holiday*, Methuen, 1908.

Fig. 3F-4 A. Moulton Foweraker *Thatched Cottage at Twilight* (1935) (W.H.Lane & Son)

Foweraker does not appear to have submitted work to the RA and the only time he was hung there, in 1909, was unintended. When his submission to the RBA that year arrived too late, the President of the RBA forwarded it to the RA where it was accepted and hung.[60] Foweraker is best known for his moonlit watercolour scenes, in which he often features a figure carrying a lamp, and these works now have a strong following amongst collectors. A painting of St Ives Harbour by moonlight was included in the Summer Exhibition at Lanham's in 1928 but he does not appear to have joined STISA until later when moonlight subjects were again to the fore. He called his house, in Swanage, Dorset, 'Carbis'.

W H Fowler (d.1944)
STISA: c.1928-1944
He first exhibited with Arthur Hayward on Show Day 1928, which suggests that he was Hayward's pupil, and he contributed to the first show in the Porthmeor Gallery in 1928 (see also Roskruge's 1929 map - Fig.1-3). He lived at Carthew House but his work is rarely mentioned either on Show Days or in exhibitions. However, he was recorded as the purchaser of Stanhope Forbes' *The Ancient Borough of Penryn* (RA 1931).

(Miss) Ellen Fradgley SWA Exh. RA 1
STISA: 1927-c.1932
STISA Touring Shows: 1932.
She moved from Burford to St Ives in 1923 and lived in 7 Albany Terrace. Her work is first mentioned in a review of Show Day in 1923 and she exhibited that year at the ROI *The Harbour of St Ives*. A founder member, she specialised in portraiture and one of her best works was considered to be a portrait of Kathleen Bradshaw (q.v.), exhibited on Show Day in 1927. She also did landscapes in watercolour. She was made an associate of SWA in 1925 and was a full member between 1939 and 1941. She seems to have left St Ives in 1931 and her addresses for her SWA exhibits for the next few years are various hotels around the country before she settled in Chilbolton, Hampshire in 1938. Her one success at the RA was in 1941.

[60] M.Whybrow, *St Ives 1883-1993*, Woodbridge, 1994, p.61.

(Miss) Hilda Freeman
STISA: 1940-1945
A wartime resident, she came to St Ives to study under Fuller. She is described as a new associate member in the review of the 1940 Spring Exhibition and her painting *Morning* was accorded the place of honour at the 1943 Autumn show.

(Miss) Maud Winifride Freeman (1874-1961) Exh. RA 11
STISA: 1932- c.1941
STISA Touring Shows: 1932, 1934, 1936, 1937.
Public Collections include St Ives.

A slightly eccentric spinster from a wealthy family and a talented watercolourist, as was amply demonstrated in her numerous contributions to the *Women Artists in Cornwall* Exhibition at Penlee House in 2002. Born in Falmouth, her family were granite merchants, who ran quarries throughout the West Country. She was therefore able to indulge her love of art and she began exhibiting with RCPS in 1888. It is not known whether she had any formal art training, although a Brighton address is used for one exhibit of 1892. However, her family knew the Falmouth marine artist Napier Hemy and he, in fact, became her brother-in-law. Accordingly, he is likely to have had a significant influence on her artistic development. So too did Henry Tuke, who admired her independent spirit. Due to introductions afforded by Hemy and Tuke, by 1897, she was living in Newlyn and her work was being associated with the Newlyn School.[61] As she worked mostly in watercolour, she no doubt looked to Walter Langley for inspiration. She was first hung at the RA in 1895 and her exhibits record the spelling of her middle name as 'Winifride', although later spellings include 'Winefride', 'Winnifred' as well as the more usual 'Winifred'. However, it will be no coincidence that she selected as the subject of her 1900 RA exhibit the scene *The Resuscitation of St Winifride*. To add to the confusion, her first name is often given incorrectly as Mary. In 1902, she enrolled at the Herkomer Art School at Bushey and, when Herkomer closed it in 1904, she stayed on in Bushey, working from Meadow Studios. Despite continuing to produce some exceptional watercolours, her last success at the RA was in 1912, when she was living in London.

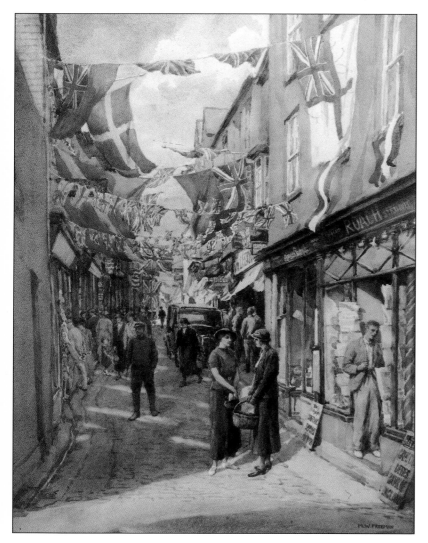

Fig. 3F-5 M.W.Freeman *St Ives in Jubilee Time*
(St Ives Town Council)

This colourful watercolour, full of life and movement, was exhibited on Show Day 1936 and at the Bath Exhibition in 1937. The Jubilee celebrations were reported in the local paper, "The run on flags was phenomenal. Streamers and festoons spanned the streets, and in the twinkling of an eye, St Ives was transformed into a town glittering like a jewel...The cars of the townspeople and visitors gaily decorated with emblematical ribbons, and shops and house windows with portraits of our King and Queen were all eloquent testimonies to a prodigious wave of unbounded loyalty to King and Country. It was good to feel the aura of joyfulness and thanksgiving reaching from everyone and everything. In fact it was good to be alive in this Jubilee time."[62]

[61] *The Daily Mail* 21/2/1901 includes her in a list of Newlyn artists.
[62] *St Ives Times*, 17/5/1935.

Her work is first mentioned in St Ives in the Winter Exhibition at Lanham's in 1923 and her embroideries *A Flying Dutchman* and *The Vikings*, the latter being an original design, won special praise at the Winter Exhibition of Arts and Crafts at Newlyn in 1924. However, she did not seem to exhibit regularly and is only occasionally listed on Show Day notices. Possibly, this is because she was an intrepid traveller, as is evidenced by the subjects of her contributions to the touring shows of the 1930s - *The Ponte Canonica, Venice* and *The Market at Cahors* (1932), *Canadian Winter* and *The Procession at Lourdes* (1934) and *A Mountain Guide in the Pyrenees* (1936). She lived at 7, Bellair Terrace, St Ives and does not appear to have exhibited with STISA after 1941. Two of her watercolours are owned by St Ives Town Council and hang in the Guildhall. One of these is a watercolour of 'The Retreat', the property that was converted into the Guildhall. Members of STISA had campaigned for this to become a permanent Art Gallery for the Town.[63] She is buried in the Freeman family vault at Swanpool, Falmouth.

(Miss) Frances Gair SWA Exh. RA 1
STISA: 1939-c.1941
A painter of landscapes with buildings, in watercolour and tempera, she lived in Spaxton, Somerset and was made an associate member in 1939 but her involvement was brief. In relation to her tempera work, a local critic commented, "She holds the medium well to the limits of each drawing and the edges of the varying forms are sympathetically yet sharply wrought."[64] Although elected a member of SWA, she only exhibited with that Society in 1939 and 1940. She was also successful with a tempera painting at the RA in 1940.

(Mrs) Meta Garbett PS (b.1881)
STISA: 1939-1953
STISA Touring Shows: 1945, 1947 (W). Also FoB 1951.
Born in Heene, Sussex, she was educated privately and studied art under the miniaturist, Edwin Morgan. Her pastels were highly praised when she first exhibited with STISA in the 1939 Autumn Exhibition and this was her preferred medium. She specialised in portrait sketches and left STISA when she moved to Paignton.

(Mrs) Jessie (Jill) Caroline Dunbar Garnier FRSA
(1890-1966)
STISA: 1934-1953
STISA Touring Shows: 1934, 1936, 1937. Also FoB 1951.
The recent exhibition at Penlee House Gallery and Museum, Penzance devoted to Jill Garnier's paintings was a revelation to all but a few close friends and family. Completely overshadowed by her husband, the quality of her portraits and still life paintings was at last revealed. Jill, as she was always known, was the daughter of W.D. Blyth LL.D, ICS. She was born in Quidenham in Norfolk and was educated at Cheltenham Ladies College. She took up art on leaving school and, in 1915, she came to Cornwall to study under Stanhope Forbes. She resided with her mother at Myrtle Cottage (known as 'the Myrtage') with Mrs Tregurtha, the home of many of the female students at the School. She soon met her future husband and they married in 1917 and had three children - Peter born in 1918, Ann in 1922 and Jeremy in 1925. Sadly, Jeremy died in 1926, an event which tested Geoffrey's faith sorely. The influence of Forbes in her portrait work is clear and her portraits of Peter and Ann, and Peter and the family dogs, dating from the early 1930s rank as her best portrait groups. The former was probably included in the 1937 Exhibition at Bath under the title *Two Children*, as it was not for sale, and the latter appears to have been accepted but not hung at the RA. She also produced a series of exquisite still life groups. In addition to her painting, Jill was also an accomplished needlewoman and she was part of the Committee responsible for the novel Winter Exhibition of Arts and Crafts at Newlyn in 1924. With a still life, *Camellias*, she did a version of the subject in both oils and embroidery.

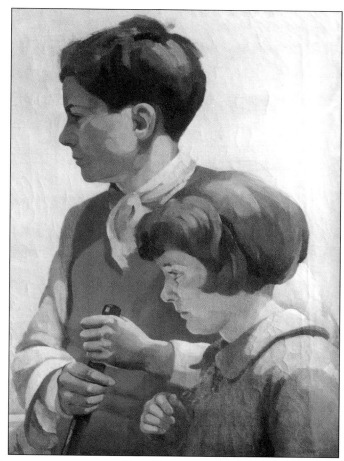

Fig. 3G-1 Jill Garnier *Peter and Ann* - detail
(Private Collection)

[63] *St Ives Times*, 8/7/1938.
[64] *St Ives Times*, 2/22/1940.

Fig. 3G-2 Jill Garnier *Tea Service* (Private Collection)

She first exhibited with STISA in 1934 but was not a regular contributor to the Society's shows. Like her husband, she seems to have stopped exhibiting with STISA after the 1953 Coronation Exhibition, but did contribute to a 1955 Exhibition at the Medici Society in London.

George J Gillingham (d.1955)
STISA:c.1950-1955
STISA Touring Shows: FoB 1951.
Gillingham retired to St Ives in the 1940s after a long and successful career as a commercial artist, working in Fleet Street. He painted principally in watercolour and was fond of depicting French crabbers in the harbour. Although he was in his 80s when he died, he continued to work daily in his studio near his residence at Porthmeor and was a popular figure in the Arts Club, with his fund of anecdotes about his journalistic acquaintances. Shortly before his death, he contributed some illustrations to a children's annual, *More Adventures of Buffalo Bill*.

George Turland Goosey (1877-1947)
STISA: c.1928-c.1931
The son of Nathaniel S. Turland of Northampton, George had adopted the surname Turland Goosey by the time he arrived in St Ives in 1921, although he reverted to the name George Turland in the late 1920s. Prior to his time in St Ives, Turland Goosey had made a name for himself as an architect in America. He designed some of the early skyscrapers, "the famous Friars Club, the theatrical centre of America's capital", and no less than seven Roman Catholic churches. He was also already an accomplished etcher - his print *Moonlight on a Venetian Canal* having won first prize in the annual exhibition in New York in 1914. He exhibited 19 of his etchings on Show Day 1922 and Smart commented, "His line is full of vigour and individuality, and a fine massing of light and dark tones seems to be the secret of his art."[65] The real purpose of his visit to St Ives, though, was to try his hand at painting and he developed an impressionistic style of depicting boats in the harbour that has won many admirers. He rarely practised as an architect whilst in St Ives - his highly regarded design for the cross on the War Memorial being an exception - but his change of status did not bother him at all:-

"He lives in a little studio perched on the rocks, where he paints and draws in black and white, so close to the sea that in the winter-time the foam dashes against the walls of his home...There he is, whiling the hours away, just doing the things that he likes best - and happy. He and Rolf Bennett, the author, sit at the window, listening to the cries of the gulls and the music of the waves, smoking Dustman's Delight, a mixture of their own concoction." [66]

[65] *Western Morning News*, 16/3/1922.
[66] Vera Hemmens *A Cornish Chelsea St Ives Times*, August 1923 reproduced from the *Daily Graphic*.

Goosey played an active role in the theatricals at the St Ives Arts Club and was invited to join STISA in 1928. On Show Day in 1930, in a new departure, he exhibited some still life paintings "full of Oriental, lacquerlike colouring, and very decorative".[67] He also held a special show of his etchings at Lanham's in the summer in 1930. However, his contributions to the Society's shows were limited, although he did not return to America until War loomed in the late 1930s. He settled in Laguna Beach, California and continued painting, for he was a member of the Laguna Beach Art Association. His death in 1947 was noted in the local St Ives press.

Ronald Gray RWS NEAC (1868-1951) Exh. RA 7
STISA: 1941-1945
Gray came down from London to stay with fellow portraitist, Leonard Fuller, in 1941 and was made an honorary member. He studied in the studio of Percy Jacomb-Hood and at the Westminster School of Art under Fred Brown before going to Julian's in Paris. He was first successful at the RA in 1919 and had a show at Goupil Gallery in 1923. That year, he was elected a member of NEAC and he exhibited regularly with that Society. In 1925, the Chantrey Bequest Trustees bought his painting *My Mother* (1908) and he also won a silver medal at the Paris Salon. He was elected a member of RWS in 1941 and exhibited with STISA regularly during the War years.

(Mrs) Mary Grylls WIAC Exh. RA 1
STISA: 1927-1956
STISA Touring Shows: 1932, 1934, 1936, 1937. Also FoB 1951.
A founder member who contributed principally to the still life section, Grylls had studied at the Crystal Palace School of Art and at Newlyn under Norman Garstin. She concentrated on painting flower studies in watercolour or in tempera (and occasionally in oil) but also did some figure work and some landscape painting. She exhibited St Ives scenes at the 1920 RCPS Exhibition and first exhibited on Show Day in 1921. She worked from Blue Studio, Wharf Road in St Ives (see Roskruge's map - Fig. 1-3) but lived at Ar-Lyn in Lelant where she did a number of sketches of local scenes. A critic commented, "Her pictures are of the type to hang on a wall in an intimate room and go to at odd moments for pure joy of seeing them... Much restraint in style, a little support from the pen, and a sparing use of colour."[68] Her one success at the RA was in 1934, with a tempera work *Polyanthus,* and she also exhibited at the SWA and RWA. In 1941, her husband, a County Alderman and a member of the County Council for over 30 years, opened the Autumn Exhibition. Her contributions to STISA shows during the 1940s were few and she was not selected for any of the touring shows, but she did exhibit more regularly after the split.

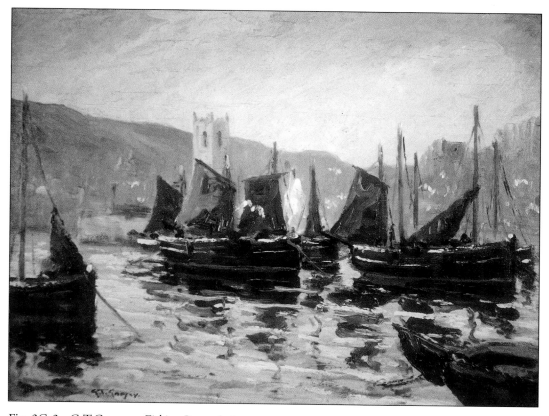

Fig. 3G-3 G.T.Goosey *Fishing Boats, St Ives* (W.H.Lane & Son)

[67] *St Ives Times,* 21/3/1930.
[68] *St Ives Times,* 17/3/1933.

(Miss) Maud H Gunn
STISA: 1929-c.1945
Between 1903 and 1913, Maud Gunn was living in Leicester and exhibited regularly at Nottingham Castle Museum. STISA's minutes for 14/7/1929 record that, having received two pictures from Miss Gunn, she was elected as a member by five votes to three. Possibly the sister of W.A.Gunn, she was resident in St Ives for a decade before his arrival but her watercolours are never mentioned in reviews or selected for touring shows.

William Archibald Gunn (b.1877)
STISA: 1939-1966
STISA Touring Shows: 1945, 1947 (SA). Also FoB 1951.
Public Collections include Sheffield (Graves Art Gallery).
He was educated in Hereford and studied at the Glasgow School of Art between 1897 and 1901. He appears to have been living in Newport in 1929 and York in 1930, when he was exhibiting at Liverpool. He first exhibited with STISA in the 1939 Autumn Exhibition and soon became fully involved with the Society, serving on the Committee during most of the War years. He lived at 'The Haven', Higher Trenwith and had a studio on Westcott's Quay, which he always fitted out on Show Days to look like an Art Gallery. He was also President of the Arts Club in 1943. He painted principally in watercolours and pastels and was noted for good composition and a strong decorative impulse. He was re-elected on to the Committee in 1950, serving for several more years and he was made an honorary member in 1964. In 1950, he moved into Smart's old studio, Ocean Wave, in St Andrew's Street.

Arthur Creed Hambly RWA (1900-1973) Exh. RA 2
STISA: 1930-1973
STISA Touring Shows: 1932, 1934, 1936, 1937, 1947 (SA), 1947 (W), 1949. Also FoB 1951.
Public Collections include Government Art Collection, Swindon, RWA and Auckland.
The son of a Bank Manager, Hambly was born in Newton Abbot and was educated at Kelly College. He then trained at Newton Abbot School of Art under Wickliffe Egginton and Conway Blatchford and at Bristol School of Art under Reginald Bush. He described himself as a landscape watercolourist, etcher and illuminator and he felt that Egginton, whom he considered to be a great watercolourist, especially of Dartmoor subjects, had been the strongest influence on his work.[69] After a brief spell teaching at Salisbury School of Art, he became Headmaster of Camborne and Redruth School of Art. He first exhibited with STISA in the 1929 Summer Exhibition and was a regular contributor of watercolours and etchings until his death over forty years later. Landscape subjects were his speciality and he sought a poetic rendering of nature's beauties. He won an international award for etching and a watercolour, *Chapelporth, Cornwall*, dating from 1928, was purchased for the Mackelvie Collection and is now in Auckland Art Gallery. Another watercolour, *Lelant Church*, was also acquired but has subsequently been sold off. His watercolour *Near Archerton, Postbridge, Devon* was one of three works bought in Swindon by F.C.Phelps from the 1945 touring show and donated to the town's Art Gallery that was then under discussion.[70] Hambly also designed the East Window above the High Altar in St Andrew's Church, Redruth, showing Carn Brea, Wheal Euny and Redruth Clock Tower, and Carn Brea featured again in his design for the seal of the local Council.

Among Hambly's students were Sven Berlin (q.v.) and Marion Hocken (q.v.). Berlin described him as a short man "with blue eyes and a fair moustache, hair neatly parted, later to be fitted with a beard, [who] wore a tweed jacket and flannels" and called him "the third of the Three Wise Men sent to guide my destiny".[71] His ideas were simple and straightforward "but the special quality of integrity as an artist and teacher made him a unique person: a man of truth". From him, Berlin learnt how to draw properly and Hambly, who considered Berlin the best and most hard-working student he had ever had, would for years come to all Berlin's shows 'to see the drawing' - a typical example of the devotion and loyalty to his students for which he was well-known.

Fig. 3H-1 Arthur Hambly

[69] Letter dated 3/8/1973 from the artist to Miss Stead of Swindon Museum and Art Gallery.
[70] This work is illustrated in David Tovey, *George Fagan Bradshaw and the St Ives Society of Artists*, Tewkesbury, 2000, at p.169.
[71] S.Berlin, *The Coat of Many Colours*, Bristol, 1994 at pp.69-72.

Hambly retained strong connections with Bristol and was involved with Gwen and Fred Whicker (q.v.) in the New Bristol Arts Club in the 1930s and exhibited regularly at the RWA, whose collection includes *Somerset Landscape* and *Little Malvern Priory*, dating from the early 1960s. A bout of tuberculosis after the War meant that he could neither paint nor teach for a while and, when he retired, he went to live with his friends, the Reverend and Mrs Greenwood at Downside Vicarage, Stratton-on-the-Fosse, near Bath. However, he still exhibited with STISA.

In a Foreword for a STISA catalogue, he passed some comments on painting. The key to success, he considered, was observation "Seeing, but seeing with knowledge - form, colour, tone, line and movement - and with a practised memory." When executing a painting, one must "see the whole work all the time - and so relate all the parts to the complete conception". Technique was a means to an end but too great a pride in skill may lead to mere cleverness. "As soon as a painting says 'Look how clever this is!' instead of 'Share this feeling,' or 'Have you seen the beauty of this?', then it leaves the realm of true art."[72]

In a letter to a student in 1942, Hambly observed, "The whole life of an artist is full of discouragement in one form or another...either from without or from within because we aim higher than we can achieve". The result can accordingly be "a pale shadow of the glory that was in the mind".[73]

(Mrs) Nora Hartley Exh. RA 13
STISA: 1927-after 1942
STISA Touring Shows: 1932, 1934, 1937.
Leonora Locking was the daughter of Dr John Locking. In 1896, she married the artist, Alfred Hartley (q.v.) but she was a respected flower and figure painter in her own right. They lived initially in Dorset but came to St Ives in 1904. She exhibited portraits and flower paintings at the RA irregularly for the rest of her life. She also exhibited at the Paris Salon. Her watercolours were particularly charming. One of her exhibits with STISA was a portrait of the Ranee of Sarawak, a keen supporter of STISA, who lived at Carbis Bay and attracted a circle of famous musical and literary figures. Nora was a founder member of STISA but, in 1931, for reasons connected with her husband's health, they moved to Llandrindod Wells. She is still recorded as a member in 1938, when she was living in Earl's Court, and she contributed to Lindner's presentation in 1942.

(Mrs) Gertrude Harvey (1879-1966) Exh. RA 20
STISA: 1945-1947
STISA Touring Shows: 1947 (SA), 1947 (W).
Gertrude Bodinnar was born in West Cornwall. Her father was a cooper and she was the eighth of ten children. Her first contact with art was as a model. The experience fascinated her and she made a note of how the painters worked. One of such painters was to be her future husband, Harold Harvey (q.v.). She found she had an innate talent for art and design and became a successful artist in her own right, although she was largely self-taught. She first exhibited with STISA in the Summer Exhibition 1929 and, in 1930, she had her first success at the RA. She specialised in still life painting, particularly flower studies, and was a regular exhibitor of such works at the RA until 1949. Unusually, though, she did not have to set up her floral subjects; she could do them out of her head and she could work on the kitchen table, with the canvas propped up on a rolling pin, while cooking the family meal! An interviewer commented, "[She] does not talk of technique: she has not drawn from the life: and yet from her brush there come drenching skies, soggy moors, flower pieces that hold the essence of growth, and decorative pictures that fire the imagination."[74] On the advice of Bernard Shaw, she always priced her paintings modestly and therefore found that they soon sold. She exhibited at Leicester Galleries in London with her husband and had her own show in Birmingham in 1939. However, she did not start exhibiting with STISA regularly until 1945 but her work did not find favour with the new Committee appointed in 1948 and she did not exhibit with STISA again, even after the split.

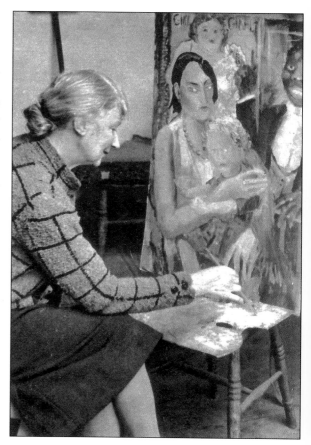

Fig. 3H-2 Gertrude Harvey painting in 1938

[72] Foreword to Catalogue for Spring Exhibition 1962.
[73] S.Berlin, *The Coat of Many Colours*, Bristol, 1994 at p.70.
[74] *News Chronicle* 1939, Cornish Artists 5.

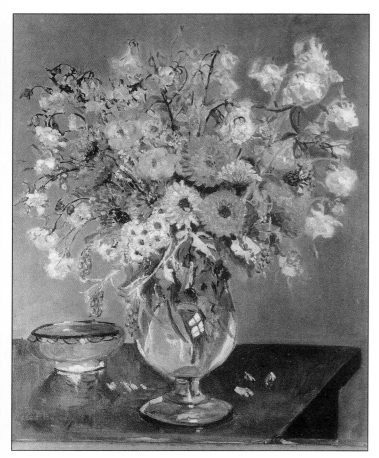

Fig. 3H-3 Gertrude Harvey *Marigolds and Columbines*
(W.H.Lane & Son)

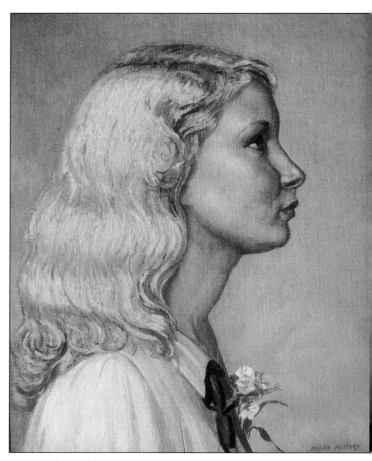

Fig. 3H-4 Hilda Harvey *Jessie Mathews* (RA 1946)
(W.H.Lane & Son)

Renowned for her wit and her lively personality, she was a multi-talented individual, being expert at gardening, cooking, needlework and clothing design. Her sister, Sophie, managed the first Crysede retail shop in New Road, Newlyn and this proved a useful source for fabrics for the house. Many of her husband's paintings, including *My Kitchen*, in this exhibition, feature her in settings in their home.

(Ms) Hilda Mary Harvey (1890-1982) Exh. RA 6
STISA: 1945-1950
STISA Touring Shows: 1945.
The daughter of the artist, John Rabone Harvey, she was a painter, printmaker and miniaturist on ivory and her figure paintings of women bestow on her subjects an aura of purity and perfection. She studied at Birmingham School of Art for six years from 1905.[75] She then worked for a firm of Birmingham silversmiths before, on the outbreak of War, joining London couture house Mechinka. At first, part-time and then, full-time, she studied at the Slade under Henry Tonks. She first exhibited at the RA in 1918 but, in the early 1920s, caught paratyphoid fever on a trip to Paris, which necessitated convalescent sojourns at St Leonards-on-Sea and two winters spent abroad. By 1924, she had married Charles Meeke and was living back in Birmingham and the birth of a son seems to have interrupted her art career. She appears to have moved to Cornwall after her divorce in the late 1930s and, for her 1937 RA exhibit *Holidays*, her address is given as Verbena Cottage, St Mawes. This superb work, which was later called *Holidays in Cornwall* (Fig. 1-19), when it was included in the 1945 tour, shows three fashionable, young Bohemian friends sitting round a table in a cramped dining room. To the right, in a manner reminiscent of Dutch painting, a door offers a view outside to a typical genre scene of a distinctive Cornish barn with some locals working outside, one of whom is tending some goats. It is no surprise to see it priced at £210, when it was first exhibited with STISA in 1945. About this time, Harvey moved to St Ives where she lived at 6, Bowling Green Terrace. She exhibited regularly with STISA until 1950, by which time she was living in Yardley in Warwickshire. She also showed at the Paris Salon.

[75] Marion Whybrow indicates that she was in St Ives at some stage between 1900 and 1910.

David Haughton (1924-1991)
STISA: 1949
Born in London and having spent some of his early life in India, Haughton came to live in West Cornwall in the spring of 1948. He has described his discovery of St Just as a magical experience and the turning point of his life. A contributor to the third Crypt Group Exhibition in August 1948, Haughton first exhibited with STISA at the Winter Exhibition in January 1949 but resigned at the EGM in February! He left Cornwall in 1951 but returned each year and, for thirty years, his paintings were wholly concerned with the area.

Malcolm Haylett (1923-2000)
STISA: 1950-1995 Secretary 1958
STISA Touring Shows: FoB 1951.
A multi-talented individual, who was a true gentleman, Haylett was an inspiring presence in St Ives for over half a century. Born in Montreal in Canada, Haylett moved back to this country with his parents at the age of two and was brought up in Southend-on-Sea. A keen jazz musician as a youth, he had his own band *Malcolm Haylett and the Collegian Swingers*. He studied art at Southend and at St Martins, where he learnt a broad range of art and design skills. He was invited down to St Ives shortly after the War by his friend, the photographer, Gilbert Adams (q.v.), and was so taken with its ambience that he rented a studio in Westcott's Quay on the spot. His fiancée, Jean, a fashion student, joined him and they married in 1946. His first Show Day was in 1947, when he exhibited portraits and views of old St Ives and he had a one-man show at Downing's Bookshop in 1948.[76] He joined STISA in 1950 and made an immediate impression as a portraitist. His favourite subject was his wife (Fig. 3H-6) but he soon began to win commissions from the rich and famous. An early sitter was Lady Marguerite Tangye (Fig. 3H-7), whose portrait was described as "elegant, stylish and natural, rather than of subtle characterisation".[77] Subsequent commissions included the Duke of Beaufort, Cardinal Heenan, Patrick Lichfield, Sir Russell Brock (the saviour of 'blue babies'), the brain surgeon, Sir Geoffrey Jefferson and many captains of industry and local dignitaries. He was also much in demand as a child portraitist and Jonathan and Hayley Mills, the children of the actor, John Mills, were amongst those that sat for him (see Fig. 3H-8). He had a keen eye for his sitters' distinctive characteristics and photographs of his models standing by their finished portraits demonstrate how adept he was at capturing their likenesses. Each portrait seems fresh and the poses adopted are natural and varied. He was also commissioned by the Royal Yacht Club to depict the return to Plymouth of Sir Francis Chichester.

As a designer, his big break came when one of the organisers of the *Daily Mail* Ideal Home Exhibition popped into the Picnic Box Café, Westcott's Quay, St Ives and was highly impressed with the decor that Haylett, whose studio was next door, had designed. He was accordingly asked to put forward a design for the Grand Hall of the Ideal Home Exhibition and his scheme was selected for the 1954 Exhibition. This was such a success that he was given the extraordinary accolade of having his design selected the following year as well.

To supplement his painting income, he turned his hand to many and varied artistic endeavours. He redesigned a number of shops in St Ives and was a design consultant to Plymouth Breweries. His interior and external designs for his homes, 'Higher Ayr Cottage', and 'High Talland', built on a plot that had formed part of Talland House, were featured in *Ideal Homes*. He also taught art at Redruth School of Art, at the St Ives School of Painting and at Camborne College. He was the first artistic director of the St Ives Festival of Music and Arts in 1953 and his wife and himself were active participants in the yearly Arts Balls. Jean Haylett, who is still alive, has herself been a long-term member of STISA.

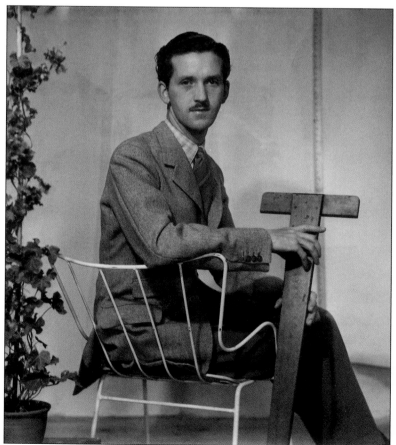

Fig. 3H-5 Malcolm Haylett (Gilbert Adams)

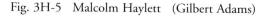

[76] *St Ives Times*, 6/8/1948.

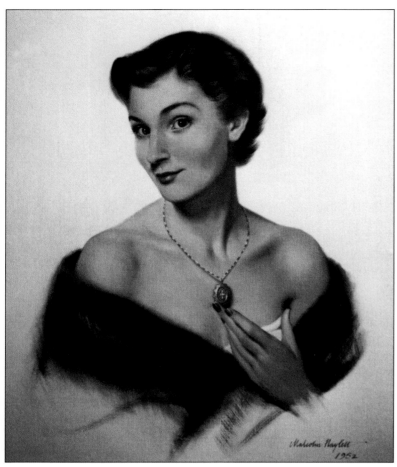

Fig. 3H-6 M.Haylett *The Artist's Wife, Jean*

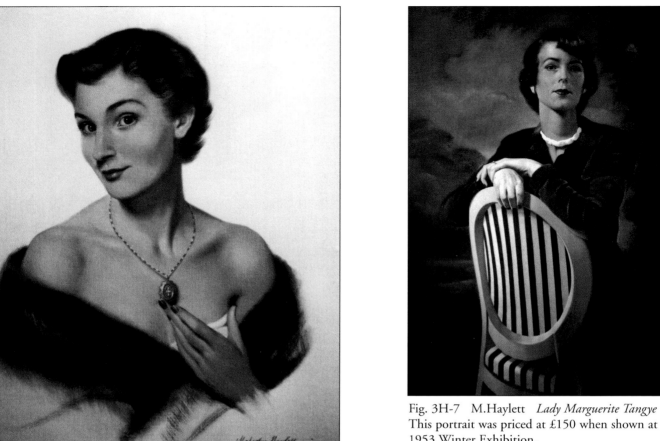

Fig. 3H-7 M.Haylett *Lady Marguerite Tangye*
This portrait was priced at £150 when shown at the
1953 Winter Exhibition.

Fig. 3H-8 M.Haylett *Jonathan Mills*

Fig. 3H-9 M.Haylett *Model*

(Ms) Isobel Atterbury Heath (1907-1989)
STISA: 1945-1949 & 1957-beyond 1982
STISA Touring Shows: 1945, 1947 (SA), 1947 (W).
Little is known of her early years but an autobiographical painting, entitled *Life*, indicates that her father was a chemist and that she was educated by nuns and lived at some juncture at 8, Silver Street.[78] She studied under William Ritson and Robert Blatchford and at Colarossi's in Paris before coming to St Ives to study further under Leonard Fuller. She first exhibited on Show Day in 1940. During the War, she worked for the Ministry of Information, making drawings and paintings of factory workers in the munitions and camouflage factories (see Fig.3H-10). She also executed a number of pencil portraits of American troops and of local characters. These wartime works are some of her best.

She was married for a time to Dr. Marc Prati, the political correspondent to *La Stampa* of Turin, whom she met when he was a prisoner of war, and they had a son. She resigned from STISA in 1949 and was a founder member of the Penwith Society but was one of the first to resign in 1950 in protest at the decision to categorize members into groups. Writing to the local paper, she commented, "As a foundation member, I was in sympathy with the ideals for which we started it, which were that all forms of outlook in painting should show together in unity, toleration and fairness shown to both traditional and the more experimental forms of art. In my opinion, the breaking up of members into two groups, A and B, is absolutely contrary to those ideals, and the true traditions of painting."[79]

Somewhat eccentric, Isobel Heath lived at Bosun's Nest, Carthew, near Clodgy and she rejoined STISA in 1957, exhibiting with the Society for the rest of her life. She had a studio in Custom House Lane but often spent days out on the moors on painting expeditions, staying overnight in her dilapidated van. She produced numerous striking but generally mediocre watercolours of the Cornish coast and she did some large figure paintings in oil, for which her favourite model was Richard Care. Sadly, the work she considered her finest, a modern rendition of *The Last Supper*, failed to attract a bid at her studio sale, possibly due to its vast size. Her pencil portraits, however, are excellent. She published three books - *Passing Thoughts* (1971), *Love* (1973) and *Reflections* (1978).

(Mrs) Jessica Heath (1883-1967)
STISA: 1936-c.1938
STISA Touring Shows: 1936, 1937.
Jessica Doherty was born in Bandon, County Cork and, in 1908, her father, who had been Agent to Lord Bandon's Irish estates, decided to retire to Newlyn, buying 'La Pietra' on Paul Hill. Jessica, who was keen to learn painting, enrolled at the Forbes School in 1908/9. She soon met Frank Heath (q.v.), an artist who had settled locally after studying earlier at the School, and they were married in 1910. They settled initially in Polperro and had already had two children by the time Jessica's father paid for them to build their own home, 'Menwinnion', at Lamorna in 1912. Two more children followed and then Frank was seriously gassed in the War and never fully recovered his health. With heavy family commitments, Jessica had little time for painting but, working mainly in oils, she enjoyed depicting the local Cornish coast while the family swam or played on the rocks (see Fig.3H-11). A small work was included in the 1936 Birmingham tour and *Calm Sea, Carn Barges* was picked for the Exhibition, *Paintings of Cornwall and Devon*, which toured Eastbourne, Lincoln, Blackpool and Leamington in 1936/7. Following Frank's death in 1936, she moved to Frampton in Dorset and, although still a member of STISA in 1938, she does not appear to have exhibited again. She moved back to Bandon, County Cork in 1942 and died in 1967.[80]

Evelyn M. Herring Exh. RA 4
STISA: 1932-c.1940
STISA Touring Shows: 1934
She lived at Pelican Hill, St Ives and her work is first mentioned in the 1932 Winter Exhibition. However, she only appears to have exhibited on Show Day on one occasion - in 1933, when she shared Shearer Armstrong's Piazza studio and was complimented on her "very distinctive watercolours". However, she may well have spent part of each year out in Spain, for her contribution to the 1934 tour was a watercolour *Spanish Village* and all four of her successes at the RA in 1937 and 1940 were Spanish town and harbour scenes. Although she does not appear to have exhibited much with STISA, her successes at the RA and RBA in 1940 are still noted in the *St Ives Times*, as if she was still a member.

[77] *St Ives Times*, 25/12/1953.
[78] I am grateful to Viv Hendra at the Lander Gallery, Truro for this information.
[79] *St Ives Times*, 10/3/1950.
[80] The majority of this information derives from H.Bedford, *Frank Gascoigne Heath and His 'Newlyn School' Friends at Lamorna*, Teddington, 1995.

Fig. 3H-10 Isobel Heath *In A War Factory* (1944)

Forrest Hewit RBA (b.1870) Exh. RA 6
STISA: 1942-1949
STISA Touring Shows: 1945.
Public Collections include Manchester.

Hewit - no relation to Pauline Hewitt - was an unusual man, who managed to combine a successful business career with a successful career in art. Born in Salford, he was educated at Manchester Grammar School and Tattenhall College. His father was a successful calico printer - a process that enabled coloured printing on textiles - and Forrest, who lived in Wimslow, Cheshire, also became a director of the Calico Printer's Association Limited and an acknowledged authority on the cotton trade in Manchester. However, he also studied art privately and then under Richard Sickert. He exhibited at the RA between 1929 and 1936 and became President of the Manchester Society of Modern Painters. In 1936, he had a one-man show of eighty oil paintings at the New Burlington Galleries in London, in which he revealed a variety of styles. His connection with Cornwall is not known but he contributed to the presentation to Moffat Lindner on his 90th birthday in 1942, which suggests he was already a member. He was initially elected as an associate member but had been made a full member by the time of the 1944 Autumn Exhibition. His contribution to the 1945 touring show was a significant work *Afternoon Tea in the Bois, Paris*. His work is last referred to in the Spring Exhibition of 1949.

Richard Heyworth ROI (1862-1942?) Exh. RA 10
STISA: 1929-c.1933
STISA Touring Shows: 1932.
Public Collections include Cheltenham.

Born in Newnham-on Severn in Gloucestershire, he studied at the Ecole des Beaux Arts in Paris under Benjamin Constant and later in St Ives under Olsson and the Australian, David Davies. His work is referred to on Show Day 1899 but, when he is signed into the Arts Club by Olsson in October 1900, he is stated to be living in London. He returned to Cornwall briefly around 1909, when he lived in Falmouth and exhibited with RCPS. Cheltenham Art Gallery have *Her Last Moorings, Falmouth*. By 1912, he had moved to Teignmouth. He was elected to the ROI in 1919. From 1923, he was living in Charlton Kings in Cheltenham and was a good friend of the curator of Cheltenham Art Gallery, D.W.Herdman. He may therefore have had some involvement in organising the 1925 Exhibition by St Ives artists in Cheltenham. Heyworth contributed six works to this show, including one of his major exhibition pieces, *Teignmouth*, (now owned by Cheltenham Art Gallery), which had been exhibited at the RA in 1915 and later at the Paris Salon. Although priced at a hefty £250, Heyworth recorded that he had been told by La Thangue to price his work at £500-£600 as, if work was only priced at £250, people thought that there was something wrong with it!

Heyworth applied to join STISA in 1929 - his application being accepted "on his reputation as a painter" - but his contributions were sparse and he did not even feature in the touring show which took in Cheltenham in 1936. A Memorial Exhibition was held at Cheltenham in 1942.

(Ms) Amy Elizabeth Blanche Hicks (b.1876)
STISA: 1949-1961
STISA Touring Shows: 1945. Also FoB 1951.
Born in Devoran in Cornwall, she studied at Truro, Falmouth and Redruth Schools of Art and in Newlyn in Norman Garstin's studio. Although included in the 1945 tour and in the 1947 tour to Newquay, where she lived, she was not made a member until 1949.[81] Her speciality was flower painting in watercolour and, in 1951, she showed at the Paris Salon. She also taught art.

Philip Maurice Hill SMA (1892-1952) Exh. RA 2
STISA: 1939-1952
STISA Touring Shows: 1945, 1947 (W). Also FoB 1951.
Maurice Hill was the first Secretary of SMA, which was formed in 1939, and he was probably persuaded to join STISA by Borlase Smart, who was also on the first Committee. Son of a judge, he was a man of many parts. He was educated at King's College School and read history at Balliol College, Oxford. His training as an architect was interrupted by the Great War and he then decided to qualify as a solicitor, which he did in 1923. He was immediately appointed Assistant General Manager of the UK Chamber of Shipping, becoming Deputy General Manager in 1938 and General Manager in 1941, a post he held until 1950. However, from 1933, he also painted and exhibited at a number of leading art societies, showing 108 works at Arlington Galleries, and he was successful at the RA and the Paris Salon. He also designed a poster of Polperro for GWR. He was a devout Roman Catholic and he and his wife, Megan Rhys, painted the panels of Christ and the 12 Apostles and the four Doctors of the Church which used to hang on the front of the organ loft at St Ives Roman Catholic Church.

His first exhibit with STISA was an oil of Corsica, which was complimented on its "rich and refined palette" and he was successful at the RA in 1941, with *The Depth Charge*, which was also included in the 1947 Cardiff show. However, by that time, he had suffered badly in the War. Sven Berlin recalled,

"Maurice Hill was a war casualty - one of those incredible cases of a sweet spirit, imprisoned in a crippled body that was always in pain. I have never come across worse. In the temple of daily life, it brings a curse upon mankind whenever he comes to my mind. I used to meet him in the Sloop most evenings in winter, where he could just make his way from his studio behind the pub, to talk over a pint about books and painting and exchange notes about our different wars."[82]

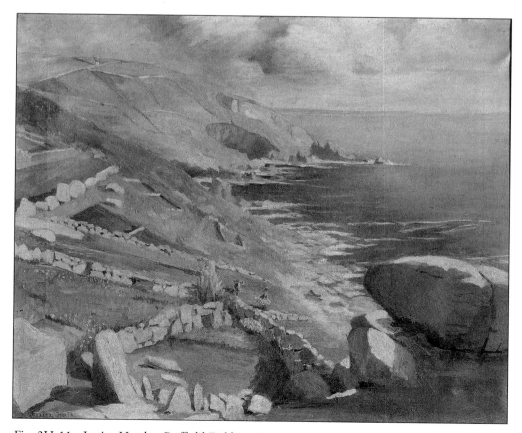

Fig. 3H-11 Jessica Heath *Daffodil Fields at Carn Barges, Lamorna* (Hugh Bedford)

[81] *St Ives Times*, 22/4/1949.
[82] S.Berlin, *The Coat of Many Colours*, Bristol, 1994, p.201.

Nevertheless, he continued to paint and exhibit Cornish coastal scenes and, in 1949, he exhibited with SMA two works that he had painted on board *S.S. Himalaya* in September that year, as it had passed St Ives and Land's End. When he died, he had just completed a new translation of the Greek poet Sappho, which was being printed by Guido Morris. Sadly, he passed away the night before the advance copy was delivered, long overdue.

Eric Hiller (d.1965)
STISA: 1950-1965
STISA Touring Shows: FoB 1951.
Hiller, who had had a show at Goupil Gallery in London in 1938, came down to Cornwall with Charles Breaker for a short holiday in 1945 and stayed at Mousehole. There they met Marjorie Mort and, in 1947, they decided to move down permanently. Hiller bought Gernick Field House and Studio in Tredavoe Lane, high on the hill overlooking Newlyn, with spectacular views across Mount's Bay. In 1949, Hiller, Breaker and Mort formed the Newlyn Holiday Sketching group and ran summer courses for the next fifteen years. Hiller's work is first mentioned in the 1950 Summer Exhibition, where his watercolours were noted for their virile technique and bold use of colour. He was made an honorary member in 1963, shortly before his death.

Edward Bouverie Hoyton RS FRSA (1900-1988) Exh. RA 11
STISA: 1951-1988
STISA Touring Shows: FoB 1951.
Public Collections include British Museum, Victoria and Albert Museum, University of Wales, Aberystwyth and Penzance.
The profile of Bouverie Hoyton has been raised dramatically by the purchase in 2000 of a huge collection of his work by The School of Art Gallery and Museum, University of Wales, Aberystwyth. Born in Lewisham, Edward Bouverie Hoyton studied etching under Stanley Anderson at Goldsmith's College. He was one of a small group of talented etchers of pastoral landscapes, along with Graham Sutherland, Paul Drury, Robin Tanner and William Larkins, who sought inspiration in William Blake and Samuel Palmer. In 1926, he won the coveted 'Prix de Rome' and he spent the next three years at the British School in Rome, travelling widely in Italy, France, Greece and Spain. He was successful at the RA for the first time in 1925 and had regular success there with his etchings and drypoints until 1933, during which time he was living in the London area. However, Devon and the West Country were a fruitful source of subjects for his work in the early 1930s. He was elected to the National Society in 1931 and to the RBA in 1936. He became Lecturer in Engraving at Leeds College of Art in 1934 before, in 1941, being appointed Principal of Penzance School of Art. He remained a close friend of Graham Sutherland who stayed with him during the war when he was drawing the Cornish tin miners, and it was Hoyton who introduced Sutherland to Ben Nicholson, Naum Gabo and Adrian Stokes. At this juncture, Hoyton was attracted towards abstraction and worked with John Wells and Naum Gabo. However, by the time he joined STISA in 1951, he was concentrating on typical Cornish landscape and marine subjects.

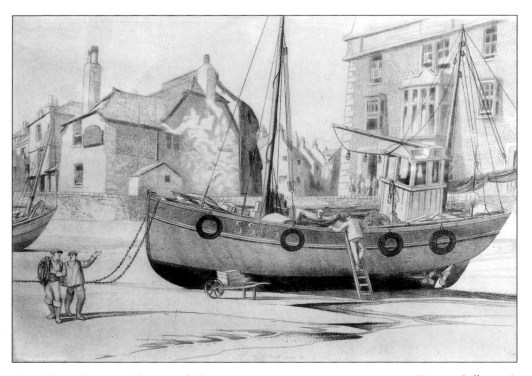

Fig. 3H-12 Bouverie Hoyton *St Ives* (Private Collection)

Although he also painted in oils and watercolours, his etchings are his finest work. He was elected a Fellow of the Royal Society of Artists in 1958. He retired in 1965 to concentrate fully on his etching and became Vice-President and Chairman of STISA, eventually stepping down in 1981. The University of Wales collection comprises 215 etchings, 6 woodcuts and 66 watercolours and drawings spanning the period 1920-1980.[83] It includes unique work such as etched portraits of Graham Sutherland and Naum Gabo, and of Mussolini and the Pope. A fine collection of his Cornish etchings have also been donated to Penlee House Gallery and Museum, Penzance and there are further examples of his etchings hanging in STISA's own Norway Gallery. His wife, Inez, was also an artist but she joined STISA later.[84]

(Miss) Winifred Humphrey Exh. RA 3
STISA: 1927-1959
STISA Touring Shows: 1936,1937. Also FoB 1951.
She studied at the Simpson School of Painting and her portrait by Ruth Simpson was exhibited on Show Day in 1921. She herself was successful at the RA that year and exhibited from 7, Piazza Studios on Show Day in 1922, when she was again successful at the RA. She was included in the 1922 joint exhibition of the St Ives and Newlyn colonies at Plymouth Art Gallery and also exhibited at the Jubilee Exhibition at the Walker Art Gallery that year. A founder member, she did not settle for any length of time in St Ives but she contributed still life paintings irregularly from her home in Cheltenham to STISA shows for over 20 years.

Harry Greville Irwin RBA (1893-1947) Exh. RA 8
STISA: 1946-1947
STISA Touring Shows: 1947 (SA), 1947 (W).
Irwin's suicide in 1947 came as a great shock as, in the short time that he had been based in St Ives, he had become well-liked for his camaraderie, enthusiasm and cheerfulness. However, this hid permanent agony, the result of very serious wounds to his spine suffered at the beginning of the First World War, from which recovery was hopeless. Despite this, Irwin had battled on to study in Paris in 1924 and in Brussels in 1926 and had made a significant name for himself as a landscape and figure painter. He was a member of the RBA and the London Sketch Club and exhibited regularly at the RA from 1936. At that stage, he was living in Ewell in Surrey. During the Second World War, he worked as a camouflage artist and on arriving in St Ives in 1946, he took Downunder Studio.[85] His contributions to the Cardiff Exhibition included *The Changing of the Guard* and *Return from Sandringham*, for which he had been awarded the Lazlo Bronze Medal by the RBA. His last RA exhibit was *Low Tide, St Ives*. A hernia problem may have been the final straw, causing him to shoot himself in his rooms.

Fairfax Ivimey
STISA: 1936-1946
STISA Touring Shows: 1936, 1937.
He lived at The Fort, Newquay and contributed landscapes in oils and watercolours to a number of STISA shows.

(Mrs) Constance Eileen Izard (d.1957)
STISA: 1940-1957
STISA Touring Shows: 1947 (SA). Also FoB 1951.
She first exhibited as a new associate member in the 1940 Autumn Exhibition. She studied under Fuller and specialised in flower paintings and portraits. She lived at Moor Cottage, Rosewall, St Ives.

(Miss) Caroline Jackson
STISA: c.1928-c.1934
STISA Touring Shows: 1932, 1934.
Jackson was the only exhibiting sculptor member of STISA in its first decade. She first exhibited in 1888, when she was living in Birkenhead. She seems to have moved to St Ives in 1904, joining the Arts Club in December 1906, but her work is not mentioned in a review of Show Day until 1910. She worked principally in plaster but exhibited the occasional bronze and some small plasticine figures. A figure of a ballet dancer was greatly admired for its pose and rhythm of line. Although not a founder member, she contributed work to shows in 1928. In 1932, she was living at 8, Bowling Green Terrace. In the 1934 Summer Exhibition, she exhibited a sculpture of her sister, Alice Marie Therese Jackson (1872-1958), a watercolour painter, who had come to St Ives

[83] The School of Art Gallery and Museum has established 'The Edward Bouverie Hoyton Archive' in Aberystwyth with the support of the Resource/V&A Purchase Fund and the National Art Collections Fund. The 'Archive' consists of prints, drawings, watercolours, some copper plates, commercial designs, correspondence, photographs, press cuttings, the unpublished manuscripts for his novel *More Things in Heaven*, and autobiographical short stories *The Art of Craft* and *The Craft of Art*.
[84] I am deeply indebted to Robert K Meyrick, Senior Lecturer and Keeper of Art, School of Art Gallery and Museum, University of Wales, Buarth Mawr, Aberystwyth for the information contained in this biographical note but any errors are my own.
[85] His address in 1940 is in Leamington.

in 1926 from Birkenhead to join her. Although her sister did exhibit in the 1930 Spring Exhibition, she was more a stalwart of the Arts Club, where she acted in many a production.

Frank Jameson (1898-1968) Exh. RA 2
STISA: 1939-1968
STISA Touring Shows: 1945, 1947 (SA), 1947 (W). Also FoB 1951.
Born in London, Jameson worked initially as an insurance salesman, attending evening classes at Birmingham School of Art. During the Great War, he served in the Worcestershire Regiment and was responsible for building bridges and blockhouses. On demobilisation, he lived in Redditch and painted landscapes, often venturing on camping tours around the south of England. His early work is signed F.Jameson-Smith. In 1926, he studied at the Forbes School of Painting. He appears to have revisited St Ives in 1937/8 as his sole successes at the RA in 1938 were both St Ives Harbour scenes. He first exhibited with STISA in the 1939 Autumn Exhibition but may not have exhibited during the War years as he is described as a new contributor in 1946. By then, he had moved to Falmouth, where he had a studio with a fine view of the River Fal, which featured often in his works (see Plate 46). He was successful at the Paris Salon with *Fishing Boat SS122 setting out from St Ives Harbour* (Plate 81) in 1948 and with *Blue Morning, St Ives* (Fig.3J-2) in 1967. In addition to his colourful marine scenes, he painted nudes and figure studies and was an important member of the Society for the rest of his life. His portraits were often highlights of STISA shows and John Penwith commented in 1950 that he was "an artist to be compared with the late Sir William Nicholson in the graceful perfection of his figures". His daughter, Daphne, who often posed for him, was also a long-term member of STISA. His studio collection was sold by W H Lane & Son in 1994.[86]

(Miss) Hilda K Jillard (1899-1975)
STISA: 1943-1949
STISA Touring Shows: 1945, 1947 (W), 1949.
Public Collections include Imperial War Museum and Newlyn.
Born in Godalming, Jillard studied at Farnham School of Art, at the Slade under Tonks, at Frank Calderon's School of Animal Painting and in Paris. She first exhibited in 1928, when she was living in King's Lynn, and was a regular exhibitor with the Guildford Art Society. In 1939, she had an exhibition of oils at the Wertheim Gallery in London.[87] Her oil, *1939 - What Harvest?*, is in the collection of the Imperial War Museum. She came to Cornwall in 1942. Her first Show Day was in 1943, and she was raised from associate to full membership of STISA in 1944. In 1947, she held an exhibition of work simultaneously at the Blue Bell Studio and at the Castle Inn. In opening her exhibition at Downing's Bookshop in 1948, which contained works, including a self-portrait, dating from the late 1930s, David Cox commented that she was "a bold and enterprising painter - one might almost say an experimentalist...[Her] pictures are clever, thoughtful, at times amusing, even alarming, but always alive and stimulating." She resigned in 1949 and became a founder member of the Penwith Society. Her large fresco paintings for the Penwith Arts Ball each year became well-known until she left the district in 1954.

J Tiel Jordan
STISA: 1929-1932
STISA Touring Shows: 1932.
His work is first mentioned on Show Day 1929 when he is complimented for approaching nature "with the true appreciation of traditional watercolour art" and he exhibited at STISA's Summer show that year.[88] Thereafter, his dainty and delicate watercolours are frequently praised. In 1931, he was one of only 22 artists invited to represent STISA at the show at Harris and Sons, Plymouth. He appears to have fitted in well to the colony and was a good friend of Bradshaw and Smart but he suffered a heart attack at one of their soirées and left the town. In 1932, he was living at Newcastle, Staffordshire.

(Miss) Phyllis Tiel Jordan Exh. RA 1
STISA: 1930-1938
STISA Touring Shows: 1932.
Her one success at the RA was in 1928, when she was living in Darlington. The only one of six applicants to be elected to membership of STISA in June 1930, she painted landscapes and still life in watercolour in a clean, crisp style. In 1931, she was one of only 22 artists invited to represent STISA at the show at Harris and Sons, Plymouth. In 1938, she was living in Leicester but ceased her membership shortly afterwards.

[86] The sale, dated 29/11/1994, included a number of portraits of his wife, Joyce, and daughter, Daphne. Further works were sold at subsequent auctions including his Paris exhibits.
[87] Much of the preceding information was obtained from J.Wood, *Hidden Talents*, Billingshurst, 1994.
[88] *St Ives Times*, 23/3/1929.

Fig. 3J-1 Frank Jameson *The Artist and his Wife*
(W.H.Lane & Son)

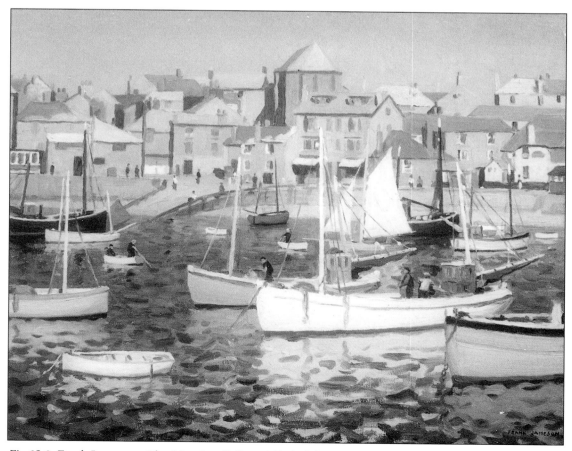

Fig 3J-2 Frank Jameson *Blue Morning, St Ives* A Paris Salon picture (W.H.Lane & Son)
The Society's Gallery can be seen at the rear in the centre.

Leslie Kent RBA SMA (b.1890) Exh. RA 8
STISA: 1940- beyond 1982
STISA Touring Shows: 1947 (SA), 1947 (W), 1949. Also FoB 1951.
Public Collections include Hull (RSMA)
Educated at Bedales and Leeds University, Kent was a pupil of Fred Milner (q.v.) between 1918 and 1920. He exhibited at the RA infrequently between 1934 and 1961 and, throughout, his address is given as in Radlett, Hertfordshire. However, probably as a result of meeting Smart through his involvement with SMA, he first started exhibiting with STISA in 1940, the year when he was also elected a full member of RBA, and Cornish subjects feature regularly among his wartime works, with his 1944 RA exhibit being *Afternoon Sun, St Ives*. Thereafter, he was a regular contributor of marine subjects, which had a simple colourful directness, and, in 1965, he was made an Honorary Vice-President of STISA and retained this title until his death in his nineties.

(Mrs) Elizabeth Lamorna Kerr (1904-1990) Exh. RA 12
STISA: 1945-1961
STISA Touring Shows: 1947 (SA), 1947 (W).
Mornie, as she was known to everyone, was Lamorna Birch's eldest daughter and, accordingly, was brought up in an artistic environment. She was much in demand as a model, sitting for Augustus John, Laura Knight, Thomas Gotch and Algernon Newton. She was educated at Badminton School in Bristol and had some classes at Bristol Art School but, naturally, her father provided additional art lessons and her style of painting and choice of subjects reflects his influence. She recalled his advice as "Paint, look around you and observe. Paint some more."[89] After school, she went up to London with the idea of becoming a ballet dancer. Instead she spent a period working as a milliner before marrying James Lennox Kerr, a mariner and author. During the preparatory voyage for his book, *Cruising in Scotland*, which was illustrated by her father, she contracted tuberculosis and subsequently lost a lung. They returned to Cornwall in 1939, the year she was first hung at the RA, and she was successful on a regular basis until 1951. In 1944, she and her husband moved to Lamorna and she looked after her father until his death in 1955. She joined STISA in 1945. Developing a somewhat freer style than her father, her beloved Lamorna featured regularly in her work and she also specialised in flower paintings. Her husband died in 1963 after which she became "the uncrowned queen of Lamorna" - a popular figure who painted and taught art and who was always keen to keep interest alive in her father's work. She was a positive, encouraging teacher and a forceful, down-to-earth personality. A short note on aspects of her life, *In Time and Place, Lamorna*, was published by Melissa Hardie in 1990, the year of her death.

Fig. 3K-1 E. Lamorna Kerr *The Arched Tree, Curlslinick* (RA 1943) (W.H.Lane & Son)

[89] M.Hardie, *In Time and Place, Lamorna*, Newmill, 1990 at p.46.

(Miss) Margaret Helen Knapping WIAC (d.1935) Exh. RA 3
STISA: 1927-1935
Helen Knapping was a respected elderly artist, who on her death bequeathed the Piazza studios to the RBA in the forlorn hope that they would remain as artists' studios.[90] She studied under E.Aubrey Hunt in England, France and Belgium. A landscape and flower painter in oils and watercolour, she first showed with RCPS in 1897, her exhibit being *St Ives Harbour*. She took over William Titcomb's Piazza studio when he left St Ives in 1905 and in 1920 purchased the freehold of the whole block. She was a member of the Women's International Art Club and also designed Christmas cards and produced illustrations for children's magazines. She was a regular exhibitor on Show Day, in later years exhibiting with Miss Davenport in 6, Piazza Studios. By then, she was working mainly in watercolour. She was still exhibiting in the 1920s at the Goupil Gallery in London and with SWA but her contributions to STISA shows were infrequent. A keen golfer, she divided her time between her house in Sloane Street, London and St Ives.

(Miss) Cecil de Wynter Lane
STISA: 1932-c.1940
STISA Touring Shows: 1932, 1937.
Although a founder member, her status seems to have undergone a number of changes, possibly due to the fact that she was the daughter of E. Tudor Lane (Lady Blumberg) (q.v.). Initially, Cecil was an associate member but she started exhibiting with the Society in 1930 and, in 1932, the Minutes record her being made up to a full member. However, her art - mainly flower paintings and landscapes in watercolour - was never that strong and, with the increase in quality of the membership, it appears that she reverted to being an associate member as she is later appointed to the Committee as representative of the associate members. She continued to exhibit on Show Days during the 1930s but was in desperate financial straits by the end of her life.

(Ms) Eliza Tudor Lane (Lady Blumberg) (d.1931)
STISA: 1927-1931
She was a regular exhibitor with RCPS and her watercolours were first shown there in 1886. She later studied under Stanhope Forbes and married General Sir Herbert Blumberg. In 1902, she was living in 'The Tower House', Boscastle. Her husband and herself retired to St Ives in the mid-1920s and became actively associated with the Art Colony, although Lady Blumberg was by then an invalid. A founder member of STISA, her first Show Day was in 1927 and she also contributed to the first show in the Porthmeor Gallery in 1928. She specialised in sea paintings, which she executed directly and spontaneously in watercolour.[91]

Faust Emmanuel Lang (1887-1973) Exh. RA 2
STISA: 1950-1973
STISA Touring Shows: FoB 1951.
Public Collections include Bournemouth and St Ives, and churches in St Ives (Catholic), Tintagel, Bodmin and Kensington (St Mary's). Faust Lang was born in Oberammergau, Bavaria. His father was the wood sculptor, Andreas Lang, and he received instruction from him from the age of seven. Between 1890 and 1930, he took part in the famous Passion Play on five occasions, often making musical contributions. A keen skier, in 1922, he won a bronze medal at the first Winter Olympics. The worsening political situation in Germany led Faust Lang to bring his family to Wiltshire in 1933. In 1934, they built a cottage at Mawganporth, near Newquay, and Faust soon developed a significant reputation for his wood carving. They moved to St Ives just after the Second World War in order to experience the ambience of the art colony. Already in receipt of significant commissions, with work in Art galleries in London and Paris, Lang's arrival shortly after the split, along with his son, Wharton, and Barbara Tribe ensured that sculpture became one of the most highly regarded sections of STISA shows during the 1950s. Numerous religious organisations commissioned figures of the Madonna, Christ and various saints, (such as, for example, St Ia for the St Ives Roman Catholic Church) and his portrait studies included one of Winston Churchill. Nudes were also a speciality but he was probably best known for his sculptures of animals, particularly horses. He was always an ardent student of nature, sometimes spending weeks at a time observing deer and other creatures in the wild. However, he rarely used sketches. "The chisel is my only pencil."- he observed - "Most people work from drawings, but I should hate to restrict myself in that manner....I watch carefully, then I pick out something that strikes me, and I try to express in wood what some say in words, some in music, and others with pencil or paintbrush."[92] Much of his work was done with driftwood that he picked up from the beach but his creative powers were tested by the many small commissions he received from members of the public. "People send me pieces of wood from favourite trees, old windmills or even wrecks with a request to have them carved into keepsakes. Others send me photos of their pets, with the request that I make a life study of the dog or cat". This English obsession with their pets he found charming, as he had a special weakness for animals as well. "I am never happier than when I am transforming a shapeless piece of wood into some proud animal - for choice, a horse."[93] His sculpture *Tern* was bought for St Ives from STISA's 1951 Festival of Britain Exhibition. He remained a valued member of STISA until his death, serving on the Council from 1964 until 1970.

[90] The terms of her bequest are outlined in *St Ives Times*, 15/11/1935.
[91] Obituary, *St Ives Times*, 1/1/1932.
[92] *News Chronicle*, 1939, West Crafts 99.
[93] ibid.

(Mrs) Una Shaw Lang (1889-1981)
STISA: 1950-1973
STISA Touring Shows: FoB 1951.
Una Shaw Lang was the English born wife of Faust Lang and was a watercolour painter, with a fondness for animals. She had an unconventional childhood and did not attend school. She received no formal art training but had guidance from her aunt, the artist, Helen Cochrane. She met her husband in Oberammergau in 1909, having journeyed with her mother, Gertrude Metcalfe-Shaw, in a gypsy caravan across Europe. Her mother, this time in conjunction with both her daughters and Faust Lang, travelled in similar fashion along the old pioneer trails in America in the mid-1920s, an experience she wrote about in *English Caravanners in the Wild West*. Una provided some of the illustrations. Like her husband, she joined STISA in 1950 and was a member for over 20 years. Her watercolours, whether landscapes, portraits, still lifes or animal studies, revealed her fine drawing abilities but she did not exhibit after her husband's death.

Fig. 3L-1 Una Shaw Lang *The Family Cat*

Fig. 3L-2 Una Shaw Lang *Still Life*
featuring a carving in wood of a foal by Faust Lang

Wharton Dietrich Faust Lang SWLA HRSMA (b.1925)
STISA: 1950-present day, Assistant Secretary 1964-66, Treasurer 1967 for many years
STISA Touring Shows: FoB 1951.
Public Collections include National Maritime Museum, RSMA, Bournemouth, Belfast and churches at St Ives, Wareham and Ashburton.
The wood sculptor, Wharton Lang, is the only current member of STISA who was also a member during the period covered by this Exhibition. His work has accordingly graced STISA shows for over 50 years. Born in Oberammergau, Bavaria, he arrived in Cornwall in 1933 with his parents, Faust and Una. While they were living at Mawganporth, he was taught by his father and, when the family moved to Fauna Cottage in St Ives, he studied painting under Leonard Fuller. He also joined STISA in 1950 and he still works from a converted fisherman's loft and wartime look-out on Mount Zion, which was the studio used by his father. He has done many commissions for churches and convents, including the twelve Stations of the Cross for St Ives Parish Church, and, in the late 1980s, he was commissioned to do a relief carving of the Castle of Mey for presentation to the late Queen Mother. However, he is now best known for his sculptures of animals in wood and, not surprisingly, sea-creatures figure regularly in his work. Cormorants with their long curvaceous necks, wide-eyed seal pups, graceful dolphins and leaping fish are just a few of the subjects that attract him. He enjoys working in all English hardwoods, particularly yew, and it is the shape and the grain of the timber that dictates his choice of subject. As the wood reveals itself whilst he is carving, the design adjusts to the flow of the grain and the emergence of knots. His aim, like his father's, is to give his subjects life, with each piece having a spirit of its own. He is now an Honorary Member of RSMA, having exhibited with that Society since 1958, and is also a member of SWLA.

Fig. 3L-4 Faust Lang *St George and the Dragon* on display in the New Gallery

Fig. 3L-3 Faust Lang at work on *St. Luke* in his studio

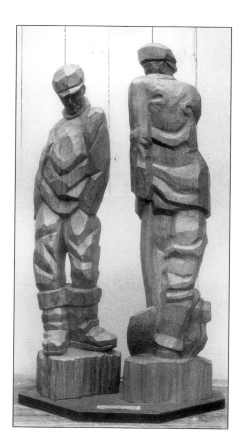

Fig. 3L-5 Wharton Lang *Nothing Doing* (a fisherman with an empty net) and *Doing Nothing* (a man leaning on a shovel)

Fig. 3L-6 Faust Lang *The Skater*
This work secured Lang's election to membership of STISA but was subsequently stolen from his studio.

(Miss) Louisa Margaret Larking SGA (b.1898)
STISA: 1932-1934
STISA Touring Shows: 1934.
The long-term companion of Marjorie Ballance, she was born in Melbourne, Australia and studied at the Slade, the LCC Central School and at the Royal College of Art. In 1929, she was living in Warlington, in Dorset, but her work is first mentioned in St Ives in the 1932 Winter Exhibition and, on Show Day in 1933, she exhibited work in pen and sepia. In the 1933 Summer show, her "exquisite flowerpiece", *Pink Campions*, was considered "the most dainty and unassuming floral group of the show". However, her work does not appear to have been included in any exhibitions after 1934, although she did exhibit on Show Day in 1938.

Denys Maurice Orlando Prideaux Law (1907-1981)
STISA: 1949-1981, Deputy Chairman 1965-1977
STISA Touring Shows: FoB 1951.
Denys Law was another of the artists who joined STISA shortly before the end of the period covered by the Exhibition but who went on to make a major contribution to the Society over the next thirty years. Born in Pangbourne in Berkshire, he was the son of an architect but his parents separated when he was quite young and he lived for a while with his mother and sister in Quimper in Brittany. It was his mother, herself a keen amateur artist, who encouraged his interest in art. He was educated at St Petrocs, Rock in North Cornwall, which was owned by a Miss Vivian who had a house in Lamorna. She was very kind to him, as an accident had affected his ability to walk, and his family probably holidayed with her in Lamorna at this juncture. He then went to Imperial Services College, before training as an electrical engineer at Faraday House. He found work in the Home Counties, married and had two children. During the Second World War, being in a 'reserved occupation', he was not permitted to join the Navy, as he desired, and became Assistant District Engineer of the region around Wembley, responsible for restoring electricity during and after bombing raids. At this time, he fell in love again and, after the War, he moved down to Lamorna with his second wife, 'Ann', as his sister was now the landlady of 'The Wink' public house in the village. He took up painting full time and supplemented his income with a variety of odd jobs, working as a fisherman and using his engineering knowledge and his skill with his hands. He did copperwork, carved wood and made furniture, whilst his wife used a loom to weave textiles.

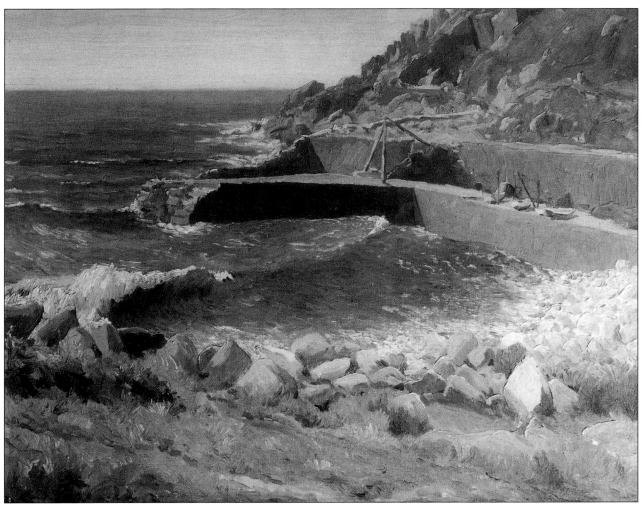

Fig. 3L-7 Denys Law *Lamorna Quay* (Private Collection)

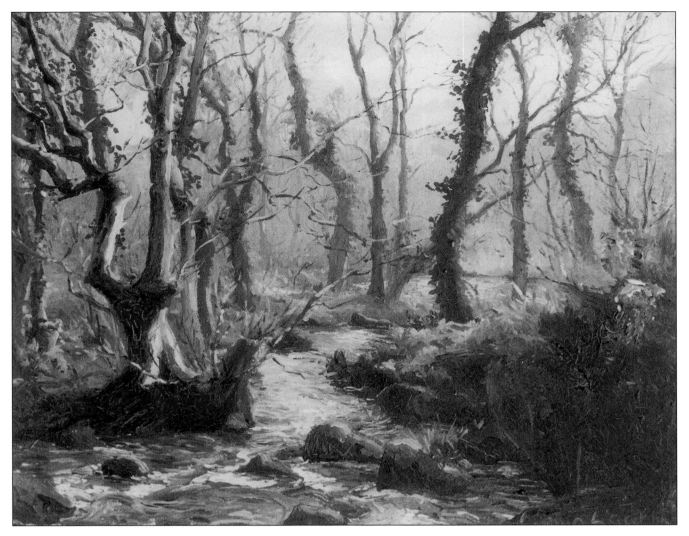

Fig. 3L-8 Denys Law *The Stream, Lamorna* (W.H.Lane & Son)

On his arrival, Lamorna Birch and Stanley Gardiner were the principal painters in the Valley. Although he did not take lessons from either of them, his depictions of Lamorna are clearly influenced by these two champions of the Valley. When describing its charms, he commented,

"It's a unique valley. There's almost something unworldly about it. From the end of September to April are the best months here, for the painter anyway. You get the colouring and you can see the shapes in the trees. When they are laden with leaves, all this is hidden. As a painter, I like to see beyond the immediate foreground...This recession and the lighting are the two main things I concentrate on."[94]

Like the original Newlyn artists, he often preferred to paint on grey days, when he felt the light was at its best. He would often be seen painting around Lamorna, but such sketches were not normally worked up into finished pieces. They were used to assist in the design and composition of paintings executed in the studio. Law worked primarily in oils and used board covered with a gesso ground, rather than canvas. He also knew a great deal about paint, having visited Winsor and Newton regularly during his time as an electrical engineer. He observed, "A knowledge of paint is a good thing for an artist. A picture largely depends on the kind and quality of the paint you use."[95] His paintings of the stream, woods and cottages of Lamorna in various seasons, of Cornish headlands and of yachts and boats off the Cornish coast are now popular and several have been reproduced by Medici but, during his life, with representational art out of favour, times were often tough and he was forced to exchange paintings with his friends in the community for fish or produce. He visited Germany often with the local youth club, which he ran with his sister, and he arranged for a number of his ink drawings to be engraved and ran off copies on his own ancient press. In addition to his great involvement with STISA, where he was Deputy Chairman for twelve years, he was also a stalwart of the Newlyn Society of Artists, where he was Chairman for many years.

[94] From M.Williams, *Painter who loved life in Lamorna*, unidentified newspaper article.
[95] ibid.

(Miss) Dorothy Alicia Lawrenson Exh. RA 7
STISA: 1940-1975
STISA Touring Shows: 1947 (W). Also FoB 1951.
Lawrenson first came to St Ives in 1940, when the school at which she was Art Mistress, The Down's School, near Bristol, was evacuated to St Ives. She had previously worked at Ayton School, Great Ayton in Yorkshire. As she had already exhibited at the RA between 1935 and 1940, she was immediately made a full member, first showing at the 1940 Autumn Exhibition. In 1942, a large painting of local St Ives schoolchildren was exhibited at the Royal Portrait Society's Golden Jubilee Exhibition at the RA. After the War, she stayed on in St Ives and, in 1947, she held a one man show at Downing's Bookshop. The reviewer commented, "The paint is put on in a direct and easy manner, and the colouring is true and remarkable in its clarity. In addition to the smaller flower paintings and harbour scenes, there are a number of portraits, which show strong characteristics."[96] A further one man show at Studio 27 in The Digey in 1957 was described as "an exhibition for people in holiday mood: the pictures are charmingly diverse, but the collection as a whole reflects the bright colours and the clear air of West Cornwall in summertime. Within academic limits, Miss Lawrenson is a versatile and adventurous artist."[97] She lived at Ballingate, Manor Road, St Ives and continued to exhibit with STISA until 1975. Examples of her work, including her portrait of Bernard Ninnes (q.v.), can be seen in St Ives Arts Club.

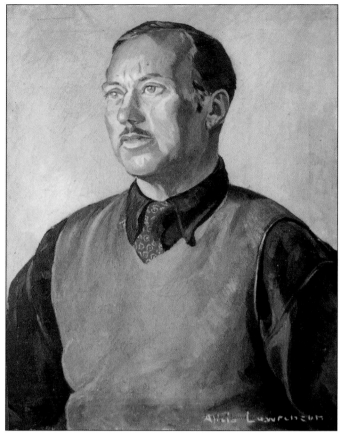

Fig. 3L-9 D.Alicia Lawrenson *Bernard Ninnes* (St Ives Arts Club)

(Ms) Gai Layor
STISA: 1951-1955
STISA Touring Shows: FoB 1951.
Her first Show Day was in 1950, when it was felt her long residence abroad had ripened her colour. She studied under Fuller and exhibited still lifes, portraits and local scenes, working principally in oils.

Bernard Howell Leach
STISA: 1927-1949
STISA Touring Shows: 1936.
Public Collections include British Museum and Tate Gallery.
Born in Hong Kong, Leach studied at the Slade under Legros and at the London School of Art and is best known for his pottery. Having lived in Japan for ten years studying Japanese pottery processes, he founded the Leach Pottery in St Ives in 1920. However, he also was a painter and etcher - he studied the latter art under Frank Brangwyn - and his etchings impressed Borlase Smart on Show Day 1922 for their draughtsmanship, quality of line and artistic expression. Four of these are in the collection of the British Museum. Despite the inclusion in the 1925 Cheltenham show of a selection of 28 Leach pots, an early decision by STISA to exclude crafts left him as a peripheral figure. Only occasionally does he exhibit work with the Society - his contribution to the 1936 tour being a portrait. Nevertheless, he remained a member. In 1930, he gave a fascinating talk to members on *The Training of An Eastern Artist* and, in 1935, he spoke again about his return trip to Japan. He resigned, however, in 1949 and joined the Penwith Society, where craftsmen were recognised.

(Mrs) Augusta Lindner (1868-1952) Exh. RA 2
STISA: 1927-1949
STISA Touring Shows: 1932, 1934, 1936, 1937.
Augusta Baird Smith is signed in at the Arts Club as a visitor of Henry Harewood Robinson in November 1895. She became one of Olsson's first pupils in St Ives. She met and married Moffat Lindner and remained based in St Ives until his death in 1949. A founder member of STISA, she painted principally in watercolour and specialised in flower and garden studies. Her work was

[96] *St Ives Times*, 15/8/1947.
[97] *St Ives Times*, 2/8/1957.

244

considered "sensitive and expressive in draughtsmanship, direct in handling and quietly harmonious in colour".[98] Her first success at the RA was in 1904 with *Eventide, St Ives Harbour* but she was not successful again until 1933. Her husband commented, "My wife has always been a great help to me. I think a lot of her criticism - in fact, I consult her on everything."[99] The Lindners lived at Chy-an-Porth, a large house on The Terrace with a lovely view over the Bay. A painting of them at home with their daughter, Hope, by Frances Hodgkins, which is now in Dunedin Art Gallery, New Zealand, was included in the 1927 Retrospective Exhibition organised by STISA. Hope was also painted by Mia Brown, wife of Arnesby Brown, and by Arthur Hayward. In the 1940s, Gussie often represented her husband at A.G.Ms as he was too frail to attend but she does not appear to have exhibited during this period. On Moffat's death in 1949, she moved to live with her daughter, first in Northamptonshire and then in Devon.

(Miss) Daphne Lindner ARE (b. 1912)　　　　Exh. RA 4
STISA: 1936-1937
STISA Touring Shows: 1936, 1937.
Public Collections include British Museum and RE.
Born in Cheltenham, she was the daughter of Murray Lindner, a manufacturer. She was educated privately and studied at the Cheltenham School of Art before winning a scholarship to the Royal College of Art, where she was a Robert Austin prizeman and a silver medallist. A niece of Moffat Lindner, she specialised in etching and was made an ARE in 1935. She contributed to STISA briefly in the mid-1930s, the period when she was also successful at the RA. In the 1936 tour, she showed *The Back Kitchen* (RA 1935), *The Blue Cockatoo* (RA 1936) and *The Harpist*, the latter being in the British Museum collection. The RE collection includes *Convalescence*.

Walter Llewellyn Lister (1876-1951)
STISA: 1944-1947
STISA Touring Shows: 1945, 1947 (W).
Public Collections include British Museum.
A watercolourist and colour printmaker, he studied at Westminster School of Art and at St Martin's School of Art between 1900 and 1904. For most of his career, he was based in London but he seems to have retired to Bodmin during the War years. He is described as a new member of STISA at the 1944 Autumn Exhibition and his speciality was wood block colour prints of Cornish subjects.

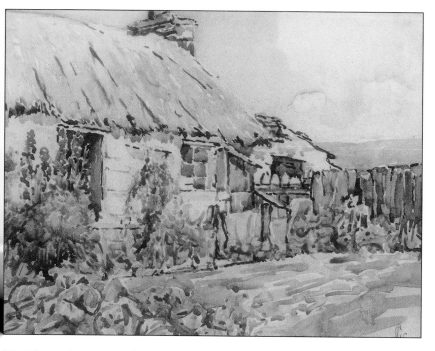

Fig. 3L-10 Augusta Lindner *The Fisherman's Cottage, Caithness*
Exhibited at the 1930 Summer Exhibition at Lanham's Galleries and in the 1934 tour
(Private Collection)

Fig. 3L-11 Augusta Lindner *Flower Study*
(Private Collection)

[98] *St Ives Times*, 18/3/1927.
[99] *News Chronicle*, 1939, Cornish Artists 2.

Fig. 3M-1 Averil Mackenzie-Grieve engraving

Fig. 3M-2 A.Mackenzie Grieve *The Sarawak River at Kuching*

(Ms) Averil Salmond Mackenzie-Grieve (b.c.1901)
STISA: c.1928-c.1931

Better known as an author than as a wood engraver, Averil Mackenzie-Grieve exhibited in St Ives before and during her marriage to Cyril le Gros Clark but, as she spent much of her time abroad, she fades in and out of the art scene in the colony. She was born into a wealthy and distinguished family in Sussex but her fondest childhood memories were of the years spent in Castle Hill House in Torrington, Devon. She was inspired towards art by her private tutor, Francis E. James, a flower painter and, in 1918, after the death of her father, she studied in Florence at Marfori Savini's studio. By this juncture, she had developed a love of ancient manuscripts, which she studied in libraries wherever she travelled on her trips through Europe with her mother. Somewhat alarmed by the rise of fascism in Italy, they returned to England and settled in St Ives, where Averil's interest in book illustration led her towards wood engraving.[100] She had hoped for lessons from Alfred Hartley but, as this was not possible due to his health, she attended for a short time the Charles Simpson School but "it was not the tuition I needed". In 1924, however, she exhibited on Show Day at Fire Station Studio, which had been newly created for her. Her exhibits included some woodcuts - of which *The New Italy*, depicting Mussolini inspecting his troops was highly regarded -, some illuminated work with fine lettering and some decorative wooden boxes. In 1925, she married Cyril Drummond le Gros Clark in St Ives but postings to China and Sarawak for some eleven years interrupted her artistic career.[101] Nevertheless, she did manage to exhibit in St Ives on occasion during visits back to England. As Averil le Gros Clark, she exhibited on Show Day 1928 and she also contributed to the first STISA show in the Porthmeor Gallery that year. On Show Day in 1931, she exhibited some of the wood engravings that were used to illustrate the translation, published that year, by her husband of a selection of poems by the Chinese Sung Dynasty poet Su Tung P'o (1036-1101).[102] She also was included in the London exhibition organised by the Kernow Group in July 1931.

Although she returned from the Far East in 1936, she continued to travel extensively and devoted more time to writing than to art. She did illustrate *John Fryer of the Bounty*, a large limited edition book published in 1939, but did not exhibit with STISA again. After her husband was killed in a Japanese prisoner of war camp, she remarried John Keevil, the medical historian. In her autobiography, *Time and Chance*, published in 1970, she admitted, "I never learned to draw well. But at least I made definite statements: you cannot be uncertain with a graver and a block of wood to cut".[103]

[100] In her autobiography, *Time and Chance*, London, 1970 at p. 37, she commented, "In those days my bible was Edward Johnston's book of lettering and illumination; my gods Sydney Cockerell, Graily Hewitt, Noel Rooke and their circle of scribes."

[101] She was able to get first hand advice as to what to expect in Sarawak from the Dowager Ranee of Sarawak, who lived at that time in Lelant, ibid, p.41.

[102] Her experiences in South China are recorded in her book, *A Race of Green Ginger* (1959).

[103] *Time and Chance*, p.37.

(Mrs) Isabel Macpherson
STISA: 1934-1952
STISA Touring Shows: 1934, 1937. Also FoB 1951.
Although a member for 18 years, her watercolour landscapes were not regularly hung and are never singled out in reviews.

(Miss) Joan Manning-Sanders ROI (1913-2002) Exh. RA 7
STISA: 1943-1944
Although she was a child protégé, who became a celebrity when she exhibited at the RA at the age of 14, her early artistic promise did not develop. Born in Devon, her parents, George and Ruth, were both authors and she spent a peripatetic youth living at various times in Sussex, France, Devon and Cornwall. Her education was entrusted to a governess, Miss Florence Bridge, who encouraged her and her younger brother, David, to visualize their history and their Bible and to put down their images on paper. At the age of twelve, Bernard Walke asked her to do a series of watercolours of the New Testament for his church at St Hilary. For her models, she used her parents, her brother, her horse, Tom, the family dog, Luck, and a mischievous pet crow. Seeing her talent and interest, her parents arranged for her to have a studio in Sennen Cove. Ernest Procter, who also did work for St Hilary, seems to have taken an interest in her development. In 1927, she exhibited two paintings, *The Pedlar* and *David and the Globe* in the *Daily Express* Young Artists' Exhibition at the RBA Galleries.[104] In 1928, she came to national prominence when her painting *The Brothers* was hung on line at the RA and received universal praise. As the youngest person ever to have been hung at the RA, she became a celebrity and was filmed. "At the Academy's private view, real live Duchesses shook her by the hand, and her picture was sold for a sum that would have made Holbein jealous."[105] She was then asked to exhibit with STISA and *The Pedlar* was included in the first show at the Porthmeor Galleries. The following year her painting, *Concertina Players*, was hung at the RA in a place of honour and Faber and Faber produced an illustrated book on her art. In 1931 - the year she was made an ROI - a similar book was produced in New York. She went on to study at Chelsea School of Art and continued to exhibit at the RA until 1935 but she does not appear to have exhibited with STISA in the 1930s and she never recaptured the freshness and surprising maturity of her early works. It is almost as if art school robbed her of her spontaneity and singular vision. However, she became involved with STISA once more in the War and she was raised from associate to full membership in 1944. However, shortly afterwards, having married and become Joan Floyd, she moved to Canada with her sons Christopher and John. On her return, she helped her mother, who had become well known as an author of folk and fairy tales, with research. She died in 2002 just a few days before her 89th birthday.

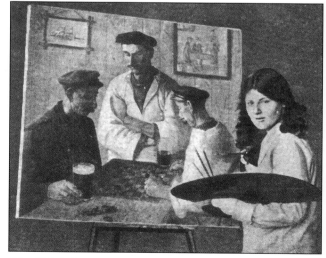

Fig. 3M-3 Joan Manning-Sanders *The Pedlar*
This was painted when she was 13 and was exhibited at the first show in the Porthmeor Gallery in 1928. The model was William Dungey from Sennen. After the portrait had been illustrated in many papers, he boasted at every door he visited that its popularity was due to his being so handsome and could not understand why artists in St Ives and Newlyn were not interested in painting him!

Fig. 3M-4 Joan Manning-Sanders at the age of 14 with her first RA exhibit *The Brothers*.

[104] This was in fact only open to artists aged over 18 but her work was so good that the organisers believed that her age must be 18 and not 13 as stated on her entry form. Joan herself had not appreciated that she did not qualify for entry.
[105] From Frank Ruhrmund's obituary in *The Cornishman*, 30/5/2002.

George H Martin
STISA: 1939-1947
STISA Touring Shows: 1947 (W).
He is recorded as exhibiting at Liverpool in 1905, when he was living in Bradford. His first Show Day, however, was in 1939 and he was made an associate member that year. He specialised in pastel drawings and his exhibit in the 1947 Cardiff show was a self-portrait in pastel.

Arthur Meade ROI (1852-1942) Exh. RA 62
STISA: 1927-1942
STISA Touring Shows: 1932, 1934.
Public Collections include QMDH, Preston, Rochdale, Worcester and Auckland.
Arthur Meade was one of the artists who had experienced the period at the beginning of the twentieth century when the landscape and marine artists of St Ives had been at the forefront of their genres at the RA. Meade, who had studied in Paris under Gerome, arrived in St Ives in 1890, having just completed a session at Bushey under Hubert Herkomer. He was to remain for the rest of his life, living first at 2, Bowling Green before moving in 1904 to 'Godrevy', Trelyon Hill. Meade was a small well-built man, who invariably wore plus-fours. He was an exceptional golfer, winning many cups in his younger days, and he also was a keen supporter of the Arts Club, being elected President in 1902, 1913 and 1920.

Meade was primarily a landscape painter in the pastoral tradition and frequent trips to Dorset, with its Hardy connections, provided copious subjects for his brush (see, for example, Plate 42). On his arrival in St Ives, he was immediately successful at the RA, having as many as five works hung a year, and during his career, he exhibited over sixty works there, as well as being successful at the Paris Salon on a regular basis. He became a member of the RBA in 1895, but his preferred London art society was the ROI, where he exhibited 92 works, being made a member in 1909. At one stage in his career, he became well-known for his bluebell depictions. Borlase Smart commented, "I remember one large picture of this bewitching subject hung on the line at the Royal Academy and how beautiful it looked in contrast to the browns and greys of the majority of the surrounding paintings. Critics of the artist at this period nicknamed him "Bluebell Meade", but no other artist could approach him, and there were plenty

Fig. 3M-5 Arthur Meade *The Wreck* (Rochdale Art Gallery)
It had been hoped to show this work in the Exhibition but significant restoration work is required.

of copyists - when he had shown the way!"[106] However, Meade could also paint a good portrait - one of his grand-daughter, Jennifer, in 1933 being well regarded - and his painting, *Sea Urchins*, showing a group of naked boys playing on the beach, could easily be mistaken for a Tuke. Unsurprisingly, marine subjects were also in his repertoire and Smart was a great admirer of these. "His artistic approach to these Cornish cliff scenes was fearless and vital. He went straight to Nature with big canvasses and painted at white heat."[107]

Meade was already aged 75 when STISA was formed but he was still being successful at the RA and for the first few years was a regular contributor to STISA's shows. On Show Day in 1929, he exhibited *The Wreck* (Fig. 3M-5), an enormous canvas measuring 48" x 72", showing a vessel with torn sails that has been wrecked in a storm and flung ashore near Hayle Bar. This was his last RA success and is now owned by Rochdale Art Gallery. That year, he also showed the fruits of a return trip to Morocco - his first RA exhibit in 1888 had been of Tangiers.

Commenting on a tranquil and subdued scene captured in *Mill Stream* in the 1932 Winter show, Charles Procter said, "This is painted in what the younger generation refers to as the "Victorian Academic style", meaning, as I understand it, that the artist has taken the trouble to study draughtsmanship and colour values before beginning to paint."[108] However, 1933 was the last Show Day at which he exhibited and his contributions to STISA shows after 1934 were rare, although Smart saw him going down to his studio in Back Road West just a fortnight before his death. A Memorial Exhibition was held at Lanham's Galleries in March 1943.

Hampden A. Minton
STISA: 1927-c.1932
Minton first exhibited in 1891 and he appears to have moved on a regular basis, as addresses are recorded in Manchester (1891), Abergele (1912), Beaumaris (1914), Exmouth (1917) and Mousehole (1920). He was a founder member of STISA, but his work is not previously mentioned in St Ives. However, by this juncture, he was living at 13, Seaview Terrace and, on Show Days, he exhibited initially at Shore Studio. He painted coastal and harbour studies in oil and, on Show Day in 1929, when his studio featured on Roskruge's map (Fig.1-3), he displayed three paintings of Perranuthnoe. Although he is still recorded as a member in 1932, his work is mentioned neither in Show Day reports nor exhibition reviews after 1929.

Denis Mitchell (1912-1993)
STISA: 1948-49
STISA Touring Shows: 1949.
Born in Wealdstone, Middlesex, Mitchell was brought up in Swansea and went to evening classes at Swansea College of Art in 1930. He moved to Barnoon, St Ives in 1930 to help an aunt renovate a cottage and started a market garden in 1938. We worked as a tin miner at Geevor, near St Just between 1942-5 and as a fisherman between 1946-8. His interest in modern art was aroused by meeting Bernard Leach and Adrian Stokes in the Home Guard during the War and he first exhibited on Show Day in 1947. He observed, "My aim in painting is to be as uninfluenced as possible and to develop my outlook on Cornish landscape as felt and seen through my jobs of working on the land and under it in the mine and around it on the sea, which gives me a much more intimate feeling towards it".[109] With his brother, Endell, he organised the first show of modern art in St Ives in the Castle Inn. However, his involvement with STISA was very brief, as he first exhibited at the 1948 Autumn show. He had two works, *Penbeagle Farm, St Ives* and *Gypsies Encampment* included in the 1949 Swindon show, before he resigned with the other moderns and became a founder member of the Penwith Society. He then became an assistant to Barbara Hepworth between 1949-1959 and started to sculpt in wood himself. He was Chairman of the Penwith Society between 1955-57 and first started sculpting in bronze, the work for which he is now best known, in 1959.

(Mrs) Edith Boyle Mitchell SWA Exh. RA 4
STISA: 1940-c.1947
STISA Touring Shows: 1945, 1947 (SA).
Edith Mitchell was a long-standing member of SWA, as well as a close neighbour of Dorothea Sharp in London, and it appears that she accompanied Sharp and Marcella Smith to St Ives during the War. A landscape painter in oils and watercolours, she first exhibited in 1905 and was first successful at the RA in 1922, when she was living in Amersham. Her principal outlet, however, was SWA and she was made an associate in 1925 before becoming a full member in 1927. She moved to Chesham Bois in 1929 but, from 1930, a large proportion of her exhibits are Cornish scenes. In 1936, she moved to Blomfield Road in London, just a few doors away from Sharp and Smith, but continued to visit Cornwall regularly. On the outbreak of the War, she seems to have joined Sharp and Smith in St Ives and she was made an associate member of STISA in 1940 and first exhibited at that year's

[106] *St Ives Times*, 8/1/1943.
[107] ibid.
[108] *St Ives Times*, 2/12/1932.
[109] *The Cornish Review*, No. 2, Summer 1949, Notes on Contributors.

Fig. 3M-6 Denis Mitchell *Knill Steeple* (1946) (W.H.Lane & Son)

Autumn show. On Show Day in 1946, she was complimented on her feeling for decoration and her ability to make pleasing pictures of unusual subjects in a fine display of watercolour landscapes painted in many parts of Cornwall.[110] The muted tones she used were considered to give a most individual colour scheme. In 1947, however, she was back in London and did not exhibit with STISA again, although her exhibits with SWA included St Ives scenes as well as an oil painting *Dorothea Sharp's House*. She remained a member of SWA until 1960, although she did not exhibit after 1956.

Frank Moore ARCA (b.1876)
STISA: 1928-1932
STISA Touring Shows: 1932.
Born in Watford, Captain Frank Moore was educated at Highgate School and University College, London. In 1910, he was living in Winkleigh, North Devon but he moved to St Ives shortly before the Great War, living at 1, Draycott Terrace and working from Beach Studio. His etchings, drypoints and aquatints are first mentioned in the review of Show Day 1914, with his aquatint of *Pudding Bag Lane* and his etching of *Hayle Estuary*, being singled out for comment.[111] His masterly technique and the great variety in his work was consistently praised and he had his own printing press so that he could personally supervise the important printing process. He was President of the Arts Club in both 1921 and 1922. He was included in the 1922 joint exhibition of the St Ives and Newlyn colonies at Plymouth Art Gallery and, in September that year, had an exhibition of 29 of his drypoints and a number of aquatints at Beach Studio. An article in the French magazine, *La Revue Moderne*, in 1925 described him as one of the best contemporary printmakers in England.[112] He was specifically invited to join STISA in March 1928 and was soon being elected on to Hanging Committees. Whybrow records that "collections of his work are in Africa, India, USA, France, Australia and New Zealand".[113] His wife was well-known for her embroidery. He appears to have left St Ives in the early 1930s as exhibition addresses are recorded as Woodchurch, Kent (1930) and Uffculme, Devon (1935).

[110] *St Ives Times*, 22/3/1946.
[111] *St Ives Times*, 27/3/1914.
[112] Reproduced in *St Ives Times*, 24/4/1925.
[113] M.Whybrow, *St Ives 1883-1993*, Woodbridge, 1994 at p.95.

(Ms) Arminell Morshead (1889-1966) Exh. RA 6
STISA: 1946-1958
STISA Touring Shows: 1947 (W).
Born in Tavistock, she trained at the Slade and studied etching at South Kensington under Sir Frank Short and Malcolm Osborne. She exhibited widely, including with the Brooklyn Society of Etchers and the American Watercolour Society, and may well have spent some time living in the USA and Canada. She is recorded as a guest of the artist, R.L.Hutton, at the Arts Club in March 1914. She was successful at the RA for the first time in 1920, when she was living in Guildford, and she won a Mention Honorable in Paris in 1928. She became known for her paintings of horses, her equestrian portraits and polo subjects and her work was illustrated in *Spur Magazine*, New York, *Cub Hunting* and *Polo Portrait*. She first exhibited in St Ives on Show Day 1946, when her studio - the re-opened Island Square Studio - was considered to contain one of the more outstanding displays of the day. This included *Guildford Cattle Market*, an earlier RA success, which was also included in the 1947 Cardiff show, a selection of animal paintings and a fine collection of etchings, aquatints and lithographs. She was successful at the RA in 1948 with *The Mariner's Church*, presumably a depiction of STISA's new Gallery, and *Gale Warning*, showing Smeaton's Pier battered by a heavy sea, with figures battling against the high winds. She also exhibited three St Ives works at SMA in the early 1950s. However, she was by then living back in London and, although she retained her membership until 1958, she exhibited little with STISA in the 1950s. Nevertheless, she maintained contact with Shearer Armstrong and Marion Hocken amongst others.

(Miss) Marjorie Mort (1906-1989)
STISA: 1950-1989
STISA Touring Shows: FoB 1951.
A founder of the famous Newlyn Holiday Sketching Group, Marjorie Mort joined STISA in 1950 and remained a member for nearly forty years. Born in Parson's Green, London in 1906, she was educated in Wimbledon but when her family moved to Derbyshire in 1921, she finished her education privately. She studied art for seven years (1924-1931) at Manchester School of Art under Robert Baxter and then, after a period of illness, attended the Slade in 1934 but, attracted by Walter Bayes' book on decorative art, she moved to Westminster School of Art, where he was teaching. Under Bayes, she realised where her true interest lay - in drawing and painting the human figure. She first came to Mousehole in 1938 and stayed with the Sampson family in Keigwin Place until the outbreak of the War, which she spent teaching in Stockport. After the death of her parents, she returned to the Sampsons in Mousehole in 1945 and there met Eric Hiller and Charles Breaker (q.v.). Together, they formed the Newlyn Holiday Sketching Group in 1949 and this became a regular Summer School for the next fifteen years. During this time, she would often be seen painting and teaching on the harbour fronts of Newlyn and Mousehole. In 1964, Marjorie left to work on her own, taking a studio in the centre of Newlyn, and she became best known for her figure paintings. She exhibited both with STISA and the Newlyn Society of Artists. A private person and immensely modest, she did not seek the limelight and was not swayed by the prevailing fashion for abstract work. She once stated that she loved drawing too much to go abstract.[114] When afforded her first one-man show at Newlyn Orion Gallery in 1985, John Halkes commented, "Her figures, near in style and execution to those of Joseph Herman, have developed into powerful statements about human relationships, work and leisure."[115] In her obituary, Frank Ruhrmund commented that she had "a tremendous talent for capturing the exceptional qualities of everyday happenings".[116]

(Ms) Marjorie Mostyn RCA SWA (1893-1979) Exh. RA 4
STISA: 1938-1949, 1952-1979
STISA Touring Shows: 1945, 1947 (SA), 1947 (W), 1949.
A daughter of the artist, Tom Mostyn, Marjorie (or Nancy as she was better known) was born in Bushey, Hertfordshire, no doubt when her father was studying there under Hubert Herkomer. She modelled on a number of occasions for her father's paintings. She trained at the St John's Wood and Royal Academy Schools, where she won silver and bronze medals. Her teachers included John Singer Sargeant, George Clausen and Sir William Orpen. In 1915, she was awarded the British Institute Scholarship in painting, an award won two years previously by fellow student, Leonard Fuller, whom she married. Principally, a portrait painter, who specialised in child studies, she also did interiors, flower paintings and landscapes. Her first success at the RA was in 1916, with a portrait of her mother, but, after her marriage and the birth of her son, she found less time for painting and restricted herself to some commercial artwork. However, when she came to St Ives with her husband in 1938, she took up 'straight' painting again and helped at the St Ives School of Painting. She also did a stint as Curator at STISA's Gallery at the end of the War. In 1948, she had a one-man show at Downing's Bookshop, which contained predominantly child portraits and still lifes. The local reviewer, probably David Cox, commented, "Marjorie Mostyn is not an imaginative interpreter, but she sees clearly, and in a personal way, the honest beauty of everyday life".[117] Her portrait of Shearer Armstrong (q.v.), exhibited at the Winter Show in early 1949, was

[114] Quoted in F. Ruhrmund, Note in David Lay Studio Sale catalogue 24/5/1996.
[115] Marjorie Mort, *Fifty years of Painting 1935-1985*, Newlyn Orion Catalogue, 1985.
[116] *St Ives Times*, 29/12/1989.
[117] *St Ives Times*, 18/6/1948.

Fig. 3M-7 Marjorie Mostyn *In the Studio*
With its more indirect and diffused lighting, this was considered to be one of the best works in her 1948 show.

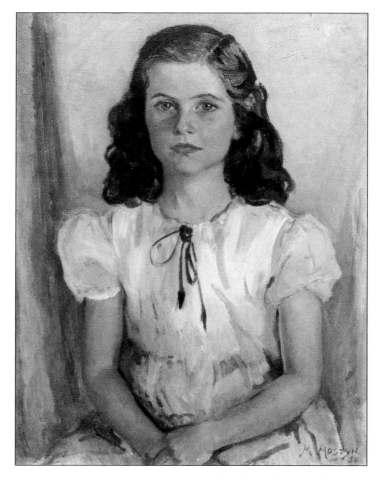

Fig. 3M- 8 Marjorie Mostyn *Greta, daughter of Sven Berlin*
At a one-man show at Studio 27 in 1957, her child portraits were praised for their "genuine sensitivity and sweetness of vision"

considered her best work to date and her 1954 RA exhibit *Misomé Resting*, featured fellow artist Misomé Peile (q.v.).[118] She resigned from STISA in 1949, along with Fuller, but rejoined in 1952 and remained a member for the rest of her life. She was made an associate of SWA in 1951 and a full member in 1953 and she exhibited with that Society until 1963.

An attractive woman, Nancy sat many times for her husband, to whom she was devoted. *Knitting* (cat.no.23) and *Woman with Long Hair* (Fig. 2F-6) are two examples. On Fuller's death in 1973, she ran the School of Painting herself, helped in her last years by Roy Ray. She therefore played an important role in ensuring that the School continued to thrive.

Sir Alfred Munnings RA RWS (1878-1959) Exh. RA 295
STISA: 1944-1950
Public Collections: "Hardly a Museum of note does not possess his work" - *A Dictionary of Animal Painters*. Abroad, this includes Adelaide, Melbourne, Perth, Sydney, Auckland, Dunedin and Wellington.
When at the 1948 AGM of STISA, it was announced that Sir Alfred Munnings, President of the Royal Academy since 1943, had agreed to become President of STISA, cheers rang round the room. It was an incredible honour for the Society that such a high profile figure should be bothered to get involved and his acceptance was seen as a great reflection upon the standing of the Society at that time. Two years later, though, he was quietly replaced as President by Lamorna Birch. In the interim period, he had caused total furore in the art world by his speech at the 1949 Royal Academy Banquet, during which he had lambasted modern art, and, at the opening of the Stanhope Forbes Memorial Exhibition in Newlyn a few months later, he had uttered similar sentiments, urging the locals to march on the Tate as Forbes' *The Health of the Bride* was languishing in the basement, while "absurd paintings by Matisse were hung preciously on the walls with half a mile between each one".

The son of a miller, Munnings was born in Mendham on the Norfolk/Suffolk border. He was educated at Framlingham and was apprenticed for six years to a firm of lithographers in Norwich, while studying at the Norwich School of Art at night. His posters, particularly for confectioners Caley and Sons, became well-known. In 1899, his first successes at the RA persuaded him to leave the commercial art world but an accident in which he lost the use of one eye nearly put paid to his artistic career at the outset. In 1902, he went to Paris to study at Julian's Academy for a few weeks, a practice he repeated several times. He also attended Frank Calderon's School of Animal Painting in Finchingfield, Essex. A passion for both horses and horse painting soon led him to acquire the first of a succession of horses which he was both to ride and paint and he was enthralled by visits to race meetings and gypsy horse fairs. Soon his horse dealings necessitated the employment of a groom and Ned Osborne and a rough, young lad, called Shrimp, with whom Munnings toured the Norfolk countryside in 1908/9, have been immortalised in Munnings' paintings, as have many of his horses like 'Augereau' and 'Grey Tick'.

In 1910, Munnings decided to move to Cornwall, which he had already visited briefly. He arrived at Newlyn with a group of girl models and soon became the life and soul of the artist community in Lamorna, matching Laura Knight in his appetite for both hard work and serious partying. Both were volatile and high-spirited, with immense energy and a tendency towards bawdiness and vulgarity, and remained friends for life. She described him as "the stables, the artist, the poet, the very land itself!" A converted mill served as his studio and provided stabling for his horses, which he hunted with the Western Hounds. He became infatuated with an elegant, young art student, Florence Carter-Wood, who modelled on horseback for him, and he married her in 1912 but their disastrous marriage, which was never consummated, ended with her suicide in 1914.

In 1913, he had a one-man show at Leicester Galleries entitled *Horses, Hunting and Country Life*, which was a great success. Norman Garstin writing about his work at this time said, "To him, it is not merely the horse but the horse in its environment that matters - there is the poetry and harmony."[119] Another skill that was admired was his ability to capture the way a horse's coat reflected light. A five day stay at Mrs Griggs' in Zennor that year resulted in many fine paintings of his horses and his groom, Ned Osborne. A trip to paint the Hampshire gypsy hop pickers was also a success. On the outbreak of war, he was rejected on three occasions from joining up because of his blind eye but eventually in 1918, he was selected to paint the Canadian Cavalry Brigade in action at the front. His 45 works were highlights of the Canadian War Memorials Exhibition held in January 1919 at Burlington House and his portrait of the Canadian Cavalry Commander, General Seely, led to many equestrian portraits. Soon afterwards, he was elected an ARA and bought the house of his dreams, Castle House, Dedham, where he was to live for the rest of his life and which is now a Museum dedicated to his work. He married again, to Mrs Violet McBride, who took control of his arrangements and organised a never-ending stream of commissions. Commercial considerations thus took over and even his wife admitted, " He was never such a good artist after he married me."[120] In 1926, he was made a full RA and, in 1928, a retrospective of nearly 300 paintings at Norwich Castle Museum was visited by 86,000 people in six weeks. Between 1920 and 1938, he had three paintings bought for the Chantrey Bequest, including *Their*

[118] The Shearer Armstrong portrait was sold at W.H.Lane & Son on 14/12/1993 Lot 174.
[119] J. Goodman, *What A Go*, London, 1988, p.124/5.
[120] J. Goodman, *What A Go*, London, 1988, p.163/4.

Majesties' Return from Ascot, 1925. In his book, *Animal and Bird Painting*, published in 1939, Charles Simpson (q.v.), also an equestrian artist, ranked Munnings as supreme among living horse painters, feeling that he had "a sculptor's grasp of essential form" and an ability to bestow his subjects with monumentality. "Few animal painters have realized the value of three-dimensional composition, building up a design by means of planes that register recession and light values throughout the picture, to the same extent as Munnings." He concluded, "The beauty of equine form has never been more perfectly conveyed".[121]

Munnings painted predominantly in oils but, in 1930, he was made a full member of the RWS. However, he did not exhibit there often. In 1931, he observed, "Water-colour efforts and love of water with me grow weaker each year and like poetry I give it up before starting, and why? Because I know its pitfalls, its traps and difficulties. I am like a rat avoiding steelfalls in a stable loft."[122]

During the Second World War, Castle House was requisitioned and Munnings stayed at his wife's house at Withypool and his paintings of Exmoor were included in a large show at the Leicester Galleries in 1945, which realised the astonishing sum of £21,000. By then, he was President of the RA but this and other responsibilities deprived him of the time for painting, making him increasingly resentful. His temper, not always improved by ever more painful attacks of gout, his bawdy humour and his distaste for modern art led him into a number of skirmishes with other members of his Clubs and the RA and he would have resigned earlier had it not been for Churchill's suggestion that the annual RA Banquet should be revived.

He was elected an honorary member of STISA in 1944 and wrote a typical tally-ho style letter to Borlase Smart urging members to do their best for the Spring show in 1945. However, such exhortations did not seem to apply to himself as he is conspicuous by his absence from STISA shows. His lack of involvement, however, did not put off his election as President in 1948. The acrimonious split between the moderns and the traditionalists occurred during Munnings' Presidency but it does not appear as if he played any part in it. No doubt, as President, he was informed of the circumstances of the split and it is a matter for conjecture how much impact this news had on his speech at the RA Banquet. The views that Munnings there expressed rather inelegantly and tactlessly would probably not have unduly upset the remaining members of STISA and his removal from the Presidency is likely to have resulted not from a desire to distance the Society from an artist who had become discredited in some art circles but from the need to have a President who was more involved, as there is no evidence that Munnings attended any STISA function or exhibited at any STISA exhibition, despite his trip to Newlyn in 1949, which would have been an ideal time to drop off some work.

Robert Morton Nance (1873-1959) Exh. RA 3
STISA: 1927-1932
STISA Touring Shows: 1932.
Public Collections include Bushey, National Maritime Museum, Science Museum and St Ives.
Morton Nance was an acknowledged authority on two distinct subjects - sailing ships and the Cornish language. He had a passion for the days of sail and was a fine modeller of ships in wood as well as an accomplished illustrator. Born in Cardiff, his parents were both Cornish and he enjoyed holidays in Cornwall with his grandparents from an early age. In 1878, the family moved to Penarth and, as many forebears had been sailors, Robert developed an interest in ships both in Penarth Docks and St Ives. He began his art training at Cardiff School of Art and, in 1893, after his mother's death, he enrolled at the Herkomer School of Art at Bushey, where he made quite an impression not only with his dark looks, long hair and unconventional dress but also with his ability as a draughtsman. Whilst there, he was successful at the RA for the first time. In 1895, he married fellow student Beatrice Michell but, under Bushey rules, this meant they had to leave. Returning to Penarth, with a young baby, they both won prizes for painting at the National Eisteddfod in Cardiff and, on the recommendation of Herkomer, set up a Painting School for a short time. In 1898, Robert's poem *The Merry Ballad of the Cornish Pasty*, illustrated with his own drawings, appeared in the *Cornish Magazine* and, in the same year, *The Studio* reproduced six full page illustrations of his drawings of St Ives in the series, *Leaves from the Sketch-Book of...*[123] His life changed, however, when Beatrice died in 1902. Distraught, he decided to immerse himself in further study in Paris and, in 1903, *The Studio* reproduced some exquisite pencil drawings of ship models in the Louvre that he executed on this trip.[124] At this juncture, Nance was also painting in oils and his paintings of sailing craft *Across the Western Ocean* and *On the Wings of the Wind*, exhibited at the New Gallery, are illustrated in *Pictures of the Year* for 1903 and 1904 respectively. However, his interest in art was soon replaced by a passion for medieval ships. In 1905, he again exhibited at the New Gallery some drawings of old battleships, highly embellished, and some of these were used for decorative screens that were later exhibited in Italy. Also in 1905, he collaborated with E.E.Speight in some

[121] C.Simpson, *Animal and Bird Painting*, London, 1939, at p.26-8.
[122] A. Munnings, *In Praise of Watercolour, The Old Watercolour Society's Club*, Volume 9, 1931.
[123] *The Studio*, Vol.66, 1898, p.257-262.
[124] *The Studio*, Volume 28, 1903, p.49-51.

books designed for schools - *Britain's Sea Story*, which looked at "British Heroism in Voyaging and Sea-Fight" from the time of King Alfred to the Battle of Trafalgar, *The Romance of the Merchant Venturers* and *Voyages*, which concerned the Vikings.

In 1906, he married Annie Maud Cawker, another fellow student at Bushey, well-known for her weaving, who had been a good friend of his first wife. They moved to Nancledra, midway between St Ives and Penzance, and exulted in leading a simple life, having to fetch water from a local well. Here he started writing his 'Cledry' plays for the children of the local school and these were eventually published in 1956. In 1914, he moved to Carbis Bay and joined the D.C.L.I. Volunteers. However, he is best known for his beautiful book, *Sailing Ship Models*, which he published in 1924 and which has become a classic. This was reprinted in 1949. In 1925, *Last Days of Mast and Sail* by Sir Alan Moore, a Naval surgeon during the Great War, was illustrated by over 220 of Nance's drawings. This again was later reprinted - in 1970. In 1930, Nance also contributed some drawings to the reprint of R.C.Leslie's *Old Sea Wings Ways and Words in the Days of Oak and Hemp*, a history of ships, sails and rigging originally published in 1890.

Nance was a founder member of STISA but he rarely exhibited. When asked why he did not paint the sea any more, he replied, "Why should I? There it is for all to see, and so much better than anyone could paint it."[125] However, a series of his drawings of 15th century ships was included in the 1932 tour, probably as a result of his talk to STISA in March 1932 on *Luggers*, which he illustrated with his models and sketches. That year, he was also President of the Arts Club. In later life, he published a number of pamphlets on the Cornish language, including an English-Cornish Dictionary, on behalf of the Federation of Old Cornwall Societies. He was elected the Grand Bard of Cornwall in 1934, a position he retained until his death, and he was invited to open a number of STISA's Exhibitions. His two sons, Robert (Robin) and Richard William (Dicon), were also fine craftsmen and his daughter, Phoebe, married Dod and Ernest Procter's son. Leonard Fuller's posthumous portrait of him hangs in St Ives Museum.

(Miss) Emily Nicholl

STISA: 1933-1938
STISA Touring Shows: 1934.
A flower painter in watercolours, her works are mentioned from time to time on Show Days between 1930 and 1935, when she exhibited with Mrs Shields, who tackled much the same subjects but in oils. However, her work does not get mentioned in reviews of STISA shows, although she was still exhibiting in 1937.

William Samuel Parkyn ARCA ARWA SMA (1875-1949) Exh. RA 4

STISA: 1933-1949
STISA Touring Shows: 1934, 1936, 1937, 1945.
Public Collections include Royal Collection, QMDH, Oldham and St Ives.
The son of an Army Commander, Parkyn was born in Blackheath and was educated privately, before studying art at Blackheath and Rochester. When he first came down to Cornwall, he lived in Newquay and he exhibited with RCPS in 1896 and 1897. It was probably during this visit that he studied further under Louis Grier in St Ives. Returning to London, he was a member for a while of the London Sketch Club and he had his first success at the RA in 1905. That year, he advertised that he would hold a class for watercolour and oil painting during July, August and September at the East Kent School of Landscape Painting in Sandwich. However, later that decade, he returned to Cornwall to live in St Ives and he first exhibited on Show Day in 1908. Principally a marine painter, he initially depicted a range of boats at sea and, during the First World War, concentrated on naval vessels. Works from this era that were reproduced as prints include *The Lone Patrol* and *Hun Hunters*. His picture of a hospital ship is in the Royal Collection and is hung at Sandringham and he painted two works for Queen Mary's Doll's House. He also offered to paint and present to St Ives Town Council a picture of any battleship or cruiser they selected and their choice was *HMS Albion*, in which many St Ives men served.[126]

Fond of walking and country sport, in his later years he lived at the Lizard and opted for more tranquil scenes, being particularly renowned for his ability to depict sand. Although he exhibited at Lanham's in 1928, he did not become a member of STISA until 1933 but was thereafter a regular contributor to the watercolour section. In 1945, a typical watercolour, *Through Yellow Gorse to Yellow Sand*, was bought by Oldham Art Gallery from the United Artists Exhibition. He was one of the many STISA members who exhibited at the early exhibitions of SMA, contributing 16 works in the short period before his death. A collection of his works hangs in the Queen's Hotel, Penzance.

[125] Mrs C. Morton Raymont, *The Early Life of R. Morton Nance*, 1962, p.37.
[126] M.Whybrow, *St Ives 1883-1993*, Woodbridge, 1994, p.77.

(Miss) Marjorie Mary Misomé Peile ASWA (1907-1983)
STISA: 1944-1949 & 1969-1972
STISA Touring Shows: 1945, 1947 (SA), 1947 (W).
Public Collections include Cornwall County Council.
Misomé Peile was born in Southsea, Hampshire. She described her education as spasmodic and she lived in London, Palma, Valletta and Rome, where she studied art, before coming to live in St Ives on the advice of her uncle, W.E.Nicholson FLS, who had discovered new and rare mosses in Cornwall. She studied further at the St Ives School of Painting under Leonard Fuller and took instruction from Enraght-Moony on tempera painting. However, Francis Barry also made a big impression on her and she often went to his studio to hear his opinions on colour, as she had not come across anyone who knew more on this subject. Barry used her as a model for a number of his pictures, transforming her into a curvaceous busty, blond for the paintings *The Young Britannia* and *Youth Triumphant* and he also did several portraits of her with striking ginger hair. She was raised from associate to full membership in 1944 and between 1945-8, she worked officially with the Royal Marine Commando 29th US Infantry Division (see Fig. 1-17). Peile was involved in the campaign to save studios in St Ives and, in 1946, she wrote to the local paper complaining that with rent increases and general rises in the cost of living, young artists were struggling. "There are young men and women among us with nowhere to work to earn their living, who are worn down with anxiety at not being able to find even a small room to expand in".[127]

She was interested in the Theatre and worked on action studies of the Adelphi Guild Theatre at Newquay, St Ives and in the North-West Midlands and her drawings were exhibited at the Central Library, Manchester in 1948 and also at the RWS Galleries in London in 1949 in a show entitled *Out and About*. The artist, Mrs Eileen Jessop Price, who had also studied under Fuller, joined her for the London show.[128] She resigned from STISA in 1949 and was a founder member of the Penwith Society, becoming Chairman in 1953-4. She was an associate member of SWA between 1949 and 1956. She wrote reviews of Show Day for the local paper and was often greatly involved in the artists' Fancy Dress Dances. Her art became increasingly abstract and she did hundreds of 'action drawings' of Carbis Bay to acquaint herself with the Cornish landscape. She lived with her mother, initially in St Andrew's Street and then, from 1954, at The Leeze, Trelyon. She rejoined STISA in 1969 but, on her mother's death, she settled in Malta and was made an honorary member. She held a number of exhibitions in Malta at the National Museum, Valletta between 1973 and 1977, including one to which Denis Mitchell contributed, but returned to a nursing home near Truro when her health began to fail.[129] A Tribute Show was held at Newlyn Art Gallery in 1985.

Fig. 3P-1 Francis Barry *Misomé Peile* (David Capps)

[127] *St Ives Times*, 6/12/1946.
[128] *St Ives Times*, 6/5/1949.
[129] *St Ives Times and Echo*, 27/5/1983.

Fig. 3P-2 Misomé Peile with Francis Barry and *The Young Britannia*, a painting for which she modelled
(David Capps)

Ernest Francis Peirce (1887-1961)
STISA: 1950-1961
STISA Touring Shows: FoB 1951.
A distinctive figure, with bushy side-whiskers and deerstalker hat, Peirce was a former West End theatre producer, who retired to Cornwall in 1928 to devote himself to painting and etching but found his dramatic talents in great demand. A native of Blackheath, London, he joined a professional touring company at the age of 19 and appeared in the gala performance to mark King George V's Coronation. In subsequent years, he devoted himself to stage management and producing, and other St Ives residents, whom he had directed, included his great friends the comic actors, Harry Welchman and Henry Caine. On arriving in Cornwall, he produced for the Penzance Operatic Society, the Penzance Players and the St Ives Operatic Society and founded the Cornwall Shakespeare Festival in 1933. His art appears to have taken a back seat but he became involved with STISA in the 1950s, when he was living at Blue Hills, Ludgvan, Penzance and working from Loft Studio, St Ives, - and he had a significant success too, as the Princess Royal bought one of his pictures from an exhibition in Harrogate. His last successful presentation was *The Story of St Ives*, a series of pageant plays written by Mary Williams for Carnival Week in 1959 and his obituary was accompanied by her poem in his memory, which speaks of a "man of warm and generous heart".[130]

[130] *St Ives Times*, 13/1/1961.

Brigadier J W Pendlebury DSO MC
STISA: 1944-1946
STISA Touring Shows: 1945.
He is described as a new member at the 1944 Autumn Exhibition and he gave the opening address at the 1945 Spring Exhibition. An exhibit on Show Day 1946 was a painting, *Dunkirk - 1a.m. - 2nd June 1940*, a scene he had witnessed himself.

George Farquhar Pennington (1872-1961)
STISA: 1945-1959
STISA Touring Shows: 1947 (W). Also FoB 1951.
Public Collections include Swedish Maritime Museum.
Pennington was a successful architect before retiring to take up painting. Born in Castleford, Yorkshire, he trained with a firm of architects in Leeds before setting up on his own in Castleford. The son of a Wesleyan minister, he had unswerving faith and made the design of Wesleyan chapels one of his specialities. He also laid out a number of housing estates and was active on local councils. Always interested in art, he was a member of the Doncaster Art Club and the Yorkshire Union of Artists. In 1935, he sold his practice and travelled with his wife, Hilda, whom he had married in 1900, through several Mediterranean countries, determined to learn to paint. He settled in Carbis Bay in 1939, studied under Fuller and joined the Newlyn and St Ives Societies. He also put on exhibitions at The Blue Studio on The Wharf. For instance, in August 1943, he held an exhibition of 106 pictures of Sicily and, in 1950, his daughter, Agnes, and himself displayed the fruits of a five months sketching tour to Southern Spain and Morocco. Unsurprisingly, he was particularly attracted by interesting buildings and old bridges; for instance, his contributions to the 1947 Cardiff show were *The North Transept, Exeter* and *The Castle Scarborough*. He painted principally in watercolour and he had a number of foreign purchasers of his work, including the Swedish Maritime Museum. His oils, particularly of St Ives street scenes, show the influence of John Park. He sometimes signed with a monogram.[131] On the death of his wife, he moved to Chichester in 1957 and joined local societies there but continued to exhibit with STISA until 1959.

(Ms) Grace Pethybridge Exh. RA 6
STISA: 1930-1936
STISA Touring Shows: 1932, 1936.
She was studying at Launceston School of Art when she first exhibited at RCPS in 1920 and her address is given as Launceston when she had her first success at the RA in 1928.[132] She applied for membership of STISA in June 1930 along with a number of other female artists but was asked to submit three recent works for judgement. These were inspected in September and she was duly elected. She exhibited watercolours and black and white prints. In 1933, she married, becoming Mrs E.Bulmer, and moved to Hereford.

William F. Piper
STISA: 1950-1967
STISA Touring Shows: FoB. 51
A resident of Newquay, his work is first mentioned in a show at Lanham's in 1938, when he exhibited watercolours and oils of the Cornish coast. However, he did not join STISA until after the split. His marine scenes were seen at STISA exhibitions for many years.

(Miss) Blanche Hamilton Powell Exh. RA 12
STISA: 1936-1946
STISA Touring Shows: 1937.
Powell was one of the miniaturist section that flourished in STISA in the late 1930s. She first exhibited at the RA in 1928, when she was living at Roseleigh, Alverton, Penzance but she moved to Egmore, Trelyon, St Ives in 1937. Her speciality was miniature portraits and her 1937 RA exhibit featured fellow member, Miss Vere Dolton. She probably moved to Truro in 1946 and ceased exhibiting with STISA. Her last success at the RA was in 1956.

(Miss) Dora C Pritchett (b.1878) Exh. RA 1
STISA: 1941-1959
STISA Touring Shows: 1947 (SA), 1949. Also FoB 1951.
Born in Folkestone, she studied under Frederick Marriott at Goldsmith's College, at Camberwell School of Art and at Redhill School of Art under William Todd-Brown (q.v.). She started exhibiting in 1903 and her one success at the RA was in 1909, when she was living in Horley. Her career between then and when she joined STISA during the Second World War is a blank, although

[131] This is recorded in J.Wood, *Hidden Talents*, Billingshurst, 1994, from which some information relating to this entry has been derived.
[132] She was most probably the daughter of the figure and landscape painter, Ley Pethybridge, who lived in Launceston, and who was exhibiting with RCPS from 1888.

her study period with Todd-Brown must have been between 1922 and 1940. By 1940, she was living in Mousehole and she is described as a new associate member at the 1941 Autumn Exhibition. She contributed watercolours of local scenes to STISA shows for nearly 20 years.

Ernest Procter ARA (1886-1935)
STISA: Exh. 1927-1935
Public Collections include Government Art Collection, Imperial War Museum, Tate, Newcastle, Worthing, Penzance, Paris and Adelaide. Ernest Procter does not appear to have become a member of STISA, although he contributed to a number of its exhibitions and his work was included in the 1936 touring show, *Pictures of Cornwall and Devon*. Born in Northumberland, he was the son of a distinguished scientist and staunch quaker. In 1906, he came to Newlyn to study at the Forbes School and was rated a star pupil. In 1910, he went on to the Atelier Colarossi in Paris, where he was joined by fellow student Doris Shaw. They married in Newlyn in 1912 but the War soon intervened and Ernest left to work in the Friends Ambulance Service in France. His sketches of the camp where he was based are now in the Imperial War Museum.

In 1920, his wife and himself were commissioned to decorate the Kokine Palace in Rangoon, where they worked with Burmese, Indian and Chinese plasterers, guilders and carvers and this experience of eastern art and design did influence some of his later work. A painting from this trip, a portrait of a Burmese peasant, was his first contribution to a STISA show, in the Autumn of 1927. It was not surprising that Dod and Ernest Procter were some of the first Cornish artists from outside St Ives to be invited to exhibit with the Society, given the huge publicity that had followed the purchase on behalf of the nation by the Daily Mail earlier that year of Dod's *Morning*. It is also understandable that, with such publicity, there was little incentive for the Procters to give much support to STISA, as the London art world opened up to them. Ernest won considerable acclaim for himself with a series of allegorical works in the late 1920s and, locally, he became interested in church decoration, designing and painting a screen for St Mary's Church, Penzance and a *Visitation* (1933) and *Deposition* (1935) for Bernard Walke at St Hilary. In 1931, he invented a new art form called Diaphenicons - painted glass decorations which provided their own light source.

In 1934, he was appointed Director of Studies in Design and Craft at Glasgow School of Art. He had always suffered from high blood pressure and the strain of this new role, whilst trying to maintain a home at the other end of the country in Newlyn, caused him to have a heart attack the following year. During his widow's Presidency of STISA in 1946, a retrospective exhibition was staged in the Society's new Gallery. *Rising Tide*, a watercolour that was included in the 1936 Eastbourne tour, is in the permanent collection of Penlee House Gallery and Museum.

Edward W Pulling (d.1947)
STISA: c.1930-1947
STISA Touring Shows: 1937.
Little is known about his early career but he was probably the brother of Phyllis Pulling (q.v.). He did exhibit three works at the London Salon in 1914 when he was living in Pall Mall. He first exhibited with STISA in the Summer Exhibition 1930 and he is recorded as a member in 1932, when he was living at Restormel, Carbis Bay. He worked principally in watercolour and travelled extensively but he rarely exhibited with STISA. However, he did feature on Show Days, when his work was exhibited in the 1930s in 3, Piazza Studios with Phyllis. In 1946, though, shortly before his death, he exhibited at Newey Studio, one of the only remaining studios in Lelant.

(Miss) Phyllis M. Pulling (1892-1951) Exh. RA 4
STISA: 1932-1940
STISA Touring Shows: 1934, 1936, 1937.
The daughter of a barrister, Phyllis Pulling was born and educated in London and studied art at the London School of Art, where she won a scholarship for life drawing, at St John's Wood School of Art and at South Kensington. Her work was first exhibited in 1919 and she had her first success at the RA in 1927, when she was living in Whitestone, near Exeter. She moved to St Ives in the early 1930s and was included in the 1932 Winter show. On Show Day in 1933, her works, which included *Pearl*, an imaginative illustration for a XIVth century poem, were exhibited in Loft Studio, Back Road but, for the rest of the decade, she was working from 3, Piazza Studios. In 1934, she was successful at the RA with a work in tempera, *Pea-pickers* but two other pictures *Willow Pattern* and a watercolour *Withermarsh Green* were accepted but not hung. She also was a painter of decorative panels and a poster artist, and her posters for the Burma Section at the 1924 Wembley Exhibition were bought by the office of the High Commissioner for India. Unusually, she moved *to* London during the War and provided decoration for bomb-damaged shop fronts. Her last success at the RA was in 1947.

Arthur Grainger Quigley
STISA: 1936-c.1942
STISA Touring Shows: 1936.
Public Collections include Liverpool.
Quigley studied at the Birkenhead School of Art and also at the Liverpool School of Art. His work was first exhibited in 1894, when he was living in Birkenhead but, by 1932, he had moved to Little Sutton in Cheshire. He moved to Cornwall a few years later and first exhibited his landscape and figure subjects in watercolours on Show Day in 1936 and he served on the Committee in 1938. His work is not referred to after 1940 but he did contribute to Lindner's presentation in 1942.

(Miss) Edith C. Reynolds
STISA: 1929-c.1947
STISA Touring Shows: 1932, 1936, 1937, 1947 (SA).
It is not known whether she was related to Reginald Reynolds (q.v.) but she lived in Leamington. Her work was first exhibited in 1909 and she showed regularly at the ROI and also with SWA and at Liverpool. She was proposed as a member of STISA by Moffat Lindner in October 1929 and she first exhibited in the Five Guinea Christmas Exhibition that year. She painted still life and village scenes which had a calm quality but her contributions to STISA shows were irregular. One critic commented, "Miss Reynolds realizes the gift of elimination to the full and her works are artistic in consequence."[133]

Reginald Francis Reynolds RBA (d.1936) Exh. RA 7
STISA: 1928-1932
STISA Touring Shows: 1932.
He first exhibited at RCPS in 1902 and appears to have been a regular visitor to Cornwall for the rest of his life. A letter published in the *St Ives Times* on 22/11/1918, in which he wonders whether he might become known as 'Reconstruction Reynolds', as this was "the theme which has chiefly occupied my pen for four years", indicates he might have been living in the town at this juncture. He exhibited irregularly at the RA between 1921 and his death but, although based in London, his three exhibits in 1921 and 1923 were all Cornish landscape scenes. He also exhibited three watercolours of the coast around St Ives and Penzance at the RBA in 1922 and, accordingly, had visited the area for an appreciable time. He was made an ARBA in 1919 and a full member in 1922. He contributed to the first show in the Porthmeor Gallery in 1928 and the following year his wife and himself had a joint exhibition at Walker's Galleries, New Bond Street entitled *Beneath the Cornish Sun*. Their studio on The Wharf, close to The Copper Kettle, is featured in Roskruge's 1929 map (Fig.1-3). Reginald resigned his membership in September 1932.

(Mrs) Hettie Tangye Reynolds ARWA Exh. RA 3
STISA: 1928-1932, 1936, 1944-1951
STISA Touring Shows: 1932. Also FoB 1951.
The wife of Reginald Reynolds, she was a Cornish girl, having been born in Redruth, and was an exceptionally accomplished painter in her own right, specialising in colourful and decorative still life paintings of fruit and flowers in oils. She too first exhibited at RCPS in 1902 and visited Cornwall in the early 1920s, exhibiting with the Cornish Artists at the annual Exhibition at Harris and Sons, Plymouth in 1923. She contributed to the first STISA show in the Porthmeor Gallery in 1928 and exhibited at the RA between 1928-1930. However, her involvement with STISA was spasmodic - most probably linked in with visits back to St Ives. She appears to have ceased exhibiting with STISA after 1932 but rejoined briefly after her husband's death in 1936. She was welcomed back as a member in 1944 but, after that year, only seems to have exhibited in the Festival of Britain show in 1951.

(Miss) Eleanor Emily Rice (d.1962) Exh. RA 1
STISA: 1936-1962
STISA Touring Shows: 1936, 1945, 1947 (SA), 1947 (W), 1949. Also FoB 1951.
She appears to have come to St Ives in 1934 and she first exhibited on Show Day in 1935.[134] A devout Catholic, she was a great friend of Agnes Drey (q.v.), with whom she lived for many years, and is buried in her grave. She lived at 3, Seagull House, The Wharf and later at Chy-an-Eglos flats. She was a competent painter whose pictures of St Ives, particularly her impressions of the harbour, sold readily. Her one success at the RA, *Lilies*, was in 1948. She left St Ives some three years before her death due to failing eyesight and was in a home for the blind in Bournemouth when she died.[135]

[133] *St Ives Times*, 15/7/1938.
[134] Her address for an exhibit with SWA in 1934 is Chy-an-Drea Hotel, St Ives.
[135] *St Ives Times*, 2/2/1962.

(Miss) Mary E. Richey Exh. RA 1
STISA: 1932-c.1940
STISA Touring Shows: 1932, 1934, 1937.
A painter of landscape and still life in both oils and watercolour, she first exhibited in 1927 when she was living in Edinburgh. She joined STISA when she moved to Polperro in 1932 but by the time of her one success at the RA in 1936, she had moved to Bridport in Dorset. She also exhibited with SWA but her work is not referred to in St Ives after 1940.

Hugh Edward Ridge RSMA (d.1976) Exh. RA 1
STISA: 1951-1976, Secretary 1952-57, Vice-President & Chairman 1958-1976
STISA Touring Shows: FoB 1951.
Public Collections include RSMA.
Another of the artists who strengthened the connections between SMA and STISA, Ridge first exhibited on Show Day in 1949 and had a one-man show at Downing's Bookshop that September. He was soon very involved with STISA, taking over from George Bradshaw as Secretary when he had a second coronary in 1952. He was a staunch traditionalist and was to be a long-serving member of the Committee, serving for six years as Secretary and then nineteen years as Vice-President and Chairman, overseeing a difficult period in STISA's history when representational art was completely out of favour.

On his arrival in Cornwall, Ridge was known for his soft Devon landscapes but he changed his style dramatically to capture the harsher aspects of the Cornish coast. For his oil paintings, he took up the palette knife, which he often used to apply paint boldly and broadly. He concentrated on marine subjects and, as one reviewer commented, "with deft strokes of the knife, he has built up the houses, churned up the cliffs and flashed light into the sea and sky".[136] For his watercolours, however, he adopted a very different style. These are more intricately detailed pen drawings with a coloured wash. He worked from Dragon Studio, Norway Square for the majority of his career but moved to Rose Lodge Studio on The Wharf in 1972. He exhibited over 100 paintings with RSMA, including a depiction of *H.M.S. Wave*, when it ran aground in St Ives in 1952. His painting *Mr Cothey builds his last boat*, which was exhibited at the RA, is in the RSMA Diploma Collection.

Fig. 3R-1 Hugh Ridge *The Wharf, St Ives* A typical example of his pen and wash work.

[136] *St Ives Times*, 16/9/1949.

Fig. 3R-2 Hugh Ridge *The Architect's Seine Loft* (W.H.Lane & Son)
An example of his palette knife technique.

Thomas Heath Robinson (1870-1954)
STISA: 1943-1954
STISA Touring Shows: 1945, 1947 (SA), 1947 (W). Also FoB 1951.
Less famous than his brother, William, whose name has passed into the English language as an adjective for any doubtful contrivance, Tom Robinson was one of a group of well-respected book illustrators that joined STISA during and shortly after World War II. Born in Islington, Robinson came from a talented family of illustrators. His grandfather, originally a bookbinder from Newcastle, had moved to London and become a successful wood engraver. His father, also called Thomas, had become chief staff artist to the *Penny Illustrated* and Tom, the eldest son, was followed into book illustration by his younger brothers, Charles and William. The three brothers, the eldest children of a family of six, were always very close. As children, they relied on their imaginations for their entertainment and would spend hours drawing on their slates depictions of pirates and highwaymen, modifying the drawings by sponge and slate pencil as the stories progressed. In his autobiography, William commented, "Ever since the days when we amused ourselves with drawing on slates, we had been in the habit of filling sketch books with slight drawings prompted by fancy or imagination...I believe this habit played a greater part in our artistic careers than the more academic training we received at our art schools."[137] Tom did study at Islington Art School and at South Kensington but he began work helping out his father in his studio in Danes Inn in the Strand. The studio was on the top floor, approached by flights of stairs with iron railings, and William commented that the only thing that belied its prison-like character was a smell of old dinners. Whereas Aubrey Beardsley and S.H.Sime were inspirations for William, Tom was most influenced by the Spanish black and white artist, Daniel Vierge. Slowly all three brothers began to get work and, in 1899, they co-operated together on *Hans Andersen*, published by J.M.Dent and Sons.

[137] W. Heath Robinson, *My Line of Life*, quoted in J.Lewis, *Heath Robinson - Artist and Comic Genius*, London, 1973 at p.21.

Drawing on the imaginative powers stimulated during his own childhood, Tom became particularly well-known for his illustrations of children's stories in magazines and books. His works in this genre include Charles Kingsley's *The Heroes* in 1899, Thomas Hughes' *Tom Brown's Schooldays* in 1903, J.R.Wyss' *Swiss Family Robinson* in 1913, Lewis Carroll's *Alice in Wonderland* in 1922, where he worked jointly with Charles Pears (q.v.), and Arthur Haydon's *The Book of Robin Hood* in 1931. He also specialised in historical reconstructions, being an expert on historical costumes. A quiet and unassuming man, Robinson was deeply religious and published many works dealing with the history of the Hebrews.[138] He was also much in demand as an illustrator of religious subjects, such as for S.B.Macy's *The Book of the Kingdom* in 1912 and *The Child's Bible* of 1928 and *The Child's Book of Saints* of 1930. By the time he moved to St Ives from Pinner in Middlesex in 1942, he was concentrating on bookplates and testimonial designs, some of which were included in STISA shows, but he also exhibited with STISA some typical swashbuckling depictions of *Vikings* and *Pirates* and he produced a number of religious paintings, including a *Crucifixion*. It was often remarked on Show Days that his studio had the aura of another world. He was initially elected as an associate member and became a full member in 1944.

As with fellow book illustrator, Harry Rountree (q.v.), Robinson found that the 1948 Selection Committee viewed him as a "commercial" artist, whose works sat uneasily with the progressive society that they had determined to create, and so his submissions to STISA shows began to be rejected. Accordingly, when he was excluded from the 1949 Swindon Exhibition, he became one of the signatories requisitioning the E.G.M. at which the split occurred. After the split, his work continued to be welcomed in STISA shows and his painting, *Cavalier*, sold at the Private View of the 1951 Winter show. At his death, he had all but finished a highly acclaimed set of pictures illustrating the Mysteries of the Rosary. One of his four daughters, Madeleine, continued the family tradition and was a Prix de Rome winner and a successful commercial artist and illustrator.[139]

(Miss) Alison Helen Rose (b.1900) Exh. RA 5
STISA: 1944-1947
STISA Touring Shows: 1945, 1947 (SA), 1947 (W).
Born in Edinburgh, she studied at Heatherley's and she may have come to Cornwall in the mid-1920s to study under Forbes. She was a landscape painter, working principally in oils. Her successes at the RA, mainly topographical scenes, were between 1927 and 1935 and her portrait by Midge Bruford (q.v.) was exhibited at SWA in 1928. Initially, her address is given as Maen Cottage, Newlyn but, by 1931, she had moved to Paul. She was one of the artists who exhibited at Arthur Hayward's Shore Studio in the early 1930s and this may be one reason why she did not join STISA earlier, for she had exhibited with the St Ives artists at Lanham's as early as 1928. In 1937, her painting *Spring Symphony* was considered the best painting at the Newlyn Spring Exhibition. When she did eventually join STISA in 1944, her membership was brief.

(Miss) Ethel Roskruge Exh. RA 1
STISA: 1927-1945
Presumably, the sister of Francis Roskruge, she appears to have studied in St Ives at the turn of the century and first exhibited with RCPS in 1900. Her one success at the RA was in 1910, when she was living at Yelverton in South Devon, but she continued to exhibit with RCPS. Nevertheless, she was only an associate member on STISA's formation. She first exhibited with STISA in the Christmas show 1929 and was made up to a full member in 1931. Her miniature flower paintings were subsequently frequently praised for their careful draughtsmanship and minute detail. In the late 1930s, the miniature section of STISA, comprising Mabel Douglas, Blanche Powell and Roskruge was highly regarded.

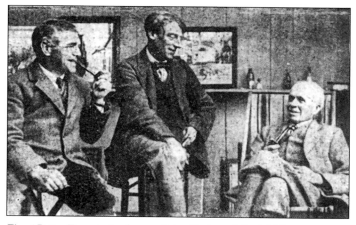

Fig. 3R-3 Francis Roskruge, John Park and Fred Milner

[138] These include *Prophecy and the Prophets in Ancient Israel*, (with O.E Oesterley), 1923, *Decline and Fall of the Hebrew Kingdoms: Israel in the 8th and 7th Centuries B.C.*, 1926, *A History of Israel* (with O.E Oesterley), 1932 and *Epistle to the Hebrews*, 1933.
[139] In addition to the sources noted above, see also obituary in *St Ives Times*, 2/1954.

Francis Roskruge (1871-1952)
STISA: 1927-1952, Jt Secretary 1927, Treasurer 1928-1939
STISA Touring Shows: 1932, 1934, 1936, 1937.
Engineer-Captain Francis Roskruge D.S.O., O.B.E, R.N.(retired) was born at St Keverne, Cornwall and educated in Truro. He served in South Africa during the Boer War and East Africa in the First World War, being mentioned in despatches and being awarded the D.S.O. and O.B.E. He moved to St Ives on his retirement from the Navy in 1922 and first exhibited on Show Day 1923. He was a founder member of STISA and served on the Committee for its first thirteen years. He specialised in etchings and aquatints and made a valuable contribution to the 'black and white' section. *In the Track of the Moon* was considered to be one of his best prints. However, he is perhaps best known for the map of the studios around the town that he prepared for the Show Day brochure each year (see Fig. 1-3). He also illustrated Greville Matheson's book of poetry about St Ives, *Crooked Streets*. He was a keen member of the St Ives Arts Club, being President in 1927 and 1928, and was not only a good actor but was also a well-respected playwright. He appears to have ceased exhibiting with STISA once he had resigned as Treasurer in 1940 but he remained a member until his death. He lived at Bosvean, St Ives and had a studio at his home.

Fig. 3R-4 F.Roskruge *Court Cocking*

Harry Rountree (1878-1950)
STISA 1942-1950
STISA Touring Shows: 1945, 1947 (SA).
Public Collections include Imperial War Museum.
Rountree, who was to play a pivotal role in the split in 1949, was the son of a New Zealand banker and was born in Auckland. In New Zealand, he worked as a lithographer in a commercial studio. His speciality was designing jam pot labels! However, in 1901, he moved to England and studied at the School of Art run by John Hassall, who was one of the first members of the London Sketch Club and its President in 1903. Rountree joined the London Sketch Club in 1904/5, eventually becoming President himself in 1914.[140] The format of the Club, with its weekly two hour sketching sessions (the fruits of which were then subjected to acerbic banter), followed by music hall style entertainment and copious alcohol, suited the mercurial Rountree, who was a breezy character with a sense of humour, all his own. His work was soon noticed by S.H.Hamer, the editor of *Little Folks*, and, as a result, he became in demand as an illustrator of children's books. In 1908, he illustrated Lewis Carroll's *Alice's Adventures in Wonderland*, a work which was reprinted time and again with his drawings of the March Hare, the Cheshire Cat, the Mock Turtle and others from Carroll's cast of oddball characters, so that, for many children, Rountree's depictions became the definitive delineation of them. Later editions combined Rountree's drawings with illustrations by two other artists who were to join STISA's ranks, Thomas Heath Robinson and Charles Pears. He also illustrated books for other members of the London Sketch Club, such as Arthur Conan Doyle, and taught at the Press Art School run by fellow member, Percy Bradshaw.

The outbreak of war decimated the illustrated book market and Rountree served in the Royal Engineers, rising to the rank of Captain. In the 1920s, though, his work was back in demand and he illustrated other classic stories such as *Aesop's Fables, Uncle Remus* and *Through The Looking Glass*. By the 1930s, he was sufficiently well-known to produce children's books both written and illustrated by himself, such as *Stories of Our Pets*. His depictions of animals, which he drew with a keen eye for humorous detail, proved to be of enduring popularity and Bernard Ninnes felt that they were the forerunner of the Disney style.[141] However, his talent was not merely due to a vivid imagination, as he took a keen interest in animal anatomy, confessing that his studio was "a nightmare to his housemaid, - with its bones and horns, hooves and skeletons".[142]

When Rountree arrived in St Ives in 1942, he, accordingly, had an international reputation as one of the leading illustrators of children's books - his latest output being *The Children of Cherry-Tree Farm* (1940) and *The Children of Willow Farm* (1942) for Enid Blyton. Furthermore, he had had great commercial success with, inter alia, his advertisements for Quaker Oats and his Mansion Polish tin-top mice. Mice, in fact, were one of his specialities and, in typical fashion, he left the Marylebone premises of the London Sketch Club with numerous mouse paintings in all the nooks and crannies where mice might be expected to enter the Club.[143] A cartoon, featuring a rabbit and a fox, entitled *It's worth going out of your way to avoid an accident*, is in the collection of the Imperial War Museum.

[140] Hassall and Rountree were also keen golfers, an interest Rountree retained until the end of his life and, in 1910, he illustrated Bernard Darwin's *The Golfcourses of the British Isles*.
[141] *St Ives Times*, 29/9/1950.
[142] Recorded by one time student Percy Bradshaw, in D.Cuppleditch, *The London Sketch Club*, Stroud, 1994 at p.60.
[143] ibid, p.136.

Fig. 3R-5 *Jack Benny*

Fig. 3R-6 *John Park*

Fig. 3R-7 *Fred Bottomley*

Fig. 3R-8 *Jimmy Limpotts*

The Sloop Inn Caricatures

Rountree was a regular at *The Sloop Inn* and, one night, he did a quick charcoal sketch of the cheery face of old Jack Benny, a disabled sailor, who could spin a good yarn. Old Jack was tickled pink and the landlord, Phil Rogers, agreed to hang the sketch over the bar. Rountree was bought a drink and soon the suggestion was made that he should do studies of all the characters from Down-a-Long that frequented the pub. Accordingly, in idle moments over a pint over the next few years, Rountree, using bright crayon and a keen wit, produced a series of caricatures of the pub's cast of characters, including several fellow artists, until the walls were filled with over a hundred works. For many years, until Phil Rogers' death, *The Sloop* was as well known for Rountree's caricatures, as it now is for the portraits of later regulars by Hyman Segal (q.v.). See also Plates 68-71 for his caricatures of Matt Pearce, John Barclay, Pop Short and himself.

Rountree, who worked from 5, Piazza Studios, not only got involved immediately with the running of STISA but also served on the Borough Council for several years, during which time he campaigned for the preservation of the town's architectural antiquities. He was also Chairman of the Publicity Committee.

Rountree was one of those characters that always prompted strong reactions. His friends found him a most convivial companion, whether in the pub or on the golf-course, always able to make a witty aside. Ninnes comments, "His passionate assertion of things he believed in were made in any company without fear or favour, but such was his humanity and charm that those at variance with his views liked and respected him equally with those in agreement."[144] That opinion is not borne out by his treatment of Marion Hocken (q.v.) and the reactions to his outspoken opinions about modern art. Although a relative newcomer to the colony, Rountree had little hesitation in rounding on Borlase Smart for introducing into STISA the moderns and their "rubbish" and he criticised him for opening the first Crypt Group exhibition. The subsequent exchange of correspondence in *The Western Echo* caused much ill feeling and Rountree's standing was not helped by the fact that it was subsequently discovered that he had not even visited the Crypt Group exhibition that he had pilloried.

Rountree's attitude towards the moderns did not soften, and when, in 1948, the rules were changed so that a member lost his right to have a work included in each exhibition, it was no surprise to find that the new Committee, with its modernist sympathies, excluded Rountree's work completely. Rountree, who took his painting extremely seriously, was incandescent with rage and demanded a meeting. In the words of Sven Berlin, "That cock-sparrow of a little man was ginned up and emasculated" by the "abstemious" Ben Nicholson and the "calculating" Peter Lanyon.[145] Probably told that he was a commercial artist, who had no place in a Fine Art Society, Rountree found a number of colleagues who were similarly concerned at the exclusion of long-standing, respected members. As Rountree put it, "A highly accomplished artist might have a picture rejected and, on going to the gallery, be confronted by a picture of what looked like a diseased snake."[146] Accordingly, the extraordinary general meeting at which the split occurred was called.[147] After the split, Rountree returned to the fray, infuriating the moderns by comments passed on *Down Your Way* in 1950. Again, some found these comments highly amusing whilst others considered them deeply distasteful.[148] Rountree died later that year and is commemorated by a plaque on Smeaton's Pier, paid for by the locals he had entertained in *The Sloop Inn*.

Ashley Rowe (b.1882)
STISA: 1929-c.1933
Born in Plymouth, he was educated at Plymouth Public School and King's College, London. Concentrating on woodcuts, aquatints and etchings, he first exhibited with STISA in the 1929 Summer Exhibition, having had some success at Liverpool in the previous couple of years. He lived in Mount Hawke, Truro and wrote hundreds of articles on the history of Truro and its surrounding parishes, having made an extensive study of early Cornish newspapers. He is recorded as a member in 1932 but his work was not selected for the touring show that year. He was secretary of the Kernow Society and was keen on archaeology, photographing nearly all the Cornish crosses. Like Borlase Smart, he was initiated as a Bard at the Gorsedd at Roche Rock in 1933 depicted by Herbert Truman (q.v.). His chosen title was Menhyryon (Long-Stones). He contributed to early editions of the *Cornish Review*, by which time he was serving as the representative of Cornwall on the General Committee of the Celtic Congress.

Louis Augustus Sargent (1881-1965) Exh. RA 1
STISA: 1939-1945
Although born in London, Sargent was the son of the French engraver, Louis Phillippe Sargent. Another forebear, Charles Sargent, was an inventor of international reputation. He studied at South Kensington and first exhibited at London Galleries in 1898. His regular exhibiting Societies were the NEAC, the International Society and the National Portrait Society. He came to St Ives in 1908. Both a sculptor and a painter, he lived initially at Clodgy View and used 1, Piazza Studios. He first exhibited on Show Day in 1910, when he was described as "one of the rising young artists of the day" and his submissions to the RA included a self-portrait and a portrait of Claude Barry's wife. He also painted landscape and marine subjects and some unconventional allegorical studies and he illustrated a number of books on animals. In 1912, his painting *The Coast, St Ives* was shown in the Venice Exhibition and *The Atlantic Coast, Cornwall* at Pittsburg. In 1913, he had a one-man show at Leicester Galleries and, in 1919, *The Studio* carried an article on his work by Folliot Stokes, in which he commented, "Few men in landscape have used colour so boldly or with such consummate knowledge and disregard of convention." In particular, Stokes mentions Sargent's use of cool colours in the foreground and warm colours in the background, against all accepted wisdom. Sargent did not seek a literal

[144] *St Ives Times*, 29/9/1950.
[145] S.Berlin, *The Dark Monarch*, London, 1962, p.167.
[146] *Western Echo*, 10/2/1949.
[147] The reasoning for this view is set out in David Tovey, *George Fagan Bradshaw and the St Ives Society of Artists*, Tewkesbury, 2000 at p.185.
[148] One of Rountree's last commissions were illustrations for a book by fellow STISA member Winifred Humphries, called *Wig and Wog* (1947). One shudders to think what this may have been about.

Fig. 3S-1 Louis Sargent *Mountainous Landscape*

rendering of scenery but sought to capture "the spiritual significance and sublimity" of mountain sanctuaries. In addition to his unusually vivid sense of colour, he applied paint thickly, using impasto to help emphasize rockfaces. By 1921, he was being described as "the most distinguished painter of coast scenery who is associated with St Ives".[149]

Although in his obituary, it was stated that St Ives had been his permanent home for more than half a century, Sargent disappears from the local art scene after 1921 for the whole inter-war period, although two of his works were included in the Retrospective Exhibition organised by STISA in 1927, and his picture of a goatherd, with "its exquisite harmony of bright, rich colours", was considered the finest picture in the Exhibition.[150]

In the 1920s and 1930s, Sargent spent a great deal of time in the south of France, depicting in particular the coast between Grasse and Nice. He exhibited in France, Switzerland, Italy and at the Carnegie Institute in the USA. He returned to St Ives in 1939 and his landscapes, particularly of the Wetterhorn Glacier, immediately attracted attention. "Technically interesting and full of rich colour and sympathy for essentials, they dominate by reason of being different from anyone else's landscapes, and they therefore strike a new refreshing note of surprise."[151] Sargent was also an excellent still life painter, both in oil and watercolour, and, having been amused by some lengthy correspondence in the local paper on the question of scientific wording in Art Criticism, he produced his answer, a work entitled *A Lemon*![152] His obituary describes him as a quiet, retiring man who took little interest in art societies and he ceased exhibiting with STISA as soon as the war was over.[153] He had been in poor health for twelve years prior to his death at Tallandside, The Bellyars, St Ives in 1965.

Sidney Elmer Schofield (1901-1983)
STISA: 1938-1945
Sidney was the second son of Elmer Schofield and was born in Southport in 1901, shortly after his parents had settled in England. After obtaining an MA in History at Christ's College, Cambridge, he trained at the Slade in the early 1920s and then went on an extended painting trip to America, France and Spain. He painted in oils and specialised in landscapes with buildings and in portraits. Being close to his father, he was undoubtedly influenced by him. However, he eventually decided to pursue a career in farming and studied agriculture at Seale Hayne College, Devon before farming at Otley High House, Suffolk, where he bred pedigree Red Poll Cattle and Suffolk Punch Horses. On one of their visits to Cornwall, he and his father had stolen a glimpse of

[149] *St Ives Times*, 1/1921.
[150] *St Ives Times*, 20/5/1927.
[151] *St Ives Times*, 13/10/1939.
[152] *St Ives Times*, 12/4/1940.
[153] *St Ives Times and Echo*, 1/10/1965.

Fig. 3S-2 Sidney Schofield *St Ives Fisherman* (John Schofield)

Fig. 3S-3 Sidney Schofield *St Ives Fisherman* (John Schofield)

Godolphin House, which had left a lasting impression, and so when he heard in 1937 that it was for sale, he set off for Cornwall immediately and bought it. In 1938, his parents moved in and Sidney, taking up his paints again, joined STISA at the same time as his father. His best work from this period is a series of portraits of St Ives fishermen (see Figs.2S-2 and 2S-3). He fell in love with Peter Lanyon's sister, Mary, who had also joined STISA (as an associate) in 1938, and they were married in 1940. Shortly afterwards, Sidney, volunteered for war service and, after the cessation of hostilities, he was raised to full membership of STISA in 1945 but he rarely painted thereafter as the rescue and repair of Godolphin House became his principal passion. The recent major restoration works at Godolphin will result in the work of Elmer and Sidney Schofield being on public display again.

Hely Augustus Morton Smith RBA RBC (1862-1941) Exh. RA 21
STISA: 1934-1941
STISA Touring Shows: 1934, 1936, 1937.
Public Collections include Victoria and Albert Museum, QMDH, Plymouth and Christchurch.
The son of a clergyman, he was born in Wambrook, Dorset and he studied at the Lincoln School of Art and in Antwerp. In 1890, he settled in Looe for a while and, as he specialised in marine subjects, in oil and watercolour, he may have studied under or become friendly with Olsson at this time. By 1899, he had moved to London and he was elected to the RBA in 1902 and was Treasurer for many years. This Society was his principal interest, for he exhibited 305 works at its shows, but he was also Treasurer of the Artists' Society and a member of the Langham Sketching Club. He was particularly adept at painting stormy marine scenes, of which Plymouth's *A Stormy Evening* is a typical example. However, he also painted portraits and flower studies. Nevertheless, it was marine subjects that he exhibited with STISA in the last decade of his life.

Francis Raymond Spenlove
STISA: 1927-1928
He is recorded as exhibiting in 1922 a series of drawings of Old St Ives and, on Show Day in 1924, he took the Wharf Studio. Principally a portrait artist, his style was felt by 1927 to be developing into something original. He was a founder member of STISA and was immediately elected on to the Committee but he seems to have moved away shortly thereafter, although his works were included in shows at Lanham's in 1930 and 1934.

(Miss) Ethel Stocker (d.1946)
STISA: c.1932-1946
STISA Touring Shows: 1934, 1937.
Her work was first exhibited in 1903, when she was living in Handsworth, Birmingham but she seems to have moved to Cornwall shortly thereafter, as she exhibited at RCPS in 1904. Her subjects included St Ives scenes as well as portrait miniatures on ivory. When she joined STISA, she lived at 6, Porthminster Terrace and exhibited watercolours of village subjects executed on her travels and locally.

(Miss) Dorcie Sykes (1908-1998)
STISA: 1950-1959
STISA Touring Shows: FoB 1951.
Daughter of the artist John Gutteridge Sykes, Dorcie was born in Sheffield but was educated in Penzance, after her family had moved down to Newlyn. Her father, a landscape and marine painter in watercolour, in fact, contributed to the first STISA show in the Porthmeor Gallery in 1928 and it is somewhat surprising that he was not involved again. Whilst looking after her father, who died in 1941, Dorcie studied at the Harvey and Procter School of Painting and under Forbes. She is best known for her flower paintings in watercolour, with their fine detail and exquisite colouring (see Fig.3S-4). Her works *Dahlias*, *The Ginger Jar*, *Reflections* and *Roses* were all reproduced by the British Art Company.

(Mrs) Kathleen Emily Temple-Bird SWA
STISA: 1940-1946
STISA Touring Shows: 1945.
Public Collections include Paris (Luxembourg).
Born in Ipswich, Kathleen Temple studied at the Slade, under Henry Tonks and Alfred Rich, and in Florence. She lived initially at Blakenham in Suffolk and exhibited 45 works with the Ipswich Art Club in the period 1898-1911.[154] For two years before the Great War, she taught art at a school in Canada and a Canadian scene was one of her exhibits at SWA in 1916. She specialised in portraiture but marriage and a family may have interrupted her artistic career as she did not exhibit her work again until 1930, when she was successful for the first time at the RA. Her son, John, was the subject of her 1933 RA exhibit. The outbreak of War probably prompted her move from Chelsea to St Ives and she lived at 3, The Warren. She was made an associate member of STISA in 1940 and first exhibited at that year's Autumn show. Her portrait of Mahatma Gandhi, which she had exhibited at the RA in 1940, made a distinct impression, and this was subsequently purchased by the Luxembourg Museum in Paris. She was successful again at the RA in 1944 with *Winter Sunshine, St Ives*. In 1949, her portrait of the late Sir Patrick Geddes won a Mention Honorable at the Paris Salon but, by then, she had returned to London. She was made an associate of SWA in 1951 and was a full member between 1953-1962. A number of her exhibits were of St Ives Harbour and The Sloop Inn but she did not show with STISA after 1946. For a number of years, she was also the Secretary of the Ridley Art Club.

(Miss) Mary Elizabeth Thompson (1896-1981)
STISA: 1936-1944
STISA Touring Shows: 1937.
Public Collections include National Museum of Wales, Cardiff.
A dwarf with severe curvature of the spine, she overcame these severe difficulties to become widely known for her portrayals of the Welsh slate and granite quarries. Born in Braunton, Devon, she attended a Quaker boarding school in Darlington and then studied at St Albans School of Art in 1913-1914 and in St Ives under Alfred Hartley (q.v.). She also trained under the noted Belgian artist, Fabry, who was in England during the Great War and he recommended that she attend the Academy in Brussels. She was there between 1919 and 1922, studying drawing and sculpture. Unable physically to pursue her love of sculpture, she adopted drawing as her medium, using carbon, rather than lead, pencils. She returned to live in North Wales, moving eventually to Bethesda in 1937. She appears to have re-visited St Ives in 1936, when she joined STISA, and her drawings of Welsh mountain scenes were considered to be cleverly executed with perfect draughtsmanship and to give a great impression of space.

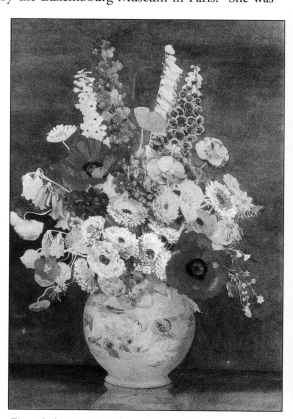

Fig. 3S-4 Dorcie Sykes *Flower Painting*

[154] This information is derived from J.Wood, *Hidden Talents*, Billingshurst, 1994.

She also showed some portraits. In 1939, when the Army took over the mountain slopes for firing practice, she began drawing in the Penrhyn slate quarry and depictions of quarrying became her principal focus. She completed a series of drawings covering the whole slate industry and 53 of these are now in the collection of the National Museum of Wales, Cardiff. In 1949, she had a show at the Geological Museum, London and a booklet *An Artist in the Quarries* was produced in 1981 to accompany a Welsh Arts Council touring show. In 1954, she moved to join her family in Tunbridge Wells, Kent. She found it difficult at first to adjust to the soft contours of the Kentish landscape but a new lyrical quality developed in her drawings. She did not draw after 1969 as she became unable to walk.

John Henry Titcomb (1863-1952) Exh. RA 2
STISA: 1927-1952
STISA Touring Shows: 1932, 1937. Also FoB 1951.
Jack Titcomb, or "Titters" as he was known to his fellow artists, was born in Lambeth and was the second son of the evangelical Anglican minister, the Reverend Jonathan Holt Titcomb, who became first Bishop of Rangoon. His brother, William Titcomb, was one of the leading artists in St Ives in the period 1887-1905 and Jack also was based in St Ives for much of this period. The two brothers were very close, with Jack frequently joining William and his wife, Jessie, on their regular painting trips abroad. Although Jack, who had studied at the Slade, was not nearly as accomplished an artist, he was extremely sociable and efficient, so that he assumed organisational roles wherever he went. He was first elected President of the Arts Club in St Ives in 1910, when he was the subject of a caricature by the American artist, Fitzherbert, and was again elected President in 1929 and 1938. He was also Secretary on a number of occasions. During the First World War, he briefly moved to Bristol to join his brother and organised the annual art exhibition of the Bristol Savages Club. Until 1920, he worked entirely in oils but, when his brother started to concentrate on watercolours during his continental painting tours of the 1920s, Jack, who accompanied him on sections of his travels, also started working in this medium and exhibited occasionally at the RI. He was included in the 1922 joint exhibition

of the St Ives and Newlyn colonies at Plymouth Art Gallery and both Jack and William were represented in the 1925 Exhibition by St Ives artists at Cheltenham.

Jack Titcomb was a founder member of STISA and retained his membership for the 25 years up to his death but his work was rarely selected for the touring shows and his contributions to exhibitions are irregular. He appears to have worked from his home as, on Show Days, he tended to exhibit at Lanham's Galleries or in the Porthmeor Galleries but, in the 1930s, his involvement in Show Days tailed off - a consequence, possibly, of marrying late in life.[155] However, he retained his interest in art and was a regular at the weekly sessions held by Smart, Bradshaw, Milner and others during which the art world was put to rights over a bottle of beer. In 1939, he was the artists' representative at the Tercentenary celebrations of the granting of the charter by Charles I, incorporating St Ives as a borough, during which the Mayor highlighted the contributions of the artists in the past fifty years to the promotion of tourism. Works by Titcomb are held in the collections of St Ives Arts Club and the Bristol Savages.

Fig. 3T-1 Mabel Douglas *Jack Titcomb*

[155] On Show Day in 1929, he seems from Roskruge's Map, to have been showing in a studio in Back Road.

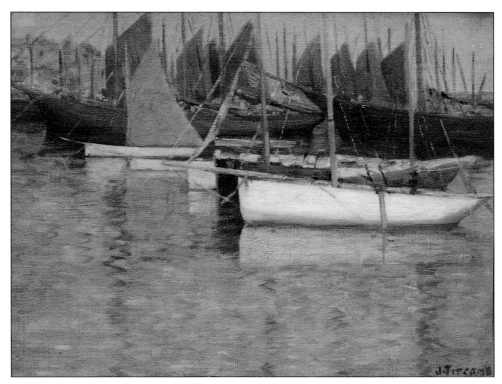

Fig. 3T-2 J.H.Titcomb *St Ives Harbour* W.H.Lane & Son)

William Todd-Brown ROI (1875-1952) Exh. RA 5
STISA: 1941-1951
STISA Touring Shows: 1947 (SA), 1947 (W), 1949. Also FoB 1951.
Born in Glasgow, Todd-Brown studied initially at the Glasgow School of Art under P. Newbery. At the age of 18, he went to the Slade, where he trained for five years under Brown, Tonks and Wilson Steer, winning a scholarship and prizes for head and figure painting. He described himself as a "portrait, landscape and decorative painter and etcher".[156] For many years, he assisted Gerald Moira in mural decoration work in a number of important buildings, such as Lloyds and the Central Criminal Courts, and he was in charge of women artists who decorated the first Wembley Exhibition restaurants. In 1922, he was appointed Principal of the Reigate and Redhill School of Arts and Crafts, a position he retained for 18 years. STISA member, Dora Pritchett (q.v.), was one of his former students. However, he paid regular visits to Cornwall, as his RA exhibits *Polperro* (1934) and *A Cornish Cove* (1938) attest. A painting of *Porthmeor Beach* was also exhibited in London in 1933. He was elected an ROI in 1934.

Todd-Brown settled in St Ives during the Second World War and first exhibited with STISA at the 1941 Spring Exhibition. His landscapes and still lifes (see Plate 52) soon attracted attention and he was successful at the RA in 1944 with *Effect over St Ives Bay*, which had been praised on Show Day for its "clever handling of paint and freedom of brushwork". His address was then given as Lyonesse, Talland Road, St Ives, but he appears to have moved with his wife and elderly sister, Marjorie Brown, to Carbis Bay in 1946. He was first elected on to the Committee in 1943 but was one of the members who was unhappy at the direction STISA took after Smart's death and accordingly signed the requisition for the 1949 EGM. After the split, he was again elected on to the Committee and continued to exhibit with the Society until his death in 1951, although a year before, he moved to Torquay. His wife was a skilful weaver and was partly responsible for founding the Cornwall Guild of Weavers, Spinners and Dyers. His obituary records that he was a modest, gentle man, with a great sense of humour, and that his wide experience and association with well-known people provided him with a fund of anecdotes.[157]

Charles Dunlop Tracy OBE SMA (d.1948) Exh. RA 2
STISA: c.1932-c.1945
His only successes at the RA were in 1909 and 1911, when he was living in Shoreham in Sussex. A marine artist, his work is first mentioned in St Ives in a review of the 1932 Winter Exhibition, when his painting of moonlight upon the sea was praised but, as he was then living in Holbrook, Ipswich, his contributions were not regular. Works are again mentioned in 1940 and 1945 but it is not certain whether he came to live in St Ives during the War. Like many others in STISA, he was one of the early members of SMA.

[156] *Who's Who in Art*, 1934.
[157] *St Ives Times*, 4/4/1952.

George Edgar Treweek
STISA: 1937-1961
STISA Touring Shows: 1937.
He first exhibited with RCPS in 1886, when he was classed as an amateur, but, by 1888, he was included in the professional section. He painted village and landscape subjects in oil and watercolour, which were quiet in tone, and exhibited regularly with RCPS until 1910. In 1927/8, he is recorded as living in Stowmarket, Suffolk, when he was exhibiting with Ipswich Art Club, although his subjects were Devon and Cornish scenes.[158] He was not involved with STISA until 1937 and then only infrequently. He exhibited on Show Day in 1939 but he was resident in Newquay when his work was included in the 1947 Cornish tour. By 1957, however, he was living at Burnham, Buckinghamshire.

(Mrs) Lilas Trewhella (d.1947)
STISA: c.1929-1947
Her first Show Day was in 1929, when a study of children at play, *La Ronde*, was considered full of fine movement. In 1931, her painting, *Zennor Cliffs*, which "emphasised the dark mystery of a wild coast", was considered one of the highlights of the small London exhibition organised by the Kernow Group, to which many St Ives artists contributed.[159] She was certainly a member of STISA by 1932, when she was living at Restronguet Farm, Mylor Bridge. Her two works at the 1932 Winter Exhibition, both of which had a dainty Chinese effect, sold immediately but she did not contribute to any of the touring shows of the 1930s. She was still a member when she died in 1947.

(Ms) Barbara Tribe FRBS (1913-2000) Exh. RA 10
STISA: 1948-2000
Public Collections include Stoke, Spode Potteries Museum, RAF Museum, Hendon and, abroad, Vienna, Adelaide, Bathurst, Canberra, Melbourne, Sydney, and the Australian War Memorial Museum, Canberra. Work is also at Minack Theatre, Porthcurno and Roxy Theatre, Sydney,

For over half a century, Barbara Tribe's sculptures were one of the highlights of STISA Exhibitions. Born in Sydney to broad-minded Bohemian parents, who had emigrated from England, she began her studies at the age of fifteen at Sydney Technical College, under Rayner Hoff, winning a bronze medal for sculpture in 1933. Hoff commented, "I have never known anyone acquire so much facility in so short a time" and she became his assistant, working on the Anzac War Memorial in Sydney's Hyde Park.[160] She first came to England in 1935 under a New South Wales Travelling Art Scholarship to the RA Schools. It was the first time that the scholarship had been awarded to a woman and also the first time that a sculptor had been chosen. The superb nude, *Caprice*, which won her the scholarship is now owned by the Art Gallery of South Australia. She then studied further at the City and Guilds School of Art, Kennington in 1936-7 and at Regent Street Polytechnic under the sculptor, Harold Brownsword. Having elected to remain in Britain, she worked during the Second World War for the Inspectorate of Ancient Monuments, recording the interiors of important London buildings in danger of demolition from enemy bombs. She also did a number of portrait sculptures of members of the Royal Australian Air Force, many of which are now in Australian Art Galleries. During this time, she met the potter, John Singleman, and, upon their marriage in 1947, they decided to settle in Cornwall. They converted the former Baptist Sunday School in Sheffield, Paul, near Penzance into a Studio, and this was to be her home for the rest of her life.

She first exhibited with STISA in the 1948 Summer Exhibition, by which time she was already an Associate of the Royal British Sculptors (Fellow 1957). Her work immediately shows signs of being influenced by Barbara Hepworth. Holes and strings appear in her works of the early 1950s and her contribution to the 1953 Football and Fine Arts Competition was an abstract work. However, she soon reverted to more traditional representational work, although in the late 1950s she was inspired by the collections of ancient and primitive art in the British Museum.

She was elected to the newly inaugurated Society of Portrait Sculptors in 1953. Her portraits included many leading figures in both Australia and England including Sir Winston Churchill, Gracie Fields, the famous Australian painter, Lloyd Rees, and the inventor of Esperanto, Dr Zamenhof. She also did portrait bronzes of Princess Elizabeth Chula Chakrabongse of the Thai Royal Family and her husband, Prince Chula Chakrabongse, who had a home at Tredethy, Bodmin. Princess Chula was a member of STISA for some fifteen years from the late 1950s, subsequently becoming Honorary Vice-President, and her husband performed a number of opening ceremonies for STISA. Through them, Tribe received many commissions from Thai private collectors. The artist, Bryan Pearce, on two occasions, and the watercolourist, Sybil Mullen Glover, another valued member of STISA, who helped finance the purchase of STISA's current Gallery, were also the subject of portraits by her. Another STISA member with whom Tribe was close was Eric Hiller (q.v.) and he did two portrait heads of her in 1963/4, shortly before his death.

[158] This information is derived from J.Wood, *Hidden Talents*, Billingshurst, 1994.
[159] *St Ives Times*, 17/7/1931.
[160] Quoted by Robin Braunson in *St Ives Times and Echo*, 22/5/1998.

Fig. 3T-3 Barbara Tribe in 'The Studio' with her 1954 work *Torso* (Yorkshire sandstone)

She sought in her work to express the miracle of creation, growth and regeneration. In his obituary, Frank Ruhrmund observed, "Few artists captured children and animals, either in wood, clay or bronze, with such accuracy, conviction and compassion, as she did."[161] After her husband's death in 1961, she began drawing, printmaking and painting, becoming particularly adept in watercolour and gouache, and she also experimented with ceramics, winning acclaim for her coiled ceramic sculptures. Brought in by Bouverie Hoyton (q.v.) to lecture in modelling and sculpture at the Penzance School of Art in 1948, she continued to shape the destiny of students for an astonishing forty-one years. Students included Terry Frost, the potter, Robin Welch, and sculptors Judy Reed and Theresa Gilder, who themselves became tutors at the School.

A major retrospective was held at Stoke-on-Trent in 1979, which was opened by the Prince of Wales, and another, *Alice to Penzance*, was held at the Mall Galleries in London in 1991. In 1998, she was awarded the Jean Masson Davidson Medal, an international award for outstanding achievement in portrait sculpture - the first time it had been awarded for twenty years. A sumptuous biography, financed by a wealthy Australian collector, was published by Patricia McDonald shortly before her death, but she was able to attend its launch at the Art Gallery of New South Wales. A 'dinkum' Aussie in character and outlook, Barbara Tribe was a traditionalist who believed fervently in the future of representational art and had little time for the media posturing of some modern artists.

[161] *The Cornishman*, 26/10/2000.

(Miss) Mildred Turner-Copperman
STISA: 1932-1933
STISA Touring Shows: 1932.
Turner-Copperman was an American artist, who stayed briefly in St Ives. Her work *Cornish* included in the 1932 tour must have been a substantial work as it was priced at £200. It was her report of the Brighton Private View that was published in the *St Ives Times*. Her Cornish landscapes at the 1932 Winter show were considered powerful works, demanding attention and "great in imaginative and pictorial strength".[162] She was also included in the 1933 London show at Barbizon House.

Reginald Turvey (b.1882) Exh. RA 3
STISA: 1931-1933
STISA Touring Shows: 1932.
Born in South Africa, Turvey was a portrait, landscape and flower painter. He is signed in as a guest of William Titcomb at the St Ives Arts Club in December 1904 but he does not appear to have settled in the locality until the 1920s. He exhibited on Show Day in 1925 at Alison Studio, when his 'advanced manner' was noted. "He has a style of his own, and if his draughtsmanship at times leaves something to be desired from an Academic point of view, he has the right colour sense and his brushwork is 'slick'."[163] Although he exhibited with STISA from 1929, his modernity was often considered crude and he was not invited to become a member until April 1931. He was then living in Carbis Bay. He contributed to the 1933 Barbizon House show in London, but appears to have moved away shortly afterwards and was living in Totnes in 1940.

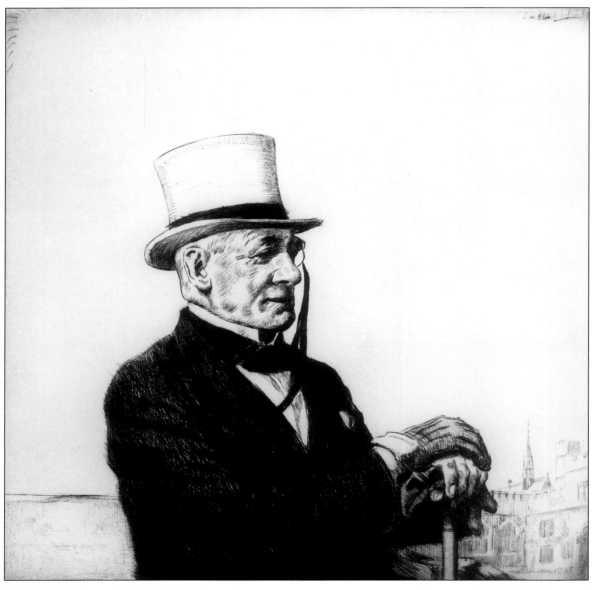

Fig. 3V-1 Salomon Van Abbé *Self Portrait* (Trustees of the British Museum)

[162] *St Ives Times*, 2/12/1932.
[163] *St Ives Times*, 20/3/1925.

Salomon Van Abbé RE RBA (1883-1955) Exh. RA 16
STISA: 1936-c.1944
STISA Touring Shows: 1937.
Public Collections include Toronto, Chicago, Nelson (NZ)

The son of a diamond dealer, Van Abbé was born in Amsterdam but moved to England with his family at the age of five and attended various London schools, including Toynbee Hall, St Martin's and Kennington Art Schools and the Bolt Court School, where tutors Walter Bayes and Walter Seymour were significant influences. He later became a British subject. He worked initially as a newspaper illustrator but, in due course, became well-known for his drypoint etchings, becoming ARE in 1923. He also illustrated books and designed book covers. He drew in a conventional style, usually with fine hatched shading. As a painter, he was best known for his portraits and he was elected to the RBA in 1933. Figure studies were his principal preoccupation, concentrating on people's attitudes, gestures and facial expressions and his penetrating eye was aided by a dry humour. He is best remembered for his etchings of the British legal system at all levels of operation and one of his first exhibits with STISA was *Out of Court*, featuring several jovial bewigged barristers.

Van Abbé, a grossly overweight man who suffered from angina, was another of STISA's members drawn from the ranks of the London Sketch Club, of which he was President in 1940. Cuppleditch records:-

> "Van Abbé housed an immense collection of "reference" books which he kept "with considerable system". In his house in South London, there were massive cupboards full of information on just about every subject available from love-making to rough-housing and costume to shipping. Van Abbé spent a good many evenings leafing through periodicals and books, excerpting promising items"[164]

Alongside these, Van Abbé also had numerous sketch books and the copies of old masters, which he had made in an effort to understand better how they had been painted. He worked in a methodical manner, initially visualising a complete mental picture and then carefully planning every aspect before committing pen or brush to paper. He considered that there must be no element of chance, no reliance upon a lucky stroke or passage "to pull it off".[165] Known to his Club colleagues as Jack, he used, for his book cover designs, the name J. Abbey or, occasionally, C.Morse (after a distant cousin).

Van Abbé's involvement with STISA seems to stem from his visits to St Ives in the 1930s. In 1933, he exhibited a work *Sun and Shadow, St Ives, Cornwall* but it was on a return visit in 1936 that he was persuaded to join STISA.[166] For STISA Exhibitions, he avoided Cornish subjects and sent work in a variety of media. In the 1937 exhibition at Bath, he was represented by an oil, *The Windmill, Wenduyne*, a watercolour, *Spring in Avignon* and three etchings - *Counsel's Opinion*, *The Boulevard* and one of his most well-known prints, *The Market Inspector*. During his membership of STISA, Van Abbé won a bronze medal at the Paris Salon (1939) and may well have spent part of the War in St Ives for, between 1939 and 1943, many of his exhibits at the RBA shows were St Ives scenes. However, he does not appear to have resumed membership after the cessation of hostilities, when he was much in demand as a book illustrator.[167]

(Miss) Beatrice Vivian
STISA: 1930-1938
STISA Touring Shows: 1932, 1936.
Her first Show Day was in 1929 and some of her 'black and white' work was included in the 1930 Spring show. She lived at Dolphincot, Carbis Bay but was not a regular exhibitor.

(Mrs) Lucia E Walsh Exh. RA 6
STISA: c.1940-1963
STISA Touring Shows: 1947 (SA), 1947 (W), 1949. Also FoB 1951.
Described by David Cox in *The Cornish Review* in 1949 as "a fine portrait painter of artistic integrity", she first exhibited at the RA in 1907, when she was living in Walton-on-Thames. By 1924, she was working from 11, Avenue Studios in the Fulham Road. She moved to St Ives just before World War II and her first Show Day was in 1939. She was successful at the RA the following year with *Chinese Dancer*, a work that was included in the 1947 Cardiff show, and her portraits were considered "convincing in their likeness, correct in style and well expressing the character of their sitters".[168] She worked from 2, Porthmeor Studios and, each Show Day, her charcoal portrait studies were well-received.

[164] D.Cuppleditch, *The London Sketch Club*, Stroud, 1994, p.145.
[165] *The Artist, Artists of Note - S.Van Abbe*, July 1949, pp.110 & 117.
[166] He exhibited at the RBA that year *A Street in St Ives*.
[167] Books illustrated in the last decade of his life include *Little Women* (1948) and *Good Wives* (1953) by Louisa Alcott, *The Wonder Book* (1949) and *Tanglewood Tales* (1950) by Nathaniel Hawthorne and *Tom Brown's Schooldays* (1951) by Thomas Hughes. For this and much of the general biographical information on Van Abbe, I am indebted to B.Peppin and L.Micklethwait, *Dictionary of British Book Illustrators - The Twentieth Century*, London, 1983.
[168] *St Ives Times*, 22/3/1946.

(Miss) Billie Waters (1896-1979) Exh. RA 27
STISA: 1946-1955
STISA Touring Shows: 1947 (SA), 1949. Also FoB 1951.
The daughter of a solicitor, Billie Waters was born in Richmond, Surrey. She studied under Massey at Heatherley's, at the Chelsea Polytechnic School of Art and under Macnab at the Grosvenor School of Modern Art. She then came to Cornwall and studied at the Harvey and Procter School between 1920 and 1925, before becoming "a kind of apprentice" to Ernest Procter.[169] He taught her technical matters, such as how to prime and stretch a canvas, as well as advising her on painting. He also used her as a model, on occasion. Under Procter, she developed a distinctive decorative style. Although she made sketches and colour notes out of doors, her decorative patterns were developed in the studio. Flowers and animals were her principal motifs. She worked primarily in oil but the way she primed her canvases gave her work a slightly matt effect, akin to tempera. She applied her paint thinly, without visible brushstrokes, and she waxed rather than varnished the finished work.

She socialised with the Procters and Harveys and their friends and also received some informal advice from Lamorna Birch, who commented, "She is very intense and looks very knowing but she is full of masterpieces which one is not allowed to see."[170] She was successful for the first time at the RA in 1928 and exhibited there regularly for the next twenty years. Although she contributed to the first STISA show in the Porthmeor Gallery in 1928, she did not join at this juncture. In 1931, she left Newlyn and went to live in London, living first in Church Street, Kensington, and later in Chelsea. In 1933, she held her first one-man show at Leicester Galleries. She became very interested in animals, spending a good deal of time at London Zoo, and from this she perceived the decorative possibilities of animal forms. Her work was taken up by the colour collotype firm, W.J.Stacey, and her prints *The Little Fawn*, *Innocence* (a young antelope) and *The Lotus Pool* were highly successful. These led to a commission to illustrate an American book, *Animals Big and Small* by Ray Edwin (1940).

In 1934, she was commissioned to carry out mural decorations at the Knightsbridge Grille, which she executed on canvas in a matt oil technique, and such mural work was particularly suited to her style. In August 1938, she featured in the *Artists of Note* series in *The Artist*.[171] During her time in London, she returned to Cornwall on a regular basis and she returned to live there during the War. She joined STISA in 1946 and remained a member after the split, although she also joined the Penwith Society. In 1949, she held a joint show at Walker's Galleries, Bond Street, with Denise Williams (q.v.) and a contemporary review mentions that she was also at that time planning a show in Vancouver.[172]

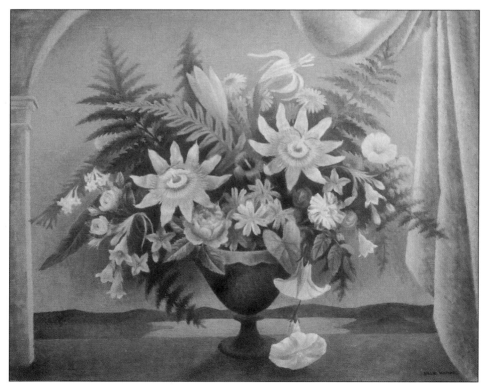

Fig. 3W-1 Billie Waters *Flower Piece* (W.H.Lane & Son)

[169] There seems some confusion about the date of her arrival in Newlyn. The Catalogue to the Women Artists in Cornwall Exhibition indicates 1923 whereas *The Artist*, in its feature on her in 1938, states 1926. However, her entry in the 1948 edition of *Who's Who in Art*, which derives from information obtained direct from the artist, indicates that she studied at the Harvey and Procter School between 1920-1925.
[170] A.Wormleighton, *A Painter Laureate*, Bristol, 1995, p.191.
[171] This is the source of much of this note.
[172] *St Ives Times*, 22/4/1949.

(Mrs) Amy Maulby Watt (1900-1956) Exh. RA 19

STISA: 1935-1945

STISA Touring Shows: 1936.

Born in Plymouth, Amy Watt (née Biggs) studied at the Plymouth School of Art under Fred Shelley and later at St Martin's in London, where she met her future husband, John Millar Watt. They married in 1923 and moved to Dedham in Essex, where Millar Watt designed and built a large house and studio. At this juncture, Amy specialised in flower paintings and landscapes and she had her first painting accepted by the RA in 1929. However, when she moved to St Ives in 1935, she took the Chy-an-Chy Studio overlooking the harbour and her five RA exhibits in 1938 and 1939 were all St Ives harbour scenes. One drew high praise at the 1938 Autumn Exhibition. "The silver light of the Harbour on an August day has never been so completely caught as in the glowing canvas by Amy Watt of *The Harbour, August*. The combination of the incidents of sky, pier and fishing craft with the crowd along Wharf Road is beautifully harmonised in brilliant tones of blue and silver."[173] Another critic commented, "There is something very individualistic about her work and she has a wonderful way of putting on her colour. Her painting is always expressive and her pictures show fine draughtsmanship and composition." She herself said, "I believe in simplicity when it comes to art, and in harmony of colour. I am not a modern in the generally understood sense of the word. I have worked out my own methods - on purely traditional lines."[174]

In 1939, the Watts moved briefly to Crediton but returned to St Ives during the war. Shortly after the war, however, they moved to Chelsea and ceased to exhibit with STISA. Amy returned to flower painting - their home was next to Harrods' Flower Department - (see Plate 51) and, whilst continuing to be successful at the RA, she also won two Mentions Honorables at the Paris Salon. However, she died early from cancer.

Fig 3W-2 Amy Watt at her Walker's Gallery show

[173] *St Ives Times*, 7/10/1938.
[174] *News Chronicle*, 1939, Cornish Artists 26.

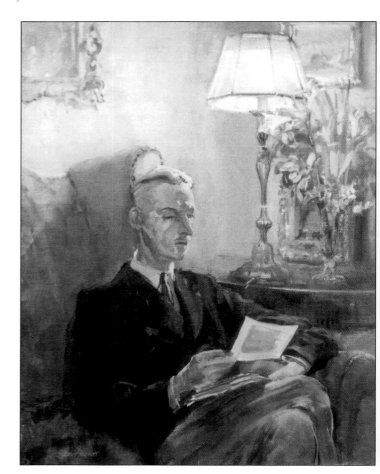

Fig. 3W-4 Amy Watt *John Millar Watt*

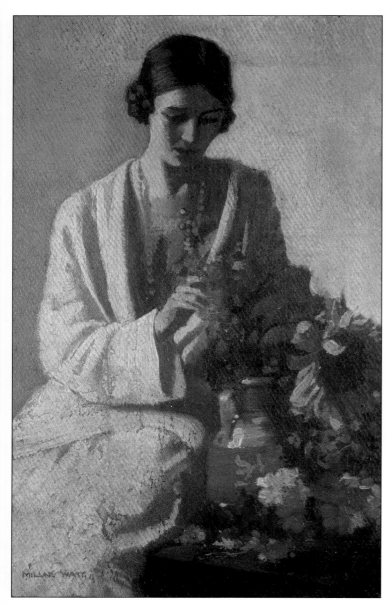

Fig. 3W-3 John Millar Watt *My Wife*

John Millar Watt (1895-1975) Exh. RA 3
STISA: 1935-1945
STISA Touring Shows: 1936, 1937, 1945.
Public Collections include Ipswich.
Best known as the creator of the character 'Pop', who was featured in a strip cartoon in *The Daily Sketch* (and subsequently *The Daily Graphic*) for over 25 years from 1921, Millar Watt nevertheless took his art seriously and his paintings were well-regarded. Born in Gourock, Clyde, he was educated in Ilford, Essex and at Cass Art Institute before joining the advertising agency Mather and Crowther. In the Great War, he enlisted in the Army and served as a lieutenant at Vimy Ridge, where he was gassed.[175] Afterwards, he continued his art studies at St Martin's and at the Slade in the evenings. In 1923, he married and settled at Dedham in Essex, where he became very friendly with Alfred Munnings, who later commented, "I have the greatest admiration for Millar Watt, both as an artist and a man. I have known him for years. Some of my happiest days have been spent out sketching with him in Suffolk. He lived in the same village and we used to go out together in his car to sketch landscapes." Between 1923 and 1935, Watt exhibited 39 works with Ipswich Art Club.[176]

Exceptionally tall, thin and rangy, with aquiline features, Watt chose to endow his comic creation, 'Pop', with short stature, a round, bald head with a large chin and a huge stomach. 'Pop', who sported a top hat, cravat and tailcoat, was almost somebody,

[175] He also invented and built a seascape target for use by the Home Guard coastal gunners, which involved models of enemy craft drawn by a concealed magnet across a 'sea' of blue-painted glass, while plain and coloured lights flashed on and off to record the battery's hits and misses.
[176] This information is derived from J.Wood, *Hidden Talents*, Billingshurst, 1994.

somewhere in the City, with a formidable wife and a no less acerbic daughter, Phoebe, and the cast of characters that Watt created ensured a phenomenal run of success for the cartoon strip. Watt had wanted to retire 'Pop' in the late 1930s so that he could concentrate on fine art but the continuance of the comic strip was considered of vital importance to national morale - King George VI and Winston Churchill were fans - and he was persuaded to carry on. 'Pop' accordingly, like Millar Watt himself, joined the Home Guard. By 1945, over 7,000 cartoons had been published. One of his 'Pop' cartoons was included in the 1936 tour but normally Watt restricted his exhibits with STISA to landscapes and still life, which he painted in the academic tradition, leading more than one critic to comment that they evoked the aura of Old Masters. In 1936 and 1937, he was successful at the RA and he was elected on to the Committee of STISA in 1936. In fact, he was clearly considered a valuable member of the Committee for he was re-elected in 1937, 1940, 1941 and 1943 and it was Millar Watt, who in 1945 first put forward the proposition that the Mariners' Chapel should become the new Gallery for the Society.[177] His departure for Chelsea after the war will have been regretted. After his wife's death, he moved to Lavenham and continued both commercial and fine art. His advertising work included the famous *More Hops in Ben Truman* campaign of the 1960s and 1970s. His illustrations featured in magazines such as *Reader's Digest*, *Look and Learn*, *Everybody's* and the *Princess* comic. Retrospectives of his work were held at the Church Street Gallery, Lavenham in 1989 and 1991.

Fig. 3W-5 John Millar Watt *An example of a 'Pop' cartoon* (Mary Millar Watt)

(Miss) Mary Millar Watt Exh. RA 7
STISA: 1945-1949
The daughter of Millar and Amy Watt, she began exhibiting with STISA in 1940, whilst still in her teens. She studied under Fuller and was first successful at the RA in 1945 and exhibited there irregularly until 1964. After leaving St Ives, she lived with her parents in Chelsea, whilst she was studying further at the RA Schools. After her mother's death, she went to live with her father in Lavenham in Suffolk. She specialised in portraiture, working in oils, watercolours, chalk and pencil, and also produced still life paintings. She was a member of SWA between 1965 and 1979, exhibiting 51 works with that Society, and also showed with RMS and RP. She is the subject of a fine portrait by her mother.

(Miss) D.G. Webb Exh. RA 1
STISA: c.1929-c.1935
She is first mentioned in a review of Show Day in 1923 and, in 1924, she is exhibiting at Skiber War Vor Studio. She does not appear to have been living in St Ives when STISA was formed and her involvement was limited. Her work is not mentioned until the 1929 Summer Exhibition. She is recorded as a member in 1932, when she was living in West Malvern. The fact that her tempera picture *Plaster and Porcelain* was sold at the Private View at the RA in 1935 was noted in the local press, suggesting that she was still a member, but there is no subsequent reference to her.

(Mrs) Nina Weir-Lewis
STISA: Exh.1928-1936
STISA Touring Shows: 1936.
Like her daughter, Helen Stuart Weir, she is first referred to in a review of Show Day in 1915. She also specialised in flower and still life subjects and worked in all media and, in 1922, they held a joint show at Lanham's, one of a number of occasions when they exhibited together. She exhibited with a number of the leading London societies, particularly the ROI and SWA, and had her works *Delphiniums in Somerset* and *A May Morning* reproduced. When in St Ives, she worked with her daughter at Rose Lodge Studio and she contributed to the first STISA show in the Porthmeor Gallery in 1928. However, she was not as regular a contributor as her daughter.

[177] Millar Watt also designed in c.1939 the wrought iron churchyard gate at St Ives Parish Church.

John Clayworth Spencer Wells (1907-2000)
STISA: 1947-1949
STISA Touring Shows: 1947 (W), 1949.
Public Collections include Tate Gallery, British Council, Arts Council, Government Art Collection, Plymouth, Ulster Museum and Gothenberg.
John Wells was one of the young artists with modernist leanings, who resigned in 1949 and went on to win acclaim as one of the St Ives Group. Born in London, he was brought up in an artistic community in Ditchling, Sussex. He was educated at Epsom College and then in 1925 went to University College and Hospital to read Medicine. In 1927, he began to attend evening classes at St Martin's School of Art and, on a visit to Cornwall during his summer holidays in 1928, he not only studied briefly at Stanhope Forbes' School but also was introduced to Ben Nicholson and Christopher Wood. Nicholson became a life-long friend. Wells qualified as a doctor in 1930 and, having worked in hospitals for six years, moved to St Mary's, Isles of Scilly in 1936, where he worked as a GP until 1945. During the war years, he made frequent visits to Cornwall where he met Nicholson, Hepworth and the Russian Constructivist, Naum Gabo, who proved a considerable influence. He also was a friend of Sven Berlin, to whom he posed in 1943 the oft-quoted question, "How can one paint the warmth of the sun, the sound of the sea or the journey of a beetle across a rock? That's one argument for abstraction...One absorbs all these feelings and ideas: if one is lucky they undergo an alchemical transformation into gold."

In 1945, he moved to Newlyn, where he took Stanhope Forbes' studio, Anchor Studio. He went for long walks with Peter Lanyon, absorbing the feel of the landscape, and watching and drawing the birds utilising the air currents, an experience which influenced some of his best known work. In 1946, he exhibited with Winifred Nicholson at Lefevre Gallery and was a founder member of the Crypt Group, exhibiting at each of their three shows. His works in the 1947 STISA exhibition at Cardiff were *City Dawn* and *Foreign Boats* and at Swindon in 1949 *Old Sea Port*. He resigned in 1949 and became a founder member of the Penwith Society. That year, he had a joint show with David Haughton at Downing's Bookshop, St Ives. He worked briefly as an assistant to Barbara Hepworth in 1950-1 and had his first one-man show at Durlacher Gallery in New York in 1952. A retrospective exhibition was held at Tate, St Ives shortly before his recent death.

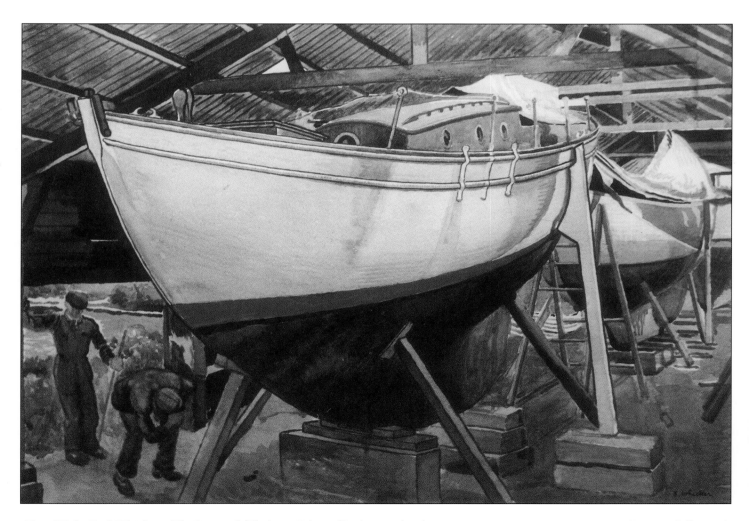

Fig. 3W-6 Fred Whicker *The Boatyard (Flushing, Falmouth)* (watercolour) (Private Collection)

Frederick John Hayes Whicker (1901-1966) Exh. RA 2
STISA: 1946-1966, Treasurer 1958-1966
STISA Touring Shows: 1947 (W), 1949.
Public Collections include Falmouth.

Born in Western Australia, Fred Whicker was working as a printer for *The Bristol Times and Mirror* when he met Gwendoline Cross at Reginald Bush's evening classes at Bristol Art School. They married in 1931 and lived in Clifton. Initially, Fred's painting style was greatly influenced by his wife's and they also tackled the same subject-matter - still life, figure painting and landscape composition all depicted realistically in the academic tradition. Fred enjoyed some success in the 1930s, exhibiting at the RA, ROI, NEAC and also with the New Bristol Arts Club, with which he was very involved. A number of his figure studies featured his wife. After their move to Falmouth at the end of the war, they joined STISA and were stalwarts of the Society for the rest of their lives. For his subjects, Fred chose scenes of local interest in Falmouth and St Ives but, increasingly, he realised that the demand for traditional style painting was on the wane and he was much more prepared than his wife to experiment with a more modern approach to form and colour. He also tried different media mixes, combining egg tempera and oil for a translucent effect and also oil with watercolour washes. His exhibit at the 1949 Swindon show was simply entitled *Doodling*. He became Treasurer in 1958, a post he held until his death. A joint retrospective was held at Falmouth Art Gallery and the RWA in 1994.[178]

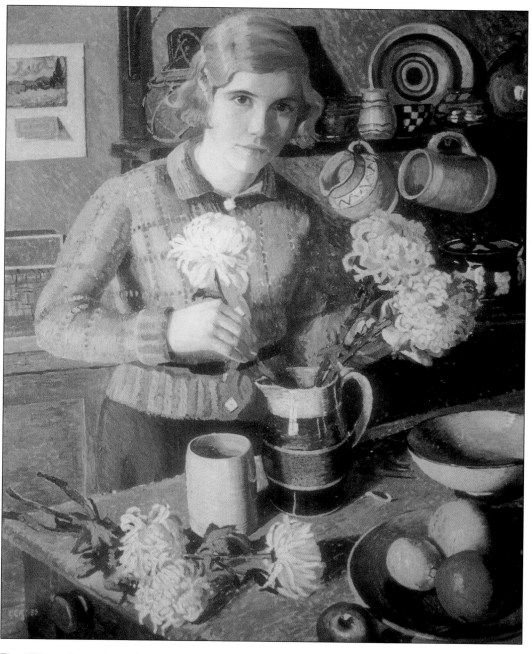

Fig. 3W-7 Gwen Cross (later Whicker) *Arranging Flowers* (W.H.Lane & Son)

[178] See Catalogue of the Retrospective Exhibition at Falmouth Art Gallery 1994.

(Mrs) Gwendoline J Whicker (1900-1966) Exh. RA 1
STISA: 1946-1966, Secretary 1964-6
STISA Touring Shows: 1947 (SA), 1947 (W), 1949. Also FoB 1951.
Public Collections include Falmouth and Chicago.

Gwen Cross was born in Bristol. Her father was a painter and decorator but was against her studying art. Nevertheless, she paid her way through art school in Bristol by undertaking medical drawings for Bristol University. Under Reginald Bush, Bristol Art School gained a significant reputation for its teaching of etching and much of Gwen's early work was in the medium of printmaking. She first exhibited her etchings of Bristol scenes at the RWA in 1923 and, by 1928, was exhibiting her prints with the Chicago Society of Etchers and in Los Angeles. Having obtained a teaching qualification, she returned to teach at Bristol Art School, where she met her husband. In the 1930s, she concentrated more on oil painting, although she continued to exhibit etchings at the RWA until 1935 and also designed cutlery and jewellery, working with silver and enamel. During this period, domestic scenes were prevalent in the work of both Fred and Gwen. She commented, "When Fred and I got married, we found lots of things about our flat which would make pictures, so we set about painting them...We are trying to make beauty out of everyday domestic life."[179] In 1933, she was instrumental in forming the New Bristol Arts Club, predominantly made up of ex-Bristol School of Art students, which set out to waken up art in Bristol and to provide a fresh outlook.[180] Gwen was the Club's first President and arranged for it to hold its exhibitions at the RWA but, after three successful shows in 1934, 1936 and 1938, the onset of war curtailed the Club's activities. After the war, the Whickers moved to Falmouth, which had always been a favourite haunt, and were quickly welcomed as members of STISA. Gwen's contributions to STISA shows were, in the main, flower paintings, painted in great detail in the classical manner (see Fig.1-44). Due to her friendship with the novelist Howard Spring and his wife, she joined Falmouth Floral Society and often took home arrangements in order to try to capture them in paint before they wilted. This often involved working through the night. Her exhibit at the 1948 Summer Exhibition *Red Boat, Falmouth Docks*, depicting a boat in for repairs, is now owned by Falmouth Harbour Commissioners. During the 1950s, Gwen served on the Committee of STISA and became Secretary in 1964. However, like many traditional artists, times were very hard as representational work fell out of favour and she died feeling that she had failed as an artist.[181]

Arthur Moorwood White (1865-1953)
STISA: 1937-1953
STISA Touring Shows: 1937, 1947 (W). Also FoB 1951.

Arthur White's atmospheric paintings of old St Ives are well-known to art collectors. The frequency with which the tower of the St Ives Parish Church appears in his paintings has led him to become known as 'Tower White' or 'Church White'. The son of an art metal craftsman, Arthur White was born in Sheffield and studied at Sheffield School of Art from 1880 under Henry Archer and J.T.Cook (along with John Gutteridge Sykes - see under Dorcie Sykes) and then at South Kensington, where he won a silver medal. Initially, he taught art at a girls' school in Sheffield but he then determined to make a career out of painting. He came to Cornwall in 1903 and, having looked at Falmouth, Newquay and Newlyn, decided to settle in St Ives. By 1909, he was advertising for pupils at 4 Tre-Pol-Pen, Street-an-Pol, offering instruction in "painting in oil and watercolour, marine, landscape, figure, etc.". However, Dorcie Sykes recalled that he insisted his pupils should learn to draw before they picked up a paint brush. White himself worked in oils and watercolours and concentrated on marine and landscape subjects but is best known for his depictions of the harbour, filled with brown sailed craft, and of the old cottages in Down-a-long. "No artist is more true to St Ives subjects" was a typical comment in reviews of White's pictures in STISA shows.[182] These were as popular in his own day as they are now and, at the 1930 Summer show at Lanham's, four of his five views of St Ives sold on the first day. He worked from Tregenna Hill Studio in the 1930s and later in his life from Fern Glade Studio, The Stennack.

It is something of a mystery why White did not join STISA until 1937, although he did contribute to some of the earlier shows. However, despite being of imposing appearance - he was tall, with thick white hair and a bushy beard - , he was an unassuming man with a gentle, kindly disposition and a great sense of humour. A keen and knowledgeable musician, he was organist for over 25 years at the Catholic Church, although himself a Wesleyan. He was also widely read on architecture and all forms of art. He never married and, from 1946, needed a housekeeper to look after him. By this juncture, he was struggling financially and losing his eyesight, leading him to wonder whether he had really made a success of his life and work. On his death, his niece and her son sold off his paintings cheaply in the local pub - a sad end for an artist who has given pleasure to many people.[183]

[179] From a 1934 article in a Bristol paper, *Cupid and A Box of Paints*, reproduced in Falmouth Art Gallery Retrospective Catalogue, 1994, p.4.
[180] Arthur Hambly (q.v.) was also a member.
[181] See Catalogue of the Retrospective Exhibition at Falmouth Art Gallery 1994 and also S. Stoddard, *City Impressions - Bristol Etchers 1910-1935*, Bristol, 1990.
[182] *St Ives Times*, 17/3/1939.
[183] Information derived from M.Whybrow, *St Ives 1883-1993*, Woodbridge, 1994, p.55-56 and Obituary in *St Ives Times*, 27/11/1953.

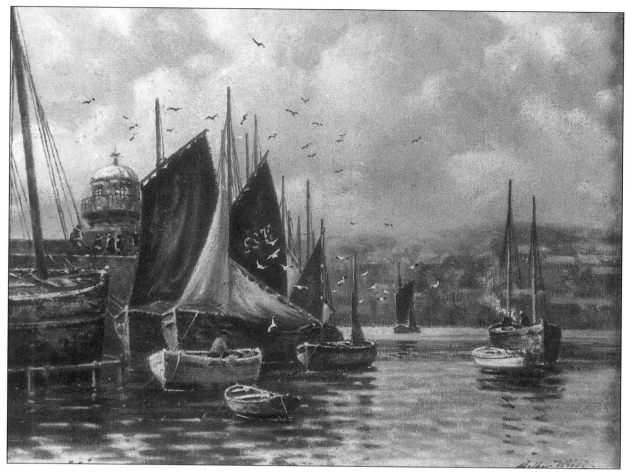

Fig. 3W-8 Arthur White *St Ives Harbour* (W.H.Lane & Son)

Arthur T White (1872-1961)
STISA: 1940-1961
STISA Touring Shows: FoB 1951.
Father of Clare White (q.v.), he always exhibited as A.T.White to avoid confusion with the long-established landscape and marine painter, Arthur White (q.v.). Born in London, he was a bank clerk by profession and lived for many years at Sidmouth and Paignton. He was a very keen amateur artist, who was knowledgeable about art, and he was a great fan of the work of Frank Brangwyn. His enthusiasm for art resulted in his daughter deciding on a career as an artist at the tender age of five. She recalled his encouragement to draw anything she saw in pencil or charcoal and his admonition, "You must never do anything from a flat copy - never, never, never!" He also first introduced his daughter to the decorative style, which in her words meant "you drew a line around everything". On his retirement, he came to live in St Ives, studied under Fuller and contributed modestly priced pastoral landscapes and architectural subjects to STISA shows for the rest of his life. Visits to Switzerland also provided him with subjects for his brush. At the date of his death, he was living at 2, Merryn Rock Flats, The Terrace, but had previously spent some time in Carbis Bay.[184]

(Miss) Clare May Emereson White (1904-1997) Exh. RA 1
STISA: 1949-1957 & 1969-c.1982
STISA Touring Shows: FoB 1951.
Clare White's idiosyncratic, decorative style of painting, with its vibrant colour and gentle humour, has in recent years become ever more appreciated and popular but, in her own time, despite her enormous input into the cultural life of the colony, her work did not gain widespread recognition, as it seemed to fall between both the modernist and traditional camps. Born in Sidmouth, Devon, she lost her mother at the age of eight and became very close to her father, A.T.White (q.v.), who encouraged her artistic tendencies from an early age. She was educated in Tavistock and Dartmouth and then went to a domestic science college at Limpley Stoke before attending finishing school in Lausanne, Switzerland, where she studied History of Art. She attended Torquay School of Art from 1920-1923, where she was one of the first female students to be allowed to work from life models but, as these were in short supply, she also sometimes attended Conway Blatchford's School in Newton Abbot. At this juncture, she was keen on Japanese designs and won a bronze medal at the Royal Drawing Society show in London with a Japanese design for a tea cosy. In 1923, she

[184] I am indebted to Andy Pollard for information on this artist. See also *St Ives Times*, 2/2/1961.

Fig. 3W-9 Clare White *The Artist painting her father in St Ives Arts Club*, c.1950

lived for a period within the artistic community in Montmartre, Paris before embarking on the extensive travels that were to be such a feature of her life. Blessed with independent means, she was not afraid to travel on her own to places such as Turkey, Egypt, Iran and Bosnia as well as throughout Continental Europe. Brought up with Edwardian values, she did little to promote her work but did exhibit occasionally at the RA, Paris Salon, and at various London art societies and galleries. In 1935, she designed scenery for a lavish production at Paignton's Palace Theatre to celebrate King George V's Silver Jubilee. She later commented, "My scenery was a very important thing in my life" and her scenery painting influenced her development as an artist. Somewhat bizarrely, on the outbreak of World War II, she moved to Paris to take an economics degree in order to "try to find out how to prevent wars" and had to pass herself off as a married Frenchwomen. As she was fluent in five languages, this did not present a problem.

Clare moved to St Ives to be with her father in 1949 and immediately threw herself into the activities of the Arts Club, where she wrote plays and designed scenery and advertising posters.[185] Her input was so great that, in 1954, she was elected the first female President of the Arts Club. She also joined STISA and was soon serving on the Committee and was writing reviews of Show Days and STISA exhibitions for the local papers. In August 1950, she had a show at 2A Piazza Studios, which included work from Switzerland and France. Yearly trips to visit her sister in Barbados, via Venice, also provided numerous subjects for her paintings and the vivid colours of the Caribbean influenced her palette. She evolved an unique and highly decorative style of watercolour painting, employing flat, bright colours and simple characterisation, with a bold, black outline around everything. Her images reflect her humour, exuberance and love of life and she captures the spirit and style of the communities that she depicts remarkably well.

In the late 1950s, possibly due to her father's health, she ceased to be a member and the 1960s proved a difficult decade as she suffered a mental breakdown. However, she rejoined STISA in 1969 and continued to exhibit until she stopped painting in 1982. There were three shows of her work held at the Salthouse Gallery, St Ives in the 1980s and more recently she has featured in a number of shows of 'naive art' in St Ives. Furthermore, exhibitions devoted to her work at Rotherham Art Gallery and Walker's Galleries, Harrogate in 2002 were great successes.[186] Clare's wish, expressed to Barbara Hepworth, that she hoped she could "produce things which, though small, may live on after me and generate a little happiness" has, accordingly, been amply fulfilled.[187]

[185] She never attempted commercial poster work, which her style would have suited admirably.

[186] These Exhibitions were organised by Andy Pollard, who has written an unpublished thesis on Clare White's work, to which I am indebted for the majority of the information contained in this biographical note.

[187] From catalogue to *Hallo Sunshine* exhibition at Salthouse Gallery.

(Miss) Emily M. Wilkinson (d.1943) Exh. RA 3
STISA: 1932-1943
STISA Touring Shows: 1937.
Born in Birmingham, she lived in Handsworth and was a member of the Birmingham Art Circle but she was dogged by ill health. Her obituary writer comments, "She studied in Paris and this influenced her work, which was decidedly impressionistic, but had the linear and narrative qualities of her own country." Her Cornish connections are unknown. She first exhibited with STISA in the 1930 Summer Exhibition and was elected a member in 1932 but she did not participate in the principal touring shows - only the 1937 show at Bath, where her exhibits were two oils *Young Russian* and *Cookery Book*. She exhibited at the RA between 1931 and 1938.

Norman Wilkinson (1878-1971) CBE PRI ROI RSMA Exh. RA 115
STISA: 1946-1947
STISA Touring Shows: 1947 (SA), 1947 (W).
Public Collections include Imperial War Museum, National Maritime Museum, Victoria and Albert Museum.
One of the foremost marine painters of his day, Wilkinson joined STISA after the War along with many of the other founder members of SMA but his success in other fields meant that his involvement was brief. Born in Cambridge, he was educated at Berkhamsted School and studied art initially at Portsmouth and Southsea Schools of Art. However, he then came to Cornwall to study under Olsson and Grier and commented, "It was mainly at St Ives that I learned what little I know about painting". Sketching out of doors, as he had done repeatedly under Grier's guidance, was, in his view, the best way to learn, and he had had fun as well. St Ives for him was "the complete artists' colony". By 1893, he was doing work for the *Illustrated London News*. In 1899, he went to Paris with two other St Ives artists, Guy Kortright (q.v.) and Hugh Percy Heard, and they set themselves up in a studio in Rue Boissonarde, sharing models for their study of the figure. He returned to St Ives for a visit in 1902 and was successful for the first time at the RA in 1903. Between 1905 and 1910, he did innovative railway poster designs for LNWR. During the Great War, he did a number of drawings of the Dardenelles, whilst serving as a naval paymaster and, along with Olsson, made an important contribution to the art of camouflage by the use of dazzle painting. In 1924, he organised the ground-breaking series of posters by Royal Academicians for the London Midland and Scottish Railway and was thereafter in constant demand for poster designs for all the railway companies. He also did commercial work for BP, Rio-Tinto Zinc and the Government of the Bahamas. In the Second World War, he was again appointed a War Artist - an accolade shared by Charles Pears (q.v.) - and produced his extensive War at Sea series (53 oil paintings), now owned by the National Maritime Museum. Further works are owned by the Imperial War Museum. When he joined STISA, he was also President of the RI. He published his autobiography, *A Brush with Life*, in 1969.

(Miss) Denise Williams SWA Exh. RA 9
STISA: 1944-1950
STISA Touring Shows: 1945, 1947 (SA), 1947 (W).
Public Collections include RWA.
Of French origin, she appears to have come to St Ives to study at the St Ives School of Painting but she was immediately successful with two works at the RA in 1944.[188] Her address is then given as Rievaulx Cottage, Porthmeor Square. Between 1944 and 1951, she was successful at the RA nine times and these works included three West Cornwall landscapes, three French landscapes and some still lifes. Her landscapes were noted for their tender, naturalistic colouring. She was active in the campaign to save the Porthmeor studios. In 1949, she had a show in Walker's Galleries, Bond Street, with Billie Waters, and in the same year, her painting *The Steeple, La Roche sur Foron* was bought by the RWA from their annual Exhibition for their permanent collection. At the Autumn Exhibition in 1950, she was described as one of STISA's best painters, but she also exhibited that year with the Penwith Society. Shortly afterwards, she moved to London. She was made an associate of SWA in 1951 and a full member in 1961. She married, becoming Mrs Hinkley, and remained a member of SWA until 1974, although her last exhibit was in 1972.

(Miss) Kathleen E Williams Exh. RA 2
STISA: 1941-1969
STISA Touring Shows: 1945, 1947 (SA).
Public Collections include Swindon.
She first exhibited with STISA at the 1941 Autumn Exhibition, when she is described as a new associate member. Her portrait, *Refugee*, was bought from the 1945 tour for the new Art Gallery at Swindon. By 1948, she was living in RAF quarters at Henlow in Bedfordshire and she then moved to Bournemouth before retiring to Andover in 1958. She remained an exhibiting member throughout, however.

(Miss) Mary Frances Agnes Williams Exh. RA 1
STISA: 1927-1936
STISA Touring Shows: 1932, 1934, 1936.
The daughter of a clergyman, Mary Williams was born in Whitchurch, Salop, but she studied art in Paris at Atelier Colarossi, where she won silver medals in the annual 'concours' for drawing and painting from the nude. In 1909, a coloured chalk drawing, *Girl In A Bonnet*, was reproduced in *The Studio*.[189] She returned to Paris for further study between 1912 and 1917, exhibiting at the Paris Salon from 1912. In a review of Show Day 1920, she is described as a recent arrival in St Ives and she lived initially at Norway House. Later she worked from Enys Studio in Victoria Place. Her work was highly regarded and she was included in the 1922 joint exhibition of the St Ives and Newlyn colonies at Plymouth Art Gallery and in the 1925 Cheltenham show. Although she also did still life and landscapes in oil and watercolour, she specialised in portraits, nude studies and figure paintings, particularly of children, and an unnamed local artist sat for two portraits entitled *The Mystic* and *The Enigma*. The former was hung at the Paris Salon. In fact, as her work reflected her French academic training, she was far more successful at the Salon, being hung there year after year, than at the RA, where she was only successful once, with her 1933 work *Melody*, depicting a girl holding a Cairn terrier. This, though, was singled out for special praise by Paul Konody, the art critic of *The Observer*; "Miss Williams' picture particularly recalls the vision, the delicate technique, and the tender charm of colour that is invariably associated with the art of Berthe Morisot."[190] An indication of her more usual style is given by the critique of *Sea Nymphs*, another exhibit on Show Day 1933, which was described as "a cleverly composed study of three nude maidens on a sandy beach. Their very positions as dots on a curve, coinciding with the sweep of the small watercourse, and the flight of the wind, depicted by the tossing of their hair; all this is indicative of artistic symmetry and a delight to those who understand."[191]

Robert Sydney Rendle Wood (b.1894)
STISA: 1944-1972
STISA Touring Shows: 1945, 1947 (SA), 1949. Also FoB 1951.
Public Collections include Plymouth.
Born in Plymouth, Rendle Wood studied at Plymouth School of Art under Shelly and at Edinburgh School of Art under David Foggie. He spent some considerable time in Ireland, working as fine art manager for the Pollock Gallery, Belfast. Between 1925 and 1930, he was Secretary of the Ulster Arts Club and he was also Secretary of the Ulster Academy of Arts. During his time in Ireland, he contributed illustrations to Walter J. Crampton's book, *Irish Life and Landscape*.

He moved to St Austell during World War II and joined STISA in 1944. In December that year, he attended, in his capacity as Regional Director of the Council for the Encouragement of Music and the Arts ("C.E.M.A."), an exhibition devoted to the Royal Watercolour Society at the Porthmeor Galleries, which had been sponsored by C.E.M.A. The Exhibition featured work by STISA members Lindner, Fleetwood-Walker, Ronald Gray and Lamorna Birch, and Wood, in his speech, congratulated St Ives on being the first town in the West of England to run all three things for which C.E.M.A. stood - music, drama and art.[192] He commented, "The man in the street tended to look on art as mere frills. He did not understand what art really meant and was sadly in need of education in this respect." He continued to exhibit with STISA until the early 1970s, working in a colourful "modern decorative style". To supplement his income, he worked as the manager of 'Widgers', a paint and wallpaper store in St Austell.

John Goodrich Wemyss Woods (d.1944) Exh. RA 4
STISA: 1933-1944
STISA Touring Shows: 1934, 1936, 1937.
A landscape painter in watercolours, Woods first exhibited in 1889, when he was living in Newbury. He had his first success at the RA in 1922, by which time he had moved to Burnham, Buckinghamshire but was resident in Seaford in Sussex by 1927. His subjects were taken from all over Southern England and it can only be assumed that he joined STISA after a visit to St Ives, as no other Cornish connection has been established. However, due to distance, he was not a regular exhibitor.

Col L.Douglas Woollcombe
STISA: 1945-1949
STISA Touring Shows: 1945, 1947 (SA), 1947 (W), 1949.
Both he and his wife, Beryl, first exhibited on Show Day 1943 and they lived in Porthmeor House. Douglas undertook study at the St Ives School of Painting and his watercolour landscapes were included in all the 1940s tours. Beryl was only represented in the 1947 Cardiff show, her exhibit being a flower study in gouache.

[188] On Show Day in 1945, she is recorded as exhibiting in the St Ives School of Painting. Her work in 1944, despite being accepted by the RA, is not mentioned at all in the Show Day review.
[189] *The Studio*, Vol 46, 1909, p.62.
[190] Reproduced in *St Ives Times*, 5/5/1933.
[191] *West Briton*, 16/3/1933.
[192] Birch, in his opening address, said he was a lover of the old style of art and a great admirer of Cotton.

(Miss) Violet M.B. Wright
STISA: 1930-1947
STISA Touring Shows: 1934, 1947 (W).
Proposed as a new member by George Bradshaw in January 1930, she lived at 5, South Terrace, Penzance. Her studies of sea and coast were only exhibited occasionally but she was included in the 1946 Exhibition in Newquay.

The Reverend Allan Gairdner Wyon RBS (1882-1962) Exh. RA 58
STISA: 1944-1955
STISA Touring Shows: FoB 1951.
Public Collections include Glasgow, Leicester, Truro and Auckland. Hereford and Salisbury Cathedrals also have works.
Wyon was the first distinguished sculptor to join STISA and soon the sculpture section became a significant feature of STISA shows, as he was joined firstly by Hepworth and Berlin and then by Faust and Wharton Lang and Barbara Tribe. The son of a successful medallist, also called Allan, Wyon was born in London and educated at Highgate School. He studied at South Kensington under Sir Hamo Thorneycroft, where he won silver medals. His first exhibit at the RA in 1908 was a medal depicting his father. He became a member of the Royal Society of Miniature Painters in 1922 and a member of the Royal Society of British Sculptors in 1926. Between 1924 and 1930, he was Secretary of the Art Worker's Guild and, in 1925, he was a bronze medallist at the International Exhibition of Decorative Arts in Paris. His principal works include memorials, in Salisbury Cathedral, to Bishop Ridgeway, Major-General Sir George Harper and the Hon. Edward Wyndham Tennant and, in Hereford Cathedral, to Bishop Percival. A bust of Sir Charles Lucas was also in the Colonial Office. Wyon was also a highly rated medallist and was responsible for artistic work at the Royal Mint.

Having decided to become ordained, Wyon moved to Saltash in 1935 and was then appointed Vicar of Newlyn. He first became involved with the Newlyn Society of Artists in 1936 and remained a staunch supporter until he left the district in 1955. To demonstrate the close links between the Newlyn and St Ives Societies, the Committee of the Newlyn Society in 1943 comprised Wyon, Dod Procter, Eleanor Hughes and Alethea Garstin, all of whom were members of STISA.

Wyon opened the STISA Summer Exhibition in 1943 and it may have been this occasion that prompted him to become involved with STISA. He certainly was exhibiting with STISA by 1945, when his exhibits included the sculpted female head *Pax Dolorosa*, which is now owned by Truro. Unsurprisingly, his sculptures often had a religious subject and one of his finer pieces was *The Worshipper*. On the death of Stanhope Forbes in 1947, Wyon was commissioned to produce a sculptured panel of Forbes' head and this was fixed to the lower front facade of the Newlyn Art Gallery and was unveiled in 1948 by Sir Alfred Munnings, then both President of the RA and STISA. He also exhibited with STISA some of his medals.

Eileen May Wyon (b.1883)
STISA: 1945-1955
STISA Touring Shows: 1945, 1949. Also FoB 1951.
The wife of the sculptor, the Rev Allan Wyon (q.v.), Eileen Wyon (née le Poer Trench) was also an artist and she specialised in portraits and figure studies. She studied at Dublin Municipal School of Art, in the studio of Sir Arthur Cope, and also at the RA schools. Her work was first exhibited in 1905, when she was still in Dublin but, by 1907, she had moved to London. She painted in oils and also did figure studies in charcoal and chalk. Her work is first mentioned in St Ives in the 1945 Spring Exhibition and her exhibit in the 1945 tour was a portrait of the actress, Cherry Cotrell. Her work commanded high prices and she was an important member of the figure painting section of the Society until her husband and herself moved to Great Shelford, near Cambridge in 1955. Her portrait of the vicar is in the church there.

James Stephen Yabsley
STISA: 1927-1930
Yabsley was a founder member of STISA and had been resident in St Ives for some years, as his first Show Day was in 1913. He painted landscape, marine and still life subjects in oils and lived at Sunrise, Penbeagle. He was included in the 1922 joint exhibition of the St Ives and Newlyn colonies at Plymouth Art Gallery. In the 1920s, he shared Atlantic Studio (see Roskruge map - Fig. 1-3) with Alfred Bailey, whose portrait he exhibited on Show Day 1930 but his work is not referred to thereafter.

THE ST IVES SOCIETY OF ARTISTS
(1927-1952)

DICTIONARY OF MEMBERS

PART C - SHORT TERM AND LESSER KNOWN MEMBERS

(Mrs) Marjorie Alington STISA: 1947 STISA Touring Shows: 1947 (W).
She first exhibited on Show Day 1943 and the following year was described as one of Fuller's students. 1947 is the only year when she is recorded as exhibiting with STISA. By then, she was living in Newlyn.

(Mrs) Lucy Bodilly STISA: c.1930-c.1934 STISA Touring Shows: 1932, 1934.
The Spring Exhibition in 1920 contained some of her needlework pictures and she also exhibited in the major Craft Show at Newlyn in 1924. She was the wife of M.A.Bodilly and lived at Rosemorran. Her exhibits included miniatures and still life. Vera Barclay Bodilly, who exhibited in the 1925 Cheltenham show, may be her daughter.

Eirys Davies STISA: 1947 STISA Touring Shows: 1947 (W)
He also exhibited at Summer 1947 show.

(Miss) E Joan Ellis STISA: c.1930
She showed some woodcuts and other work at shows in 1930.

W Emery STISA: c.1932
His first Show Day was 1927 when he exhibited a seascape, a still life and a self-portrait. He is recorded as a member in 1932, living at Rosebank.

Mrs Fenn ARE STISA: c.1932
A printmaker, she is recorded as a member in 1932 with a London address. She contributed to Lindner's 90th birthday presentation in 1942. She died in 1946.

(Mrs) Norah Fisher STISA: 1950-1954 STISA Touring Shows: FoB 1951.
Her work was first reviewed on Show Day in 1931 and she exhibited with STISA that year and received favourable comments. However, she is not recorded as a member in 1932 and her work is not mentioned again until Show Day 1950. By then, she was working in gouache and experimenting over a range of semi-imaginative subjects.

(Miss) Penelope E T Fisher (d.1946) STISA: 1945-1946 STISA Touring Shows: 1945.
It is not known whether she was related to Norah Fisher but, sadly, she died shortly after joining. The first of her five successes at the RA was in 1937, but her address, when exhibiting, is often given as a hotel, suggesting a peripatetic life style. She seems to have been based in Kensington during the War and her exhibit in the 1945 tour, *Early Morning Walk in Kensington Gardens*, was an oil. In 1945, she was based in Devon and clearly visited St Ives then

Miss K.Glover STISA: c.1932
She is recorded as a member in 1932, living at Hillside Bungalow.

P H Hay RI STISA: 1941
He first exhibited with STISA at the 1941 Autumn Exhibition, when he is described as a new member but is never referred to again.

Alex J.Ingram STISA: c. 1945 STISA Touring Shows: 1945.

(Miss) Miriam Israels STISA: 1944
The wife of Naum Gabo, she is described as a new member when she exhibited at the Spring Exhibition 1944 but may not have exhibited again.

P Buxton Johnson STISA: c.1937 STISA Touring Shows: 1937.

(Mrs) Violet MacDougall STISA: c.1945 STISA Touring Shows: 1945.
Her work was not included in any other shows in 1945.

Betty Nankervis STISA: c.1949
Her work is mentioned in the 1949 Spring show but not thereafter.

Mrs V Oxland STISA: c.1928-1932
She contributed to the first show in the Porthmeor Gallery in 1928. She is recorded as a member in 1932, living in Camborne, but her work is rarely mentioned in reviews.

Minnie Painter STISA: c.1945 - c.1947 STISA Touring Shows: 1945.
Her work is also mentioned in 1947.

Emily M Paterson (d.1934) STISA: 1934 STISA Touring Shows: 1934.
Moffat Lindner, when reporting her death the previous year at the 1935 AGM commented, "She was an artist of charming oil paintings; she was also well-known in watercolour".[1]

Dr Henry T Rutherfoord STISA: c. 1930
His first Show Day was in 1929, when he exhibited some Canadian scenes. He was proposed as a new member by Borlase Smart in January 1930.

C Douglas Salisbury STISA: 1951 STISA Touring Shows: FoB 1951.

(Mrs) Mabel Shone STISA: c.1932
Recorded as a member in 1932, her work is first referred to in a review of Show Day 1919, the first held since 1915. She was a watercolourist, who specialised in harbour studies and worked from Chy-an-Chy studios. She was married to Captain R.E. Shone, an associate member who was also President of the Arts Club in 1935, and they lived in Talland Road. He died in 1944.

(Miss) K. Smith Batty STISA : c.1932
She is recorded as a member in 1932, when she worked from Bluebell Studio..

R. Herdman Smith STISA: c.1941
A well-known artist, he is recorded in St Ives in 1941. When he first exhibited on Show Day in 1941, a reviewer commented, "His welcome watercolours are of a delightful technique and of great variety. Some are strong and vigorous, with very direct colouring."[2]

Ada Somerville STISA: c.1951 STISA Touring Shows: FoB 1951.
She is recorded as a member in 1938, when she lived at Northam in Devon. Mention is made of a lino print in a 1948 show.

J Lewis Stant STISA: 1935-c.1937
He moved to St Ives in 1934 and exhibited a collection of his etchings at Lanhams Five Guinea Christmas Exhibition that year, which included some corners of old St Ives. His exhibits at Birmingham in 1935 included *Herring Fishing, St Ives*. He gifted work as a prize for 1935 Arts Ball and exhibited at Lanhams in 1938.

Doris Thomas STISA; c.1944
She is described as a new member at the 1944 Autumn Exhibition

[1] *St Ives Times*, 8/2/1935
[2] *St Ives Times*, 21/3/1941

A D Trounson STISA c.1951 STISA Touring Shows: FoB 1951.

(Miss) C Vyvyan STISA: c.1928
She contributed to the first show in the Porthmeor Gallery in 1928.

W G Webb STISA: c.1932
Recorded as an exhibitor in the 1932 Winter show

(Mrs) Maud L Wethered STISA: c.1942
Described as a newcomer in Jan 1942 when she exhibited woodcuts and sculptures.

Constance White STISA: 1950-1958 STISA Touring Shows: FoB 1951.
Her first Show Day was in 1950, when it was considered her long residence abroad had ripened her colour. Although she did not exhibit after 1951, she is still recorded as a member in 1957, when she was living in Dulwich Village

Sibylla Wightman STISA: c.1951-1959 STISA Touring Shows:FoB 1951.
She did not exhibit much after 1951 but is recorded as a member in 1957, when she was living in Hove.

H P Wilson STISA: 1933-1934
Recorded as a new member in 1933 but had died by 26/1/1934.

N Winder Reid SMA STISA: c.1947 STISA Touring Shows: 1947 (W).
A well-known marine artist but she seems only to have exhibited with STISA in 1947.

ARTIST	EXHIBIT		PRICE	CAT. NO Brighton	Stoke
OIL SECTION					
Shearer Armstrong	Sewing Woman		£25	48	
	Flower Piece		£10-10	49	7
	Girl with Apples		£25	58	
S.J.Lamorna Birch	The Little Farmstead, Trewoofe, Lamorna		£65	34	20
	King Charles' Castle, Salcombe	RA 1923	£250	39	
	Hosking's Barn, Lamorna		£65	41	17
Lucy Bodilly	Anemones		£4-4	18	
Fred Bottomley	The Kitchen Table		£10-10	59	3
	Pots		£5-5	66	
	The Cut Rick		£15-15	74	9
George Bradshaw	Wind and Canvas		£42	8	5
	Porthmeor Beach		£63	32	
Arnesby Brown	Study for The End of the Village	(RA 1929)	£85	26	19
Arthur Burgess	The Elite		£26-5	15	
	Sundown		£15-15	44	
	Crossing the Bar		£52-10	46	8
Eleanor Charlesworth	Still Life		£16	13	30
	Roses		£12-12	25	
Alfred Cochrane	Some of the Gods		£10-10	28	
Shallett Dale	The Lily Pond, Tregenna Castle		£15-15	2	21
John C. Douglas	Shore Study		£5-5	35	
Mabel Douglas	Sweet Peas		£12-12	62	23
Stanhope Forbes	The Italian Garden		£80	38	10
	The Pool		£60	45	14
Nora Hartley	A Fisherman's Child		£20	75	27
Pauline Hewitt	Phillip Oppenheim's Yacht at Antibes, Riviera		£12-12	12	
	Pigs		£12-12	61	
	Pyrenees		£12-12	82	22
Richard Heyworth	A Green House, Withington		£5-5	42	
J.Tiel Jordan	A Wet October		£8-8	30	
Moffat Lindner	A Wild Night, St Ives		£42	21	
	Fresh Breeze on the Maas	RA 1930	£100	22	2
Thomas Maidment	Farm Scene, St Ives		£31-10	5	
Mary McCrossan	Boats Passing, Dordrecht		£26-5	27	16
	Old Church, Biot, A.M.		£8-8	40	
	St Paul du Var		£16-16	53	6
Arthur Meade	The Mill Stream		£63	7	26
	A Devon Valley		£52-10	51	
	The Cornish Coast		£26-5	64	
	The Pigsty		£21	76	
Fred Milner	Fordingbridge, Hampshire		£16-16	37	
	Morning on the Hampshire Avon		£52-10	57	
	An Ancient Stronghold, Corfe Castle	RA 1928	£120	68	33
Bernard Ninnes	A London Garden		NFS	6	
	Flowers and Fruit		£12	55	
	In For Repairs		£15	71	4
Julius Olsson	The Sunset Shower	RA 1928	£42	24	
	The White Cloud, Northern Ireland		£42	36	18
	Breezy Day off Falmouth		£42	43	
John Park	Winter Sun	RA1930	£60	14	15
	Concarneau		£11	20	24
	Rochester		£60	72	
Reginald F.Reynolds	The Upland Path, Tintagel		£30	33	
Tangye Reynolds	Flaming Begonias		£100	67	31
Mary E.Richey	The Blue Pen		£7-10	54	

Leonard Richmond	Chioggia, near Venice		£50	79	
	Lake O'Hara, Canadian Rockies		£75	80	
Borlase Smart	Traghetto della Casson, Grand Canal, Venice		£150		
	Shipbreakers		£35		
	Coast Scene, St Ives		£50		
	A Little Cornish Farm, St Ives		£25		
Algernon Talmage	St Tropez, Cote d'Azur		£36-15	19	13
	Reflections		£25	63	25
John Titcomb	Estuary, Pont Aven, Brittany		£8-8	23	
Herbert Truman	A China-Clay Pool, Cornwall		£20	16	
	Model Resting		£25	17	28
	The Sun God, a decoration		£10	69	
	From Japan		£8	73	
Mildred Turner-Copperman	Cornish		£200	3	29
Reginald Turvey	Green Apples		£10-10	9	
	Boer Woman		£20	31	32
	San Ambrosio		£26-5	50	
Helen Stuart Weir	The Lacquer Dragon		£26-5	10	
	Camillias		£6-6	47	
E.M.Wilkinson	Eucalyptus		£24		
	Anything For Polly		£24		
	The Cry		£21		
Mary F.A.Williams	Sweet Peas and Silver		£18-18	29	

WATERCOLOUR SECTION

A.C.Bailey	Chelsea Power Station		£10-10	106	45
	Thames-side		£10-10	130	
Joan Birch	The Ash Bough		£5-5	116	
	The Medlar		£5-5	131	
George Bradshaw	Rough Sea	(tempera)	£7-10	60	
Kathleen Bradshaw	Reflections	(tempera)	£7-7	114	
	The Red Lacquer Tray	(tempera)	£7-7	120	
	Voyage of Discovery	(tempera)	£6-6	135	
John M. Bromley	Sunshine and Shadow		£15	100	47
	On the Conway		£4-4	102	
Taka M. Cochrane	Roses		£3	122	
	Violets		£5-5	128	
E.Fradgley	Sospel		£8-8	136	
M.W.Freeman	The Market at Cahors		£5-5	113	
	The Ponte Canonica, Venice		£18-18	117	49
Mary Grylls	Spring Flowers	(tempera)	£6-6	99	
Arthur Hambly	A Forgotten Corner		£6-6	132	
J.Tiel Jordan	A Cornish Fishing Village		£5-5	122	
Phyllis Tiel Jordan	Brixham Trawlers		£4-4	126	43
Cecil de W. Lane	A Wet Harvest		£2-2	98	
Gussie Lindner	Hellebores		£10-10	129	
Moffat Lindner	The Spanish Bridge, Ronda		£21	115	
	Dutch Boats at Anchor		£21	121	
Thomas Maidment	Old Farm, St Ives		£5-5	110	
Mary McCrossan	Polperro, Cornwall		£7-7	133	
Fred Milner	In Newhaven Harbour		£8-8	112	
R.J.Enraght Moony	A Cornish Farm	(tempera)	£12	77	11
	Rain	(tempera)	£20	81	
Job Nixon	The Slipway, St Ives, Cornwall		£16-16	105	44
Grace Pethybridge	The Corner House		£8-8	103	50
Edith C. Reynolds	A Sussex Farm		£3-3	108	42
Reginald F.Reynolds	Mounts Bay		£8	119	
Mary Richey	Irish Regatta		£4-4	107	
Ethel Roskruge	A Mixed Bunch		£10-10	104	
Helen Seddon	Spring Flowers from Cornwall		£6-6	101	
	King's Gate, Winchester		£4-4	125	
Adrian Stokes	An Essex Pool		£31-10	118	46

Terrick Williams	A Canal, Venice		£12-12	109	
	Lake Como from Menaggio		£21	124	48
	A Fruit Boat, Venice		£12-12	127	

BLACK AND WHITE SECTION

Dorothy Bayley	The Challenge	(aquatint)	NFS	142	
	The Roadmaker	(aquatint)	£2-10-0	147	
Frances Ewan	Arran Boats	(aquatint)	£2-10-0	138	
	Fountain Court	(drypoint)	£2-10-0	141	
	Sennen Cove	(etching)	£2-10-0	146	
	Windsor Castle	(drypoint)	£2-12-6	150	
Geoffrey Garnier	The End of the Chase	(colour aquatint)	£4-10-0	85	
	"There was a certain rich man"	(drypoint)	£4-4-0	86	
	Days of Yore	(colour aquatint)	£5-5-0	91	
	H.M.S.Revenge & French Prize Hulk	(colour aquatint)	£5-5-0	97	37
Arthur Hambly	Tin Mines of Carn Brea	(etching)	£2-2-0	139	
Alfred Hartley	The House called "Little in Sight"	(aquatint)	£3-13-6	87	
	A Wooded Hillside	(aquatint)	£4-14-6	88	36
	Christchurch Gate, Canterbury	(aquatint)	£10-10	90	35
	An Essex Stream	(etching)	£3-13-6	93	
	Late Evening in Wales	(aquatint)	£3-13-6	94	
R. Morton Nance	Before the Gale	(pencil)	£5-5-0	137	
	The Crane, XV century	(pencil)	£5-5-0	145	
	Carrack in Port, XV century	(pencil)	£5-5-0	148	
	Carrack at Sea, XV century	(pencil)	£5-5-0	149	
Job Nixon	The Flour Mill	(engraving)	£3-8-6	83	39
	Pont Neuf, Paris	(etching)	£4-14-0	84	40
	Bank Holiday, Hampstead Heath	(drypoint)	£5-12-6	96	38
	Italian Festa	(etching)	£17-6-6	144	
Francis Roskruge	In the Track of the Moon	(aquatint)	£2-2-0	92	41
	Rolling Home Across the Bay	(aquatint)	£2-10-0	95	
	From the Top of the Hill, St Ives	(aquatint)	£2-2-0	143	
A.Bliss Smith	The Beggar's Bridge	(colour aquatint)	£3-0-0	89	34
Beatrice Vivian	The Rock Castle, Carn Brea	(drypoint)	£1-1-0	140	

SCULPTURE SECTION

Caroline Jackson	Primrose	(plaster)	£15-15	151
	Pirouette	(plaster)	£15-15	152
	Patrick	(bronze)	£15-15	153

APPENDIX B

THE EXHIBITION AT NATIONAL MUSEUM OF WALES, CARDIFF, 1947

LIST OF WORKS

ARTIST	EXHIBIT	CAT. NO
Gilbert Adams	Old St. Ives	9
Marjorie Alington	Chinatown	52
Garlick Barnes	The Pineapple	2
W. Barns-Graham	Rubbish Dump	24
	Grey Sheds, St Ives	31
Medora Heather Bent	Displaced Persons, 1947	87
Lamorna Birch	The Quarry	63
	The Queen's Rocks, Bettws, N. Wales	64
Fred Bottomley	Polperro	47
George F. Bradshaw	Low Tide, Porthmeor Beach	62
Kathleen Bradshaw	Summer (tempera)	51
M. F. Bruford	Churchyard, St. Just in Roseland	27
	The Visitor (R.A., 1946)	81
Arthur J. W. Burgess	On the Tide to London	43
Irene Burton	Daffodils	6

Eleanor Charlesworth	Syringa (R.A., 1943)	20
	The Grace of the Earth	38
Sir Francis Cook	Cornish Studio, Winter Sunshine	59
David Cox	Little Cornish Girl	42
Eirys Davies	Welsh Landscape	74
Olive Dexter	Flower Picture	37
Agnes E. Drey	Portrait of a Child	48
Jeanne Du Maurier	Spanish Vermouth	55
Ann Duncan	Mousehole	4
B. Fleetwood-Walker	Nude (R.A., 1947)	30
	Study for Peggy	54
Terry Frost	The Chair	3
	Homage to Cezanne	19
Leonard J. Fuller	My Friend Adrian Hill	5
	Tom Mostyn, R.O.I., at Work	8
S.H. Gardiner	The Torridge Vale, N. Devon (R.A., 1947)	50
	Morning Gilds the Tree	78
Alethea Garstin	Regatta Day, Hayle	41
	Evening Pipe (R.A., 1938)	82
Fred Hall	One Winter's Morn	34
Gertrude Harvey	Flowers on Table	12
	On the Kitchen Table	56
Pauline Hewitt	St Ives	77
P. Maurice Hill	The Longships	61
	The Depth Charge (R.A., 1941)	70
Marion Grace Hocken	Early Autumn Bunch	45
The Late Greville Irwin	The Changing of the Guard	15
	Return from Sandringham (Lazlo Bronze Medal, R.B.A.)	44
Frank Jameson	The Blue Shoe	83
Hilda K. Jillard	The Three Apollos	39
Leslie Kent	Low Tide, Tenby	32
	Dinas Head, Pembrokeshire	46
E. Lamorna Kerr	The Lane in Winter, Lamorna	10
	Spring Evening, Lamorna (R.A., 1947)	13
Peter Lanyon	Prelude	73
Denys Law	Winter Morning	35
T. Maidment	Garden Scene, Helston (R.A., 1945)	86
Arminell Morshead	Changing Ponies	22
	Guildford Cattle Market (R.A.)	67
Marjorie Mostyn	Snow in St Ives	65
Ben Nicholson	Painting, 1946	71
	Still Life, 1946	72
Bernard Ninnes	In the Conway Valley	36
	The Vale of Corris	79
Charles Pears	Torpedoed Tramp Under Searchlight (R.A., 1944)	69
Dod Procter	The Smiling Girl (R.A.)	16
	The Victorian Vase (R.A., 1936)	28
N. Winder Reid	Godrevy Lighthouse	1
Leonard Richmond	Porthmeor Beach, St Ives	40
	Falaise (Battle of the Gap)	76
Alison Rose	The General	21
Dorothea Sharp	Autumn Flowers	18
	On Porthmeor Beach, St Ives	85
Charles Simpson	Midsummer Mosaic	68
Borlase Smart	Lockpitch Bridge, Brecon	33
	Moonlight, St Ives Bay	66
Stanley Spencer	Looking at a Drawing	23
	Choosing a Dress	25
The Late Stanhope Forbes	The Old Weighing-in House	57
	The Pigeon Loft	58
Maude Stanhope Forbes	Statuette (R.A., 1938)	29
W. Todd-Brown	Low Tide	49
	Dutch Shrimpers, Veere	60
Ann Fearon Walke	Rosina	80
	Christ Mocked	84

L. E. Walsh	Chinese Dancer	14
R. C. Weatherby	Bridget	17
John Wells	City Dawn	26
	Foreign Boats	53
Gwen Whicker	Magnolia	7
Norman Wilkinson	A Newfoundland Fisherman	75
Denise Williams	The Trevail Valley, Cornwall (R.A., 1946)	11

SCULPTURE SECTION

Sven Berlin	Women Singing (bas relief - concrete)	88
Barbara Hepworth	Sculpture with Colour Blue and Red (wood, painted with strings)	89
	Nesting Stones (white marble)	90

WATER-COLOURS

Sven Berlin	Woman With a Veil (ink and wash)	91
Frederick S. Beaumont	National Gallery	92
Agnes E. Drey	Still Life	93
Dorothy Everard	Aperitif	94
Meta Garbett	The Watcher (pastel)	95
	Portrait in Pastel	96
Arthur C. Hambly	Lough Leane, Killarney	97
	Old Beech Trees, Dartmoor	98
Isobel Heath	The Smiling Boy (pencil)	99
	Old Houses, Manaccan, Cornwall	100
Eleanor Hughes	Spring's First Garment	101
Hilda K. Jillard	Swans	130
Peter Lanyon	Heart of the Sea	132
D. Alicia Lawrenson	Boats, St Ives	102
Moffat Lindner	Summer Morning, Venice	103
W. L. Lister	The Old Bedruthan Steps (wood block colour print)	104
W. Westley Manning	Pembroke Castle (aquatint)	105
	Settignano	106
Geo. H. Martin	Self Portrait (pastel)	107
Edith B. Mitchell	Mill at Lower Slaughter	108
Misome Peile	Sitting of the States Assembly, Jersey (pencil)	111
Geo. F. Pennington	The North Transept, Exeter	109
	The Castle, Scarborough	110
E. E. Rice	The Sloop Inn	131
T. H. Robinson	Book Plate (pen)	112
	Vikings (wash)	113
Helen Seddon	June Roses	114
	Blooms from St. Erth	115
H. Segal	Negro Thinking (charcoal)	116
	Rickshaw Boy (chalk)	117
Marcella Smith	Spring Flowers	118
	Autumn Flowers	119
F. Whicker	M.F.V. 1005 Dry Docked at Falmouth	120
	Craftswoman	121
Arthur White	Danger Signals, St Ives	122
J. Coburn Witherop	Hillside Farm, Wales	123
	St. Martin in the Fields (pen)	124
L. D. Woollcombe	Collacombe Farm, Devon	125
	Tinhay Bridge, Devon	126
Beryl Woollcombe	Summer Flowers (gouache)	127
Violet Wright	A Scotch Fall	128
Bryan Wynter	Mountain Landscape (wash-drawing)	129

THE FESTIVAL OF BRITAIN EXHIBITION 1951

LIST OF WORKS

ARTIST	EXHIBIT	PRICE	CAT. NO
Marcus Adams	Moses Proclaiming the Blue Print to Mankind	105	91
H Allport	Portrait Study	6	164
E.Lovell Andrews	Bank Holiday, The Island	10-10	19
	A West Country River	7-7	123
	A Corner of St Ives	5-5	144
Stuart Armfield	Tin, Fur and Feathers	47-5	68
	The Black Hen	52-10	99
Helen Banning	Spring Morning, St Ives	5-5	153
Howard Barron	Godrevy and the Coast	32-11	45
	Early Morning, St Ives	16-16	89
Dorothy Bayley	From Trencrom	22	43
	Dutch Boat, Hayle	9	157
	Hayle	10	161
Amelia M Bell	The St Ives Road, Gwithian	7-7	148
Medora Heather Bent	St Ives by Moonlight	65	39
Lamorna Birch	The Old Quay	21	1
	Ormidale	21	5
	A Day in June	100	41
Frances Blair	The Canal Basin	10	134
	Puffers in the Lock	10	145
Sydney J.Bland	The Men and the Boats, Newlyn	12-12	14
	French Fishermen	15-15	33
Fred Bottomley	The House Built on a Rock	40	110
	Storm Approaching the Island	25	125
	Porthgwidden	12	158
G A Bowden	West Wittering Church	12-12	102
	Buckland Church, Glos	6-6	170
George Bradshaw	Summer Night	21	48
	White Boats	31-10	79
	In St Ives Bay	63	115
Kathleen Bradshaw	The Porcelain Jug	16	103
	The Orange Jar	16	112
Charles Breaker	At Newlyn Old Harbour	10-10	24
	Newlyn Harbour	10-10	28
	Granite and Old Chains	10-10	35
Midge Bruford	Summer Evening	25	85
Emma Bunt	Royal Colours	9	88
	Where the Sun Shines	9	90
Irene Burton	The Harbour Window	12	98
	The Harbour, St Ives	5	90
Alice C Butler	Aunt Jenny Hosken	8-8	179
	Cornish Spring	4-4	180
	Pen-a-Gader, St Agnes	4-4	181
David Cobb	Onshore Wind	42	93
Taka Cochrane	Burmese Buddha	14	23
	Anemones	15	141
Gertrude Crompton	On the Fowey River	15-15	3
	The Little Housemaid	12-12	71
	Still Life	15-15	162
C. Crossley	St Michael's Mount	12	18
	Jacobean	14	25
	Hodgson's Fold, West Riding	16	29
Violet Digby	Scaffolding in St Ives	12-12	36
Mabel Douglas	Marigolds	10-10	6
	Miniatures x 3	10-10	182-184
Frances Ewan	Anemones	8-8	47
	Hydrangeas	16-16	78
Norah Fisher	Paris Market	15-15	8
	The Puppets at Play	25	142

Maude Stanhope Forbes	The Goldfish Bowl	35	49
Meta Garbett	Spring Cleaning, Marazion	5	124
	Gypsies	5	140
Stanley Gardiner	Mount's Bay from Boswarthen	78-15	106
	Planting the Spuds	40	109
	Spring's Awakening	75	119
Geoffrey Garnier	H M S Malabar Leaving Harbour	5-5	147
	H M S Revenge and French Prize Hulk	5-5	149
	H M S Orion at Trafalgar	5-5	152
Jill Garnier	Old Studios, Newlyn	8	27
	Myrtle Cottage	12	120
Geo. Gillingham	Decorative Panel (Chrysanthemums)	20	9
	Twilight, St Ives Harbour	8-8	131
	Cromwell's Tower, Isles of Scilly	12-12	167
Mary Grylls	The Green Studio at St Ives	5-5	139
W A Gunn	The Flower Shop	20	87
	Power Station, Hayle	10	125
	Room with a View	10	130
Arthur Hambly	Tankers at Falmouth	12	146
Malcolm Haylett	Inspiration	75	96
Pauline Hewitt	Austrian Tyrol	40	54
	St Paul's Cathedral 1942	40	63
Amy Hicks	The Lantern Pool	6	15
Ernest Hill	Cottage at Carngloose, St Just	9-9	69
P Maurice Hill	The Depth Charge	31-10	116
	Cheyne Row, Chelsea	15-15	168
Eric Hiller	Mount's Bay and Penzance	26-5	132
	Trees and Barn at Newlyn	26-5	138
E. Bouverie Hoyton	The Mount from Perranuthnoe	35	17
	St Michael's Mount	90	127
Robert M Hughes	Boscawen Point	50	64
	The Alps from La Grave, France	14	159
Winifred Humphrey	A Present	12-12	111
	Arrangement for April	25	165
Eileen Izard	Memories of a Cornish October	30	94
	The West African Carving	30	117
Frank Jameson	Beginning the Day	75	42
	In the Studio	NFS	108
Leslie Kent	The Harbour, St Ives	38	52
	Hazy Day, St Ives	45	56
	Afternoon Sun, St Ives	21	80
Una Shaw Lang	Portrait of a Carthorse	25	150
Denys Law	Lamorna Woods	20	76
	St Michael's Mount	20	82
D Alicia Lawrenson	Camelias	15-15	84
	Clodgy, St Ives	8	151
Gai Layor	Fleur Mort	18-18	2
	Apples	18-18	81
Isabel Macpherson	Old Cottage, Boscastle	8	12
	Misty Morning, St Ives	8	22
Thomas Maidment	The Slipway, St Ives	14-14	13
	Ayr Lane, St Ives	10-10	32
	Man's Head Rock, St Ives	35	114
Marjorie Mort	Mousehole	8-8	37
Bernard Ninnes	The Shop at the Corner, St Ives	40	40
	A Cornish Hamlet (Nancledra)	50	55
	Quay House, St Ives	18-18	61
John Park	Summer, St Ives	35	50
	Spring on the Rive	21	59
	Symphony in Grey, St Ives Harbour	18-18	160
Charles Pears	The Clerk's Dream	52-10	95
	In Dock	105	107
Ernest Peirce	Buckden Pike from the Steke Pass, Yorks	25	75
G.F.Pennington	A Cornish Farm, Boscawn-un	5-5	15a

William Piper	Watergate, near Newquay	10	135
Dora Pritchett	Old Quay Street, Mousehole	7-7	133
E Tangye Reynolds	Roses	45	97
Eleanor Rice	Pedn Olva	6-6	10
	Wharf Road	6-6	30
	Snow on Wharf, St Ives	7-7	129
Hugh Ridge	Sennen	25	72
	Sunlit Harbour	25	74
Thomas Heath Robinson	Man's Head	5-5	4
	Bookplate	19	156
C Douglas Salisbury	Terra Cotta Mask	3-3	163
Helen Seddon	Flowers of Autumn	20	11
	From A Cornish Garden	18	31
	From A Cornish Garden	18	38
Dorothea Sharp	Springtime	60	101
Charles Simpson	Lamorna Stream in Early Spring	50	44
	Herring Gull, Lamorna Cove	40	118
Marcella Smith	Flowers from a Cornish Garden	26-5	26
	The Quay	18-18	46
Ada Somerville	Tulips	3-10	137
	Polperro, Cornwall	1-10	154
	Polruan, Cornwall	1-10	155
Dorcie Sykes	Festival of Spring	25	7
	Polyanthus	18-18	34
John Titcomb	Near Christchurch, Hants	6-6	122
William Todd Brown	Resting	10	20
	Garden by the Sea	35	73
	View from My Window	14	169
A D Trounson	S S Nellie	8-8	143
Ann Fearon Walke	Fine Morning	26	67
L E Walsh	St Ives Studio Window	30	65
	Portrait of a Cornish Sailor	45	66
Billie Waters	Back Garden, Lelant	21	76
	Flowerpiece	21	113
	Design of Poppies	17-17	136
R.C.Weatherby	My Chestnut Horse	60	51
	The Lost Pony	60	60
	The River Thames	40	105
Helen Stuart Weir	Flower Decoration	36-15	53
	The Christmas Cake	36-15	57
	Camelias	18-18	171
Gwen Whicker	Belladonna Lilies	20	104
	Inner Harbour, Falmouth	20	166
A.T.White	Old House in St Ives	6	58
Arthur White	Evening Glow, St Ives Harbour	40	86
	A Showery Morning, St Ives	50	100
Clare White	Court Cocking	9	21
	Old House at Mousehole	9	128
Constance White	Siesta	15-15	92
Sibylla Wightman	Cornish Water	21	70
Rendle Wood	Springtime in Cornwall	25	83
Eileen Wyon	A Cornish Priest	84	62
SCULPTURE SECTION			
Faust Lang	Tern	27-10	175
	Fish Salesman	64	176
	Marten	52-10	178
Wharton Lang	Spaniel Puppy	18-18	173
	Carthorse	21	174
	Ibex	36-15	177
Allan Wyon	Venetia	NFS	172

APPENDIX D

AUCKLAND ART GALLERY ⁄ THE MACKELVIE COLLECTION

ARTIST	WORK OF ART	MEDIUM	DATE ACQ'D IF NOT 1930-1
Sir William Ashton	Loscinsko	oil	
Lamorna Birch	Old China Clay Pit, Penwithack	oil	
	River Deveron	w/c	
	On the Deveron	w/c	
	Piha	oil	
Arnesby Brown	After the Heat of the Day	oil	1936
Lowell Dyer	Landscape	oil	c.1900
Stanhope Forbes	Penzance	oil	1937
	A Cornish Fisherman	oil	
Arthur Hambly	Chapelporth, Cornwall	w/c	1912
Alfred Hartley	Stone Pines	aquatint	
	Evening in Provence (Two figures in a Landscape)	aquatint	1978
	St Ives Harbour	aqua/etch	
	Old Archway, Asolo	etching	
	Landscape	aqua/etch	
	In the Forest	aquatint	
	Garden Gate, Bordighera	etching	
	Chateau de Blonay	etching	
Arthur Hayward	Village of Paul, Penzance	oil	
Moffat Lindner	On the Giudecca, Venice	oil	
	On the Maas	w/c	
Arthur Meade	Dorset Farmyard	oil	
Job Nixon	Madonna in the Wall, Subiaco	etching	1932
Dorothea Sharp	Lambs	oil	
Salomon Van Abbé	The Little Handful	etching	?
Terrick Williams	Concarneau	w/c	

Works originally acquired but subsequently sold

ARTIST	WORK OF ART	MEDIUM	
Hurst Balmford	Mousehole	oil	
	Low Tide	oil	
George Bradshaw	Breakers	w/c	
	St Ives Bay	oil	
Arthur Hambly	Lelant Church	w/c	
Arthur Hayward	A Sunlit Garden	oil	
John Littlejohns	Berkshire	w/c	
Arthur Meade	Ramparts	oil	
	Farmyard	oil	
Fred Milner	Cotswold Stream	oil	
	Chichester Plain	oil	
Julius Olsson	Evening Shower	oil	
John Park	Morning Light, St Ives Harbour	oil	
	Fishermen's Quarters	oil	
Borlase Smart	Westerly Gale	oil	
E.M Willetts	The Sloop Inn, St Ives	w/c	

The collection also includes work by Frank Bramley (*For of such is the Kingdom of Heaven*), Frank Brangwyn, Harold and Laura Knight, Alfred Munnings, Henry Tuke, Norman Wilkinson, and a Christopher Wood oil, *The Sloop Inn, St Ives*, dating from 1926.

BIBLIOGRAPHY

H.Bedford, *Frank Gascoigne Heath and His 'Newlyn School' Friends at Lamorna*, Teddington, 1995

Belgrave Gallery/John Lindsay Fine Art, *Bernard Fleetwood-Walker*, London, 1981

S.Berlin, *The Dark Monarch*, London, 1962

S.Berlin, *The Coat of Many Colours*, Bristol, 1994

Bourne Gallery, *Eleanor Hughes*, Reigate, 1982

R.Brangwyn, *Brangwyn*, London 1978

David Buckman, *The Dictionary of Artists in Britain since 1945*, Bristol, 1998

Katie Campbell, *Moon Behind Clouds - An Introduction to the Life and Work of Sir Claude Francis Barry*, Jersey, 1999

Canynge Caple, *A St Ives Scrapbook*, St Ives 1961

B.Cole and R.Durack, *Railway Posters 1923-1947*, London, 1992

T.Cross, *The Shining Sands*, Tiverton, 1994

T.Cross, *Painting the Warmth of the Sun*, Penzance and Guildford, 1984

T.Cuneo, *The Mouse and his Master*, London, c.1978

D.Cuppleditch, *The London Sketch Club*, Stroud, 1994

Langston Day, *The Life and Art of W.Heath Robinson*, London, 1947

C.B. de Laperriere, *The Society of Women Artists Exhibitors 1855-1996*, Calne, 1997

C.B. de Laperriere, *The Royal Society of Marine Artists Exhibitors 1946-1997*, Calne, 1998

M.Evans, *Marianne and Adrian Stokes - Hungarian Journeys*, London, 1996

Falmouth Art Gallery, *Faces of Cornwall - An Exhibition of Portraits of Cornish Men, Women and Children from the 16th Century to the Present Day*, Falmouth, 1987.

Falmouth Art Gallery, *Gwen Whicker and Fred Whicker*, Falmouth, 1994

C.Fox and F.Greenacre, *Painting in Newlyn, 1880-1930*, London, 1985

L.Fuller (illustrated by M.Mostyn), *Cornish Pasty*, St Ives, early 1960s

M.Garlake, *Peter Lanyon*, London, 1988

Peter Garnier, *Geoffrey S. Garnier ARWA, SGA (1889-1970) and Jill Garnier, FRSA (1890-1966)* in H. Berriman, *Arts and Crafts in Newlyn 1890-1930*, Penzance, 1986

W.A.Gaunt, *The Etchings of Frank Brangwyn*, London, 1926

J.Goodman, *AJ - The Life of Alfred Munnings*, Norfolk, 2000

Algernon Graves, *Royal Academy of Art*, 1796-1905

L.Green, *W. Barns-Graham : A Studio Life*, London, 2001

K.Guichard, *British Etchers 1850-1940*, London, 1977

M.Hardie, *100 Years in Newlyn - Diary of A Gallery*, Penzance, 1995

M.Hardie, *E. Lamorna Kerr - In Time and Place, Lamorna*, Newmill, 1990

P.C.Hills, *A Cornish Pageant - Father Bernard Walke and Artist Annie Walke*, Camborne, 1999

J. Johnson & A. Greutzner, *British Artists 1880-1940*, Woodbridge, 1976

L.Knight, *Oil Paint and Grease Paint*, London and New York, 1936

J.Laver, *A History of British and American Etching*, London, 1929

David Lewis, *Terry Frost*, Aldershot, 1994

J.Lewis, *Heath Robinson - Artist and Comic Genius*, London, 1973

J.Littlejohns, *British Water-Colour Painting and Painters of To-Day*, London, 1931

Valerie Livingston, *W. Elmer Schofield, Proud Painter of Modest Lands*, Bethlehem, Pennsylvania, 1988

Norbert Lynton, *Ben Nicholson*, London, 1993

A. Mackenzie-Grieve, *Time and Chance*, London, 1970

K.McConkey, *British Impressionism*, Oxford, 1989

K.McConkey, P.Risdon and P.Sheppard, *Harold Harvey - Painter of Cornwall*, Bristol, 2001

Patricia R. McDonald, *Barbara Tribe - Sculptor*, Sydney, 2000

David Messum and Linda Wortley, *British Impressions*, Marlow, 1998

Newlyn Orion, *Marjorie Mort, Fifty years of Painting 1935-1985*, Newlyn, 1985

Penwith Society, *Borlase Smart Memorial Exhibition*, St Ives, 1949

Penwith Society, *Norman and Alethea Garstin - Two Impressionists*, St Ives, 1978

Penwith Society, *Borlase Smart - The Man and his Work*, St Ives, 1981

Brigid Peppin and Lucy Micklethwait, *Dictionary of British Book Illustrators - The 20th Century*, London, 1983

Mrs C.Morton Raymont, *The Early Life of R.Morton Nance*, 1962

L.Richmond, *The Art of Landscape Painting*, London and New York, 1928

L.Richmond, *The Technique of Still Life Painting in Oil Colours*, London, 1936

L.Richmond, *From the Sketch to the Finished Picture: Oil Painting*, London, 1953

Royal Academy Exhibitors 1905-1970

Royal Birmingham Society of Artists, *Bernard Fleetwood-Walker Memorial Exhibition*, c.1966

St Ives Society of Artists & W.Fisher, *Edward Bouveroe-Hoyton - The Lifetime's Work*, St Ives, 1987

M.Salaman, *Modern Woodcuts and Lithographs by British and French Artists*, The Studio, 1919

H.Segal, *As I Was Going to St Ives*, St Ives, 1994

D.Sharp, *Oil Painting*, London, 1937

C.Simon, *Mist and Morning Sunshine - The Art and Life of Terrick Williams*, London, 1984

C.Simpson, *Animal and Bird Painting*, London, 1939

C.Simpson, *The Fields of Home*, Leigh-on-Sea, 1948

Borlase Smart, *The Technique of Seascape Painting*, London, 1934

Marcella Smith, *Flower Painting in Watercolour*, London and New York, c.1951

F. Spalding, *Twentieth Century Painters and Sculptors*, Woodbridge, 1990

J.M.Stacpoole, *James Tannock Mackelvie and his Trust*, an essay in the catalogue for *The Mackelvie Collection - A Centenary Exhibition* 1885-1985, Auckland, 1985

Ed. MaryAnne Stevens, *The Edwardians and After - The Royal Academy 1900-1950*, London, 1988

Tate Gallery, *St Ives 1939-1964*, London, 1985

Rosalind Thuillier, *Marcus Adams : Photographer Royal*, London, 1985

David Tovey, *George Fagan Bradshaw and the St Ives Society of Artists*, Tewkesbury, 2000

C.E.Vulliamy, *Calico Pie*, London, 1940

Walker Art Gallery, *Memorial Exhibition of Mary McCrossan*, Liverpool, 1935

Walker Art Gallery, *James Hamilton Hay*, Liverpool, 1973

G.Waters, *Dictionary of British Artists Working 1900-1950*, Eastbourne, 1975

Welsh Arts Council, *An Artist in the Quarries - Miss M.E.Thompson*, Cardiff, 1981

M.Whybrow, *St Ives 1883-1993*, Woodbridge, 1994

Who's Who in Art - various editions

R.H.Wilenski, *Drawings and Paintings by Joan Manning-Sanders*, London, 1929

C. Wood, *Dictionary of Victorian Painters*, Woodbridge, 1971-1985

J.Wood, *Hidden Talents - A Dictionary of Neglected Artists Working 1880-1950*, Billingshurst, 1994

A. Wormleighton, *A Painter Laureate - Lamorna Birch and his Circle*, Bristol, 1995

A.Wormleighton, *Morning Tide - John Anthony Park and the Painters of Light*, Stockbridge, 1998

L.Wortley, *British Impressionism - A Garden of Bright Images*, London, 1988

PERIODICALS

Artist, The - passim but particularly

Dr G.C.Williamson, *Moffat P.Lindner and his Work*, The Artist, April 1902

H.Sawkins, *Famous Artists - Arnesby Brown*, The Artist, August 1933

H.Sawkins, *Famous Artists - Stanhope Forbes*, The Artist, October 1933

G. Kortright, *Decorative Landscape Painting*, The Artist, September and following months 1934

T. Williams, *Harbour and Fishing Subjects*, The Artist, March and following months 1935

H.Sawkins, *Artists of Note - Dorothea Sharp*, The Artist, April 1935

H.Sawkins, *Artists of Note - John Park*, The Artist, September 1935

Herbert Grimsditch, *Artists of Note - Billie Waters*, The Artist, August 1938

H.Sawkins, *Artists of Note - Arthur Burgess*, The Artist, February 1942

Artists of Note - Frederick S. Beaumont, The Artist, August 1948

C.Wade, *Artists of Note - Charles Pears*, The Artist, December 1948

Artists of Note - S.Van Abbe, The Artist, July 1949

C.Pears, *On Marine Painting*, September and following months, 1949

S.Van Abbé, *What's In A Book Jacket*, The Artist, January and February, 1950

G.M.Place, *Artists of Note - Leonard Fuller*, The Artist, July 1950

H.Segal, *Drawings of Character*, The Artist, September and following months, 1951

Ed. L.Richmond, *Art Therapy - Hyman Segal's Work in Cornwall*, The Artist, February 1953

Cornish Review - passim but particularly

Notes on Contributors

Charles Marriott, *Memories of Cornwall's Art Colonies*, The Cornish Review, Spring 1949, No.1

David Cox, *Painting in Cornwall*, The Cornish Review, Summer 1949, No.2

Noel Welch, *The Du Mauriers*, The Cornish Review, Summer 1973, No 24

News Chronicle - 1939 series on Cornish Artists

St Ives Times - passim

St Ives Weekly Summary and Visitors List - passim

Studio, The - passim but particularly

A Hartley, *A Painter's View on Photography*, The Studio, Vol 4, 1894

C.Lewis Hind, *Mr Moffat Lindner's Watercolours of Venice*, The Studio, Vol 32, 1904

A.G. Folliott Stokes, *The Landscape Paintings of Mr Algernon M Talmage*, The Studio, Vol.42, 1907

A.G.Folliott-Stokes, *Mr Algernon Talmage's London Pictures*, The Studio, Vol.46, 1908

A.G.Folliott Stokes, *Julius Olsson, Painter of Seascapes*, The Studio, Vol 48, 1909

C.Lewis Hind, *An American Landscape Painter, W.Elmer Schofield*, International Studio, 48, 1913

M.C.Salaman, *The Woodcuts of Mr Sydney Lee ARE*, The Studio, 1914

A.G.Folliott Stokes, *Alfred Hartley, Painter and Etcher*, The Studio Vol 64 1915

A.G.Folliott Stokes, *The Paintings of Louis Sargent*, The Studio, Vol.77, 1919

A.L.Baldry, *Modern Painting III : The Work of Arnesby Brown*, 1921

Campbell Dodgson, *Mr. Job Nixon's Etchings*, The Studio, Vol. 87, 1924

Jessica Walker Stephens, *Guy Kortright*, The Studio, Vol.91, Jan 1926

B.Smart, *The St Ives Society of Artists*, The Studio, 1948

G.S.Whitter, *David Cox*, The Studio, August 1952

West Briton - passim

Western Echo - passim

INDEX

Artists whose names are in bold type have entries in the Dictionary of Members. Those artists whose names are also underlined are included in Part A whereas those whose names are not underlined are in Part B. Artists whose names are in italics are in Part C. Reference should be made to Dictionary entries for paintings exhibited or illustrated.

COLOUR ILLUSTRATIONS
Front Cover - Dorothea Sharp Low Tide (Rochdale Art Gallery)
Back Cover - John Park The Fringe of the Tide (Leamington Spa Art Gallery and Museum, Warwick District Council)
The colour plates can be found between the pages mentioned below:-
Plates 1-9 are between pages 24-25, Plates 10-20 are between pages 48-49, Plates 21-30 are between pages 64-65, Plates 31- 37 are between pages 72-73, Plates 38-46 are between pages 80-81, Plates 47-55 are between pages 96-97, Plates 56-62 are between pages 152-153, Plates 63-71 are between pages 168-169, Plates 72-79 are between pages 176-177 and Plates 80-88 are between pages 208-209.